art

&

trousers

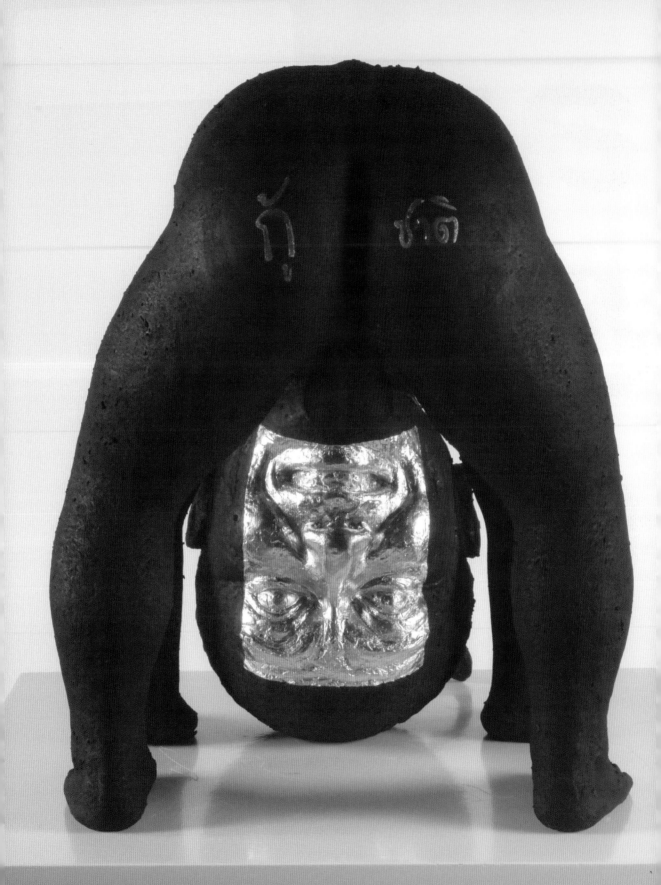

art

&

trousers

TRADITION AND MODERNITY IN CONTEMPORARY ASIAN ART

artasiapacific

David Elliott

Contents

1 | Chatchai Puipia | Better than Ever? | 2008 |
Patinated, gilded, and painted bronze | 40 x 32 x 35 cm |
P. Chirathivat Collection

Acknowledgements
David Elliott

Throughout this book, I have tried to acknowledge the generosity of those who have taught, advised and helped me in different ways. Consolidating their contributions here, I should also like to mention many others who may not even realize how much they have been an inspiration or example. But firstly, I should like to thank Elaine W. Ng, publisher of ArtAsiaPacific, and HG Masters, the editor of this book, for their guidance, advice and cheerful forbearance in taking on such a far-reaching project. What was initially discussed, six years ago, as a collection of previous essays about artists quickly morphed, for the better, into this wide-ranging Bildungsroman about art, history and power. Much new writing was produced as a result, including the historic record of the Museum of Modern Art Oxford's pioneering engagement with Asian modern and contemporary art during the 1980s and '90s, as well as the idiosyncratic (and first) historical narrative of the trouser that glues the whole book together.

At the turn of the 1960s and '70s, when I first began to work with art, I derived energy and knowledge by following the example of fellow-undergraduates Ian and Sandy Barker, and of luminaries such as Ken Baynes, Lutz Becker, Joanna Drew+, Lionel Lambourne+, Jack Pritchard+, Philip Rawson+ and Frank Whitford+. A little later, when I became director of the Museum of Modern Art Oxford, I depended on the enthusiastic support of my colleagues. I would like to thank in particular Rob Bowman, Astrid Bowron, Carol Brown+, Ian Cole, Mark Francis, Graham Halstead, John Hoole, Chrissie Iles, Toby Jackson, Pamela Kember, Marco Livingstone, Donna Lynas+, Janet Moore, and Christine Newton, as well as the museum's board, in particular its chairmen, Alan Griffiths, Nicolas Mann, David Pears+, and Louis van Praag+, and its Presidents John Piper+, Arnold Goodman+, and Patrick Nairne+. Here, I should also mention my long-standing New York friend Richard Menschel, who far-sightedly and generously sponsored many of what were then described (by some British art bureaucrats) as "unsponsorable" exhibitions—and he has also supported this book.

At the beginning of the millennium, when I traveled to Tokyo at the invitation of Minoru Mori+, to become director of the Mori Art Museum, I was indebted to Yoshiko Mori, the head of the museum board (and also a generous supporter of this book) for her confidence and support. I should also like to thank Natsumi Araki, Edan Corkill, Mami Hirose, Yumi Hojo, Mami Kakaoka, Sun-Hee Kim, Kenichi Kondo, Tomoko Kuroiwa, Yoko Miyahara, Takako Nagano, Fumio Nanjo, Asako Ogita+, Yu Serizawa, Yukiko Shikata, Kenichiro Shinohara, Eise Shiraki, Mina Takahashi, Mizuki Takahashi, Shinya Takahashi, Reiko Tsubaki as well as the other curatorial, administrative and technical staff who researched and worked there so meticulously.

In addition to all the artists listed in the contents and index, without whose lives, work and example this book could never have been created, I should also like to convey my deep gratitude to the following whose presence, in vastly different ways, is reflected among these pages: Leeza Ahmady, Ebrahim Alkazi+, Roshen Alkazi+, Uma Anand, Deepak Ananth, Peter Bagrov, Irene Bradbury, Andrew Brighton, Christopher Brown, Tsong-zung Chang, John Clark, Craig Clunas, Jeremy Coote, Andreas Dammertz, Rhana Devenport, Joe Earle, Oya Eczacıbaşı, Fei Dawei, Hilary Floe, Doug Hall, Peter Hamilton, Francis Haskell+, Larissa Haskell, Chester and Davida Herwitz+, Oscar Ho, Mark Holborn, Richard Hollis, Hou Hanru, Haruko Hoyle, Claire Hsu, Kazu Kaido, Geeta Kapur, David King+, Naum Kleiman, Gabriele Knapstein, Vasıf Kortun, Komal Kothari+, Aleksandr Lavrentiev, Jay Levenson, Kim Levin, Angelika Li, Agnes Lin, Brian Love, Rogert Malbert, Nonna Materkova, Lydie Mepham, Henry Meyric Hughes, Viktor Misiano, Alexandra Monroe, Howard Morphy, Trilokesh Mukherjee, Djon Mundine, Victor Musgrave+, Seiji Oshima+, Tetsuya Ozaki, Leon Paroissien, Apinan Poshyananda, Waldo Rasmussen+, Donald Ritchie+, Rachel Rits-Volloch, Andrew Robinson, Angela Schneider, Peter-Klaus Schuster, Wendy Shaw, Yuliya Sorokina, Jim Supangkat, Michael Sullivan+, Chie Sumiyoshi, Deborah Swallow, Ryutaro Takahashi, Akira Tatehata, Gilane Tawradros, Pier Luigi Tazzi, Philipp von Matt, Joni Waka, Kunio Yaguchi+, Satoru Yamashita and Nataliia Zabolotna. I should also like to warmly thank Vishakha Desai who has so kindly contributed the forward to this book as well as Judith Neilson, Ek-Anong Phanachet, Fabio Rossi, Leng Lin, Sueo Mitsuma, and Hidenori Ota, who, with other mentioned above, have generously provided support for its publication.

I first used "Art & Trousers," this book's title, in 2002 for a talk at the Asia in Transition: Representation and Identity symposium that Yasuko Furuichi had organised for the Japan Foundation Asia Center in Tokyo. Its scope has exploded since then and in 2010 was given a shot in the arm through my work for the Toshiba Lecture series Rethinking Art After the Age of "Enlightenment" that Nicole Rousmaniere, founding Director of the Sainsbury Institute for the Study of Japanese Art and Cultures, asked me to deliver at the British Museum and in Norwich. Although neither Yasuko nor Nicole could have realised how this would end, I am grateful to them both for having prompted me to get on with

The format of this book, its playfully surrealistic montages reflecting the trans-disciplinary nature of the authorial approach, is the work of award-winning designer and typographer Jonathan Barnbrook, with whom I have cooperated for nearly two decades. I should like to thank him warmly as well as Anıl Aykan, his managing partner, whose sensitive and skilful design for the book is, I hope, matched by its words and ideas. The responsibility for any lacunae or errors, however, must remain mine alone.

Last, but certainly not the least, I should like to thank my family. They have not only shown impressive forbearance by tolerating, and at times sharing, my peripatetic travels, but have also been an unending fount of good humor, support, inspiration and hope. •

Publisher's Note
Elaine W. Ng

The idea to produce a collection of David Elliott's writings about contemporary art from Asia dates back to a 2014 dinner in Hong Kong. Now, more than six years later, ArtAsiaPacific is pleased to publish 33 essays written by Elliott between 1988 and 2016 in Art & Trousers: Tradition and Modernity in Contemporary Asian Art. Accompanied by a spirited cultural history of pantaloons from prehistoric Central Asia to Victorian England, Elliott's writings capture his broad interests in the early modernism of Meiji-era Japan and the first decades of the Republic of Turkey, to the many contemporary artists with whom he has worked closely during his five decades as a curator and museum director.

Art & Trousers begins with a reflection on Elliott's time as director of the Museum of Modern Art in Oxford, where in the 1980s, he launched a series of exhibitions about the modernist avant-gardes in India, Japan, and China. These projects highlighted many artists largely unknown at the time to audiences in the United Kingdom, from the members of Mumbai's Progressive Artists' Group and Nalini Malani, to the Japanese artists of the Gutai collective and Yayoi Kusama, and pioneering contemporary Chinese artists such as Huang Yong Ping and Zhang Peili. These curatorial initiatives marked the beginning of what Elliott describes as a period of "going global" not only for himself but for the wider art world. Elliott went on to become director of Moderna Museet in Stockholm from 1996 to 2001, and then was recruited to direct the newly established Mori Art Museum in Tokyo from 2001 to 2006 before helping to launch the Istanbul Museum of Modern Art in 2007. In his post-institutional career, Elliott was selected as the artistic director for the 17th Biennale of Sydney (2008–10), the 1st Kiev International Biennial of Contemporary Art (2011–12), curated the "Bye Bye Kitty!!! Between Heaven and Hell in Contemporary Japanese Art" at the Japan Society Gallery in New York in 2011, among many other large-scale curatorial projects in locations around the world.

The essays in Art & Trousers reveal not only Elliott's wide-ranging interests but the depth of his historical and cultural knowledge and keen insights to the lived experiences of artists themselves. From penning a eulogy for the Thai artist Chatchai Puipui's exhibition that was staged as a mock funeral, to analyzing the puerile humor in Makoto Aida's satires of Japanese cultural taboos, Elliott has been consistently drawn to artists who reflect on the world through ribald humor and dark comedy. Yet he is also sensitive to the adversity that many artists have faced in their lives that gives rise to the subjects of their works. Throughout we see how art, for Elliott, is a means through which to learn about people and the places from which they come.

Bringing together Elliott's writings about artists from across Asia in Art & Trousers offers readers—whether students of art history or those interested in history and culture more broadly—an opportunity to reflect on the growing interconnection of the world in the late 20th century and early 21st century through contemporary art. This collection would not have been possible without the time and support of many people.

Our thanks goes to Vishakha Desai, President Emerita of the Asia Society in New York, who penned the foreword. The design of the book is by award-winning British designers and typographers Jonathan Barnbrook and Anıl Aykan, with whom Elliott has worked extensively. We are grateful to the many people and organizations who have given us permission to reproduce these texts and images, and especially to those who have supported the publication of this book including: Yoshiko Mori, Judith Nelson, Aey Phanachet and Roger Evans, the Charina Foundation, Rossi & Rossi, the Korea Arts Management Service (KAMS), Pace Hong Kong, Perrotin, Mizuma Art Gallery, and Ota Fine Arts. At a time of increasing fragmentation and global tensions, Elliott's writings in Art & Trousers offer a powerful testament to the shared histories and experiences that we all can relate to, no matter what kind of trousers or pants or jeans we are wearing today. •

Prologue
Vishakha N. Desai

I first met David Elliott at a conference on museums at Harvard University in the spring of 1989. I remember the encounter well as it changed the trajectory of my professional life. I was a curator at the Museum of Fine Arts, Boston, with the responsibility to oversee the great traditional collection of Indian, Southeast Asian, and Islamic art. As the conference was small and primarily intended for the participants, there were plenty of opportunities to have long and substantive conversations. After learning about David's deep interest in and knowledge of modern Indian art, I shared with him my experience of discovering early 20th-century works by the Tagore family, including some by the Nobel Laureate Rabindranath Tagore (1861–1941) and his nephew Abanindranath (1871–1951), in the Museum's collection. The renowned scholar and longtime Boston Museum curator Ananda Coomaraswamy gave the works as a gift, but because of the department's policy of not collecting 20th-century art at the time, they were shipped off to the department of prints and drawings, never to see the light of day again. As I relayed the story to David, he immediately piped up: "Aren't you now occupying the position once held by Coomaraswamy? What are you going to do about it? Have you thought about why so many encyclopedic museums refuse to collect or exhibit 20th-century works of art from Asia even when they hold a treasure trove of pre-modern works from the region?" A light bulb went off in my head. Indeed, why? I gave a feeble answer. Modern art was less "authentic" precisely because it was created under the influence of colonial western powers. Because of its hybridity, 20th-century Asian art was often perceived as a pale reflection of the dominant western influences; neither pure enough, nor good enough. David smiled as he asked who decided that. His question kept ringing in my head long after the conference.

Growing up in early independent India with parents who were freedom fighters and proud nationalists, I was used to ferocious discussions among my parents' friends, especially writers, artists, and journalists, about the role of modern art and for the need to preserve cultural heritage in the new nation. No distinction was made between creating and supporting new art and caring for the old works. My father, a passionate collector of art and books, had accumulated 6th-century temple sculptures, 17th-century folk bronzes, 19th-century embroideries, as well as paintings by modern artists of the day. I had grown up with these eclectic works. But as a graduate student in art history in the United States and as a curator at a distinguished American art museum, I had bought into the prevailing notion that traditional works were worthy of study and acquisition because they were "authentic" and therefore more illustrative of the civilizational ethos of the country before the strong influence of the colonial West.

David's question turned this logic on its head. Who decides what is "authentic" and therefore "good"? As anthropologist James Clifford has pointed out, it is ironic that just as the western powers began colonizing Asia, they determined that the art produced under their influence was not "pure" and hence unworthy of study or appreciation. David had intuitively rejected this dominant paradigm and had begun to explore works by such major Indian artists as KG Subramanyan. He had come to his position from a preference for alternative narratives in art. He defiantly questioned the Euro-American centricity of the market and the art institutions, especially in the prevailing political context of Thatcher-Reagan regimes in Great Britain and the United States. I was taken as much by David's intellectual argument about the need to broaden the perspectives that were stymied by the gatekeepers of the western establishment as by his political sensibilities that fought vociferously against implied racist or exclusionary tendencies of the times.

Now, for me, there was no going back to staying within the confines of traditional or pre-modern Asian art. I read everything I could find on modern and contemporary Indian art and was pleasantly surprised that among my favorite publications were Gods of the Byways and The Other India, both published in 1982 by the Museum of Modern Art, Oxford, under David Elliott's direction. I began to include some aspects of modern and contemporary art in the university course I taught and made arguments about the need for presenting Asian art of our times in museums. Finally, I had the opportunity to make this case at the institutional level when I joined Asia Society as the director of its museum in 1990. A Rockefeller institution renowned for its presentation of traditional Asian art as well as for its focus on contemporary political and social issues, Asia Society seemed to be an ideal place to shake up the traditional norms surrounding Asia and Asian art. But America was still in the dark ages when it came to exhibiting, collecting, or even researching 20th-century Asian art. Given the dearth of scholars, curators, and educators in the country, the first order of business was to bring together curators and scholars from Asia and around the world with their counterparts in the US. David was one of the first people I contacted. That gathering in 1992 had the same sense of transformation that I had felt when I first met him in Boston. Full of excitement of discovery for some—many American curators had no idea about the thriving art scene in many parts of Asia—combined with expressions of pent up frustration for others (several Asian curators were visibly dismayed and simultaneously pleased that finally they were having their say in the contemporary art center of the world), the meeting paved the way for a long-term strategy to present contemporary Asian art at Asia Society, one of the first American institutions to do so. David was central to that strategy.

Over the last 25 years, the modern and contemporary Asian art landscape has dramatically changed, just as much as the perception of Asian countries in the geopolitical and economic arena. The rise of China as a significant global player, now vying to eclipse the United States, as a sole superpower is a significant fact of our times. The Indian diaspora in the UK and in the US is a major player in the acquisition of modern Indian art from auction houses. Major Chinese, Indian, Korean, and Japanese artists are routinely seen in international biennials, triennials, festivals and commercial art fairs in the West as well as in Asia. One could argue that gone are the days when contemporary Asian art was seen as exotic at best, provincial and derivative at worst. However, when it comes to a serious study of Asian artists, either modern or contemporary, there is still a dearth of comprehensive scholarship. David Elliott is one of those unusual scholar-curators who has stayed the course, moving to other countries in Asia when everyone seemed to have found a new frontier in China, connecting the art of our times with the art of the past when the art-world fashionistas firmly aligned themselves with the star artists of Asia. And he has done all this with a biting sense of humor (who else would combine art with trousers?), unabashed curiosity, vigilant reflection, and unalloyed adventurism. His accumulated wisdom is evident in the collection of essays that form this book.

Over the last two decades, I have had the pleasure of meeting David in far-flung places (Oxford, New York, Tokyo, Amsterdam, Berlin, and more) working on a myriad of projects. I am delighted that so many of his explorations, from Kiev to Ulaanbaatar, and so many of his reflections on artists from all parts of Asia and living in places beyond Asia are now brought together. Forever intellectually young but physically recognizing his age, David has thankfully decided to slow down just enough to create this book. The winners are all of us who care to gain a deeper understanding of contemporary Asian art, and those who will come after us to uncover the short history of the study of contemporary Asian art at the intersection of the last century and the present one. •

Foreword
Me and My Trousers
David Elliott

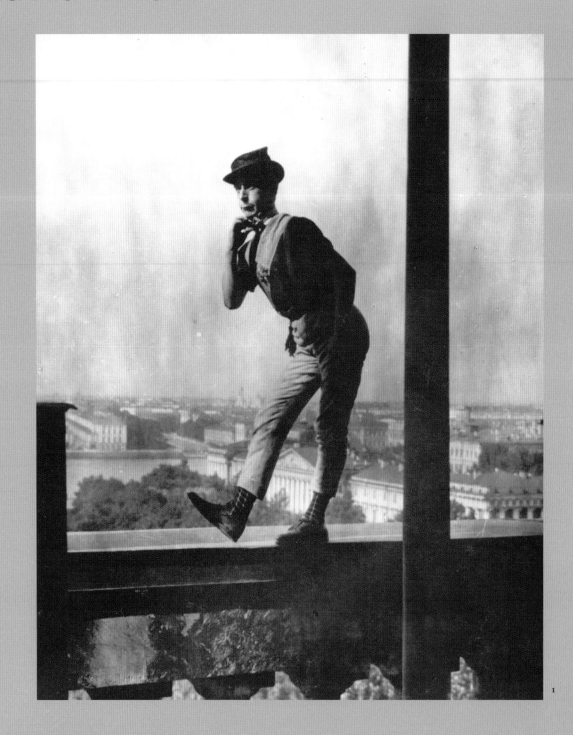

The trouser is a humble but redolent garment. Through millennia and over centuries, different threads of symbolism, fact, and use have been woven through its fabric, amplifying or undermining each other to create randomly shifting narratives. In the title of this book and the prefaces to each of its parts, I have enlisted the trouser not only to reflect the unpredictable trajectories of continuing cultural interchange and development, shaped as they always have been by wars, famines, diseases, migrations, conquests—as well as by much more trivial events—but also to express the self-righteous, masculine character of western colonization. This includes, eventually, the backlash that came once women had realized that their gender had also been colonized.

Rational and practical, bastions of modesty, models of rectitude: who could disagree with a trouser? They withstood hard wear and allowed free movement and were adopted as uniform by businessmen and workers as well as by the military. Colonizers, missionaries and soldiers carried them, along with much heavier baggage, to their newly conquered domains where they served as an index of the extent and penetration of western civilization. Radiating sweaty, righteous probity in the face of fit-for-climate sarongs, *lungis, dhotis, mundus, panchas, dishdashas,* loincloths, and penis sheaths, trousers became another visible expression of the "stiff upper lip" and of adherence to the supremacist ideals of Empire of whatever kind.

As well as presenting a concise history of the trouser from different points of view, this book is composed of 32 essays about art and artists from Central Asia, China, India, Indonesia, Japan, Korea, the Ottoman Empire, Pakistan, the Philippines, Russia, Thailand, Tibet, Turkey, and Ukraine that, under the headings of "Histories," "Stories" and "Migrations," scrutinize specific individual, collective, or national histories and the links between them, and examine different ways in which modernity and traditional culture have impacted contemporary art. Some tell the stories of artists and art that have migrated, or switched, between cultures; others are monographic and examine the development of single bodies of work within broader regional and international contexts; a great number of them have been written as accompaniments to exhibitions. They also reflect, and reflect on, the profound political, social, and cultural changes that have been taking place in both the world and art, the most far-reaching being the relative decline of the influence of the West—and the resulting rise of the East and South.[1]

Over the period to which these essays refer, in line with developments elsewhere, a large number of Asian women artists have emerged as significant international figures.[2] At the same time, attitudes to empire have been transformed, particularly since the end of apartheid in South Africa in 1994 and the British handover of Hong Kong to China in 1997, although, for the great majority, the harsh economic realities of the "new order" have proved to be not so different from before. This common era has also been characterized by the consolidation of a powerful, non-national capitalist oligarchy (whose surplus wealth has, among other things, pushed the market in contemporary art to ridiculously high levels), accompanied by the expansion of Asian economic and cultural influence abroad, and, in the case of China, by the establishment of new kinds of economic "empires," particularly in Africa.[3][4] The art market, still largely dominated by western interests, has flourished in this environment; it, too, has a tendency to "colonize" in that artists who are successful in it, whether they like the idea or not, are inevitably faced by the paradox of seeing their work commodified and monetarized within a system over which they have no control.

In 1976, when I took up the directorship of the Museum of Modern Oxford, the words "modern" and "contemporary" meant more or less the same thing, and one could still use the term "avant-garde" without any tinge of irony. Attribution of quality in art was then limited to a discrete set of discourses—a canon of progressive development—in which each part justified the development of the whole. This, however, was a gilded cage,

1 | Grigori Kozintsev and Leonid Trauberg [FEKS] | *The Adventures of Oktyabrina* | 1924 | silent feature film | courtesy Peter Bagrov | Made in Ektsentropolis [Petrograd], this classic "eccentric" revolutionary film is now lost.

[1] Both Franz Fanon (1925–1961) and Edward Said (1935–2003) have been inspirational figures in their critique of western colonialism, but such western scholars as Basil Davidson (1914–2010), Jack Goody (1919–2015), and Eric Hobsbawm (1917–2012) have also contributed greatly to the creation of well-founded critical perspectives, both on colonization and on the continuing institutionalization of Eurocentricity. [2] Long-neglected Japanese women artists like Yayoi Kusama (b. 1929) and Yoko Ono (b. 1933) have been at the forefront of this wider recognition. Over the past fifteen years, both have been recognized and celebrated in a number of large touring exhibitions and catalogues. See p. 43. [3] For instance, the Mumbai-based Tata industrial conglomerate owned (until recently) most of what little remains of the British Steel industry as well as the production of the "typically British" Jaguar and Land Rover automobile marques. The government of China invests widely overseas and is the largest foreign holder of US debt. [4] In Africa, Zambian artist Stary Mwaba (b. 1976) refers directly to the cultural effects of Chinese "colonization" on food production and the appropriation of natural resources in a number of works. See *Stary Mwaba: Life on Mars* (exh. cat.), Berlin, Künstlerhaus Bethanien, 2015. Chinese artist Xu Zhen also, obliquely, touches on this subject. See pp. 218–227.

11

bounded by the Grecian prejudices of the European Enlightenment and the myopic conservatism of the art market. Contemporary art then was largely a white boys' club with its scope restricted, more or less, to Western Europe and North America. I realized that I was a member of this, but wanted to be at its edge.

What better place than Oxford! Suddenly, with responsibility for an institution, and my decisions, thrust publically upon my shoulders, it seemed completely ridiculous that modern or contemporary art worthy of consideration could be limited by its location, ethnicity, or lack of trousers. So, I resolved to look elsewhere—including home—to compare the work I found, or was led to, with what I knew.[5] This meant unlearning much of the history I had been taught as well as absorbing unfamiliar histories and cultures in order to move towards a more widely comparative approach. I quickly realized that contemporary art was an area of activity and endeavor that could no longer be limited. It was becoming an open, level playing field on which anyone—of any sex or origin—could join the game.

Comparison is one of art history's most basic methods but, traditionally, what was compared was always of like with like. The wide span of contemporary art, however, disrupted this as hide-bound distinctions of gender, ethnicity, and geography were swept away. In their place were no longer the Eurocentric compromises of "enlightened" universalism, but an egalitarian, non-judgmental, self-renewing, even banal category: the "contemporary" that simply describes art made recently or now. Yet, as a result of this, a much more important, age-old question was again thrown into relief: "Is a particular work of art (whenever/wherever it was/is made, whoever made/makes it) really any good?"

I have tried to answer here this seemingly simple question, along with the complex issues it inevitably raises, truthfully and in a number of different ways. This has entailed an analysis of "goodness" in different contexts and from points of view that range in scope from moral philosophy to utilitarianism, and revert to the language and standards of aesthetics, a subject much reviled during the 1960s and 1970s by the competing materialist ideologies of both "western" capitalist and "eastern" communist states. The discussion here privileges the integrity, autonomy and honesty of the artist, as well as the question of the current role of beauty in art and that of its necessary opposites: horror, terror, ugliness, cruelty—and the thoughtful emotions they all invoke. Within this maelstrom, the human quality of art is decisive in making it "good" and, even though a work may refer to things other than itself, the point at issue is *how* good the work is *as art*—not as anything else. Sketching out an artist's biography has been an important first step in establishing a context, yet this does not eclipse the primary importance of an artist's unique intelligence, talent, and vision—without which there can be no spark or any work worth looking at.

In recent debates on "global art," much stress has been laid on the significance of cultural difference as well as on the holy cow of diversity that is dependent on it. In the UK, for instance, one of the main goals set by the government-funded Arts Council England in its current Ten Year Plan is promoting "a diverse workforce . . . as well as a more diverse leadership and governance."[6] Presumably, this is in contrast with the postcolonial, postmodern mishmash that prevailed before, and the "workforce" probably includes artists. But diversity in the "English" mind does not begin at home: when I worked for the Arts Council in the early 1970s it covered the whole of Great Britain, four different "countries" each with its own language, until 1994, when it was balkanized into separate entities for England, Wales, Scotland, and Northern Ireland. Now, four institutions encourage a diversity that no longer implicitly includes the countries of the UK on an equal basis with the rest of the world but each chooses, rather, to focus on diversity as "doing good" for "others." In such ways, out of the best of intentions, insidious barriers are consolidated or raised.[7]

[5] "Art From Elsewhere" is the title of a traveling exhibition and related book I produced in Glasgow, Birmingham, Middlesbrough, Preston, Eastbourne, and Bristol during 2014–16. David Elliott, *Art From Elsewhere: International Contemporary Art from UK Galleries,* London, Hayward Publishing, 2014. [6] Arts Council England, *Great Art and Culture for Everyone Ten Year Strategic Framework,* London, 2nd edition, 2013, Chapter 6 "Our Goals," No. 4 "Diversity and Skills," p. 55. [7] Rasheed Araeen's experience of emigration to the UK and of European attitudes to non-Europeans is relevant here. See pp. 344–353. [8] I am using the term "non-western" here as a way of describing that vast portion of the globe that used to be known as the "Third World," the "Developing World" and now the "Global South." Not one of them is really accurate in that considerable disposable wealth is located all over the world, including some of the poorest countries, but it is not distributed fairly either by taxes or other means. Also, in relation to what used to be the relative poverty of Asia, Japan has been an anomaly since the 1960s. Nevertheless, compared to the rest of the world, the "West"—the countries on the "Atlantic Rim"—are, per capita, still more wealthy.

In relation to contemporary "non-western" art, two polarized views have been forcefully held. [8] The first accepts that difference is for the most part attractive, necessary, and can be learned about and celebrated as an enhancement of common humanity without much threat of its being homogenized. The other view—a defensive, or, in some cases, "genetic" position—advocates that difference may not be fully "understood," or mediated, by anyone outside the culture in question because outsiders do not have the native linguistic, emotional, and, perhaps, intellectual capacity to appreciate its complexity. My choice has always been to follow the first path although, of course, I have had no alternative.

Gathered together, under the rubric of the humble, mobile, adaptable, diverse, and infinitely suggestible trouser, these essays present a record of the particular ways in which I, a non-Asian, have learned about contemporary art in and from Asia, and have explored its roots, through a study of both its modern manifestations and traditional canons. They trace a winding and fallible path of discovery and education that has served as both complement and supplement to what I already knew and had experienced. But they also pay tribute to the life-changing inspiration of "good" art, wherever it is made, as well as to the generous help of the many friends, Asian and otherwise, who have helped me to see it. ●

2 | Makoto Aida | still from **Ueno Pantaloon Diary** | 1990 | video | 1'10" | courtesy Mizuma Gallery, Tokyo | Like some kind of holy fool, this Japanese artist repeatedly wets himself in public. **See pp. 228–237**

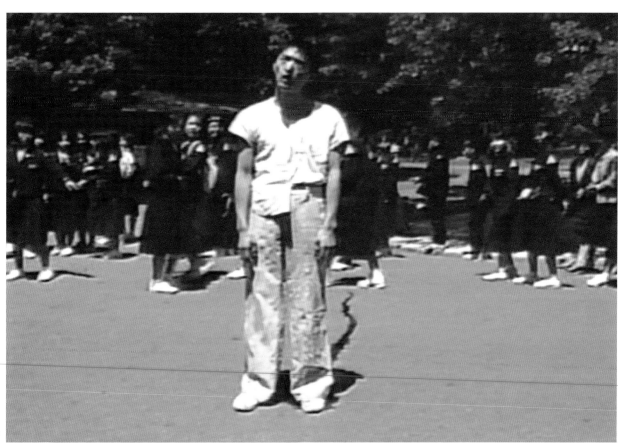

2

Part

One

Histories

The Slippered Pantaloon

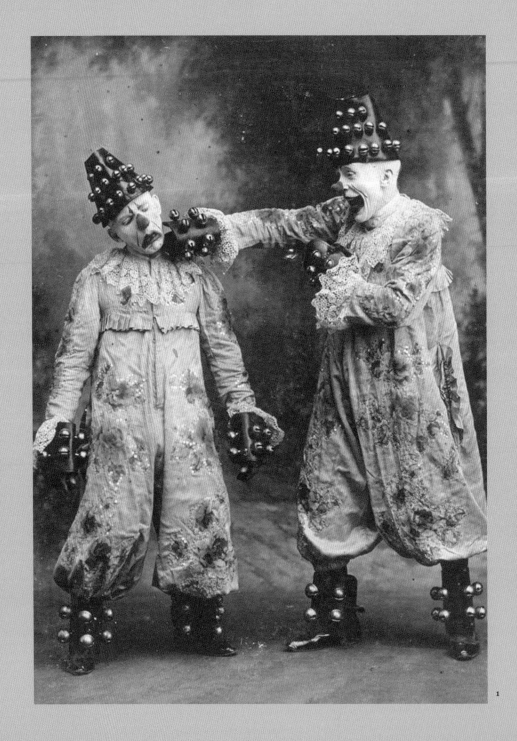

The Sixth Age Shifts

INTO THE LEAN AND SLIPPERED PANTALOON,

With spectacles
on nose
and pouch on side,

his youthful hose,
well saved,
a world too **wide**

FOR HIS SHRUNK SHANK,

AND HIS BIG MANLY VOICE,

turning again
toward
CHILDISH TREBLE,
PIPES and WHISTLES
IN HIS SOUND.

William Shakespeare
As You Like It
c.1599 [1] (fig 3)

A rouged-cheeked, white-faced clown, sporting a spangly one-piece with voluminous trousers, a pointed hat, ruffled collar, and white shoes and stockings, nonchalantly munches a banana. Replete, he carelessly tosses the skin over his shoulder where his detritus becomes an unwitting agent of another's *lèse majesté*: the floppy, flapping outsized boot of a passing Auguste (with red nose, a bright orange wig, and seriously oversized baggy-plaid-trousers) who executes an excruciating, slow-motion slide. A few spasmodic steps of faultlessly executed imbalance choreograph his rapidly withering dignity and, because neither gods nor odds were ever on his side, this unfortunate, eternal victim falls soundly, loudly and inevitably on his arse —to the welling amusement of a rapidly gathering crowd.

The Germans have a word for this: *schadenfreude,* delight in the misfortune of others, **(fig. 1)** an antipathetic, Teutonic variant of Greek κάθαρσις—catharsis: the process of releasing, or "cleansing," strong, repressed emotions. But when mishap is transformed into allegory—of overweening power ridiculed and therefore curbed—the dilemma of whether or not to empathize is dissipated and vicarious pleasure is opened to all. In life, a slip may be irritating, humiliating, or painful, but in art it becomes tragic, humorous, heroic—or pathetic. It is the observer's responsibility to choose.

The two clowns each live in their own small worlds, oblivious of each other, doomed to repeat the same mindless acts. Yet both are interdependent, unable to survive without the other. In his supreme arrogance, sovereign detachment, and limitless sense of entitlement, the white-faced, litter-lout clown could be a fascist or psychopath; the Auguste, obviously, is his slave and victim. Proof, if ever it were needed, that god is vengeful and cruel, untouched by mortal compassion. Circumscribed by the circus, these trapped creatures both wear very large trousers.

The empire of the absurd—of behavior, dress, appearance, and circumstance—parodies, and subverts, the illusory comforts of "normality" by shining a spotlight onto an unknowable, random, pitiless, and parallel world in which there can be no correct way of doing things. The trouser, guardian of genitals, legs, and nether regions, that may be worn strategically—slashed, torn, or not at all—is one of its foot soldiers. In such a world, it has to be accepted that things will get much worse before they improve, and realized that the main obstacle to improvement is the greedy, paranoid pretension of the powerful who grasp, and hold onto their control, dignity (and trousers) to the detriment of everyone else. Sometimes, as in the bawdy Saturnalia of ancient Rome, or in the rampant misrule of the medieval religious Feasts of Fools or Asses, the world is turned upside down to lay bare, just for an instant, its ridiculous, self-serving cruelty—and then everything snaps back into the everyday dumb show of "normal" acceptance. [2]

A similarly disruptive, and corrective, spirit continues in the tales of Till Eulenspiegel, the trouser-dropping, bottom-baring, medieval German trickster—re-imagined in the present by Thai artist Chatchai Puipia **(fig. 9, pp. 2, 254–261)**—and in the ribald, clowning of *commedia dell'arte*, in which the old, hunchbacked Pantalone—Shakespeare's "lean and slippered pantaloon," greedy and lecherous—is one of its stock characters. [3] **(fig. 3)** It is stretched further in the primordial, archetypical stories played by popular puppets and their entourages: in the amoral knockabout of hook-nosed Pulcinella, who from the 16th century radiated from Italy as Polichinelle in France, as Mister Punch (and his aggressively long suffering wife Judy and dog Toby) in the British Isles, as Petrushka in Russia, as Kasper in Germany, as well as in the stories of many other trickster heroes, ne'ere-do-wells, and their dependents, whose likenesses, marionettes, and shadows have, across time and space, spanned Asia and other continents: from Karagöz in Turkey, to Sun Wukong (the Monkey King) in China, to Semar in Java and Sumatra, to Kappa and Kitsune in Japan—and further on to the Raven or "Old Man Coyote" in Native America, to Eshu for the Yoruba and Anansi for the Ashanti peoples in Africa, to Māui for the Māori and on and on to many others elsewhere. [4]

1 | Unknown photographer | **Comedy and Tragedy: Two Circus Clowns** | c. 1880s | hand-tinted photograph

2 | "TJ a well-willer to King, Parliament and Kingdom," **The World Turn'd upside down Or A briefe description of the ridiculous Fashions of these distracted Times** | The British Library, London | a broadside ballad published in London by John Smith in 1646 during the English Civil War

3 | Jacques Callot | **Pantalone** | 1618/20 | etching and engraving | 24 x 15.2 cm | courtesy National Gallery of Art, Washington, DC | one of a series of characters drawn from *commedia dell'arte*

4 | Viktor Vorobyev & Elena Vorobyeva | **Kazakhstan: Blue Period #11** | 2002–05 | one of a series of 42 photographic color prints | 70 x 46.5 cm | courtesy Aspan Gallery, Almaty | **See also p. 118**

[1] William Shakespeare, *As You Like It* (c. 1599), Act II Scene VII, Jacques. [2] See Mikhail Bakhtin, *Rabelais and his World*, Bloomington, Indiana University Press, 1984, Chap. 1 "Rabelais in the History of Laughter." Although largely written in the 1940s, for political reasons this book was not published in the USSR until 1965. It appeared in the West three years later. See also Timothy Hyman, Roger Malbert (eds.), *Carnivalesque* (exh. cat.), London, National Touring Exhibitions, 2000. [3] Pantalone gave his name to the absurd trousers that covered his bony shanks. As *"Pantaloon"* Shakespeare categorized him, a step before death, as the sixth age of man. See note 2. See also Allardyce Nicoll, *The World of Harlequin, a Critical Study of the Commedia Dell'arte*, Cambridge, Cambridge University Press, 1987. [4] Graeme Harper (ed.), *Comedy, Fantasy and Colonialism*, London, A & C Black, 2002; Lewis Hyde, *Trickster Makes this World: Mischief, Myth and Art*, New York, Farrar, Straus & Giroux, 2010.

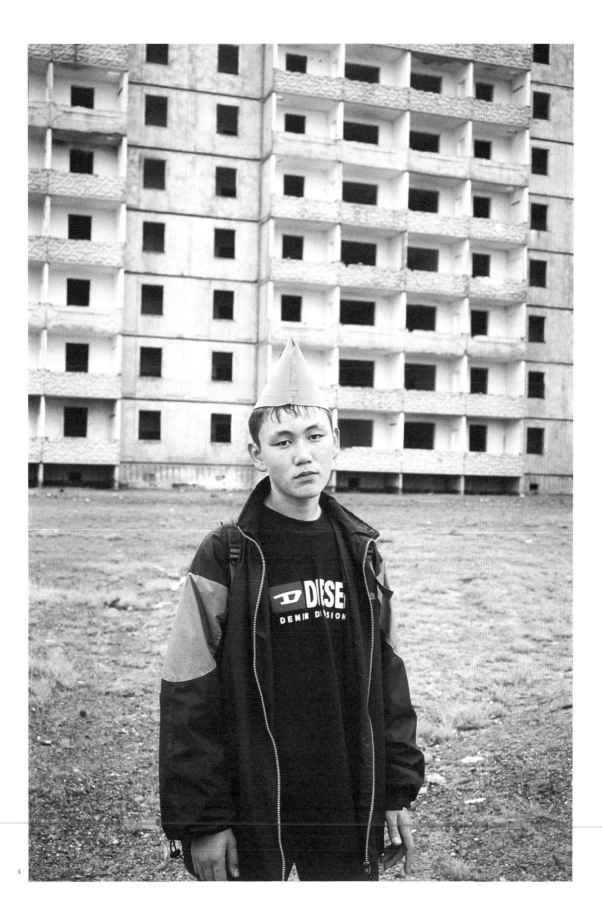

5

6

5 | Theater and film director Sergei Eisenstein
(1898–1948) in eccentric mode, Moscow c. 1922 |
courtesy Naum Kleiman, Moscow

6 | Vladimir Mayakovsky relaxing in Simferopol, Crimea,
with Lily Brik, the subject of many of his lyrical love
poems | 1926

7 | Heri Dono | **Wayang Legenda** | 1988 | shadow-puppet
performance | courtesy the artist | Indonesian artist
Heri Dono made this production in Yogyakarta as a
covert, semi-traditional satire of contemporary social
and political life. **See p. 251**

Grown out of the same dark tilth as folk and fairy tales, the ritual telling of such stories creates an alternative morality of human aspiration, far from the limitless, but confining, power of god. Here, objects are charmed into life by nightmares where worst fears are reborn as hybrid archetypes of beast and thing. In literature and art such energies have long merged to surface in the Renaissance monstrosities of Hieronymus Bosch, Pieter Brueghel the Elder, or François Rabelais, the enlightened chimaeras of Jonathan Swift, William Blake, Francisco Goya, or Mary Shelley the positivist perversities of Lewis Carroll, Jean-Jacques Grandville, Odilon Redon, or James Ensor. And then there are the modern dystopias of an endless list of malcontents that includes Alfred Jarry, Franz Kafka, Bruno Schulz, TS Eliot, Daniil Kharms, Antonin Artaud, Hans Bellmer, George Orwell, Samuel Beckett, Jorge Luis Borges, Joseph Heller, Francis Bacon, Harold Pinter, and Margaret Atwood. Here, things are rarely what they seem and, as in any good story, one form shifts seamlessly, and often horribly, into another.

But there also is a less inverted, more intuitive, way of turning the world on its head. Rather than boring his pupils to death with instructions, sermons, or koāns, a Zen master may decide to rap a meditating student on the back of the head and through this sudden shock induce a flight from mind, intellect and consciousness that could end in enlightenment—a point from which there is no return. In effect, this is not so dissimilar from a random slip on a banana skin. When control is lost, anything may happen.

Around the time of World War I, when, in European visual art, Cubists and Futurists had begun to pull the world apart to reconstruct it in their own fashion, Russian Formalist writers and critics (such as Yuri Tynyanov and Viktor Shklovsky) had begun a similar analysis of literature. Here, the slap, the slip, the caesura, the change of voice—part of any traditional storyteller's art—were found to be in keeping with the absurd jumps of logic and montage in the new medium of cinema. In Russia after the revolution, this took the form of new egalitarian genres of poetry, fiction, painting, object-making, and reportage as well as in a theater and cinema that were inspired by both music hall and increasingly popular Hollywood slapstick two-reelers. In 1922, in Petrograd (St. Petersburg), FEKS (The Factory of the Eccentric Actor), a group of young film directors, went so far as to declaim their "SALVATION IN THE TROUSERS OF THE ECCENTRIC!!!" climaxing their energetically absurdist manifesto with the punchline "We prefer Charlie [Chaplin]'s Bottom to Eleonora Duse's Hands!" [5] **(fig. 1, p. 10 and fig. 5 above)**

Rather than pandering to an individual's desire to empathize with a comic "victim," or dabbling in *schadenfreude,* Tynyanov and Shklovsky asserted that formal devices made audiences more critically aware of how they perceived normality. Distance, perspective, and judgment within narrative were highlighted, the better to apprehend their problematic nature. The *way* a story was told, therefore, as much as *what* was told, emphasized and implicitly challenged the viciously random, "natural" unfairness of the authority that ordained what "normal" life should be. [6]

But the trouser had been on the Russian horizon since long before the revolution. For Tsar Peter the Great, at the beginning of the 18th century, it had been an active symbol of westernization and, just over two hundred years later, when, in 1915, poet and artist Vladimir Mayakovsky completed his first major work, perversely he called it *A Cloud in Trousers.* [7] With the pathos of a Nietzschean god (bathetically restricted by the Imperial censor), he preached a sermon of conflagration to the pre-revolutionary masses in order that a liberated and reformed humanity should emerge from it unscathed. As was often the case in his poems, this was an autobiographical exorcism of a disastrous love affair, written in laconic, emotional, Futurist shorthand that lamented emotional havoc. Torn between fury and passion, the poet could appear as man, beast, or cloud: *If you prefer, / I'll be pure raging meat, / Or if you prefer, / I'll be absolutely tender, / Not a man, but a cloud in trousers!* [8]

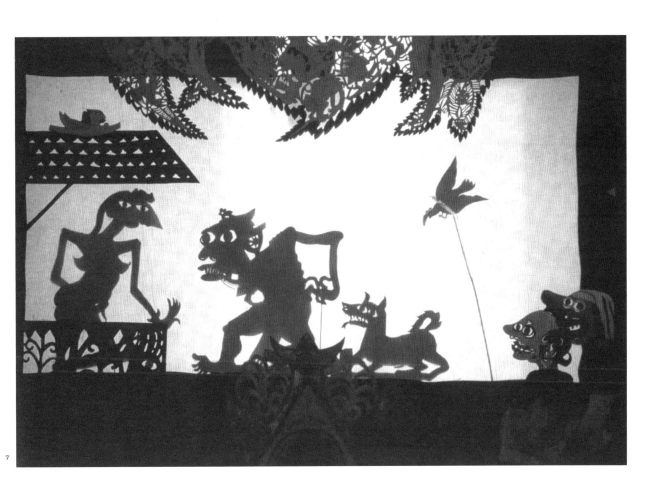

[5] Grigory Kozintsev (1905–1973), "AB! Parade of the Eccentric," part of *The Eccentric Manifesto* in G. Kozintsev, G. Kryzhitsky, L. Trauberg (1902–1990), S. Yutkevich (1904–1985), *Ekstsentrizm*, Ekstsentropolis (formerly Petrograd), Factory of the Eccentric Actor [FEKS], 1922. Translated by Richard Sherwood in Sherwood & I. Christie (eds.), *The Film Factory. Russian and Soviet Cinema in Documents 1896–1939*, London, Routledge, 1994, pp. 58–64. Eleonora Duse (1858–1924) was a famously expressive Italian actress. [6] Yuri Tynyanov (1894–1943) and Viktor Shklovsky (1893–1984) were Moscow-based writers, critics and members of the influential OPOYAZ (The Society for the Study of Poetic Language). The most important of their devices were disjunction and montage [characterized through *sdvig* (displacement/ eccentricity) and *ostranenie* (estrangement)]. In *Art as Device*, Moscow 1917, Shklovsky defined *ostranenie* as a mechanism that engendered social or political criticism by "removing the automatism of perception." Leading Russian/Soviet poets such as Velimir Khlebnikov (1885–1922), Aleksei Kruchenykh (1886–1968), and Vladimir Mayakovsky (1893–1930) also employed such devices in their work. [7] For Peter the Great's view on "trousers" see p. 292. Mayakovsky published "A Cloud in Trousers," *Oblako v Shtanakh* (a Futurist love poem) in 1915. Its original title had been *The 13th Apostle* but he had renamed it at the request of the censor who also removed six pages from the work on political grounds. An unexpurgated edition was not published until 1918 (after the two revolutions of 1917) by which time Mayakovsky had grown fond of its revised title and decided not to change it back. For the complete Russian text of this poem, with revisions, see the first volume of Vasily Katanian's 13-volume compendium of Mayakovsky's work, Moscow, GIKhLM, 1955–57. [8] Mayakovksy, "A Cloud in Trousers," translated by Bob Perelman and Cathy Lewis in John Glad and Daniel Weissbort (eds.), *Russian Poetry: The Modern Period,* Iowa, University of Iowa Press, 1978, pp. 8–30. Mayakovsky committed suicide in 1930, the result of unhappy love affairs with both the RSFSR and a young woman. See Wiktor Woroszylski, *The Life of Mayakovsky,* London, Victor Gollancz, 1972, pp. 457–530.

8

9

By the early 1970s, in a vastly transformed world, the wounded faux-whimsy of Mayakovsky's supercharged masculinity had, within the shadow play of Russian-American literature, transmuted into more recessive irony: trousers became the means for the demise of Henry Emery Person, father of Hugh, the protagonist of Vladimir Nabokov's novel *Transparent Things.* Person Senior met his rapid, unexpected, and tragic end in chapter five, while sheltering from a thunderstorm, in a macabre glissando on the fitting room floor of "a shabby garment store" in a small Swiss mountain resort. In his quest to find his father, after a bracing walk in the mountains, Hugh discovered that "few things are funnier than three pairs of trousers tangling in a frozen dance on the floor—brown slacks, blue jeans, old pants of gray flannel." Here the effort of "struggling to push a shod foot through the zigzag of a narrow trouser leg" had provoked a catastrophic and bathetic stroke. His father had dropped dead. [9]

At the crossroads between tenderness and cruelty, Portuguese artist, Paula Rego, echoing Goya's etchings, embarked during the mid-1980s on a series of paintings of two young girls and a dog. Conceived as "family paintings" and made during the time of her husband's terminal illness, the girls carry out various acts: the dog is shaved, its jaws are forced apart to be fed, it is teased as one girl lifts her skirt, it is dressed as one girl holds the dog while the other forces trousers onto its hind legs. "You have to hurt the dog in order to give him his medicine," Rego said of these works. "There's often violence in trying to help people. I even dressed one little girl up as a little fascist . . . I did like doing these paintings very much indeed." [10] **(fig. 8)**

In 1955, three years after the end of the Allied Occupation of Japan, On Kawara, still living in Tokyo, completed a painting that rendered the whole lower half of the male body, enclosed, threatening, impotent, and absurd. [11] The previous year he had depicted an inverted naked pregnant woman in a white-tiled bathroom full of dismembered bodies **(see fig. 21, p. 40)** but this large, irregular canvas isolated a character that had become a familiar, yet strange sight, on the city's streets. *Black Soldier* is seen from below in violently receding perspective, climbing up or down scaffolding in an endlessly claustrophobic pipe or tunnel. This off-duty American GI with hardly a body and no head, is defined by his crushing boots as well as by his diminishing legs and smooth, pink crotch. His absurd half-trousers, the crux of the work, are not only an expression of style, or lack of it, but also a silent protest against what the artist saw as a broken and constricted life. **(fig. 10)**

Four years later, Kawara left Tokyo and, via Paris and Mexico, settled in New York. His work had completely changed, and surrealistic reportage was consigned to the past. His daily life now became the subject of his art—the passage of its dates: days, hours, minutes, and actions measured out in paintings, postcards, and telegrams—in an everyday existentialism derived from the French authors he had first read in Japanese. **(fig. 11)**

As a succession of slips and pratfalls, some calculated, others not, history —personal or political—becomes subject to a disingenuous, self-justifying warren of uncontrollable empires, covert interests, and suppressed emotions that conspire to profit from the miserable situation they describe as "normal." As an agent of both hubris and hope, absurdity thus becomes the two-faced companion of such states—its friendly doppelgänger and critical antidote. Within this unpredictable maverick framework, trousers have played a slippery, and at times sinister, role as agents of repression. They have been invented and reinvented wherever there has been the need for innocent, and occasionally ridiculous, expressions of sartorial and other freedoms. But as symbols of patriarchy, progress, empire, false modesty, and oppression they have also

8 | Paula Rego | **Two Girls and Dog** | 1987 | acrylic on paper on canvas | 150 x 150 cm | courtesy the artist

9 | Chatchai Puipia | **Better Than Ever** | 1999 | oil on linen | 165 x 130 cm | courtesy the artist and Aey Phanachet, 100 Tonson Gallery, Bangkok | In 2012, this image appeared in the form of a bronze self-portrait in a number of colored patinas with a gilded face | See pp. 2, 254–261

10 | On Kawara | **Black Soldier** | 1955 | oil on canvas | 164 x 201 cm | courtesy Ohara Museum of Art, Kurashiki

[9] Vladimir Nabokov (1899–1977), *Transparent Things*, London, Penguin Books, 1972, pp. 12–14. Nabokov's father, Vladimir Dmitrievich Nabokov (1870–1922), a liberal lawyer, statesman, and journalist, who had to leave Russia after the October Revolution, was fatally shot in Berlin by a Russian monarchist when trying to shield Pavel Milyukov, one of the leaders of the Constitutional Democratic Party-in-exile. Unexpected, random death runs as a leitmotif through Nabokov junior's novels. [10] Paula Rego (b. 1935), Portuguese/British artist, in Mick Brown, "The Artist Interview," *The Telegraph*, London, 4 November 2009. [11] On Kawara (1933–2014), *Kokujinhei* (1955), oil on canvas, 164 x 201 cm, Ohara Museum of Art, Kurashiki. At this time Kawara was allied with a number of young radical artists who were resisting what they regarded as the materialism and Americanization of Japanese society. See also pp. 39–40 and Shigeo Ishii's painting *Pleasure* (1957), p. 41.

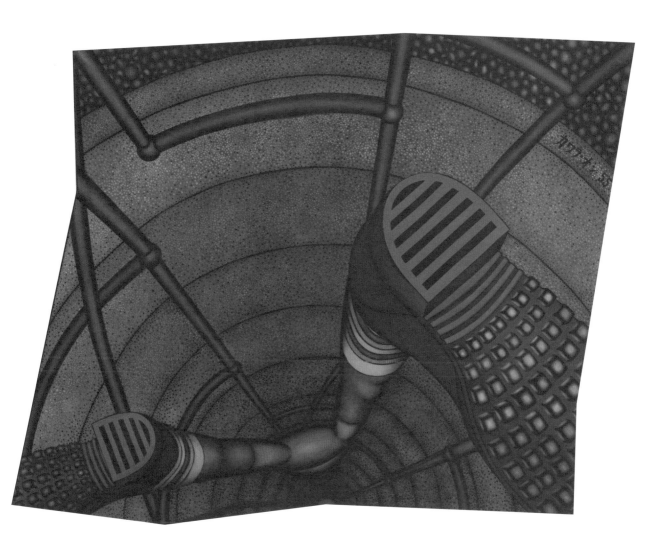

goose-stepped, marched, stomped, flapped, slipped, and been carried, across the extent of the whole world.

Starting out from Oxford in the last quarter of the last century, the "Histories" recounted in the essays of this section present various, random, personal, often unsuspected, narratives about art, culture and how they interact. But, although some similarities may be discerned between artistic developments in Asia and other parts of the world, what they share most is their difference—a diversity given shape by, whatever the circumstances, desire and respect for the power that only art at its best reveals. As a result, they often confront the savage conditions that have molded culture, as well as the hubris of the power that attempts to govern it, as they examine, from different points of view and contexts, different historical models of modernity that navigate and follow their own paths between tradition and the future.

* * *

Those readers, however, who wish to complete uninterrupted this chronicle of the trouser as artifact, fashion item, symbol and metaphor, should jump to "Who Is Wearing the Trousers?" (p. 160–169) at the beginning of *Stories*, the second section of this book, and, finally, to "A Short History of the Trouser" (p. 288–297) at the start of *Migrations*, the final part, before returning to this point. ●

11 | On Kawara | **I Am Still Alive** | 1970 | telegram | 14.6 x 20.3 cm | courtesy LeWitt Collection, Chester, Connecticut, USA | sent in February 1970 to fellow New York artist Sol LeWitt, this is one of a series of over 900 telegrams delivered to acquaintances and friends between 1969 and the late 1990s

12 | Frederick W Glasier | Clown, Skeleton | Sparks Circus, USA | 1923

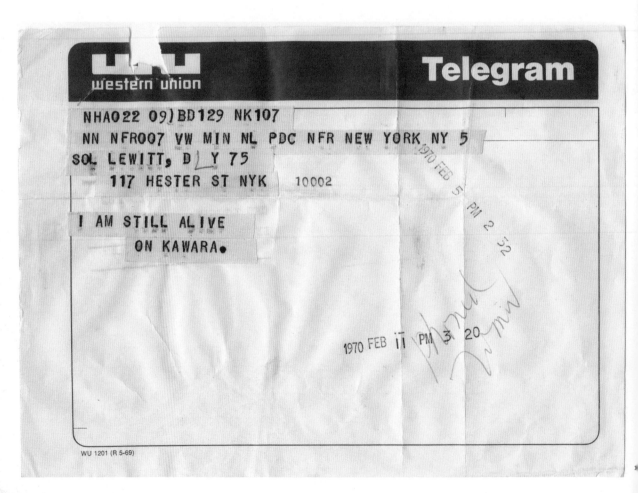

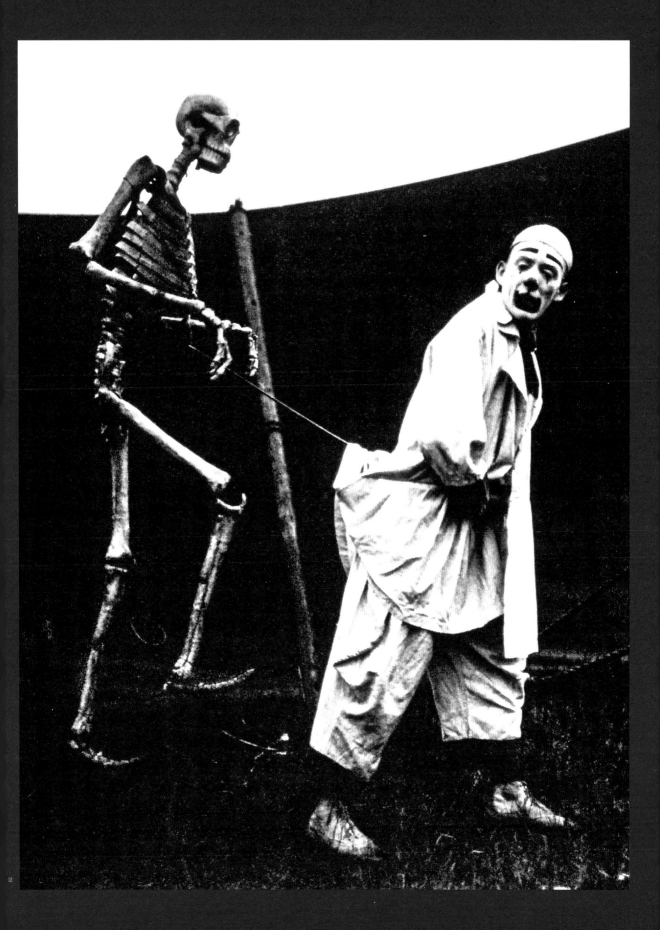

Going Global

Alterity and Other Things at the Museum of Modern Art Oxford [1]

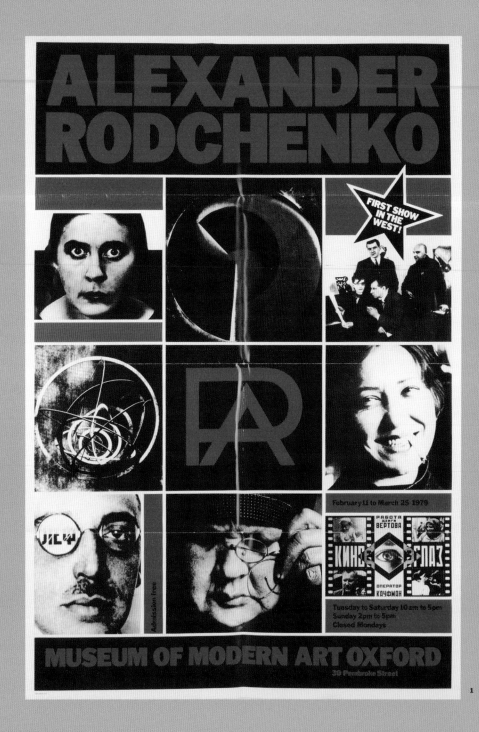

I. Getting Going

By the second half of the 1970s, in what was once described as the "developed world," it was clear that something was coming to an end. The optimism of the early 1960s had long evaporated and people were in a bad mood. The student protest movements of 1968 had gone underground and, although the United States had been kicked out of Vietnam, in the name of anti-imperialist warriors such as Mao Zedong, "Uncle Ho" Chi Minh and Che Guevara, extremist "anti-fascist," anti-capitalist factions and "armies" orchestrated bombings, assassinations, kidnappings, bank robberies, and shoot-outs in the hope of paving the way to revolution and freedom. In a less aggressive and ideological struggle, the punks, progeny of skinheads, had eclipsed hippies and glam rockers in a class war of frustration, style and music. Overall, inflation was high and rising—wages, for the vast majority, were low.

By that time, more by luck than judgement—skeptical of the likely success of world government by unions of peasants, workers, and students—I had ended up with an Honours Degree in history and a Master's in art history. This led to a short spell at the Art Department of the Leicester Museum and Art Gallery and two years as a regional art officer at the Arts Council of Great Britain. I had also managed to organize some art exhibitions.

Slowly the realization began to dawn on me that, rather than directly reflecting or commenting on its time, contemporary art was becoming entrapped within a vicious circle of its own making: the fully distended title of critic-activist Lucy Lippard's seminal book *Six Years: The Dematerialization of the Art Object from 1966 to 1972* describes perfectly this fragmentation and confusion.[2] The progressive movements of the avant-garde had moved from abstract expressionism and pop art towards "minimal" and "concept" art in an implicit critique of the ways in which art itself had become fetishized, commoditized, and institutionalized. None of us then realized that the situation would get much worse.

During this period of navel gazing, which postmodernists wrongly regarded as the death rattle of modernity, new art was defining itself by what it was not. In fact, modernity was fit, well, and still toxically exploitative, but the ideas, vain hopes, and ethos of successive "avant-gardes" seemed to have passed away.[3]

In 1976, during one of the hottest English summers in living memory, I was, at the age of 27, offered the directorship of the Museum of Modern Art in Oxford. The labor unrest of the bitterly cold "winter of discontent" of 1978–79 was just around the corner, climaxed by a general election that swept Margaret Thatcher and the Conservative Party into what the Labour Party subsequently, and predictably, described as "18 years of Tory misrule."[4] This anticipated political change in the United States when, in 1981, Republican Ronald Reagan swept away Democrat Jimmy Carter as president and two monetarist titans unleashed upon the world a neoliberal wave of Thatcherite "Big Bang" "Reaganomics." The debilitating evil of rampant "stagflation" would be vanquished by radically reducing taxes and "state interference" while, at the same time, international markets were freed from regulation and tariffs. In the orgy of utopian libertarianism that followed, it was believed, the rich would be made richer and the deserving poor would be truly grateful for the bounty that would inevitably "trickle down" into their pay packets and larders. Unfortunately, only the first half of this equation has worked.

The sudden dawning of this quasi-Victorian mindset—along with the mechanisms to satisfy its needs—meant to many that the intellectual, sometimes etiolated, artistic attitudes of the 1960s and 1970s, with their implicit critique of the market economy, no longer seemed either interesting or relevant. In any event, the market needed novelty and excitement and both art dealers and auction houses were beginning to get bored. Now they were turbo-charged by a newly wealthy "class" of art collectors, "material girls (and boys)" who, impelled by a desire for social betterment

1 | Exhibition poster for "Alexander Rodchenko" | MoMA Oxford | | 1979 | design by David King | courtesy MoMA Oxford archive

[1] In 2002, MoMA Oxford was, without any intended Sinological reference, rebranded as MAO (Modern Art Oxford). MoMA had been set up in 1965 as an independent charity and Company Limited by Guarantee. It was annually, if inadequately, funded by the Arts Council of Great Britain, with other public institutions, as one of six "centres of excellence." [2] This book's full title, as set out on its cover, is *Six Years: the dematerialization of the art object from 1966 to 1972; a cross-reference book of information on some esthetic boundaries: consisting of a bibliography into which are inserted a fragmented text, art works, documents, interviews and symposia, arranged chronologically and focused on so-called conceptual and information or idea art with mentions of such vaguely designated areas as minimal, anti-form, systems, earth or process art, occurring now in the Americas, Europe, England, Australia and Asia (with occasional political overtones), edited and annotated by Lucy R. Lippard. New York, Praeger, 1973.* [3] From the end of the 1970s until 1989, when the idea and ethos of the avant-garde was resuscitated dramatically in China. see p. 45. [4] The conservatives stayed in power from 1979 until 1997. This "winter of discontent" referred to the struggle between the governing Labour Party and the public sector Trade Unions during which there were widespread strikes and disruptions.

[5] The song *Material Girl* by Madonna had appeared on *Just Like a Virgin* (1984), her second album. In a 2009 interview she described these songs as "ironic and provocative at the same time . . . I liked the[ir] play on words, I thought they were clever." Austin Scaggs, "Madonna Looks Back: The Rolling Stone Interview," *Rolling Stone*, San Francisco, October 29, 2009. [6] "A New Spirit in Painting," curated for the Royal Academy of Art in London in 1981 by Norman Rosenthal, Christos Joachimides and Nicholas Serota, was the initial international manifestation of this tendency. A tendentious and muddled call for a return to painting, it included the work of 38 male artists of different generations, including eleven West Germans, nine from the US, eight from Great Britain, four from Italy, and the rest from other parts of Europe. "Magiciens de la Terre (Magicians of the World)" was shown at the Centre Georges Pompidou and Grande Halle de la Villette in Paris in 1989. Curated by Jean-Hubert Martin, it showed the work of 100 artists, split equally between recognized western artists and those from elsewhere (this latter category included some from China). Selection was made on what Martin described as an "intuitive basis" with a view to counteracting Eurocentricity by using the unifying symbolical trope of "magic." This led to the unresolvable criticism that this approach was simultaneously neocolonial, exotic, and empowering. See Thomas McEvilley, *Art and Otherness: Crisis in Cultural Identity,* Kingston (NY), McPherson, 1992. [7] The first bubble lasted until the economic slump of 1990. See also Georgina Adam, *Big Bucks: The Explosion of the Art Market in the 21st Century,* London, Lund Humphries, 2014. [8] As part of his extension of Freudian psychoanalysis, Jacques Lacan (1901–1981) described the "Other" as a powerful symbolical agent, never fully known, that originated in the oedipal complexes of childhood development. His theories influenced Mary Kelly and other feminist artists (see footnote 14). [9] As a vicarious pleasure, this had been pushed much further in European art and literature during the 19th century, both by admiring romantics and orientalists as well as by jeremiads of degeneracy who, appalled, saw it as a constant threat. See Edward W. Said, *Orientalism,* New York, Pantheon, 1978, McEvilley (footnote 6) and Flam & Deutsch (footnote 12), who discuss from different points of view the impact of western ideas about non-western art on contemporary art discourse. Max Nordau's influential book *Degeneration, (Entartung,* 1892) maintained that western art had become an instrument of degeneracy and, although he was Jewish, during the 1920s and '30s, this work greatly inspired Nazi theorists. [10] My first exhibition, made in Durham, Sheffield, and Leicester in 1970, was entitled "Germany in Ferment: Art and Society in Germany 1900 to 1935." I revisited the questions raised in this show in 1995 in the exhibition and book "Art and Power: Europe under the Dictators 1930–45," London Hayward Gallery / Thames & Hudson. It was reprinted as "The Battle for Art in the 1930s" in *History Today,* London, Vol. 45 (11), 1995, pp. 14–21. [11] Previous to 1992, Oxford Brookes University had been known as Oxford Polytechnic. The Museum of Modern Art Oxford was not part of either university in Oxford but was strongly affiliated with both. [12] I. Sandler and A. Newman (eds.), *Defining Modern Art. Selected Writings of Alfred H. Barr, Jr.,* New York, Harry N. Abrams, 1986. Under the heading of "primitive" art, Barr had, during the 1930s, integrated the art of other cultures within his programs. By the changed cultural climate of the 1980s, however, MoMA seemed much less open in its attitudes. See the critical controversy around its exhibition "'Primitivism' in 20th Century Art" (1984) in Jack D. Flam and Miriam Deutsch (eds.), *Primitivism and Twentieth-century Art: A Documentary History,* Berkeley, University of California Press, 2003, pp. 311–414. [13] Catalogues were produced for both these exhibitions. "The Falling Leaf" was curated by Brian Love. "The Inner Eye," curated by Christine Newton, was not an exhibition of *art brut,* although there were a few crossovers. It was particularly concerned with documenting the role of art therapy in the UK from the points of view of both therapist and patient. The 1985 exhibition "Hiroshima: Paintings by Survivors" also fell into this category. See footnote 39. [14] During 1977–78, the following women artists had exhibitions at the museum: Jo Baer ("Paintings 1962 – 1974"), Rita Donagh ("Paintings and Drawings"), Simone Forti (performance and workshop), Jackie Lansley, Rose English, Sally Potter ("Mounting," performance and publication), Susan Hiller ("Fragments," installation and publication), Mary Kelly ("Post-Partum Document," installation and publication), Yvonne Rainer (films and presentation, with Laura Mulvey).

and recognition, sought to collect a "new" kind of contemporary art, simultaneously "ironic and provocative," "edgy," and "traditional," to which they could relate.[5]

In contemporary art, the magic machismo of numinous "spirituality"—anathema to the laconic materialism and nascent feminism of the previous decade—now proved to be decisive: the shamanistic actions, didactic ramblings, and "healing" installations of felt and fat by the West German artist Joseph Beuys had paved the way, followed by the large, historically portentous, neo-expressionist paintings of Georg Baselitz, Anselm Kiefer, and other—previously overlooked, or just young—European and American male artists who began to take a central place on the world stage. In 1981, the death knell of "dematerialization" resounded with the proclamation of a new order, marked symbolically by the exhibition "A New Spirit in Painting" at the Royal Academy of Art in London. This opened the way in 1989 for the more authentic, but no less contested, "spirituality" of "Les Magiciens de la Terre," an exhibition shown across two venues in Paris, that mixed established western artists (who fitted the bill) with unknown artists, some of them real magicians, or craftsmen, from different parts of the rest of the world.[6]

Soon, the demand for new art—particularly paintings by western artists that offered the promise of the "different" or "spiritual"—began to outstrip supply, and prices increased exponentially. Previously a staid and relatively low cost concern, the contemporary art market now chugged into action like a vast industrial laundromat: cleansing money of dubious origins and flipping works as if they were assets, to create an initial spume of steadily rising, global bubbles—and their inevitable bursts.[7]

This is the "globalized" world that was beginning to unfold during my first five years in Oxford. Fortunately, the city's reputation for cosmopolitan learning stretched back to the beginning of the Middle Ages and I decided to capitalize on this but, first of all, had to decide on the general criteria within which to work. Should I attempt to anticipate and go along with the mainstream? Or should I attempt to broaden it by looking for equally "good" things in other places? Of course, I resolved to do both.

Although not a word I used then, the idea of "alterity" became, from this time, a defining element of my way of looking at and coming to grips with contemporary art. By implying the necessity of comparison in order to see more clearly who or what one is oneself, it avoided the neurotic self-obsession of Lacanian "otherness," current among some artists and many theorists at that time.[8] More importantly, it also sidestepped the widespread contemporary taste for the spiritual, the primitive, or the exotic, the latter a distant handmaiden of "decadence"—an idea that Edward Gibbon had long before converted into a vicarious parable in his *History of the Decline and Fall of the Roman Empire* (1776–89).[9]

Alterity provided a simple strategy for avoiding the pitfalls of these approaches in that it modified one's view of oneself by both broadening and refining one's perspectives. In terms of criticism and aesthetics, such a comparative process was a helpful tool in establishing why a particular work, or artist, should be better than another, not only by concentrating on the question of individual talent, but also by considering broader structural questions of cultural specificity, aesthetic tradition, context, meaning, and power that had contributed to how and why the art in question had been made. Such questions, of course, also impacted on how a work was seen.

My first impulse to study art had been through an encounter with pre-World War II German art as a teenager. Not only had I been deeply impressed by the dynamism and raw emotion of Expressionism and the *Neue Sachlichkeit* (New Objectivity), that seemed quite unlike anything produced in Britain at that time, but I was also fascinated by its social engagement and by the fact that the Nazis had denounced such works as

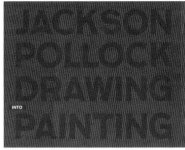

2 | Covers for the exhibition catalogue "Jackson Pollock: Drawing into Painting" | MoMA Oxford |
photo by Hans Namuth | design by Richard Hollis |
courtesy MoMA Oxford archive

[15] Between 1976 and 1997, out of a total of around 320 exhibitions and events of different sizes and durations, I organized at MoMA 15 major exhibitions of Russian/Soviet art, design, film, and photography. For the Hayward Gallery in London, I was also curator and writer for its exhibitions "The Twilight of the Tsars" (1991) and "Art and Power" (1995), op. cit., footnote 11. [16] Until perestroika (the end of the 1980s), the art of the early Soviet avant-garde was still tarred by Stalinism inside the USSR and was excluded from museum and other public displays. However, it became possible to borrow such works to show abroad, and Oxford MoMA was one of few museums in the West to open up this field. The Aleksandr Rodchenko exhibition in 1979 marked the first occasion that works were loaned directly from an artist's family in Russia. [17] D. Elliott (ed.), Vladimir Mayakovsky: 20 Years of Work, Oxford, MoMA, 1982; D. Elliott and I. Christie (eds.), Sergei Eisenstein 1898–1948: His Life and Work, MoMA Oxford, London, British Film Institute, 1988; D. Elliott (ed.), Orozco!, MoMA Oxford, Oxford / New York, Pantheon Press, 1980. [18] Andre famously described his works as "atheistic, materialistic, and communistic" in David Bourdon, "The Razed Sites of Carl Andre" in Artforum 5, October, 1966. The works of Andre, Judd, and LeWitt were shown in Oxford both before and during my time as director: "Carl Andre: Poems 1958–74" (1975), "Carl Andre: Sculptor 1958–1996" (1996); "Donald Judd: Drawings 1956–76" (1976), "Donald Judd: Objects, Furniture, Prints, Posters and Architecture" (1995); "Sol LeWitt: Wall Drawings" (1973), "Incomplete Open Cubes" (1977), "Sol LeWitt: Drawings 1958–92 and Structures 1962–93" (1993). [19] "Jackson Pollock: Drawing into Painting," curated by Bernice Rose for the International Council of the Museum of Modern Art New York, Museum of Modern Art Oxford, and the Arts Council of Great Britain, 1979. See also Francis V. O'Connor, Jackson Pollock (exh. cat.), New York, Museum of Modern Art, 1967.

"Bolshevik" and "degenerate" to such an extent that they set out to destroy them. It had never before occurred to me that art could be so upsetting or powerful. [10]

So, along with the humdrum, everyday business of running an art museum, the main questions that confronted me at this time were: what characteristics, or conditions, made particular works memorable or good? And what contextual factors enabled art to be seen in certain ways and not others? Established historical methods of research, comparison, and analysis were a starting point but, increasingly, I was stimulated, or prompted, by contact with people who were working close by in related fields: at the University of Oxford with its Department of Art History, Institute of Social and Cultural Anthropology, the Ruskin School of Drawing and Fine Art, the Ashmolean, Science, Natural History, and Pitt Rivers Museums, as well as with others in the Departments of Humanities and Architecture of Oxford Polytechnic. [11]

Initially, I modeled the museum's exhibition program on the Bauhaus-derived precedent of Alfred Barr's Museum of Modern Art in New York during the 1930s, centering on the "fine arts" but also incorporating design, photography, film, video, and architecture, all of which had their own canons. [12] It was a reasonable start, but I felt it was important to be able to step outside prescribed taste so to compare what one knew with other things that either crossed such disciplines or never even approached them. Two exhibitions from 1978, "The Inner Eye: Work Made in Psychiatric Hospitals" and "The Falling Leaf: Aerial Dropped Propaganda, 1914–1968," illustrate this point: they each displayed visual material that was not made as art but which nevertheless had a strong relationship to it and could be interpreted aesthetically as if it were. [13] Artists who happened to be women had also been historically disregarded and, in what were steps within a different realm of alterity, their presence was clearly expressed in the museum's exhibitions. [14]

My early interest in German art had an oblique impact on this approach, in that it led me towards Russia—from around 1905, art from both countries had shown a strong aesthetic and social engagement and, from the 1930s, had suffered from harsh ideological repression. I began to study this field intensively, organizing exhibitions of previously unseen or disregarded areas of work. [15] Furthermore, it seemed to make good, if oblique, sense to exhume, show, and re-contextualize the work of the still suppressed, Soviet and other avant-gardes at a time when the ethos of its western descendants was running out of steam. (fig. 1) [16] In this respect, one thing led to another: records of visits to post-revolutionary Mexico by Soviet poet Vladimir Mayakovsky and film director Sergei Eisenstein in the 1920s had also opened my eyes to the art made there and, in 1981, resulted in a large exhibition of the Mexican muralist José Clemente Orozco. [17] And there were the still-to-come exhibitions that would reveal, as yet unknown in the West, avant-gardes in Japan and China.

Although these exhibitions presented views of alterity through their difference from work being made in the West, the cross currents that ran between them and western art were also important. Carl Andre, Donald Judd and Sol LeWitt leading "minimal" and "conceptual" artists in the United States, cited the Soviet Constructivists as forerunners of their work. [18] Before them, in the 1920s and 1930s, the young Jackson Pollock had been strongly impressed by the murals of Orozco along with the holistic philosophical ideas of the Indian guru Jiddu Krishnamurti, the techniques and simplified images of Native American Navaho sand painters and the imaginal processes of Jungian psychoanalysis. (fig. 2) This disparate range of influences not only fed into his myth of himself as an artist but also, at the end of the 1940s, into the substance of his first action paintings. An exhibition of work by Pollock had followed that of Rodchenko and preceded that of Orozco in Oxford. [19]

It was the sea change in politics, culture, and art in Britain and America at the beginning of the 1980s that confirmed for me the ethnocentric, market-based myopia of the contemporary art world. In a world of many cultures, it seemed ridiculous—at worst colonial or covertly racist—to believe that ideas of quality in modern or contemporary art should have to be filtered through an exclusively western discourse and perspective. But, like any sovereign intellectual territory, western modernity had its own self-appointed gatekeepers and border guards—panjandrums of different kinds—art critics, academics, art dealers, collectors, curators and some artists, who, for different reasons, shared a common interest in keeping things as they were.

II. India (1981–94)

It was during the summer of 1981 that Victor Musgrave, a London-based poet, gallerist, and curator, asked me if I would like to meet Ebrahim Alkazi, a prominent Indian theater director, cultural entrepreneur, and collector of art and photography. He wanted to sponsor, during the time of a planned Festival of India in London in 1982, an independent exhibition about modern and contemporary Indian culture and was looking for a partner.[20] I had been fascinated by classical Indian art and music since a student but I knew virtually nothing about its modern or contemporary art.[21] Meeting with Alkazi, the project seemed possible: I was frank about the poor state of my knowledge and the limitations of the museum finances; he had an enthusiastic, "can-do" approach and, even though he had firm ideas about what he would like to see, accepted that I had to get to know the field before I could decide whether MoMA Oxford would make an exhibition and, if it did, what form or forms it would take.

On this basis, at first tentatively, we went ahead. I made two trips to India, one with Musgrave, visiting artists' studios and meeting curators, collectors, and critics in Ahmedabad, Baroda, Bombay, Calcutta, Delhi, Jaipur, Jaisalmer, and Jodhpur.[22] On return from the first trip, I talked over the idea with the British painter Howard Hodgkin, one of the museum's board members, who knew India well and had also built up a fine collection of classical Pahari painting. With the exception of the work of his friend Bhupen Khakhar, he was unenthusiastic about Indian modern and contemporary art. This, with other encounters, made me keenly aware that, with few exceptions, the British art world, and its market, held strong prejudices against any form of modernity that it regarded as "peripheral," particularly when the culture in question was that of a former colony.[23]

And it was not too difficult to understand why. For almost two hundred years, the Indian subcontinent had been ruled by the British and had experienced, but not governed, its own modernization. With an obsession with class that mirrored that of Britain itself, India also provided a symbolic smokescreen of imperial pomp and colorful tales of derring-do, while the benefits of cheap labor and materials were leached from it back to the motherland. The great former civilizations of this imperial "jewel" had long passed away, and what remained was superiorly disregarded as, at times, "amusing," at others, as "charming" or "picturesque" but always as subordinate.

In this light it was much easier to respond to the ahistorical dynamism, "surrealistic" imagery and bright palette of Indian folk art than to the harsh realities, subdued colors and self-conscious existentialism of an art for which modernity had once been a form of oppression.[24] Even 35 years after independence, the colonial view still had a lot to answer for and I was sure that the collective "myopia" and self-compensating sense of unease that I perceived in others in the UK—and could also recognize in myself—were derived from an erroneous, unconscious sense of entitlement.

Talking things over with Musgrave and Alkazi, we agreed that if we were to engage with a broad, as well as an informed audience, some of whom would

[20] Between 1953 and 1963, Victor Musgrave (1919–1984) ran Gallery One, a small, avant-garde commercial space in London, where he made several exhibitions of Francis Newton Souza (and other Indian artists) as well as showing Bridget Riley for the first time and giving Yves Klein his first solo exhibition in the UK. He was also an early and constant champion of *Art Brut* and Outsider Art. Ebrahim Alkazi (b. 1925-2020) had been director of the National School of Drama, New Delhi (1962–77) and, from the late 1940s, was strongly associated with the Bombay Progressive Artists' Group. In 1977, with his wife Roshen, he founded the Art Heritage Gallery in New Delhi. The official Festival of India in London, organized by the Government of India, included a vast range of exhibitions, performances and events in different venues. The exhibition "Contemporary Indian Art," curated by Richard Bartholomew, Geeta Kapur, and Akbar Padamsee at the Royal Academy of Arts in London, was part of this and included the work of 45 artists, most of whom were also shown in Oxford. This show, which was purely contemporary, was split into two parts, each of three weeks, shown from September 16 to October 13, 1982. [21] I first got to know Philip Rawson (1924–1995), curator of the Gulbenkian Museum of Oriental Art and Archaeology in Durham, while I was a student there. He was a specialist in this field but, at that time, we had talked mainly about early 20th-century German painting, which he knew well, and Tibetan thangkas. [22] The exhibition was supported by a charitable foundation in Kuwait with which Alkazi was connected. My first visit to India was with no strings attached, and if, after it, there was no interest from the museum's side, it was agreed that we could pull out of the project with no costs incurred. As well as a range of artists, the people I met there included writer and critic Geeta Kapur, whom I had previously encountered in London, ethnologists Jyotindra Jain and Komal Kothari, as well as the American collectors Chester and Davida Herwitz, who were generous lenders to the exhibition. [23] Howard Hodgkin (1932–2017), an eminent British painter and Turner Prize winner, was on the board of a number of national museums as well as Oxford. When invited, Bhupen Khakhar declined to be in the Oxford exhibition, although he was in the official RA show. Nicholas Logsdail, director of the Lisson Gallery, London, who represented Anish Kapoor, strongly advised him not to be involved with the Oxford exhibition but Kapoor disregarded this. Another exception to the prevailing atmosphere of haughty wariness was the British painter, art writer, and curator Timothy Hyman (b. 1946) who visited India regularly and, during the early 1980s, was a visiting professor at the Faculty of Fine Arts, MSU University, Baroda. [24] All of the chosen artists were working figuratively. This, in different forms, had been the predominant, but not only, tendency since Independence. [25] "Gods of the Byways/Screen Idols" took place May 9 – June 20; "Aspects of Modern Indian Art / The Indian Calendar," June 27 – August 8; "The Other India," August 15 – October 3, 1982. [26] E. Alkazi, U. Anand, *Gods of the Byways: Wayside Shrines of Rajasthan, Madhya Pradesh and Gujarat;* this also included essays by Stephen Fuchs, Komal Kothari, Jyotindra Jain, and Haku Shah. E. Alkazi, D. Elliott, V. Musgrave [eds.], *India Myth and Reality: Aspects of Modern Indian Art;* this included essays by Deepak Ananth, Krishna Chaitanya, Geeta Kapur, FN Souza, and KG Subramanyan, and poems by MF Husain and Gieve Patel. D. Elliott [ed.], *The Other India: Seven Contemporary Photographers.* All were published by the Museum of Modern Art Oxford, in 1982, with design by Trilokesh Mukherjee. [27] The artists in both the modern art and photography exhibitions are listed in the Appendix at the end of this essay.

3

4

5

be of Indian origin, we should not present only one exhibition but a layered, kaleidoscopic view of contemporary Indian culture that engaged with such problems of seeing and feeling by examining how, at different levels, artists from cities and countryside communicated their views of what they felt was real. This would include, of course, Indian views of itself *and* the West, and the work would be shown in the same way as the museum's other exhibitions. This approach was built around three core exhibitions with the generic title of "India: Myth and Reality" that ran consecutively from May 9 to October 3, 1982. [25]

Part 1: "Wayside Shrines of Rajasthan, Madhya Pradesh and Gujarat" focused on examples of folk art, music and documentation of places of worship that related to the pre-Hindu popular religions and festivals in parts of Northern India. (fig. 3) Part 2: "Aspects of Modern Indian Art," the core of the project, presented a thematic, generational view of the development of art from the Bombay Progressive Artists' Group in the late-1940s to the present, showing a wide range of key artists' work; (figs. 4, 5, 8–13) Part 3: "The Other India" concentrated on the art and documentary approaches of seven photographers and included Pablo Bartholomew's series "Time is the Mercy of Eternity" (1975) depicting western drug addicts stranded in Delhi; Mitter Bedi's portraits of refugees from the countryside now working in heavy industry; and TS Nagarajan's documentation of decayed, forgotten palaces, mansions and temples in southern India. Illustrated catalogues with specialist articles on different aspects of these subjects accompanied each exhibition. [26] (fig. 6–7)

The "Aspects of Modern Indian Art" exhibition was the central pivot for "Myth and Reality" because it questioned head-on the picturesque and comfortable exoticism with which Indian culture was, and often still is, associated. In sculptures and paintings by nineteen artists spread across three generations, it engaged with actual political and social conditions through the images and words of the artists themselves. [27] Looking back, the didactic structure devised for the catalogue seems a little creaky, although the hanging of the exhibition itself was more free and intuitive. But we all agreed that it was necessary to provide a framework that expressed unfamiliar discourses on contemporary Indian art and, accordingly, works were grouped in the catalogue under the genre-like headings of "Hinterland of Myth," "Nature as Pictorial Metaphor," "Dislocated Persona," "Social Satire and Political Protest," "Strangers in the City," "Middle Class Alienation," and "New Myths, New Realities."

But what was most exhilarating about the exhibition was that in it, like in life, everything was jumbled up: the gods and saints of Hindus with Muslims and Christians; humble shrines with the victims of war and images of the generals who had caused their destruction; vain, self-regarding pandits; fish-out-of-water hippies; and alienated urban workers, anguished, isolated women with looming forest "deities" hand-woven into uncanny representations of the female sex. All these works had been made in the struggle of a newly independent republic.

The exhibitions and their related publications provided an aesthetic and educational armature around which smaller displays, film programs and events were hung. The first of these, "Screen Idols; Indian Film Posters from the '50s to the Present," was followed by "The Indian Calendar," a show of gaudy, largely religious, popular art. Lectures and workshops were arranged with MF Husain (who having started his "career" as a painter of large street billboards advertising new films in Bombay, had no compunction about making a very different kind of work inside the museum), artist Timothy Hyman, art historian Partha Mitter, and ethnologists Rupayan Sansthan and Komal Kothari who all gave talks, the latter supported by concerts of Rajasthani folk music; an extensive screening of Indian films and documentaries was also organized. Yet, rather than scheduling these exhibitions and events in a single homogenous block, it was decided

3 | Catalogue cover for "Gods of the Byways: Wayside Shrines of Rajasthan Madhya Pradesh and Gujarat," MoMA Oxford | 1982 | showing a painted and dressed stone icon of **Vanekhan Mata** | a protective tribal deity associated with the Hindu goddess Durga | photographed by Vivek Anand in Amlia, Udaipur | design by Trilokesh Mukherjee

4 | Tyeb Mehta | **Trussed Bull** | 1956 | oil on canvas | 94 x 107 cm | from "India: Myth and Reality – Aspects of Modern Indian Art" | MoMA Oxford | 1982

5 | KG Subramanyam | **Terracotta Bangladesh** series | 1971 | 78.7 x 78.7 cm | terracotta relief | catalogue cover for "Aspects of Modern Indian Art" | design by Trilokesh Mukherjee

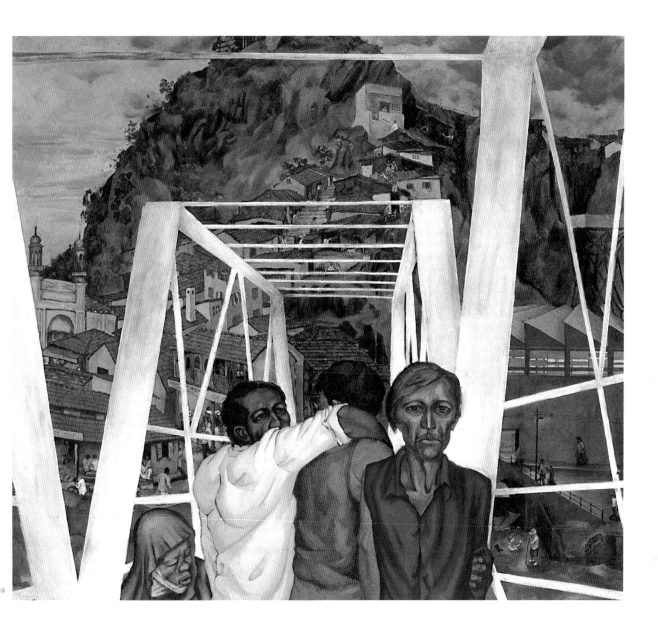

6 | Pablo Bartholomew | **Time is the Mercy of Eternity** |
1975 | from a photo essay about the life of a morphine addict
in New Delhi | 1975 | from "The Other India" | MoMA Oxford |
1982 | courtesy the artist

7 | TS Nagarajan | **Nagappa and his wife live in what
remains of their ancestral home** | Najangud, Karnataka |
c. 1978 | from "The Other India"

8 | Sudhir Patwardhan | **Overbridge** | 1981 | oil on canvas |
142.2 x 127 cm | from "Aspects of Modern Indian Art" |
courtesy the artist

9

10

11

12

9 | Nalini Malani | Woman in a Pink Room | 1975 | oil on canvas |
182.9 x 122 cm | from "Aspects of Modern Indian Art"

10 | Mrinalini Mukherjee | Devi II | 1982 | woven hemp |
208.3 x 106.7 x 132.1 cm | from "Aspects of Modern Indian Art"

11 | Krishen Khanna | Che Dead: Preparation for the
Photograph | 1970 | oil on canvas | 150.5 x 127.7 cm | from
"Aspects of Modern Indian Art"

12 | FN Souza | Crucifixion | 1959 | oil on board |
183 x 122 cm | Tate Collection, London | from "Aspects of
Modern Indian Art"

13 | MF Husain | Man | 1951 | oil on fiberboard | 121.9 x 243.8 cm |
gift of Chester and Davida Herwitz | Peabody Essex Museum,
Salem, MA | Herwitz Family Collection | from "Aspects of
Modern Indian Art"

14

to integrate them within the museum's regular programs so that they overlapped with other exhibitions—with a large show of pared-back, abstract landscapes and figures by the British painter Peter Kinley, for instance, that ran at the same time as "Gods of the Byways"; Peter Phillips's turbo-charged pop works and a small display of Japanese *Ex Libris* prints coincided with "The Other India." [28]

Though it may have seemed confusing to some, a seamless sense of continuous programming was vital in that it emphasized that, although the Museum of Modern Art Oxford had no permanent display, it was a platform that showed a broad, diverse range of new and unknown work because it believed it was important—as well as "modern" or "contemporary"—and "good."

With these exhibitions as a basis, the museum began to research modern and contemporary art from other Asian countries, and continued thinking about incorporating art from other continents into its exhibition program. [29] Building on the context and resources created by these first exhibitions, further solo shows of modern and contemporary Indian artists were planned. These included the haunting gouache and watercolor heads and figures made by Rabindranath Tagore during the 1920s and '30s **(fig. 14)**; Sunil Janah's photographs of famine, war, and independence in Bengal from the early 1940s to the 1960s; KG Subramanyan's sardonic responses to the cloistered halls of Oxford filtered, during a residency in 1987, through the conventions of Indian glass painting **(fig. 5, pp. 170–173)**; and the statuesque perversity of Mrinalini Mukherjee's large woven-hemp sculptures and installations that only today are starting to receive the widespread attention they so clearly deserve. [30] **(fig. 10)**

After the immersive experience of producing "India: Myth and Reality," with its interweaving narratives of folk art, myth, modernity, and modernism in many different media, the museum's next step in Asia would be much further east.

III. Japan (1984–1997)

Still hungover from the cultural quarantine that had followed the war, Japan had, by the mid-1960s, rebranded itself as a reserved, peaceful land of picturesque, uncontroversial, tradition—with *nihonga*, a kitschy yet super-expensive traditional style of art to match. Its booming economy suggested quite another reality yet, from outside, it was difficult to penetrate the polite smokescreen of convention to see what was actually happening in modern or contemporary art. [31] The Kansai-based Gutai group was the one exception. Its performative, action-based use of materials rhymed with both French *art informel* and American abstract expressionism to create ripples in the western art world that even provoked a brief appearance on British television. [32] Closer to home, from the mid-1960s, Yoko Ono had become a public figure in the UK (and the West), not as a substantial artist in her own right, but as an unwelcome distraction for John Lennon. [33]

In brief, other than as an exotic and traditional prompt for formal innovation that engaged some late-19th- and early-20th-century painters, or as an example for connecting nature with art that inspired a few early modern craftsmen and architects, or, from the 1920s, as a timeless example of simplicity and humility picked up by Bernard Leach and his British school of studio potters, Japanese art of any kind was regarded as "peripheral" and usually "derivative" by the West and omitted from its narrative of modernity. [34]

Early in 1984, during a brief chat with Andrew Brighton, then a senior lecturer in art history at Oxford Polytechnic, I mentioned casually that I was interested in finding out more about postwar art in Japan. Brighton introduced me to Kazu Kaido, a D.Phil. student at the University of Oxford

14 | Rabindranath Tagore | Untitled | 1931 | watercolor and pen on Japanese silk | 90.4 x 60.8 cm | Collection Rabindra Bhavan, Visva Bharati | from "Rabindranath Tagore: A Celebration of his Life and Work" | MoMA Oxford | 1986

15 | Taro Okamoto | **The Law of the Jungle** | 1950 | oil on canvas | 181 x 260 cm | Taro Okamoto Museum, Kawasaki | from "Reconstructions: Avant-garde Art in Japan 1945–65" | MoMA Oxford | 1985–86

[28] Peter Kinley (1926–1988). "Peter Kinley: Paintings 1956–82," May 9 – June 20, 1982; Peter Phillips (b. 1939), Peter Phillips: RetroVISION, Paintings 1960–82" and "Ex Libris Japan," August 15 – October 3, 1982. [29] As well as "Orozco!," exhibitions of work from Latin America included "Dreams-Visions-Metaphors: Photographs of Manuel Alvarez Bravo" (1984, Mexico); "Tierra y Libertad! Photographs of Mexico 1900–1935 from the Casasola Archive" (1985); "José Guadalupe Posada: Messenger of Mortality" (1989, Mexico); "Jac Leirner" (1991, Brazil); "Ana Maria Pacheco" (1991, Brazil/UK); "Art from Argentina 1920–1994" (1994); "Sergio Camargo: Sculpture 1960–1990" (1995, Brazil). Exhibitions relating to Africa included "Makonde: Wooden Sculpture from East Africa" (1989); "Art from South Africa" (1990); "John Muafangejo: 'I was lonelyness' [sic]" (1991, Namibia); "Signs and Emblems: The Flags of the Fante Regiments" (1993, Ghana). [30] "Rabindranath Tagore (1861–1941): Paintings and Drawings." See R. Monk, A. Robinson [eds] Rabindranath Tagore: A Celebration of his Life and Work, Rabindranath Tagore Festival Committee / Museum of Modern Art Oxford, 1986. The exhibition traveled also to the Barbican Art Gallery, London; The Cornerhouse, Manchester; Third Eye Centre Glasgow; and Cartwright Hall, Bradford. Sunil Janah (1918–2012): "Sunil Janah: Images of Bengal" took place from April 5 to May 31, 1987, at the same time as the Tagore exhibition; no catalogue was published. "KG Subramanyan: Fairy Tales of Oxford and Other Paintings," took place from February 21 to April 3, 1988. "Mrinalini Mukherjee: Sculpture" took place from April 17 to June 19, 1994, at the same time as "Kalighat: Indian Popular Painting," an Arts Council Touring Exhibition curated by Balraj Khanna. See C. Iles, D. Robinson, Mrinalini Mukherjee Sculpture, Museum of Modern Art Oxford, 1994. (This exhibition also traveled to the Yorkshire Sculpture Park, Wakefield, and the Royal Festival Hall Galleries, London). After a period of neglect, at the time of her death in 2015, Mukherjee's work was again attracting attention: a major work had been included in the 2014 Gwangju Biennale and a retrospective exhibition "Transfigurations: The Sculpture of Mrinalini Mukherjee" had opened at the National Museum of Modern Art in New Delhi in January 2015. [31] An exception in the UK was Jasia Reichardt's 1968 exhibition "Fluorescent Chrysanthemum" at the Institute of Contemporary Arts in London. Described as "a show of Japanese fluorescent sculptures, Japanese abstract cartoon films, graphics, and kites," it included the work of Seiichi Hayashi, Yoji Kuri, Tatsuo Shimamura, Ushio Shinohara, Kohei Sugiura, Jiro Takamatsu, and Tadanori Yokoo. [32] In September 1958, the "6th Gutai Group Exhibition" opened at the Martha Jackson Gallery, New York, before traveling to Bennington, Minneapolis, Oakland, and Houston. In May 1959, Gutai artists were first shown in Europe in "Arte Nuova: International Exhibition of Painting and Sculpture" at the Palazzo Granieri, Turin. In February 1959, a BBC film crew had filmed Gutai artists at work over two days in the Osaka area. Hirai Shōichi, "Chronology," in M. Tiampo and A. Munroe (eds.), Gutai: Splendid Playground, New York, Guggenheim, 2013, pp. 238–290. French critic and collector Michel Tapié (1909–1987) had been a leading figure in integrating abstract Japanese art in the 1950s with the international tendencies of Informel painting and Abstract Expressionism. See M. Tapié and Toru Haga, Continuité et Avant-garde au Japon, Turin, Edizioni D'Arte Fratelli Pozzo, 1961. [33] In September 1966, Yoko Ono had traveled from New York to London to perform in the Destruction in Art Symposium and decided to stay. She met John Lennon at the opening of her solo show at the Indica Gallery in the following November. See also note 53. [34] See pp. 60–81 for reciprocal links and influences between Japanese and German culture since the Meiji Restoration. See also Gabriele P. Weisberg (ed.), Japonisme: Japanese Influence on French Art 1854–1910 (exh. cat.), Cleveland Museum of Art, Walters Art Gallery Baltimore, 1975, and Tomoko Sato and Toshio Watanabe, Japan and Britain: An Aesthetic Dialogue 1850–1930, London, Lund Humphries, 1991. Bernard Leach (1887–1979), acknowledged as the father of British Studio Pottery, had worked for a time in Japan and established a long relationship with Japanese potter Shoji Hamada (1894–1978).

16

17

18

whose topic was exactly this. I quickly arranged a meeting. Kaido brought along some pictures. The punk colors and pseudo-innocence displayed by the open-mawed, crimson shark that diagonally bisected Taro Okamoto's large painting *The Law of the Jungle* (1950) made my jaw drop. (fig. 15) A large zipper ran the length of its back and a dead feline/humanoid lolled in its mouth as "cartoon" creatures fled away while three deaf monkeys stared impassively ahead. [35] This, I was told, was a comment on the Red Purges that were at their height in Tokyo when the work was made.

The range, sophistication and energy of the works Kaido had assembled were impressive and compelling. Not only were they undeniably part of a common history of modernity, unacknowledged by the West, but they also sketched out a narrative of styles and personalities that interacted with a rapidly evolving postwar culture and society that completely contradicted conventional touristic stereotypes. Her story came to a natural end in the mid-1960s, just after Japan had fully re-entered the international community by hosting the 1964 Summer Olympics. The period of intense artistic ferment, it seemed, was largely over. A number of artists had gone abroad, those who remained seemed even more isolated. I had no doubt that this body of work deserved much wider recognition and asked Kaido if she would curate an exhibition around this topic. She agreed, although neither of us had any idea about how the necessary support would be found to make it possible.

Kaido began to sound out artists and collectors in Japan about the idea; I discussed the project with the British Council in London, which had recently successfully organized in Japan an exhibition titled "Aspects of British Art Today." [36] Out of this, a joint initiative developed between the Japan Foundation in Tokyo and the British Council to invite a group of curators from each country so that they could familiarize themselves with each other's culture and, in particular, with contemporary art. [37] Their tacit aim was that exhibitions, or other forms of cultural exchange, should result and, as MoMA Oxford was the only institution in the UK that had a concrete proposal, I was included in the group. The visit took place at the beginning of 1985, with Kaido as its British Japanese-speaking liaison, and kicked off with a tour of museums and galleries in Tokyo where particular emphasis was laid on the importance of the Mono-ha artists as typical representatives of Japanese contemporary art. Unfortunately, none of the group seemed particularly enthusiastic about this work. [38] The generous and well-organized program continued with visits to the cities of Fukuoka, Hiroshima, Kurashiki, Kyoto, Nara, and Nikko. [39]

This visit, led by Henry Meyric-Hughes, head of the Visiting Arts Section of the British Council, provided an opportunity for making a presentation to senior officials at the Japan Foundation about our idea for an exhibition of postwar Japanese avant-garde art that, Kaido and I argued, would provide a necessary grounding for an appreciation of its more recent manifestations. The proposal was received politely if bemusedly and, although few opinions were expressed, Yoichi Shimizu, the senior, asked Kunio Yaguchi and Fumio Nanjo, two younger officers in the Fine Arts Department, to keep an eye on its development. [40] This was a far from simple task: the multiple styles, tendencies, and artistic groups we wished to show did not yet constitute a coherent period within Japanese art history. Moreover, the exhibition would inevitably stray into such sensitive questions as local reactions to the effects of the war and nuclear attack, the social impact of the US occupation (1945–52), the role of the Communist Party in art during the early 1950s, political-aesthetic debates about the future of Japanese society and art, and—its proposed climax—the deconstruction of art itself in the street demonstrations and wild paintings of the Neo-Dada Organizers and in the "scandal" of Genpei Akasegawa's 1,000 yen-note trial. [41]

In slowly edging the project forward, we were helped greatly by the artists Kaido had already contacted as well as by galleries and museums that

16 | Shomei Tomatsu | **Protest, Tokyo** | 1969 | from "Black Sun" | MoMA Oxford | 1985

17 | Masahisa Fukase | from **The Solitude of Ravens** | 1976–82 | from "Black Sun"

18 | Tadanori Yokoo | poster for the publication and exhibition of the photographic series of works **Kamaitachi** by Eikoh Hosoe | Tokyo | 1969 | silkscreen | 103.1 x 52.6 cm | from "Black Sun"

19 | Kikuji Yamashita | **The Tale of Akebono Village** | 1953 | oil on jute | 137 x 214 cm | Nippon Gallery, Tokyo | Collection of the Museum of Modern Art, Tokyo

20 | Hiroshi Nakamura | **Revolutionary Metropolis** | 1959 | oil and collage on canvas | 96.8 x 162 cm | Tokyo Metropolitan Art Museum

[35] Taro Okamoto, *The Law of the Jungle (Mori no Okite),* 1950, oil on canvas, 181 x 260 cm, Taro Okamoto Museum, Kawasaki. Okamoto had studied in Paris before World War II and had exhibited there with the Surrealist group. [36] The exhibition traveled to five venues throughout Japan during 1982. [37] Five British curators, one arts administrator, and one art journalist were on this delegation. A group of Japanese curators had already visited Britain and this exchange became the first of a number of Japan Foundation initiatives that invited curators from different countries to Japan. [38] Mono-ha means "School of Things" and refers to a diverse group of artists working in Japan from the late 1960s whose work explored different encounters between natural and industrial materials. [39] Following a visit to the Peace and Culture Center in Hiroshima, I was struck by the rawness of "Hiroshima: Paintings by Survivors," a traveling exhibition of paintings made by survivors of the atomic bomb that recorded their memories of the event. Within the UK, there was considerable popular concern during the mid-'80s about the proliferation of nuclear cruise missiles on US bases and, in response to this, MoMA Oxford opened this exhibition at the beginning of August 1985, just before the 40th anniversary of the dropping of the atomic bomb. It was shown from August 4 to September 29, 1985, at the same time as Austrian artist Arnulf Rainer's (b. 1929) "Hiroshima Zyklus." The book *Unforgettable Fire. Pictures Drawn by Atomic Bomb Survivors,* Tokyo, NHK/New York, Pantheon Books, 1977, served as the catalogue. [40] Fumio Nanjo was the second director of the Mori Art Museum, Tokyo. [41] In 1963, Akasegawa Genpei (1937–2014) sent out invitations for an exhibition in Tokyo with the image of a 1,000 yen note on the front, and used partial reproductions of the 1,000-yen in later artworks. He was put on trial in 1966 and convicted of counterfeiting.

readily agreed to lend work. Seiji Oshima, director of the Setagaya Museum of Art in Tokyo and chairman of the Japan Association of Art Museums also gave valuable support on the Japanese side and Mark Francis, director of the Fruitmarket Gallery Edinburgh, committed to provide a second venue for the exhibition. Five months after our visit was over, critical mass was reached when both the Japan Foundation and the Yomiuri Newspaper group agreed to participate as major sponsors.

The last, breathless stage of the research and organization went hand in hand with securing further funding; this was by no means straightforward, and only at the last moment was it sure that we could go ahead. An opening date was tentatively fixed for December 1985. The exhibition title "Reconstructions: Avant-Garde Art in Japan 1945–1965" referred "literally to the rebuilding of a [war-] shattered country as well as metaphorically to the reassessment of the cultural history of postwar Japan." [42] It showed the work of 35 artists from three generations.

In a structure similar to that of "India Myth and Reality," "Reconstructions" also became the core of a number of related exhibitions and events. The main exhibition occupied the three galleries on the top floor of the museum while, on the middle level "Black Sun: The Eyes of Four," showed work by four Japanese photographers. The lower-floor gallery hosted "Dada in Japan 1920–1970," a documentary display that made a revealing link between the recent past and Japan's, even less recognized, pre-war avant-garde. [43] The photography show, curated by Mark Holborn, amplified the symbolic ground of the larger exhibition: Eikoh Hosoe's *Kamaitachi* (1969), a haunting demon of the rice fields brought to life by Butoh dancer Tatsumi Hijikata, re-enacted memories and impressions of the last months of the war. (fig. 18) Shomei Tomatsu's images of Nagasaki embodied time and life stopped still at the moment of nuclear impact. (fig. 16) Masahisa Fukase's grainy calligraphies of crows, images of ill omen, were also distant shadows of wartime bombers that, like black holes, sucked time into destruction. (fig. 17) Daido Moriyama's dark textures of worn-down cityscapes revealed how, even in the most godless and destitute of places, a strange, uncanny beauty survived. [44]

The fluorescent pink covers of the "Reconstructions" catalogue enclosed essays by Kaido, the art critic Ichiro Hariu, and the artist Genpei Akasegawa, as well as commentaries and illustrations of works and a detailed chronology. [45] The half title page, printed in black, illustrated *Landing Operation* (1942), a war painting by Kenichi Nakamura showing the battle of Kota Bharu in Malaysia. (p. 76, fig. 35) On the next page, a newspaper photograph recorded an anonymous bombed-out street in Tokyo in 1945. Neither was in the exhibition. The inside back cover showed seized wrapped objects from Akasegawa's *One Thousand-Yen Note Trial* (1963–65) in which, for making an obvious replica of a Japanese bank note as an artwork, the artist had been accused of counterfeiting and had used his arraignment as an opportunity for an extended performance in which a number of artists participated. Objects, traces and documentation of this ephemeral work were in the exhibition. (figs. 22–23)

In between these poles, both the catalogue and exhibition moved from Surrealism and postwar reconstruction, during which artists enlisted fantasy and horror to get to grips with the enormity of what had happened, to the radical realism of the 1950s in which works as different as Kikuji Yamashita's surrealist vision of landlord violence against untenured peasants in *The Tale of Akebono Village* (1953) (fig. 19), On Kawara's inverted view of a naked pregnant woman and dismembered bodies in *Bathroom (Pregnant Woman)* (1954) (fig. 21), Shigeo Ishii's searing image of a trouser-less, impotent, desolate "marionette" culture in *Pleasure* (1957) (fig. 25), and Hiroshi Nakamura's satirical collage of milling demonstrators set against armed police cordons and a barricade of men's urinals in *Revolutionary Metropolis* (1959) (fig. 20). Altogether the works communicated a sense of profound anxiety and disillusionment with the rottenness of a lost, Americanized, and newly corporate Japan. [46]

21 | On Kawara | **Bathroom (Pregnant Woman)** | 1954 | oil on canvas | 140 x 134.5 cm | National Museum of Modern Art, Tokyo

22 | Genpei Akasegawa | "One Thousand-Yen Note Trial: Catalogue of Seized Works" | poster | 1967

23 | Natsuya Nakanishi | **Clothes Pegs Assert Churning Action, 5th Mixer Project** | 1963 | action and performance | these performances and related installations developed at the same time as Genpei Akasegawa's **One Thousand-Yen Note Trial** | courtesy the artist

24 | Neo-Dada Organizers' performance in Ginza Tokyo | April 1960 | participating artists Masanobu Yoshimura (center) and Ushio Shinohara (left)

25 | Shigeo Ishii | **Pleasure** from **Violence** series | 1957 | oil on canvas | 130.7 x 162 cm | Yokosuka Museum of Art, Kanagawa

45

[42] David Elliott and Kazu Kaido, "Introduction," *Reconstructions: Avant-garde Art in Japan 1945–65,* Oxford, Museum of Modern Art, 1985, p. 10. [43] The showing dates for these exhibitions were December 8, 1985, to February 9, 1986. "Reconstructions" was curated by Kazu Kaido with David Elliott and presented by the Museum of Modern Art Oxford with the Japan Foundation and the Yomiuri Newspaper Group (additionally supported by the Visiting Arts Unit of Great Britain, Japan Airlines, the Kajima Foundation for the Arts, Kao Co. Ltd., Sabre International Textiles Ltd., Toppan Printing Ltd. (Japan) and Yamato Transport Co. Ltd.). See the Appendix for the artists list. "Black Sun: Native Roots and Innovation in Contemporary Japanese Photography" was curated by Mark Holborn and Tatsuo Fukushima and jointly presented by the Arts Council of Great Britain, the Museum of Modern Art Oxford, the Philadelphia Museum of Art, Aperture and the Japan Foundation (Tokyo). It showed discrete bodies of work by Masahisa Fukase (1934–2012), Eikoh Hosoe (b. 1933), Daido Moriyama (b. 1938) and Shomei Tomatsu (1930–2012). The documentary exhibition "Dada in Japan 1920–70" had been assembled by Yoshio Shirakawa and had been first shown at the Kunstmuseum Düsseldorf in 1983. A catalogue in German was available. [44] The program was completed by showings of the classic films of Kenji Mizoguchi (1898–1956) and by the program "Society and Morality: Cinema in Post-War Japan" that had been devised by the Japan Foundation. A local cinema also compiled its own selection of recent Japanese films. In co-operation with the Ashmolean Museum and the Nissan Institute of Japanese Studies, a wide range of speakers was invited to participate in a two-day symposium on "Post-War Art and Culture in Japan." [45] Commentaries were written by Kaido, Fumio Nanjo, Yasuyoshi Saito, and Yasuhiro Yurugi. The chronology was by Elliott, Kaido, and Masatoshi Nakajima, and the bibliography was by Nakajima. The catalogue design was by Walter Nikkels. Kaido also published, in Japanese only, a description of the ideas behind the exhibition in *Bijutsu Techo,* Tokyo, April, 1986. [46] Kikuji Yamashita, *Akebonomura Monogatari* (1953), oil on jute, 137 x 214 cm, Nippon Gallery, Tokyo; On Kawara, *Yokushitsu (Ninpu)* (1954), oil on canvas, 140 x 134.5 cm, National Museum of Modern Art, Tokyo; Shigeo Ishii, *Pleasure* (1957) from "Violence" series, oil on canvas, 130.7 x 162 cm, Yokosuka Museum of Art, Kanagawa; Hiroshi Nakamura, *Kakumei Shuto* (1959), oil and collage on canvas, 96.8 x 162 cm, Tokyo Metropolitan Art Museum. Both Ishii and Kawara were, from April 1955, members of the Artists' Discussion Group *(Seisakusha Kondankai).*

20

[47] Operating between 1960 and 1963, the membership of the Neo-Dada Organizers fluctuated. Under the leadership of Masonobu Yoshimura and Ushio Shinohara, ten other members joined the group, including Shusaku Arakawa; Tetsumi Kudo was affiliated to it but not a member. Hi-Red Center, formed in 1963, was an anglicization of the first part of the last names of its three members: Jiro Takamatsu, Genpei Akasegawa, Natsuyuki Nakanishi. They exhibited both together and individually and made a large number of public actions. [48] Although they would allow that one or two works showed "energy," most critics, such as Waldemar Januszczak (*The Guardian*, December 27, 1985), worried about the "western influences" on Japanese art and seemed unable to grasp that Japanese art in the early 1960s was patently much more energetic and radical than anything being made in London at that time. John Russell Taylor (*The Times*, January 7, 1986) noted the "originality" of much of the work, percipiently pointing out that the language of its painting would have been reminiscent of the then current Neo-Expressionism and Transavanguardia had it not been made 30 years earlier. [49] Art Vivant, Tokyo, Special Issue: *Reconstructions: Avant-garde Art in Japan 1945–65,* 1986. In an addendum to this, Kaido discussed the debate the exhibition had caused both within and outside Japan, advocating an inclusive view of art history that embraced and analyzed the specific characteristics of Japanese modernity. This was published in English in D. Chong, M. Hayashi, K. Kajiya, F. Sumitomo (eds.), *From Postwar to Postmodern. Art in Japan 1945–1989, Primary Documents,* New York, Museum of Modern Art, 2012, pp. 401–403; *Japon des Avant-gardes 1910–1970,* Paris, Centre Pompidou, 1986. [50] See Frederik L. Schodt's book *Manga! Manga! The World of Japanese Comics,* published by Kodansha International (New York) in 1983. It was not until 2009 that, at the tale end of the cult of *kawaii,* the Japanese government started to use manga and animé characters as "cultural ambassadors." See p. 84, fig. 4. [51] There was, however, a large promotion of Japanese manga and animé in 1988 at the *15th Salon International de la Bande Dessinée* in Angoulême. This French city also has a museum dedicated to *bandes dessinées* (comics and graphic novels). [52] *Eisenstein 1898–1948: His Life and Work,* 1988, op. cit. [53] The Kusama exhibition took place from November 5, 1989, to January 5, 1990. The Yoko Ono exhibition was shown from November 23, 1997, to March 15, 1998. [54] "Chinese Picture Stories" was shown in the lower floor gallery of MoMA from August 2 to October 18, 1987. An illustrated catalogue in English, with the title *Chinese Comics,* was published by the China Exhibition Agency, Beijing.

With less controversy, the Osaka-based Gutai artists led the charge into abstraction and performance as part of an extended section that also included the heavily textured *informel* paintings of Toshimitsu Imai as well as the later "calligraphic" paintings of Yoshishige Saito and Kumi Sugai. The exhibition ended with an anarchic thunderclap of Neo Dada interventions, Hi-Red Center actions and performative or iconoclastic objects by such artists as Yayoi Kusama and Tetsumi Kudo. [47]

If the senior officials at the Japan Foundation had been bemused when the exhibition was first suggested to them, so was the British public when it had a chance of seeing it. Everything seemed so unfamiliar and, other than the war, there were few points of common reference. [48] In spite of the obsession of the British art press with how "western" the art was, there was no doubt that the exhibition and the works in it made an extremely strong impact. At the end of the following year the broader survey "Japon des Avant-gardes 1910–1970," independently organized by the Centre Pompidou, opened in Paris, while the text and illustrations of the Oxford catalogue were awarded the rare honor of being reprinted in Japanese. [49]

Having established a firm interest in Japan, I was then keen to develop ideas for further exhibitions. Manga—popular comic books and graphic novels— were the most impressive of the current "art" I had seen there and was my first choice. Kaido collected examples and genres with the idea of analyzing the different styles and storylines to give insight not only into this vibrant, quintessentially Japanese, form of visual culture, but also into the developing synapses of Japanese society itself. The Japan Foundation, however, could not have been less interested in this idea because it seemed to them far too low-brow even though there was growing interest in manga abroad. [50] The manga publishers and artists also did not respond; millions of people already enjoyed their work in Japan and, in any case, they did not regard what they were doing as "art." [51]

Equally frustrated was the idea of making an exhibition about the art, cinema, and life of film director Akira Kurosawa (1910–1998), in the same spirit that Oxford MoMA had already devised for the work of Sergei Eisenstein. [52] I had friendly conversations about this in Tokyo with the writer and film critic Donald Richie, who had worked with him on a number of occasions, as well as with Kurosawa's brother. During this latter meeting it became clear that, because no income was derived from rights for his early classic Toho films, Kurosawa's only preoccupation was to raise funding for the films he had yet to make and this was now exclusively from foreign sources. An exhibition of this kind would not be an honor but an unwelcome distraction.

A happier outcome was making contact again with Yayoi Kusama, with whom I had stayed in touch since "Reconstructions." She was delighted with the idea of a large solo show in Oxford, her first in the UK, and in 1989 "Soul Burning Flashes: Painting and Sculpture" stretched across the museum's top floor. (fig. 26) In the same spirit, during the mid-1990s, I made contact with Yoko Ono in New York, who had appeared briefly in "Reconstructions" in a Hi-Red Center video. In 1997, a year after I left Oxford, "Yoko Ono: Have You Seen the Horizon Lately?"—the first major reassessment of her work—took place at MoMA Oxford, curated by Chrissie Iles. [53]

IV. China (1987–1993)

Although the manga project proved to be unsuccessful, a related proposal arrived soon after from an unexpected quarter. At the beginning of 1987, the Chinese Embassy in London approached the museum about "Chinese Picture Stories," a small traveling exhibition of original artwork for comic books that reflected a completely different context and approach to that of Japan. (fig. 27) In the work of 39 artists, it illustrated, in traditional as well as contemporary styles of drawing and painting, myths, tales, and struggles, including some with impressive "wide-angle" cinematic effects. [54]

26 | Installation view of Yayoi Kusama's works in "Soul Burning Flashes: Painting and Sculpture" | 1989 | Upper Gallery MoMA Oxford | courtesy MoMA Oxford archive

27 | Catalogue cover for the Chinese Picture Stories exhibition | 1987

This was providential because, since "Reconstructions," I had been looking for aspects of contemporary art from other parts of Eastern Asia that would make sense in the Oxford program. China was the first and obvious candidate. In the chaotic aftermath of the Cultural Revolution (1966–76), Deng Xiaoping's revolutionary "Open Door" policy had, from the end of the 1970s, turned the tide of 40 years of war, chaos, self-imposed isolation, and hardline ideology not only to open up China to the art, philosophy, and science of the West but also to rediscover its suppressed and previously condemned traditional beliefs and cultures. In this context, the variegated works in the "Chinese Picture Stories" exhibition made it clear that we were dipping a toe into a vast, unexplored ocean. We realized we should research a large exhibition of contemporary Chinese art but had no idea about how to go forward.

In 1980, Michael Sullivan, one of the pioneers of modern Chinese art history, had moved from the US to Oxford as a Fellow of St. Catherine's College and started to take an interest in the museum. [55] Although he had not lived in China since the 1940s, he had visited there often, knew a number of younger as well as established artists, and was a great source of sound advice; he also later provided a valuable contact with Tsong-zung Chang, director of Hanart TZ Gallery in Hong Kong, who was researching contemporary art on the Chinese mainland. [56]

At the same time, MoMA's work in India, Japan, the Soviet Union, and elsewhere, had strengthened its links with the British Council and, when visitors from abroad wanted to visit Oxford's fabled "dreaming spires," we were often enlisted to provide an antidote. [57] The British Council had no office in Beijing at the time but put me directly in touch with the Culture Section of the British Embassy and, to get the ball rolling, the Cultural Counselor agreed to include our proposal for an exhibition of new art from China in the discussions on the mutual Cultural Exchange Program that were then underway.

So, when Wang Meng, the Chinese Minister of Culture, visited Oxford late in 1987, the British Council steered him in my direction. I referred to our project but he knew nothing about it and seemed not to be interested. [58] The seed, however, had been sown in Beijing and the idea had been accepted in principle by the Chinese. This good news, however, was tempered by the Ministry's referral of the project to the China Exhibition Agency that would prepare an exhibition without any reference to the museum. We made it clear that we had no interest in such a proposal and requested a research visit to discuss what we could make together and, at the same time, visit artists' studios. After a few months, I received a message that a trip could take place, but at the museum's cost. [59]

The timing of this could not have been worse. We were then occupied on large projects in the Soviet Union (perestroika was in full flood) and in South Africa, where I was negotiating with the ANC (African National Congress) government-in-exile and the UDF (United Democratic Front) inside the country that, under their auspices, an exhibition in Oxford of contemporary art from the "new" South Africa would be neither premature nor break the cultural boycott. As it was not clear if the funding for the Chinese exhibition was in place, or if they were committed to allowing the museum free access in selecting work, neither I, nor any of the other museum staff, could take the risk of breaking off to make a visit. The whole project was in a mess.

In March 1989, Ying Ruocheng, the vice minister of culture, passed through Oxford and, in the immediate aftermath of the controversy that the large "China/Avant-Garde" exhibition that had just taken place in Beijing had caused, I again raised the question of the exhibition. [60] He was politely enthusiastic but again noncommittal. Because there were no alternative structures, it was difficult to envisage how the necessary permissions to bring work and artists to Britain would be granted without official

[55] Michael Sullivan (1916–2013) had been the Christensen Professor of Chinese Art in the Department of Art at Stanford University and the Slade Professor of Fine Art at the University of Oxford. His collection of Chinese art is now housed in the Ashmolean Museum, Oxford. [56] At the beginning of 1993, Tsong-zung Chang with Li Xianting curated "China's New Art, Post-89 with a Retrospective from 1979–89" as part of the Hong Kong Arts Festival, January 30 to February 28, 1993. Under the title "Mao Goes Pop," part of this exhibition traveled to Sydney, Melbourne, Vancouver, and to five venues in the US. Asia Art Archive, Hong Kong, reprinted the original exhibition's extensive catalogue in 2001. [57] Oxford is famously and aptly known by two descriptions composed by the Victorian poet Matthew Arnold. It is both the city of "dreaming spires" (Thyrsis, 1866) and the "Home of lost causes, and forsaken beliefs . . ." (Essays in Criticism, 1865). [58] Wang Meng (b. 1934) was Chinese Minister of Culture from 1986 to 1989. He was best known as a writer and had been denounced as a "rightist" both in the 1950s and throughout the Cultural Revolution. [59] Letter from Head of Cultural Section of British Embassy Beijing to David Elliott, April 21, 1988. MoMA Oxford Archive. [60] Ying Ruocheng (1929–2003) was vice minister of culture from 1986 to 1990. He was a well-known actor who made a number of western (as well as Chinese) films—most famously Bernardo Bertolucci's The Last Emperor (1987); he also worked as a director and playwright. During the Cultural Revolution he had been exiled to the countryside as a manual laborer. [61] Few British companies were involved with China at this time, but if any arts sponsorship had been on the horizon it would have favored established, traditional art rather than potentially contentious contemporary work. [62] See Don J. Cohn, "Shots Heard 'Round Beijing," ArtAsiaPacific, Issue 65, Sep/Oct, 2009. One closure of the exhibition was prompted by artist Xiao Lu firing two bullets at her Telephone Booth installation; the other was caused by an unexplained bomb scare. [63] The "China/Avant-Garde" exhibition had little pre-publicity outside China although, once open, it was widely reported in the international press. No one from Oxford was able to travel to Beijing during the exhibition's two-week duration, but Fei Da Wei, one of its organizers, made a full set of slides that the museum immediately ordered. Fei later informed me that this was the only order he received for the slides. [64] The Haus de Kulturen der Welt (HKW, House of World Cultures) was set up by the German government in 1989 to reflect the radically changed international cultural political and cultural situation. The HKW team for the Chinese exhibition consisted of Hans van Dijk, Jochen Noth, Wolfger Pöhlmann and Andreas Schmid. Wim van Krimpen of the Kunsthal Rotterdam later decided to take the Berlin exhibition as did Karsten Ohrt of Kunsthallen Brandt's Klaedefabrik in Odense. [65] China Avant-garde (exh. cat.), Berlin, Haus der Kulturen der Welt, 1993 in German, English, and Chinese editions. The exhibition "China Avant-garde: Moderne chinesische Kunst nach '89" was shown at the HKW from January 30 to May 2, 1993. See Appendix on p. 49 for the list of exhibited artists in Berlin and Oxford. [66] D. Elliott and L. Mepham (eds), Silent Energy: New Art From China, Oxford, Museum of Modern Art, 1993, with essays by the curator, Hou Hanru, and texts by the artists. MoMA Oxford also produced a brochure entitled New Art From China that provided an extensive historical context for the work in both exhibitions.

28

29

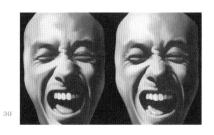

30

Chinese logistical and financial support, and this, combined with the lack of potential commercial sponsors on the British side, made it impossible to plan the next move. [61]

While these intermittent, at times desultory, discussions had been taking place, huge developments had been continuing in China: artists were becoming increasingly active and, across the country, a wide range of different positions and tendencies had been adopted by artists, as well as the use of new media. This coincided with animated political discussions, both within the Communist Party and at the grass-roots level, about the shape and structure of the new China.

The artistic climax of the whole period of intellectual and cultural ferment that had followed the Cultural Revolution came at the beginning of February 1989 with "China/Avant-Garde," an exhibition at the China Art Gallery (now the National Museum of China) in central Beijing where, for two weeks, the works of nearly 300 artists provoked elation, incomprehension, and even fear, amongst its visitors. As a result, it was dogged by constant surveillance and periodic closure. [62] Its widely replicated logo, the crossed out symbol for a U-Turn, was an obvious endorsement for the continuation of Deng Xiaoping's policies which were then being strongly challenged by a government counter-campaign to stamp out "bourgeois liberalization." [63]

On June 4, 1989, four months after the exhibition's opening, the student-led "Democracy Movement" demonstrations in Tiananmen Square, to which the "China/Avant-Garde" exhibition was related in spirit, were brought to an end by military intervention: an unknown number of demonstrators perished, many were arrested, martial law was declared. China, with its contemporary art, entered a phase of what is often described as "cynical realism" and, for almost three years, the UK, along with many other western countries, severed cultural links.

From a western viewpoint, it was difficult to assess the exact cultural significance of what was happening. Funding for a research trip had eventually arrived from the Visiting Arts Unit of the British Council but, within a few months, the offer was withdrawn. Although the Chinese exhibition had to be put on hold, I was unwilling to let it slide.

At the beginning of 1990, a *dea ex machina* suddenly broke the impasse. Lydie Mepham, a French-born Chinese scholar resident in Brighton, had been living in Beijing through the 1980s and knew the artists and their work as well as the burgeoning art scenes in Shanghai and Hangzhou. She was happy to collaborate on the idea of making an exhibition, and her knowledge, documentation, and connections short-circuited the need for an immediate research trip. She added her material to what we already had and started to collect more. Mepham and I agreed that we would work together as co-curators of the Chinese exhibition; I would concentrate on those artists who had left China.

Shortly after, we heard that the newly founded Haus der Kulturen der Welt (HKW) in Berlin had begun work on a similar exhibition and we met to explore what could be done together. [64] The German team was more of a committee than the Oxford duo and, although we quickly realized that we were interested in many of the same artists (and works), there were a number of points on which we differed. Essentially, the HKW project set out to document the work of 60 artists working throughout China during the 1980s and '90s in a catalogue that would also include articles by Chinese and western writers on different aspects of contemporary culture. Out of these artists, an emblematic sixteen were exhibited. The emphasis of the exhibition was a response to the much larger 1989 Beijing show and, with a preponderance of painting, took the subversion of popular imagery and media as a starting point. MoMA's interest included this but was also concerned to focus on large scale, site-specific works that would clearly

28 | Yu Youhan | Chairman Mao in Discussion with the Peasants of Shao Shan | 1991 | oil on canvas | 167 x 119 cm | from "China Avant-garde" | courtesy Shanghart Gallery, Shanghai

29 | The front facade of MoMA Oxford | 1993 | photo: Chris Moore | courtesy MoMA Oxford archive

30 | Geng Jianyi | The Second State | 1987 | oil on canvas | 145 x 200 cm | from "China Avant-garde" | courtesy Shanghart Gallery, Shanghai

31

[67] "New Art from China Part 1: Silent Energy," June 27 – August 29; "Part 2: China Avant-garde," September 5 – October 24, 1993. There was, in addition, a supporting program of talks and workshops at the museum, as well as related displays of Chinese art at the Ashmolean and Pitt Rivers Museums. [68] During the 1970s and '80s, Sots Art parodied the State clichés of Soviet art in the same way that Pop Art replicated capitalist clichés in the West. "Komar & Melamid History Painting," Edinburgh, Fruitmarket Gallery, Oxford, Museum of Modern Art, 1985, showed two of the masters of Sots Art in full form. Ilya Kabakov, Erik Bultatov, and the work of other non-official artists were subsequently shown in "100 Years of Russian Art 1889–1980: From Private Collections in the USSR" (1989). See also D. Elliott and Matthew Cullerne Bown, Soviet Socialist Realist Painting 1930s–1960s, Oxford, Museum of Modern Art, 1992. [69] At the same time as "Silent Energy," a display of posters and ceramics produced during the Chinese Cultural Revolution was shown in the museum's lower-floor gallery that, in subject, rhymed with the much-larger survey exhibition "Art Into Production: Soviet Textiles, Fashion and Ceramics 1917–1935," put together by the museum in 1984. During "China/Avant-Garde," "A Tale of Two Cities: Mexico and Beijing," by Magnum photographer Stuart Franklin, also took place in the lower-floor gallery. [70] Animal-rights protesters, led by British TV personality Johnny Morris, strenuously objected to this work. See, for instance, Bill Heine, "Museum Visitors See Animals Killed in Tank of Death," Oxford Star, July 8, 1993, pp. 1, 11. [71] Chen Zhen in Silent Energy, p. 11. The title of the exhibition was derived from Chen Zhen's words. [72] See pp. 298–309 for a discussion of other works related to this. [73] These principles were somewhat compromised by British over-cautiousness and unfamiliarity of working with gunpowder that led to a slower fuse being supplied for this work than had been ordered. Instead of taking about 30 seconds, it lasted for about 10 minutes. [74] Yang Jiechang in Silent Energy, p. 22. Yang's statement about this work in the catalogue reframed Aesop's story of The Boy Who Cried "Wolf" as the continuous action described by its title, without any moral being drawn. [75] Two cots contained placenta powder from a healthy birth, one cot was bare (suggesting, to Gu, abortion), the fourth cot contained powder from a deformed birth and the fifth that from a stillborn child. [76] Gu Wenda, Silent Energy, p. 15. [77] Craig Clunas, "The Refusal to be Exotic," Times Literary Supplement, September 10, 1993. [78] Tom Lubbock, "Lost in the Outback," The Independent, August 3, 1993. This, at least, was more thoughtful, and less offensive, than "Chinks of Light," Sarah Kent's short write-up for Time Out. [79] Lynn MacRitchie, "Chinese Puzzles," Financial Times, July 16, 1993, "Back to Beijing for Bohemian Principles," Financial Times, September 24, 1993.

stand out in the context of western contemporary art as well as in their relation to the museum's previous exhibitions.

After discussion, this led to an agreement by which MoMA would show eleven out of the sixteen artists in the HKW's "China Avant-garde" exhibition and also help produce and buy into its excellent catalogue. [65] Independently, Mepham and I decided that Oxford would also organize another exhibition, "Silent Energy," that would include new site-specific works by eight Chinese artists, seven of whom were not shown at the HKW. [66]

By the end of 1992, the funding position in the UK had improved towards China, and, as soon as it was clear that the cultural embargo was no longer active, Berlin first and then Oxford swung into action. Under the heading "New Art From China," the MoMA and HKW exhibitions ran consecutively in Oxford from June 27 to October 24, 1993, with "Silent Energy" shown first. [67]

The poster image for "New Art From China" was taken from a detailed close-up of one of the "screaming heads" in Geng Jianyi's painting The Second State (1987). (figs. 29, 30) Grotesque, painful, shocking, it seemed like an angry retort to the Soviet-inspired paintings of the Cultural Revolution—a reaction with which "Oxford watchers" would have been familiar, as the museum had earlier shown "unofficial" Russian Sots Art and, once the regime that had supported such work had crumbled, had also presented the first western survey of "official" Soviet Socialist Realism. This included the influential paintings of Konstantin Maksimov (1913–1993) who, in the mid-1950s, had been invited to the Central Academy of Fine Arts in Beijing to teach young Chinese artists the finer points of Stalinist painting—an interchange that made a huge impact on the art of the Cultural Revolution. [68]

In "China Avant-garde," socialist-realist propaganda images of Mao or the Red Guards were appropriated for other ends in the "Political Pop" paintings of such artists as Yu Youhan and Wang Guangyi who, in their source material, satirical intent, and cheeky references to western pop art, were not unlike the Russian Sots Artists. [69] (fig. 28) In a more sardonic form, Zhang Peili's actions, paintings, and videos directly subverted the voice of authority. By making bureaucratic lists of pointless instructions, by arbitrarily mailing used surgical gloves to members of the art world at the time of a hepatitis epidemic (widely known, but unreported in the press), by filming the continuous soaping and washing of a chicken (the suspected bearer of this disease), (fig. 31) or by persuading a famous TV news presenter monotonously to read out on video seemingly endless entries from the official Chinese dictionary, Zhang quickly became established as one of the most radical and important practitioners of the new art.

The works made specially for "Silent Energy" were equally confounding. In Yellow Peril (1993), Huang Yong Ping, riffing on an anti-Chinese, late-19th-century German caricature, created two high canvas tents, lined with imperial-yellow silk, at the entrance to the museum's galleries through which all visitors had to pass. Above their heads a vivarium contained (around) 1,000 locusts and five scorpions. Weird, shocking, to some offensive, this doubly inverted work of "masters and slaves," in which visitors simultaneously empathized with and were repelled by the animals above them, showed a composure and self-confidence that refused to acknowledge western precedence. [70] (fig. 32) Terraced Field: Earth Energy (1993), a large structure made by Chen Zhen out of the ashes of newspapers incinerated in the museum yard, presented a double edge of a different kind, in that it combined the erosion of culture with the idea of purification. Impressed by Buddhist, particularly Tibetan mysticism, this dark work was "an energy field . . . which presents a bounty after the destruction of the past . . . the basis for a future revival . . . a black energy—silent and luminous." [71] (fig. 36)

Cai Guo-Qiang presented three new works as well as a video of previous, huge-scale pyrotechnic events in Japan. One of these, a "gunpowder drawing," The Oxford Comet: Project for Extraterrestrials No. 17 (1993), was

related to an "Explosion Event" that took place on June 26 on Angel Meadow in Oxford. [72] Referring directly to Halley's Comet (identified in 1707 by the Oxford astronomer Edmund Halley), the event reiterated how traditionally, in both Asia and the West, comets had been regarded as harbingers of disaster and how, more recently, some scientists had suggested that catastrophic meteorite collisions may have brought with them the origins of life. Following age-old principles of Chinese medicine and *feng shui*, Cai's "event" and drawing embodied cosmic principles of balance, destruction, and reincarnation, although rather more slowly than its creator had expected. [73] (fig. 37, see pp. 298–309)

Drawing directly with black and red marker pen around the industrial architecture on the walls of one of the smaller top floor galleries, Wang Luyan created a Kafkaesque torture chamber in which amputated organic "bags" were threatened by the implacable machinery of band saws. (fig. 33) By way of contrast, Xi Jianjun's poured wax "pathways" expressed a more essential aspect of the human body in a tensely permeable membrane of spirit, muscle, and skin. A similar feeling was expressed in a dramatically different way by Yang Jiechang's large, intensely black, untitled paintings made on folded, crumpled, compacted rice paper in which the "skin" of the ink wash was mixed with medicinal plants. Rooted in the energies of Tao and Buddhism, these dark voids both conveyed "joy and a sense of space … [and we]re never dark nor devoid of meaning" while also suggesting a threatening and absorbing sense of stasis. [74] (fig. 35)

In his large installation *Oedipus Refound II: The Enigma of Birth*, Gu Wenda brought together four scrolls made in the mid-1980s with five infants' cots that stood on a floating sea of opaque white wax. Different kinds of placenta powder (an ingredient in Chinese medicine derived from human placentas)— had been sprinkled on the cot mattresses suggesting possibilities of health, absence, death, and deformity. [75] The red and black calligraphy of the tall, vertical scrolls, with their cryptic references to the propaganda of the Cultural Revolution, implied violent movement and growth, while the low cots, and splashed wax on the floor around them, seemed like a field out of which only a few seeds could germinate. Gu regards this work, and others related to it, as a form of "material analysis" centered round the deconstruction of the human body. By reducing this to basic, primal materials, he dispensed with illusion "to penetrate through [to] a sense of spiritual presence." By using this poetic strategy, he sought to both invade and transcend "the self" to pass beyond the conventions of "mortality, morality, and civilization." [76] (fig. 34)

Setting aside unfounded accusations of the museum's "scorpion on locust" cruelty, the response of the British press to these exhibitions, although widespread, was mixed. Many critics commented on the (for me) relatively unimportant point that only one of the artists in "Silent Energy" was still living in China, implying that this somehow made their work more "western." Art historian Craig Clunas argued, however, that the new Chinese art "refused to be exotic," because the format of the works, the platform of the museum itself and the minimal interpretation in the galleries clearly put it on a par with western contemporary art. He pointed out that those artists who still lived in China were less fortunate than those who had left, in that they were still searching for "an audience that will accept innovation and support experiment" and this necessarily had an impact on how their work looked. [77]

In a review that set "Silent Energy" alongside "Aratjara: Art of the First Australians" at the Hayward Gallery, Tom Lubbock found it easier to write about the "boredom" of the small show of Cultural Revolution propaganda posters and ceramics in the lower-floor gallery and the public response to Huang Yong Ping's *Yellow Peril* than to confront what he had actually experienced. [78] Other than Clunas, three critics reviewed both exhibitions: Lynn MacRitchie astutely confronted the unsettling inscrutability of the large installations as "Chinese Puzzles" and highlighted the revival of "bohemian principles" in "China/Avant-garde" as representing an avant-garde that no

31 | Zhang Peili | still from **Document on Hygiene No. 3** | 1991 | single-channel video | from "China/Avant-garde" | courtesy the artist

32 | Huang Yong Ping | installation view of interior of **Yellow Peril**, with 1,000 locusts and five scorpions overhead | from "Silent Energy" | 1993 | courtesy the artist and MoMA Oxford archive

33 | Wang Luyan | **Untitled** | site-specific wall drawing with marker pens | 1993 | from "Silent Energy" | courtesy the MoMA Oxford archive

34

35

longer existed in the West. [79] Liberally quoting from Mao, William Feaver empathized with the aesthetic alienation of "Silent Energy," commenting particularly on the visceral olfactory impact of many of the works. In a less curious and more dyspeptic vein, the paintings in "China/Avant-garde" failed, for him, to transcend academicism and even the irony of Zhang Peili's video *Water (Standard Edition of Cihai Dictionary)* was completely lost. [80] It was only in Tim Martin's extended review in *Third Text* that both exhibitions were discussed fully and in context. [81]

V. Opening Out . . .

About a year after KG Subramanyan's solo exhibition at MoMA, in the spring of 1989 at a museum conference in Harvard University, I met Vishakha Desai, curator of the renowned Department of Asian Art at the Boston Museum of Fine Arts, which, long before, had been run by such eminent scholars as Tenshin Okakura and Ananda Coomaraswamy. [82] We talked about "India: Myth and Reality" and the Subramanyan exhibition, and she was surprised to discover that in Oxford, from a contemporary point of view, we were considering different aspects of Asian art within a broader global context. We met again in Oxford in 1990 just before she moved to New York as director of the Asia Society Museum, where subsequently she became the president and CEO of the whole organization.

In 1992, I received an invitation from her to attend the first of a series of Asia Society regional round tables. At these events, contemporary art curators from South, Southeast, and East Asia were assembled together in New York, not only to enlighten each other by articulating their different perspectives, but also by presenting their current research and work. It was a remarkable occasion. Communications within the region flowed either along colonial lines or not at all, and many of the participants—from the Philippines, Indonesia, Thailand, India, Malaysia, Japan, Korea, and Singapore, as well as Australia, the US, and UK—had never met before. These encounters quickly changed into friendships as we began to visit each other and what had previously been a "black hole" in the perception of contemporary art became vivid. Suddenly, it became increasingly "normal" to exhibit different tendencies and traditions of contemporary Asian art not only within the region itself but also on an international scale. [83]

With the rapid collapse of state communism in the West, and its harsh resurgence in China, something obviously was in the air. In May 1992, Leon Paroissien, director of the Museum of Contemporary Art in Sydney, invited me for a first visit to Australia to acquaint myself with its contemporary art scene. This seemed, at first, an uneasy colonial amalgam of the art of settlers, of different pedigrees, with various groups and conditions of first peoples, but there was a genuine, not always attained, desire to see and do things differently. This stimulated further research that resulted, in summer 1997, in my co-curating with Howard Morphy, "In Place (Out of Time) Contemporary Art in Australia," the last exhibition I made for Oxford MoMA. [84] Morphy, a former curator at the Pitt Rivers Museum in Oxford (and a specialist in the art of the Yolgnu people of Northern Australia), had moved as director of the Research School of Humanities and the Arts to the Australian National University (ANU) in Canberra. His knowledge of Aboriginal and other cultures was indispensible for me in coming to grips with all kinds of art, as well as with the art of first peoples elsewhere. [85]

As well as maintaining a fascinatingly diverse if still conflicted culture of their own, the Australians, perched at the rim of both Asia and the Pacific, were also at the forefront of western academic research into contemporary Asian art and culture. At the University of Sydney, John Clark was systematically scrutinizing different aspects of Asian modernity while producing specialized publications on Japanese, Chinese, and Thai art. At the ANU in Canberra, Geremie Barmé had been working on recent Chinese history and culture, and had published widely on the seismic cultural and political changes in China

[80] William Feaver, "Crushed Petals Create a Stink," *The Observer*, July 11, 1993; "Paintings White Beyond the Pale," *The Observer*, September 26, 1993. [81] Tim Martin, "Silent Energy and New Art From China," *Third Text 25*, Winter 1993–94, pp. 91–94. [82] For more about Tenshin, see foonote 29, p. 86, and Coomaraswamy, p. 5. [83] Impressed by Apinan Poshyananda's sardonic presentation on Thai art at this meeting, I made my first research trip to Bangkok in 1993 on the way back from the 1st Asia Pacific Triennial. Subsequently, we have worked together on a large number of projects in different parts of the world. In 1997, the newly constituted Japan Foundation Asia Center in Tokyo took over the baton of intercultural Asian co-operation from Asia Society, New York, by organizing "Asian Contemporary Art Reconsidered," the first of three biennial forums on this subject. [84] "In Place (Out of Time): Contemporary Art in Australia" was shown from July 20 to November 2, 1997. See Appendix on p.49 for list of artists. I had left MoMA Oxford in October 1996 to take up the directorship of Moderna Museet in Stockholm so this exhibition took place after I had left. [85] I had known Morphy in Oxford since the mid-'80s. The contemporaneity of aboriginal and other forms of indigenous and folk art later became one of the main themes in "The Beauty of Distance. Songs of Survival in a Precarious Age," the 17th Biennale of Sydney (2010), of which I was the artistic director. [86] Both have vast bibliographics. See, for instance, J. Clark (ed.), *Modernity in Asian Art*, Sydney, Wild Peony Press, 1993, and Geremie Barmé and John Minford, *Seeds of Fire. Chinese Voices of Conscience*, New York, Hill and Wang, 1988. I was referring to both these books at that time. [87] The city of Fukuoka in Kyushu, Japan, was also an important pioneer in collecting and showing contemporary Asian art. Its first "Asian Art Show" took place in 1980 and was repeated at five yearly intervals until, in 1999, it was transformed into the 1st Fukuoka Asian Art Triennale. This event also coincided with the opening of the city's Asian Art Museum. [88]

36

during the 1980s. [86] In the field of museums, the Queensland Art Gallery in Brisbane (and the city of Fukuoka in Japan) made a real difference. [87] Since 1993 when, under the initiative of Doug Hall, the first Asia Pacific Triennial of Contemporary Art (APT) took place, Brisbane has built up an exemplary and enviable collection of contemporary Asian-Pacific art. Its ninth edition took place in 2018.

During the Australian spring of 1993, I visited the opening of the first APT and experienced, without any patronizing colonial spin, a huge amount of good, bad, and perplexing art that I had never seen before. The energy and desire to make good work was palpable. On one evening, Heri Dono, from Yogyakarta, produced a contemporary version of a traditional Javanese shadow play that lampooned military dictatorship in Indonesia. It would only be a couple of years before a version of this, with *Blooming in Arms* (1996), a large, a new site-specific installation he made for MoMA, was stirring things up in Oxford—and much further afield—with extremely surprising results. (See pp. 248–253)

The essays that continue this book are, in many ways, an extension and refinement of my experiences in Oxford. It had become necessary for me not only to travel in and out of Europe but also to leave it to get a wider picture. In 2001, I moved from Stockholm to Tokyo, where I lived for five years, and then spent two years in Istanbul. Running museums in both places, I was no longer an engaged and interested voyeur from beyond, but a flâneur within the fabric of so many fascinating cultures. ●

34 | Gu Wenda | Red and Black | 1986 | four scrolls ink and wash on paper; Oedipus Found: The Enigma of Birth | 1993 | five babies' cots | paraffin wax | placenta powder | courtesy the artist and MoMA Oxford archive

35 | Yang Jiechang | Untitled (six works) | 1993 | ink on rice paper | from "Silent Energy" | courtesy the artist and MoMA Oxford archive

36 | Chen Zhen | Terraced Field: Earth Energy | 1993 | newspaper, ashes, wood | 240 x 655 x 810 cm | from "Silent Energy" | courtesy the artist's estate and MoMA Oxford archive

37 | Installation view of Cai Guo-Qiang's works in "Silent Energy" | all 1993 | right: Infusion of Smoke, Chinese herbal medicines, bricks, fire, charcoal, and three drawings showing acupuncture points | left: Silent Volcano | gunpowder (1kg sulphur, 7.5 kg potassium nitrate, 1.5 kg charcoal), paper, scales, chain, metal bar, volcanic stones | center: Project for Extraterrestrials No 17: The Oxford Comet | gunpowder, chaff, paper | courtesy the artist and MoMA Oxford archive

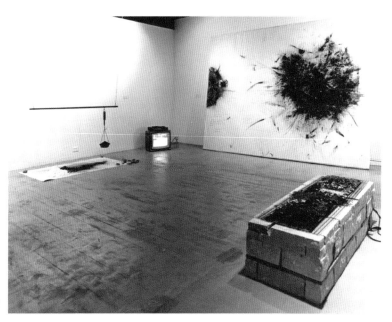

37

From Ottoman Empire to Turkish Republic

Modernity at a Time of Change

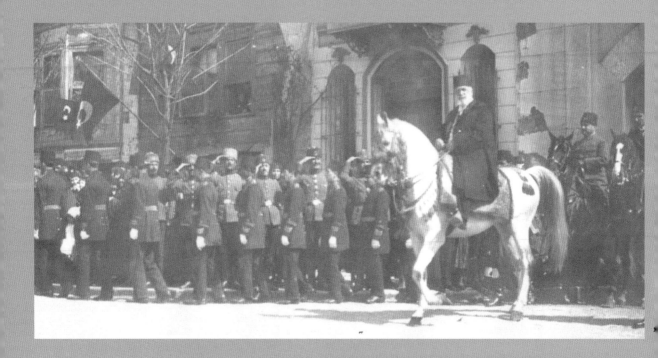

This essay was written to mark the exhibition of the same name that I curated in 2007 for the Istanbul Museum of Modern Art (known as Istanbul Modern), soon after I became its first director. I felt strongly that the view of modernity, both within the Ottoman Empire and the new Turkish Republic, which the museum had previously presented, was contentiously limited, and I set out to borrow works from a range of public and private collections that had not been previously approached. I was not a specialist in this field but was convinced that a clear methodology and more rigorous approach to chronology would yield an indispensible baseline with which to view contemporary art. Wendy Shaw, at Istanbul Modern, and Vasıf Kortun, director of Platform Garanti, as well as the curators of the different museums from which I borrowed work, most kindly gave me their help and advice. I decided, however, to leave the museum soon after, as it was clear that my view of how art should be presented and contextualized did not coincide with that of its president. The essay was published in Turkish and English in **Modern Experiences**, Istanbul, Istanbul Modern, 2007, pp. 14–25.

2

3

Istanbul Modern has been open for nearly three years. The previous displays of Turkish art that have been shown have concentrated on common themes or genres that tie different works together, even though they may have been made in different decades or even centuries. This exhibition takes a radically different approach that stresses the chronological development of painting in the Ottoman Empire and Turkish Republic from the 19th century until the end of the 1940s, shown in the light of its changing social and political contexts. In the scope of 66 paintings, it could never claim to present a complete history of these complex and challenging times but, rather, it has created a framework within which different aspects, tendencies, and marks of modernity can be seen as they begin to appear within Ottoman and Turkish art. These works have been tracked and measured with the benefit of hindsight, as well as within the context of the times in which they were made.

In order to do this, a simple thematic structure has been established that, at the same time, expresses this chronological development. The exhibition begins with portraits of sultans from the 18th and 19th centuries, the first western-style paintings to be made in the Ottoman Empire, which incorporate modern ideas not only through the "new" medium of oil painting and the formats that it demanded, but also in the different settings and poses in which these rulers chose to show themselves. In fact, outside the traditional format of miniature painting in books or albums—an artistic phenomenon which stretched from the Ottoman lands through Persia to the Mughal Empire—large-scale portraits of individuals in oil paint were intrinsically "modern" in that they ignored the sayings of the Prophet which warned against the depiction of human form for fear of idolatry or usurping the power of divine creation. The introduction of western-style painting into the Ottoman court was made all the more significant by the fact that the Sultan was also *de facto* the Caliph—the spiritual head of Islam across the world.

As a result, when looked at from an international context, the exhibition begins with a number of profound paradoxes. From the 18th century Age of Enlightenment, modernity in the West had implied a challenge to the absolute power of the divine right of kings and emperors in favor of innovatory, secular ideals related to the rights of the individual, as well as to the new collective ideology of nationalism. Hand in hand with discoveries in technology and their exploitation in industry, these ideas constituted the strongly contested political, economic, social, and cultural system of modernity within which everything was linked to a greater or lesser degree.

Outside Europe, the adoption of modernity demanded development on many fronts and almost inevitably implied a degree of colonization; this led to questions of conflict and compromise that could endanger the absolute power of the ruler. During the latter years of the 19th and opening years of the 20th centuries, patterns similar to those in the Japanese or Russian Empires can be seen emerging in the Ottoman Empire, in which westernizers or modernizers set themselves both at court and within culture against different forms of Asian tradition which were perceived as

[1] The similar patterns to those in the Ottoman Empire that emerged at the same time in the Russian and Japanese Empires all had radically different outcomes. More recently the Kingdom of Saudi Arabia has allowed and introduced modern art as part of its modernization program. [2] This artist is best known in the West from John Berger's book *About Looking*, London, Writers and Readers, 1980, "Sekar Ahmet and the Forest," pp. 79–86.

"backward." [1] In Istanbul, the center of this westernizing influence was the Pera district on the Galata side of the Golden Horn where, after the Crimean War (1853–56), many private schools of painting started to flourish, and even the sultan's palace moved away from Topkapı to Dolmabahçe, on the "European" side.

In the history of culture now generally accepted but not fully written, there may be many different paths to and forms of modernity that need not be western; yet, in the 18th and 19th and well into the 20th century, modernity was a necessary co-relative of development that could only be adopted by identification with, or subjugation by, western values. Under such circumstances the preservation of traditional, non-western, presumably undeveloped, values could easily be typified as "anti-modern" and therefore a threat to the twin doctrines of progress and manifest destiny that fuelled nationalism, imperialism, and colonization across the world. What we would now describe as the multiculturalism of the Ottoman Empire, its strongest suit as a bridge between East and West, flawed as it was, did not fit into this western model and was therefore not given value.

The main paradox was that when modernity began to filter into the Ottoman Empire it could not be widely disseminated without seriously threatening the whole imperial structure, which, because of failures within itself, was already in entropy. As a result, both political reform and ways of seeing—or showing the world—were channeled from the top by the sultan and his court, and then allowed to trickle down slowly to the rest of society. In the terminology of a later age, the Ottoman Empire aspired to become a command economy of ideas, culture, and even art. (figs. 4, 5) This tendency, favoring hierarchy and collectivity rather than individual action, was a dominant feature in art, as well as in some other sectors of society, until the end of the 1930s, long after the foundation of the Republic. It only began to be challenged in some of the works shown towards the end of this exhibition that were made by artists who had an intimate knowledge of possibilities within international art and had the means to support themselves without selling their work.

The second section of the exhibition concentrates on landscape and particularly on the significance of different representations of the city of Istanbul. Some of these, like the night scene of the Bosphorus by the Armenian Ottoman painter Mıgırdiç Givanian or the sun-lit view of Göksu Stream by Hoca Ali Rıza, are romantic, even nostalgic, eliminating or minimizing any signs of modernity. (fig. 7) Other works like the view of Galata Bridge by Theo van Rysselberghe or the record of the state visit of Kaiser Wilhelm II show a more industrialized, smoky city bustling with commerce. Interestingly, this latter work, painted in 1898 by court artist Fausto Zonaro, does not really focus on the presence of the German emperor (who was trying to get support for building a railway from Berlin to Baghdad) but more on the newly built Dolmabahçe palace from which he is emerging and the industrial smoke of the undeniably modern city of Istanbul. (fig. 6)

The third section of the exhibition focuses on the first generation of artists who in the 1860s were sent to Paris to study painting. Şeker Ahmet Paşha (1841–1907), Osman Hamdi Bey (1842–1910), and Süleyman Seyyid (1842–1913) made very different contributions to the development of western-style art in the Empire. In spite of his academic training, Seyyid focused very little on the human figure, preferring to make direct studies of nature and still-lifes. He was particularly interested in studying perspective as a way of enhancing a sense of reality in his paintings and introduced this to his students—along with the then-radical idea of working directly from nature; this was in contrast to previous art teachers who had encouraged copying from engravings, other paintings, and photographs. Şeker Ahmet Paşha had been strongly impressed by the Barbizon School of landscape painting during his stay in Paris, as can be seen in his *Landscape with Sheep*

6

7

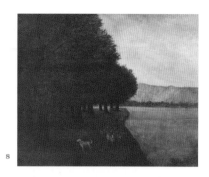

(c. 1875). [2] He also made a number of portraits and still-lifes, but perhaps his greatest contribution to the Ottoman art world was as artistic advisor to Sultan Abdülaziz, purchasing artworks to decorate the newly completed Dolmabahçe Palace, as well as to Sultan Abdülhamid II. [3] **(figs. 8–9)**

Osman Hamdi Bey was the most progressive member of this trinity, although it is difficult to understand this by looking at his work alone. In Paris, he studied in the studio of the orientalist painter Jean-Léon Gérôme and on return to the Empire continued his teacher's realistic approach along with his taste for archaic, exotic subject matter. Orientalism has often been criticized as a form of visual colonization in which the West typifies the East by stressing its otherness, violence, and sensuality. It was felt that such a reductive approach ignored the exploitative colonial relations between East and West and was ultimately dehumanizing, but significantly, at the time, Hamdi Bey did not regard "orientalism" in this light, partly because his treatment of it replaced the passive or violent characters of Gérôme and other French Orientalists with figures engaged in thought and prayer. Although it seemed old-fashioned, Hamdi Bey's way of working and view of the East were undeniably modern and attractive because they valued and humanized tradition, creating in the process a sense of shared culture and history. **(fig. 10)** This is in line with the growth of archaeology in the empire and recognition of architectural heritage as seen in the architectural paintings of Hüseyin Zekai Paşa and Şevket Dağ. Old buildings, like traditional ways of living, were being threatened by modernization, the idea of common heritage was a way of counteracting this threat and could be used as a stabilizing force to establish a sense of cultural and historical cohesion which gave a modern state historical and cultural legitimacy upon which it could be further built. Osman Hamdi Bey was also a leading arts administrator and reformer who helped create an arts infrastructure for the Ottoman Empire. In 1881 he became the first Ottoman director of the newly founded Imperial Museum; two years later he set up the Imperial Academy of Fine Arts also as director; in 1887 he directed the first Ottoman archaeological excavations and set up the new archaeological museum in 1891.

The section of the exhibition devoted to the Ottoman court is based on two large contradictory paintings. Prince Abdülmecid's *Goethe in the Harem (Pondering)* (c. 1917) shows his first wife some time in the late 1890s soon after they had been married. She is uncovered, wearing fashionable western dress and the tone is somber and restrained. Although we are looking at an aristocratic, modern, well-educated woman, in a setting denoting tradition, empire, and modernity, this work is not without allegorical content and could be said to present a kind of existential dilemma: her unwavering gaze, the fact that the book she is reading is Goethe's *Faust*—in which a man gets everything he desires by dedicating his soul to the devil—perhaps reflects the problems that Prince Abdülmecid, himself a reformer, could see facing the Empire as it embarked on change. Modernity and its benefits were obviously necessary, but was it, in fact, a Trojan Horse that contained the seeds of its own destruction? **(fig. 11)**

A similarly somber mood can be seen in Fausto Zonaro's *The Tenth of Muharrem (Ashureh)* (1909), the last work that he made as court painter just before the deposition of Sultan Abdülhamid and his own sudden departure from Istanbul for Italy. The subject is based on the self-flagellatory ceremonies of the Rufa'i dervishes whose lodge in Karacaahmet (Üsküdar, Istanbul) Zonaro had often visited. The Sultan had intended to present this work to Razek Han, the Shiite leader, no doubt in a desire to acknowledge the different traditions of the Dervish and Shiite minority in the Empire and to reinforce his religious role as caliph of all Muslims. But this image of the faithful in a trance-like state of self-mortification is the antithesis of rationalism and modernity; rather it is the enshrinement of esoteric Islam by a western painter who expressed both wonder and a profound sense of difference in what he saw. It would never have occurred to an Ottoman

8 | Şeker Ahmed Paşa | **Landscape with Sheep** | 1880s | oil on canvas | 140 x 175 cm | Ankara State Museum of Painting and Sculpture

9 | Şeker Ahmed Paşa | **Still Life** | 1906 | oil on canvas | 89 x 130 cm | Ankara State Museum of Painting and Sculpture

10 | Osman Hamdi Bey | **The Tortoise Trainer** | 1906 | oil on canvas | 221.5 x 120 cm | Pera Museum, Istanbul | In this large, pointedly anachronistic, painting, made at a time of increasing social and political turmoil, the artist satirizes the slow and ineffective attempts of the Ottoman Empire at reforming itself. Not in the exhibition

11 | Abdülmecid II | **Goethe in the Harem (Pondering)** | c. 1917 | oil on canvas | 132 x 173 cm | Ankara State Museum of Painting and Sculpture | The subject of this painting by the last Ottoman sultan and chair of the Ottoman Artists' Society is Şehuvar Kadınefendi, his Circassian first wife

12 | Turgut Zaim | **Nomads at their Upland Camp** | early 1940s | oil on canvas | 136 x 173 cm | MSFAU-Istanbul Painting and Sculpture Museum Collection

[3] Sultan Abdülaziz reigned from 1861–76; Sultan Abdülhamid II from 1876–1910. [4] See David Elliott, "What is Modern?" in *Modern Means: Continuity and Change in Art 1880 to the Present*, New York, Museum of Modern Art, 2004, and "The Battle for Art" in *Art and Power: Europe under the Dictators 1935–1945*, London, Thames & Hudson, 1995.

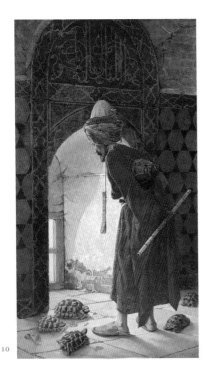

10

11

12

painter at this time to embark on a work with this subject or on this scale. It would not have been modern enough and the image was far too shocking.

The next section of the exhibition examines the long period of war from 1911 to 1923 that culminated in the foundation of the new Turkish Republic. When the Ottoman Empire entered the First World War in 1915 on the German side, artists studying in Paris had to return to Istanbul and quickly were set to work recording military actions. The reasons for this were twofold: first, such works were made as a kind of visual propaganda to promote the war effort inside the Empire; second, it was realized that a positive, humane, and above all modern image of the Ottoman Empire needed to be projected to the Allies in particular and to the rest of the world at large, and one of the best ways of doing this was through art. Leading artists such as İbrahim Çalli, Ali Cemal, Hüseyin Avni Lifiji, Hikmet Onat, and Sami Yetik became members of the Şişli Studio, the costs of which were underwritten by Prince Abdülmecid. (figs. 13, 14) Here they worked on large canvases showing the heroism of the Ottoman Army in the Gallipoli Campaign and War of Liberation, yet it was a heroism tempered by compassion in that many works such as Ali Cemal's *Helping the Wounded* (1917), stressed the common humanity of soldiers on opposite sides as well as the horrors and hardships of war. A large exhibition of these and other works from the Empire took place in Vienna in 1917, the first exhibition of Ottoman modern art to be shown abroad. It was planned to move it to Berlin the following year but developments in the war prevented this.

This body of work by the military painters was followed by the art of the new Republic and while there were many continuities, as can be seen in Ömer Adil's *Call to Duty* (1924), a reminiscence of the War of Liberation (1919–23), a number of new styles and subjects emerged. Namık İsmail's allegorical painting *The Harvest* (1928) is one of the key works of the early Republic, in that the subject is literally the founding of the Republic itself after long years of war, struggle, and famine. Ostensibly a local rural scene this, in fact, is an arcadian work that encapsulates the whole of rural Anatolia from the mountains, to the seas, to the agricultural heartland.

In connection with the tenth anniversary of the founding of the Republic, more propagandistic styles began to emerge, as in Zeki Faik İzer's *On the Road to Revolution* (1933), in which he appropriated Delacroix's famous painting *Liberty Leading the People* (1830) as a basis for a similar composition in which Mustafa Kemal Atatürk, President of the Republic, leads the Turkish people to liberation. The War of Liberation continued to be a popular and highly charged subject, as this was the crucible within which the new nation and its ideology had been forged. Some of these works are unapologetically heroic as Şeref Akdik's *Atatürk on the Telegraph* (1934), which is based on a painting by Soviet artist Igor Grabar referring to Lenin's involvement in the Russian Civil War of 1920–23, (fig. 15) but others, such as Ali Avni Çelebi's *Comrades in Arms* (1937) or Cemal Tollu's *Manisa Burned During the War for Liberation* (c. 1937) transcend specific historical context through their modernist, anti-realist styles to become more general statements about the human condition.

During the early years of the Republic, Turkish society underwent radical change: women were given the vote and a middle class became more established. İbrahim Çalli's painting of women bathing in the sea, Hale Asaf's portrait of her husband, the artist İsmail Hakkı Oygar, (fig. 17) or Naci Kalmukoğlu's fine portrait of an unknown woman in a fur coat capture this new, predominantly urban mood. Yet, just as had been the case in the Ottoman Empire, there was an opposing, more traditional view of Turkish identity. This is clearly expressed in Turgut Zaim's large painting *Nomads at their Summer Camp*, made in the early 1940s (fig. 12). By adopting a range of colors and decorative style based on the folk art of Central Anatolia, where government policies were putting traditional nomadic life styles under threat, Zaim makes a clear stance against modernity in general

13

14

16

17

18

and modernism in particular. At the end of the 1930s and beginning of the 1940s, this rural view of Turkishness was reinforced in a kind of New Deal when a number of artists were sent into the countryside to work on the government sponsored Homeland Tours Program, with the aim of bringing back impressions of the Anatolian heartlands into the cities.

During the 1920s and 1930s, throughout the whole of Europe, it became increasingly clear that while ideas of modernity and modernism could sometimes coincide and often overlap, they were by no means the same thing, and that under certain conditions they could become diametrically opposed. [4] This became evident, for instance, in both Germany and the Soviet Union during the 1930s, continuing long after the war in the Soviet Union, and in China in the 1950s, '60s and '70s. The reason for this was that modernism adopted a critical attitude towards conventional perception that was often extended toward society at large. It also depended on the autonomous vision and imagination of individual artists that could not be subject to compromise. As a result, modernist artists presented alternative models of reality that were not always easy for either governments or the general public to understand and which could sometimes be misinterpreted as pathological deformations or subversion. Often such artists could be categorized in stylistic groups—Impressionists, Fauvists, Expressionists, Cubists, *Neue Sachlichkeit*, Surrealists, and so on—but these categories were not recognized by the artists themselves who worked individually or with groups of friends who happened to come together in a particular place and time. The so-called "isms" of modernism were a critical institutionalization of particular ways of making art.

The works illustrated here show how aspects of modernism could be easily adapted to express the realities of the new Republic, but only in competition with other non-modernist approaches. But as there was no strong state policy in favor of any one particular approach—other than the conservatism of the Academy—the need to gain a livelihood by selling work became the main arbiter of public taste.

The last part of this exhibition examines in more detail approaches towards modernism that have already been seen in some previous works. Hale Asaf's portrait of her husband indicates that she was well acquainted with cubism and had spent a considerable time in Paris and Berlin in the 1920s and early 1930s; a similar interest informs her small still life of a bottle on a table. In Paris she had studied with the Cubist artist André Lhôte and in Berlin with German Impressionist-turned-Expressionist Lovis Corinth, an artist of great power and importance. Similar engagements with Cubism can be seen in Zeki Kocamemi's monumental nude of 1941. (fig. 18) He had studied under Hans Hoffmann at the Munich Academy of Fine Arts before becoming, like Hale Asaf, a founder member of the Society of Independent Painters and Sculptors back in Istanbul. Hamit Görele's masterwork *Forest Nymph* (c.1935) is also part of the same story. Görele had been a pupil of Lhôte in Paris and in 1933 became president of the Independent Society of Painter and Sculptors in Istanbul and one of the leading advocates of Cubism in Turkey.

But one of the greatest barriers for the development of modernism in Turkish painting at this time was that there was no market for avant-garde art of any complexion. As late as the 1930s, Impressionism, long outdated in Western Europe, could still be regarded as both a modern and modernist style. Nazmi Ziya Güran was one of its very best practitioners, and two late works *Istanbul* (1934) and *Pine with Broken Branch* (1937), show little evidence of the scientific analysis of color of the early French Impressionists but radiate more a romantic, even symphonic, approach to color and its harmonies, which are specific attributes of this kind of painting in Turkey during the 1920s and 1930s.

The work of İbrahim Çallı has already appeared in the "War and New Republic" sections of this exhibition, but he became best known for his

13 | İbrahim Çallı | **The Night Raid** | 1917 | oil on canvas | 172 x 225 cm | Military Museum Collection, Istanbul

14 | Hüseyin Avni Lifij | **Allegory** | 1917 | oil on canvas | 160 x 200 cm | MSFAU-Istanbul Painting and Sculpture Museum Collection

15 | Şeref Akdik | **Atatürk on the Telegraph** | 1935 | oil on canvas | 178 x 138 cm | MSFAU-Istanbul Painting and Sculpture Museum Collection

16 | İbrahim Çallı | **The Ney Player** | c. 1921 | oil on plywood | 45.5 x 34.5 cm | Türkiye İş Bankası Collection

17 | Hale Asaf | **Portrait of İsmail Hakkı Oygar** | c. 1928–29 | oil on canvas | 91 x 72 cm | MSFAU-Istanbul Painting and Sculpture Museum Collection

18 | Zeki Kocamemi | **Nude** | 1941 | oil on canvas | 93 x 72 cm | Sema–Barbaros Çağa Collection

19

soft-edged depictions of sophisticated society from the mid-1920s and after, and has often been described as the founder of the national school of painting. Yet in the Şişli Studio during the First World War and at the beginning of the 1920s, he had briefly flirted with modernism: the dramatic lighting and terror-contorted faces of *The Night Raid* (1917) makes a strongly expressionist impact. (fig. 13) After this, he was influenced for a short time by the work of the young Ukrainian painter Alexis Gritchenko, who stayed in Istanbul during 1920 and 1921 during his escape from Soviet Russia. Çallı's work *The Ney Player* (c.1921) reflects this latter influence, in its simple folkloristic subject and primitive style, echoing perhaps the work of the Moscow-based Donkey's Tail group of a few years earlier, as best known in the work of Mikhail Larionov and Natalia Goncharova. (fig. 16)

A strongly expressionist impulse also informed the early work of Namık İsmail. Before the First World War he had studied in Paris at the Académie Julien and then at the atelier of Fernand Cormon. During the war, he was stranded in Berlin and studied with Lovis Corinth. His *Self Portrait* (1918), made in Berlin, echoes Corinth's own psychologically penetrating self portraits, his bleak Istanbul landscape of 1920, made at the time of the Allied occupation, presents a very different and unsettling image of the city compared with the usual romantic or nostalgic views. (fig. 19)

But during this time, the greatest freedom seems to have been experienced by artists who were able without hindrance to travel abroad or who were not dependent on selling work for their living. Fahrelnissa Zeid (1901–1991) lived in Istanbul, Ankara, Berlin, Baghdad, London, Paris, and Amman and, because her husband was an ambassador, had the freedom to develop artistically in the way she wanted. As can be seen from the works shown here, her fine self portraits of the early 1940s have an almost *Neue Sachlichkeit* intensity that alternates with more complex and decorative figure studies. (fig. 20) By the end of the 1940s and the beginning of the 1950s, these works have been channeled into in a unique form of abstraction, initially built out of layers of texture and color but then evolving into densely structured networks of overlaid forms separated and supported, like stained glass windows, by the tracery of strong black lines. (fig. 22)

Although often living on the bread line and battling mental illness and alcoholism, Fikret Muallâ (1903–1967) found the freedom to develop as an artist by emigrating to live in France in 1939. He had already been a successful painter and illustrator in Turkey but found the atmosphere there constricting and was anxious about his personal safety. (fig. 21) The three small works shown here from the 1940s indicate how quickly he was able to establish himself within this new environment.

This exhibition ends at a point around 1950 when art in the new Republic of Turkey was beginning to come of age and tentatively setting some of its own agendas. But with the lack of major patrons and a government that did not regard the development of the arts as a priority, the market was the main source of support and this inevitably eroded artists' choices. A dependence on pictorial ideas from outside continued and in times of duress—political, social, and personal—it often made sense to live abroad. During the 1960s, '70s, and '80s successive military governments became increasingly restrictive. Artists, and others, reacted against this with the result that Turkish art, perhaps for the first time since the declaration of the Republic in 1923, began to have a life that was deeply rooted in local experiences and conditions. Over the past two decades, following the establishment of the Istanbul Biennial in 1987 and the development of contemporary art throughout the whole region of the former Ottoman Empire, new generations of Turkish artists have become firmly established on the international stage. This earlier period of transition, however, has been neglected, and it is clear that more significant research needs to be carried out if the many gaps in the story of modernity and modernism in Turkish art are ever to be filled. ●

19 | Namık İsmail | **Self Portrait** | 1918 | oil on fiberboard | 41 x 37 cm | Dr Nejat F Eczacıbaşı Foundation Collection

20 | Fahrelnissa Zeid | **Self-Portrait** | 1944 | oil on canvas | 60 x 50 cm | Sema–Barbaros Çağa Collection

21 | Fikret Muallâ | **The Guitar Player** | 1945 | oil on canvas | 34 x 27 cm | Oya–Bülent Eczacıbaşı Collection

22 | Fahrelnissa Zeid | **Triton Octopus** | 1953 | oil on canvas | 181 x 270 cm | Istanbul Modern Collection, Eczacıbaşı Group Donation

20

21

Tokyo–Berlin
A Continuing Dialogue from Empire to Democracy

This essay is an extended version of the one first published in Japanese, German, and English for the exhibition catalogues **Tokyo–Berlin / Berlin–Tokyo: The Art of Two Cities**, Tokyo, Mori Art Museum, 2006, and **Berlin–Tokyo / Tokyo–Berlin: Die Kunst zweier Städte**, Berlin Neue Nationalgalerie, 2006. The exhibition was the result of a two-year research project set up between the Neue Nationalgalerie, Berlin and the Mori Art Museum, Tokyo. I headed the Tokyo research team with Fumio Nanjo and Mami Kataoka; under the benevolent eye of Peter-Klaus Schuster, director of the Staatliche Museen zu Berlin, Angela Schneider with Gabriele Knapstein led the Berlin team. Prior to this, the accepted art-historical wisdom had been that during the Meiji Restoration (1868–1912) and Taishō period (1912–1926), Paris was the main reference point for the development of modern art, architecture and culture in Tokyo. This exhibition challenged that view by showing how Berlin, as capital of the newly formed German Reich, wielded considerable influence on the development of art, architecture, literature, city planning, and then subsequently on film, photography, and dance in Japan and, conversely, how Japanese influences also flowed in the opposite direction. The exhibition also tracked the relationship and parallels between the cultural and political lives of the two cities throughout the 20th century.

2

I. A Mutual Regard

Since the middle of the 1980s, a number of international exhibitions have examined the absorption of modernity into Japanese art and culture.[1] These have generally regarded modernity as an import into Japan from the West as part of a general program of modernization that was necessary after over two hundred years of self-imposed isolation. In a cultural sense, "modernity" has usually been associated with the political, philosophical and scientific advances of the 18th-century European Enlightenment. Yet at the time of the Enlightenment, Edo, as Tokyo was then known, had already sustained a culture that, in its size, lively use of images and media, and levels of consumption of goods, could already be regarded in many ways as "modern." This kind of modernity, however, was framed within a feudal social and economic structure that had been unaffected by the revolutionary republican ideals and industrial innovations that had impacted so strongly on the countries of the Atlantic Rim.

Certainly by the 1880s—the starting point for this exhibition—Tokyo and Berlin, now the new capitals of two newly reinvented empires, were more evenly balanced in terms of their modernity, and there were striking similarities in the situations in which they then found themselves. Uncomfortable with the post-Napoleonic world order because they had played no decisive part in its formation, the recently united German Empire and the newly constituted Japanese government under the Meiji Emperor both sought assertively to develop their industries and economies and to establish themselves as world military powers.[2]

This exhibition focuses on cultural links between these two capital cities—both on their concrete contacts and on the parallel developments between them—from the end of the 19th century until the present. As a result it takes a somewhat different approach from previous exhibitions in that it examines a cultural flow that has continued to run in many directions—each side taking what they needed most from the other at the time. In particular, it shows how Berlin has been an important cultural model for Tokyo, how its avant-garde art, architecture, photography, theater, and dance provided inspiration for Japanese artists—and how Tokyo, with its radically different forms of expression and ways of looking at the world, gave a strong impetus to the innovations of Berlin artists, designers, and architects.

Softened by late encounters with French Impressionism, the beginning of modern art in Tokyo is generally attributed to the introduction of realism around 1900; this is clearly expressed in the picturesque detail, and western-style signature, in Rinsaku Akamatsu's oil painting *Night Train* (1901). **(fig. 2)** Between this time and the Dada-influenced avant-garde experiments of the early 1920s, an important transitional stage has been overlooked. This was before World War I, when a number of young artists were reacting strongly to the diverse European influences of Symbolism, Post-Impressionism, French Cubism, Italian Futurism, and German Expressionism.

1 | Ernst Ludwig Kirchner | **Girl under a Japanese Umbrella** | 1909 | oil on canvas | 92 x 80 cm | Photo: Walter Klein | courtesy BPK and Kunstsammlung Nordrhein-Westfalen, Düsseldorf

2 | Rinkasu Akamatsu | **Night Train** | 1901 | oil on canvas | 160 x 200 cm | Collection of the Tokyo University of the Arts

[1] Among the earliest were "Reconstructions: Avant-garde Art in Japan 1945–1965," Oxford, Museum of Modern Art, 1985; "Japon des Avant-Gardes," Paris, Centre Pompidou, 1986; "Japanese Art After 1945: Scream Against the Sky," Yokohama, New York, and San Francisco, 1994. Among the most recent have been "The Unfinished Century: Legacies of 20th Century Art," Tokyo, National Museum of Modern Art, 2002; "Remaking Modernism in Japan 1900–2000," Tokyo, Metropolitan Museum of Art and Gedai, 2004; "Cubism in Asia," Tokyo, National Museum of Modern Art, 2005. [2] The Meiji Restoration took place in 1868. This marked the end of the Tokugawa Shogunate and the moving of the capital from Kyoto to Tokyo (formerly Edo). The new German Empire was constituted in 1871 with Berlin as its capital after victory in the war with France.

3

4

At the turn of the century, artists and connoisseurs in Tokyo would have been able to experience the most advanced art from Berlin, Germany, and Central Europe vicariously in the pages of *Pan* (1895–1900), a periodical that included original prints, a popular art form much valued. [3] From 1910, they would also have had been able to peruse Herwarth Walden's polemical magazine *Der Sturm: Wochenschrift für Kultur und die Künste* ("The Storm: A Weekly Broadsheet for Culture and the Arts"). [4] Produced in Berlin, it quickly became one of the leading advocates for radical art from Germany, Central Europe, Italy, and France. In 1912, Walden consolidated this impact by founding a gallery of the same name that promoted the artists published in the magazine.

But this was part of a much broader flow: in addition to there being an almost insatiable appetite for scientific and practical knowledge as well as culture from the West, there was also a lively, if minority, Japanese interest in western philosophy and Freudian psychology. [5] Whether as a result of direct exposure or in response to a more generalized zeitgeist, deep cultural changes may be discerned in the intensifying subjectivity clearly seen in the landscapes and portraiture of such artists as Kiyoshi Hasegawa, Ryoku Kawakami, Kōshirō Onchi, Seiji Togo, and Tetsugurō Yorozu. [6] **(fig. 5)** Influence is promiscuous and knows no direction. In any case, German Expressionism itself was far from "pure," it had been influenced by the work of such non-Germans as Edvard Munch, Vincent van Gogh, Paul Gauguin, and the French Fauves—not to mention by the "exoticism" of *ukiyo-e*, traditional Japanese colored woodblock prints.

In the art-historical game of ping pong that tries to establish who, or what, influenced whom in early-20th-century Japanese art, Yorozu's *Self Portrait with Red Eyes* (1912) is an irrefutable item of evidence: not only is this work one of a series of trailblazing studies of individual psychological insight, it is also a homage to the power of radical German art. Why else would Yorozu, who had never visited Europe, have written on the back of this canvas, in perfect script, *Selbstbildnis*, the German word for "self portrait"? **(fig. 6)**

In spite of obvious personal passions, there was no single dominant tendency in Tokyo at this time, and artists felt free to synthesize, appropriate, or even willfully "misunderstand" many different approaches and styles. But in March 1914, as Europe and Japan lurched towards the brink of war, an important exhibition of over 70 works by 26 leading European Expressionists and Futurists—including Oscar Kokoschka's drawings for his play *Murder Hope of Women*, **(fig. 4)** Max Pechstein's ecstatically "primitive" nudes, and Franz Marc's images of the mystical union of animals with nature—was consigned from Berlin's *Der Sturm* gallery to take place in the well-appointed halls of the small, privately-funded Hibiya Art Museum. [7] **(fig. 3)**

Art had traveled a long way since the earliest encounters between Tokyo and Berlin in the 1850s, when popular woodcuts depicted the first westerners to enter Japan as strange—almost monstrous—hairy folk. [8] From the other side, Japan's picturesque customs, culture, and style of dress seemed out of step with western efficiency and ideas of progress. In 1859, Yokohama had been opened to the world as a free port but with a separate compound where foreigners had to live. Then in 1867, in one of its last acts, the Tokugawa Shogunate allowed non-Japanese to live also in Tokyo and the Prussian Eagle flew with other western flags over the roofs of the Tsukiji district, where the famous fish market was situated.

Slowly at first, Japanese students and envoys started to travel across the world. In between 1862 and 1873 over one hundred top politicians, administrators, and scholars circumnavigated the globe in a government-sponsored survey of the most important cities in the United States and Europe. Their aim was to provide a firm basis of knowledge about different ways of living, systems of governance, and economy that would help Japan in its forward development. They also wanted to look out for possibilities for

3 | "Der Sturm" exhibition at the Hibiya Art Museum | Tokyo | March 1914

4 | Cover for Herwarth Walden's expressionist periodical **Der Sturm** | July 14, 1910 | with drawings and script for Oscar Kokoschka's play **Mörder, Hofnung der Frauen** **(Murder, Hope of Women)**

5 | Tetsugorō Yorozu | **Nude Beauty** | 1912 | oil on canvas | 162 x 97 cm | The National Museum of Modern Art, Tokyo

6 | Tetsugorō Yorozu | **Self-Portrait with Red Eyes** | 1912 | oil on canvas | 60.7 x 45.5 cm | Tetsugorō Yorozu Museum, Iwate

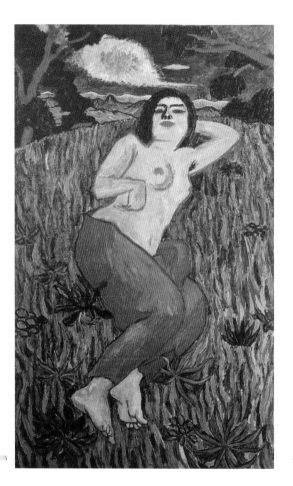

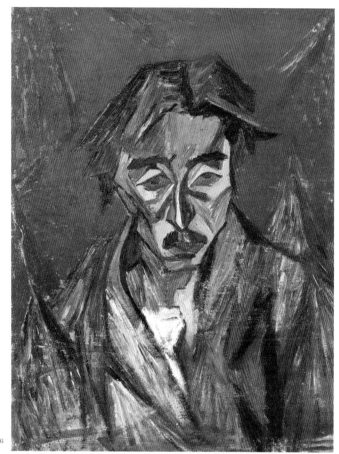

5

6

[3] *Pan* was published in Berlin between 1895 and 1900 and was edited by OT Bierbaum and Julius Meier-Graefe. Other art magazines of this time, such as the Vienna-produced *Ver Sacrum* or London-produced *The Studio*, also circulated freely. [4] *Der Sturm* (1910–32) appeared initially as a weekly magazine but quickly moved to appearing fortnightly. From 1915 it was produced as a monthly. [5] Between 1905 and 1908, novelist Jun'ichirō Tanizaki (1886–1965), with Naoki Sugita of the Medical Faculty at Tokyo Imperial University, was reading some of Sigmund Freud's early works in English translation. See Shogo Nomura, *Tanizaki Jun'ichirō no sakuhin* (The Works of Jun'ichirō Tanizaki), Tokyo, Rokko Shupan, 1974. [6] Tetsugurō Yorozu (1885–1927), who in 1910 founded the Absinthe Group of artists and was a leading figure in the Tokyo avant-garde, synthesized influences of French Cubism and German Expressionism in strong, unsettling paintings. Only 18 paintings by Kyōku Kawakami (1887–1921) survive, primarily oil paintings of scenes in nature. Kōshirō Onchi (1891–1955) was a printmaker and photographer. He studied both traditional calligraphy and western-style painting and in his earliest work was strongly influenced by German Expressionist prints. [7] This exhibition was organized by Kōsaku Yamada (1886–1965) who, from 1910, had been studying music composition in Berlin, and by Kazo Saito (1887–1955), who had moved to Berlin in 1912 to study design. At the beginning of 1913 they both met Herwarth Walden (1879–1941) and became good friends. The idea of making a large exhibition in Tokyo, especially of expressionist woodcuts and drawings, took root. One-hundred-and-fifty-two works were consigned by Walden to Tokyo but not all were hung. Yamada and Saito arrived back in Tokyo at the beginning of 1914. See Hisae Fujii, "Die Tokyoter Holzsnitt-Ausstellung Der Sturm von 1914," *Berlin – Tokyo im 19. und 20. Jahrhundert*, Berlin, Japanisch-Deutsches Zentrum, 1997. The war, in which Germany and Japan were on opposing sides, disrupted the return of the work. [8] This genre of woodblock prints is known as *yokohama-e*.

7

8

[9] The mission was named after its head, Tomomi Iwakura (1825–1883), one of the Meiji Emperor's closest advisors. [10] Kunitake Kume (1839–1931), *The Iwakura Embassy 1871–73, The True Account of the Ambassador Extraordinary & Plenipotentiary's Journey of Observation through The United States of America and Europe,* Matsudo, The Japan Documents, 2002, vol. 3, p. 302. [11] The Ryōunkaku Tower was 69 meters high and was set in an amusement park close to the Asakusa entertainment district. Designed by Scottish engineer WK Burton, it was built in 1890 but had to be demolished after the Great Kantō Earthquake of 1923. Even before then it had to be shored up because of the effects of previous earthquakes. [12] Ōgai Mori (1862–1922), surgeon, translator, and novelist, trained in medicine in Germany from 1884 to 1888, spending 1887 and '88 in Berlin studying at the Robert Koch Hygiene Institute, now part of the Humboldt University. A memorial museum is situated at his former lodgings in Luisenstrasse 39. [13] Kume, op. cit., pp. 316–319. [14] Ibid., p. 323. [15] During the later Meiji period, Japanese art and art education were divided into two main categories: *nihonga,* Japanese-style painting, characterized by traditional materials and subject matter, and *yōga,* western-style painting that adopted foreign models.

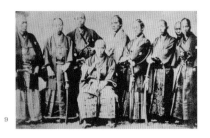

9

10

11

trade but, with their baggy *hakama* trousers, straw hats, and samurai swords, they looked to the West as if they came from another planet. (figs. 9–10)

II. 1873: The Iwakura Mission

The Iwakura Mission, as this group was known, arrived in Berlin, on March 9, 1873, and stayed there as the guest of the emperor until March 27. [9] (fig. 10) Prussia was already respected in Japan for its "political skill, flourishing literature, and the success of its military system," [10] and the report made about what was described as its predominantly brick-built "emerging capital" reflected interests in economic and military development, as well as different things that the visitors found strange.

Building with bricks was important evidence of modern life for the inhabitants of the predominantly wooden capital of Tokyo who were only just then starting to point proudly to their own modern, fireproof-brick constructions in the expanding shopping district of Ginza. They would soon after erect the city's first "skyscraper," the twelve-story Ryōunkaku Tower. [11] (figs. 7, 8)

Although he could see that Berlin was not as industrially developed as Paris or London, Kunitake Kume, Iwakura's private secretary and the author of the Mission's report, was fully aware of its potential: the expansion of its rail networks to Vienna and the South and the recent opening of the Suez Canal (in 1869) meant that quicker trade links to the East could be established. Prussia's trade with the East had already been second only to that of the United States but now that Berlin had just become the capital of a united German Empire, Kume could see that there would be even greater opportunities.

The Mission was lodged centrally and they visited the most advanced factories and impressive public buildings. The new electrical telegraph machinery they inspected at Siemens Works made a strong impact, and the semi-automated production processes at the Royal Porcelain manufactory seemed very different from the traditional kilns still used in Japan. The field of medicine was particularly important: the Meiji Emperor had been impressed by German doctors, and many Japanese doctors, including the army surgeon and novelist Ōgai Mori, would subsequently train in Berlin. [12] The Charité and new Augusta Hospitals were admired for exposing recovering patients to as much fresh air as possible; the physiological reasons for this were enumerated at length in the report. [13]

But there were other, more strange and "exotic" sights to be seen and noted: the multileveled, cave-like aquarium just by the Brandenburg Gate presented a wondrous reptilian and undersea world, with the spectacle of a rabbit being eaten alive by a python at feeding time. Paintings in the Royal Museum met with general approval, but at the Academy of Fine Arts, Kume was taken aback to see that "men and women are paid to pose in the nude, standing, lying down, or crouching, to enable artists to depict the human form accurately, and to allow sculptors to create models of their figures from clay. Today there was a beautiful young woman lying naked on a bed . . . taking a break only once every one and a half hours . . . Copying the human form is a technique which requires the utmost care on the part of the artist, but even so, it seems disgraceful that the pursuit of refinement [in art] should lead to such a shocking situation." [14] It would not be long before western-style painting with its different materials and ways of conceiving the world became absorbed within Japanese culture. [15]

Although there were already a few Japanese works of art in the Royal Collections, it would not be until 1885 that Berlin would have the opportunity of seeing a wide range of Japanese culture first hand, in an exhibition that showed art and architectural drawings alongside theatrical and religious artifacts. Here, Adolph Menzel, the Berlin academician who was famous for his monumental paintings on the life and achievements

7 | Utagawa Hiroshige III (1842–1894) | The Most Famous Views in Tokyo: Brick Merchant Houses on Ginza Main Street | 1874 | triptych woodblock color print on paper | 37 x 23.8 cm (each) | Vancouver, University of British Columbia Library: rare books and special collections

8 | View of Tokyo's first brick-skyscraper: the 12-story Ryōunkaku Tower in Asakusa Park built in 1891 | woodblock print on paper

9 | Members of the First Japanese Embassy to Europe | 1862 | Sadataro Shihata, head of mission is seated

10 | Center: Tomomi Iwakura, head of the Iwakura Mission | left to right: Takayoshi Kido, Masuka Yamaguchi, Hirobumi Itō, Toshimichi Ōkubo | London | 1872

11 | Otto von Bismarck, Minister President of Prussia, first Chancellor of the German Empire | c. 1870

of King Frederick the Great, as well as for a series of equally large and heroic images of the new heavy industries that had grown around Berlin, was moved to paint a small impressionistic gouache of a Japanese artist at work. [16]

The levels of security and hospitality afforded to the Iwakura Mission were, they thought, the best provided by any city they had visited, and while they were impressed by "the many parks laid out all over the city [where] there is always a café" where men and women could sit and drink together, they were surprised by the very high level of alcohol consumption. The city seemed to them to be "decadent" and this was attributed to the "volatile and wild" behavior of its inhabitants. The cause was correctly thought to be the "recent spate of military campaigns"—the Franco-Prussian War (1870–71) had ended only two years previously—and "the domineering bearing of soldiers and students." Prostitution was also running rife and struck the visitors as being completely unregulated—unlike the closed and carefully ordered "red light" zone of Tokyo's Yoshiwara. [17]

The way in which the new German constitution protected the authority of the emperor was of great interest to the Meiji administrators because they were just starting to draft a constitution of their own. But the words that must have been still ringing in their ears when they left Berlin en route for St. Petersburg were those of Bismarck, Germany's "Iron Chancellor," who at an informal meeting had shared his insights into such matters as the difficulties of small countries, patriotism, and *Realpolitik.* They should not be "taken in," he admonished; not everything was as it seemed. "Nations these days all appear to conduct relations with amity and courtesy, but this is entirely superficial, for behind this face lurks a struggle for supremacy and mutual contempt." He warned them to take care of the territorial ambitions of the great colonial powers, adding that for the Japanese "friendship with Germany should be the most intimate of all because of the true respect in which we hold the right of self-government." (fig. 11) An affinity had been established. As Kume summarized in his report, "We relished our chance to learn from the prince's eloquent words, knowing full well what a master tactician he is in the world of politics." [18]

III. From East to West and Back Again

With the marked exception of Japan's sequestration of Germany's Pacific territories in the Mariana, Caroline, and Marshall Islands during World War I, along with its settlements in Shangdong Province in China that included the coastal beer-producing city of Qingdao (Tsingtao), the most significant contacts between Tokyo and Berlin over the next 60 years proved to be cultural rather than political. But, in the rapidly deteriorating international climate of the 1930s, the relationship would change dramatically for the worse.

But, even the beginning of this tragic learning curve was marked by a mutual regard for the symbolic mechanisms of governance and power. In the middle of the 1880s, Berlin architects Hermann Ende and Wilhelm Böckmann, with their assistant Hermann Muthesius, were invited to the Japanese capital to plan, design, and build eclectic, western-style buildings for a new governmental zone. Yet, although their proposal for the justice ministry was approved, the government rejected their designs for a parliament and other buildings on the grounds that they were too "oriental" and not sufficiently "modern." [19] (fig. 12) On return to Berlin, however, these architects encouraged an exotic, oriental style used to good effect in the still-standing "Elephant Gate" and the now-destroyed administrative buildings for the new zoological gardens. [20] (fig. 13)

But the flow from East to West did not stop there. By the end of the century, Japanese style was the rage throughout Europe, at first with artists and cognoscenti but then more widely. In winter 1901, the ex-geisha Sada

12 | Ende & Böckmann, Köhler | unrealized design for the first Japanese Parliament Building in Tokyo | 1887–91

13 | Carl Zaar and Rudolf Vahl | Berlin Zoo: The Elephant Gate and the now destroyed Japanese-style buildings on Budapester Strasse | 1899

14 | Max Slevogt | **Portrait of the Dancer Sada Yakko with Her Foster Son Raikichi** | 1901 | oil on canvas | 132 x 110.5 cm | Formerly Dr János Plesch Collection, Berlin | Signature in Japanese (top right) is by Yakko herself

14

[16] Adolph von Menzel (1815–1905), *Japanischer Maler (in der japanischen Ausstellung)*, 1885, gouache on cardboard, 17.5 x 14.5 cm, Merz Collection. [17] Kume, op.cit., pp. 296, 298. The *Yoshiwara* was a moated, closed licensed quarter set up just north of Asakusa on the edge of Tokyo in the late 17th century. It is described full in JE de Becker, *The Nightless City or the History of the Yoshiwara Yuwaku*, Yokohama/Bremen, Max Nössler & Co., 4th edition, 1904. [18] Ibid., p. 323–325. [19] In 1886, Ende (1829–1907) & Böckmann (1832–1902) presented an unrealized master plan for a new government quarter in Hibiya and during 1887–95 designed, and completed, an imposing neo-Gothic building for the Ministry of Justice. Hermann Muthesius (1861–1927), their assistant, stayed on in Tokyo and constructed there a Protestant church in neo-gothic style finally completed in 1895. Later, while working in the German Embassy in London, he became a solid champion of the English Arts and Crafts movement and the author of the influential survey of British architecture *Das englische Haus* ("The English House"), 1904. In 1907 he founded the Deutscher Werkbund, an organization to promote good design in Germany, that was a forerunner of the Bauhaus. [20] These were designed and completed in 1899 by the firm of Zaar & Vahl; Carl Zahr had previously worked for Ende & Böckmann. [21] Sadayakko Kawakami (1871–1946). See Lesley Downer, *Madame Sadayakko: The Geisha Who Bewitched the West*, New York, Gotham, 2003. [22] Max Slevogt (1868–1932) spent much time in Berlin in the company of his collector and doctor János Plesch (1878–1957) who bought one of his portraits of Sada Yakko. [23] EL Kirchner (1880–1938), *Japanese Theater*, 1909, oil on canvas 113.7 x 113.7 cm, Scottish National Gallery of Modern Art, Edinburgh. [24] Futurists David Burliuk (1882–1967) and Viktor Palmov (1888–1929) arrived in Japan in September 1920 from Vladivostok where they had been working in the Soviet Far East. They immediately opened in Tokyo "The First Japanese Exhibition of Russian Painting" that they had brought with them and which then traveled to Kyoto and Ōsaka. As well as their own, it included works by Vasily Kamensky (1884–1961), Kazimir Malevich (1878–1935), and Vladimir Tatlin (1885–1953), as well as by some artists from Vladivostok. The Russian art exhibition with the artists' presence made a huge impact on the young generation of Japanese artists in the just formed Futurist Art Association (FAA). In April 1920, Palmov left Tokyo, via Manchuria, for Chita, a town on the Trans-Siberian Railway in the Soviet Far East where other artists were based, where he remained until November 1922. Wanting to leave the Soviet Union, Burliuk stayed longer in Japan, held three solo exhibitions in Tokyo, Osaka, and Nagoya, and wrote poetry as well as two books; he left for Vancouver en route to the USA in September 1922. See Burliuk, *Portrait of a Family*, 1921, oil on canvas, 94.2 x 136.4 cm, Hygo Prefectural Museum of Art; Palmov, *Japanese Woman (Mother and Child)*, 1920, oil on canvas, 65.5 x 50 cm, Tetsugorō Yorozu Museum, Iwate. See also Toshiharu Omuka, "Russian Avant-garde in the Russian Far East: Art Crosses the Border," *Modernism in the Russian Far East and Japan 1918–1928* (exh. cat.), Machida, City Museum of Graphic Arts, 2002, pp. 32–38.

Yakko introduced to Berlin (as well as to many other cities) a new type of "classical" Japanese theater completely unknown in her native country. [21] She became an immediate sensation, and the fashionable Berlin painter Max Slevogt completed two large portraits of her as well as a number of sketches. [22] (fig. 14) Her taste for archetypical characters, and for the expression of strong emotion through gesture, movement, and setting, were brought together in a form of neo-*kabuki* that, along with the colorful stylizations of traditional *ukiyo-e* woodblock prints, was picked up in different ways in German Expressionist painting, theater, and film. This perhaps explains why, following less chastely in van Gogh's footsteps, Ernst Ludwig Kirchner made extensive sketches of *ukiyo-e*—particularly the erotic *shunga*—and also kept Japanese folding screens, parasols, and fans in his Berlin studio. By 1909, while still working in Dresden, he had already completed large paintings of a seductive nude woman posing under a Japanese umbrella (fig. 1) and of people attending a performance of kabuki. [23] In 1913 he returned to the former motif, posing Erna, his Berlin mistress, model and muse, as a "geisha".

After World War I, similarly unpredictable, but more desperate currents, came into play. After successful military campaigns against the Chinese (1894–95) and the Russians (1904–05), the Japanese Empire again found itself on the winning side. The German Reich was in defeat, and Russia was consumed by revolution and war.

The war and the impact of the Russian Revolution (1917) strongly affected both cities. The Soviet Union was immediately embroiled in civil war and an enclave of Futurists was based in Vladivostok producing propaganda, poetry, and art. This included artists David Burliuk and Viktor Palmov, as well as writers Nikolai Aseev and Sergei Tretiakov. In autumn 1920, Burliuk and Palmov traveled to Tokyo via the eastern seaboard and immediately set up there "The First Japanese Exhibition of Russian Painting" they had carried with them. (fig. 17) As well as their own, it contained works by Vasily Kamensky, Kazimir Malevich, Vladimir Tatlin, and lesser-known artists. After the inevitable cultural isolation of wartime, over a year earlier than the similar exhibition held in Berlin (fig. 15), this first exhibition of Soviet avant-garde art outside Russia strongly impressed many young Japanese artists. [24]

In the winter of 1918–19, now stripped of its Kaiser, Berlin led the whole country in its disastrously short-lived November Revolution. Cynically and brutally suppressed by the military, the new republic had to declare itself in Weimar, and an incurable and fatal enmity was created between socialists and communists. Both the USSR and the newly constituted Weimar Republic (1919–33) found themselves to be pariah states, and this sense of being an underdog brought them together. Curiosity about the revolutionary culture of Russia in Berlin was intense, and, as had already happened informally in Japan, an official selection of different kinds of avant-garde art was gathered together in the "Erste Russische Kunstausstellung" ("First Russian Art Exhibition") at the Van Diemen Gallery on Unter den Linden in 1922. (fig. 15)

Architecture also played an important part in imagining what form the new world would take, and in Berlin, as well as in other parts of Germany, it joined together with art in the *Novembergruppe* ("November Group"), a dynamic broad-based association, born out of revolution, in which new, often not practical, ideas for combining living and building were exhibited. The visionary, "crystalline" concepts developed at this time by architects such as Hans and Wassily Luckhardt, Erich Mendelsohn, Hans Poelzig, and Bruno and Max Taut have a strong, but inexplicable, affinity with the contemporary, equally organic designs of the Tokyo-based *Bunriha Kenchikukai* (Secessionist Architectural Society)— Kikuji Ishimoto, Sutemi Horiguchi, Mayumi Takizawa, Keiichi Morita, Mamoru Yamada, and Shigeru Yata—who, like their Berlin doppelgänger, initially followed

15

17

15 | El Lissitzky | catalogue design for the "Erste Russische Kunstausstellung Berlin" ("First Russian Art Exhibition") | Van Dieman Gallery | Berlin | 1922

16 | Tomoyoshi Murayama's "constructivist" poster for the "Sanka" performance art space | Tokyo | 1925

17 | Viktor Palmov | Dancing Woman | 1920 | oil and collage on board | size and location unknown | this work was shown in the Tokyo exhibition of Russian art

18 | Tomoyoshi Murayama | Sadistic Space | c. 1921–22 | oil on canvas | 45.5 x 60.8 cm | National Museum of Modern Art | Kyoto | this work was made in Berlin and reflects the influence of both Dada and Cubo-Futurism

[25] Hans Luckhardt (1890–1954) and Wassily Luckhardt (1889–1972), Erich Mendelsohn (1887–1953), Hans Poelzig (1869–1936), and Bruno (1880–1938) and Max Taut (1884–1967). For the work of the German architects see Wolfgang Pehnt, *Expressionist Architecture,* New York, Praeger, 1973. Kikuji Ishimoto (1894–1963), Sutemi Horiguchi (1895–1984), Mayumi Takizawa (1096 1983), Keiichi Morita (1895–1983), Mamoru Yamada (1894–1966), and Shigeru Yata (1896–1958). The *Bunriha* was active from 1920 to 1928, and from 1920 to 1923 published many of its futuristic designs with the Iwami Shoten Press in Tokyo. During its span it organized seven exhibitions exploring new ideas in European architecture as well as acting as a forum for dissemination of these ideas. For instance, Kikuji Ishimoto's bands of almost continuous glazing for his redesign of the Shirokiya Department Store (1923–24) reflect the formal language of Erich Mendelsohn's Berlin Tageblatt building (1921–23) as well as later buildings by Bruno Taut. See Andres Lepik and Iride Rosa, "Tokyo–Berlin und zurück. Bezeihungen im Bereich der Arkitektur bis 1945," *Berlin–Tokyo / Tokyo–Berlin: Die Kunst zweier Städte,* Berlin, Nationalgalerie/Hatje Cantz, 2006, pp. 148–163. [26] Tomoyoshi Murayama (1901–1977) was self-taught as an artist and had been brought up as a Christian in an intellectual, proto-feminist milieu that led him, from an early age, to combine the idea of art with moral and social criticism. Tomoo Wadachi (1900–1995) immediately gravitated towards *Der Sturm* as Walden had published many leading Expressionist poets and writers. Yoshimitsu Nagano (1902–1968) was already studying art and had benefited greatly from his stay in Paris with his brother-in-law, the painter Seiji Tōgō (1897–1978). [27] In the Berlin Futurist exhibition, Murayama showed an expressionist cityscape. See Gennifer Weisenfeld, *Mavo: Japanese Artists and the Avant-Garde 1905–1931,* Berkeley, University of California Press, 2002, pp. 33–37. [28] A lost collage by Murayama refers directly to Impekhoven: *"As You Like It" Danced by Niddy Impekhoven, c.* 1922–23, mixed media on wood, 45.5 c x 38 cm. Weisenfeld, op. cit., p. 40. Impekhoven had also appeared as one of many figures in Hannah Höch's collage *Cut with the Dada Kitchen Knife Through the Last Weimar Beer-Belly Cultural Epoch in Germany,* 1919. [29] *Die Kunst ist Tot Es lebe die neue Maschinenkunst TATLINS* ("Art is Dead Long Live TATLIN'S new Machine Art"). [30] Murayama regularly attended the Berlin Volksbühne where he saw the latest radical plays by Georg Kaiser (1878–1945) and Ernst Toller (1893–1939) (particularly Karl Heinz Martin's (1886–1948) production of Toller's new play *Machine-Wreckers [Machinenstürmer]* (1922), and on return to Japan translated Toller's prison diary *Das Schwalbenbuch* ("The Swallow Book") into Japanese. He later credited Toller, along with the artist George Grosz (1893–1959) and the Volksbühne producer Karl Heinz Martin, with inspiring him to become a socialist. [31] Weisenfeld, op. cit., p. 37. [32] Dancer Kazuo Ohno (1906–2010) was influenced by German *Ausdruckstanz* in a more indirect way. In 1931, he attended the Tokyo performances of Harald Kreutzberg (1902–1968), who had studied in Hellerau (Dresden) with both Mary Wigman (1886–1973) and Rudolf Laban (1879–1958). After the interregnum of war and reconstruction, this seed finally blossomed in 1959 in the formal birth of *butoh,* a new expressionistic style of dance, when under Kazuo Ohno's supervision, Tatsumi Hijikata and Yoshito Ohno (b. 1938, his son) first staged in Tokyo a menacing and sinister version of Yukio Mishima's (1925–1970) early novel *Kinjiki* ("Secret Pleasure," 1951).

an organic and futuristic path before propagating a more "international" rationalist and functional approach. [25]

At the beginning of 1922, three young Japanese artists—Tomoyoshi Murayama, Yoshimitsu Nagano, and Tomoo Wadachi—found themselves together in Berlin and immediately began to network feverishly. [26] Wadachi, a poet as well as an artist, had arrived there in August 1921 to pursue his interest in new German writing—particularly in expressionist poetry and theater. Murayama, his school-friend, came there the following February to study moral philosophy but, blocked entry to university because of his lack of Latin, fell back on his interest and talent as an artist. They were quickly joined from Paris by Nagano, who had been staying there since the previous summer with Seiji Tōgō, his brother-in-law, a well-established western-style painter in Tokyo who had already introduced him to the angular dynamism of the Cubo-Futurists. Together, they began to explore the Berlin art world. The first, indispensible, stop was *Der Sturm,* where they met with Herwarth Walden. It was obviously a successful encounter in that, in March 1922, both Murayama and Nagano were invited to show in the *Die Grosse Futuristische Ausstellung* ("The Great Futurist Exhibition") at the Neumann Gallery in Berlin, where their work was seen in the company of established artists such as Umberto Boccioni. [27]

Through Ruggero Vassari, an Italian advocate of Futurism in Berlin, an expressionist cityscape Murayama exhibited there was first published, and he gained introductions to performers and dancers. He later recalled the emotional impact on him of the new *Ausdruckstanz* (interpretive dance) of Mary Wigman and Niddy Impekoven whose extreme postures and jerky movements seemed to be of the same cloth as the eccentric movements of expressionist drama and film, whilst also echoing memories of the fluttering motions and strong poses he knew from the Japanese theater of *noh* and *kabuki.* [28]

In May, Murayama and Nagano were both invited to Düsseldorf to participate in the *Erste Internationale Kunstausstellung* ("First International Art Exhibition") and the concurrent *Kongress der International Fortschrittlicher Künstler* ("International Congress of Progressive Artists") that attracted delegates from eighteen different countries working in a wide variety of styles. This was the first occasion that the Dadaists and Constructivists had publicly come together even though, as early as June 1920 at the First International Dada Fair in Berlin, George Grosz and John Heartfield had visibly shown their enthusiasm for Constructivism by proclaiming "Art is Dead / Long Live Tatlin's New Machine Art." [29] For Murayama, this physical confluence was an epiphany subsequently reinforced by what he saw and learned in Berlin, particularly by his experience of radical theater. This had the effect of bringing together his feelings about art, theater, politics and life. [30] (fig. 18)

When Murayama returned to Tokyo in January 1923, he took back with him a unique hybrid of nihilistic negativity and idealist positivism made whole by a transformed aesthetic awareness. He also benefited from an address book bulging with the contacts of influential artists, artists' groups, magazines, and dealers. Initially, he affiliated with the Futurist Art Association (FAA) but found its painting-based activities staid. [31] In July 1923, he announced the debut of *Mavo*—a magazine and art group with a meaningless neologism for a name. Now, through assemblages, constructions, collages, posters, interpretive dance, cross-dressing, actions, and political theater, he and his associates, began to confront the combined effects of modernization, militarization and alienation on Japanese society and culture. [32] (figs. 16, 19)

There was also a more restrained, aesthetic aspect of Japanese culture that rhymed in the West with early rationalist ideas about modernity. Echoes of this may well be seen in Walter Gropius and Adolph Meyer's wood-built

19

20

Sommerfeld House (1921) as well as in the use of natural materials, open interior planning, and relationship to the outer landscape in some of Mies van der Rohe's early houses. [33] But there were clearer encounters: in 1922–23, Kikuji Ishimoto, a founder member of the *Bunriha Kenchikukai* traveled to Germany to research new ideas about light, materials, and construction. For a time, he worked with Walter Gropius at the Weimar Bauhaus and took back inspiration, ideas, and contacts to Tokyo. (fig. 20) In 1923, after the disastrous Great Kantō Earthquake, *Sousha,* a new group of modernist architects, formed in Tokyo, and together these two associations provided a platform for the development of a social and political function for architecture along the lines proposed at the Bauhaus under the direction of Gropius (1919–28) and his successor Hannes Meyer (1928–30). [34]

The Bauhaus and, to a lesser extent, the VKhuTeMas (the State Art and Technical School) in Moscow, became international paradigms for the development of education in modern architecture and design. In Weimar, local opposition meant that in 1925 the Bauhaus was forced to move to Dessau, where Gropius designed its famous campus as well as, in 1927, the Siedlung Dessau-Törten (a workers' housing suburb). From 1927 to 1929, Takehiko Mizutani, an associate professor at the Tokyo Academy of Arts, came to study in Dessau on a government scholarship. He attended the foundation classes on materials and form taught by Josef Albers and László Moholy-Nagy and continued successfully with master classes in furniture and building. After he returned to Japan, Mizutani joined with progressive architect Renshichiro Kawakita to develop, in 1931, a Bauhaus-based curriculum for the *Shin Kenchiku Kogei Gakuin* (New Architectural Arts Academy) that for the next six years actively produced graduates and publications until the war in Asia forced it to close. [35]

At this time the Bauhaus itself was riven with internal dissent about educational ideology, exacerbated by a worsening political situation. In 1930, Mies van der Rohe succeeded Meyer as director but in the following year the National Socialists gained control of the city council and demanded that the school be shut. It was able to hang on until the end of 1932 when Mies briefly moved the school to a derelict factory in Berlin before its final closure in April 1933.

In 1930, two Japanese students, Iwao Yamawaki, and his wife Michiko, arrived in Dessau. Iwao, like Mizutani, had graduated in architecture from the Tokyo Academy of Arts and had worked briefly in Tokyo as an architect and designer for avant-garde theater; now, on their Bauhaus foundation, they studied form under Albers and color with Wassily Kandinsky. In 1931, Iwao moved to architecture and interior design where he was able to concentrate on photography and photomontage, while Michiko studied textiles and weaving under Gunta Stölzl and Otti Berger. [36] Before they could complete their studies, however, the National Socialists closed the Dessau building; they decided to return to Japan but Iwao took back with him many strong images of Germany's changing cityscape and architecture. The *Attack on the Bauhaus* (1932), one of his most striking photomontages, expressed the spirit of resistance on the final day of the Dessau campus: students wildly demonstrated as jack-booted Nazi officials stomped over its vertiginously tilted facades. [37] (fig. 21)

But the most influential Berlin architect to have visited Japan was Bruno Taut, who lived there for three years. Both before and immediately after World War I, he had been a leading advocate of the spiritual technology of "Alpine Architecture" but, during the 1920s, in keeping with the transformed cultural climate in both Europe and Japan, he became a major innovator in the provision and design of social housing. [38] In 1930, he was appointed an honorary professor at the Technical University of Berlin and an honorary member of the Japanese International Association of Architects. But, fascinated by Constructivist

19 | Mavo (Murayama uppermost **en travesti**) performing the "Dance of Death" adapted from the third act of Frank Wedekind's 1905 play **Tod und Teufel (Death and Devil)** | Photograph from **Mavo**, No. 3 | September 1924

20 | Kikuji Ishimoto, with Bunzo Yamaguchi, was the chief architect of the Bauhaus-style Shirokiya Department store, the first phase of which opened in Tokyo in 1928

21 | Japanese Bauhausler Iwao Yamawaki was the only person to capture the final moments of the Dessau Bauhaus in this photomontage **The Attack on the Bauhaus**, showing Nazi stormtroopers shutting down Walter Gropius's school and building in October 1932 | Gelatin silver print montage | 6 x 9 cm | courtesy The Museum of Modern Art, New York

[33] Lepik and Rosa, op. cit., pp. 148–150. Walter Gropius (1883–1969); Adolph Meyer (1881–1929); Hannes Meyer (1889–1954). [34] Bunzo Yamaguchi (1902–1978), one of the leaders of *Sousha*, had previously been a member of *Bunriha* and a draftsman in Ishimoto's office. In December 1930, he left for Europe and worked for four years with Walter Gropius in his Berlin office. When Gropius left Berlin in 1934 for London, Yamaguchi travelled with him, before returning to Japan. [35] Tomoko Kuroiwa, "Japan and the Bauhaus," *Berlin/Tokyo – Tokyo/Berlin: Die Kunst zweier Städte,* op. cit., pp. 176–185. Takehiko Mizutani (1907–1969); Josef Albers (1888–1976); László Moholy-Nagy (1895–1946); Renshichiro Kawakita (1902–1975) [36] Ibid. Iwao Yamawaki (1898–1987); Wassily Kandinsky (1866–1944); Gunta Stölzl (1897–1983); Otti Berger (1898–1944). Weisenfeld, op. cit., p. 37. [34] Bunzo Yamaguchi (1902–1978), one of the leaders of *Sousha*, had previously been a member of *Bunriha* and a draftsman in Ishimoto's office. In December 1930, he left for Europe and worked for four years with Walter Gropius in his Berlin office. When Gropius left Berlin in 1934 for London, Yamaguchi traveled with him, before returning to Japan. [35] Tomoko Kuroiwa, "Japan and the Bauhaus," *Berlin/Tokyo – Tokyo/Berlin: Die Kunst zweier Städte,* op. cit., pp. 176–185. Takehiko Mizutani (1907–1969); Josef Albers (1888–1976); László Moholy-Nagy (1895–1946); Renshichiro Kawakita (1902–1975) [36] Ibid. Iwao Yamawaki (1898–1987); Wassily Kandinsky (1866–1944); Gunta Stölzl (1897–1983); Otti Berger (1898–1944). [37] This photomontage was published in *Kokusai Kenchiku* (International Architecture), 8, 12, Tokyo, 1932, p. 272.

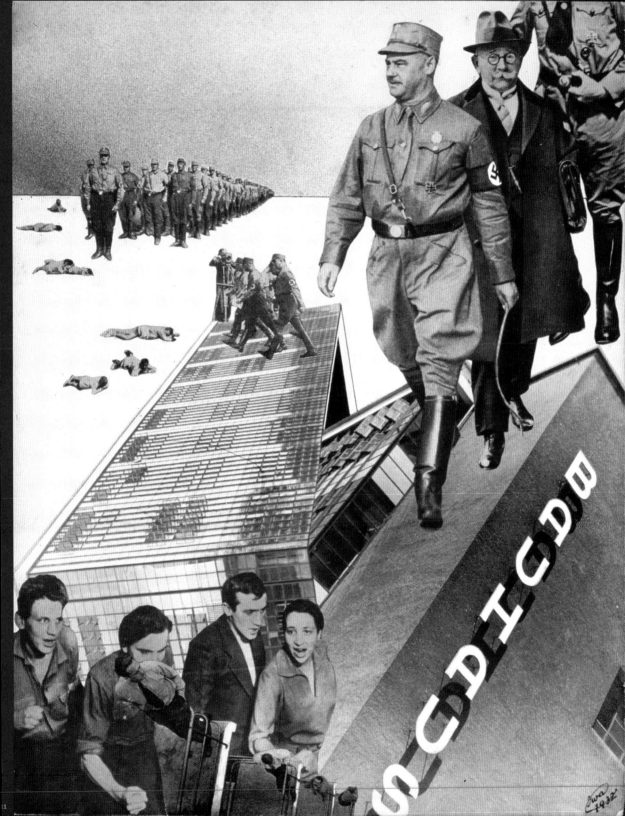

22

23

24

architecture and the Socialist experiments in the Soviet Union, and disillusioned by the rising wave of Nazism at home, he decided in 1932 to set up an office for new building in the city administration in Moscow. This, however, led to nothing, and he returned to Berlin in February 1933 at the very moment President Hindenburg had just made Adolph Hitler the chancellor of Germany, and Nazi violence and terror was unleashed against the unions and Communist Party. Taut's Jewish origins, along with his close friendships with radicals and communists, would have made remaining in Berlin fatal; he had to leave the country quickly.

He fled first to Switzerland, then, with an invitation from Japanese architect Isaburō Ueno, traveled, via France, Greece, Turkey and Vladivostok to Japan, arriving there on May 3, 1933. **(fig. 22)** [39] Initially expecting his stay to be short, he traveled the country, gave lectures, and wrote articles. In July, he published his first impressions *Nippon mit europäischen Augen gesehen* ("Nippon Seen with European Eyes") that was very well received when it was translated into Japanese the following year. In 1935, in a collection of essays published in the Paris-based journal *L'Architecture d'Aujourd'hui,* he focused on new public-housing projects and industrial architecture in Japan as well as on the need to develop such architecture to improve the quality of life. During his stay he published three more books about Japanese art and architecture. [40]

Taut settled in Takasaki in Gumna Prefecture but found it difficult to secure any architectural commissions. In 1933, he made drawings for a large unrealized housing development in Ikomayama outside Nara. Although he listed fifteen possible projects in his diaries, only one, a co-operation with architect Tetsuro Yoshida, was built, in 1936. This was a part-modern, part-traditional extension to the Hyuga Villa in the seaside spa town of Atami that would provide additional space for social events and a breathtaking view of the bay. **(fig. 23)** His main energies, therefore, were spent on writing and design: chairs, chests, lamps, clocks, and boxes out of wood, lacquer, and steel in a form of modern Japanese vernacular that was sold at the Miratiss shop in Tokyo. And he also became intensely fascinated by historical Japanese buildings—such as the Ise Shrine and the Katsura Imperial Villa in Kyoto—writing commentaries and making watercolor studies of their architecture and settings. In this, he was the first of many western architects to identify and appreciate their minimalist ethos as a precursor of the anonymity, functionalism, and spirituality of the best of Europe's new architecture. [41]

25

26

Ironically, the house that Taut was never able to build in Japan took form on the banks of the Bosphorus in the Ortaköy neighborhood of Istanbul. Unable to return home, he moved to Turkey in 1936 as professor of architecture at the State Academy of Fine Arts and was allowed to practice again, although not without criticism. From the water his villa looks like a Japanese pagoda, yet the studio that nestles against a slope at the rear suggests a more radical organic modernity. Tragically, he did not live long enough to enjoy it. [42] **(fig. 24)**

IV. The Modern Metropolis

One of the closest affinities, perhaps, between the two cities of Tokyo and Berlin has been in their continuing embellishment of the elements and ideas that constitute our vision of what a modern city may be. In the middle of the 18th century, at the very dawn of modernity, Edo/Tokyo was one of the most developed urban centers in the world, with a population of around one million. Although still feudal in its social structure, and crammed with the military retainers of the *Daimyō*—the clan heads who were forced regularly to travel there to show obeisance to the *Shōgun*—arts, crafts, and images of many different kinds were avidly consumed by large numbers of people from all walks of life. At this time Berlin had a population of only around 100,000 and the smell of a garrison town.

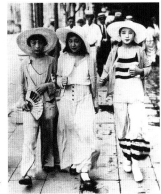

27

22 | Bruno Taut with Isaburō Ueno, a Japanese architect, in the small traditional Japanese house called Senshintei ("Purity of Heart") just outside Takasaki in which he lived. Ueno had sponsored his invitation to live in Japan and first introduced Taut to the Katsura Imperial Villa in Kyoto.

23 | Spaces unfold within Taut's design for the interior for the Hyuga Villa, Kasuga-cho, Atami | 1936 | this interior was his only major project as an architect in Japan

24 | Taut's last building: the "Japanese" villa and studio he never built in Japan constructed in 1938 on the banks of the Bosphorus in Istanbul. Sadly, he passed away before he could occupy it.

25 | The "City of the Future" from Fritz Lang's film Metropolis | 1927

26 | Masamu Yanase's dada photomontage The Length of the Capitalists' Drool published in Mavo, issue 1, July 1924

27 | Modern Girls "Moga" in Ginza | Tokyo | c. 1932

[38] In 1919, Bruno Taut (1880–1938) published in Berlin a visionary illustrated book on new, spiritual forms of architecture entitled Alpine Architektur. A facsimile was made by November Books in London in 1972. [39] Isaburō Ueno (1892–1972). [40] Bruno Taut, "Architecture nouvelle au Japon," L'Architecture d'Aujourd'hui, 4, 1935, pp. 46–83. During his time in Japan, Taut published three more books: Japanese Arts Seen With European Eyes (1936), in English and Japanese; Fundamentals of Japanese Architecture (1936), in German and English; and Houses and People of Japan (1937), in English. [41] Taut published an album of his drawings and commentaries on the Katsura Villa. Lepik and Rosa, op. cit., p. 150. See also B. Taut, Ich liebe die japanische Kultur! Kleine Schriften über Japan, Berlin, Manfred Speidel, 2003, p. 23. [42] Taut died suddenly of an asthma attack on December 24, 1938; his final work was the catafalque used for the official state funeral of President Mustafa Kemal Atatürk in November 1938. [43] Walter Ruttmann (1887–1941); Edmund Meisel (1894–1930); Berlin Die Sinfonie der Großstadt, (1927). [44] Fritz Lang's (1890–1976) script was written by Thea von Harbou (1888–1954), his wife, who subsequently supported the National Socialists; in 1934 Lang left Germany. Siegfried Kracauer's From Caligari to Hitler: a Psychological History of the German Film, Princeton, 1947, still provides one of the best analyses of the development of film in Germany from 1914 until 1945. [45] Robert Siodmak (1900–1973), Menschen am Sonntag (1929). Billy Wilder (1906–2002) co-wrote the screenplay.

Slowly the balance began to change. In Edo/Tokyo, philosophy, economy, and the development of technology remained relatively static, and it did not begin to benefit from the fruits of industrialization until the reforms after the Meiji Restoration (1868). By the 1870s, the time of the Iwakura Mission, the population of Berlin stood at around 826,000, but by 1900 it had more than doubled to 2.7 million. Tokyo had not quite stood still, but at the turn of the 20th century its population was only around 2.1 million. Berlin was set to become the quintessential modern metropolis with all the characteristics that could be associated with it: an embodiment of what Kunitake Kume had prophetically described in 1873 as the "decadent," "wild and volatile" elements of the city.

This new idea of the city as a self-feeding organism was most skillfully articulated by film director Walter Ruttmann, who in 1927 made a full-length "symphonic" documentary montage about a day in the life of Berlin with a full, live-orchestral score by Edmund Meisel. Speed, machinery, dynamism, neon lights, and nightclubs were rhythmically cut against a cycle of despair, alienation, ugliness, and suicide—as if the city itself were a vast machine that had to be fuelled by energy and human souls. [43] Fritz Lang's silent science-fiction film Metropolis, released in Berlin in the same year, showed the future city in a similarly contrasting light—as dream and nightmare. On the land and in the sky monorails and micro-lights whizzed overhead while the high-tech buildings throbbed with energy—like Tokyo, it even had a pleasure quarter called the Yoshiwara—yet underground robotic workers toiled and were brutalized. (fig. 25) Encouraged by the son of the industrialist, in love with a girl who had taken sympathy on their plight, the workers planned revolt. At the last moment, however, in a disquieting premonition of the pact between Hindenburg and Hitler in 1933, the rebellious son became reconciled with the inflexible father in a scene that illustrated the willing and uncritical subjugation of the workers to unbending paternalist authority. But not all such views of Berlin had the same ostensibly "happy" endings. [44]

For many expressionist painters and writers, the city had been a swamp of alienation in which the individual was either disorientated or drowned. Ernst Ludwig Kirchner's angular, darkly colored Berlin street scenes of around 1914 show prostitutes dressed like war widows, plying for trade on one of the main shopping streets. Echoing the loss of values that accompanied postwar hyperinflation, George Grosz's view was equally dystopian: uniform office blocks topple over onto streets populated by faceless mannequins and none of his drawings or paintings seemed complete without their due complement of profiteers, cripples, murderers, and tarts. A similar sensibility was expressed by Tokyo artists, writers, and filmmakers after the Great Kantō Earthquake.

But another film from the late 1920s shows a different, almost rural side of Berlin, an aspect still present today. Robert Siodmak's People on Sunday (1930), is a pseudo-documentary—almost without a plot—using amateur actors in a gentle, aimless love affair in which the strongest impression is how working people found refuge in the lakes and rivers that are scattered around the capital. [45] Seen today, its slow, silent sequences seem to depict another world, yet its pace, innocence, and relationship to nature are still an important and necessary part of Berlin life.

In both art and literature, expressionism was followed by realism, usually cynical, in what the Germans described as Neue Sachlichkeit—a new, sardonic matter-of-factness. After the widespread destruction of the earthquake, Tokyo, too, started to assume a similarly double-edged identity. Sandwiched, also, between heaven and hell, its capacity for amoral freedom could be made to express all that was good or bad about the present and future. Masamu Yanase, a member of the Mavo group, had earlier evoked the satire of George Grosz in his anti-capitalist and militarist cartoons of 1921 and, late in 1923, he followed these with images of the desperate condition

28

29

DEUTSCHLAND

30

of Tokyo after the quake. [46] **(fig. 26)** The city—its street life, crime, and colorful inhabitants—depicted in novels such as Jun'ichirō Tanazaki's *Naomi* (1924) [47] (its female protagonist was a Japanese equivalent of the temptress Lulu in Frank Wedekind's play cycle), [48] Yasunari Kawabata's early reportage thriller *The Scarlet Gang of Asakusa* (1930), in Teinosuke Kinugasa's ground breaking film *A Page of Madness* (1926), or in Hiroshi Shimizu's lost film *Undying Pearl* (1929), could have easily been recognized as Berlin's double. In this floating world of pleasure and pain, confidence tricksters, bar girls, and gangsters—sleek, fashionably dressed "modern girls" and "modern boys" (immortalized in the Japanese neologisms of *moga* and *mobo*)—shimmied with bobbed hair and sharp suits to the ecstatic melodies of *ero, guro, nansensu*, (the erotic, the grotesque, and nonsense)—a cultural phenomenon that reached its heyday in "here and now" myopia but was derived, in fact, from a long-standing taste in Edo-period art and literature for extreme sensation. [49] **(figs. 27, 28)**

As in Berlin, this apotheosis of decadence stimulated resistance from strong proletarian movements in art, literature, film, and theater, often underwritten by the Soviet Comintern. But Tokyo proletarian artists seem to have taken a lead from Berlin rather than directly from Moscow, and for a time, until the military police began systematically to crack down, leftist novels and films were extremely popular. [50]

The global depression of the early 1930s wrought even more profound changes on both cities. Their unstable political, social, and cultural balance was overturned by rabid nationalism, aggressive militarism, and racism. Both became authoritarian police states, and to survive any independent or critical culture had to either emigrate or go underground. In 1936, Tokyo and Berlin signed the Anti-Comintern Pact, later joined by Rome in the Axis, and became embroiled in aggressive wars on a global scale. Japan had begun to occupy parts of China as early as 1931 and in June 1937 provoked a full-scale war with China which, after the attack in December 1941 on the American base in Pearl Harbor, escalated into World War II.

V. The Dark Years: 1931–1945

Although Germany and Japan had extreme nationalism and militarism in common, the nature of their cultural ideologies was very different. Ever since the beginning of the 1920s, Hitler had been obsessed by the idea that racial and political degeneracy had led to Germany's defeat in World War I and to the "unfair" Versailles settlement after it. Eugenic theories of Social Darwinism had developed in Europe and America since the end of the 19th century, and Hitler, with other right-wing ideologues, simplified these into a hierarchy with the "healthy" Nordic, Aryan, and Teutonic races at its summit and Jews, Africans, Communists, criminals, and the insane at its base. Modern art was regarded as degenerate because it was "unclean," often "Jewish" or left-wing, or all of them. What is more, it distorted "reality."

Initially not all Nazis believed this to be the case and there was no agreement within the party about whether expressionism, with its German roots and insistence on *Blut und Boden* ("Blood and Soil"), could express the authentic spirit of a new Germany. Josef Goebbels, a collector of modern art, thought it could, whereas party ideologue Alfred Rosenberg propounded the virulently racist view that modern art was "degenerate." **(fig. 29)** This conflict, however, was not really about art or aesthetics but about power. Goebbels wanted to control the whole realm of culture and propaganda and although he was the eventual victor—in 1933 the *Reichskulturkammer* that controlled all cultural production came under the direction of his Ministry for Public Enlightenment and Propaganda—his public statements about art became increasingly like those of Rosenberg, whose influence in the party steadily declined. **(fig. 31)**

31

32

Academic kitsch—whether *völkisch* genre painting or bombastic neoclassical sculpture or architecture—now became the official Nazi style. Modern artists were branded "degenerate," and their works ridiculed, removed from museums and destroyed or sold abroad. Many, like Max Beckmann, went into exile, those who stayed were forbidden to exhibit and in some cases even to work.

Arno Brecker's or Josef Thorak's steroid-pumping, neoclassical heroes are typical of the new official taste, (fig. 30) while Georg Kolbe's *Menschenpaar* ("Couple") (1936), treads a more delicate line between a vision of an ideal breeding unit and a softer, more personal touch. In spite of oppression, many "degenerate" artists continued to work even through the darkest years of the war. Käthe Kollwitz was to some extent protected by international respect as a feminist and communist, and her Berlin studio on Klosterstrasse became a haven for sculptors and painters who felt out of step with the regime. Her *Pieta* (1938), is a universal image directed against the carnage of war as well as a personal homage to the memory of the son she had lost in World War I. [51]

Hans Grundig also was a communist and a painter of proletarian life, yet his *Kampf der Bären und Wölfe* ("Battle of Bears and Wolves") (1938), an image of a country tearing itself apart, has an epic resonance with Ernst Jünger's critical novel *Auf den Marmorklippen* ("Under the Marble Cliffs") of the following year. (fig. 33) Grundig was systematically harassed by the Gestapo and from 1940 to 1944 was interned in Sachsenhausen concentration camp. Carl Hofer had suffered from premonitions of disaster since the end of the 1920s and these figured increasingly in his work. *Die schwarzen Zimmer* ("The Black Rooms") (1943), a version of a previously destroyed painting, repeats a confined, naked figure impotently beating a drum of alarm. [52] (fig. 32)

Japan differed from Nazi Germany in that it had no consolidated cultural ideology or bureaucracy. The passing of the Peace Police Law in 1900 was one of the first measures directed against radical groups and this, with subsequent legislation, was applied with varying severity according to the character of the government in power. As a general rule, the police tended to equate radicalism with foreign influence: novelist Ōgai Mori remarked on this in 1910 when "men of letters and artists were looked at askance in case they might be Naturalists or Socialists. Then some of them discovered the phrase 'dangerous western books'." [53] By the 1930s, surrealism rather than naturalism had become associated in the military police's mind with communism, and the painter Ichiro Fukuzawa, among others, was imprisoned as politically suspect on the grounds of his work. [54]

The period of Taishō Democracy in the 1920s saw both the foundation of the Communist Party of Japan and the devastation of the Great Kantō Earthquake, when vigilante committees roamed Tokyo, randomly murdering people whom they thought were Koreans or leftists. In 1925, universal male suffrage had been introduced simultaneously with the repressive Peace Preservation Law. This was followed in 1928 by the Tanaka Government's punitive Maintenance of Public Order Act which led to over 1,600 arrests of workers, tenant farmers, and students.

It was at this time that the idea of *kokutai*—originally a word that referred to any country's national characteristics—came to mean the peerless and mystical national structure of Japan headed by its state religion and emperor. People soon began to believe that any extreme act to preserve the *kokutai* could be justified because Japan was spiritually pre-ordained to be the world leader. Rightists regarded democratic reforms as unworthy of this ideal and therefore waged a campaign of terror in which business leaders and politicians were assassinated by activists. Attacks, such as the Blood Oath Corps Incident of Spring 1932, the assassination of Major General Tetsuzan Nagata in August 1935, and the Military Uprising of February 1936, were also justified by a perversion of Zen Buddhism in which, without irony,

[46] Masamu Yanase (1900–1945) "Jiji manga gojūdai" (50 Cartoons on Current Affairs), *Nihon oyobi Nihonjin*, No. 818 September 1921. See also Weisenfeld, op.cit., pp. 146–47, 152–53. [47] Jun'ichirō Tanazaki (1886–1965). The Japanese title of "Naomi" is directly translated as "A Fool in Love" [*Chijin no ai*]. [48] Frank Wedekind's (1864–1918) plays *Erdegeist* ("Earth Spirit," 1891) and *Die Buchse der Pandora* ("Pandora's Box," 1904) were condensed into GW Pabst's (1885–1967) 1929 film *Pandora's Box*. [49] Yasunari Kawabata (1899–1972); Hiroshi Shimizu (1903–1966). For *moga* and *mobo* see Barbara Sato, *The New Japanese Woman: Modernity, Media and Women in Interwar Japan*, Durham and London, Duke University Press, 2003. For *ero, guro, nansensu*, see Ian Buruma, *Inventing Japan 1853–1964*, New York, The Modern Library, 2003, pp. 67–68. [50] Shigekichi Suzuki's film *What Made Her Do It? (Nani ga kanojo wo so sasetaka*, 1930), based on the novel by proletarian writer Seikichi Fujimori (1892–1977), was claimed to have caused local riots and was so popular that it was the highest earning silent Japanese film. Film director Kenji Mizoguchi (1898–1956) also cut his teeth on films that spoke out against the plight of the oppressed masses as in, for example, *Blood and Spirit (Chi to rei*, 1923), *Tokyo March (Tokyo Koshinkyoku*, 1929), *Metropolitan Symphony (Tokai Kokyokyoku*, 1929). For a discussion of proletarian film made in Tokyo at this time, see Donald Richie, *A Hundred Years of Japanese Film*, Tokyo, Kodansha, 2001. In Berlin, Prometheus Film was one of the main production companies for proletarian cinema. Throughout the 1920s, left-front proletarian organizations for all the arts flourished in both Tokyo and Berlin and were subject to increasing government censorship and harassment. [51] Max Beckmann (1884–1950); Arno Brecker (1900–1991); Josef Thorak (1889–1952); Georg Kolbe (1877–1947); Käthe Kollwitz (1867–1945). [52] Hans Grundig (1901–1958); Ernst Jünger (1895–1998); Carl Hofer (1878–1955). [53] Marius B. Janssen, *The Making of Modern Japan*, Cambridge, MA, Belknap Press, 2002, p. 505. [54] After the war Ichiro Fukuzawa (1898–1992) continued on the same tack in such anti-war paintings as *Haisen Gunzo* ("Lost War"), 1948, in the Gunma Prefectural Museum of Modern Art.

33

34

35

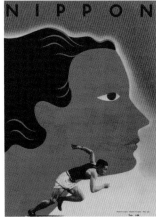

36

33 | Hans Grundig | **Der Kampf der Bären und Wölfe** (The Battle of the Bears and Wolves) | 1938 | oil on plywood | 90 x 102.5 cm | Nationalgalerie | Staatliche Museen zu Berlin, Berlin | from 1940 to 1944, Grundig was interned in the Sachsenhausen concentration camp

34 | Seifū Tsuda | **The Sacrifice** | 1933 | oil on canvas | 193 x 95.4 cm | National Museum of Modern Art, Tokyo | this refers directly to the torture and death in prison of the communist novelist Takiji Kobayashi

35 | Kenichi Nakamura | **Landing Operation: The Battle of Kota Bharu, Malaysia, 1941** | 1942 | National Museum of Modern Art, Tokyo (not in the exhibition)

36 | **Nippon** magazine, modelled on the German periodical **Die Böttcherstrasse Internationale Zeitschrift** (The Böttcher Street. International Journal, 1928–30), was produced from 1934 to 1944 | Takashi Kono designed this cover for its 1936 Berlin Olympics issue | photo by Yōnosuke Nattori of model Takanori Yoshioka

[55] Brian Daizen, *The Ethical Implications of Zen-related Terrorism in 1930s Japan*, Victoria Centre for Asian Studies, University of Adelaide, 2004. [56] Shunsuke Tsurumi, *An Intellectual History of Wartime Japan 1931–1945*, London, KPI, 1986, pp. 11, 63–64. The Manchurian Incident in 1931 was staged by the Japanese Kwantung army against the Chinese army to give it a pretext to occupy Manchuria, where they immediately set up a puppet government. It is generally regarded as the starting point of the Pacific War. [57] Seifū Tsuda (1880–1978); Takiji Kobayashi (1903–1933); Kogenta Hamamatsu (1911–1945); Kakuzo Namba (1905–1995). [58] Yōnsuke Nattori (1910–1962); Hiromu Hara (1903–1986). [59] Masanori Ichikawa, "20th Century Japanese Art in the Context of Civilisation and Culture" in *The Unfinished Century: Legacies of 20th Century Art* (exh. cat.), Tokyo, National Museum of Modern Art, 2002. [60] Kenichi Nakamura (1895–1967); Ryushi Kawabata (1885–1966).

the perpetrators claimed to tap into the spiritual power of the *kokutai* through a form of meditation that enabled them both to apprehend and protect its true nature by completely by-passing rational thought. [55] Unfortunately, many members of the public sympathized with the sincerity of such beliefs and the self-sacrifice of such actions.

Militancy on the right was compounded by weakness on the left, which led in 1933 to the dramatic dissolution of the Japanese Communist Party when, from his prison cell, Manabu Sano, its chairman, renounced Soviet Russia and espoused the national cause. Within three years, 74 percent of all communist detainees had followed his example. In 1934, the Proletarian Artists' League was dissolved. One of the main reasons for this was that leftist intellectuals had started to feel isolated from the public, which in 1931 had responded so enthusiastically to the military's occupation of Manchuria. [56]

Against this background Seifu Tsuda's painting *Giseisha* ("The Sacrifice") (1933) seems all the more remarkable. It shows the death of proletarian novelist Takiji Kobayashi, who had been tortured by the Kempeitai, the secret military police. (fig. 34) Kogenta Hamamatsu's *Genealogy of the Century* (1938) criticizes the futility of the military ambitions of the Axis powers while Kakuzo Namba's *Chiang Kai-shek, Where Are You Going?* (1939) replaces the allied Axis swastika flag in Hamamatsu's work with that of Chiang Kai-shek's Nationalist Chinese army. But, in spite of its surrealist style, this latter painting seems to be supporting Japanese aggression: by the end of 1938 most major Chinese cities were in Japanese hands, but Chiang Kai-shek's Kuomintang government (that at one point had tolerated Japanese presence in its fight against the Communists) had retreated from its former capital in Nanjing to Chongqing and refused to surrender. The Japanese army became overextended and frustrated because it could not force the issue; the artist seems to be attempting to capture this difficult moment. [57]

There was no official Japanese art at this time because there was no single party to demand it. In 1934, the cultural propaganda magazine *Nippon* was set up with the help of photographer Yonsuke Nattori who, in 1936, would work in Berlin covering the Olympic Games. Its radical, eye-catching design aimed to show the best of both traditional and new Japan. In 1942, designer Hiromu Hara launched the war propaganda magazine *Front*, a finely produced publication in fifteen language editions, which paradoxically owed a clear debt, not to the Nazi's lumpen art journal *Kunst im Dritten Reich*, but to the photography, neo-constructivist designs and high production standards of the Soviet propaganda magazine *SSSR na Stroike* ("USSR in Construction"). [58]

In 1938, the National Mobilization Law enabled the co-option of painters into the army and a "painters' unit" led by Commander Kenichi Nakamura was formed at the request of the Army Press Department. [59] In 1939, the *Seisen* ("Holy War") exhibition of over 300 works, including 200 war paintings, was held in the Tokyo Metropolitan Art Museum. Nakamura traveled from Singapore through Indochina in 1942 and made a number of prize-winning works. (fig. 35) But in the war's closing years he stayed on the home front, recording with spare accuracy the *kamikaze* attack of Sgt. Nobe on two American B-29s over Northern Kyushu. *Nihonga* artist Ryushi Kawabata adopted a similarly minimal approach in his traditional painting of leaves and insects that subtly, but no less effectively, are blown by the impact of an exploding bomb in a Tokyo neighborhood. [60]

VI. Two "Unfinished" Cities

By 1945, both cities—and countries—lay in ruins, and for a time their futures were very different. (fig. 37, 38) In spite of its Nazi past, West Berlin became a symbolic island of western values isolated in a sea of Soviet power, while East Berlin, as Hauptstadt der DDR, the capital city of the Soviet-controlled German Democratic Republic, was absolved of Nazism because of its communist allegiance. As a western military outpost in the domino game of

37

38

39

combating international communism, Tokyo found itself in a gilded cage, and, as its economy slowly began to recover, saw its former "metropolis" inflate into a vast megalopolis with a population that has now expanded to around 35 million. [61] This process has not been without sadness, because the fabric of the city, like Berlin, was substantially destroyed and it, too, had been an amalgam of many different neighborhoods, all with their own histories, memories and identities.

For both cities, the process of postwar reconstruction was not only a matter of bricks and mortar but also of spiritual, mental, and cultural depth. In spite of their close relations until 1945, after defeat they went into quarantine yet, although both were occupied by the Allies and were affected deeply—culturally, economically, and politically—by Americanization and the Cold War, for a long time Tokyo seemed to be the "winner," and Berlin the "loser."

Because of its strategic importance in the US-led wars in Korea and Vietnam, Tokyo's size and economy grew at breakneck speed. The district of Roppongi, with the cryptic slogan "High Touch Town," emblazoned over its expressway crossing, burgeoned as a red-light-district for US servicemen and foreigners. Isolated, frozen behind the Iron Curtain, West Berlin was kept going as an ideological outpost of the West, but industry had left and the city could do little to grow or develop. Soviet-occupied East Berlin with its prized developments of Stalin Allee and Sputnik-inspired Alexanderplatz retained an equally symbolic role. (fig. 39)

From 1949 to 1989, Berlin remained split into two separate cities and only very recently has been able to think of itself as a unified entity. Not until the end of the Cold War could the two cities again be regarded as being on an equal footing. But even before this, slowly and tentatively, artistic contacts became re-established, initially, in the 1950s, through the Subjective Photography movement, which harkened back to the *Neue Fotografie* of the 1920s and '30s they both shared, and then in the fashion for Zen-style abstraction, which became popular in both Europe and North America and was showcased in Japan by the action-based works of the Ōsaka-based Gutai Group. [62] In the early 1960s, the spirit of youthful revolt that so clearly motivated Fluxus and Neo-Dada echoed both cities' involvement with Dada in the 1920s. Now, in a less polarized, more globalized world, exchanges between artists and musicians from both cities seem to be happening all the time.

Almost in spite of its disarming reticence—and perhaps because of its location in an earthquake zone—Tokyo has become an experimental laboratory for art, film, and architecture, as well a symbol of a post-apocalyptic vision of what the city could become in the future. The endless Tokyo expressways that appear in Russian director Andrei Tarkovsky's science-fiction film *Solaris* (1972) recur in Ridley Scott's *Blade Runner* (1982), where robotized hybrids try to escape from dripping concrete canyons in the urban chaos of an imaginary amalgam of Asia, Europe, and America. In Chris Marker's *Sans Soleil* (1983), however, the "strangeness" of actual Tokyo becomes a metaphor for memory and history across the world. In a similar gesture of displacement, Wim Wenders's film *Tokyo-ga* (1985) is a meditative voyage around the contemporary city based on trying to recapture the unique vision of Yasujirō Ozu's classic films of the 1950s. (fig. 40) The stark drawings and baroque twists of plot in Katsuhiro Ōtomo's graphic novels, however, turbo-charge the pessimism of many *manga* and *animé* artists: in *Akira* (1982–90), bike gangs run wild in the ruins of a post-World War III Neo-Tokyo. [63] (fig. 43) Yet in spite of having to cope with this apocalyptic alter-ego, Tokyo continues to renew itself and plays host to some of the most imaginative architects working today who, in their radical use of structure, materials, and form, have transformed the way we think about people and their relation to cities. [64]

If the countdown LEDs on the flickering walls of Tatsuo Miyajima's stacks of ever-changing numbers all suggest a point zero at some unspecified time

40

37 | Kouyou Ishikawa | "Tokyo in ruins after aerial bombing, circa 10 Mar 1945" | documentary photograph

38| Brandenburg Gate and Unter den Linden in ruins | Berlin | 1945

39 | "Alex," the new center of Berlin, Hauptstadt der DDR (Berlin, Capital of the German Democratic Republic), twenty years after the founding of the state | a documentary photograph by Horst Sturm showing Alexanderplatz with the Haus des Lehrers (House of Teachers), left, and the Fernsehturm (TV Tower), center left | October 2, 1969 | courtesy German Federal Archives

40 | Poster for Wim Wenders's film homage to Ozu, Tokyo Ga | 1985

41 | View of Roppongi Hills, a fourteen-hectare, mixed-use development in the center of Tokyo constructed by the Mori Building Company that was opened in 2003. A number of leading architects and designers such as Fumihiko Maki, KPF, Richard Gluckman, and Terence Conran worked on the site.

[61] Berlin's population in 2005 was around 3.5 million. [62] *Neue Fotografie* describes the Constructivist photography of the 1920s and '30s shown in Tokyo in April 1931 at the "German International Traveling Photography Exhibition" that included around 1,200 works. See Christine Kühn, "Film und Foto," *Berlin/Tokyo – Tokyo/Berlin: Die Kunst zweier Städte.* op. cit., pp. 164–175. *Subjektiv Fotografie* became the dominant trend in German photography after World War II and three exhibitions took place under this title in 1951, 1954, and 1958. Its leading protagonist was the Essen-based photographer Otto Steinert (1915–1978), whose work had a considerable impact on young photographers both in West Berlin and Tokyo. In Tokyo, the *Nihon Shukanshugi Shashin Remmei* (Japanese Subjective Photography Group) was founded in 1956 with 40 members and held its first international exhibition showing the work of Steinert, which had an impact on the early work of such photographers as Daido Moriyama (b. 1938) and Nobuyoshi Araki (b. 1940). In East Berlin, documentary or Soviet-influenced socialist realism was the favored photographic style and although some leftist Japanese photographers worked in a similar style it was regarded as outdated. See Ludger Derenthal, "Subjektive fotografie," *Berlin/Tokyo – Tokyo/Berlin Die Kunst zweier Städte,* op. cit., pp. 196–97, 224–26. The new abstract painting in postwar Berlin is shown in the exhibition through the colorful lyricism of Ernst Wilhelm Nay (1902–1968) and the densely scumbled brushstrokes of Fred Thieler (1916–1999). During the late 1950s, Thieler's freely brushed "force fields" corresponded strongly with the movement-based work of such Tokyo-based painters as Toshimitsu Imai (1928–2002). [63] Andrei Tarkovsky (1932–1986); Ridley Scott (b. 1937). The futuristic scenes for both *Blade Runner* and *Solaris* were shot in Tokyo. Chris Marker (1921–2012); Wim Wenders (b. 1945); Katsuhiro Ōtomo (b. 1954); in 1988 *Akira* was made into an *anime*. [64] The first generation of such architects were the Metabolists in the 1960s led by Arata Isozaki (b. 1931), Kiyonori Kikutake (1928–2011), Kishio Kurokawa (1934–2007) and Fumihiko Maki (b. 1928) as well as other younger architects such as Tadao Ando (b. 1941), Toyo Ito (b. 1941), Jun Aoki (b. 1956), Kengo Kuma (b. 1954), and SANAA (Seijima [b. 1956] and Nishizawa [b. 1966] Associates).

in the future, **(fig. 42)** so the childlike forms in the work of such *manga*-related artists as Takashi Murakami or Chiho Aoshima suggest another kind of tabula rasa: that of a knowing but child-like refuge in fantasy. In a recent exhibition (and accompanying book) called "Little Boy"—the name of the atom bomb that was dropped on Hiroshima—Murakami has attributed the infantilist strain of *otaku* culture within contemporary Japanese art to the country's acquiescence and subsidiary role in current world politics. [65]

Since the reunification of Germany in 1989 and the demolition of the Wall, Berlin has started to re-examine its place in the world. Promoted during the Cold War as a center for free artistic expression, such ambitions have accelerated in the present to encompass former mayor Klaus Wowereit's proclamation on a 2004 TV interview that the city is "poor but sexy." With a lower cost of living than many capital cities—let alone Tokyo, where land prices are phenomenally high—Berlin has attracted many artists, creatives, and students to live there, and its international cultural presence has been consolidated by the state-sponsored German Academic Exchange Service (DAAD) as well as by the more modestly funded studio programs of Künstlerhaus Bethanien. These bring artists to the city from across the world, many stay, and even more come of their own accord.

The legacy of having once been two cities, has also meant that, after unification, Berlin has been extremely well-endowed with orchestras, choirs, concert halls, ballet, opera, theater, and museums as well as with the professionals to run them and the audiences to attend them—many of them growing numbers of tourists. The constraints on development that previously seemed so negative have meant that, unlike Tokyo, Berlin has been able to retain its green spaces and, unlike almost any other city in the world, has many potential vacant sites at its center. But the post-1989 flagship redevelopment projects employing world famous "starchitects" already completed around Potsdamer Platz and in Mitte have, for the most part, been disappointing in their quality, both in terms of architecture and city planning.

It is perhaps the greatest strength of both cities that Tokyo and Berlin are in a sense "unfinished"—and that this exhibition may be regarded as little more than an interim report on their inevitable change and development. As a result, the two exhibitions shown in Tokyo and Berlin differed in their treatments of the recent past and present. In Tokyo, the final section concentrated on how contemporary artists in Berlin reflected the diverse culture of their city and its environment stressing how this is markedly different. In Berlin, the main focus of Toyo Ito's specially designed "set" for the great hall of Mies van der Rohe's Neue Nationalgalerie (1968)—itself a significant exhibit—showed how contemporary artists and designers from Tokyo creatively expressed their popular culture. **(fig. 44)**

In this collaboration, the recently opened Mori Art Museum (2003)—which occupies the 53rd floor of the main tower in the 27-acre development of Roppongi Hills—juxtaposed both historical and newly commissioned art with a bird's eye view of the city itself, all framed by a distinctly Asian perspective. Its activities were regarded by Minoru Mori, its founder, as a symbol of the strong and resourceful cultural values that continue to epitomise the rebuilding of Tokyo. **(fig. 41)** ●

42 | Tatsuo Miyajima | **Region no, 126701 – 127000** | 1991 | 300 units of light emitting diodes (detail) | Art Gallery of New South Wales, Sydney

43 | Katsuhiro Ōtomo | scene from **AKIRA** | 1982–90 | a manga series set in post-apocalyptic Neo-Tokyo

44 | Toyo Ito with Florian Busch architects | Installation for the ground floor of the exhibition "Tokyo–Berlin / Berlin–Tokyo" in Mies van der Rohe's Neue Nationalgalerie | 2006 | photo courtesy of Christian Gahl

[65] *Otaku* is a Japanese word that describes mainly young people with obsessive interests in manga, anime and computer games. It implies that such people are confined to the house (their own small world) and are interested in little else. Tatsuo Miyajima (b. 1957); Takashi Murakami (b. 1962) (ed.), *Little Boy: The Arts of Japan's Exploding Subculture*, New York, The Japan Society, 2005; Chiho Aoshima (b. 1974). For a discussion of Murakami's book and the relation of such ideas to contemporary Japanese art, see pp. 82–105.

Bye Bye Kitty!!!...
Between Heaven and Hell in Contemporary Japanese Art

This essay was written in 2011 to accompany an exhibition of the same title at the Japan Society in New York. Joe Earle, its director, invited me to do this and I chose, as my starting point, to challenge the infantilist view of Japanese contemporary culture that was popular in the West, and even amongst some Japanese.

2

1 | Poster for Gilbert and Sullivan's opera **The Mikado** (1885) performed in its first year at the Royal Lyceum Theatre, Edinburgh, by Doyle Carte's Opera Company

2 | The final suicide scene from Puccini's opera **Madame Butterfly** (1904) performed by Henry Savage's New English Grand Opera Company at the Garden Theater in New York City | 1907

[1] Yum-Yum in WS Gilbert & A. Sullivan's light opera, *The Mikado or The Town of Titipu*, London, 1885, Act 2. See also the Trio from the first act, "Three Little Maids . . ." (fig. 1) [2] United States Army general Douglas MacArthur, May 5, 1951, following his dismissal by Truman for insubordination in the Korean War. John Dower, *Embracing Defeat: Japan in the Wake of World War II*, New York, WW Norton & Company, 2000, p. 550. [3] Takashi Murakami, *Little Boy: The Arts of Japan's Exploding Subculture*, New York, Japan Society, New Haven, Yale University Press, 2005, p. 100. [4] The taste for the small, the weak, and the vulnerable as well as for natural beauty has in a recent international exhibition been identified as a tendency among some contemporary Japanese artists. See Fumihiko Sumitomo, "New Individualism" in *Beautiful New World: Contemporary Visual Culture from Japan* (exh. cat.), Beijing, Guangzhou, 2007, pp. 19–20 (co-published by The Japan Foundation). [5] In the first act of *Madama Butterfly*, Pinkerton, the protagonist, muses about the 15-year-old he had just purchased for 100 yen: *Amore o grillo, / dir non saprei. Certo costei / m'ha coll'ingenue arti invescato. / Lieve qual tenue vetro soffiato / alla statura, al portamento / sembra figura da paravento.* [Is't love or fancy / I cannot tell you. All that I know is, / she, with her innocent charm has entranc'd me. / Almost transparently fragile and slender, / Dainty in stature, quaint little figure, / seems to have stepped down / straight from a screen,]. [6] See also Oscar Wilde's comment, "The whole of Japan is pure invention. There is no such country, there are no such people. The Japanese people are simply a mode of style, an exquisite fancy of art." "The Decay of Lying," *The Nineteenth Century*, 25, no. 143, London, Jan. 1889, p. 52.

I. Childhood

Yes, I am indeed beautiful! Sometimes I sit and wonder, in my artless Japanese way, why it is that I am so much more attractive than anybody else in the whole world. Can this be vanity? No! Nature is lovely and rejoices in her loveliness. I am a child of Nature, and take after my mother.

– WS Gilbert, 1885 [1]

Well, the German problem is a completely and entirely different one from the Japanese problem. The German people were a mature race.[. . .] If the Anglo-Saxon was say 45 years of age in his development, in the sciences, the arts, divinity, culture, the Germans were quite as mature. The Japanese, however, in spite of their antiquity measured by time, were in a very tuitionary condition. Measured by the standards of modern civilization, they would be like a boy of 12 as compared with our development of 45 years.

– General Douglas MacArthur, 1951 [2]

2005. Sixty years after the war. Contemporary Japan is at peace. [. . .] But everyone who lives in Japan knows—something is wrong. [. . .] Young girls butchered; piles of cash donations, scattered recklessly on foreign soil; the quest for catharsis through volunteerism; a brazen media prepared to swallow press restrictions in support of economic growth. The doorways of passably comfortable one-room apartments, adorned meaninglessly with amulet stickers from SECOM, a private security company. Safe and sound, hysteria.

–Takashi Murakami, 2005 [3]

Ever since the mid-19th century, when after nearly 250 years of self imposed isolation, Japan re-established contact with the rest of the world, its population has been both admired and denigrated for its "child-like" nature. This paternalistic outsider's view equating lack of western modernity with being pre-modern, feudal and, by extension, a state of childish immaturity was founded on the notion that Japan was essentially "different" and that this could easily be "proven" by a perceived taste for miniature versions of things, or a preferences for natural beauty and materials. [4]

On a personal level, this could also be discerned in social constructs of "innocence" and deference in female demeanor and language, which could, just as "childishly," blur into seduction. It was fetishized in sexually charged encounters such as the liaison with a young Japanese girl chronicled in the French novelist Pierre Loti's semi-autobiographical *Madame Chrysanthème* (1887), one of the sources for Giacomo Puccini's opera *Madama Butterfly* (1904). [5] (fig. 2) To other writers, such as WS Gilbert, librettist of the Savoy operas, Japan was a godsend. It represented a rarefied aesthetic ideal rather than a real country, a land of fantasy in which the inhabitants looked and moved like works of art. [6] But it was also a blank screen onto which they could project desires and fears not so easily expressed at home. (fig. 1)

Douglas MacArthur's assessment of Japan, presented to Congress in 1951, after six years as Supreme Commander of the Allied Powers, also stressed its "child-like" quality but more from the point of view of the then-still-prevalent belief in the manifest superiority of the "Anglo-Saxon race." The

3 | Remote-controlled robots compete with live girls in the **Robot Restaurant** | Kabukichō red light district | Tokyo | 2015

4 | "Japanese Envoys of Chic: Three Young Women as Cultural Ambassadors Dressed in Outfits Inspired by Animé Films and Manga" | **Asahi Shimbun** (English Edition) | March 13, 2009

5 | Yukio Mishima urges members of the Ground Self-Defence Force to carry out a coup on November 25, 1970, moments before he committed ritual suicide | Asahi Shimbun file photo

[7] Keizai Koho Sentaa, *Japan: An International Comparison*, Tokyo, Keizai Koho Sentaa, 1983, p. 5. One of the reasons for this rapid growth was that Japan was forbidden from committing large amounts of its GNP to arms or defense. [8] As early as 1953, both the effects of rapid urbanization and the breakdown of the extended family had featured in Yasujiro Ozu's (1903–1963) award-winning film *Tokyo Monogotari* ("Tokyo Story"). In 2010, Tokyo was the world's largest megacity with an estimated population of 34 million. [9] Ishiro Honda's (1911–1993), *Gojira* ("Godzilla"), Tokyo, Toho, 1954, and the films that span off from it, referenced the origin of these destructive monsters in mutations caused by nuclear radiation. Created in 1952 by pioneer *manga* artist Osamu Tezuka (1928–1989), *Atomu* ("Astro Boy") was a robot made by a scientist as a replica of his dead child but was then rejected because he would not grow up. *Atomu* then joined the circus and commenced the boyish world of adventure. *Akira* is a novel-length black-and-white serial *manga*, drawn by Katsuhiro Ōtomo (b. 1954) between 1982 and 1990, set in the ruins of a post-apocalyptic "Neo-Tokyo." (p. 80, fig. 44) More recently, in *Twentieth Century Boys* (2001), a manga extended into three films (2008–09), a doomsday cult causes the apocalypse. [10] The idea of women's rights first made an impact following the Meiji Restoration (1868), but it had no political voice until after the World War I. Universal female suffrage was only granted in 1946 under the American occupation. From the mid-1950s a number of women artists, such as Atsuko Tanaka (1932–2005), Yayoi Kusama (b. 1929), Yoko Ono (b. 1933), Shigeko Kubota (b. 1937) and Mako Idemitsu (b. 1940) played important roles in the avant-garde but often had to live or work abroad. Feminist ideas have only relatively recently started to make a significant impression on the Japanese art world. See Michiko Kasahara, "Contemporary Japanese Women's Self-Awareness," in Linda Nochlin, Maura Reilly (eds.), *Global Feminism* (exh. cat.), New York, Brooklyn Museum, 2007.

pubescent child in MacArthur's analogy had certainly been a "naughty boy" at Pearl Harbor and afterward, but, like a strict but sympathetic headmaster in a new post-World War II era school, the general sincerely hoped that in the future he would do much better.

And so he did, through unprecedented economic regeneration and growth. In 1951, Japan's GNP had been USD 14.2 billion, half of that of Germany, a third of that of Great Britain, and 4.2 percent of that of the United States, but by 1980 it had increased over 70-fold to over USD 104 trillion, roughly 40 percent of that of the USA, 20 percent higher than Germany, and 45 percent greater than Great Britain. [7]

But the economic miracle was only achieved at considerable political and social cost. With only two short interruptions, Japan was ruled, from 1955 to 2009, by the conservative, business-friendly policies of the Liberal Democratic Party (LDP), which did not prioritize social or legal reform. The rapid, sprawling growth of the new megacity of Tokyo had progressed hand in hand with the depopulation of the countryside, which further exacerbated the breakdown of the extended family that left many Japanese feeling isolated and cast adrift. [8] In spite of superficial optimism, hard won after the shame of defeat and occupation, the long hours and pressures of a strictly hierarchical work place did little to alleviate the ever-present premonition that something terrible was again about to happen.

Nuclear-age-fueled anxieties, frenetically driven by the collective dread of an ever-apocalyptic future, were either expressed in, or alleviated by, escapist promises such as the neon-lit "floating worlds" of entertainment districts like Shinjuku's Kabukichō, the *ero* (erotic) fantasies of tired salary men and etiolated geeks, the rapidly growing taste for things "cute" or small, and the proliferation of films, *manga*, and *animé* that all imagined Tokyo as the epicenter of the end of the world. [9] (fig. 3, 4) Reality kept track with fantasy. By the end of the 1980s, the booming economy had started to run out of steam. The speculative bubble of land prices and consumption had become so bloated that it had to burst, followed, at the beginning of the 1990s, by the astringent shower of severe economic recession.

For artists born between the mid-1960s and the early 1980s, like those featured in this essay, the times of growth and excess, followed by a dramatic reversal of fortune, fostered cynicism about the values, attitudes, compromises and arrogance that had allowed this to happen. As a result, a more critical, and at times brutal, view of the world developed, as well as a desire to scrutinize the power relationships that had created it.

The growth of feminism within Japan, and the related spread of gender studies, was central to this scrutiny. Deep-rooted social pressures that required women to behave in specific, time-honored ways, considered acceptable in a still largely male-dominated society, were increasingly exposed and questioned. [10] But the new "threat" of potential female insubordination was accompanied by a reciprocal male riposte: the spread, from the 1980s, of the "Lolita complex," the fantasy of dominating, or being dominated by, over-developed prepubescent girls. This appeared initially in popular culture and pornography but, from the middle of the 1990s, it also became a subject in art. [11]

Obviously all was not well, either within the economy or between the bed sheets, as was illustrated, eloquently and disquietingly, by Japan's plummeting fertility rate. [12] In an ageing society, obsessed on different levels by "cuteness" and youth, fewer babies were being born. The ideal of childhood had rapidly become virtual and detached from life, and was increasingly confined within a highly competitive educational environment in which growing levels of bullying, abuse, and murder of children—along with an increasing number of violent acts committed by young people themselves—were constantly being reported in the press. [13]

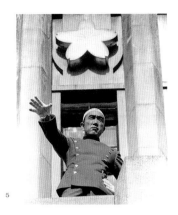

5

And in the 1990s, the decade of deflation, downsizing, and rising unemployment, some of the worst nightmares came true: on January 17, 1995, the Great Hanshin Earthquake flattened a large part of Kobe with over 6,000 people dead. (fig. 12) Two months later, on the morning of March 20, as part of a self-fulfilling doomsday prophesy, members of the Aum Shinrikyu ("Supreme Truth") cult released lethal sarin gas in an attack on five trains in the Tokyo subway.[14]

II. Little Boy

In the catalogue of an exhibition held at the Japan Society in 2005, artist and curator Takashi Murakami (b. 1962) also employed the metaphor of childishness in his analysis of Japanese culture. Unlike Gilbert or MacArthur, he had been born in Tokyo and had directly experienced the postwar years of boom and bust. One of the most high-profile artists of his generation on the international stage, Murakami maintained that a lack of maturity was a defining characteristic of an increasingly vital contemporary Japanese subculture and that he, as an artist, was unavoidably and inextricably implicated in it. "Little Boy: The Arts of Japan's Exploding Subculture," the title of this exhibition, sardonically echoed the nickname of the atomic bomb that had been dropped on Hiroshima.

Murakami argued that the root cause of contemporary Japanese art's retreat from the "adult world" into an infantile, hermetic, "superflat," fantasy universe was his country's political emasculation by the United States and other western powers following the end of World War II. "Superflat," a term coined by Murakami, alludes to the flattened spaces in Japanese traditional art, graphic art, *manga*, *animé*, and pop art, and by extension to the chronic empty consumerism of contemporary Japanese culture. With economic growth more a distraction than a compensation for Japan's wartime devastation, the culture that MacArthur and others had envisioned as "juvenile" had mutated into a passive-aggressive playground, periodically pierced by incontinent shrieks of impotence. It seemed as if the whole establishment had entered into a Faustian pact with the West, in which high standards of living and endless consumerism had been the price for its soul. Consumption had become an addiction and the political lack of will to move with the times could no longer be endured. By holding his political breath, the "Little Boy" had attained unimaginable riches, but at the cost of retarding his social growth.

Some two decades earlier the same political conditions had infuriated and alienated novelist Yukio Mishima and had given him the pretext for his notorious failed *coup d'état*.[15] But, rather than assembling a fashionably uniformed paramilitary group in an abortive attempt to revive the spirit of *bushido*,[16] as Mishima had done, (fig. 5) the protagonists of Murakami's disorderly generation had either forgotten or did not care why they were so angry. Instead, they massed together in sullen protest, withdrawing into the bubble of an increasingly virtual and self-reflexive universe.

For many young people in the 1980s and '90s, ideas of the state or society seemed irrelevant. Linked by cyberspace, they assembled online under the emblem of the *otaku*, a "class" of house-bound, largely middle-class, male geeks, with female counterparts in *fujoshi*, who, in denial of the social world, lived out their fantasies in *manga*, *animé*, *cosplay* (costume role play), (fig. 4) pornography, and video games.[17] Their apotheosis was *hikikomori*, the highly publicized phenomenon of reclusive young people who had become so alienated that they stayed at home, isolated in their rooms, and withdrew totally from all forms of social contact.[18]

During the same time, the related cult of *kawaii* (cute) had spread like wildfire through the whole of Japanese society. Developing in the early 1970s out of a new childish-looking style of teenage girl's handwriting that used big, round characters with randomly inserted pictographs such as

[11] In Japan, pornography has traditionally been strongly linked with fine examples of popular culture in *shunga* (pillow books). See Timon Screech, *Sex and the Floating World*, (2nd edition), London, Reaktion, 2009. "The Lolita complex," abbreviated in Japanese as *lolicon* or *roricon*, appears to have emerged, at least in part, out of a passive-aggressive male response to perceived threats of economic insecurity and loss of status. See Sharon Kinsella, "Minstrelized Girls: Male Performers of Japan's Lolita Complex," *Japan Forum* 18 (1), 2006, London, Routledge, pp. 65–87. In visual form its influence has been pervasive at many levels including fashion, *manga* and *animé*. From the 1990s artists of both sexes, such as Makoto Aida, Chiho Ayoshima, Mr., Takashi Murakami, and Ai Yamaguchi, have, in different ways, used, commented on and critiqued *roricon* imagery. [12] According to the CIA World Fact Book, the projected fertility rate in Japan for 2008 is 1.22. This is mirrored by a rapidly decreasing marriage rate. Conversely, Japan also has one of the longest life-expectancies in the world—according to AP/Kyodo, 85.99 years for women and 79.19 for men—which, unless there is a marked change soon, implies a rapidly ageing and less-productive society. [13] There is no evidence that child murder rates in Japan are significantly higher than in other developed countries but because of outdated respect for the no-longer existing social network of the extended family, they were thought to have been much lower. Over the past decade, as a result of legal initiatives, greater awareness and increasing disclosure, reported rates of abuse have increased dramatically. See Sheryl WuDunn, "Japan Admitting, and Fighting, Child Abuse," *The New York Times*, August 15, 1999; Dominic Al-Badri, "Japan Hit by Huge Rise in Child Abuse," *The Guardian*, London, June 27, 2006; Eric Prideaux, "Rising Child-Abuse Deaths Draw National Scrutiny," *The Japan Times*, Tokyo, March 19, 2007. The absence of children's rights to appeal against abuse within the Japanese legal system has been a serious impediment to improving this situation. In terms of violent crimes perpetrated by young people, Japan has kept in step with the rest of the developed world. [14] Twelve commuters were killed, 54 seriously injured and an estimated 980 were affected by the attack. Novelist Haruki Murakami devoted his first work of nonfiction to interviews with survivors of the attack and his analysis of it. See "Underground: The Tokyo Gas Attack and the Japanese Psyche," trans, A. Birnbaum and P. Gabriel, New York, Vintage International, 2001 (Japanese edition, Andagaraundo, Tokyo, 1997/8). [15] Yukio Mishima committed ritual suicide at the Tokyo Headquarters of the Eastern Command of Japan's Self-Defence Forces in November 1970 after a failed attempt to trigger a military putsch. [16] This can be loosely translated as "the way of the warrior," the honorable code of conduct for samurai before the Meiji Restoration. [17] In Japanese, the term *otaku* has a rather negative connotation that suggests an unhealthy obsession with particular pastimes. It is derived, somewhat ironically, from an honorific form of a word for "house." Sometimes the word is used to refer to women. [18] *Hikikomori* conveys the sense of "pulling away," "being confined" hence its sociological meaning of "acute social withdrawal."

hearts, stars, and smiley faces into the text, the vogue was quickly amplified by firms like Sanrio which produced ranges of stationary, diaries, and cartoon characters, including, from 1974, the Hello Kitty products, to satisfy this rapidly burgeoning market. [19]

By the 1980s, this style had made its way into the mainstream in packaging, advertising and *manga* while, in teenage culture, it had become linked with a new fashion for acting and dressing childishly and using infantile slang words. The fantasy, role-playing styles of dress that began to emerge at this time can still be seen, haunting the streets of Harajuku and Akihabara or outfitting international cultural ambassadors sponsored by the Japanese government to stimulate exports. [20] **(fig. 4)**

The appetite for the vacuously cute seemed boundless. People of all ages responded to a tsunami of kitschy cartoon-like creatures that existed in their own right, or as a form of popular commercial art, adorning household goods, vehicles, shop windows, and sign boards or, even more incongruously, served as logos for the police force, different local authorities, and a TV station. [21]

It was in response to such "pop art" goods that, through the medium of his company and artists' collective Kaikai Kiki Co., Ltd., Takashi Murakami started to create his own cartoon-like figures, produced and reproduced on different scales, as graphic images, paintings, sculptures, and soft, fluffy toys, which cast a tolerant but detached eye on the "cute." He contrasted the relative innocence of this taste with American body/identity obsessions: "The cute obsession is a complicated problem, but I think that it's a pleasant and not-so-intimidating aesthetic ideal, so that is why it's very popular. It's good for people who are introverted, which many Japanese are. Cute is so fetishized in Japan that it's actually also sexualized. It's just like how Americans have a fetish with steroid body builders and breast implants. Personally, I think *that's creepy*." [22]

But then, he also appropriated the "cute" pornographic *manga* images of *otaku* culture from the same point of view, making his own supersize (and mini) "steroid body" sculptural versions of them. As many artists have shown before, in the right circumstances any image can adopt the mantle of art, and as part of this process Murakami was insistent on minimizing the differences between different forms of popular subculture and so-called "high art." [23]

In this way, the banality of the "cute" may express many things, even self-critique, but sociologist Sharon Kinsella has been more forthright in her opinion about how this phenomenon is the result of a painful chasm between the different postwar generations: "Cute style is anti-social; it idolizes the pre-social. By immersion in the pre-social world, otherwise known as childhood, cute fashion blithely ignores or outrightly contradicts values central to the organization of Japanese society and the maintenance of the work ethic. By acting childish, Japanese youth try to avoid the conservatives' moral demand that they exercise self-discipline (*enryou*) and responsibility (*sekinin*) [. . .] Rather than working hard, cuties seem to have just wanted to play and ignore the rest of society completely." [24]

Murakami, however, did not limit himself to an elaboration of the mass aesthetics of the *otaku* or *kawaii*, and has also designed exclusive ranges of luxury consumer goods for brands like Louis Vuitton. In the same way that he had tried to break down distinctions between subculture and fine art, these works erode the line between fine art and commerce, maintaining that both were never as clearly separated in Japan as they had been in the West. [25]

Murakami's comments about his work are difficult to reconcile with his view of Japanese culture. On one hand, as in the passage quoted at the beginning of this essay, he appears to be excoriating the empty soullessness of the situation that has lead to the current situation of "safe [. . .] hysteria," [26] yet, on the other, he enthusiastically—and lucratively—participates in it. In this catch-22, Tokyo style, unmediated public response, plus the advocacy of the

[19] See Sharon Kinsella, "Cuties in Japan" in Linda Skove and Brian Moeran (eds.), *Women, Media and Consumption in Japan*, Honolulu, University of Hawai'i Press, 1995. See also Yuko Hasegawa, "Post-Identity Kawaii: Commerce, Gender and Contemporary Japanese Art," in Fran Lloyd (ed.), *Consuming Bodies: Sex and Contemporary Japanese Art*, London, Reaktion, 2002, pp. 127–141. For an analysis of and about women in Japan since the Edo period, see David Elliott, "Beauties, Monsters and Heroes. Women and the 'Floating World'" in L. Fritsch and C. Pollard, *Images of Tokyo*, Oxford, Ashmolean Museum, 2021, pp. 120–133. [20] "Japanese Envoys of Chic. Three young women as cultural ambassadors dressed in outfits inspired by anime films and manga." *The Asahi Shimbun*, English Edition, March 13, 2009, p. 1. [21] Each of Japan's 47 prefectures has its own cute mascot, a trend followed by different sections of the Tokyo Police Force as well as by the government television station. [22] Magdalene Perez, "Takashi Murakami: The AI Interview," Artinfo.com, June 9, 2006, www.artinfo.com/news/story/17056/takashi-murakami. [23] Such works have met with large success in the western art market and include *Hiropon* (1996), with her massive milk-spraying breasts, the ejaculating *My Lonesome Cowboy*, 1997 (both oil, acrylic, synthetic resin, fiberglass, and iron) and the cyborg *SMP2Ko2, Second Mission Project Ko2 Mega-Mix (Human Type)*, 1999, oil, acrylic, fiberglass, and iron. On May 15, 2008, *My Lonesome Cowboy* was auctioned by Sotheby's, New York for a price of USD 15 million. See also Midori Matsui, "The Place of Marginal Positionality: Legacies of Japanese Anti-Modernity" in Fran Lloyd (ed.), op. cit., pp. 142–165. [24] S. Kinsella, op. cit., p. 251. [25] Perez, op. cit. [26] See footnote 3. [27] See pp. 60–81 and Alexandra Munroe, *The Third Mind: American Artists Contemplate Asia* (exh. cat.), New York, Solomon R. Guggenheim Museum, 2009. [28] *Yamato-e*: classical Japanese style of painting originally inspired by Chinese Tang Dynasty art. [29] *Nihonga*: This term was coined towards the end of the 19th century by artist and educator Tenshin Okakura (1863–1913) to describe a synthetic style of pseudo-traditional painting created in response to the equally new phenomenon of *yōga* (western-style painting), which was first practiced by Japanese artists in the 1880s. [30] This approach was pioneered by Korean curator Kim Sun-Hee in her exhibition "The Elegance of Silence," (Mori Art Museum, Tokyo, 2005), in which she examined the different ways in which East Asian aesthetic traditions are still expressed in the contemporary art of China, Japan, Korea, and Taiwan.

western art market seem to be the main criteria for judgment. Trapped by time and place, as well as by previous equivocations between art and its market by such artists as Andy Warhol and Jeff Koons, Murakami seems to have decided to fight disease with the language of its infection in a homeopathic treatment for Japanese art.

By treading a tightrope, tightly stretched between the extremes of commerce and "childishness," Murakami's work fits into both an aesthetic and a trajectory that are familiar to the art market; this, no doubt, accounts for much of its popularity among western collectors. Yet, there are many other aesthetic and critical approaches towards making art inside Japan, affected by the same history, social context and present, which take a different, more explicitly critical tack.

III. Growing Up

Since the beginning of the 20th century, Japanese art has developed in timely and constructive conversation with western modernism but the scope of this complex interchange has not been widely acknowledged. [27] With few exceptions, its contemporary art has too easily been either embraced or dismissed in the West as either a derivative reflection of its own image (some children are very good at copying), or as quaintly traditional, *otaku* or *kawaii*—a stereotypical state of child-like grace— which the simply drawn, mouth-less features of Hello Kitty, Sanrio's iconic multinational children's toy brand, have epitomized in their bland inscrutability.

Many artists, however, especially those selected for this exhibition have produced work that indicates a more complicated, adult view of life, melding traditional viewpoints with perceptions of present and future in radical, creative and sometimes unsettling combinations. This mixing, or hybridity, one of the essences of Japanese pictorial creativity, has created a fertile seedbed in which the struggle between extremes of heaven and hell, fantasy and nightmare, ideal and real, take place. There is no room for Kitty's blankness here. But the boundaries between the extremes are often not clear. In a fiercely critical, socially rigid, and historically loaded environment, where irony is used as a weapon, one element may be unveiled to reveal, in fact, its opposite.

"Bye Bye Kitty!!!" examines contemporary Japanese art through the prism of tradition and its critical relation to the contemporary world—"tradition" referring here in particular to the conservative, idealized aesthetics of *yamato-e*, [28] traditional sculpture, decorative arts and architecture as well as the more popular *ukiyo-e* ("Pictures of the Floating World," a term used today to refer to woodblock prints). Along with the phenomena of *yōga* (western-style painting) and *nihonga* [29] (neo-traditional painting), which both emerged at the end of the 19th century and are still separately taught in Japanese art schools, these historic modes of expression have been reframed by artists who feel free to move in and out of their respective conventions and contexts. "Bye Bye Kitty!!!" shows how this legacy is often the starting point for critical or subversive images that question conventional ways of seeing and thinking. [30]

Aside from Yoshitomo Nara, the sixteen artists in the show range in age from their late twenties to their mid-forties. Eight are women whose presence reflects fundamental changes taking place in gender roles and expectations. Selected for individual strength and quality, these paintings, objects, photographs, installations, and videos shown are loosely grouped here under three, not mutually exclusive, headings: "Critical Memory" (tradition, history and society), "Threatened Nature" (beauty, ecology and vulnerability), and "Unquiet Dream" (interrupted fantasy and nightmare). Taken together, these form a particular, and quintessentially Japanese, view of both the present and future.

6 | Katsushika Hokusai (1760–1849) | **The Dream of the Fisherman's Wife** | 1814 | color woodblock print on paper | 19 x 27 cm

7 | Makoto Aida | **Giant Member Fuji Versus King Gidora** | 1993 | acetate film | acrylic | eyelets | 310 x 410 cm | Takahashi Collection, Tokyo. **See p. 228 for a larger illustration**

8

9

IV. Critical Memory

Makoto Aida must have had an inkling of his later calling when, at the age of ten, he realized that "I wanted to become a cartoonist, just like Osamu Tezuka." [31] He showed an early talent for drawing and painting but apparently for little else: "I was an eccentric child who developed in a rather unbalanced way. I wet my bed until the second grade of junior high school." Yet, in spite of this, he obviously discovered a broad field of culture: formative influences at school included the writings of peace activist Makoto Oda, the novels of Yukio Mishima, and, at university, the analytical texts of literary critic, Hideo Kobayashi.[32] (See also pp. 228–235)

Since his first solo exhibition in 1992, Aida's work has been characterized by sardonic social critique, underwritten by forthright nihilism and anger. In a staggering range of different kinds of production, he has deconstructed the stylistic history of modern art in Japan, including many influences on it from the West, to reassemble it as a contemporary critique of the bourgeois heartlessness of a completely demotivated society.

Aida has a natural facility for strategic parody, made all the more powerful by his respect for the rules and conventions that identify the styles he lampoons. He is as comfortable using the materials and conventions of *nihonga*, *ukiyo-e*, or *yōga* as those of the contemporary avant-garde, sometimes combining elements of all these styles within a single work. In a more than four-meter-wide painting on acetate film, *Giant Member Fuji vs King Gidora* (1993), he not only directly references the erotic sci-fi preoccupations of much *otaku manga*, but brings them together with the subject of a small erotic print by the *ukiyo-e* master Katsushika Hokusai, *The Dream of the Fisherman's Wife* (1814), [33] in which a young woman is multiply ravished by the tentacles and beaks of a pair of large, predatory octopuses. (figs. 6, 7) Aware that because both *manga* and *ukiyo-e* were "closely connected with indecent taste... [they] can't get acknowledged as art," Aida sought to give them expression as "the most honest and original forms of visual expression for Japanese people."[34]

A similar impulse fuels *Harakiri School Girls* (2006), a work in a series Aida started in 1999: this example was drawn by Aida but colored by his friend Muneteru Ujino (b. 1964). (fig. 10) It joins the fetishistic fashions, uniforms, and nubile bodies of *kogal* or *gyaru*—typical fantasy schoolgirls—with the practice of ritual suicide. The magnificent drawing alludes to the style of the 19th-century artist Tsukioka Yoshitoshi, the last great master of the woodblock print, who, because of his violent subject matter, madness, and absorption of the perspectival innovations of western illustration, has often been dismissed as decadent. As Mishima's death had tragically illustrated, the samurai code of honor maintained that *harakiri* (or, more correctly, *seppuku*) was the last recourse in the face of shame or defeat, yet here Aida transforms this time-honored tragic duty into a childish, erotic game as, in the most beautiful arabesques of gory violence, young schoolgirls seductively and ecstatically disembowel themselves.[35]

It is the calculated ambivalence of such works, including Aida's *nihonga* series of "Dog" paintings, in which, against traditional backgrounds of changing seasons, naked amputee schoolgirls submissively cavort in animal-like states of bondage, that give them their force. (p. 234, fig. 11) A transgressive delight, or shock, may result from the energy, skill and subject of each work, but this is offset, and made all the more powerful, by the serious and heartfelt critique that Aida presents of a magnificent culture that has lost its way.

The series of works "War Picture Returns" (1995–99) refers to the subject, taboo in Japan, of the military nationalism of the 1930s and '40s, when such *yōga* artists as Tsuguharu Foujita (1886–1968) and Kenichi Nakamura (1895–1967) recorded the battles of the Pacific War. (p. 77, fig. 38) A pair of sliding screens, *Beautiful Flag* (1995), the first in this series, collides—with bitter humor—past atrocities with present realities through the image of two massively heroic schoolgirls silhouetted against a wasteland, one holding the

8 | Miwa Yanagi | Windswept Women 2 | 2009 | framed photograph | 400 x 300 cm | Art Gallery of New South Wales collection, Sydney

9 | Miwa Yanagi | My Grandmothers/MISAKO | 2002 | c-type print, plexiglass, text panel | 120 x 80 cm | courtesy of the artist and Yoshiko Isshiki Office

10 | Makoto Aida | Harakiri Schoolgirls | 2002 | print on transparency film, holographic film, acrylic | 119 x 84.7 cm | courtesy Mizuma Art Gallery | Watai Collection

[31] Aida: email interview with the author, June 8, 2009. [32] Ibid. Makoto Oda (1932–2007), novelist and peace activist. Hideo Kobayashi (1902–1983), author and critic. [33] This print was published in 1814 in the book *Young Pine Saplings*. [34] Makoto Aida, *Monument for Nothing: A Catalogue Raisonné*, Tokyo, Graphic-sha Publishing Co. Ltd, 2007, pp. 138–139, 211. (See also pp. 228–235). [35] Ibid., pp. 134, 227.

11

11 | Akira Yamaguchi | **Votive Tablet of a Horse** | 2001 |
oil and varnish on plywood | 182.5 x 183 cm | private
collection | courtesy Mizuma Art Gallery, Tokyo

12 | Tomoko Yoneda | **Vacant Space III** from the series
Ten Years After | 2005 | the houses are located in one of
the most damaged areas and untouched since the 1995
earthquake in Kobe | c-type print | 76 x 96 cm |
courtesy Shugoarts,Tokyo

13 | Tomoko Yoneda | **Minefield** from the series
Scene | view of a previously mined football pitch,
Sarajevo | 2004 | c-type print | 76 x 96 cm | courtesy
Shugoarts, Tokyo

14 | Tomoko Yoneda | **János Kádár's Villa II, Club
Aliga** from the series **After the Thaw** | Balatonaliga,
Hungary | 2004 | c-type print | 65 x 83 cm | courtesy
Shugoarts, Tokyo

[36] This work was made in Japan and was exhibited in New
York in Lawrence Rinder's exhibition, "The American Effect
– Global Perspectives on the United States 1990–2003," held
at the Whitney Museum of American Art in 2003. The critical
response at the time was harsh. See for example: Karen
Rosenberg, Art Monthly 270, London, October 3, p. 41; Steven
Vincent, Resisting the American Effect," National Review,
September 9, 2003. [37] "Monument to Nothing" is also the title
of Aida's catalogue raisonné, op. cit. This work is illustrated on
pp. 14–15, 233. In Monument to Nothing III, (2009) Aida returns
to the subject of schoolgirl suicide through the satirical use of
manga-style illustration, lampooning also salary men's sexual
fascination with schoolgirls. See Yasuko Furuichi (ed.), Twist
& Shout. Contemporary Art from Japan (exh. cat.), Bangkok,
2009, pp. 54–55, (organized by the Japan Foundation, Tokyo).
[38] See, for example, Tomoko Otake, "Japan's Gender
Inequality Puts It to Shame in World Rankings," The Japan
Times, February 24, 2008; Dolores Martinez (ed.), The Worlds
of Japanese Popular Culture: Gender, Shifting Boundaries and
Global Cultures, Cambridge, UK, Cambridge University Press,
2008. [39] "Dominique Gonzalez-Foerster, Hans Ulrich Obrist,
Miwa Yanagi: Interview," Miwa Yanagi, Berlin / Frankfurt am
Main, Deutsche Bank Art, 2007, p. 48. [40] See Mako Wakasa,
"Interview with Miwa Yanagi," Journal of Contemporary Art,
Kyoto, August 2001, www.jca-online.com/yanagi. [41] Miwa
Yanagi, email correspondence with the author, December 26,
2008. [42] Tomoko Yoneda, An End Is A Beginning (exh. cat.),
Tokyo, Hara Museum of Contemporary Art, 2008, p. 96.

Japanese flag and the other holding the Korean flag. **(p. 235, fig. 14)** *Picture of an Air Raid on New York City* (1996) shows the pale, ghostly outlines of wartime Mitsubishi Zero fighters endlessly circling over the bombed, burning skyscrapers of New York in an evocation of the conflagration that consumed Tokyo after firebombing in 1945. [36] **(p. 231, fig. 7)** The impulse behind this work is neither misplaced nationalism, nor mindless provocation. Juxtaposing two periods and kinds of empire with an obvious reversal of historical outcome, Aida seems to be implying that, for him, America's ambitions of aggrandizement in the world today are not so different from those of Japan during its nationalist expansion before and during World War II. Using the tactics of fantasy, allegory, and embittered joking, Aida reincarnated the monumental lone schoolgirl in *Monument to Nothing* (2004), the first in a continuing series. In this vast mock-heroic installation, a naked girl, more than six meters tall, is painted standing astride a "marble" plinth amid the cardboard ruins of a postwar, prefabricated house determinedly looking to the "future." Adding a further frisson, the ruins have been skewered from behind by a vast, phallic underground drill. [37]

In the battle for urban cultural life, Aida's principle enemy is the gray-suited "salaryman," whose reputation for unquestioning conformism, lubricious sexlessness, and lack of individual spirit, he abhors. The salaryman's exploitative, immature attitude toward the opposite sex is dramatically expressed in *Blender* (2001), a painting more than three meters high that shows naked women being puréed in an enormous kitchen appliance. **(p. 229, figs. 2–3)** In the installation *Demonstration Machine for One Person (Against Salaryman)* (2005), Aida had designed an apparatus to protest against salarymen, showing it in operation with him haranguing them through a portable loudspeaker in one of Tokyo's business districts. In a recently completed seven-meter-wide painting *Ash Color Mountain* (2009–10), the corpses of salarymen are piled high, each shown in loving detail, slumped higgledy-piggledy, over their office equipment, on a vast gray tumulus. **(p. 231, figs. 4–5)**

Although gender roles in patriarchal Japan have historically been rigid, this social arrangement reflects only a part of the picture. [38] Within their own spheres of influence, particularly the home, women have always wielded considerable power. They have also been able to gain independence by entering the glamorous worlds of entertainment, theater, and film. Kyoto-based Miwa Yanagi (b. 1967), one of the leading feminist artists of her generation, has described both her grandmother and mother as frustrated actresses, noting that that they projected their theatrical aspirations onto her, with the result that her work since the early 1990s has developed in five complex groups that express the power of women and their desire for autonomy through the means of staged fantasies or theatrical tableaux: [39] "Elevator Girls" (1993–99), "My Grandmothers" (1999–), "Granddaughters" (2002–), "Fairy Tale" (2004–06), and "Windswept Women" (2009). **(pp. 236–239)**

Reflecting on women's actual and potential roles, and on the psychology that underpins them, these different series of large photographs and videos have moved from the anachronistic and hidebound society of her childhood and youth towards the yet-to-be experienced freedom and ambivalence of old age. Corporate Japan of the 1970s and '80s is reflected here in the pert uniforms, marionette-like, fixed grimaces, and hierarchical deference of the "Elevator Girls" whose seductive youth is cruelly and allegorically cut short by the different forms of violent oblivion Yanagi devises for them. The "My Grandmothers" series, which includes *Misako* (2002), *Geisha* (2002), *Hyonee* (2007) and *Mitsue* (2009), depicts the fantasies and fears of a group of young women whom Yanagi asked to imagine what they wanted to be 50 years from now. **(fig. 9)** Working closely with her subjects, and employing makeup and digital manipulation, she staged visual sets of their imagined futures in the form of photographs with written descriptions of their "dreams." In this work, both the optimism and pessimism of youth are telescoped into a future

12

13

14

fantasy of old age yet to come. Tellingly, none of the "grandmothers" selected by Yanagi ever imagine the conventional fate of bringing up a family and of living happily within it. [40]

The compression of time is even more dramatic in the "Granddaughters" videos, which include testimony from women both in and outside Japan. Here, elderly women look back over their lives to describe their memories of their grandmothers when they were young girls and, in the process, "naturally slip back to the time when they were granddaughters themselves." [41] Conventional notions of distance and time are further displaced by the devices of putting each woman in front of a backdrop of the city where they live, as if she were a newscaster, and by replacing the speakers' voices with those of unrelated young girls who are the age of their own granddaughters. In a scenario that covers three generations, Yanagi creates a paradigm of the mechanism of history itself, in which the voices of both present and future constantly reshape the memory of the past.

In "Fairy Tale," Yanagi moves completely away from her Japanese context to consider more universal manifestations of fantasy and collective imagination. Here, dichotomies of youth and age are expressed in idiosyncratic restagings of scenes from fairy tales. Although a part of a commonly shared literature, these tales have usually been written down by men and have often privileged youthful beauty against age with a strong misogynistic bias. But, in a grotesque inversion of youth with age, all the characters in Yanagi's versions of these old stories are played by young girls, some wearing latex masks to make them appear old. In a celebration of the reversal of roles, the stereotypical character of the "evil old witch" is challenged in series of *mises en scène*, in which the young as well as the old are shown as being capable of the utmost cruelty. By adopting an iconoclastic approach to the fetishized "innocence" of traditional children's literature and, by extension, to its blind superimposition onto the actual behavior of children, Yanagi has shattered sentimental clichés and has begun to approach the ambivalent harshness of reality. In "Windswept Women," first shown in the Japan Pavilion at the 2009 Venice Biennale, Yanagi again mixes youth with age but in the bodies of five, massive, goddess-like women, each more than four meters tall, whose features, skin, breasts, and hair are buffeted and distorted by both the artist and the wind. These forbidding, ageless, yet aged, creatures stand firmly, even ecstatically, against adversity and threat. (fig. 8)

The London-based artist Tomoko Yoneda (b. 1965) concentrates on suppressed historical and cultural narratives that have helped form the power relations of the present. She is particularly concerned with the effect of time, with how it covers events without expunging their memory or influence. Some of her earliest photographs, from the series "Ten Years After" (1995–2005), show the effects of the Great Hanshin Earthquake, exhibited alongside photographs of the same area taken in 2005. Her photographs of the destruction of the original event are allusive rather than horrific, but a decade later, life seems normal—almost. It is as if the spirit of those who died violently lives on in the restrained somberness of these images, as well as in the overgrown gaps where once buildings stood and have yet to be replaced. (fig. 12)

In "Scene," a series of works begun in 2000, Yoneda insists that "history is not only apparent in tangible monuments on buildings, but also expresses itself impassively in various intangible ways. [It] surrounds us . . . but it appears quiescent and disconnected from our thoughts. However, its shadow communicates itself with the awareness stored within our experiences, entering into the depths of our vision and dwelling in our daily lives." [42] Some of the earlier images in the series depict sites related to World War II where destructive and significant events occurred; one of the most redolent of these, *Path* (2003), traces the route to the cliff in Saipan from which Japanese families willingly jumped to their deaths as American troops

15

landed in 1945. But many of the works in the "Scene" series refer to events in Yoneda's own lifetime. *Minefield* (2004), a photograph of an ostensibly unremarkable rural football pitch had been a deadly minefield during the Serbian siege of Sarajevo (1992–96). **(fig. 13)** *János Kádár's Villa II* (2004), which shows the old Hungarian dictator's holiday bedroom, neatly laid out in a Party officials' resort on the shore of Lake Balaton, epitomizes the bourgeois normality of totalitarian abuse. [43] **(fig. 14)**

The "Kimusa" series (2009) [44] focuses on interior views of the abandoned headquarters of the National Military Defence Security Command (DSC, abbreviated in Korean as *Kimusa*) in Seoul, soon to become a new branch of the National Museum of Modern and Contemporary Art. During the Joseon Dynasty (1392–1897) this site had housed important government offices that were replaced during the Japanese Colonial Rule (1910–45) by the main military hospital and then taken over in 1971 by the DSC, a counter-intelligence agency that interrogated, and at times tortured, its own nationals, as well as fomenting political unrest. On December 12, 1979, presidents Doo-Hwan Chun and Tae-Woo Roh planned their notorious coup d'état from this site. Yoneda's photographs, however, make no direct reference to these histories. The bare details of the almost monochrome walls, curtains, and windows in these forlorn offices and cellars, reveal only the spare geometries of the shadows of the furniture, shelves, and appliances that used to be housed there. By extension, these abstractions, not unlike minimalist paintings, become both beautiful and allusive visual metaphors, not only of times past, but also of the continuing banality of state terror and violence, albeit now at other locations.

Like Makoto Aida, Yamaguchi Akira (b. 1969) [45] brings together different kinds of identifiable Japanese traditional style and imagery in his work in order to create a critical view of the present. Yet his approach is gentler, more light-hearted, and allows a possibility for human development. His early work shows a synthesis of different styles and formats—scrolls, *yamato-e*, folding screens, *ukiyo-e*—in images of cyborgs that, as in *Votive Tablet of a Horse* (2001), meld people or creatures with machines. Some of these reflect the visual dynamism of propaganda prints from the time of the Russo-Japanese War (1904–05), but the expression of others is more static and reminiscent of the flattened spaces and translucent golden clouds and mists of classical Japanese painting. Yamaguchi touches humorously on the subject of war in paintings such as *Weapons and Warriors* (1996), *Postmodern Silly Battle* (1999), and *Postmodern Silly Battle: Headquarters of the Silly Forces* (2001), the latter showing a serpentine scroll of smartly suited businessmen ready as if they were a column of samurai. [46] **(fig. 15)** In these, as in all his works, there is not much blood. Aware of "how stylish weapons and armor can be," he works from a position of ironical detachment. His paintings "are inspired by my personal observations of the world rather than by any political or social views. If I wished to make a political statement, I would stand in the street with a placard." [47] Yamaguchi insists that his interaction with the world is through art alone, devoid of any moralistic or moralizing intent. [48] Yet this does not mean that his work is without specific reference: *Tōkyō Tokei (Tokyo): Shō-Da-Furaku* (2001), appropriated a Japanese transliteration of George Bush's exhortation to "Show the Flag!" as part of its title, and a related oil painting, *Shō-Da-Furaku* (2003), is an oblique criticism of Japan's financial support for American and allied engagements in Iraq and the Persian Gulf. [49]

As well as an obvious distaste for militarism, Yamaguchi's work also reveals the artist's wistful anger about the effects of environmental despoliation and urban and social change. Many of these, like *Tōkei (Tokyo) Shiba Tower* (2005), or the two views of *Narita International Airport* (2005), show with gentle irony the urban rape of contemporary Tokyo and its environs through the prism of traditional paintings of famous views, tantalizingly veiled under the golden clouds that blanket the city in aesthetic waves of toxic smog.

[43] János Kádár, (1912–89) was the Communist leader of Hungary from 1956 to 1988. [44] *Kimusa* is an abbreviation for *Kuk-goon Kimusa-ryeongbu*, the National Military Defence Security Council. [45] The artist has asked that, even in its English form, his name should appear in the Japanese way, with the surname first. [46] The Japanese title for *Postmodern Silly Battle* is "There are Silly People Today and They are Fighting;" the English title for the work was invented by someone at Mizuma Gallery, Tokyo. Interview with the author, Tokyo, December 11, 2009. [47] Hammond, op. cit., p. 32. [48] Yamaguchi, interview, op. cit. [49] Ibid. [50] Hisashi Tenmyouya, *No Borders* (exh. cat.), Tokyo, Museum of Contemporary Art, 2006, p. 34. [51] *No Borders*, op. cit., illustrations pp. 37, 41. [52] Tenmyouya, interview with the author, Tokyo, December 11, 2009. [53] Tenmyouya, interview, op. cit. [54] Ed.'s note: The Transformers toy line, a series of alien robots that converted their mechanical bodies into vehicles, electronic devices or weapons, was originally launched by the Japanese Takara Tomy company in 1984, and later became a comic book, animated television, and film franchise in collaboration with the US-based Hasbro corporation. [55] As note 53. See also artist's web page: www3.ocn.ne.jp/~tenmyoya/art_new/kabuku.

16

17

A meditative, reflective yet, at the same time, contrarian character pervades Yamaguchi's entire oeuvre. In his oil painting *The Nine Aspects* (2003), he graphically depicts the Buddhist concept of a material world existing in a state of continuous flux and decay, using the metaphor of a rusting motorbike with a horse's head coursing through a derelict wasteland punctuated by motifs from classical Chinese painting. *Manjushri Crossing the Sea* (2007), a nearly four-meter-high painting, depicts a subject usually associated with the Japanese Shingon sect of esoteric Buddhism, showing the God of Divine Law and Wisdom on a lotus throne astride a roaring lion, an animal symbolic of the power of Buddhism to overcome all obstacles.

Hisashi Tenmyouya (b. 1966) is another artist concerned with updating and transforming aspects of traditional Japanese art in work which he describes as neo-*nihonga*: "I fight with my brush, giving irony to the various schools of traditional Japanese art, the Kano School, Maruyama School, and Tosa School, raising the banner for a school of art I call the *Buto-ha* (fighting school)." [50] He did not train at art school but worked initially as design director for a record label, teaching himself the different styles of Japanese art and melding them with different aspects of popular culture and science fiction. [51] He has become increasingly concerned about the narrow contemporary view of traditional art, suspecting that the western predilection for the *wabi-sabi* aesthetic, which privileges the imperfect, impermanent and incomplete, has started to distort and enervate Japan's view of its own culture. [52] Against this, he elevates the popular, decorative tradition of the *furyū* (the elegant and extravagant) and *basura* (a dandyish, heroic, adversarial attitude) in works that evoke the woodblock prints of Tōshūsai Sharaku (active briefly, from 1794–95), traditional body tattoos, and portable shrines for festivals. For him, the cross-fertilization between the contemporary and the traditional decorative arts are analogous to the way that European baroque art, with religious, cultural, linguistic, and even culinary influences, from Portugal and Spain had made a profound impact on 17th-century Japanese taste and design. [53]

Neo-Thousand Armed Kannon (2002–03), in traditional triptych format, is a meditation on the aftermath of the events of September 11, 2001. It presents the paradox of Kannon, the Buddhist goddess of mercy, whose many arms are supposed to embrace the world to alleviate suffering. She appears holding rifles, machine guns, knives, and other weapons, and is flanked by two terrifying guardians wielding Kalashnikovs. **(fig. 16)**

Kamikaze (2003), one of a series of paintings under the title of "Kabuku," depicts a Mitsubishi Zero fighter aircraft from World War II with absurd toy-like weaponry grafted onto its body. The plane is shown like a Transformer that can morph into a truck or a motorcycle, [54] but the painting's gold-leaf background and national flag contribute an element of pomposity to this child-like image. This combination of a suicide-plane with the flattened spaces of traditional art and the tawdriness of cheap toys creates a critical tension, attraction, and absurdity that underlines the idea that war should remain the fantasy of children rather than the reality of adults. The idea of *Kabuku*, the word at the root of *kabuki* theater, signifies "a tendency to don garish and outlandish costume." [55] In this work, the artist makes a conscious parallel between the nationalistic self-destructive force of the *kamikaze* pilots of World War II with the contemporary "kamikaze" motorbike gangs who have adopted a similar ethos.

In *Defeat at a Single Blow*, *Robust and Magnificent Feature*, and *Gallant and Brave Behavior* (all 2008), the *basura* and *kabuku* are combined in a work that eschews the religious image one would expect from its triptych format in favor of an almost feral expression of fighting spirit. On the gold-leaf side panels, naked tattooed warriors sit astride heavily armored fantastic beasts while, on the dark center panel, an armor-horned elephant is dominated by the dramatic arabesque of a sword-wielding samurai. Here Tenmyouya seems to be implying, both seriously and ironically, that the making of

15 | Yamaguchi Akira | **Postmodern Silly Battle: Headquarters of the Silly Forces** | 2001 | oil and watercolor on canvas | 185 x 76 cm | courtesy Mizuma Art Gallery | Takahashi Collection, Tokyo

16 | Hisashi Tenmyouya | **Neo Thousand-Armed Kannon** | 2002–03 | triptych | acrylic on wood | 227.3 x 162 cm (center panel) | courtesy Mizuma Art Gallery | Takahashi Collection, Tokyo

17 | Hisashi Tenmyouya | **Defeat at a Single Blow** (left) | **Robust and Magnificent Feature** (center) | **Gallant and Brave Behavior** (right) | all 2008 | triptych, acrylic and gold leaf on wood | 178 x 60 | 178 x 86.2 | 178 x 60 cm | collection of Katsumi Nozawa

18

art that is both true and relevant is like a battle, and its values should be protected at all costs. (fig. 17) The idea of the artist's role of cultural custody and advocacy is reinforced by the two large paintings of mythical beasts, *Kylin* and *Nine-Tailed Fox* (2004), that stand like the guardians of an absent temple.

It is a measure of the calculated archaism of painters such as Tenmyouya, Yamaguchi, and Aida that they have the detachment of dandies—not unlike traditional Chinese literati—in which their estrangement from the world enables them to comment more clearly on it. Yanagi and Yoneda, however, use photography to adopt a critical stance on what they see around them. Yanagi's theatrical tableaux analyze behavior and desire through the expression of fantasy, while Yoneda's documentary approach alludes to the vagaries of history through traces and details that are almost unseen.

V. Threatened Nature

19

Although Motohiko Odani (b. 1972) and Manabu Ikeda (b. 1973) have sometimes incorporated traditional elements into their work, they are more concerned with interactions between systems and issues of natural balance. Odani's series "Malformed Noh Masks" (2008), perhaps makes him look more traditional than he actually is: over a short career he has used a wide range of media to make art that combines ideas of myth, nature, and deformation in startling and sometimes unsettling ways. The masks are related to other works of the same year that examined aspects of the human face, starting out from the idea that by unbalancing a traditionally symmetrical form such as a mask, one can create a sense of *yūgen*—an eerie, otherworldly aesthetic associated with *noh* drama. The result is not only the deformation of a classical form of beauty, but also a clear reference to the effects of imbalance on life in general.

A gothic, free-associative quality runs throughout his work, as in an early conflation of a woman and a wolf in *Human Lesson (Dress 01)* (1996) or the cyborg-like, pseudo-musical extensions of *Finger Spanner* (1998) and in the not-so-*kawaii* callipers in *ERECTRO (Bambi)* (2003), that keep the little deer standing. (fig. 18) *SP2 "New Born" (Viper A)* (2007), made in cast resin, "imagines the skeletal head and body of a viper in motion that is reproduced in a vortex many times over as it curls in on itself to become like the petals of a flower, or a firework." [56] Even deformity has a peculiar beauty of its own. *SP4 The Specter – What Wanders Around in Every Mind* (2009), is ostensibly a meditation on the fate of traditional Japanese wooden sculpture in which a skeletal samurai returns "like a zombie from death" on a flayed horse sculpted in a western manner. [57] (fig. 19) Odani maintains that the work of Rodin has had a huge influence in Japan, and this is why he was thinking of it when he modeled the horse. More generally this haunting image, which may refer also to the Four Horsemen of the Apocalypse, expresses the dread we all share when faced by the terrifying immensity of the unknown. [58]

Manabu Ikeda works in only one medium, ink and acrylic paint applied by pen on paper, in large, intricately detailed works that have the quality of life-cycles or grand narratives. He was brought up in the southwestern countryside of Saga prefecture where there were "only mountains and rivers, no museums or galleries and no chance to see art or exhibitions. So I spent a lot of time fishing, catching insects—I was not even much interested in *manga*." [59] When he eventually arrived in Tokyo, he was impressed not so much by the contemporary art he found there, as by the work of 18th- and early-19th- century "old masters" such as Maruyama Ōkio (1733 95), who introduced western naturalism to Japan, the eccentric painter, Itō Jakuchu (1716–1800), and Katsushika Hokusai (1760–1849).

Like most of his large works, *Existence* (2004), his first, took over a year to complete. It was triggered by his experiences during a four-month trip through southeast Asia, and the central motif of the tree of life was partly

18 | Morohiko Odani | **ERECTRO (Bambi)** | 2003 | stuffed fawn, cast aluminium, and other media | 61 x 60 x 29 cm | courtesy of Yamamoto Gendai | private collection

19 | Motohiko Odani | **SP4 The Specter – What Wanders Around in Every Mind** | 2009 | fiber-reinforced plastic, cloth, horsehair, and other media | 230 x 235 x 105 cm | courtesy of Yamamoto Gendai

20 | Manabu Ikeda | **Existence** | 2004 | detail | pen and acrylic ink on paper mounted on board | 145 x 205 cm | Collection of Joan and Michael Salke | courtesy of Mizuma Art Gallery, Tokyo

21 | Manabu Ikeda | **Ark** | 2005 | detail | pen and acrylic ink on paper mounted on board | 89.5 x 130.5 cm | collection of Mori Art Museum, Tokyo

22 | Kohei Nawa | **PixCell Elk #2** | 2009 | mixed media | 240 x 249.5 x 198 cm | work created with the support of Fondation d'Entreprise Hermès

[56] Odani, interview with the author, Tokyo, December 8, 2009. [57] Ibid. [58] "Motohiko Odani: "SP4 'the specter' in modern sculpture," Yamamoto Gendai, Tokyo, 2009. [59] Ikeda, interview with the author, Tokyo, December 12, 2009.

20

21

22

23

24

25

suggested by the vast, rampant fig trees that straddle (and often demolish) the walls of the Khmer temples in Angkor Wat; the idea of layering or terracing different levels around the roots of the tree also derived from the same journey. [60] (fig. 20) As in the other works by Ikeda shown here, we see the details of teeming, mutually interdependent life with different worlds socially and metaphysically linked. In *Ark* (2005), the central motif is a huge, rotting urban hulk isolated in the midst of an ocean. Here the struggle is not only between humans and the forces of nature but also between civilization and entropy. With its buildings stacked high upon one another, the vast blackened city, in which there appears to be no human presence, park, or public space, is in a state of perpetual decay, with pollution spewing out both into the city and the surrounding sea. An ark is traditionally a means of survival or refuge, but this work offers cold comfort about the kind of world in which it will eventually land. (fig. 21)

In *History of Rise and Fall* (2006), success and failure, nature, history, and human presence co-exist within the symbolic confines of an ancient castle rising high in the air. The almost organic building is supported by branches and roots that simultaneously reflect the four seasons, while streaks in the sky top left represent missiles bearing down on Japan from North Korea, inspired by an incident that took place whilst Ikeda was working on the painting. In this song of existence without beginning or end, countless details compose the mass: small African huts morph by reflection into Islamic mosques, corpses hang from trees, dragon-shaped roof tiles fall like dominos to reveal the figure of a demon. Near the center of the work the empty hands of Buddha wave in the air where a funeral is taking place. The range of experience seen here is almost overwhelming and this, for Ikeda, is the point: "I want to show hope and despair, a sense of precariousness to life." [61]

Foretoken (2008), Ikeda's most recent work, recreates the curling crest of *The Great Wave*, of one of Katsushika Hokusai's most famous woodblocks. [62] But here the wave does not represent the ocean but a cataclysmic avalanche of melting snow caused by global warming. As civilization is swept away, a new landscape is revealed, hidden beneath the permafrost. The discovery of this lost city offers a ray of hope but this is quickly dashed as toxic gases, trapped beneath the icepack, enter into the atmosphere. In this chaotic landscape of destruction, creation, and flux, humanity struggles to reconstruct the environment it has destroyed, but the clock cannot be turned back and the situation seems irreversible.

Almost devoid of literal representation, the work of Tomoko Shioyasu (b. 1981) is based on the traditional art of paper cutting, which she transforms into minimal sculptural forms. (fig. 23-25) The delicate, white membranes she produces are more concerned with reference than illusion, with space rather than image, and they modulate flows of energy across surfaces, space and light. Shiyoyasu's earliest works, from 2003, are clearly based on the structures of plants. She first thought of making art by studying the form of different kinds of leaves and cutting out the spaces between their veins. "I started to make similar 'cuts' using tracing paper because I wanted to express the image of water flowing through these veins, and how this expressed the invisible flow of the energy of nature, such as the growth of cells." [63] Working to a width of just over a meter, she created tracery maps of vein-like nets, then, more assertive, swirling plant- and tree-like forms that were mounted between sheets of plexiglass to float freely in space.

In the large installations *Veining* (2004) and *Acorn* (2005), she began to work site-specifically, making decisive interventions into the physical spaces of the gallery where they were shown, creating the possibility of the work being viewed from both sides. *Veining* was installed in front of a long strip window so that it could be seen both from the street, as well as from inside. At certain times of day, it appeared like an ornate decorative screen, but in other lights it seemed almost transparent. As the direction of the sun

23 | Tomoko Shioyasu | **Breathing Wall, Blessing Wall** | 2006 | cut paper | 283 x 450 cm | courtesy SCAI the Bathhouse, Tokyo

24 | Tomoko Shioyasu | **Cosmic Perspective** | 2015 | synthetic paper | 500.5 x 789.5 x 17.6 cm | photo by Nobutada Omote

25 Tomato Shioyasu | **BIRTH** | 2013 | paper, lighting system | 600 x 356 cm | photo by Shizune Shiigi | Collection of Museum of Contemporary Art Tokyo

26 | Rinko Kawauchi | three untitled works from the series **AILA** | 2004 | c-type print | dimensions variable | courtesy of the artist and Foil Gallery, Tokyo

[60] During this trip Ikeda visited parts of China, Vietnam, Cambodia, Thailand, and Malaysia. [61] Ikeda, interview, op. cit. [62] Hokusai, *The Great Wave off Kanagawa*, c. 1826–33, wood block print, 10 x 15 in (25.4 x 37.1 cm). From the series, "Thirty-six Views of Mount Fuji." [63] David Elliott, interview with Tomoko Shioyasu, in *Tokyo Visualist*, ed. Satoru Yamashita, Tokyo, DD Wave, 2009, p. 25. [64] Ibid. [65] *Vortex* (2011), cut paper, 271 x 400 cm. [66] Rinko Kawauchi, *Aila*, Tokyo, Little More, 2004. [67] Rinko Kawauchi, *The Eyes, The Ears*, Tokyo, Foil, 2005.

changed, so did the shadows cast on the work through the window, and this, in turn, changed the projection of its internal structure into the space of the room.

In *Breathing Wall, Blessing Wall* (2006), the intricate shadows cast both on the floor and walls of the gallery are animated by the constantly changing pressure of air in the room, in which the work serves as a membrane to create a sense of flux, even of breathing. Here Shioyasu has contrived not so much a structure, an installation or an environment, but a fugitive, numinous sense of space in which constantly changing motifs move in and out of focus according to the intensity of the light and air that passes through them. **(fig. 23)** In *Root of Heaven* (2006), Shioyasu returned to a more two dimensional, wall-mounted format in which abstract flame-like cuts suggested the infinite spaces of heaven (or hell) that have often been depicted in traditional Buddhist art. *Waterfall* (2007) is a three dimensional, scroll-like structure, giving an impression of the immense power of fast-flowing water moving across four, over-six-meter-high sheets. Whether concentrating on cells, veins, trees, rocks, or cosmic flows of energy, Shioyasu has continued to develop a vocabulary of organic structure that refers back to primordial forms of nature. These move from openness to density, from spring-like tension to release, from animal to plant life, from non-existence to matter. Both the body and reflection of a work such as *Cutting Insights* (2008), give the impression of an ancient tree that has been transformed into the form of a dragon, or a sense that we are gazing at the molecular birth of a solar system billions of light years away through some as yet unbuilt telescope.

More recently Shioyasu has been working with synthetic plasticized paper on which she can use a soldering iron as well as a scalpel. Its stronger structure allows a greater pliability that has enabled her to experiment by making more expressive, even sculptured, cuts that tracing paper could never support. **(fig. 24)** Asked about content in her work, Shioyasu replied: "simply nature itself, particularly that which has existed over an extended period of time—rocks, trees, water channels, cells. I want to look into the essence and roots of life, making works that focus on these basic forms." [64] A new site-specific work will be made specially for "Bye Bye Kitty!!!" [65]

Tokyo-based Rinko Kawauchi's (b. 1972) poetic and allusive photographs also celebrate primordial experience. They are best known through the books she has produced since 2001, when she burst onto the scene with three publications: *Hanako* (the name of a disabled girl), *Utatane* (Siesta), and *Hanabi* (Fireworks). Subsequent books include *AILA* (2004), the title of which is derived from the Turkish word for "family" (*aile*), *The Eyes, The Ears* (2005), *Cui Cui* (2005), a thirteen-year reflection on the life of her family, and *Semear* (2008), a work that touches on the fate and context of 1.5 million people of Japanese ancestry who now live in Brazil; it includes a portrait of 99-year-old Mrs Nakagawa who in 1908 had emigrated on the *Kasato Maru*, the first ship to leave Japan for Brazil. Photography for Kawauchi is a way of interjecting herself into the stream of life: "From the black ocean comes the appearance of light and waves. It helps you imagine birth. I want imagination in the photographs I take. It's like a prologue. You wonder, 'What's going on?' You feel something is going to happen." [66]

The works are never captioned, but they present a flow of consciousness and imagery modulated through a fragile but self-aware sense of beauty. In *The Eyes, The Ears* she sequences highly textural, at times ambiguous, images that do not illustrate any "theme" of perception but may be read in terms of the book's title. A flash-lit photograph of a playground of empty children's swings in motion at night not only evokes an impression of human absence but also of the eerie, squeaky sound such swings may make as they are buffeted by the wind. A spread from the book shows the delicate silhouette of a moth resting on a window screen with a view onto a garden; here, a different kind of sound is implied, the scutter and beating of wings should the creature burst into motion. On the right hand page, an equally dark but

more finely patterned moth rests on the work-clothes of a man standing in a greenhouse. More humorously, later in the book, she juxtaposes an image of joints of meat laid on a butcher's slab with a close-up of a "conga line" of half naked men and women. Throughout this book, Kawauchi sets images such as these against allusive, at times, sardonic texts: "I escaped from / a box with no lid / I've been suffering so long / didn't even notice / I was born. / Yeah, I'm always callous at the end. / And I'm a genius when it comes to irony. / It becomes longer / and smaller / freely/ endlessly / it's up to me."[67]

The pastel colors in *AILA* provide a backdrop for a meditation on the origins and interconnectedness of life with the related cycles of seasons and nature. An egg has cracked and a young chick is about to be born, a curious deer stands alone, vulnerable in the forest, the shape of a bush, shot from below, mutates into a vast, threatening cloud in the sky far above it, a close-up of a horse's eye gazes back, contrasting textures of skin and hair with the dreamy, strangely fish-like, surface of its cornea. As in all of Kawauchi's celebrations of the vulnerability, sanctity, and tenderness of life, the specter of death, however beautiful, is never far away: the plucked, twisted necks and heads of chickens on a butcher's block are frozen in focus and time in a chilling reminder of our own mortality. **(fig. 26)**

Kohei Nawa's (b. 1975) work, like that of Kawauchi and Shioyasu, has developed out of an awareness of the spiritual intensity or power of natural forms or structures, but his approach has been very different from theirs. Nawa studied in Kyoto, where he still works, and was influenced by the "beautiful quiet spaces of Buddhist and Shinto temples,"[68] as well as by his professor, Hitoshi Nomura (b. 1945), whose work incorporates images of the universe and refers to DNA and the origins of life.[69] Other sources of inspiration for Nawa have been the nature-inspired dance of Min Tanaka (b. 1945), a performance and butoh artist whose festivals he regularly attends, and environment-themed installations by such artists as Kenji Yanobe (b. 1965), who turns survival after nuclear holocaust into a darkly humorous nightmare.[70] After seeing a large exhibition of work by British sculptor Antony Gormley (b. 1950) that examined the structure of the human body from both inside and out, Nawa decided in 1998 to take up the offer of an exchange program at the Royal College of Art in London.[71] It was at this time he started to think about structure "not only about the organic beauty of nature but about the genetic program that allows a tree to grow and develop in sunlight"[72] and related this to different factors, from the molecular to the universal. Since all matter is composed of different units of information and representation, from the atom and the molecule, to the genome, bit, and pixel, Nawa began to concentrate on the relationship between the building blocks of matter or life and their representation by digital technologies. Sculpture was "an analogue approach to the realization of a digital idea."[73]

Nawa's subsequent work has developed out of this idea in a logical hand-made way. He uses the invented term "PixCell," which pairs a biological cell with the smallest unit of a picture in digital imaging to describe series of works that reflect the same hybrid ideas at different levels, and contain, reflect, or replicate various aspects of the natural and human world. He obtains the preserved animal bodies and other materials he needs for these works via the internet. Part of the series "PixCell (Prism)," works such as *Coyote* (2004), consist of boxes constructed out of refractive sheets of plexiglas so that it appears that an animal is trapped inside, floating in space and visible from many different angles. PixCell bead works such as *PixCell-Bambi #2* (2005), and *PixCell-Elk #2* (2009) **(fig. 22)** are constructed by a process of addition. Each animal—he obtains the stuffed animals and other materials he needs online—is covered by a skin of plastic or glass balls "that is sufficient to erase any strong sense of the objects beneath and even the symbolical meanings usually associated with them."[74] As the agglomeration of beads continues, the object becomes encased in an irregular, artificial, globular skin that contradicts expectations of sight and touch by intensifying through reflection, not only the spirit and matter of what is contained inside, but also

27 | Kohei Nawa | **Villus** | 2009 | found objects encased in white polyurethane foam | dimensions variable | courtesy SCAI the Bathhouse, Tokyo | Fondation d'Entreprise Hermès | photo by Omote Nobutada

28 | Haruka Kōjin | **Reflectwo** | 2006 | artificial flowers, acrylic | dimensions variable | Collection Museum of Contemporary Art | Tokyo | photo by Jacqueline Trichard

[68] Nawa, interview with the author, Tokyo, December 8, 2009. [69] See Nomura Hitoshi, *Genesis of Life: The Universe, The Sun, DNA* (exh. cat.), Mito, Art Tower Mito, 2000. [70] See p. 141, fig. 23. [71] Nawa, interview, op. cit. [72] Ibid. [73] Ibid. [74] Nawa, artist's typewritten text supplied by SCAI the Bathhouse, Tokyo, 2009. [75] Kōjin, interview with the author, Tokyo, December 7, 2009. [76] The exhibition "Real/Life: New British Art" was traveling to museums throughout Japan during 1998–99. The work she saw by Gallaccio was *Red Door*, 1998. [77] Kōjin, text accompanying *Reflecttwo* (2008).

27

28

the work's environment. The effect is shimmering yet disorientating: the differently sized "beads" act like lenses, amplifying both the exterior room and what is caught inside. A less confined, but equally organic, approach runs through drawings such as *Gush #15* (2006), which suggests the self-replicating structure of a crystal, and glue works such as *Catalyst #11* (2008), which spread out across a wall like tentacles. These contrast with the unruly, looser, three-dimensional forms of large free-standing objects, such as *Scum Spectrum* (2000), that are poured out of foam polyurethane. As their outer skin expands and hardens, it evokes the bubble structure of the "beads."

At an exhibition in the Hermès Gallery, Tokyo, in 2009, Nawa showed 25 works from "Villus," which developed out of the "Scum" series. **(fig. 27)** Exhibited side by side in a line and encased in a thin opaque layer of white polyurethane foam, religious and cultural kitsch, toys and trash were all given the same aesthetic weight. The title of the work refers to villi, minute finger-like projections in the small intestine that aid digestion, the appearance of which reminded the artist of the surface of this work. In this chain of association between biology and culture, in which value is indicated by size, the largest image is that of the Japanese deity Kannon, while the smallest is a toy hand grenade. Through constant movement between the macro and the micro, the analogue and the digital, the spiritual and material, Nawa reflects on causes and effects in the moral universe, situating his works somewhere between celebration and elegy, leaving the viewer unsure whether these are illuminating a process of transformation or the end of nature and life.

Haruka Kōjin, born in Hiroshima in 1983 and the youngest artist in the exhibition, identifies her earliest realization of wanting to do something different—although at the age of 12 she did not know that this meant being an artist—with her memories of flashing a torch out of the window of her mountainside house and seeing other lights flashing in the city beyond. [75] Her delight in simple activities and natural processes was later re-enforced by a traveling exhibition of young British artists where a glass covered panel of violently red, wilting gerbera by Anya Gallaccio (b. 1963) made a lasting impression. [76] Kōjin decided to study at the Tokyo University of the Arts, under Tadashi Kawamata (b. 1953), who since the 1970s has been a celebrated pioneer of social sculpture.

Some of her early experiments, like *Ma Ma* (2004), humorously and whimsically reflect on childhood experience. The title of the work refers to a popular brand of spaghetti that her mother sent from home, out of which she constructed a series of suspended ladders and floors, described as "nests" for either ants or mice, connected to each other by staircases that Kōjin claimed were rather like the flashing windows she remembered from her childhood. Less lighthearted was *Toi Toi Toi* (2003), a chandelier made out of broken glass collected from car crashes that was exhibited with photos of crash scenes that became reflected within it. Her work took on a more architectural character in such installations as *R.G.BB.G.R* (2008), a three-by-five-meter mirror image in which a delicate tracery of different, brightly colored, interlinked elements cut out of paper floats in space. In *Reflecttwo* (2006–10), she uses brightly colored, plasticized fabric flowers to create a similar sense of disorientation by the use of mirror effects. **(fig. 28)** The installation is based on an experience she had when walking by a river late at night. The reflection of trees and bushes on the still surface of the water transmuting into an image the disconcerting and disorientating image of a tower floating in the air. "The appearance of this floating organism gave me a strange sensation of gravity, as though I was lost in space, without any landmark. The fear of the unknown made me feel sick. It was a living thing totally paralyzed in the air ... Its form seemed to be alive in its perfection but its outline at that moment, even in an incomplete state, was strong enough to give me the false impression that it would continue to be like that forever. It had a beauty which looked as though I could touch it. Then suddenly I realized that everything was a dream." [77]

VI. The Unquiet Dream

The anxiety of living in a precarious age is confined neither to Japan, nor to any one generation but, as we have seen, anxieties about the force and control of nature are matched within the Japanese imagination by feelings of frustration, impotence, and sense of foreboding. In a densely urbanized, highly stratified society, situated in the heart of an earthquake zone, the fear that the worst could easily happen lies at the back of many minds.

Kumi Machida (b. 1970) studied *nihonga* in Tokyo but unlike Aida, Tenmyouya, or Yamaguchi, she only works with traditional Japanese pigments, laid carefully down on handmade paper. Her allusive subjects, however, are nontraditional, strongly personal, dreamlike, and, at times strangely threatening. She describes them as relating to her longstanding fascination with "communication or relationships with others," yet this is obviously not the whole story. [78] "When I was born," she said, "my parents wanted a boy . . . I always felt I was denying myself and my gender. These paintings are my home and my voice." [79] Through a process of trial and error, Machida settled on a working method typified by spare, dark, elegant lines that are sometimes chillingly highlighted, or muted, by dramatic dabs of color—because, she explained, this seemed "the easiest method to express my emotions." [80] Machida's smooth brushstrokes and unsettling imagination summon forth creatures from a hermetic, twisted universe where biomorphic, androgynous figures appear to be fixed in different states of alienation, communion, arousal, or pain. Many of these creatures look like babies, caught in close-up from unusual angles, made strange by a focus on the back of a neck, or some other dissociated part of the body. Others appear to be dressed in armor or strange carapaces, or subjected to bizarre, antiquated instruments of torture. In *La Degrange* (2003), a wall-eyed, demonic baby-like head with a stapled mouth appears to be extruding from the tightly confining bonnet which is padlocked around it, yet this shocking sight of exploding blood or flesh could just as easily be understood as the delicate petals falling from a red flower. **(fig. 29)**

Equally bizarre, or sadistic, is the two-panel painting *Late Night Zone* (2004), a close-up of two hands clasped on the crown of a smooth bald head, the fingers of which are capped by augmented, razor-sharp nails. *Relation* (2006) shows the head and shoulders of a small person from behind, holding the manicured hand of a larger person, an adult. Yet the head of the "child" is in the form of a smooth surfaced globe with five small vertical vents at the nape of its neck and what appear to be the dismembered fingers of the adult's hand breaking through its surface. Machida explained that these indicated that the child was mentally rejecting the relationship. [81] **(fig. 30)** In *Letter* (2009) and *Rocking Horse* (2009–10), a conventional view of a mother carrying a baby on her shoulders becomes transformed into a celebration of the strange symbiosis of two white bonneted figures in which the "mother" looks up at the child and is "deluged" by tiny threads of "beads" from its eyes that both encompass and confine her. **(fig. 31)**

Protection and imprisonment, alienation and affection are continuing themes in the surreal world that Machida has created where normal relations or expectations of power have little sway. It is as if she muses on what she both knows and remembers, using this as a basis to imagine something new: "There are certain things that always lie vaguely in the field of my consciousness, doubts and a sense of distance between me and society . . . Sometimes they are related to gender and to my relationship with the world . . . they do not seem to be turned toward anyone or anything in particular." It is as if each work were a symbolic record or incident in Machida's life, a way of processing memory, experience, and anxiety, that once completed would vanish: "When I finish a painting, it's like closing the door to a room. I hardly ever reopen a door once it has been closed." [82]

Chiharu Shiota (b. 1972) has lived and worked in Berlin since 1996. **(See also pp. 240–243)** This has provided her with necessary distance from the vivid and

[78] Machida, email to the author, April 8, 2010. [79] CB Liddell, "Surreal Visions Point the Finger at Bad Relations," *International Herald Tribune*, June 16, 2006. [80] Machida, email to the author, April 8, 2010. [81] Liddell, op. cit. [82] Kumi Machida, artist's statement in *No Border – From Nihonga to Nihonga* (exh. cat.), Tokyo, Museum of Contemporary Art, 2006. [83] See, for example, her sets for *Oedipus Rex*, Dresden, Festspielhaus Hellerau, 2009; Berlin, Hebbel Am Ufer Theater, 2010; and for *Tattoo*, New National Theater, Tokyo, 2009. [84] Chiharu Shiota, *Raum* (exh. cat.), Berlin, Haus am Lützowplatz, 2005, p. 33. [85] Ibid., p. 14.

32

poignant memories of her childhood and youth although they still fuel much of her work. In the early 1990s, when she was first studying in Kyoto, she had begun to work with yarn, and during a brief stay in Canberra, in such works as *Becoming Painting* (1994/2007), she started breaking down the barriers between performance, painting and sculpture, as her body became both the subject and object of her work. During the late 1990s she worked under Marina Abramović at the Hochschule für Bildende Künste in Braunschweig, Germany, an experience that reinforced her interest in the importance of duration in performance and the numinous power of the body—even when its presence is only suggested. As a result, many of Shiota's works have the appearance of sites where some momentous event either has just passed or is about to take place; when she designs sets for theatrical performances, the event itself takes center stage. [83]

Throughout her work, the sense of dislocation is overpowering, made more intense by the skeins of dark woolen yarn that tightly confine its spaces, obscuring, confining, centering, rather like a spider's web. The interiors of these webs may contain a dress, a chair, a bed, or furniture, and the yarn creates both a barrier and the illusion of a dream—a semi-transparent membrane between fantasy and reality. In other installations Shiota may use red yarn or plastic tubing with red liquid pulsing through it, making the whole work a body, an umbilical support of veins and nerves linking, feeding and nurturing the found objects within them, which begin to take on a life of their own.

These works suggest a dream-like, unconscious state of anxiety in which actual and imagined barriers surround both the artist and observer. Two early memories are repeated like leitmotifs. The first is of a fire set by an arsonist in a neighbor's house during which Shiota heard the sound of a grand piano being consumed by flames, and then saw its blackened skeleton within the burnt-out hulk of the building. Writing about this experience, she realized that she had been woken by the sound of the burning piano and she has continued to relive this moment in a series of installations titled *The Way into Silence* (2003): "I always carry this silence within me. Deep in my heart. When I try to express it I lack the necessary words. But the silence lasts. The more I think about it, the stronger it gets, the piano loses its voice, the painter does not paint any more, the musician stops making music. They lose their function but not their beauty. They even become more beautiful. My true word has no sound." [84] (see fig. 3, p. 241)

The second memory is of near-death experience: as a young woman, she had cancer and was confined to a hospital bed. Shiota alludes to this experience in many works, such as *During Sleep* (2001–07), an installation-performance in which young women in white nightgowns lie motionless in hospital beds enmeshed by skeins of yarn. (fig. 32) This idea was further developed in the magnificent installation *Flowing Water* (2009), in which water rains down over twenty metal framed hospital beds rising into the cavernous space of the Nizayama Forest Art Museum in Toyama. (fig. 33) The absence of the human body in this and other installations, implying physical transcendence, is made all the more poignant by symbols of its former presence—girls' and women's dresses and nightgowns, worn out shoes, beds, chairs, pianos, even old window frames—suspended within the worlds that Shiota has created, wrenched away from their owners' lives.

A Room of Memory (2009), a large circular tower made for the 21st Century Museum of Contemporary Art in Kanazawa, was constructed out of discarded window frames taken from East Berlin building sites. These dejected objects suggest to Shiota the torn history of the formerly divided city as well as the hopes of the people who once peered out of them. As with all the materials she uses, her engagement with them is compulsive: "I go on searching . . . because the windows are in my eyes like a skin. They are like the boundaries of my self that I cannot cross. I have the impression of being in a forlorn abyss of being neither inside nor outside." [85] (See fig. 4, p. 242)

29 | Kumi Machida | La dégrange | 2003 | sumi (blue), mineral pigments and other pigments on kumohada linen paper | 29.5 x 42 cm | Takahashi Collection, Tokyo

30 | Kumi Machida | Relation | 2006 | sumi (blue), sumi (brown), mineral pigments on kumohada linen paper | 181.5 x 343 cm | BIGI Co Ltd collection

31 Kumi Machida | Letter | 2009 | sumi (blue & brown) pigments, mineral pigments and coloured pencil on kumohada linen paper | private collection

32 | Chiharu Shiota | During Sleep | 2004 | performance with sleepers during the opening | beds, black thread | Kunstmuseum Luzern, Lucerne, Switzerland | photograph by Sunhi Mang

34

Shiota has recently been working a new site-specific installation, *Empty Home* (2011), made from more than one hundred used suitcases, stacked in two converging blocks like a rapidly narrowing corridor. The artist's ties to Berlin make the Holocaust reference of these materials unavoidable, yet the resonance of the work goes far beyond this to remind us of the hopes, ambitions and fears of people who have experienced any form of diaspora or physical upheaval.

Hiraki Sawa (b. 1977) was born in Kanazawa and wanted to be an artist from childhood but a serious illness prevented him from submitting his portfolio to the major Tokyo art schools in time. Because he would have had to wait another year to resubmit, he decided to study in London where he continues to work and live. While finishing an MFA in sculpture at the Slade School of Fine Art, he became fascinated with computer animation and started to make videos that were characterized by incongruities of scale and content. At first he used his apartment as a set, and his earliest work, *dwelling* (2002), creates an initial impression of surprise and wonder as miniature airliners taxi along work tops, eiderdowns and bathroom surfaces and loop around his domestic airspace. [86] But soon the charm of this airborne choreography starts to strike a more anxious note: humor is accompanied by claustrophobia as more planes take off and proliferate, in an air-traffic controller's nightmare. Resolution, and relief, comes when one of the planes, seen in silhouette against a windowpane, flies through the glass to join a "real" airliner in the distant sky. (fig. 35) Sawa once described his working method as follows: "Fundamentally my videos are all ambiguous fabrications. As neither a documentary filmmaker nor a photographer, I tend to be in limbo to start with, and insert lies in each piece as I go along. And when I say 'lies,' I don't mean throwing in dramatic falsehoods, but finding ingenious ways to make things seem as real as possible." [87]

Soon after graduation, Sawa began working in education workshops at London's Hayward Gallery, a revelatory experience: the ways in which children magically transformed objects by adding seemingly illogical elements to them, made him realize how strong the power of dissociative imagination could be for his own work. [88] Many of his early works refer to travel—by plane, boat, foot, or beasts of burden. *Going Places Sitting Down* (2004) alludes directly to it, as well as to the imagination of the armchair traveler or a child, which he sees symbolized by the rocking horse that moves through the video's many scenes. [89] The mood quickly escalates from an initial sense of English country-house fantasy and enters more ghostly, alienated, and surreal territory, with Lewis Carroll-esque inversions of meaning and scale. (fig. 34)

Working outward from this, in increasingly meditative installations, Sawa has established an approach toward image-making that may be best described as a collage of reflections. In this he superimposes one layer of reality onto another; sometimes, as in *eight minutes* (2005) showing many scenes (and screens) within a single channel. [90] By reversing expected relationships and hierarchies between people, animals, and objects, he creates a series of meditative spaces that telescope the miniature with the infinite to overthrow any possibility of objective reality.

Recently, Sawa has started to move away from his usual "cast list" of animated toys, utensils, rocking horses, goats, camels, and elephants to think on a more cosmic scale. In *Hako* (2007), a seascape at sunset, reminiscent of the paintings of JWM Turner, shimmers in counterpoint to an evocative soundtrack that has the disrupted yet cyclic character of a dysfunctional music box. [91] A shot of a nuclear power station, silhouetted against a dark evening sky and rhythmically lit by fireworks, pans to show sand, rocks, a vast full moon, and finally the boundless ocean beyond. In this work there is purposely no narrative; Sawa reveals himself through a considered play of images and impressions, which he invites viewers to interpret in their own way.

33 | Chiharu Shiota | **Flowing Water** | 2009 | thirty hospital beds, telephones, water | dimensions variable | Nizayama Forest Art Museum, Toyama

34 | Hiraki Sawa | stills from **Going Places Sitting Down** | 2004 | 3-channel color video | 8'40" | courtesy of the artist | Ota Fine Arts Tokyo and James Cohan Gallery, New York

35 | Hiraki Sawa | still from **Dwelling** | 2002 | black-and-white video | 9'20" | courtesy of the artist | Ota Fine Arts Tokyo and James Cohan Gallery, New York

36 | Tomoko Kashiki | **Morning Glory** | 2009 | acrylic, carbon, linen, wooden panel | 227.3 x 181.8 cm | courtesy Ota Fine Art, Tokyo | collection Museum of Old and New Art, Hobart

[86] Black-and-white, single channel, stereo, 9'20". [87] Sawa, interview with Toyoko Ito, *Art-It*, 18, Tokyo, Winter/Spring 2008. [88] Sawa, interview with the author, Tokyo, December 8, 2009. [89] Ibid. Video is in color, three-channels, stereo, 8'40." [90] Black-and-white, silent, 8'48". [91] Color, six channel, 12'.

The idea of distance has become vital to his work. He does not work in Japan or make obvious references to Japanese culture because he feels that it is too close and "wants to keep it at arm's length." The same is true of the materials and imagery he employs; just as he had to learn a new language to survive and be educated in England, he now realizes that he has to "learn his materials," in the same way, rather than choosing them instinctively. [92]

In *Silts* (2009), another meditation on the scale of vastness, grains of sand are mirrored by floating particles in a crystalline solution to create an image that looks like a map of the infinite universe. [93] The true subject of this work no longer touches on the relationships among the sizes of the different elements in it but rather refers to the irrelevance and insignificance of scale, whether in our lives, our possessions, our dreams, or our desires. [94]

Tomoko Kashiki's (b. 1982) beautifully crafted paintings are concerned with an intimate life of art, dream, and desire. They are sketched out in pencil, then painted in acrylic on fine cotton cloth mounted on large, chamfered-edged wooden boards. She has invented this fluid form of presentation, in which the edges of the works are softened by shadow, to ensure a subtle separation from the environments in which they are shown. Born and educated in Kyoto, she has made drawings continuously from childhood and only during her time at art school began to take an interest in the work of other artists or the history of art. Images of women have affected her work greatly, particularly the traditional genre of *bijinga* (paintings of beautiful women), and *taisho nihonga*, the super elegant, traditionally painted Japanese Art Deco screens and scrolls made from the mid-1920s until the end of the 1930s. [95]

Kashiki has never questioned why she paints images of women but is aware that over the past four years she has progressed from painting featureless or fragmented figures, as in *Sambucus Sieboldiana* (2007), to depicting faces, hairstyles and other details that make her characters more specific. In two related works from 2008, *Drawing Person* and *Painting Person,* she focuses on the act of making art. In the former, she shows someone who "concentrates so much on creating everything around her that her body literally melts away." [96] The moment Kashiki depicts is when the painter makes the finishing touch on the wall. *Painting Person* echoes this theme, not only in its subject but also in the hunched, Narcissus-like pose of the protagonist; this work, however, shows the beginning of the process, when an artist makes the first marks. *In a Box* (2008), with its disorientating perspectives and decorative details, shows a young woman at rest, in a reverie or dream, lying on her back enjoying the comforting arabesque of the curtains as they billow languidly above her, moving slowly in the breeze.

The more tense subject of *Roof Garden* (2008), in which a young wind-blown girl teeters dangerously on the parapet of a high building, could be regarded as the knife edge on which all good art has to be made; equally, it could have the added connotation of a figure disappearing, "evaporating into the landscape." [97] This need, or desire, for absorption or obliteration into the space of art can also be strongly felt in Kashiki's other works. Even within the comfort zone of art, the dream has been corrupted and threatening notes of alienation and anxiety have increasingly begun to appear: in *Shadow Play* (2009), two willowy-limbed, elegantly dressed young women seem more interested in clawing each other than in participating in an innocent children's game. In *Wind-Bell*, a pair of paintings from 2009, a young woman hangs from a light fitting or bell, swinging in the breeze in an aesthetic mockery of an execution by hanging. In the ironically titled *Morning Glory* (2009), she is hunched in the corner of a bleakly tiled bathroom, staring ahead, alone, legs pulled up, tightly crouched in a urinal. (fig. 36, see also pp. 244–247)

VII. Bye Bye . . .

Yoshitomo Nara (b. 1959), like Takashi Murakami, is an artist who is well known both in Japan and the West for his engagement with popular *manga* culture. Cartoonlike paintings of children, or installations of toys, form the basis of his work, yet they undermine the *kawaii* aesthetic through their subversive, at times malicious, self-awareness. He also takes photographs; in 2008 he published an image of a beautifully maintained gray-granite gravestone. [98] At its foot are two baskets containing models of a small dog and a family of cats, mementos which might be found in a Japanese cemetery, but the tomb is also crowned with two large, symmetrical, "Hello Kitty" polychrome stone "guardians." At last, it seems, even Kitty has passed beyond the veil of cuteness and has had to say, "Bye Bye . . . " (fig. 37)

Tracing different paths between reality and imagination, the artists in "Bye, Bye Kitty!!! Between Heaven and Hell in Contemporary Japanese Art" have discovered beauty, terror, insight, and potential. The route between heaven and hell is one we all, in various ways, traverse. The related ideas of balance, and the risks of upsetting it, are fundamental to the work shown here, as well as to the psyche and aesthetic of contemporary Japanese art. In this exhibition we can see how a relatively small selection of contemporary Japanese artists have been digesting and challenging the social, political, and aesthetic conditions of their times. The art they have created often strikes hard against established hierarchies and stereotypes, but it also expresses realistic, at times even idealistic, hopes for the future. These artists have negotiated the personal, the social, and the political in their lives to illuminate the fragile balance of an allusive, subtle, vulnerable world. Here meanings are not encapsulated by theories or texts but revealed slowly, with both respect for and suspicion of the aesthetic traditions and values they represent. Such emotions are heightened by an awareness of the way the legacies of the past can be faced in the present through the irony of anachronism and the paradox of contradiction. It is as if a desire to mitigate the ethical, social, and natural carnage of rapid change is underscored by a devastating yet creative sense of reality.

Art such as this, that is mindful of, but not bound by, tradition, history, or context, always finds a way to negotiate between beauty and horror, heaven and hell. In such works, we can see both the atom and the universe, amplified by, or condensed within, the infinite possibilities of a single detail. ●

37 | Yoshitomo Nara | **Untitled** | 2008 | c-type print | 26.6 x 20 cm | courtesy Tomio Koyama Gallery, Tokyo

[92] Sawa, interview, op. cit. See also pp. 246–249. [93] Black-and-white, single channel with installation, stereo, 14'50". [94] For "Bye Bye Kitty!!!," Sawa is specially making a new single-channel work. [95] *Taisho nihonga* strictly refers to traditional-style painting made during the rule of the Taishō Emperor (1912–26) but in art has acquired this broader definition. See Kendall H. Brown & Sharon Miniciello, *Taisho Chic: Japanese Modernity, Nostalgia and Deco*, Seattle, University of Washington Press, 2002. [96] Kashiki, interview with the author, Tokyo, December 7, 2009. [97] Ibid. [98] Yoshitomo Nara, *Foil*, vol. 2, 2008, Tokyo, np.

37

Heaven and Earth
Contemporary Art From the Center of Asia

This essay was first published in the catalogue for the exhibition "Between Heaven and Earth: Contemporary Art from the Centre of Asia" that I curated in 2011 for Calvert 22, London, a new space that specialized in contemporary art and culture from the former USSR and Eastern Bloc. Ever since I had seen Moscow-based curator Viktor Misiano's presentation at the first Central Asia Pavilion in the 51st Venice Biennale in 2005, I had been fascinated by the new generation of artists, particularly in new media, that was emerging there. I was particularly impressed by how their work translated the primitivism of the classical Soviet avant-garde, with the traditional forms of popular or folk art, into a vital contemporary language. In 2007, I had met a number of the artists in Istanbul and later in Venice with Yulia Sorokina, an Almaty-based curator who organized "Muzykstan, Media Generation of Contemporary Artists from Central Asia," the Central Asian Pavilion at the 52nd Venice Biennale. She and New York-based curator Leeza Ahmady also kindly helped me with contacts on this project.

There are more things in heaven and earth, Horatio
Than are dreamt of in your philosophy.

– William Shakespeare, Hamlet 1, V, 166–67, 1601

I. The Hole in the Fist

In 1949, Rustam Khalfin was born in Tashkent in the Uzbek Soviet Socialist Republic; his family were Tatars. One year later his parents moved to Alma-Ata, [1] then the capital of the Kazakh SSR. He studied architecture in Moscow, returning home in 1972. Around that time he had a fateful meeting with the painter Vladimir Sterligov (1904–1973), who during the 1920s and '30s in Leningrad had been a close associate of the charismatic avant-garde artist Kazimir Malevich (1878–1935), as well as of the members of OBeRIu ("The Association of Real Art"), a younger but influential collective of absurdist writers, poets,and performers. [2] Sterligov was married to Tatiana Glebova (1900–1985) who had been affiliated with Pavel Filonov's (1883–1941) Masters of Analytical Art, the other main wing of the Leningrad avant-garde. During the 1930s, the work of all these artists was savagely suppressed by First General Secretary of the Communist Party Joseph Stalin (1878–1953) to create a uniform system of politics and culture enforced by the state. Sterligov spent five years in a gulag in what is now central Kazakhstan. Others were murdered in the camps.

In the early 1970s, Khalfin decided to work as an artist. The relation between him and Sterligov, however, was not one of imitation but of example: the artist should take responsibility for his work rather than defer to convention or the dictates of the Communist Party. Khalfin became an innovator and leader who gradually realized that it was important to "get back to the fundamentals of our craft [to] distance ourselves from the avant-garde." [3] The metaphor he employed for his later work was the paradox of the *pulota*, [4] a small void in a clenched fist through which one could, if lucky, see the light. For Khalfin, the Manichean contrast between emptiness and flesh was art and through his encounters with the work of Marcel Duchamp and Joseph Beuys, he began to realize that rather than concentrating purely on the visual or the conceptual, "art had to actualize tactile perception."

In Central Asia in the 1980s and '90s, contemporary art had no platform. One had to be built, and for a whole generation of artists Khalfin led the way. At the end of the decade, digital technology first became available, enabling him to move from vast Duchampian installations based on the human body to video: *The Northern Barbarians* (2000), both celebrates and ironizes the presumed primitivism of Central Asian culture. (fig. 1) Its title replicates the dismissive expression the Chinese used to describe the Mongols, Huns, Kazakhs, Uzbeks, and others who had originated from the other side of the Great Wall and its first part, *Bride and Groom*, was not based on current custom but on an account written by a 17th-century English traveler describing the tantalizing segregation of a couple before their wedding night. *Love Races*, the second part, was based on 18th- or 19th-century erotic Chinese drawings of the imaginary love-making habits of "barbarians" that, like everything

1 | Rustam Khalfin | **Northern Barbarians** | 2000 |
Bride and Groom Part I | single-channel DVD, sound |
10' | Rustam Khalfin (with Yulia Tikhonova) |
Love Races Part II | single-channel DVD, sound | 7' |
courtesy the artist's estate

[1] The city was re-named Almaty after independence in 1992. In 1997, Astana was made the capital of Kazakhstan; in 2019 it was renamed Nur-Sultan in honor of the former president [2] Leading members of OBeRIu included Daniil Kharms (1905–1942), Aleksandr Vvedensky (1904–1941), and Nikolai Oleinikov (1898–1937). [3] Rustam Khalfin from catalogue for "Clay Project. Level Zero" (1999–2000) in Almaty, quoted in Valeria Ibraeva, *Rustam Khalfin. Seeing Through the Artist's Hand* (exh. cat.), London, White Space Gallery, 2007, p. 12. [4] A neologism composed out of the Russian words *pustota* (void) and *kulak* (fist).

3

else they did, had to be done on horseback. Khalfin found his leading lady in Almaty's red-light district and also managed to temporarily extract her boyfriend from the Kazakh army. In spite of its subject, there is no historical role-play in these works, rather a celebration of sensuality, tactility, and eroticism rooted completely in the present. After such a tragic and complicated past this was not a bad starting point.

II. Fate

Panmongolism—fierce the word may seem, yet how I love its sound.

– Vladimir Solovyev, 1894

During the 13th and 14th centuries the greater Mongolian state expanded to become the largest contiguous land empire in history. Originating from a union of Mongol and Turkic tribes in the Central Asian steppe, it stretched at its height from Eastern Europe to the Sea of Japan, covering Siberia and large parts of Russia in the north and penetrating south into China, South East Asia, the Indian Subcontinent, and the Middle East. With speed, fine horsemanship, strict discipline, and brilliant military strategy, they swept everything in their path. Like all nomadic peoples, the Mongols had little by the way of permanent architecture or material culture. They administered their newly acquired lands well but were gradually absorbed by the cultures they had occupied, leaving as traces behind them a legendary reputation for ruthlessness and cruelty, a few borrowed words and, of course, their genes.

When, in January 1918, the Petrograd-based[5] superstar poet Aleksandr Blok (1880–1921) decided to compound his revolutionary face with his Asiatic identity in *The Scythians*,[6] he was prompted by the unequal peace that was being forced on the newly formed Bolshevik government by the German High Command.[7] The Germans were then the enemy, as was the whole of the corrupt, capitalist West. The Scythians were Blok's secret weapon. Yet by invoking this rich and bloody fantasy of the past, he was articulating much more than the spirit of the moment. Little did he suspect how accurately he was predicting Europe's future. The cruel horror to come had nothing to do with the Scythians.

Influenced by the writings of Vladimir Solovyev, whose paean to "Panmongolism" he had quoted at the beginning of his poem, Blok had crystallized a series of dramatic swings between apocalypse and redemption that had been reverberating throughout the whole of the Russian intelligentsia in the years leading up to World War I. These had resuscitated, in bipolar form, the ambiguous landscape between fascination and terror that had been explored by many late 19th-century Slavophile writers and philosophers as they sought to establish a specifically Russian spiritual identity in opposition to the materialistic modernizing impulses of the West.

Addressing both his own people and the West, in a language where the contemporary collided with Asian and classical mythology, Blok declaimed: *"You are millions. We are hoards and hoards and hoards. / Try to take us on! / Yes, we are Scythians! Yes, we are Asians – / With slanted and rapacious eyes! … Oh, Old World! While you still survive, come to a halt … Before the ancient riddle of the Sphinx! / Russia is a Sphinx. Rejoicing, grieving / And drenched in black blood, she gazes, gazes, gazes at you, / With hatred and love."*

Although characterized as violent and primitive, the Scythians, in Blok's imagination, were a halfway house, a last chance. If embraced, they were civilized enough to save their "white brothers" from the more terrible metaphorical pillage of the Mongol and Tatar hoards that, in his mind's eye, were waiting to attack.

Since the late 16th century, the Russian Empire—colonizing in return for once having been colonized itself—had gradually but inexorably spread east to provide a *cordon sanitaire* against those who had once been marauding enemies. Slowly the realization began to dawn that the Russian population was not only

2 | Baasanjav Choijiljavin | **The Taste of Money In-Between Clouds** | 2010 | gouache on cotton | 112 x152 cm | courtesy Hanart TZ Gallery, Hong Kong | these paintings along with those by Uuriintuya are made in the traditional Mongolian *zurag* style that is used for religious *thangka* painting

3 | Uuriintuya | **The People Bring Me a Silence** | 2011 | acrylic on canvas | 160 x70 cm | courtesy Hanart TZ Gallery, Hong Kong

[5] Because of its Germanic associations, the name of St. Petersburg, capital of Tsarist Russia, was changed on outbreak of war in 1914 to Petrograd. In 1924, on Lenin's death, the city was renamed Leningrad. In 1991, at the dawn of the post-Soviet age, it was changed back to St. Petersburg. [6] A. Blok, *The Scythians (Skifi)*, January 30, 1918, a nineteen-stanza poem. [7] The Treaty of Brest-Litovsk was finalized on March 3, 1918, between the Russian Soviet Federated Socialist Republic and the Central Powers.

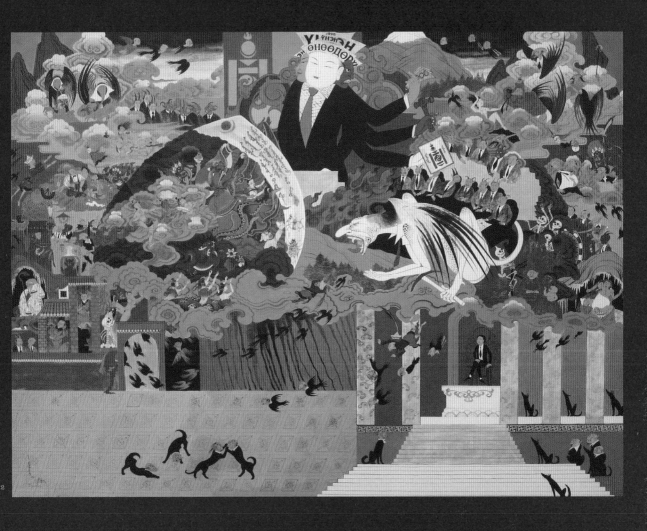

4

5

6

diverse but also hybrid. Conquest, trade and settlement had continued for thousands of years, and Russians had to learn how to embrace what they feared or hated the most. This was part of their political and genetic history—their fate—and could not be separated from daily existence. And as the carpet of history slowly unrolled, it was revealed that the fate of Russia was inextricably interwoven within the destinies of others. No ideal was so perfect it could never be surpassed, nor horror so great that it could not hide another far greater behind it. Central Asia became like a blank sheet of paper upon which any image could be drawn.

III. From the Quaintly Picturesque to the Primitively Modern

. . . A terrible beauty is born.

– WB Yeats, *Easter 1916*

But there was a lighter, more picturesque side to the interplay between East and West. From the end of the 1850s photographers had started traveling east not to capture the dark, bloody side of the Russian soul but to discover and record the strange, exotic customs and costumes of the different people who lived there.

Lieutenant-Captain KI Kostenkov of the Brigade of Guards was one of the first when in 1860 he published *The Kalmuck Steppe and Its Inhabitants,* an album of hand-colored photographs showing the Buddhist temples and customs of a group of nomadic people who had come to rest around the Caspian Sea but whose close relatives could be traced back to what is now western China and Mongolia. [8] The further east these photographers traveled, the more colorful and thickly painted their photographs seemed to become. In 1872, Mikhail Bukhar's *Views and Types of the Orenburg Region* showed, among others, a "Rural District Steward in the Kirgizian Steppe," in his yurt, resplendently enthroned in brightly colored robes (fig. 4) or "A Cossack Woman from the Urals," against a blood-red sky and the silhouette of an Orthodox church, [9] while, at the same time, Tashkent-based photographer GN Nekhoroshev, focused not so much on how such people, with their different customs and religions, looked but on taxonomies of everyday life in such collections as *Jewish Wedding Customs or Funeral Customs in Middle Asia*, that made up part of his extensive *Turkestan Album*. [10]

The representation of the exotic soon became a staging post on the way towards an unconditional embrace of the primitive as Turkestan quickly became visualized as part of Western Russia's imagination of itself. Many Russians helped colonize the "Wild East," and Pavel Kuznetsov (1878–1968) was one of the first modern painters to bring back an image which many others subsequently copied. Initially a member of Sergei Diaghilev's World of Art group, then an exhibitor with the symbolist Blue Rose painters, by 1910 he was making studies of life on the Central Asian steppe. These scenes were both picturesque and melancholic in that they represented a nomadic pastoralism that was under threat in Europe as well as the remnants of a once great empire that had fallen into decay.

At the same time avant-garde Futurist artists including David Burliuk, Natalya Goncharova, Mikhail Larionov, and Kazimir Malevich had, mirroring similar developments in Paris, Dresden, Berlin and Munich, found another route to the regenerating force of the primitive. This was by way of the angular dynamism of Scythian gold and other artifacts discovered in the south, as well as folk art, children's art, and painted shop signs that, around 1912, provided a conduit between the simplification of the perceived world and the creation of a universe that was completely nonobjective. By that time Diaghilev had accelerated the exotic flamboyance of his Ballets Russes, formed in Paris in 1909, to the *succès de scandale* of *The Rite of Spring* that opened in May 1913. Here Stravinsky's dissonant, primordial music was combined with Vaslav Nijinsky's revolutionary, angular choreography in a primitive, pagan fertility ritual that demanded as its climax the death of a virgin. [11] (fig. 5)

[8] Copy in the Russian State Library, Moscow. See David Elliott (ed.), *Photography in Russia 1840–1940,* London/Berlin, Thames & Hudson/Ars Nicolai, 1992, pp. 42, 129, 238. [9] A special hand-colored edition presented to Tsar Aleksandr II is in the collection of the State Historical Museum, Moscow. See above, pp. 43, 132–133, 136, 258. Until 1925 when Kazakhstan became a separate Republic of the Soviet Union, the term "Kirgizian" was also used to denote Kazakh so as to avoid confusion of the latter with Cossack, a completely different ethnic group. [10] In the Saltykov-Shchedrin State Public Library, St. Petersburg. Nekhoroshev's work was not hand-colored. [11] Pavel Kuznetsov (1878–1968), Sergei Diaghilev (1872–1929), David Burliuk (1882–1967), Natalia Goncharova (1881–1962), Mikhail Larionov (1881–1964), Kazimir Malevich (1879–1935), Vaslav Nijinsky (1890–1950), Igor Stravinsky (1882–1971). [12] Ergun Çağatay, Doğan Kuban (eds.), *The Turkic Speaking Peoples: 2000 Years of Art and Culture from Inner Asia to the Balkans,* Munich, Prestel, 2006. [13] It was also the land from which the Scythians originated, although Blok was not aware of this and thought that they had originated from further west. [14] Their salt-dried, mummified bodies and well-preserved clothes and artifacts can be seen in the Xinjiang Regional Museum in Urumqi (see p. 291). [15] This reached its highest expression from the 1st to the 5th century CE during the Kushan period. See Benjamin Rowland, *Art in Afghanistan: Objects from the Kabul Museum,* London, Allen Lane, 1971, pp. 3–10.

Cultivated Russia, like much of Western Europe at that time, needed the fantasy of the primitive to help cleanse itself of the clutter and corrupting materialism of modern life. But for many, what had seemed an innocent dream was shattered by the unprecedented carnage of war, revolution, revenge and terror as events unfolded that were far more horrific in extent than anything Genghis Khan or Tamburlaine could ever have imagined.

IV. Roadside Culture

Christian, Jew, Muslim, Shaman, Zoroastrian, stone, ground, mountain, river, each has a secret way of being with the mystery, unique and not to be judged.

– Rumi

Turkestan was the vast region southeast of the Urals that comprises the present-day nations of Kazakhstan, Kyrgyzstan, Tajikistan, Turkmenistan, and Uzbekistan. By 1860, following a series of gradual encroachments, the Russian Empire had finally annexed all this territory as part of the settlement after its defeat of Persia. The name Turkestan means literally "the land occupied by the Turkic peoples" and it extends east to what is today known as the Xinjiang Uyghur Autonomous Region in western China. Not all inhabitants were Turkic but many of them converted to Islam between the 8th and the mid-13th centuries, but the Mongolian Empire allowed complete freedom of worship and many different beliefs continued to exist side by side.

Blok had appropriated Scythians as a term to describe almost any nomadic "barbarian," although they included a wide range of diverse cultures stretching eastwards from the Balkans and shores of the Black Sea to western China. The Turks in Turkestan were similarly heterogeneous. Originating from northeastern Asia, they had migrated westwards over the centuries in different waves, groups, and tribes. The Seljuks and Osmans [Ottomans] had kept moving to settle in parts of the Caucasus, Middle East, and the Anatolian Plateau, (fig. 8) just as the Huns (Xiongnu), Avars and Mongols had passed through before them on their way to pillage Europe. (fig. 7) But some had put down roots, as much as nomadic people can, either setting down in the big cities and trading posts, or moving with their herds and flocks according to the pasture and seasons. [12] After the Russian Revolution, in 1918, the Turkestan Autonomous Soviet Socialist Republic was created with Tashkent as its capital. After 1924, this was split up into the different Soviet Socialist Republics (SSR) which, with a number of adjustments, we can still recognize as independent nations today.

The many tentacles of the Silk Road passed through and animated this region, the western part of which was known historically as Sogdiana and, by travelers from the West, as Transoxiana, as it was situated either side of the Oxus (Amu Darya) River. [13] Although predominantly rural, and in some parts mountainous, this area was far from uncivilized as it nurtured, and was fertilized by, the traffic of ideas, art, religions, technologies, and trades that moved back and forth across it. As is the case with any highway, the traffic went two ways, and was dependent on cities and trading posts to make things work. The religions, styles, and in some cases institutions, of animism, Buddhism, Christianity, Islam, Judaism, Manichaeism, shamanism, Sufism, Tengriism, and Zoroastrianism moved seamlessly along its channels.

Even four-and-a-half millennia ago, people were migrating east as well as towards the west, and colonies of light-haired, blue-eyed Caucasians settled in what is now the Tarim Basin and Lop Nor Desert in western China. [14] (fig. 6) Greeks had also crossed Persia to settle in Central Asia long before the 4th century BCE, when Alexander the Great's army vanquished the Persians and established the colony of Bactria, whose descendents, the so-called Indo-Greeks, moved to present day southern Afghanistan. This contributed to the unmistakeably Hellenic realism and decoration that characterizes the Gandhara style of Buddhist sculpture. [15] (fig. 9)

4 | Mikhail Bukhar | "Rural District Steward in the Kirghizian Steppe" from the album Views and Types of the Orenburg Region | 1872 | albumen print and watercolor | 19.4 x 16.8 cm | State Historical Museum, Moscow

5 | Vaslav Nijinsky (left) rehearsing the ballet The Rite of Spring | Paris | 1913 | costume design by Nikolai Roerich

6 | Wall painting of "Tocharian Princes" from the Cave of the Sixteen Sword-Bearers (no. 8) | Qizil, Tarim Basin, Xinjiang | 432–538 CE | Museum für Indische Kunst, Berlin

7 | Gold Xiongnu belt buckle with paired felines attacking ibexes | Mongolia or Southern Siberia | 3rd – 2nd century BCE | 6.65 x 7.92 cm | Metropolitan Museum of Art, New York | gift of J. Pierpont Morgan

8 | Detail of stone carving in the Seljuk Yakutiye Medrese | c. 1310 | Erzurum, Turkey

9 | Buddha | Gandhara | 1st – 2nd century CE, grey schist | height c. 100 cm | Tokyo National Museum

10

11

12

Although the importance of the Silk Road declined after the 15th century with the rise of trade by sea, its internal structures and mythologies did not disappear, as borders remained permeable. Only relatively recently, when they were completely shut by Stalin in the 1930s, did Soviet Central Asia become a cul-de-sac, a black hole, a place of secrecy that was "East of Nowhere." [16]

Before that time, from the end of the 19th century to the middle of the 20th, remote Central Asia, the Himalayas, and Afghanistan had become ripe for discovery by intrepid explorers and archaeologists such as the Swede Sven Hedin (1865–1952), the Hungarian Aurel Stein (1862–1943) and the Russian Pyotr Kozlov (1863–1935) who helped discover and excavate previously unknown cultures and archaeological sites.

Discovery and archaeology, however, were not completely innocent and became enmeshed in what Rudyard Kipling popularized in *Kim* (1901) as "The Great Game," called somewhat more romantically by the Russians "The Tournament of Shadows." [17] Under the derring-do veneer of spies, agents, and subterfuge, the British and Russian Empires fought for influence or control throughout the whole of Central and Eastern Asia. The Game continued until the beginning of the 1940s when Britain allied with the Soviet Union against Germany in World War II but, as can be seen from the work in this exhibition, its corpse was brutally revived at the end of the 1970s with the deployment of Soviet troops in the Afghan Civil War and the involvement of the United States in supporting the Taliban opposition. [18] Although the Soviet army withdrew in 1989, the struggle still continues as Afghanistan tries again to govern itself democratically and the US winds down its "War on Terror," now against the Taliban, by withdrawing its own troops from that country. [19]

Mariam and Ashraf Ghani's work *Afghanistan: A Lexicon* (2011) looks back at the history of modernity in that country from a specifically Afghan point of view, researching facts and events but also making it clear that they have added speculation and rumor to the mix. In this way they create an alternative, local narrative while highlighting that the histories already created by the West have also been dependent on different kinds of unacknowledged rumor, speculation, and bias.

From the beginning of the 1990s, in the newly independent republics of Central Asia, the Great Game took a radically different turn, as Kazakhstan and Turkmenistan in particular became major players in global energy markets and, for a time, Uzbekistan and Kyrgyzstan provided military bases for American forces operating in Afghanistan—a point wryly picked up by Said Atabekov in his camouflage-lined, traditionally woven, silk kaftans, trousers, and other artifacts entitled *United States Marines in Central Asia* (2008-18). (**fig. 11**) As Kazakh artists Galim Madanov and Zauresh Terekbay suggest in their ironical series of oil-colored paintings *The Defragmentation of History* (2011), American, Russian, and other commercial interests have recently combined to create a new version of the Great Game as they compete through multinational energy and mining companies. (**fig. 10**) A similar point is differently made in Oksana Shatalova's *Rainbow Dreams* (2007), three close-up photographs of the Asiatic eyes of father, mother, and son, in the same family, all masked by the iridescent glow of oil.

By way of contrast, a wrenchingly melancholic view of life in a post-Soviet industrial wasteland is presented in Aleksei Shindin's three-part film *Ice* (2008). Set in the bleak iron-ore mining district around Rudny in north Kazakhstan, he depicts a brutally evanescent world in which love, human contact, and beauty can only be fleetingly experienced. (**fig. 12**)

In the previous Soviet protectorate of Mongolia, which has the lowest population density in the world, vast mineral wealth has also recently been discovered. Its extraction is having disastrous effects on both the environment and society as the countryside becomes depopulated with dramatic rises in levels of homelessness, pollution, prostitution and HIV in the cities. [20] High

13

14

levels of social tension and revulsion against corruption can be seen in the coruscating paintings of Baasanjav Choijiljavin. In their ferocious exposure of corrupt capitalists and profiteers they are reminiscent of the Weimar drawings of George Grosz, yet they are made in the traditional Buddhist *zurag* style used for *thangkas*. (figs. 2, 14) The same sentiments are reflected in a less violent way in the more introspective feminist works of Uurintuya. (figs. 3, 13)

In the blinkered, protected West, however, the rich cultural and physical landscapes of Central Asia are perceived as little more than a black hole. Dismissed as the "Stans," downgraded to little more than theaters of environmental abuse, religious conflict, and war, they are characterized as devoid of contemporary culture, nuance, or humanity and processed into the clichés of a "Borat" style, post-Soviet wasteland. Although misguided, ultra-conservative and seriously out of date, there are reasons for this view.

V. Desert

If it had not been for the destruction of the Russian avant-garde in the 1930s, Soviet art would be entirely different today, as would [the whole of] contemporary art … In 1913 the headlong development of Russian art rose to new, previously unimagined, frontiers and horizons. "The centre of artistic gravity moved to Russia," wrote Pavel Filonov … Russian artists were tackling formal problems that had appeared in art for the first time … The phenomenon of non-objectivity had come into being, a line which the French Cubists had not the courage to cross.

– Evgenii Kovtun, 1989 [21]

In 1989, at the height of the cultural liberalization of *perestroika*, a surprising and unprecedented book with an introduction by the eminent art historian Evgenii Kovtun appeared in Leningrad. In the liberal spirit of this time, *Avant-Garde: Stopped at Full Tilt* published the work of those Russian artists who since the early 1930s had officially been forbidden to show their work, many of whom had also been imprisoned or murdered. But the book went further by linking this "arrested movement" in art to the current environmental disaster of the desertification of the Aral Sea, caused mainly by the diversion of water for intensive cotton farming. There were two deserts in question here: the actual and the cultural. Both, it was implied, had the same cause.

Not far from the Aral Sea, in the small town of Nukus on the Amu Darya River Delta in the northwest of the Uzbek SSR, archaeologist-turned-art-historian Igor Savitsky (1915–1984) had, since the early 1960s, been systematically building up a collection of art by artists who officially did not exist. [22] In doing this Savitsky was following a "non-conformist" path also trodden by the Kasteev State Museum of the Arts, founded in Alma-Ata in 1935. Although not as adventurous as Nukus, this institution had purchased Filonov's and Sterligov's works, as well as those of a number of other avant-garde artists, concentrating especially on those who had lived or settled in the region.

Savitsky successfully exhumed the lost Uzbek avant-garde of the 1920s and 1930s. Mostly trained in western Russia they, or their parents, had settled in Tashkent, Samarkand, or Bukhara. It was an impressive but completely forgotten list: the social critic, Mikhail Kurzin (1888–1951); the Futurist and art activist, Aleksandr Volkov (1886–1957); the cosmic surrealist, Evgenii Lysenko (1903–1950s); the classic portraitist, Valentina Markova (1907–1941); the folk-art-influenced Aleksandr Nikolayev (1897–1957), who converted to Islam and was also known as Usto Mumin (The Faithful Master) (fig. 15)—and many others. At the same time Savitsky also assembled a large collection of Russian avant-garde artists, using state funds to do this. Like ghosts at a banquet, the presence of this art created a different kind of "Tournament of Shadows"—one that mutely denounced the aridity of official Soviet culture. The reason Savitsky got away with it was because he was working

10 | Galim Maidanov & Zauresh Terekbay | "Edwards M The Great Game and the New Great Gamers," from **The Defragmentation of History** | 2011 | 40 acrylic paintings on canvas | 40 x 30 cm each | courtesy the artists

11 | Said Atabekov | from the series **United States Marines in Central Asia** | 2017 | silk and cotton, leather saddle | courtesy the artist

12 | Aleksei Shindin | stills from **Ice** | 2008 | single-channel video, sound | 16'46" | **Part I: No Love (Romance)** | music by Kino [1990s Russian punk band] | **Part II: Matrix (Work)** | music by Prodigy | **Part III: Smoke (Nature)** | music by Dépêche Mode | courtesy the artist

13 | Uuriintuya | **In my breast** | 2011 | acrylic on canvas | 100 x 80 cm | courtesy Hanart TZ Gallery, Hong Kong

14 | Baasanjav Choijiljavin | **Entreaty** (detail) | 2010 | ink on paper | 92 x 122 cm | private collection | courtesy Hanart TZ Gallery, Hong Kong

[16] The title of an exhibition catalogue and book: Valeria Ibraeva, Enrico Mascelloni and others, *A Est de Niente. East of Nowhere. Contemporary Art from Post-Soviet Asia,* Turin, Edizione 107, 2009. [17] *Turniry Tenei.* See also Karl E. Meyer and Shareen Blair Brysac, *Tournament of Shadows: The Great Game and the Race for Empire in Central Asia,* New York, Basic Books, 2006 (revised edition). [18] Without a trace of irony, Sylvester Stallone's film *Rambo III* (1988, dir. Peter MacDonald) commemorates this nadir of US foreign policy. [19] Ed.'s note: The US military is again pursuing a more aggressive strategy in Afghanistan, following a wave of Taliban attacks on Kabul in 2017–18. More than 14,000 US military troops were reportedly stationed in the country at the end of 2018. [20] The obviously sensationalist tone of this Agence France-Press syndication nevertheless gives the flavour of some recent changes in Mongolia. See, "Mongolia: Prostitution Boom Sees Girls Sell Sex for a Litre of Diesel," *South China Morning Post,* 12 July 2011, A9. [21] MN Grigoreva (ed), *Avangard, octanovlennyi na begu,* Leningrad, Aurora, 1989, Kovtun introduction, np. [22] Nukus is situated in what was the ancient Persian Kingdom of Khorezm. The Karakalpakstan State Museum of Art there, where this collection is kept, is now named after Savitsky.

113

[23] Official acknowledgement of Stalinist repression has been increasingly intense and a number of contemporary art exhibitions have been organized on this topic. Most recent was "Archipelago Karlag," curated by artist Almagul Menlibayeva, at the National Museum of the Republic of Kazakhstan in Astana during June/July 2016. [24] Mosfilm was the largest and oldest Russian film corporation, based in Moscow. Lenfilm was based in Leningrad. also the catalogue Bread and Roses: Four Generations of Kazakh Women Artists, Berlin Momentum/Nur-Sultan, National Museum of the Republic of Kazakhstan, 2018.

in a closed, secure region in a town that was a center for the production of chemical weapons—also, he was a very long way from the political center.

The spreading desert around the Aral Sea provides the setting for Almagul Menlibayeva's disturbing and disorientating video *Transoxiana Dreams* (2011), in which mythical female creatures—centaurs, foxes, and peris—adorned by fragments of Soviet army uniforms, appear like chimeras against the stark ruins of long abandoned rusty hulks that loom threateningly out of the desiccated wasteland. (fig. 18) This newly formed desert has become both a reality and metaphor for the whole region.

As defoliants used in the failing cotton-growing industry poisoned the shrinking waters of the Aral Sea, Semipalatinsk in the east of the Kazakh SSR suffered from a different kind of pollution. It became a vast no-go area because it was the main Soviet nuclear test site. To the west, the Baikonur Cosmodrome and ICBM site was the headquarters of the Soviet space-race. Over the border in Uzbekistan, on the now-disappeared island of Vozrozhdeniye in the Aral Sea, the Soviet bio-weapon industry tested new products. In Eastern Kyrgyz SSR, Lake Issyk Kul, now a nature reserve, was the Soviet navy development center for nuclear submarines.

At more than twice the size of Alaska, Kazakhstan, independent since December 1991, is by far the largest of the Central Asian Republics, yet it is the least populated. During the years of the Stalin Terror (1936–38) many gulags were built there, which, ironically, as we have already seen in the case of Sterligov and Khalfin, helped kick start contemporary art in the region many years later. Karlag, in Karaganda, in particular, housed a number of artists from the Leningrad avant-garde. Its ruins now appear in contemporary artists' works. [23] (fig. 17)

Stalin's first major purges started in 1934 after the assassination of Sergei Kirov, the Leningrad Party Boss. Several artists from Malevich's circle were indiscriminately arrested and sent to Karlag. Vera Ermolaeva (1893–1937), one of the best known, was shot in custody. (fig. 16) Sterligov, more fortunate, was released after five years and returned to Leningrad where he was wounded during the siege and then evacuated to Alma-Ata, where he stayed until 1945. At that time he married painter Tatiana Glebova. Like many other survivors, they provided a living example and testimony of a lost culture of free artistic innovation that had been brutally suppressed.

The effects of the Second World War, the industries of the Cold War, the purges, the gulags, and mass evacuations brought waves of migrants to the region, some temporary, some not. Constructivist filmmaker Dziga Vertov (1896–1954) had first visited the area in the mid-1920s to make his propaganda film *One Sixth of the Earth* (1926) and returned in 1942 to film *Kazakhstan. To the Front!* Mosfilm had moved there in 1941 when Sergei Eisenstein (1898–1948) began work on the first part of his perceptively contemporary political costume drama *Ivan the Terrible*, which was finished on return to Moscow in 1944. [24] Lenfilm was also evacuated there in the following year, bringing with it Pavel Zaltsman (1912–1985), like Glebova, a former associate of Filonov, who stayed and became the chief designer of Kazakhfilm. This fertile period marked the birth of the now vibrant Kazakh film industry. In Mongolia, Soviet avant-garde filmmaker Vsevolod Pudovkin (1893–1953) filmed his semi-documentary *Storm over Asia* (1928), telling the fictional story of a modern Genghis Khan who fought with the Soviets against the colonial British army. (fig. 19)

From the 1930s until the early 1990s, Central Asia was regarded by the state as a place of security and confinement far from contact with the capitalist world. Accordingly, it became a desert, a place of sequestration where—"enemies," internal and external—vast numbers of "suspect" Poles, Koreans, Volga Germans, Moldovans, Jews, Tatars, Japanese war prisoners, and other ethnic groups could be deported and forgotten. In the 1950s, after the territorial partitions of the Yalta Agreement had been enacted, and the

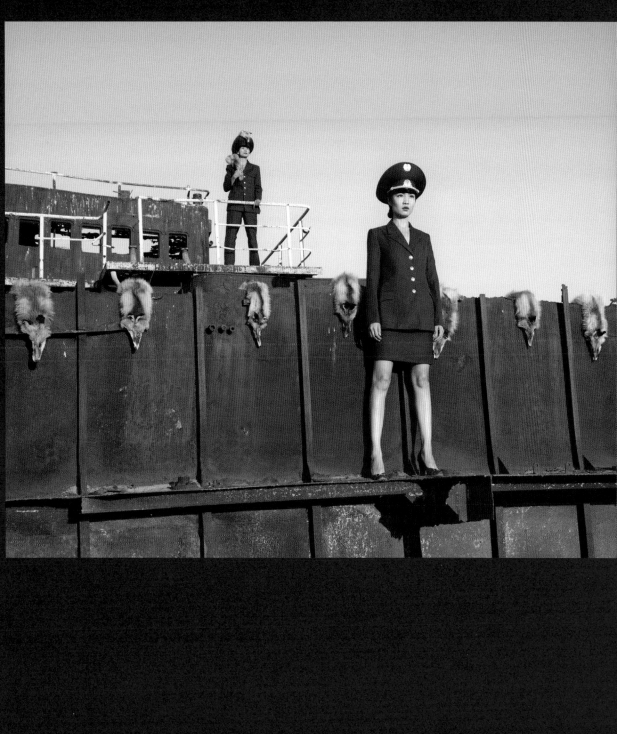

19

20

19 | An occupying British Imperialist in Vsevolod Pudovkin's feature film **Potomok Chingis-Khana (Storm over Asia)** | 1928

20 | Erbossyn Meldibekov (in collaboration with Nurbossyn Oris) | **Plates** (a series of thirteen painted and collaged ceramic plates depicting the war in Afghanistan) | 2009 | diameter 32.5 cm | courtesy Elaine W. Ng and Fabio Rossi, Hong Kong

21 | Erbossyn Meldibekov | **Alien** | 2008 | digital photograph | 100 x 70 cm | courtesy the artist and Rossi & Rossi, London

[25] The Yalta Agreement was made between Great Britain, the Soviet Union, and the United States in February 1945. At this meeting the principle of the partition of Europe between the eastern and western powers was first agreed. [26] "Interview with Valeria Ibraeva," *Erbossyn Meldibekov The (Dis)order of Things* (ex. cat.), London, Rossi & Rossi, 2009, p. 34. [27] The members of Transavantgarde and Kyzyl Traktor included Smail Balayiev, Moldakul Narimbetov, Vitaly Simakov, and Said Atabekov. Green Triangle consisted of about twenty artists, poets and philosophers. For membership of these groups and other developments see the chronology in *A Est di Niente*, op. cit., pp. 262–286.

paranoia of Stalin's crimes against humanity had been secretly acknowledged by the Politburo, many were sent home but others remained. [25] Sizeable Korean and Tatar communities still live in the region and, alongside the indigenous people and Russians, make a significant contribution to its contemporary art scene.

VI. Beyond Zombie

To my mind official art, whether Soviet or post-Soviet, is zombie art. I try to imitate my country in the matter of creating imitations; it's a kind of game with them, since of course it's impossible to become a second Matisse. I also make zombie art: I copy art, improving it in ways that I consider necessary . . . in our system I appear an idiot, a madman, and as an artist.

– Erbossyn Meldibekov, 2009 [26] **(fig. 21)**

The early Central Asian avant-garde of the 1920s and '30s had originated in the West. For the indigenous Kazakh, Kyrgyz, Tajik, Turkmen or Uzbek peoples there had been no tradition of academic, avant-garde or even of easel painting, partly because they already had strong pictorial, musical, decorative, and craft traditions in their arts and little demand for western styles. Some locally born artists, however, like Semyon Chuikov (1902–1980) from the Kyrgyz SSR or Abilkhan Kasteev (1904–1973) from the Kazakh SSR, managed to establish themselves as official artists, combining the heroic dogmas of Socialist Realism with local, more folkish subject matter. During the late 1980s and early '90s the influence of *perestroika* on the local communist parties in the Central Asian republics led to the creation of a free press and multiparty system that culminated in independence. Artists began to cleanse themselves of the legacies of their Soviet past. For many, this involved a revisiting of the "barbarism" that had been brutally suppressed by Soviet modernization, industrialization, and "enlightenment."

In 1985, Transavantgarde, the first group that looked to developments in the West, was set up in Shymkent, in the south of the Kazakh SSR; the following year, the much broader based Green Triangle was founded in Alma-Ata. [27] In 1990, the Shymkent group reinvented itself as *Kyzyl Traktor* (Red Tractor), a collective that in spite of its ironic Soviet name based its performances on reinvented versions of folk and shamanic rituals. By the mid-1990s the *Kokserok* (Wolf Cub) group, led by Kanat Ibragimov and Erbossyn Meldibekov, had adopted an even more aggressive "Mongol" or "Scythian" persona, sacrificing live sheep, for instance, at the Moscow Art Fair. In Mongolia, the Green Horse Society was started in Ulaanbaatar in 1990 and took as its inspiration the expressionist Blue Rider movement that had flourished in Munich between 1911 and 1914.

After independence, the local strong men soon got themselves back into political power, and the face of the region remained more or less the same. Kyrgyzstan, though, had its "peaceful" Tulip Revolution in 2005, recorded somewhat equivocally in Gulnara Kasmalieva and Muratbek Djumaliev's film montage, and serious riots during 2010; from 1992 to 1997 Tajikistan was tied up in a civil war. The other republics, however, remained authoritarian but more or less stable and began self confidently to project specifically national rather than Soviet identities. Nowhere is this seen more clearly than in the design of official monuments or in the renaming of famous places.

Kazakh artist Erbossyn Meldibekov, who trained as a monumental sculptor in Soviet times, embodied a dramatic and far from politically correct expression of this evolution in *Mutation* (2009), a series of four strongly related bronze busts in which the archetype of Lenin reappears in the stylistic and ethnic forms of Giacometti, Patrice Lumumba, and Genghis Khan. **(fig. 22)** He makes this point even more explicit in *Family Album* (2007–09), a series of works in which old family photographs made in front of Soviet memorials are compared with recent pictures taken in the same spot after independence. The heroic

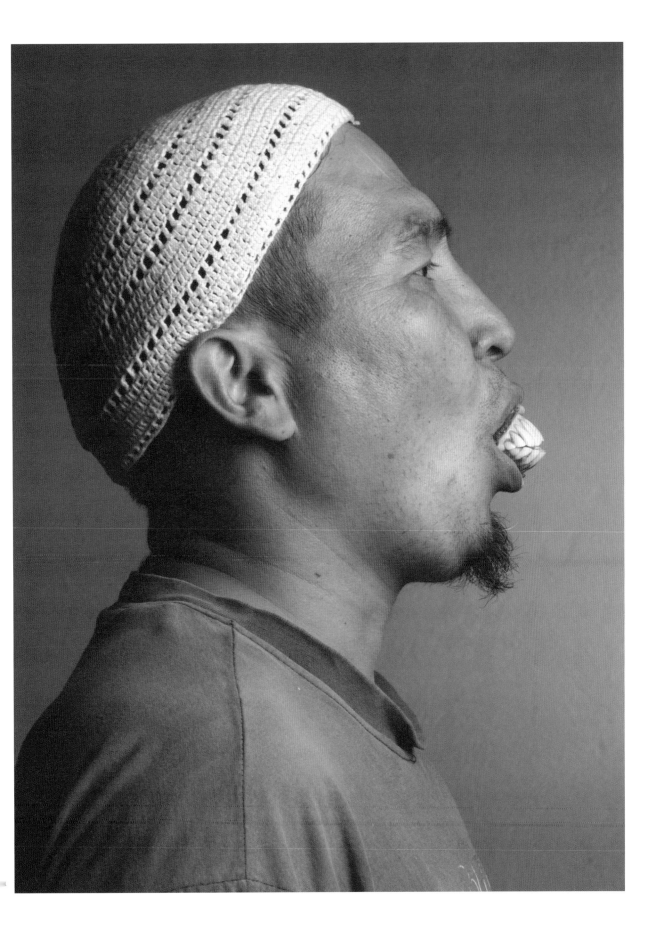

22

symbolism of the national monument has been completely transformed, with often only the plinth remaining. Working in the same vein but taking landscape as his subject, he fashions different "views" of mountain peaks, made by hammering old enamel saucepans which he has turned upside down or by making ceramic plates showing the current Afghan war. In Tsarist and early Soviet times the highest peak in Russia was known as Mount Garma; in 1932, it was renamed Mount Stalin; in 1962, eight years after Stalin had fallen out of favor, it was born again as Mount Communism and, in the early 1990s, after the independence of Tajikistan, where it is situated, it reached its apotheosis as Mount Ismoil Somoni, named after the Tajik founder of the Central Asian/Persian Samanid Dynasty (819–999 CE). Meldibekov has fashioned these different manifestations of the same mountain into a series of objects, which he perversely entitles *Peak Communism* (2009). (See p. 150, fig. 39)

23

Young Almaty-based artist Ekaterina Nikonorova, like many of her generation, comments caustically on the collision of authoritarianism with folk art and kitsch. In her installation *Turn Turk* (2008), she treads a careful path between clichéd stereotypes of Turkic-ness, as expressed in bad quality rugs and an Astroturf reference to the endless grasslands of the steppe, and ancient decorative archetypes such as the "rams horn" fertility motif still found in many Caucasian and tribal rugs and kilims. She also deconstructs the way in which national styles are confected by rolling her carpets in the form of rams' horns that when stood on their ends make 3D models of a modern city peppered by skyscrapers—such as Astana, Kazakhstan's proud new capital. (fig. 23)

A similarly critical approach to the bombast of national representation can be seen in *Kazakhstan Blue Period* (2002–05), a large series of photo images by Elena Vorobyeva and Viktor Vorobyev. The nod to the melancholic mood of Picasso's early paintings is partly mitigated by the pervasive appearance of the bright blue Kazakh national color within each picture. However when seen together these images create a sour-sweet montage of the diversity, complexity, poverty, and cultural richness of a society still very much in the process of finding itself. (fig. 24 and p. 19, fig. 4)

Painter Rashid Nurekeyev, also from Almaty, approaches the same question with a sharper edge. His recent large canvases depict the new society in a far from flattering light. Young people from the streets appear as hunched, frustrated, angry homunculi, devoid of real power, but his new works on paper, *01* (2011) cast an eye in the opposite direction. This numeral obviously represents the most powerful leader in the land, a nomenclature that is re-imagined and remodeled by the artist in different, not always respectful, styles and formats. (fig. 25)

In a region that still accommodates many different active beliefs, the nomadic figure of the shaman or dervish—a character made familiar in western contemporary art by Joseph Beuys (1921–1986), part of whose work was based on the claim that nomadic Tatar tribesmen had healed his war wounds—appears skeptically and sarcastically in the work of many artists. Sometimes this is balanced by a feeling of respect for the many different layers of religious observance that remain in the region.

24

In *Molitva (Prayer)* (2007), Tashkent-based Aleksandr Nikolaev creates a sense of mystery and alienation through the haunting sound of wind and gushing water of a mountain stream. This is set against the overpowering whiteness of snow in a stark landscape through which a single, bearded man makes his way to pray. Here, in a rather oblique way, authenticity of individual feeling is elevated above fundamentalist religious dogma. Shaarbek Amankul, from Bishkek, also focuses on individual experience in *Duba (Cleaning the Soul)* (2007), but with a direct approach. The close-up facial expressions and rhythmical, at times inhuman, sounds of a female exorcist and healer are meticulously recorded as she absorbs and digests the troubled and troubling spirit of a woman we never see. (fig. 27)

25

22 | Erbossyn Meldibekov | 2009 | Mutation | bronze |
24 x 29 x 15 cm each | M HKA collection, Antwerp

23 | Ekaterina Nikoronova | Turn Turk | 2008 |
mixed-media installation | dimensions variable |
courtesy the artist

24 | Viktor Vorobyev & Elena Vorobyeva | Kazakhstan:
Blue Period | 2002–05 | images from a series of 42
photographic color-prints | 70 x 46.5 cm each | courtesy
Aspan Gallery, Almaty | see also p. 19

25 | Rashid Nurekeyev | Series 01 | 2011 | from a series of
seven acrylic paintings on paper | 60 x 80 cm | these refer
obliquely and ironically to the Great Leader of Kazakhstan |
courtesy the artist

[28] This also includes passing reference to Marina Abramović's
and Ulay's 1977 face-slapping performance Light/Dark.
[29] Ministry is an industrial-metal band from Chicago from
the 1980s, founded by Al Jourgensen. Their album Land of
Rape and Honey was released in 1988 and featured the track
Hizbollah that samples Lebanese singer Fairuz's arabesque
ballad Kad Ataka (1966).

A more ethereal approach can be seen in the work of younger artists such as Aleksei Rumyantsev from Tajikistan. The editing of *Kara Bolo (Circle of Time)* (2007) adopts the convention of music videos. Electro-folk is accompanied by a series of revolving images that spin psychedelically like dervishes: appliqué patterns from traditional textiles, architecture, round stamps of bread dough, baked bread itself, beehive bread ovens, clay of the earth broken like bread—with the regularly orbiting cycles of sun, moon, and stars.

Yet the potential transcendence of such symbolism is often undercut, especially when the figures of the wandering Sufi dervish or nomadic shaman are brought together in a single figure. In *Neon Paradise* (2003), Said Atabekov wears a costume derived from a sketch by Russian painter Vasily Vereshchagin (1842–1904) as he bows in uncomprehending supplication to doors of newly built shopping malls as they automatically, randomly, and mysteriously open. In *Pastan III* (2005), Erbossyn Meldibekov presents his version of the western "Stans" joke [28] in which he plays the role of a Kazakh country bumpkin who, to the bemusement of everyone else, is repeatedly insulted, slapped, and beaten by a demented über-Kazakh. This cameo of violence and humiliation—a mirror of new post-Soviet society—is further nuanced by Tashkent-based artist Vyacheslav Akunov who in *Cleaner* (2007) ironizes the image of the artist as holy fool, as well as the peripheral status of Uzbekistan at the edge of the western art world. At famous London landmarks, including the National Gallery in Trafalgar Square, he plays the role of "cleaner" by meticulously, humbly, irritatingly, and ritually scrubbing paving stones, steps, and decorative details with a toothbrush. **(fig. 28)**

Kyrgyz artist Ulan Djaparov takes an ecumenical, but no less satirical, view of both art and religion in his three-part DVD *Train Art* (2005), in which the long, cramped corridors of the Trans-Siberian Express provide a unified setting for different views of Islam, Buddhism, and Christianity. In the first performance, *The Green Path*, the long carpet of the corridor is rolled up endlessly to the backing of *Hizbollah* by Ministry [29]; in the second, *Train Buddha*, people sit meditating in lotus position perched on narrow, pull-down seats; in the last, *Saint Sebastian*, a pallid Caucasian boy appears submerged in equal parts by suffering and ecstasy.

A similar combination of the satirical with the elegiac may be found in the film work of Aleksandr Ugay, one of the two Kazakh artists of Korean extraction in the exhibition. *Tea Ceremony* (2001) makes exuberant fun of his oriental origins, **(fig. 29)** while *Waltz* (2009) animates "self-defense manuals" from the wild early 1990s to the tune of a perky Soviet favorite. *Bastion* (2007) is slower. In a flickering Super-8 montage that looks as if it was shot on old film, he brings together memories and premonitions. Against a bleak horizon, three men look out to sea, their slumped pose parodying the optimism of Aleksandr Deineka's (1899–1969) famous Socialist Realist painting *Future Pilots* (1937). Yet unlike this painting, no plane—no image of a bright new future—can be seen in the sky. Slowly, and somewhat improbably, a model of Vladimir Tatlin's (1885–1953) iconic post-revolutionary masterpiece *Monument to the Third International* trundles by. A symbol of a never-achieved utopia, this vast unbuilt tower was designed as a parliament for a new world government. Its ponderous, historic progress here within the context of avant-garde and official culture, both of the Soviet Union and contemporary Kazakhstan, liberates hard-to-explain emotions of nostalgia, regret, and hope. **(fig. 26)**

Happystan (2007) by Natalya Dyu, also of Korean background, has a similarly bittersweet taste. A sentimental and mindless love ballad written and performed by Aliya Belyaeva, the wife of a Kazakh oligarch whose husband was in prison at the time it was made, provides the soundtrack. The imagery of the film, however, presents a hard and dispassionate look at the economic and social conditions of the vast majority of Kazakh people, particularly of women, highlighting with poignant and tragic humor the discrepancy between the naive optimism of the lyrics and the harsh, colorless realities of everyday life. **(fig. 30)**

26

Timur Mirzakhmedov examines the ways in which the media influence ways of thinking. In *Chicken Coop* (2011), he focuses on Uzbek and Russian news programs in which the all-powerful role of the presenter is undermined by the appalling repetition of the same absurd image and sound: squawking chickens crammed together in a battery farm. This surreal "news story" becomes both fantastic and banal as it is further amplified by signers for the deaf and, in a concatenation of images and sounds, becomes a paradigm for the chaotic overload of information through which nothing of importance is ever communicated.

Saken Narynov works as both an architect and artist. His wire-woven hanging structures are imbued with an internal mathematical logic that gives an impression of them being discrete objects in themselves as well as illustrations of the structures of far off universes. In this respect they echo the hanging objects the Constructivist artist Aleksandr Rodchenko (1891–1956) made in 1919–20, as well as El Lissitzky's (1890–1941) series of "PROUNS" ("Projects for the Affirmation of the New")—prints, drawings, and paintings of imaginary space stations. *Kazak Bottle* (1988) was dedicated to the Cambridge physicist Stephen Hawking and *Mole Holes* (1999) seems to depict tunnels in both time and space. *Tower* (2011), on the other hand, has more the character of an architectural model and reflects Narynov's long-standing interest in the structural and philosophical concerns of avant-garde architecture. The frame of his reference is extremely wide—from Tatlin's *Monument* and man-powered *Flying Machine* in the 1920s to the futuristic, utopian, pod-like cities imagined by the Tokyo-based Metabolism group in the late 1950s and '60s.

VII. The Sun

Our ancestors were sensitive to large spaces. This is a powerful way of thinking. We are in tune with our homeland and customs through symbolism. This enables us to recreate ourselves and to negate the entire system of education we have grown up with. Art must be about free-thinking, which is not governed by any particular theory of viewpoint. Human thought is a continuous process. Only our desires, confidence, and choice shape us. Art is happiness, sadness and regret, and even belief in magic.

– Manifesto of the Green Horse Society, Ulaanbaatar, Mongolia, 1990 [30]

In this manifesto, written in 1990, when Mongolia was still very much allied to the Soviet system, young artists imagine a future that would enable them to become part of a larger world by liberating identity, vision, and desire. In their openness and energy, they seem to have been speaking for all contemporary artists working in the center of Asia—at that time and since.

Rooted in a history and culture that has often been denied or suppressed, they reinvent themselves endlessly, mutating from one form or image to another in ways that defy expectation. In the ancient religion Tengri, lord of the heavens, was accompanied by Umai, mother and fertility goddess. Together they ruled both heaven and earth. But what remains "beyond my philosophy" is the link between this and the work of the 23 artists and collectives in this exhibition. How they are able to meld the ether of idealism—the rare capability to imagine a more beautiful world in every sense—with a sensual practicality that is savage, earthy, and ironical.

It is as though the bubble of a long, deeply submerged memory has suddenly burst through the surface. They have little time for the tragedies of the past, Soviet or otherwise, and their self-assuredness and talent is impressive. In the spirit of their nomadic forebears, they move east and west, between heaven and earth as it suits them, addressing present and future confidently, their lit-up faces turned equally towards the rising and setting of the sun. ●

26 | Aleksander Ugay | **Bastion** | 2007 | single-channel DVD transferred from 8mm cine-film, sound | 5'10" | courtesy the artist

27 | Shaarbek Amankul | stills from **Duba (Cleaning the Soul)** | 2007 | single-channel video, sound | 7' | a traditional Kyrgyz shaman is healing an unseen patient | courtesy the artist

28 | Vyacheslav Akunov | stills from **Kingdom U: Cleaner** | 2007 | single-channel DVD, sound | 16'42" | courtesy Aspan Gallery, Almaty

29 | Aleksander Ugay | stills from **Tea Ceremony** | 2001 | single-channel DVD, sound | 2'13" | courtesy the artist

30 | Natalya Dyu | **Happystan** | 2007 | single-channel DVD, sound | 5'10" | courtesy the artist

[30] Members of the Green Horse Society included G. Erdenebileg, Y. Dalkh Ochir, B. Gansukh, S. Mashbat, and T. Enkhbold. *A Est di Niente*, op. cit., p. 267.

I will be reading you poems,
Millions of poems;

I'll do you any favour -

Oh, I don't need much

Tibet
What If . . . ? Pitfalls of Identity in a Slippery Age

Ever since I had first started working with art I had been fascinated by the iconography of Mahayana Buddhist, and particularly classical Tibetan, art. As a young curator, this strange, unpredictable world of benevolent and ferocious gods, goddesses, and guardians, was a guilty pleasure in which I peripherally indulged by buying the odd carpet and small sculpture. When, about fifteen years ago, rumor began to circulate that there was a generation of young artists working in Tibet, I began immediately to take notice. This first essay appeared in the exhibition catalogue **Anonymous: Contemporary Tibetan Art** (ArtAsiaPacific, 2013). "Anonymous: Contemporary Tibetan Art" was curated by Rachel Perera Weingeist and first mounted at the Samuel Dorsky Museum of Art, at SUNY New Paltz, New York, in July 2013, before traveling to the Queens Museum, New York, in September 2014.

I. Worlds and Ends

In a short video made in Lhasa a couple of years back, a young man, standing sideways to the camera, blows up a balloon. On it a glyph—the Tibetan word for "I," or "self"—is written in black ink. Slowly the balloon inflates until the inevitable happens: a big bang, a convulsion of shock and then a smile. The process is repeated with a different person, but with the same word in a different language written on the balloon. Each blower has his or her own style: one young woman in the video takes it very slowly, protecting her now-huge balloon with small breaths; but it, too, bursts. A policeman tries to take control of the situation, but it has gone too far. He also succumbs to the shock of recognition that evinces a small grin. (fig. 1) In Tibet, a country with vast unexploited natural resources that feels itself both occupied by China and caught in a vice between east and west, the question of "who we are" seems to be on everyone's mind. As we see from the works in "Anonymous," the answer is both simple and incredibly complex.

In Tibet, which has always been sure of its culture in which individual identity hardly matters, such a question has become a recent preoccupation. In a time that prides individualism, transparency, and openness as human virtues, the characteristics of anonymity and self-effacement, as traditionally practiced by artists in Tibet, seem like anachronisms. Yet now, some Tibetan artists have decided to return to the convention of anonymity and to ask that we look at their works "blindly," evaluating them only for what they represent and the means the artists have chosen to represent them.

Ever since the European Enlightenment, cultural heritage, personal recognition, and democratic freedoms have been regarded as essential rights. In return, artists have been expected, one way or another, to locate and communicate moral touchstones in the beauty and horror of their perceptions of existence. [1] Such practice presupposes courage, the will to stand out.

In Tibet, the idea of enlightenment has a more deep-rooted, spiritual, rather than cultural, philosophical or political end, and artists have embodied the ethics of Buddhism in a timeless way. Within a conservative social structure, individual talent has been confined within prescribed iconographic styles and disciplines with relatively little scope for deviation. Yet, as we can clearly see, there is a widely recognized need for change. To make good traditional art today requires a different kind of talent and courage.

In spite of the shrinking effect of television, with the internet and mass communications, it almost seems as if we live in several separate worlds. Not the old, colonial divisions of "East" and "West," or of "haves" and "have-nots," but of fundamental differences in thinking, looking and being. Yet how can we begin to think about these worlds within the same frame when in their nature they seem incompatible? Is there any chance of bringing diverging views together without slipping on our built-in prejudices? Does the work I have just described, as well as the other works in this exhibition, imply that because Tibetans do not have the freedom to decide their lives

1 | ANONYMOUS | Self | date unspecified | video | 5'47"

2 | ANONYMOUS | Footprints | date unspecified | video | 101'31"

3 | ANONYMOUS | Taking Lives Sparing Lives | date unspecified | video | 9'8"

4 | ANONYMOUS | Matchsticks | 2012 | video | 13'35"

[1] Kantian aesthetics are based on autonomy, moral acuity, and an artist's ability to express these in terms of positive or negative beauty. For a helpful discussion, see: Terry Eagleton, "The Ideology of the Aesthetic," *The Kantian Imaginary*, Chapter 3, Oxford, Blackwell, 1990.

5 | Benchung | **Ascetic** | 2012 | acrylic on canvas |
120 x 80 cm | Shelley and Donald Rubin Private collection

6 | Nortse | **Big Brother** | 2007 | chromogenic color print |
55.1 x 52.8 cm | courtesy the artist

7 | Tenzing Rigdol | **Unhealed** | 2010 | chromogenic
color print | 60.9 x76.2 cm | courtesy the artist

[2] Isaac Babel (1894–1940) was referring in 1934 to the recently
instituted Bolshevik Party censorship of the arts. He was arrested
on the false charges of being a spy in 1940 and murdered by firing
squad. From the transcripts of the first congress of Soviet writers,
Moscow, 1934. See Lionel Trilling, "Introduction," in *Isaac Babel:
The Collected Short Stories,* ed. Nathalie Babel, New York, Signet,
1974, pp. 12–14. [3] This refers to *Matchstick,* a 13-minute-long
video shown in "Anonymous." What is momentarily illuminated
is a *vajra,* a ritual object used in Tibetan Buddhism that
symbolizes the properties of a diamond (indestructibility) and a
thunderbolt (irresistible force). [4] George Orwell (1903–1950)
found it difficult to get *Animal Farm* published after the end of
World War II because it openly criticized the Soviet Union at
a time when it was an ally of Britain. Orwell was suspected of
Trotskyism by many members of the British establishment. The
first part of Orwell's slogan paraphrases American politician
Thomas Jefferson's *Declaration of Independence* (1776): "All
men are created equal." George Orwell, *Animal Farm,* London,
Secker and Warburg, 1945. [5] This new style, blending different
aspects of historical Japanese art, was strongly promoted by
writers and curators Okakura Tenshin (1862–1913) and Ernest
Fenollosa (1853–1908). The Tokyo School of Fine Arts, founded
in 1887, was the center from which this style was disseminated.
[6] See, for instance, the exhibition catalogue: Hiroko Kato and
Kikuya Yoshio, *No Border: From Nihonga to Nihonga,* Tokyo,
Museum of Contemporary Art, 2006. [7] See, for instance, the
paintings of Baasanjav Choijiljavin discussed on pp. 108, 113,
152. [8] Hangzhou was capital of the Southern Song Dynasty
(1127–1279) and a major artistic center. The China Academy of
Art was founded in 1928. In Beijing, at the Central Academy of
Fine Arts, artist and educator Wang Huangsheng is today at the
forefront of new approaches to brush painting. See also note 12.
[9] Lewis Henry Morgan (1818–1881), American anthropologist.
Clare E. Harris, *The Museum on the Roof of the World: Art, Politics
and the Representation of Tibet,* Chicago, University of Chicago
Press, 2012, p. 219. [10] The Dalai Lama now leads the Tibetan
government in exile based in Dharamshala, India.

for themselves they have a massive crisis of identity, almost as if they
do not exist as individuals?

What if . . . in an age where historical distinctions between different
ideologies no longer make sense, and the media is obsessed not by content
but by celebrity and fifteen-second sound bites, it makes sense to stand
back and to adopt what, at the height of Joseph Stalin's purges, writer
Isaac Babel ironically describes as "the genre of silence"? [2]

What if . . . in an age of constant covert surveillance, with drones, "smart
bombs," and Big Brother wallpapering primetime TV, the anonymity of
an isolated artist repeatedly striking a match in the dark to illuminate for
a millisecond a glimmering image of indestructibility and power could be
regarded as the performance of a sacrament, a necessity, a right to privacy,
a way to resist—as well as a cause for suspicion? [3] **(fig. 4)**

In the more than 90-minute-long video *Footprints* (2013), shown for the
first time here in "Anonymous," it is as though we are in an interrogation
room: a man constantly paces around a simple, dimly lit table. To the sound
of a rotating prayer wheel, his progress is irregularly and subliminally
intercut with fragmentary images, as if for a moment the film or his
consciousness were in the process of a meltdown. As the film progresses,
the man gets tired, slows down, deviates from his previously sure path,
until eventually he stumbles with exhaustion. **(fig. 2)** These are undeniably
images of struggle, difficulty, even of torture, yet how and in what context
should they be understood?

What if . . . George Orwell's postwar satirical slogan "all animals are equal,
but some are more equal than others" reflects a contemporary reality in
which those in power have no greater ambition than holding onto power, to
the exclusion and submission of others? [4] In such extreme circumstances,
as Orwell himself clearly realized, anonymity, the genre of silence, was not
only a necessary expression of free will in the face of repression but also
could be a timely disappearance—a form of self-protection.

Such ideas and impressions congregate around the video *Taking Lives
Sparing Lives* (2013), another work shown in "Anonymous," which begins
with searing close-ups of animals' final minutes in a slaughterhouse. As
their throats are cut, blood gushes out and the last light of life leaves their
eyes; the brutality and lack of empathy in these scenes are overpowering.
Their meaning, however, becomes clear as the film progresses away
from images of prolonged cruel death to representations of freedom and
openness. **(fig. 3)** The slaughterhouse becomes an obvious reference to China
and its relation to Tibet: the freeing of animals refers to an established
custom in Buddhism that is particularly observed in Tibet. We are brought
back to the confrontation of incompatible worlds.

II. Between Trauma and Tradition

The autonomy of the individual as understood today is derived from the
cause of human rights and, with freedom of expression as a vital element,
still powers the aesthetics of contemporary art. In theocratic cultures
uninfluenced by the European Enlightenment, freedom of expression
has been regarded as irrelevant because the final destination is the
discovery and integration of the self as part of a greater whole. Within
this worldview, *dharma*—the eternal law of the cosmos—or the will of god
takes precedence. The prime concern is for the fate of the individual rather
than that of society.

Ever since its political origin in the late-18th-century revolutions in
America and France, the founding myth of modernity has been based
on the need to break away from the perceived corruption of the old to
make way for the green shoots of the new. To an extent, this story can be
seen as an essential element within human nature that mirrors previous

historical patterns, but it was accompanied by a new belief in progress and in the perfectibility of humanity that also heightened vigilance against corruption and degeneration. This deterministic, materialist, essentially secular view of the world sidelined the continuities that defined traditional cultures because they were living evidence that modernization had not yet taken place. The cultures of those who had been conquered—First Nations, minorities, and colonized peoples—were particularly disregarded. As, during the 19th century, the influence of the West began to make itself more keenly felt, many countries within Asia began to operate two cultural systems: a modern (western) approach and an indigenous (eastern) way of working that sterilized and closeted traditional culture. Only recently has this started to be challenged.

Japan was the first country to operate these two cultural systems, during modernization in the Meiji Restoration (1868–1912). *Nihonga*, a new synthetic style of traditional art with its own rules, protected the integrity of Japanese culture by "competing with" newly adopted western styles. [5] Today, the iconography of this "modern traditional" form is transmuting into both pop and abstract imagery, but its special materials and ways of painting are still preserved. [6] In Mongolia, after suffering decades of pseudo-heroic Socialist Realism derived from the Soviet Union, the Fine Arts Academy in Ulaanbaatar has, since the early 1990s, taught both western art and the traditional *zurag* style, based on long-suppressed religious *thangka* painting. There are parallels here with contemporary Tibetan art in that a number of young, socially critical painters have moved away from traditional iconography toward a more surrealistic approach to their work. Realizing the artists' fondest dreams, corrupt politicians and businessmen are roasted and tortured in the virtual flames of neo-Buddhist hell. [7]

At the leading art academies in China, the same dichotomies of "traditional" and "western" also exist. During the early years of the People's Republic, traditional art was discouraged and then forbidden and destroyed; but by the 1980s, any artistic approach was theoretically possible and brush painting and calligraphy were rehabilitated. It was not long before the aesthetic system by which traditional art was evaluated was also remodeled to allow reflection on contemporary ideas and realities. The China Academy of Art in Hangzhou is the longest-established institution in teaching both traditional painting and western-style art, but radical work in brush painting is now also being carried out at the Central Academy of Fine Arts in Beijing, once a hotbed of Soviet-style Socialist Realism. [8]

These divisions in culture were not only a matter of the "modern" West versus the "conservative" East, but also of supposedly relative standards of development within different regions. Following the earlier example of the West, Mao Zedong's newly formed People's Republic of China (PRC) classified its ethnic minorities, including the population of Tibet, according to the evolutionary principles of 19th-century American anthropologist Lewis Henry Morgan who regarded "earlier stages" of social evolution as "living fossils." [9] The aim of Chinese custodianship was to subjugate in order to modernize. The PRC began to take over power in Tibet in 1950; but until 1959, Tibet's feudal political structure, with the Dalai Lama as the effective head of state, remained unchanged. Art in Tibet was either religious or decorative, and often both, and was taught and practiced in monasteries and at main religious and educational institutions. In response to the Chinese takeover, however, a mini-extension of the Cold War ensued. Tibetan guerrilla forces, backed by the United States Central Intelligence Agency, made a series of attacks against China's People's Liberation Army that, in return, provoked punitive expeditions with military aid from the USSR. In 1959, the situation further deteriorated: a popular uprising in Lhasa quickly spread to other parts of the country. The Chinese tried to imprison the Dalai Lama but thousands surrounded his palace, allowing him to escape to India where he still remains, accompanied in exile by more than 80,000 supporters. [10]

8

9

The Chinese crackdown on Tibetan culture then became increasingly severe, with nothing other than Socialist Realism to put in its place. [11] A program of systematic destruction of monasteries ensued. Several years later, during the Cultural Revolution (1966–76), Red Guards attacked intellectuals, landowners, monks, and nuns; many were tortured or killed, the Tibetan language was suppressed and countless temples, monuments, libraries, and works of art were vandalized or destroyed.

A reflection on this time can be seen in much contemporary Tibetan art. Benchung's (b. 1971) series of paintings "Ascetic" (2012), in which a single, half-naked, self-questioning male figure is confined by Chinese slogans and characters along with uncertainties, anxieties, and other harsh realities expressed in English phrases, indicates the situation in which many Tibetans find themselves today. (fig. 5) Being trapped between two impassive systems inevitably attracts feelings of powerlessness and vulnerability. In his multimedia work, Nortse (b. 1963) satirizes new social types found in Tibet—commissar, car salesman, pilgrim—by showing them as victims, all with heavily bandaged heads. Yet what seems to be a joke is not funny at all, as it reflects the insidious way that Tibetan culture has become limited and proscribed. (fig. 6) Tenzing Rigdol (b. 1982) has produced mandalas and other religious works that enclose images of destruction, Chinese domination, and resistance within their segments, (fig. 10) but in *Unhealed* (2010), a map of Tibet has been drawn on a man's naked back; within its outlines, the place and year of important uprisings against the Chinese are marked. (fig. 7)

The external image of Tibet has, in fact, long been colonized by both East and West, and this has had a continuing impact on Tibet's self-image. The brutal reality of rule by China was complemented by the disingenuous western fantasy of a picturesque, closeted, mythical Tibetan culture that existed outside time and place, and therefore needed "benevolent" custodianship. In the West, this was a by-product of "The Great Game," the long-standing contest between Britain and Russia to colonize Tibet. While severely threatened by Chinese culture, artistic development in Tibet was, to an extent, dependent upon it—a number of Tibetan artists studied in China and some Chinese artists strongly contributed to the development of contemporary Tibetan art, although not always in positive ways.

III. The Slippery Path

For the past 30 years, artists in Tibet, including those of Tibetan origin who live abroad, have been searching for a voice in the present. In order to do this, they tried to find their own way—neither that of China's nor of the West's—not only by looking back into their own culture, as well as to other cultures, but also by closely examining the world around them. [12]

This path has not been easy. The political situation has been fraught with a sense of hopelessness that periodically leads to violence. The opening of a direct railway link between Lhasa and Beijing in 2006 intensified Tibetans' fears of being swamped by increasing numbers of Han Chinese migrants, although relatively few appear to have permanently settled in Lhasa. [13] With Chinese-government backing for education, economic development and tourism growth, the GDP of the Tibet Autonomous Region is slowly increasing, and large mineral deposits found under the Tibetan Plateau still have to be exploited. [14] Yet, between March 2011 and April 2013, more than 115 people self-immolated in protest against Chinese rule. [15] There is currently no communication between the Beijing government and the Tibetan government in exile, and Chinese officials have accused the Dalai Lama and his allies of orchestrating recent waves of protest and self-immolation. [16] Any kind of settlement appears to be distant.

In their historical, cultural, geographical, and political separation, artists in Tibet have had few of the freedoms accorded to their colleagues in either

8 | Ai Xuan's oil painting **Tibetan Girl** (1992) is typical of his sentimental and anachronistic treatment of contemporary Tibet

9 | Han Shuli | detail of **Chairman Mao Sends his Emissaries** | 1979 | 232 x 143 cm | Central Academy of Fine Arts, Beijing

10 | Tenzing Rigdol | **Om Money Padma Hum** | 2012 | collage | 152 x 152 cm | courtesy Rossi & Rossi, Hong Kong

[11] From 1954 to 1957, Soviet artist Konstantin Maksimov (1913–1993) lived and worked in China at the request of the Chinese government. He was particularly associated with the Central Academy of Fine Arts in Beijing; the Socialist Realist style of painting, which he taught there, quickly spread across the whole country. See p. 308. [12] About the idea of being culturally stereotyped, contemporary Tibetan artist Gade has said, "Yes, we want to change, but foreigners want us to stay still." Cited in Kabir Mansingh Heimsath, "Untitled Identities: Contemporary Art in Lhasa, Tibet," December 16, 2005, www. asianart.com. [13] The 2010 census figures are contested, but even allowing for this, the vast majority of the population of Tibet is still ethnically Tibetan. [14] How this will be done without serious environmental damage is a cause of considerable anxiety and tension between TAR residents and regional officials. [15] Inevitably, the subject of self-immolation is alluded to in the work of contemporary Tibetan artists. See Nortse's installation, *Zen Meditation* (2012), shown here in "Anonymous," and the poetry and painting *Ripple in Time* (2013) of New York-based Tibetan artist Tenzing Rigdol. [16] The Tibetan government in exile strongly denies this.

127

11

12

13

[17] See Tenzing Rigdol's collage *Heroes of Our Time* (2012).
[18] Clare E. Harris, op. cit., p. 219. [19] At the time, the Chinese
government felt that Tibetan artists, due to their "feudal"
training, did not possess the requisite skills to produce realistic
propaganda works. [20] Ai Xuan's father, Ai Qing (1910–1996),
one of the finest modern Chinese poets, was imprisoned during
the Cultural Revolution. Ai Xuan first encountered Tibet during
when from 1969 to 1973 he was forced to join the Red Guards
and to work hard labor on a military farm. He is the half-brother of
artist Ai Weiwei (b. 1957). [21] Clare E. Harris, "The Creation of a
Tibetan Modernist: The Painting of Gonkar Gyatso," in Elizabeth
Edwards and Kaushik Baumik, eds., *Visual Sense: A Cultural
Reader*, Oxford, Berg, 2008, p. 353. In Gonkar Gyatso's series of
four photographic works, "My Identity" (2003), made in London,
the artist restaged the different conflicting Tibetan personas
that he remembered from this time. [22] Ibid., pp. 353–54.
[23] Gonkar Gyatso mostly made his mature work and career in
London, where he stayed after earning his MA from the Chelsea
College of Art and Design. In 2003, he re-formed the Sweet
Tea House in London as a gallery for contemporary Tibetan
art. [24] See the documentary film *Angry Monk: Reflections on
Tibet (2005)*, dir: Luc Schaedler, Switzerland, 97 min. [25] The
photorealist portraiture and other work of Amdo Chamba
(1916–2002) was also added to the prehistory of a still-to-be-
realized Tibetan modernity.

China or the West, and many subjects remain taboo. Works that comment adversely on the impact of Chinese rule or, however loosely, that could be regarded as incitement to riot are forbidden and, as in the rest of China, all art is subject to censorship at the time of exhibition. As a result, many of the most directly critical works are made by artists no longer living in Tibet.

The issue of self-censorship has made this situation even more difficult. Immediately following the Cultural Revolution, through the 1980s, art in China rapidly went through a liberating succession of different movements, from Scar Painting to avant-garde groups: The Stars, Xiamen Dada, Political Pop, Cynical Realism, and others. While these movements commented on and criticized China's social and political structure, such possibilities were not open to artists in Tibet. Beginning in the mid-1980s, Chinese artists such as Yu Youhan (b. 1943) and Wang Guangyi (b. 1957) made ambivalent images of Chairman Mao that deflated his heroic status, (p. 44, fig. 28) while the nearest equivalent—serially produced images of disintegrating pop Buddhas—only began to be produced by Tibetan artists living abroad more than a decade later. The image of the Dalai Lama, however, remains sacrosanct, although in one artist's work he has assumed the avatar of a superhero. [17] The Tibetan government in exile maintains supreme moral authority and is extremely difficult to criticize. Such an action would not only puncture the official view of a closeted Tibetan culture but also, by extension, comment adversely on the Dalai Lama, its head.

The cultural climate in Tibet has been further complicated by the fact that not all Chinese influence can be regarded as damaging to Tibet. There was an unavoidable symbiosis between Chinese and Tibetan interests in seeing contemporary art develop. However, there was no possibility of this happening until the beginning of the 1980s when, in keeping with developments elsewhere in the country, Chinese government policy favored the "manufacture" of modern art in Tibet in order to show how much Tibetan culture had progressed under its rule since its "primitive" state at the beginning of the 1950s. [18] In the rest of China, the relaxation in control over art was supposed to indicate how much the country had emerged out of the shadows of the Cultural Revolution.

In 1981, the first Independent Artists' Association was formed in Lhasa, with Chinese artist Han Shuli (b. 1948) as its head. Any independence, however, was illusory as its policy strictly followed the Beijing line. In 1973, during the Cultural Revolution, Han first traveled from Beijing to Lhasa, where he produced the large propaganda painting *Chairman Mao Sends His Emissaries* (c. 1979). (fig. 9) [19] While living in Lhasa, Han became fascinated by Tibetan popular culture and religious art, publishing a number of books on these subjects. Around the beginning of the 1980s, his own work changed and was strongly influenced by Tibetan mysticism. His Buddhist-inspired paintings have encouraged a widespread curiosity and sympathy for traditional Tibetan culture throughout China—yet positive feelings for Tibetan culture do not coincide with the government's willingness to grant it independence.

Other Chinese artists, including Ai Xuan (b. 1947), were first sent to Tibet in the 1970s as a form of punishment. [20] In the more permissive cultural climate of the 1980s, Ai's encounter with the Tibetan landscape and people provided him with subjects for his paintings. Exotic, nostalgic and sometimes sentimental, they project a romantic image of Tibet that has little relation to how people actually lived. (fig. 8) The more "realistic" approach in the Tibetan paintings of Chinese artist Chen Danqing (b. 1953) created a sensation in Beijing when they were first shown there at the beginning of the 1980s. Breaking with the conventions of Socialist Realism, they depict primitive life on a large scale in brutish peasant realism reminiscent of the 19th-century paintings of French artist Jean-François

14

Millet. (fig. 11) In 2008, in his "Shangri-La" series, Tibetan artist Tsewang Tashi (b. 1963) made staged photographs that were satirically based on Chen Danqing's works. Here the idea of the primitive countryman collides with the techno-world of the modern city to make the humorous point that although both could be said to exist, neither is real, as both extremes are the projections of other cultures. (figs. 12, 13)

Like Tsewang Tashi, Gonkar Gyatso (b. 1961) also attended the Central Institute of Nationalities, a school for minorities in Beijing, where he studied traditional Chinese brush painting. Both of his parents were communists, and Gyatso grew up without any notion of traditional Tibetan culture. Returning to his native city of Lhasa in 1984, he enrolled, the following year, in the Fine Arts Department of the newly founded Tibet University, and was shaken by the discrepancies between the official propaganda with which he was familiar and the conditions in which many of his countrymen lived. Like many of his generation, he began to question Maoist dogma, a theme that surfaced later in his work, and remembers "a sense of depression and emptiness . . . [that] reflected the boredom and feeling of vacuity I had felt during these idle days of senseless arguments." [21]

Gyatso now felt the need to distance himself from his Beijing education. Skepticism about the kind of work that would be included in the official exhibition to honor the 1985 Festival for the Day of World Youth, planned by the Party-led Independent Artists' Association, led him to contemplate a whole new initiative. Gyatso therefore became a leading member of the Sweet Tea Artists' Association, named after a cheap and popular Tibetan drink. He recalled that "by taking inspiration from the shapes, events, and elements in our own environment, I and a group of art students . . . were striving to create a form of specifically Tibetan modern art." [22] Staging only a few exhibitions, this group of artists and intellectuals focused mainly on questions of politics and ethnicity. However, they managed to kickstart a different kind of perception and experience of Tibetan landscape and reality.

In 1987, after one of the Sweet Tea exhibitions had been widely covered in the Tibetan media, Chinese authorities demanded that Party-approved Han Chinese artists also be included as members in the artists' association. As this went against their aim of propagating a specifically Tibetan culture, the association refused the request and disbanded. Gyatso left Tibet in 1992 to study traditional *thangka* painting in Dharamsala, and the iconography he learned there fed into his mature work. [23] In 1996 he moved to London to work. (fig. 14)

As the generation brought up under Mao began to discover Tibetan culture for itself, the less-constricted spirit of the 1980s saw an intensification of interest in Buddhism in both China and Tibet. Since its founding in 1985, the Fine Art Department of Tibet University had taught *thangka* painting under the now-rehabilitated master painter Tenpa Rabten, who had been forbidden to work in the style during the Cultural Revolution. As a result, religious art underwent a revival.

As well as searching out both old and new experiences, Tibetan intellectuals had, from the end of the 1970s, begun to reexamine history for examples that could cast light on the present. The life, writings, and art of a roisterous iconoclast—monk, scholar, and intellectual Gendün Chöphel (1903–1951)—were of great importance in this reevaluation. [24] Chöphel's independent thinking and critical writings about the stagnation of Tibetan society in the 1930s and '40s became both a model for action and a symbol of hope. [25]

As Tibetans try to find a modern Tibetan identity, opposition to Chinese rule inevitably became more militant. From 1987 to 1989 there was unrest both within Tibet and among the Tibetan settlements in different parts of

11 | Chen Danqing's realist paintings such as **Pilgrimage** created a great stir in China at the beginning of the 1980s and heralded a more brutal, less nostalgic view of Tibetan society. Later these were sardonically restaged by Tsewang Tashi in his photographs.

12 | Tsewang Tashi | **Shangri-La No. 2** | 2008 | digital photograph | 100 x 150 cm | courtesy the artist

13 | Tsewang Tashi | **Shangri-La No. 3** | 2008 | digital photograph | 100 x 150 cm | courtesy the artist

14 | Gonkar Gyatso | **My Identity** | 2003 | 4 c-prints | 61.5 x 78 cm each | courtesy the artist

15

16

China. At the same time in China, a pro-democracy student movement was flourishing, accompanied by the explosion of contemporary art. In March 1989, martial law was declared in Tibet—in response to demonstrations that marked the 30th anniversary of the 1959 uprising—and many people were killed. On June 4, 1989, following the student occupation of Beijing's Tiananmen Square, the Democracy Movement was brutally checked by tanks and soldiers. As a period of stasis and open cynicism ensued in Tibet as well as in China, some artists emigrated, and cultural innovation of any kind was, for a time, virtually impossible.

During the 1990s, under increasingly stifling Chinese patronage, the commercialization of Tibetan contemporary art and its institutions intensified, as shops and market stalls opened to cater to a growing number of tourists. Traditional art was no longer threatening to Chinese rule, and could now be co-opted as picturesque folk art, appropriate to one of many minorities in the PRC. In their search for a reality with which they could be comfortable, a wide range of contemporary Tibetan artists felt trapped between Chinese presence, the language of mass marketing, bland images of ethnicity, and a mounting tide of trash.

The spirit of this time can be seen in the anonymously produced video *The Barkhor, August 2012*, shown in "Anonymous." Filmed secretly, the eye of the camera wanders at low level through the narrow streets and square that surround Jokhang Temple in Lhasa, an area that ever since the pro-independence uprising of 1987 has been a symbolic center of Tibetan resistance. It scans through the stalls and booths of Tromzikhang market, which caters to tourists; the chaotic sound of the street is a constant backdrop. Night falls and the sinister presence of the armed Chinese military is widely evident. It is a site of energy but also of extreme anxiety. **(fig. 15)** A similar sentiment can be felt in Losang Gyatso's (b. 1953) suite of prints *Signs from Tibet, Jokhang, Labrang* (2008), which consists of screen-printed close-ups of the distorted faces of monks who in 2008 were involved in demonstrations against the Chinese presence outside Lhasa's Jokhang Temple and Labro Monastery in the Tibetan province of Amdo. **(fig. 16)**

Around the turn of the millennium, a group of young artists, the Gendün Chöphel Artists' Guild, grew up in Lhasa. [26] In 2003, the centenary year of its patron's birth, the guild opened a gallery that, for the first time in Lhasa, provided a regular program of monthly exhibitions. Here, following the chaotic example of their patron, the artists started to make surrealistic social commentaries on what they saw around them, and found different ways of expressing the anguish of the country as a whole.

On some level, art has to be "about" representation—it cannot avoid a political dimension—but the members of the guild had no desire to be hijacked by other causes. The cultural climate had changed radically from that of the 1980s, and the establishment of a critical and vital contemporary art within Tibet was now the primary task. Becoming a member of the guild did not depend on being Tibetan; it was far more important that its members share a common view of art, humanity and experience. Gade (b. 1971), one of its leading figures, himself the son of a Chinese People's Liberation Army soldier and communist Tibetan mother, explained that "There was no question of Chinese or Tibetan [when forming the gallery cooperative]; it's only afterwards that outsiders ask us about ethnicity. Chinese were included in Gendün Chöphel from the beginning because they were part of the same group of friends and had the same ideas about art." [27] **(figs. 17, 18)**

Works by some members of the guild figure into "Anonymous," mainly in the form of paintings in a variety of styles. In the artists' approach, there is no single view but a common hunger to find and test reality. The tension between trauma and tradition is, however, still evident in the fact that painting is the predominant medium, partly owing to the fact that

15 | ANONYMOUS | **The Barkhor, August 2012** | 2012 | video | 26'46" | courtesy the artist

16 | Losang Gyatso | **Signs from Tibet, Jokhang Labrang** | 2008 | gelatin silver print on aluminium | six panels | 45.7 x 45.7 each | courtesy the artist

17 | Gade | **Mahakala** | 2012 | acrylic and oil on canvas | 153 x 139.7 cm | Shelley and Donald Rubin Private Collection

18 | Gade | **Ultraman** | 2008 | acrylic and oil on canvas | 147.3 x 116.8 cm | Shelley and Donald Rubin Private Collection

19 | Tenzing Rigdol | Still fram from **Scripture Noodle** | 2008 | video performance | 7'59"

17

18

19

production facilities for digital media are not easily available or felt to be appropriate to the circumstance. [28] In a text written in 2003 describing the guild, Gade summarized the slipperiness of the dilemma faced by artists who choose to live in Tibet:

Modern art in Tibet never seems to relate to the modern art movement in the outside world, seldom even participating in any contemporary art program in mainland China . . . It is like a strange creature, itself grown and developing without preparation, but it has just happened [rather like] the red and blue neon lights of the nightclubs mingle with the butter lamps, and the Potala Palace with the plastic evergreen coconut trees at its foot. Modern art in Tibet has grown up in such a fantastic ecosystem and environment. It's like an underage person who has to face a life-and-death crisis without any preparation or experience while, at the same time, having to confront the bars and fetters of his own ancient culture, and the stereotypes of the outsider. [And we are] still being hampered by a lack of the information and communication with the external world . . . Perhaps what artists think about modern art in Tibet is just in their imagination—or maybe there is no modern art in Tibet. But what is important is that artists are recording both the transmigration of a civilization and a disappearing myth.[29]

As, over the past decade, a consciousness has developed outside the country that there is contemporary art in Tibet, artists themselves have been reviewing their practice. A substantial body of video art—ranging in approach from the conceptual to the documentary, from the political to the poetic—is being shown for the first time here in "Anonymous."

Whatever form it may take in the future, artistic autonomy is a step toward political autonomy. A contemporary Tibetan aesthetic has now developed that brings into account traditional ways of looking at oneself and the world with the exigencies and views of the present. Genres of anonymity and respect for culture are being transformed by the necessity for clear individual thought. Two videos in "Anonymous," *Drifting* and *Landscape Movements* (both 2010), indicate this; in both works, the protagonist is the impressive Tibetan landscape. In *Drifting*, the landscape's natural beauty is contrasted with alienating new Chinese construction, as a boat on which the camera is placed drifts, seemingly aimlessly, down a river. As in *The Barkhor, August 2012* video, Tibetans become secret, anonymous observers of their own land. In *Landscape Movements*, the landscape is metaphorical: what seems to be an aerial view of a mountainous landscape is, in fact, a simulation, refashioned and eventually brushed away by the hand of the artist to reveal a complex drawing underneath.

The works shown in "Anonymous" walk a tightrope between the contemporary reality of "What is . . . ?" and the eternal question of "What if. . .?" and embody the friction between the contemplative aesthetic of traditional art and the desperate need for new thought and action. As implied by Tenzing Rigdol's performance piece *Scripture Noodle* (2008)— in which a Tibetan sutra is cut up, stir-fried and then consumed by the artist in a small Chinese fast-food restaurant—this inevitably entails the digestion of cultural traumas past and present to create a new and different energy. [30] **(fig. 19)** Contemporary art is the perfect platform for this process: it builds on present realities, harms no one and may even prefigure real change for the better. As part of the realization that time cannot be reversed or even stand still, it is infinitely preferable to the disempowering tragedy of stasis. ●

[26] In writing about art by Tibetan artists from this time, the words "contemporary" and "modern" are synonymous. [27] Gade, in Kabir Mansingh Heimsath, "Untitled Identities: Contemporary Art in Lhasa, Tibet," December 16, 2005, www.asianart.com. [28] At this time, a number of these artists felt that new media were not appropriate for the conditions in Tibet. Tsering Dhondup said of his time as an artist-in-residence in New York, and his attempt to utilize new styles: "It is not my life! It does not relate to this place, nor to most people." Gade also stated, "You can't just go out and make an installation or video without some kind of background." In Kabir Mansingh Heimsath, op. cit. [29] Gade, Gendün Chöphel Artists' Guild brochure, Lhasa, November 30, 2003. [30] This work unconsciously echoes Song Dong's 1994 installation *Cultural Noodles*. See p. 209, fig. 6.

The Best of Times,
The Worst of Times
Contemporary Art along
the Post-Soviet Silk Road

This essay was published in 2012 as the main text in the catalogue of "The Best of Times, The Worst of Times: Rebirth and Apocalypse in Contemporary Art," the 1st International Kyiv Biennale of Contemporary Art. As Ukraine had been created as an independent state in 1991 during the break-up of the Soviet Union, its pre-history, along with its present and future, was a matter of considerable fluidity and dispute. As this was the first exhibition of contemporary art on this scale to be held in the country, I wanted to avoid the provincial cliché of its present culture being narrowly defined as "post-Soviet" by examining how its historic position as a bridge between north and south, east and west could make sense in terms of contemporary art. For this reason I showed the work of many Ukrainian and Asian artists within a context that also acknowledged ancient routes of migration and cultural exchange as an integral part of current globalization.

2

I. Pictures at an Exhibition (A Rift, a Ruin, a Shooting, a Straw Oven, a Lost Civilization, Some Cells, Rights, Revolutions, Dinosaurs, Factories, Woods . . .)

Kyiv, whose famous Golden Gate features as an exotic, triumphant finale in Modest Mussorgsky's piano suite *Pictures at an Exhibition* (1874), is a historic Slavic city. Located on routes of trade and migration, it absorbed Vikings from the north in the 9th century, who invited Byzantine monks from Constantinople in the south to introduce Christianity and its art into the state of Rus. At different times Huns, Khazars, Greeks, Mongols, Goths, Pechenegs, Wends, Scythians, Tatars, and other nomadic peoples, many of whom originated in the Far East, have swept through, sometimes settled, and in the process have added their layers of culture (and rubbish). Their burial mounds mark the landscape, and it is a place that still contains many spirits, many ghosts. I have tried to bring some of these together in this exhibition, along with others from much further afield. Rather than limiting myself to the closed Soviet *cul de sac* of what were previously known as "Friendship Countries" (the old Eastern Bloc), the selection of work I have made for the 1st Kyiv International Biennale of Contemporary Art reflects the diasporic heritage of the vast Eurasian landmass. Space does not allow me to address all these works in the course of this short essay, but one of this exhibition's salient features is that artists from the Ukraine and CIS states are shown alongside those from the north, south, west—and particularly from the east.

The cavernous 18th-century vaults of the exhibition halls at Mystetskyi Arsenal were built for the manufacture and storage of weapons. Yin Xiuzhen, an artist from Beijing, playfully reflects this in *Weapons* (2003–07), airborne assemblages of household implements, covered in discarded scraps of brightly colored clothing, which manage to seem handmade, even folksy, while still projecting an undertow of distinctly male aggression. (fig. 1) This, and the many other works shown here, underline how these vast spaces have been transformed and echo today not to the martial imperatives of war but to the more subdued, but no less powerful, emanations of over 225 works of art, all made recently, from many different parts of the world.

The striking new series of large images of factories by Berlin-based, Ukrainian artist Boris Mikhailov, shown for the first time here, both liberates and captures the superannuated power of the era of Soviet heavy industry, which both marked and scarred vast tracts of Ukraine. Like the bemedalled veterans in Oleksandr Chekmenyev's photographs, these behemoths of iron and steel stand their ground proudly, dwarfing the few surviving workers who slouch across their horizons. (fig. 2) They project bittersweet memories of construction and sacrifice onto an anti-heroic present that seem banal in contrast.

In *Rift*, a vast, three-part, site-specific installation, British artist Phyllida Barlow responds to the revolving cycle of ruin and reconstruction that

1 | Above: Yin Xiuzhen fabricates **Weapons** (2003–07) as a mixed-media installation using kitchen implements with fabric stretched over them | courtesy Beijing Commune Gallery, Beijing | below: Vyacheslav Akunov's 26-meter-long carpet | **Alley of Super Stars** | a continuing project in which notorious politicians are "honored" by being walked on | courtesy the artist

2 | Oleksandr Chekmenyev | from the series "Winners" | 2007 | digital print | 100 x 100 cm | courtesy the artist and Gallery Ya | Pavlo Gudimov Art Center, Kyiv

so strongly impressed her when she first visited Kyiv earlier this year. Influenced by the atmosphere and height of the Arsenal space, it is a celebration of collapse and upheaval in abstract form, composed largely of industrial offcuts and discarded materials. Tellingly, she describes the sections of the work as follows: "Seventy empty hoardings occupy the left, while on the right is a 'massing piece,' which, although no specific reference is intended, is made up of shapes which happen to be reminiscent of bombs and cogs . . . and then there is the third bit which I call an 'industrial unit.' It makes me think of those Soviet factories I saw on the way in from the airport. They looked ruined but still remain there, rusting away under the glossy surface." [1] **(fig. 6)**

* * *

Unpacking the crates as they arrive, pressing the play buttons, putting the works together in the same space, watching the many new works being installed, all this builds up in a crescendo of possibilities that resounds much louder than the sum of its parts. It is as if their collective presence has invoked a chain reaction in which good and bad become fused together. In dark times, art may express metaphors of either bravery and sacrifice or hubris and frailty, both made evident by circumstance. During happier times too, there are infinite possibilities for either positive or negative interpretations. But in the final analysis, it is the responsibility of us all to decide whether the perplexingly ambiguous cups that life can offer are half full, half empty—or even poisoned.

Three magisterial cells by Louise Bourgeois of different dates point to one of the Biennale's main ideas: memory can serve as both a prison and a platform that enables us both to perceive the present and think about the future. In cathartic fragments of thought and experience that cannot find any other expression, each cell references the smallest biological unit in our bodies as well as ideas of solitude or prison. The artist has described these works as representing "different types of pain; physical, emotional, and psychological, mental and intellectual . . . Each deals with a fear. Fear is pain." [2] And by giving form to this in these works she absolves herself of both. **(fig. 7)**

Fear is rooted in desire, often unacceptable or unrequited. A similar sensibility informs the white porcelain sculptures of British artist Rachel Kneebone. At first glance their seductive, opaque white-glazed bodies appear almost decorative, like long-lost refugees from the Court of Augustus the Strong. [3] But on looking closer, it is not clear whether the violently tumbling torrents of bodies, limbs, and genitals out of which they are composed are the last scene of an orgy or a massacre. Whether rooted in pleasure, pain, or both, they command a compelling vital beauty, which the artist has said is grounded in fear. [4]

In *Footprints to the Future* (2012), a new installation made especially for this exhibition by Yayoi Kusama, an earlier mirror work, *Aftermath of Obliteration of Eternity* (2009), and two new paintings, this eminent Japanese artist recycles the sublime terror she has experienced from an early age as raw material for her work. The fear of obliteration of all forms of identity and being is here transformed from negative to positive. She has often claimed that without the redemptive outlet of art she would certainly have killed herself. [5] Her signature dots, which in dense networks cover virtually everything, originally appeared in visions. In both her installations and paintings they bond together to create a protected zone of freedom and happiness that hovers between this world and eternity. In this way her works act like portals into an aesthetic metaphysical space that extends far beyond the vastness of infinity. She is delineating a territory which human language or understanding has either yet to recognize or identify. **(figs. 3, 4)**

Chiharu Shiota, also from Japan, has lived and worked in Berlin since 1996. This has provided her with distance from those vivid and poignant memories of childhood and youth that still fuel much of her work. The sense

3 | Yayoi Kusama | **Footprints to the Future** | 2012 | a mixed-media, site-specific immersive installationfor Kyiv | 14 x 7 m | courtesy the artist and Ota Fine Arts, Tokyo

4 | Yayoi Kusama | **Aftermath of Obliteration of Eternity** | 2009 | mixed-media installation | 415 x 15 x 287.4 cm | courtesy of Ota Fine Arts, Tokyo

5 | Chiharu Shiota | **After the Dream** | 2012 | a site-specific installation with dresses, paint, black wool | courtesy the artist | **See also pp. 101, 103, 240–243**

6 | Phyllida Barlow | **Rift** | 2012 | details of a site-specific, mixed-media installation for Kyiv | courtesy the artist and Hauser & Wirth, London

7 | Louise Bourgeois | **Culprit Number Two** | 1998 | painted steel, wood, glass, metal, and mirror | 381 x 289.6 x 335.3 cm | courtesy Hauser & Wirth, London, and Cheim & Read, New York

8 | View and detail of Shigeo Toya's installation **Woods IX** | 2008 | wood, ashes, acrylic paint | 30 pieces, 220 x 30 x 30 cm each | courtesy the artist and ShugoArts, Tokyo | Toya uses a chainsaw to gouge different forms he describes as "minimal baroque" out of tree trunks and regards this process as a conversation that amplifies the vitality and rhythm of his materials

[1] Phyllida Barlow, conversation with the author, April 1, 2012. [2] "Louise Bourgeois," Educational Dossier, Paris, Centre Pompidou, March – June, 2008. [3] Augustus II The Strong (1670–1733), elector of Saxony, King of Poland, Grand Duke of Lithuania, founder in 1710 of the Meissen Porcelain Factory, the first to produce white porcelain in Europe. [4] David Elliott, "The Anatomy of Loss," *Rachel Kneebone* (exh. cat.), London, White Cube, 2011, p. 51. [5] Since 1977, Kusama has lived at her own request in a psychiatric hospital in Tokyo. Her studio is nearby.

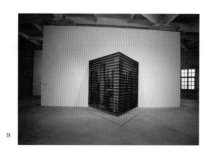

9

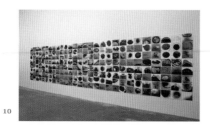

10

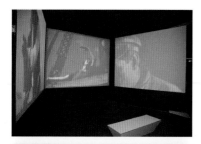

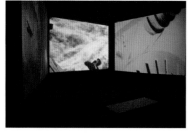

11

of dislocation is overpowering, made more intense by skeins of dark woolen yarn that tightly bind the spaces she occupies, obscuring, confining, and centering, rather like a spider's web. **(fig. 5)** The interiors of these webs may contain a dress, a chair, a bed, or other furniture, and the yarn creates both a barrier and the illusion of a dream—a semi-transparent membrane between fantasy and reality. These works suggest a dreamlike, unconscious state of anxiety in which actual and imagined barriers surround both the artist and observer. Two early memories reappear like leitmotifs. The first is a fire set by an arsonist in a neighbor's house during which Shiota heard the sound of a grand piano being consumed by flames and then saw its blackened skeleton within the burned-out hulk of the building. The second memory is of a near-death experience: as a young woman she had cancer and was confined to a hospital bed. Shiota alludes to this experience in many works. The eventual absence of the human body in installations, which are often the remains of performances, is made all the more poignant by symbols of its former presence—girls' and women's dresses and nightgowns, worn-out shoes, beds, chairs—suspended within the worlds that Shiota has created, wrenched away from their owners' lives.

Memory, in a more fragmented form, appears in the complex photo-panels of Rashid Rana and Lara Baladi, based in Lahore and Cairo, respectively. In Rana's work, small photographs, showing threatened or disappearing urban realities, combine, like the tesserae in a mosaic, to create one completely new super image of actuality. In his sculptural installation *Desperately Seeking Paradise II* (2010–11), time and the power of different viewpoints become the central subjects in that, within the space between the unit and the whole, a far-reaching critique is implied of urbanism, wealth, development, and power. **(fig. 9)** For Baladi, time is the unit of life. Her works from the "Diary of the Future" (2008–10) series deal with the last months of her father's life. Knitting, crocheting, sewing, waiting—the dominantly female life of the home—the coffee grounds of the many visitors which told the future, the stories of the past are "embroidered" as photo-vignettes in the enlarged tracery of lace doilies. **(fig. 10)**

Teetering on an eternal tightrope between individual experience and collective knowledge, memory and hope provide both platform and solace in these works and all the others in this exhibition. They also share a certain history, one the historic building of the Arsenal could certainly recognize. But as we look ahead, we try not to think about the different constellations of order we were all once taught and which still influence many. Today we need a different history, one that that can work for us all, now as well as for the future. [6]

* * *

Echoing the first words of *A Tale of Two Cities* (1859), Charles Dickens' novel set at the time of the French Revolution, "The Best of Times, The Worst of Times. Rebirth and Apocalypse in Contemporary Art" fast forwards to the present to consider how contemporary art and aesthetics need the past to express the future. Growing out of the ideals of the 18th-century European Enlightenment, long before they bifurcated into the twin poles of capitalism and socialism, human rights found their first dramatic political expression in the revolutions in America (1775–83) and France (1789–99). Combining ideology with action, these initiated a hunger for self-determination that culminated in a series of national uprisings that continues to the present. At the beginning, though, these rights were initially limited to a small group of men who all had to have property and power. Although in theory increasing numbers of people (including women) have subsequently been enfranchised, in reality the attribution of rights has often paid little more than lip service to democracy while powerful minorities find them a convenient smoke screen to consolidate property and power in their own self-interest.

The Scream (2012), a film installation made especially by Lutz Becker for this exhibition, collides and confuses the best and the worst in Soviet

[6] The main problem in current historical research is not so much in matters of detail (although there will always be work to be done), but in the frameworks used to mediate perspectives or viewpoints. The frameworks relating to world history, for instance, are now largely obsolete and new broadly acceptable forms of comparative history still need to be conceived and written. This may be much more difficult than it sounds. See Jack Goody, *The Theft of History*, Cambridge, Cambridge University Press, 2006. [7] Artist's note, April 4, 2012. [8] Note from the artists, January 6, 2012. [9] *The Second of May 1808*, also known as *The Charge of the Mamelukes*.

propaganda in a montage of passages from the work of classic Ukrainian filmmaker Aleksandr Dovzhenko (1894–1956). But Becker has assembled these fragments as if Dovzhenko were able to tell truths that could never be spoken under Stalin. Its presentation on three screens highlights dramatic interactions and accidental synchronicities between sound and image. For Becker, "The sound structure of the work emphasizes the associative, allegorical nature of the screen events. *The Scream* is the call to the ancestral spirits of an Old Believer being executed, a scene symbolic of the inhuman demands of the regime, the tragedy of fratricide and total alienation. The violence of revolution and of the elimination of the past is contrasted by illusions of social peace, but also by the solidity of the symbols of the Ukrainian metalworker and farmworker, two types less defined by the Revolution than by their struggle for a national identity. The sounds of factory sirens and locomotive whistles are not just emblematic of the triumph of productive labor but also signals of Party discipline and subjugation." [7] **(fig. 11)**

Covering Letter (2012), Mumbai artist Jitish Kallat's walk-through installation specially made for this exhibition, looks back to an equally violent time. A historical document becomes a transparent veil, an evocative and permeable tunnel between a miserable past and unsure present. Projected on a fog screen is a letter from Mahatma Gandhi, pacifist father of India's independence, written in 1939, immediately before the outbreak of the Second World War. In not very fluent English, he addresses Adolf Hitler, the German *Reichskanzler*, as the only person who can, "prevent a war which may reduce humanity to the savage state. Must you pay that price for an object however worthy it may appear to you to be? Will you listen to the appeal of one who has seliberately [*sic*] shunned the method of war not without considerable success?" The rest, as they say, is history. But this letter is here today as a memorable, pertinent, and ultimately futile confrontation between the forces of humanity and barbarism. **(fig. 12)**

In *The Oven of Straw* (2012), a new, specially commissioned work by Hong Kong-based art collective MAP Office, archival material is presented from a range of films in reference both to Ukraine's historic and economic role as the barn of Europe and "as a starting point for a meditation on the fragility of capitalism." [0] An installation and two-channel video projection, this work explores the symbolic role of wheat as a valued system of exchange, contrasting the role of the speculator with that of the poor laborer or seasonal worker, yet both can be crushed by intractable forces of nature. Extracts from DW Griffith's silent film *A Corner in Wheat* (1909) are contrasted with wheat-filled landscapes from a range of Soviet filmmakers including Aleksandr Dovzhenko, Sergei Eisenstein, Aleksandr Medvedkin and Ivan Pyryev. This theme is further extended in Fred Zinnemann's Hollywood musical *Oklahoma* (1955), Terrence Malick's elegiac hymn to the prairies *Days of Heaven* (1978), and finally in *Wheat* (2009), He Ping's historic Chinese epic of war and home. **(fig. 13)**

Folkert de Jong's large pigmented polyurethane and Styrofoam tableau *The Shooting . . . At Watou* (2006) returns to the origins of modern capitalism by exposing how ideals, however noble, often deny human feeling. Although inspired by Goya's famous painting *El 2 de Mayo de 1808* (1814), [9] a cry of outrage against the violence of the Spanish War of Independence (1808–14), de Jong takes a very different view. Here the moral point of Goya's painting is turned on its head in a David-and-Goliath allegory in reverse in which the heroism and probity of the victor cannot be taken for granted. **(fig. 14)** A different order of power relations, but not necessarily conclusion, is played out in Ola Kolehmainen's twenty-meter-long photographic frieze *Composition with David and Goliath* (2008). Here one insignificant weed struggles for both notice and survival within the modular regularity of a seemingly unending facade built by avant-garde architects Future Systems for a shopping center in Birmingham.

9 | Rashid Rana | **Desperately Seeking Paradise II** | 2010–11 | UV print on aluminum and stainless steel | 386.4 x 386.4 x 332.1 cm | courtesy the artist and Tiroche DeLeon Collection & Art Vantage Ltd. **See also pp. 178-83**

10 | Lara Baladi | **Chronologie** (from **Diaries of the Future**) | 2010 | permanent prints on Somerset paper | 220 x 980 cm | courtesy the artist

11 | Lutz Becker | **The Scream** | 2012 | a homage to the cinema of Aleksandr Dovzhenko | three-channel film transferred to video installation | 10' | courtesy the artist

12 | Jitish Kallat | **Covering Letter** | 2012 | fog screen projection | **See also pp. 174–177**

13 | MAP Office [Laurent Gutierrez + Valerie Portefaix] | **The Oven of Straw** | 2012 | two-channel film converted to video installation with MDF board, straw bales, and neon | courtesy the artists

14 | Folkert de Jong | **The Shooting . . . At Watou; 1st of July 2006** | 2006 | pigmented Styrofoam, PU spray foam, rope, wood, iron | 2000 x 800 x 300 cm | courtesy the artist and James Cohan Gallery, New York

15

16

In de Jong's installation, however, the action is transposed away from the present to the Eighty Years War (1568–1648), which marked the struggle for independence of the new Dutch Republic from Spain. The macabre, lumbering victim, over three meters high, grimacing before certain death is Spain; the much smaller, righteous-looking executioners represent the Dutch. By paradoxically reverting to the origins of the Dutch State, fuelled by Calvinism, capitalism, and national self-righteousness, de Jong makes it clear, in a somewhat Brechtian way, that he is actually referring to the religious, economic, and political conflicts of the present. This imaginary incident rooted in what seems to be eternal actuality—a field execution by anonymous soldiers—makes a general point about the pathology of violence and how often it is unquestioned by those in power who perpetrate and benefit from it.

Greek artist Stelios Faitakis also uses the past to depict the present in *Pincer of Germany – Revolution of Machno* (2012), a new, large wall-painting made especially for the exhibition. In a style and range of colors that reference Mexican murals, classical Persian miniatures, and Orthodox icons, he re-presents motifs from the best and worst incidents in the history of Ukraine. These include the peasant army under the black banner of anarchist revolutionary Nestor Machno during the 1920s, the brutal Battle for Kiev, and the tragic massacre of Jews at Babi Yar in 1941. **(fig. 15)**

In a body of work first shown in London last year, Jake & Dinos Chapman present their contemporary version of *Entartete Kunst*, "Degenerate Art," by imagining that the Munich exhibition of the same name organized by the Nazis in 1937 espoused, rather than denounced, modernism. Here skeletal SS-uniformed figures gurn and gape at oversized, child-like abstracts and dinosaurs, observed by a flock of feral pigeons (one of them pooping insouciantly on an errant Nazi). In this parody of an exhibition which could almost be a large art fair, the Chapmans are returning to one of their favorite targets: the conformist, homogenous pretentiousness of the contemporary art world and how this expresses much more unpleasant external realities. Many of the sculptures on display are like parodies of the orthodox modern art of the 1960s or '70s. Their obvious childishness speaks for itself. The stuffed birds actually accomplish what Maurizio Cattelan could only dream of in his intervention in the last Venice Biennale. [10] The skewed humor of these slapstick depredations sets up both a mirror and an allegory about how wealth, influence and power can be manipulated, about how a gilded cage can render art impotent, and about how culture is sometimes a front to launder ill-gotten gains. **(fig. 16)**

This and other works make the rather depressing point that culture is often a mask for lack of civilization, and progress little more than a hackneyed dream. Old forms of oppression have come to an end but their rapacious handprint can still be found in new, so-called independent, regimes. [11] After all, capitalism views the whole world as little more than a series of markets to be prized open and exploited. The fragile benefits of Adam Smith's "invisible hand" have patently failed to "trickle down" to benefit the whole of society. [12] The public ideals of freedom, democracy, and human rights have often been cynically regarded as adjuncts of power, rather like commodities or weapons, which can be dispensed sparingly, as if they were aid, scattering compliance or silence in their wake.

* * *

"The Best of Times, The Worst of Times" reflects on seemingly utopian dreams of freedom, equality, and security, as well as on their opposites: terror, inequity, poverty, and war, that are very much at the heart of our lives today. It is this destructive impulse—some may say necessity — within both man and nature that seems to make a more ideal or stable life impossible. Yet the Kantian idea of "artistic autonomy," a human right much derided by Marxist critics, is one of the significant survivors of this age of revolutions. Without it, art would always be the servant of some greater

[10] Cattelan's installation *The Others* (2011) consisted of 2,000 stuffed pigeons positioned at high levels throughout the Italian Pavilion. [11] See, for example: Anna Politovskaya, *Putin's Russia*, London, The Harvill Press, 2004, and Basil Davidson, *The Black Man's Burden: Africa and the Curse of the Nation State*, London, 1992. [12] Adam Smith (1723–1790), Scottish social philosopher and pioneer of political economy who believed that the market was benevolently governed by "an invisible hand." [13] This includes Arsen Savadov and Vasily Tsagolov. [14] Paolo Falcone, "Interview with the Artists," in Ilya and Emilia Kabakov, *Monument to a Lost Civilisation*, Milan, Edizioni Charta, 1999, p. 17. [15] Note from the artist November 30, 2011.

17

18

19

power, and contemporary criticism would end up as little more than a small, rudderless, leaky boat at the mercy of a boundless, all-consuming tide.

Ukraine was created in its current form in 1991 after the break-up of the Soviet Union, yet the Ukrainian culture and language are rooted in antiquity. As is the case with any new country, it seeks to establish and clarify its identity by looking back, long before statehood, to patriots, artists, filmmakers, and others who were either born or lived there. The search reveals a roll call of famous Russian figures as well as of members of the early 20th-century avant-garde that was violently suppressed by Stalin in the 1930s and '40s. Classic writers such as Anton Chekov and Nikolai Gogol jostle against later personalities such as Isaac Babel, Myhailo Boychuk, Mikhail Bulgakov, David Burliuk, Aleksandr Dovzhenko, Aleksandra Ekster, Vasil Yermylov, Kazimir Malevich, Viktor Palmov, Esfir Schub, and Vladimir Tatlin, who all lived and worked in Ukraine. However, as we can easily recognize from contemporary life, those who are hailed as national patriots by some are just as easily denounced as terrorists by others.

Ukrainian artists today, however, have to deal with a very different environment, and works shown here by Mykola Matsenko, the REP collective and Vova Vorotniov (fig. 17), as well as by an older generation discussed below, [13] deconstruct and rearrange symbols of Ukrainian and other identities in ways that are intended to both expose and exorcise post-Soviet legacies. Ilya Kabakov, an artist who, although born in Ukraine, is associated with the generation of Moscow Conceptualists from the 1970s and '80s, has embarked on a similar exorcism throughout his work. In his large, anti-monumental installation *Monument to the Lost Civilization,* made in 1999 with Emilia Kabakov, he pulls apart the meanness, absurdity and cruelty of a system that ruled over Russia, Ukraine, and many other states for over 70 years. Kabakov's contrasting vision of official and interior life in the time of the Soviet Union shows "a dream, a wonderful paradise where everything works [and] . . . completely the opposite. It is depressing, pessimistic about the future in which life is miserable. It is a crazy combination of everyday life and the paradise constructed by propaganda." [14] (fig. 18)

In *Russian Woods* (2012), the St. Petersburg artists' collective, Chto Delat? ("What Is To be Done?") employs the Brechtian medium of *Lehrstück* ("learning play") to focus on present problems of national representation, discipline and power. Here they question the strategies used by the establishment in Russia to benefit from political, economic, and social change. In this new work, made especially for the Biennale, they touch on popular perceptions and misrepresentations of politics and power as well as on how different groups of people can be mobilized to interpret reality in a more pragmatic way and to work for change.

As well as reflecting the complex culture, history, and genealogy of this region, the Biennale also refers to recent cataclysmic changes in the balance of wealth and power throughout the world in which the mixed legacies of the European Enlightenment have almost seemed to disappear. The crisis in socialism and the whole idea of public space, adventures in the Gulf and Afghanistan, corporate greed, and the collapse of belief in capitalism, the rise of Chinese and Indian influence, the "Arab Spring" and "Jasmine Revolutions" in northern Africa, and the continuing civil war in Syria, have all clearly revealed that the now-challenged hegemony of the west has been fatally compromised.

Sound and Fury (2012), a three-channel video installation made especially for this exhibition by Dihn Q. Lê, a Ho Chi Minh City-based artist, was triggered by the recent wave of revolutions in North Africa and the Middle East. (fig. 19) Using archival footage from Vietnam's turbulent history, it is a lamentation for lost ardor and revolutionary ideals that have been replaced by what the artist describes as "an authoritarian system, where kleptocracy is business as usual." [15] It is a passionate call to re-examine the idea of revolution and what it should really mean.

15 | Stelios Faitakis | Pincer of Germany – Revolution of Machno (P o G – R o M) | detail | 2012 | latex, acrylic, and spray paint | this site-specific installation was painted in two arches on the ground floor of the Mystetskyi Arsenal | courtesy the artist and The Breeder, Athens

16 | Jake & Dinos Chapman | The Almighty Disappointment | 2011 | detail | clothes mannequins painted cardboard | David Roberts Art Foundation Collection, London

17 | Vova Vorotniov | Terra Cosaccorum | 2012 | digital print on aluminum | four pieces, 90 x 60 cm each | Vorotniov combines monochrome images of devastated Cossack lands with degenerate or kitsch representations of romantic Cossack folk life | courtesy the artist

18 | Ilya & Emilia Kabakov | Monument to the Lost Civilization | 1999 | room installation of 140 artworks | 25 x 25m | courtesy the artists and Pace Gallery, New York

19 | Dinh Q. Lê | Sound and Fury | 2012 | three-channel video installation | 10' | courtesy the artist

On their current score, neither modernity nor post-revolutionary society could be deemed a success. World poverty has reached record levels in spite of there being the resources to alleviate it. [16] The problem, it seems, is that poverty breeds upon itself, the resources are all in the "wrong place," and there is no way to "free them up." Yet, although poverty can be found almost everywhere, its incidence across the world is largely linked with race. Together race and poverty constitute a dinosaur in the sitting room that few people deign to notice. Environmental despoliation also continues apace and many people (and some governments) are in denial, although it is obviously destroying our future. But progress and population growth mean that the people must have energy. After the disasters of Chernobyl and Fukushima, nuclear power seems to many more of a threat than a blessing.

In seemingly childlike sculptures and installations, Japanese artist Kenji Yanobe reflects on the seduction and terror of nuclear fission, as well as on the potential devastation it brings in its wake. The iconic mushroom clouds of the atomic weapons dropped on Japan in 1945 are a starting point, yet, as a young boy, Yanobe also remembers visiting a more benevolent representation of nuclear power in the form of artist Taro Okomoto's sculpture *Tower of the Sun*, which in 1970 became the central symbol of the ground-breakingly futuristic World Expo in Osaka. (fig. 22) Both views run parallel in Yanobe's work. His installation, *Blue Cinema in the Woods* (2006), is ostensibly a playground for children modeled on a Soviet prototype in which the serially repeated toy-like figure of *Torayan* (in yellow anti-radiation suit) is modeled on a ventriloquist's dummy that belonged to his father. In the short-cartoon-like film projected in this space, his father and *Torayan* joke together, heightening the absurdity of propaganda films from the 1950s, also shown, that are completely oblivious of the dangers of radiation. (fig. 23) As part of his research Yanobe visited the devastated site of Chernobyl, and one of the works he made is shown here. His most recent, a sculpture more than six meters tall, *Sun Child* (2012), is a reaction, embodying both pain and hope, to the impact of the devastating tsunami that struck the Tohoku area of Japan last year, [17] as well as to the still continuing disaster at the Fukushima Daiichi Nuclear Power Plant.

A different kind of evidence is presented in Tomoko Yoneda's stark, minimal photographs that show the landscape of contemporary Japan expressed in the faces of ageing families, devastated coastlines, deserted townships and nationalist extremism. Yet the bleakness of this view is mitigated by the fragile transience of her images' beauty. For the artist they are a distillation of Japanese history, sensibility, and thought. Are these images representations of "Good and evil? Normal and abnormal? Faithful and unfaithful?" she asks herself. "It seems that existence is ordinarily defined in terms of polarities. But what comprises good or evil, normal or abnormal? These things are invisible." [18] (fig. 21. see also p. 91, figs. 12–14)

In her new five-channel video installation *Kurchatov 22* (2012), Almaty-based artist Almagul Menlibayeva combines documentary footage with surrealistic pantheism in a work that focuses on the continuing legacies of the arms race as seen today at the now-abandoned Soviet nuclear test site of Semipalatinsk where, both above and below ground, bombs many times the strength of those dropped on Hiroshima were detonated. Not only did the blast and radiation scour and devastate the surrounding countryside, it also still continues to harm the people who live there. (fig. 24. See also p. 115, fig. 18)

Danica Dakić's new film, *Sretno / Good Luck* (2011), shown for the first time, is set in a now almost disused coal mine in Bosnia-Herzegovina. The name of the mine means "good luck," a daily greeting among miners that dramatizes ever-present danger. This is expressed at the opening of the film (fig. 20) by a young woman dressed as a chimney sweep, a widespread symbol of good fortune. A relic from the golden age of industrialization, in 1949, at its height of production, this mine broke all records by exceeding the yields set in 1936 by Soviet miner Aleksei Stakhanov in Ukraine's Donbas. [19] It

20 | Danica Dakić | **Sretno / Good Luck** | 2011 | video projection | 27' 51" | courtesy the artist

21 | Tomoko Yoneda | **Cumulus #2 Chrysanthemums** | 2011 | c-print | 83 x 65 cm | courtesy the artist

22 | Taro Okomoto | **Tower of the Sun** | Osaka World Expo | 1970

23 | Kenji Yanobe | **Blue Cinema in the Woods** | 2006 | projector, film, steel, aluminum, Geiger counter and other media | 225 x 218 x 218 cm | courtesy Yamamoto Gendai, Tokyo

24 | Almagul Menlibayeva | **Kurchatov 22** | 2012 | five-channel HD video installation, surround sound | courtesy American-Eurasian Art Advisors LLC

25

is now deserted. The narrator, caretaker and a former miner himself, like Charon, the ferryman to Hades in classical Greek mythology, moves between the darkness of the pit and the daylight. **(fig. 20)** Dakić describes the film as follows: "As eight coal miners take us ever deeper into the world beneath the earth, the caretaker's voice recounts a yet untold dream—one he dreamt as a young man; a dream of his past life as someone else, and of his rebirth. Is an existence in a dream just another level of the real?" [20]

* * *

It is impossible to know exactly how others experience something or what they perceive. And in art, the subjectivity of the observer identifies and combines with the vision of the artist in recognition of the harsh beauty of truth. Here lies the soft but implacable power of what is good in good art and this is why, almost to a man, dictators and despots fear and hate it. It may seem banal to assert that things are not always what they seem, yet the adage is true and in vast tracts of the totalitarian world, irony and allegory became everyday means of telling the truth. In the early 1930s, optimistic, enthusiastic, official paintings of Ukrainian peasants on newly formed collective farms masked the reality of ravaged landscapes, widespread famine and mass murders. At the same time, without any hope of public display, Kazimir Malevich (1879–1935) and members of his Leningrad Circle made sketches of solitary, faceless peasants standing alone in desolate wastelands. **(fig. 26)** Malevich was lucky in not being arrested, yet his associates were interrogated and incarcerated; some were murdered in the Gulag. [21]

Although they were never published at the time, Daniil Kharms's (1905–1942) now-famous *Incidents* absurdly listed random scenes of death and violence just as if they were normal, everyday events. Kharms was also arrested a number of times and died in prison. Yet violence, abuse of power, and art's reaction to it were not purely local phenomena. In his racial hatred and abhorrence of what he described as *Kulturbolschewismus* ("Cultural Bolshevism"), Adolf Hitler also attacked the autonomy of art as a prelude to the murder of millions. He was not alone; during the 1960s and '70s, Mao Zedong was to embark on a not so dissimilar project.

Throughout the whole of the troubled 20th century, in both East and West, the subject in art had been wounded, fragmented, broken, and reconstituted in both real and symbolic acts of sacrifice and violence that, while the world fell apart, the creative autonomy of art claimed the power to ameliorate. Widespread dreams of a better, fairer world have still to be enacted. Democracy in whosoever name—the people, proletariat, elected government— continues to privilege the minority. Yet, in spite of this, many people are actually happy, even in the darkest of circumstances. And good art too, however dark it may have to be, lies somewhere near the heart of humanity and happiness.

II. Lord Price and Miss Value (A Short Digression on Judgment)

One day Lord P, a rich man who had recently been admitted to the British aristocracy, went to an auction and bought a contemporary art installation for a very large sum. This caused a sensation in the saleroom. Even the auctioneer nearly fainted and the successful bidder was swamped by the popping of paparazzi and endless interviews on CNN. "It must be good because I think it is," said the proud collector "and because I had to bid a lot for it, many other people must also have thought the same thing." It was, in fact, a rather nondescript installation by a famous artist and the high price was based more on his name and the size of the work than on its aesthetic merit. But the court magicians had cast a spell on the work and no one breathed a word of this before, during or after the sale. This did not really matter anyway. Because he was famous, the artist was extremely popular and many collectors wanted to be his friend. This increased the demand for anything he made.

25 | In his photo and video installation **Bomb Ponds** (2009), Cambodian artist Vandy Rattana slowly reveals the forgotten realities behind these bucolic scenes. Between 1964 and 1973, the US Air Force dropped 2.7 million tons of bombs on Cambodia. All that now remains are these beautiful, seemingly natural, bomb craters in which the water is still toxic and causes degenerative disease. | courtesy Sa Sa Bassac, Phnom Penh

26 | Kazimir Malevich | **Peasant and Horse** | 1928–32 | oil on canvas | 57 x 43 cm | Musée Nationale d'Art Moderne, Paris | not in exhibition

[16] There are many different indications of world poverty but there can be little doubt that the present situation is extremely serious and largely avoidable. According to the World Hunger Education Service, one in seven people are seriously under-nourished, while other indicators show that at least 80 percent of humanity subsists on less than USD 10 a day. For over one half of the world access to clean drinking water is becoming an increasingly serious problem. The tragedy of widespread water shortage is obliquely alluded to in Kader Attia's installation, *Untitled (No Water)*, 2010. [17] The 9.0-magnitude Tohoku earthquake of March 11, 2011. [18] Artist's note, March 30, 2012. [19] Stakhanov gave his name to a new kind of shock worker: the Stakhanovite, a man-machine who exceeded all expected norms of production. [20] Artist's note, March 24, 2012. [21] See pp. 113–114.

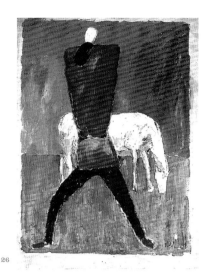

26

The next day, before the work was shipped to its new owner, an elderly cleaner at the auction house was working in the storeroom. He looked up at the work and could not understand what all the fuss was about. Certainly it was large—and different—but not really so different from the artist's work in earlier sales. "Maybe that's the point," he chuckled to himself, "this fellow has become a luxury and his work has to cost a lot. This one is top of the range—a Lamborghini or a Prada, certainly not a Lada or an H&M!" Now, satisfied with this reasoning, and feeling that he understood a little better the machinations of the art market, the cleaner went outside to have a smoke.

Soon after he had left, Alice V, a young intern who was also studying for a PhD at a famous art-history institute, cautiously entered the room. She had taken little notice of the work before the auction but now wanted to take a closer look to test her own judgment. Echoing the simple yet terrifying maxim of her old professor at the Humboldt, "Is this work really any good?" she now asked the same thing to herself. "And what in any case do I mean by 'good'? In art, because it is autonomous, the only designation of quality can be that which is pertinent to it and that must be its aesthetic quality. There can be no other standard," she thought but nervously remembered that in contemporary art a can of shit may be as significant as an oil painting and that there was no overarching McKinsey-like method in which one could tick boxes to come to an easy "objective" judgment. The only way for her to make any assessment was through deep reflection about the thing itself and where it fitted in. In any case, it was not "significance" she was interested in but artistic quality.

"Is it really any good?" she asked herself again as slowly she began to realize that what she thought of as "goodness" located art within a zone that in both western and eastern philosophy could be broadly called "moral." But, of course, she realized that this did not mean that the work in question had to be moralistic or moralizing. Far from it! Whether one agreed with this or not, art could only exist within a moral field which imposed no obligation on the individual artist to have any moral stance whatsoever. The art would just have to be "moral" in spite of itself. Alice was of sufficiently young an age that such paradoxes appealed to her.

And so she walked round and through the work for what seemed an age, looking at it from different angles, close up and far away, even changing the light levels to see what would happen. She discerned much cleverness but little excitement. And what she had come to call the "knock on effect," the suggestibility of the work and the way it could enable one sensation and train of thought to build on another, was almost completely absent. She concluded that the whole experience has been rather like attending a dull dinner party at which the guests could only talk about themselves rather than about their experiences and opinions of other people, things, and the world at large.

Regretfully she came to the conclusion that, although competent, this work was not at all "good" and deduced that although price and value sometimes coincide they are not related. Only this could explain why so much contemporary art she valued was excluded from the market. She knew that art was made all over the world and it could not *all* be bad, yet the market would only embrace the relatively small circle of what it already knew and could identify, and was only occasionally prepared to speculate on what it didn't. What a shame it was that so much good art in the world simply did not have a home either in the great private collections or public museums! She thought of this as "refugee" or "homeless" art because even where it was made people did not really value it.

"Art if it is any good," she mused "has to be necessary in that its strong point of view and internal structure reverberate throughout many other fields. The market was merely a mechanism that denoted the price someone would pay rather than an indication of aesthetic value." At this point the words she had once heard from Sebastian M, a friend of her uncle, shot into her mind: "A cynic is a man who knows the price of everything and the value of nothing." [22]

27

27 | Lam Tung Pang | **The Huge Mountain** | 2011 | ink, charcoal, pencil, acrylic and transferred image onto plywood | 300 x 500 cm | courtesy the artist and Hanart TZ Gallery, Hong Kong

28 | Ai Weiwei | **Circle of Animals (Zodiac)** | 2010 | bronze, twelve pieces | installation variable | courtesy AW Asia, New York

29 | Shanghai-based artist Liu Jianhua's work **Discard 2** (2011) contrasts the white porcelain out of which it is made with the appearance of being trash—or the remains of a terrible accident. It was installed at the bottom of a shaft in the former Arsenal building as if it were some archaeological discovery. | courtesy the artist

[22] Sebastian Melmoth, an alias adopted by Oscar Wilde while hiding in Paris. This epigram first appeared in his play *Lady Windermere's Fan* (1892). [23] Alice wanted to be a curator in one of the national art museums, but unfortunately these, like the health service and the universities, had been privatized by the time she had graduated. She ended her days inventing titles for exhibitions as head of public relations in the world's largest museum of contemporary art. [24] Contemporary Chinese artist Cai Guo-Qiang, whose work *Nursery Rhymes*, produced in 2011 by Isolyatsia in Donetsk, has been included as part of the Biennale's Parallel Program, has long been fascinated by Maksimov's impact on Chinese art. He has assembled a collection of over 230 examples of Maksimov's work and has recently exhibited these at major cultural institutions in China. See p. 308, fig. 16. [25] Michael Sullivan, *Chinese Art in the 20th Century*, London, Faber & Faber, 1959, pp. 23–30. The Chinese Republic was founded in 1911, and Sun Yat-sen became its first provisional president in the following year. [26] Lam Tung-Pang, *Long View Under Scrutiny*, (exh. cat.), Hong Kong, Hanart TZ Gallery, pp. 17, 18. [27] The Old Summer Palace was looted and destroyed in October 1860. The two Opium Wars (1839–42 and 1856–60) were fought between Britain and China to assert the right of British traders to export opium and other goods to China in defiance of its laws and to gain other trading and residency rights. Hong Kong was temporarily ceded to Britain as a result of the First Opium War. [28] Ed.'s note: In 2013, collector François Pinault, who owns Christie's parent company Kering, returned the rat and rabbit heads during a diplomatic visit to Beijing by French president François Hollande. How he acquired them from Bergé is not known. Christie's was subsequently given a license to hold auctions in mainland China. [29] Yinka Shonibare, press release, New York, James Cohan Gallery, February 2012.

"I haven't got time to be cynical!" she exclaimed, stamping her foot. "An independent view has to be the lifeblood of aesthetic judgment. If everyone has a financial stake in the value of a work, conflict of interest is inevitable. Why, the whole art world would become like a game of cricket without an umpire! If there are neither rules nor referees to enforce them, whose opinion can you take at face value?" She sat down and was silent for a while. "I have still a lot to learn and I might often be quite wrong," she thought to herself, "but unlike that installation my independent judgment is really beyond any price." [23]

III. The Journey (Heroes and Monuments)

In 1955, Stalin Prize-winning painter Konstantin Maksimov (1913–1993) embarked on a long and arduous journey which took him from the Surikov Institute of Art in Moscow, where he was a professor, to the Beijing Academy of Arts where, for the next two years, he instructed a whole generation of Chinese artists in the methods and theories of Soviet Socialist Realism. The reason for this was not that the Chinese did not know how to paint—they had a refined, unbroken tradition that extended for at least eleven centuries—it was that they just did not know how to paint in the right way. [24]

Although Maksimov did not realize it at the time, his journey was part of a much broader trajectory that continues to the present. During the 19th century, the West had initially begun to show an interest in China as a market for opium and other goods; it also seemed an easy prey for extending its own rapidly expanding empires. The Chinese Empire had also begun to decompose as a result of corruption and entropy. Established artistic traditions came to be regarded by many Chinese as both anti-modern and synonymous with an old way of life that embodied feudalism, hierarchical Confucian beliefs, and backwardness. Traditional art and aesthetics were sidelined, and beauty as it had been understood for centuries suddenly began to seem empty. The modern national culture engendered by the new Republic of China (1912–49) began to lead art down a path of social concern and populism that later dovetailed into the aesthetic ideology of the Chinese Communist Party. [25]

Hong Kong-based artist Lam Tung-Pang combines the traditional Chinese painting styles of *shansui* ("mountains and water") with the contemporary dynamism of Japanese *manga* as a way of expressing both the challenges and paradoxes of living and working at the edge of China. In the two large works shown here, *The Huge Mountain* (2011) **(fig. 27)** and *The Youngest and Oldest* (2011), he combines a number of different monochrome styles and motifs taken from traditional painting manuals, some painted or drawn but others transferred directly onto the raw plywood ground. These are enthusiastically integrated with colorful, almost childlike, depictions of the kinds of modern tower blocks that typify Hong Kong and many other rapidly growing Chinese cities. In contrast to the avant-garde desire to subvert or even destroy old art—as expressed in the work of many mainland artists—Lam feels the need to invoke something he describes as "ancient and rigid," not so much out of conservatism but out of the need to make art that is "uniquely individualistic, a quality that enables [the artist] to either dismiss or accept pressure or criticism." [26]

In *Circle of Animals (Zodiac)* (2010), Beijing-based artist and human-rights campaigner Ai Weiwei eschews the idea of artistic individuality in a typically Duchampian way by faking, or making a replica of, the set of zodiac heads originally designed by the Italian Jesuit Giuseppe Castiglione (1688–1766) for the Qianlong Emperor (reigned 1735–96). Castiglione, who had arrived in China in 1715 and was court artist to three emperors, introduced western perspective to Chinese painting and also designed a number of western-style buildings. *The Zodiac* was part of an ornate water clock and fountain made especially for the Old Summer Palace (Yuan Ming Yuan), a monumental complex of gardens and pavilions that was looted and eventually destroyed nearly one hundred years later by British and French troops. This action, a

28

retaliatory gesture for the torture and murder of twenty British subjects, brought the Second Opium War (1856–60) to an ignominious close and is still widely resented in China as an unwarranted act of cultural vandalism. [27] Five of the zodiac heads survived and gradually made their way back to Beijing, but in February 2009 two more, the rat and the rabbit, from the collection of Yves Saint Laurent and Pierre Bergé, suddenly appeared for auction at Christie's in Paris. The Chinese government unsuccessfully tried to stop the sale and Bergé, the surviving owner, perhaps rather disingenuously, caused further affront by offering to return the heads to China on the condition that its government respect human rights and free Tibet. At the sale each work sold for 15 million euros. Cai Mingchao, the successful purchaser and also a member of China's Lost Cultural Relics Foundation, refused to pay the price on principle, creating both a hiatus and a scandal. [28] **(fig. 28. See also pp. 202–205)**

On grounds of public security, Ai Weiwei, who at this point had decided to remake the whole of this partially lost work, is banned by the Chinese government from using social media, giving interviews, or traveling. This is because of his widely voiced criticisms of the government, particularly in relation to cover-ups of corruption following the large earthquake in Sichuan Province in 2008. He also finds that the design company belonging to his wife is under investigation for alleged tax evasion. In truly Kafkaesque style, he is fascinated by questions of interpretation and power and, in the case of the *Zodiac*, particularly by how a work made by a European Jesuit nearly 250 years ago can suddenly become a militant symbol of traditional Chinese culture. Uncritical nationalism, he feels, is used as a smoke screen for state control and masks "the biggest crime of a dictatorship, the eradication of feelings from the people." Setting aside its imposing physical presence, *Zodiac* succeeds not only because it engenders ambivalence about Chinese culture and history, but also because it expresses the inflexible, complex, and often inhumane ways this culture and history is manifested in the present.

Following on from the installation of his widely acclaimed work *Nelson's Ship in a Bottle* in 2009 in Trafalgar Square, the symbolic heart of the British Empire, London-based artist Yinka Shonibare continues his elaborations of Lord Nelson's contemporary significance in his *Fake Death Pictures* (2011), "a re-enactment of suicide through the history of death in painting." Here he reconstructs dramatized photographic tableaux of Admiral Nelson's death in action at the Battle of Trafalgar (1805) in five photographic allegories based on different scenes in historical paintings. Shonibare suggests that his reflection on heroic myth is emblematic of the position of the West in the world today: "The imperial West is in decline at a time of great economic challenges as we see the rise of the East. The old world is in decline and new worlds are emerging through the economic successes of China and India and the revolutions in the Arab world. We are re-experiencing a new age of the 'Decline and Fall of the Roman Empire.'" [29]

29

Since his first solo exhibition in 1992, Japanese artist Makoto Aida's work has been characterized by sardonic social critique underlain by forthright nihilism and anger. His initial target was the mindless arrogance and aggression represented by Japan's imperial past and how this still continues in a bastardized form in the present. In a staggering range of production, he has deconstructed the history of traditional and modern art in Japan, including its war paintings, and reassembled it as a critique of bourgeois heartlessness in a demotivated society. In the battle for urban cultural life, Aida's principal enemy is the gray-suited "salaryman," whose reputation for unquestioning conformism, lubricious sexlessness, and lack of individual spirit he abhors. In a recently completed seven-meter-wide painting, *Ash Color Mountains* (2009–10), which at a distance looks like the misty peaks of a classical Chinese or Japanese landscape, the corpses of salarymen are piled high, each depicted in loving detail, slumped higgledy-piggledy over office equipment on a vast gray tumulus. [30] **(fig. 30. See also pp. 87–89, 228–235)**

* * *

30

30 | Makoto Aida | installation view of **Ash Color Mountains** | 2009–11 | acrylic on canvas | 300 x 700 cm | courtesy of Mizuma Art Gallery, Tokyo | Taguchi Art Collection

31 | Luo Gongliu (1916 – 2004) | **Mao Reporting on the Rectification in Yan'an** | 1951 | oil on canvas | 164 x 236 cm | not in exhibition

32 | Chinese Cultural Revolution poster **Greet the 1970s with New Victories of Revolution and Production** | 1974 | not in exhibition

33 | AES+F | **Allegoria Sacra** | 5-channel HD video installation | 2012 | 48' | courtesy the artist

34 | Yeesookyung | **The Very Best Statue in Kyiv** | 2012 | FRP | 190 cm | courtesy the artist

[30] See pp. 230–237. [31] Hoxha followed this line until the death of Mao in 1976, when he broke with China and pursued a completely independent but equally disastrous policy. [32] See David Elliott, "Painting of the Stalin Period," *Engineers of the Human Soul. Soviet Socialist Realist Painting 1930s to 1960s*, Oxford, Museum of Modern Art, 1992, pp. 10–17. [33] As early as 1926 members of AKhRR had argued for a new form of "Heroic Realism." See VH Perelman, "Ot peredvizhnichestva k geroicheskomu realizmu," and NG Kotov "Chto takoe geroicheskii realizm?" in VH Perelman (ed.), *4 goda AKhRR 1922–1926*, Sbornik I, Moscow, 1926, pp. 102–125; 126–135. [34] The acronym AKhRR stands for Association of Artists of Revolutionary Russia. [35] These terms were only used in the West and then not until the 1960s. In official terms within the Soviet Union, art that was unacceptable to the union was either not art or worse: criminally subversive anti-Soviet politics. [36] Arnold Chang, *Painting in the People's Republic of China: The Politics of Style*, Boulder, Colorado, Westview Press, 1980. [37] See C. Vaughn James, Soviet *Socialist Realism: Origins and Theory*, London, 1973, and David Elliott, "The Battle for Art" in D. Ades, T. Benton, D. Elliott and I. Boyd Whyte (eds.), *Art and Power: Europe under the Dictators 1930–1945*, London, Thames & Hudson, 1995. [38] A concern touched on peripherally in Soviet aesthetics in the concept of *ideinost* (new, progressive thinking). [39] Chang, op. cit., pp. 7–8, 73–77. [40] See Igor Golomstock, *Totalitarian Art*, London, The Harville Press, 1991.

Even before Mao Zedong became the founding father of the People's Republic of China in 1949, many political and cultural links had been forged between the Chinese Communist Party and the Soviet Union, particularly during the War of Liberation (1946–49) against the Nationalists. This resulted in a quasi-Soviet style of heroic painting by such artists as Luo Gongliu (1916–2004) **(fig. 31)** and Hu Yichuan (1910–2000), the former traveling to Leningrad to study in 1955, the same year that Maksimov had moved to Beijing. In 1950, Mao and Josef Stalin signed a Sino-Soviet Treaty of Friendship, Alliance and Mutual Assistance, which continued until 1960 when China broke it off, feeling that the Soviet Union had deviated from the correct path of Communism by undermining the legacy of Stalin and appeasing the West. In the following year, Albanian president Enver Hoxha also broke with Moscow and followed the Beijing line. [31]

But even though the peasants' and workers' paradise had been enshrined in the new People's Republic in 1949, this did not mean that there was any clear direction as to what form or aesthetic the new Chinese art should adopt. The Soviet government had encountered this problem earlier in their Cultural Revolution (1928–32) and they had solved it initially by stealth, turning art groups against each other in a series of polemical battles that focused on identifying "enemies" of the new social and political order. The conflicts however quickly veered from aesthetics, dismissed as "bourgeois" and "idealist," to genetics, defined as the class origins of the newly empowered proletariat. Yet this provided little guidance on what a work should depict or how it should look. In spite of all the politics, artists were still individuals.

By April 1932, Stalin and the Central Committee feared that these battles were spiraling out of control and decided that the Party should take a firm hand. A resolution *On the Reformation of Literary-Artistic Organizations* accordingly decreed that all artistic groups, with their magazines and journals, should be disbanded and that artists who supported "the platform of Soviet power" should come together into centralized, state-controlled unions for each individual art form.

This brought the proletarian arts movement to an end and replaced it with art that was directly controlled and regulated by the Party. Yet, just as the identification of enemies had tended to be imprecise because it was based on personal rivalries, as well as on the family backgrounds, friends and associates of the victim, so the establishment of positive standards for official art was similarly vague. [32] The doctrine of Socialist Realism was officially announced at the First All Union Congress of Soviet Writers in 1934 when newly appointed culture boss Andrei Zhdanov mouthed Stalin's words by exhorting writers to become "engineers of human souls" and to use the method of "revolutionary romanticism" to stand with "both feet on the ground of real life." It was left to the artists' unions to decide what this meant in the stylistic terms as it related to each medium and discipline. In painting and sculpture, artists who during the 1920s had been associated with the realist, ultra-conservative AKhRR group were the most favored. [33] It seemed like a return to the academic painting of the 19th century. [34] Art that did not fit in with the new union's vague definitions was subsequently labeled (only in the West) as "dissident," "unofficial," or "non-conformist." [35]

Unlike Stalin, Mao was a reasonably talented poet and calligrapher, and was faced by a similar dilemma. Traditional styles of painting were neglected and taste gravitated towards more easily accessible folk art or revolutionary graphics. [36] Yet, unlike in the Soviet Union where tenets of *partiinost* (the expression of the central and leading role of the Communist Party in all aspects of Soviet life), *klasovost* (awareness of and commitment to the class struggle) and *narodnost* (awareness of national destiny and of the importance of the masses in achieving it), [37] had provided a loose infrastructure for Socialist Realism, Mao made a firm distinction between what he described as *puji* (popularization), something close to *narodnost*, and *tigao* (the raising of aesthetic standards). [38] For Mao, both of these had to be present in any

31

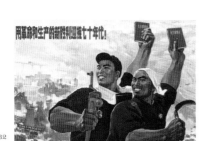

32

33

34

worthwhile work of art. [39] However, as the People's Republic lurched from one economic disaster to another, the inherent contradiction between popularization and aesthetic improvement caused great tension, the former predominating over the other.

The stage was now set for Mao's own Cultural Revolution (1966–76). Like Stalin had previously, he consolidated control by purging senior party members and "Smashing the Four Olds"—his way of describing established habits, customs, culture, and ideas. He quickly achieved this goal, like Pol Pot in Kampuchea (now Cambodia) did after him, by mobilizing a young, impressionable, violent, and often barely educated generation of Red Guards. (fig. 32)

Only in the early 1990s, after the end of *perestroika*, did official, as opposed to nonconformist, Russian art begin to find a place in the western art market. The same is now proving true for official art from China, although its "nonconformism" has long been exhibited in the West. In much contemporary art originating from China, as well as from Ukraine, Russia, and other post-Soviet countries, the aesthetic language and iconography of officialdom has been re-appropriated and turned on its head to combine the pain or melancholy of the past with the absurd inequities of the present.

* * *

The coruscatingly sarcastic romantic *and* neoclassical idealism of *Allegoria Sacra*, the most recent part of Moscow-based AES+F's immersive video triptych—a *Gesamtkunstwerk* covering hell, paradise, and now purgatory— is constructed out of photo-animations related to compositions of famous old master paintings, also one of the sources for the secular monolith of Socialist Realism. [40] Like the other works in this series, it presents a critical image of the world that celebrates an unholy marriage between the abuses of Putin's Russia and the aggressive arrogance of the West's sense of entitlement. (fig. 33)

Unlike the disquieting, sputtering, computer-game violence of the sadistic children in *The Last Riot* (2005–07) (hell), or the frenetic, multicolored consumerism of *The Feast of Trimalchio* (2009) (paradise), this work is monochrome and slow. Purgatory is after all a reception hall for the dead, and the artists have chosen to make this a vast airport lounge, based on the title, subject matter, and arid open space of the painting *Allegoria Sacra* (c. 1490–1500) by Giovanni Bellini (c.1433–1516) that hangs in Florence's Uffizi Gallery. The ostentatious vulgarity and inequity between the north and the global south that permeated *Trimalchio* (fig. 35) is replaced here by a stasis and lassitude underwritten by something that could either be a clash or syncretization of civilizations that reference both the image and content of Bellini's enigmatic work. In life, it seems to say, death is the only real point of equality. It is where we all end up—whatever our culture, belief, or religion.

Korean artist Yeesookyung's new work, made especially for the Biennale, *The Very Best Statue of Kyiv* (2012) combines cultural syncretism with democracy through the ironic path of a rather different trajectory. (fig. 34) It is the most recent outcome of a questionnaire sent out to local citizens in different cities, asking them which depicted features (from different sculptural and religious traditions) they think would make the best work. In Kyiv, the work shown in this Biennale is the outcome of the local peoples' vote. (see also pp. 278–285)

The images in Miao Xiaochun's computer-generated digital paintings, *The New School of Athens* and *Parnassus* (both 2009), based on frescos by Raphael, are also derived from the western tradition in which he studied. (fig. 36) As their titles imply, these works deal with the subject of learning, knowledge, and civilization, challenged by the naked homogeneity of seemingly oriental CG figures based on the artist's own body. Here, the humanistic tradition is re-imagined as either a horror story or puppet

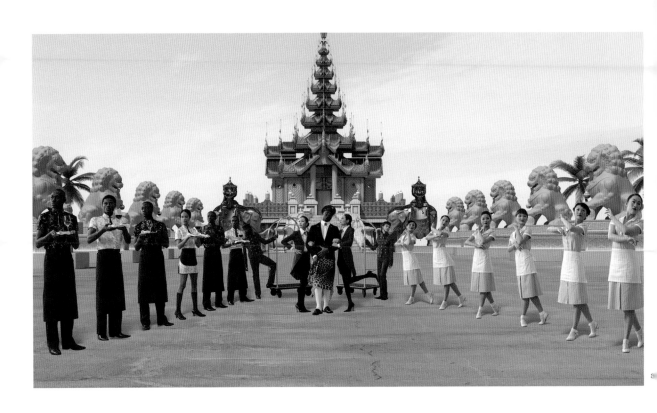

37

38

show. No less disconcerting are the apocalyptic themes in his related 3D video *Restart* (2008–10), which begins with an animation of Pieter Breughel's *The Triumph of Death* (c. 1562). Here, one famous western masterpiece morphs into another and classical civilization crumbles into modern chaos. Seminal paintings such as Goya's *The 3rd May 1808* (1814) and Gericault's *Raft of the Medusa* (1819), highlight one of the most positive legacies of the European Enlightenment: the artist's duty of conscience to expose abuse, violence, and oppression. As the video continues, images of the present also begin to take hold, some reflecting China's recent economic growth and technological prowess. Yet no triumphalism is intended in what after all is a continuing cycle. In Miao's works, the figures, dead or alive, represent everyman—his joys and horrors as well as the endless struggles between life, love, and death.

The intensely colored, minutely detailed, almost hallucinatory imagery of New York-based artist Fred Tomaselli's newly made paintings provides a contemporary parallel for a descent into hell. *Tower of Peace Towers* (2008) hearkens back to the idealism of 1960s peace movements in Europe and the Americas, when building and decorating towers became a symbol of youthful solidarity. But here the structures are thrown on top of each other in a bonfire of vanities in which good intentions evaporate in dark toxic smoke. *Starling* (2010) picks up on earlier images of birds, a particular interest of the artist, by making reference to the premonition of doom in Edgar Allen Poe's 1845 poem *The Raven*. Shown in silhouette with its beak gaping open, it seems as if this predatory bird could consume the whole universe, depicted here as the chaos of "an abstract expressionist background." *Generator* (2012), made especially for this exhibition, is a much larger rendition of a never completed small study. As with most of Tomaselli's landscapes, this depicts the gothic, survivalist underbelly of the American paradise. The chimney of Thoreau's idyllic cabin at Walden Pond seems to be churning out the redolent multiheaded snake symbol of the Maoist Symbionese Liberation Army: "I've always wanted to make it bigger, since I think it would gain malevolent force at a larger scale." [41] A glowering apocalyptic twilight is dwarfed by a many-headed hydra—an image derived from Hindu mythology and the seven-headed beast of the biblical apocalypse. (fig. 38)

The words of the apocalypse, as well as the classical myth of Icarus, are invoked in a radically different form by Shen Shaomin in his new installation, *I Saw the Face of God* (2012). Here metallic debris from the first Chinese space flight in 2004 is riveted with apocalyptic text in the tactile characters of Braille writing for the blind. The name of the first rocket was *Shenzhou*, meaning "God's Ship." "Human beings are like blind men when we face the universe," the artist writes. "Yet we are filled with short-sighted and prideful madness in our fantasies of conquest, occupation, invasion. We attempt to control what we cannot understand. But the situation is gloomy. Is it only when we recognize our blindness that we can 'see' how our conceit and folly will cause our demise?" [42] (fig. 37)

In Trenton Doyle Hancock's two epic mixed-media paintings, *Descension and Dissension* and *The Bad Promise* (both 2008), the American Dream has been transformed into a mythical, racially charged battleground. On the good side are the comical, color-loving, meat-eating "mounds" who attack the knobbly, misanthropic, white-skinned, subterranean "vegans." But neither side has any hope of victory; the only product of this conflict is fear. Here, the apocalypse is played out within a stylistic deconstruction of western modernism that cannot fail to reflect contemporary American life. In the spirit of Argentine poet Jorge Luis Borges' description of the Falklands War (1982) as "two bald men fighting over a comb," Hancock enthusiastically marshals the blobs of Abstract Expressionism against the cartoon-like tropes of Crumb and Guston in an epic, even biblical, fight to the death for what seems to be, in the end, a sclerotic cause. [43]

35 | AES+F's panoramic nine-channel video installation The Feast of Trimalchio (2009–10) transposes Petronius's fable of unbridled consumption and luxury to the present in which Asia or Africa are merely places for enjoyment and their inhabitants are obedient and carefully manicured servants | courtesy the artists

36 | Miao Xiaochun | The New School of Athens | 2009 | digital painting on canvas | 346 x 500 cm | courtesy the artist and Osage Art Foundation, Hong Kong

37 | Shen Shaomin | I Saw the Face of God | 2011 | Rocket debris, steel, rivets, rock salt | variable dimensions | Redtory Museum of Contemporary Art collection, Guangzhou

38 | Fred Tomaselli | Generator (Large) | 2012 | photo-collage, acrylic resin on wood panel | 182.9 x 182.9 cm | courtesy the artist and James Cohan, New York

[41] Email to the author, December 2, 2011. Henry David Thoreau (1817–1862) was an American author, poet, philosopher and naturalist. The Symbionese Liberation Army (SLA) was militant left-wing group active in the United States between 1973 and 1975. It considered itself a revolutionary, vanguard army. The group committed bank robberies, two murders, the kidnapping of Patty Hearst, and other acts of violence. [42] Shen Shaomin, note to the author, November 10, 2011.

39

40

41

Ukrainian artists Arsen Savadov and Vasily Tsagolov, who first emerged in the late 1980s and early '90s, have both made large new paintings for the Biennale. Their take on the apocalypse is through an ironic form of anticapitalist realism. Savadov, in particular, reflects on the hypocrisy of the present in a perversion of traditional archetypes, while Tsagolov's work *The Ghost of Revolution* (2012) refers to the geriatric obsolescence of power and protest. (fig. 40) In the paintings of Lesya Khomenko, who belongs to a younger generation, the heroism of previous worker figures is revisited, yet their style, color, and mode of installation distances them from historic models to make reference to the real situation in which many working people currently find themselves. Mykola Ridnyi and Nikita Kadan both touch on unpleasant realities of surveillance or control. Kadan's *Procedure Room* (2009–10) is a set of "souvenir plates" incongruously printed with drawings used to instruct local police in the use of torture, while Ridnyi's new installation *Platforms* (2012) reinvents the plinths of heroic monuments as if they were works of art in themselves and now appear as neo-Constructivist sculptures.

As can be seen from works in the Biennale by such radically different artists as Vyacheslav Akunov, Lutz Becker, Phyllida Barlow, Choi Jeong Hwa, Aleksandra Domanović, Stelios Faitakis, Daniel Faust, Rodney Graham, Liu Jianhua, MadeIn Company, Erbossyn Meldibekov, Anila Rubiku, Yinka Shonibare, Song Dong, Canan Tolon, Wang Qingsong, and Mikhail Ridnyi, the idea of the monument with its desire to fix moments in the past—as well as the subtext of its mutation or disintegration in the present—is a continuing concern in art. As Bojana Pejić makes clear in her accompanying essay, "This is Tomorrow," the monument has traditionally been a means of holding the past, yet when this is no longer stable, it becomes either like the ruins of a lost civilization or the serendipitous trash of the present. Or, in a world without real heroes, it can quickly mutate into a gravestone—commemorating only those who can no longer speak for themselves—as a kind of stark warning in the present.

Canan Tolon, an artist based in both Istanbul and San Francisco, has in her site-specific installation *What Game Shall We Play Today?* (2012) created a disquieting fragmentation of reflections using police interrogation two-way mirrors facing each other. Incongruously, a child's swing hangs between them creating what the artist describes as a rather sinister "playground, a merry-go-round fit for a lunapark . . . that touches upon such subjects as interrogations, policing, incarceration and torture, political intrigues, and games." [44] In the age of rendition, perhaps this could be a monument to the invisible political prisoner?

In her new work made especially for the Biennale, Albanian artist Anila Rubiku aestheticizes the all-pervasive legacy of ex-president Enver Hoxha's system of national defense by making it into an installation. Symbols of resistance against a nonexistent enemy, *Bunker Mentality/ Landscape Legacy* (2012) elaborates the paranoid form of the concrete bunker (about 750,000 ruins still litter the country) in a "celebration" of the economic stagnation caused by the same mentality in which Albania is still mired. (fig. 41) Difficult to demolish and expensive to remove, they have even become a kind of kitsch national emblem in the form of souvenirs and ashtrays. In some cases they have actually been transformed into kiosks, storerooms, cafes, discos—even a chapel. Yet in spite of their ostensible normalization, these structures still mask a largely unknown story of violence and sorrow.

Vyacheslav Akunov from Uzbekistan proposes a no less critical but more direct view of power in his new works: *Superstar*, a Hollywood-style red carpet with embedded images of historic and actual politicians and world leaders, and *Monument to a Match* (both 2012), a model tower made out of matchboxes with depictions of "inflammatory" political leaders serially plastered onto them. (figs. 1, 43, see also p. 121, fig. 28) Kazakh artist

39 | Erbossyn Meldibekov | **Peak Communism** | 2012 | beaten enameled sanitary ware | courtesy the artist and Rossi & Rossi, Hong Kong

40 | Vasily Tsagolov | **The Spectre of Revolution** | 2012 | oil on canvas | 250 x 550 cm | courtesy the artist

41 | Anila Rubiku | **Bunker Mentality/Landscape Legacy** | 2012 | mixed media | dimensions variable | courtesy the artist

42 | Yang Fudong | **Ye Jiang (The Nightman Cometh)** | 2011 | 35 mm black-and-white film transferred to video | 19'21" | courtesy the artist and ShanghArt Gallery, Shanghai | In this poetic, single-screen work Yang enlists the character of an ancient wounded warrior as an enigmatic "neo-realistic" foil to equally anachronistic figures from the 1920s or '30s. Drowning in the incomprehensibility of their own emotions they founder within a snowstorm of signs and melancholy that points to the present.

[43] Robert Crumb (b. 1943) is an American artist, illustrator, and musician. Founder of the Underground Comix movement in the 1960s. Philip Guston (1913–1980), an important member of the New York-based Abstract Expressionists who, in the late 1960s, became a leading neo-expressionist, employing a cartoon-like style. [44] Canan Tolon, email to the author April 8, 2012.

43

44

43 | Vyacheslav Akhumnov | **Monument to a Match** |
2012 | matchboxes | 155 x 40 x 40 cm | courtesy the artist

44 | Song Dong | **Wisdom of the Poor** | 2005–12 |
Living with the Pigeons | 2005–06 | variable
dimensions | courtesy Pace Gallery, Beijing.

45 | Wei Dong | **Nosy #1** | 2011 | acrylic on canvas |
102 x 101 cm | courtesy the artist and Hanart TZ Gallery,
Hong Kong

46 | Wang Qingsong | **Goddess** | 2011 | photopanel |
180 x 250 cm | The artist not only confines the Statue
of Liberty within the bamboo scaffolding of a chaotic
Chinese building site but also dresses her in a Mao jacket,
satirizing the superstitious fetishization of people's belief
in ideology. Wang also touches on the sore point that
communist China now owns a significant portion of the
US national debt. In a capitalist system, does this mean
that China now owns part of that liberty?

47 | Zhou Zixi | **Liberate Beiping China 1946–1949** |
2007 | oil on canvas | two panels: 160 x 120, 150 x 200 cm |
courtesy the artist and ShanghART, Shanghai

[45] As with their Russian and Ukrainian opposites, the practice
of these artists also takes other directions, but I have decided to
concentrate here on those works that reflect these problems of
history which have still not been exorcised. [46] See, for example
the work of Quentin Massys (1466–1529). [47] Zhou Zixi, *China
1946–1949* (exh. cat.), Shanghai, ShanghART Gallery, 2007.

Erbossyn Meldibekov shows how the iconography of public monuments
has changed between Soviet past and national present, often with only
the plinth remaining. In a series of upturned, old-fashioned bath tubs,
hammered into outlandish landscapes, he also re-creates the abused peaks
and valleys of the Hindu Kush and Tianshan Mountains, which have not
only been host to countless conflicts but have also regularly had to change
their names according to the whims and ideologies of the governments in
power. (fig. 39, see also pp. 116–118)

Since the early 1990s, the previously Soviet protectorate of Mongolia
has skillfully managed to embrace both the best and worst aspects of
independence. Many different tendencies in art can now be found there,
but the strongest work has moved away from the European tradition
to appropriate the traditional *zurag* style that is rooted in the hieratic
painting of Tibetan and Mongolian Buddhist *thangkas*. The subjects,
however, are far from traditional. High levels of tension and revulsion
against corruption can be seen in the socially critical paintings of
Baasanjav Choijiljavin. Reminiscent of the Weimar drawings of George
Grosz (1893–1959), they ferociously expose corrupt capitalism and
profiteers. The same sentiments are reflected in a less violent way in the
lyrical, more introspective feminist works of Uurintuya. (See pp. 108–119,
figs. 2, 3, 13, 14)

But, as we have seen, the influence of Maksimov's actual and metaphorical
journey stretched much further than Mongolia or Central Asia. A number
of artists such as Wei Dong, Zhou Zixi, or the younger MadeIn Company,
also reflect on the shared hollowness of their collective past: the time of
the Liberation and Cultural Revolution, when in China the "Russian style"
went into overdrive and ran riot. [45]

Wei Dong's paintings refer back to the ritual humiliations of the Cultural
Revolution, but with a gendered twist: the denounced enemies/victims
are all young women. As in Stalin's purges, "intellectuals and capitalist
freeloaders" were routinely publically humiliated and forced to confess
their "crimes," but the artist updates these tragic occurrences into scenes
of sadistic voyeurism. In *Democracy* (2010), a half-naked woman, a refugee
from a painting by Jan Vermeer with a Duchamp urinal at her feet, stands
in the midst of a crowd of threatening figures. This is as much about the
empty confusion of present day politics as it is about the past. In *You
Are a Bird* (2010), the surrealistic nightmare of humiliation is repeated
but the girl is blindfolded, standing in a Congress Hall full of Red Guards
with a dead bird round her neck and an all seeing portrait of Mao in the
background. This refers back to a disturbing memory when a fellow
student of the artist was sentenced to death for a minor theft; now,
in a spirit of expiation, he makes the figure rise above the crowd as if
she were a goddess. In *Nosy #1* (2011), the female becomes more
complicit. Like the treasure in a Renaissance painting of moneylenders,
she is an object of desire, curiosity, and amusement for the crowd of
men around her. [46] (fig 45)

The three paintings from the series "China 1946–1949," made in 2007
by Zhou Zixi, also occupy a territory somewhere between high art and
kitsch. Busy with what has been described as "the banality of amnesia,"
they bring together motifs from China's chaotic development in the "best"
and "worst" of current social and economic change. In a skillful montage
of past and present, he quotes ironically, but also not completely without
admiration, heroic archetypes associated with the years of struggle that
led to the foundation of the People's Republic. [47] (fig. 47)

The Wisdom of the Poor (2005–12), a large installation developed by
Beijing-based conceptual artist Song Dong, steps outside the heroic
tradition of the fine arts to create a monument to the aesthetics of
everyday life. In densely populated Chinese cities this has increasingly
revolved around creative economic and utilitarian uses of space as a

result of severely cramped living conditions. The artist explains the synthesis of Zen, ingenuity and bureaucratic savvy needed to make the best out of such bad situations: "The *Wisdom of the Poor* shows how Beijing's *hutong* dwellers engage in a conscious 'borrowing of rights' to expand and improve their living conditions. [People] were constantly taking over what had formerly been public areas, and turning them into private spaces of their own. Yet, because so many were squeezed so tightly together and sound carried so easily between homes, the resulting private space was never 'private' in any real sense of the word. When there was no public space left to expand into, and several households found themselves living around a piece of open ground occupied by a tree, it seemed to be a situation they could do little about ... Local laws and regulations forbade the residents from chopping it down. The wise among them, however, were able to take possession of this space by 'borrowing the tree,' incorporating it into their own home and allowing it to grow out of what was now the center of their bed ... I collected a lot of material from family homes that were being destroyed because of redevelopment and have preserved this kind of wisdom by showing how people used to enclose and construct many different kinds of spaces to make their lives better." [48] (figs. 44, 48. See also pp. 206–213)

Xu Zhen, the Shanghai-based artist who founded the MadeIn Company in 2009, has described his enterprise as "a limited democracy." [49] In this formation, each employee contributes ideas and Xu, as art director, makes the final decision. Unlike in Andy Warhol's Factory or Takashi Murakami's company Kaikai Kiki, however, he does not attempt to embrace either capitalism, or any other system, but seeks rather to question both authority and orthodoxy. The works from 2011, shown here, result from such an approach. *Prey*, comprises three sumptuously detailed oil paintings of "poor people's houses" based on photographs taken on a research trip to Sichuan. By working against the manipulation or sentimentality of the media, widespread grinding poverty is made picturesque and elevated to the status of a seductive commodity. *Play*, two hanging sculptures of bound, naked "tribal" women, is derived from sadomasochistic depictions of bondage and combined with colorful images of "exotic, primitive" cultures. Here, the prisons of ethnicity and sexuality are breached by making both pain and vicarious pleasure evident in the exploitation and voyeurism of neocolonialism. This idea is continued in *Divinity* but directed more towards the realm of ideology. A series of massive polyurethane foam sculptures are carved in a pseudo-primitive style as if they were the charred artifacts of a dark, primordial culture. Their absurd subjects and studied crudity, however, express the almost comic combination of power, frailty, and banality that characterizes so many of our contemporary institutions and gods. (figs. 49, 50. See also pp. 218–227)

IV. The King is Dead ... (What Now?)

In its bittersweet elevation of intransigence and vulnerability *The King* (2011), one of Paul McCarthy's most recent installations, is reminiscent of some of his earlier videos. [50] At the center of the work, enthroned on a raised dais, a nude, silicon self-portrait of the artist, with closed eyes and long silver hair, presides over the space. While we are not sure whether this imposing figure, like Rip van Winkle, is alive, dead, or just sleeping, it seems as if he is located outside normal time. [51] Throne room, altar, or artist's studio, the location is not clear. Behind him a vast unfinished portrait of a semi-naked black man is pointedly propped on an easel. The four air-brushed paintings leaning against the columns echo dated posters or vulgar paparazzi photographs and flank four rows of pews which, along with the naked figure and its partially severed limbs, reinforce the disquieting impression that perhaps we should be venerating this body rather than thinking of obeying it.

48 | Song Dong | **Shan Shui – Mountains and Water** | 2012 | from the series "Wisdom of the Poor" | 2005–12 | courtesy the artist

49 | Xu Zhen | **Divinity: Marx** | 2012 | polyurethane foam, leather | 205 x 130 x 450 cm | courtesy the artist

50 | Madeln Company | **Play 1** | 2011 | silicon, iron, cotton filling, hemp cordage, fur, feathers, shells | 80 x 80 x 170 cm | courtesy the artist and ShanghART Gallery, Shanghai

51 | Olga Chernysheva | **Trash Man** | 2011 | color video, sound | 6'30" | courtesy Diehl Gallery, Berlin

[48] Song Dong, press release, Beijing, UCCA, 2011, and conversation with the author, Beijing, December 18, 2011. A *hutong* is a traditional Chinese building with a courtyard. [49] "Made Up Interview of Xu Zhen by Chris Moore" in *Action of Consciousness*, Shanghai, Madeln Company/ShanghART Gallery, 2011, p. 20. [50] For administrative reasons relating to transport, this work was not ultimately shown in the exhibition. [51] Rip van Winkle is the hero of a short story by Washington Irving, published in 1819, set in New York's Catskill Mountains. After drinking a magic potion, the hero fell asleep and awoke twenty years later in a completely changed world. He had completely missed the American Revolutionary War, George III was no longer king and his children had grown up. [52] Maxim Gorky, *The Lumière Cinematograph*, July 4, 1896.

50

51

This ironic image of everyman as either king or god can be looked at in many different ways. Its contemplative simplicity is in contrast with the unwarranted sense of entitlement that has corrupted western values. Its trashy imagery refers to the leveling kitsch of commercialism, easy money and sexual exploitation. Its absurd hierarchy lampoons abuse of power of whatever kind. Its pseudo-portentousness throws into relief the overweening pride of an art market that tries to make artists into mini-gods. Its somnolence implies oblivion. And the obvious discrepancy between the three-dimensional white figure of the king and the painted black body of the figure behind him reflect harsh social and economic divisions of race within the formal politics of aesthetic representation.

This work is also a reflection of the arbitrariness and pathos of power: the king wears no clothes, his eyes are shut, the rows of benches in front of him are empty and his body has been subtly mutilated. In Kyiv, this work inevitably glosses the false heroism of a Socialist Realist past while at the same time depicting the vainglorious mess in which we all find ourselves today. Above all, it is an image of a world that is bankrupt of spirit, creativity, leadership, and energy and ruled by a self-serving gerontocracy with a past but no future.

In her short video *Trashman* (2010–11), Olga Chernysheva captures a similar sense of nobility amongst worthlessness but without using irony. It focuses on the figure of Eldar Usmanov, a guest worker from Uzbekistan, who collects rubbish in a large Moscow cineplex. Standing still at the end of each film, holding the trash bag open for the audience to deposit their rubbish, he seems both peripheral and ageless. To the background music of the changing soundtracks of each film, from its solemn, almost heroic, beginning to its mystical fade out, he stands passively, almost invisible, absorbed by his surroundings. Only then does he become human, as his animated, smiling face is shown as the final titles roll. There is something touchingly noble in the way Usmanov now conducts himself as the star of this film. Shot in a cinema, in what Maxim Gorky memorably described as "the kingdom of shadows" this no-longer anonymous worker at last reigns supreme. [52] (fig. 51)

Zamach (Assassination) (2011), the final part of Israeli-born artist Yael Bartana's film trilogy *And Europe Will Be Stunned...* (2007–11) that premiered in the Polish Pavilion at the 2011 Venice Biennale, revolves around the activities of the Jewish Renaissance Movement in Poland (JRMiP), a fictitious political group that calls for the return of the 3.3 million Jews who lived in Poland before World War II. Of course this population disappeared in the Holocaust and through emigration, and these films describe the subsequent tragic history of Europe and the Middle East, scarred by competing nationalisms, conflicts, and interests, intertwined with narratives of the Israeli settlement movement, Zionist dreams, anti-Semitism, and the Palestinian right of return.

The story of *Zamach* puts the dream of a multinational community to the ultimate test. It shows the funeral ceremony of Sławomir Sierakowski, the charismatic, idealistic leader of the JRMiP, who had been murdered by an unidentified assassin. After respectful, but tense and unyielding, elegies by both Poles and Israelis at the victim's funeral, the viewer is left in a state of uncertainty over the actual status of the JRMiP. Is it an allegory, a hallucination, or rather a concrete and constructive possibility for the future of Poland, Europe, and the Middle East? Has its young leader been sacrificed to preserve vested interest? Can the harmony of the past ever be reconstructed once it has been broken? Is there real hope in the future for change?

Kyoto-based Miwa Yanagi, one of the leading Japanese feminist artists of her generation, has since the early 1990s developed complex groups of work that express, by means of staged fantasies or theatrical tableaux, the power of women and their desire for autonomy. "Windswept Women.

52

53

The Old Girls Troupe" (2009), her most recent large series, was first shown in the Japan Pavilion at the 2009 Venice Biennale. In a wild, even threatening way, Yanagi collides youth with age in the dominating, photoshopped figures of five massive, goddess-like women, each four meters tall, whose features, skin, breasts, and hair are buffeted and distorted by both the artist and the wind. These forbidding, aged yet ageless creatures stand firmly, even ecstatically, against adversity, threat, and time. **(fig. 53. See also pp. 88, 90, 91, 236–239)**

Bill Viola's impressive film *The Raft* (2004) shows a similar triumph over adversity, yet the threat is not time but some unknown external force. The shock is considerable, yet not all is lost. The artist describes the work as follows: "A group of nineteen men and women from a variety of ethnic and economic backgrounds are suddenly struck by a massive onslaught of water from a high-pressure hose. Some are immediately knocked over and others brace themselves against the unprovoked deluge. Water flies everywhere, clothing and bodies are pummeled, faces and limbs contort in stress and agony against the cold, hard force. People in the group cling to each other for survival, as the act of simply remaining upright becomes an intense physical struggle. Then, as suddenly as it arrived, the water stops, leaving behind a band of suffering, bewildered, and battered individuals. The group slowly recovers as some regain their senses, others weep, and still others remain cowering, while the few with any strength left assist those who have fallen back to their feet." [53]

In slightly more than life-sized, carved polychrome wooden sculptures and large paintings of delinquent historical temptresses, Ana Maria Pacheco, a Brazilian-born artist who lives in the UK, has mapped out a very different kind of world: a mythic, post-Freudian world of male oppressive power counteracted by sly female revenge. Here subterfuge is the last resort of survival. *Shadows of the Wanderer* (2008), a work showing twelve interacting figures, is led by a young man carrying a frail old man on his shoulders. The people in the background seem anonymous, rather like shadows, subjects, followers, perhaps refugees, but they could also be commentators on the action, like a Greek chorus. This work is rooted not only in classical tragedy (it revives memories of Aeneas carrying his noble father Anchises away from the smoking ruins of Troy) but also in baroque Brazilian church sculpture, as well as in a flood of more recent photographic documentation showing multitudes of people all sadly displaced. Yet the work is perversely dominated by what the artist calls its "interior space," the ambiguous reflectiveness of the silent figures who, purposely it seems, position themselves behind the main action. [54] What is this silence? There is obvious tension in their gaze, yet its significance is made general. We are left with an overwhelming impression of fear and solitude—bleakly democratic feelings that can be recognized by all. **(fig. 52)**

Helsinki-based video artist Eija-Liisa Ahtila asked the inmates of a women's center to play most of the parts in her three-channel installation triptych *Marian Ilmestys – The Annunciation* (2010). The biblical story of the conception of Christ is for the artist "part of our shared common history, meaning that it belongs to our culture, whether you are a believer or not. It's a kind of metaphor that we're not always aware of. My installation has everything to do with the way that perception and knowledge are linked. And regarding miracles, I ask these questions: can an ordinary thing be mysterious? How does one recognize a miracle? And how do we recognize what is not familiar to us? Then how do we judge such a thing?" [55] Set in an artist's studio and divided into three acts, Ahtila invokes historical paintings of this scene in counterpoint to her partly improvised exploration of the encounter of Mary, the Angel Gabriel and the Holy Spirit. Two understandings of the world—one holy, one human—overlap and eventually interpenetrate in Ahtila's celebration of the potentially miraculous in everyday life.

54

55

VI. Epilogue (The Open, Level Playfield)

One way of thinking about the "best" and "worst" is as opposites, as part of a continuing dialectic within western logic, in which existence is formed by desire, choice and circumstance. Yet, in a different way, the best and the worst may be regarded as embedded within the same cyclical rhythm in which the finest dreams are inevitably crushed by uncontrollable forces, the worm of individual greed consumes collective balance and the green shoots of hope perpetually spring forth in the most sterile wasteland.

Certainly we seem perpetually to return to the idea of art and experience as an interlocked series of circles, capable of bridging heaven and hell in forms not so dissimilar to those imagined by Dante, unnamed Hindu or Buddhist monks, or even Aleksandr Solzhenitsyn. [56] In this sense the art shown here is the opposite of the theoretical platform associated with it, in that its production is an essentially redemptive leap into the unknown in an age of power and powerlessness.

The necessary tragedy within this or any other cycle is that empathy ultimately renders us human by triggering our feelings for others. This enables us to digest the immensity of both beauty and terror. Rooted in mud, as suggested by Choi Jeong Hwa's eleven-meter-wide golden lotus flower, we unfold, blossom briefly, and in our openness perceive the stars. It is an experience that we can neither deny nor forget. The apprehension of a beauty and vastness infinitely greater than we can understand is what enables us to be noble—even sovereign—in the universe. (fig. 54. See also pp. 272–277)

Or, to look at this question in another, more grounded way, within the "worst" redemption lies dormant, while what we think is "best" may be only illusory and harbor the seeds of its own destruction. Nevertheless, in spite of this alterity, our choices in life are vital, and there are few places where the complexity and ambiguity of such decisions may be explored as on the level playing field of contemporary art.

This open, level field is what distinguishes contemporary from modern art, for it is able to accept many different cultures and traditions. Obsessed by its own myths and drunk on its own power, modernity would only admit outsiders if they knew the right password. Now that we are no longer governed by a monoculture, the most important question relating to art is not whether something is "modern" or "contemporary" but rather if it is any "good." For the most part unbound by language, it is possible for visual art to be apprehended across the whole world—although, as implied in the two enigmatic, poker-faced self-portraits in Rodney Graham's work *Good Hand Bad Hand* (2010), it is unlikely that it will be appreciated by different people in the same way, even those in the same place. (fig. 55)

The intelligence, intuition, and humanity of the artists who have made the work in, and for, this Biennale is not directed towards providing any solutions. Art does not work that way. Rather, it gives inspiration by its example. In their critical, sardonic, humorous, or iconoclastic views of the world, in their ability to see and think outside the prisons into which we so often willingly confine ourselves, and in their clarity and commitment to truth in art, these artists energize us to go a step further—to experience and analyze more keenly for ourselves the causes and effects of life, the very fountainhead of creation. ●

52 | Ana Maria Pacheco | Shadows of the Wanderer | 2008 | carved polychrome wood | detail | courtesy the artist and Pratt Fine Art, Kent

53 | Miwa Yanagi | Windswept Woman | 2009 | installation view | four images | detail | 400 x 300 cm each | courtesy the artist and Loock Gallery, Berlin

54 | Choi Jeong Hwa | Golden Lotus | 2012 | Prior to the Biennale's opening, Choi's slowly inflating and deflating eleven-meter wide sculpture was installed next to the Ukrainian National Monument by Maidan Square in the center of Kyiv. | courtesy the artist

55 | Rodney Graham | Good Hand Bad Hand | 2010 | two light boxes | 89.5 x 74.3 x 17.8 cm | Lisson Gallery, London

[53] Bill Viola, note from the artist, November 18, 2011. [54] Ana Maria Pacheco, "Story, Silence and the Present Imagination," transcript of a discussion, London, St John's Church, Waterloo, November 29, 2010. [55] Eija-Liisa Ahtila, *Interview,* Blouin Artinfo, December 17, 2010. [56] Dante wrote *The Divine Comedy,* describing the circles of paradise, purgatory, and hell, between 1308 and his death in 1321. Mandala is a Sanskrit word meaning "circle." Different maze-like Hindu and Buddhist mandala images have been made that contain elements of paradise and hell on the road to enlightenment. Aleksandr Solzhenitsyn wrote his autobiographical novel *The First Circle,* about educated people in Moscow who remained under the threat of the Gulag, in 1968.

Part

Two

Stories

Who is Wearing the Trousers?

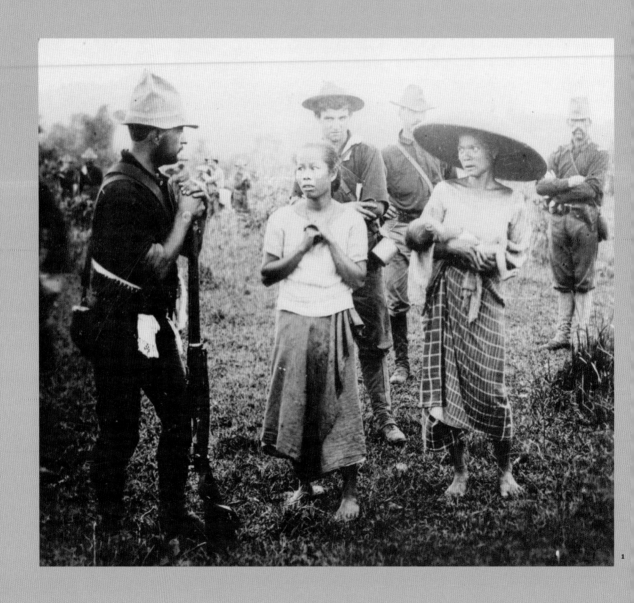

Southward of Lahore
WE SEE THROUGHOUT INDIA

A RACE OF MEN,

whose make, physiognomy,
and muscular strength,
convey ideas of an effeminacy

WHICH SURPRISES WHEN ...
COMPARED TO THE
FORM OF THE EUROPEAN

WHO IS MAKING
THE OBSERVATION.

Robert Orme
Effeminacy of the Inhabitants of Indostan
1785 [1]

The tumultuous close of the 18th century in Europe—marked by revolution, terror, and war across the whole continent—was a momentous time for the trouser. [2] In this febrile, paranoid atmosphere, breeches (*culottes*) were becoming too dangerous, outmoded, and aristocratic to wear as regular dress, and henceforth were to be confined to alpinism, hiking, Masonic and parliamentary rituals, shooting, and golf. The "modern" male trouser evolved out of this political hiatus—a new style based on a marriage of the full-leg French workers' *pantalon* with the long-hose tights or leggings that had been in circulation since the Middle Ages. Animated by horror of both *sans culottes* and the Terror, the earliest examples of this new garment appeared in anti-revolutionary, English high society during the mid-1790s when previous ideas of refinement in deportment and dress coalesced into the figure of the dandy, an assertive and refined form of what would have previously been called a "fop." [3]

In 1794, George Bryan "Beau" Brummell had joined the 10th Royal Hussars as a commissioned officer, and his sharp wit and snappy dress quickly caught the attention of the Prince Regent (the future George IV) with whom he became a close friend. (fig. 2) After leaving the army, Brummell became an arbiter of taste in London society and, according to his biographer, developed a unique decorum and style in direct response to "an atrophy [of] dress [that had] never [been] felt till the era of Jacobinism and of Equality in 1793 and 1794. It was then that pantaloons, cropped hair, and shoe strings, as well as the total abolition of buckles and ruffles, together with the disuse of hair powder, characterized the men." [4] By way of contrast, Brummell's new, fragrant, sleek style of dress, the antithesis of that of the French Revolution, was characterized by understated, perfectly fitted, and tailored garments, as well as by his "invention" of a tight, full-length "trowser" that "opened at the bottom of the leg, and was closed by buttons and loops." [5]

A scion of political upheaval, as well as a green shoot of the textile mills of the burgeoning Industrial Revolution, the fate of the trouser now began to bifurcate: one "leg" becoming more conservative, authoritarian, and standardized; the other increasingly outlandish, sometimes effeminate, and edgy in a tradition of dandyism that is still preserved. With regard to the former, the vexed question of "who wears the trousers?" began to be posed more often as the garment took on an independent symbolic life, expressing an implicit and growing conflict of the sexes: between inflexible, colonizing, masculine power (with concomitant abhorrence of female domination), and the chronic legal, social, political, and financial inequality of women. [6] (fig. 3)

In the early histories of both Asian and European theater, travesty—in the form of men dressing and acting as women—was the rule. Theater was rooted in the enactment of religious ritual in which, as elsewhere, men played the dominant role while women, regarded as the weaker, and in some religions "unclean," sex were excluded. [7] Outside theater, however, cross-dressing, either by men as women or vice-versa, took different forms, and there could be many reasons for it: a fundamental belief in the complementary energy of the sexes, the need for a trans- or third gender, a desire to transgress gender for personal, social or political reasons, or a carnivalesque urge to parody the world by turning it on its head. [8] It was not until the middle of the 17th century that women were allowed to work as actors in Europe, thereby opening up a completely new area for transgressive female impersonation by male actors that continues to the present in the work of drag queens and pantomime dames. In this comedic form contested, often illegal, LBGTQ rights have been asserted and re-enforced

In Japan, the male bastion of acting was not breached until the beginning of the 20th century, and then only by unconventional female performers such as Sada Yakko and Tokoku Takagi, who had first established their reputations abroad and, from 1913 at home, by the strange and continuing phenomenon of the Takarazuka musical theater in which all parts, including male roles, were played by young unmarried women. [9] Ruan Lingyu, the first woman silent-film star in China, made her debut in 1926, but her first massive hit

1 | J. Tewell | American soldiers confront two Filipinas and a baby begging for food during the Philippine-American War | 1899 | courtesy US Library of Congress. See p. 264, fig. 2

2 | Richard Dighton | caricature watercolor of Beau Brummell | 1805

3 | A colored print | c. 1780 | based on **The Transmutation of Sexes**, a satirical painting by John Collet | the man is obviously a soldier

4 | In New York, as early as 1851, the "emancipation dress" of Amelia Bloomer was ridiculed not only as being immodest, but also as only one step away from what was then regarded as the preposterous idea of dressing in an oriental style. See note 16

HALLOO! TURKS IN GOTHAM!

Mrs. Turkey having attended Mrs. Oaks-Smith's Lecture on the Emancipation-Dress, resolves at once to give a start to the New Fashion and in order to do it with more Effect, she wants Mr. Turkey to join her in this bold Attempt.

[1] Robert Orme (1728–1801) was the historiographer of the East India Company. His essay "Effeminacy of the Inhabitants of Indostan," an early but typically righteous apologia for British colonialization, was published in his book *Historical Gragmens of the Mogul Empire, of the Morrattoes, and of the English Concerns in Indostan from the Year MDCCLIX,* 1785, London, W. Wingrave, pp. 462–63. [2] See pp. 294–295 for a discussion of this time. [3] According to the *Oxford English Dictionary,* a fop is "one who is foolishly attentive to and vain of his appearance, dress, or manners" (first noted 1681), and a dandy is "one who studies above everything to dress elegantly and fashionably" (first noted c. 1780). [4] William Jesse, *Life of George Brummell, Esq., Commonly Called Beau Brummell,* London, Saunders and Otley, 2 vols, 1844, Vol. 1, p. 60. [5] "Brummell's tailors were Schweitzer and Davidson in Cork-street, Weston and a German of the name of Meyer who lived in Conduit-street . . . The trowser [*sic*] which opened at the bottom of the leg, and was closed by buttons and loops, was invented either by Meyer or Brummell: the Beau at any rate was the first who wore them, and they immediately became quite the fashion, and continued so for some years." Ibid., p. 64. [6] "She wears the trousers" is a common expression in English, meaning that a particular wife (or partner) is dominant, bossy, or overbearing and, by extension, that her husband—the "rooster"—is "henpecked." The archetypical duo of a "trouser-wearing" woman and her passive husband has been the source of much comedy (in England since at least Chaucer's *Canterbury Tales),* that also provokes a current of unease as it touches on fundamental male fears and desires. But, as we will see, when European women actually began to wear trousers this initially parodied and rejected male domination but later became a coquettish expression of sexual allure. In Asia, however, the idea of women wearing trousers struck a more military chord. [7] In classical Greek plays like Aristophanes's *Lysistrata* (411 BCE), in which the comedy pivots on women's power to influence men by withholding sex from them, men played all the roles. The actors, however, would have been wearing masks that expressed the character, emotions, and genders of the different parts they played. Throughout China, Japan, India, and Indonesia masks were also widely used as part of early ritual/theatrical performances. [8] Not all belief systems held that the genders were opposites but, as in the *yin and yang* of Taoism, complementary aspects of the same life energy. In 4th century BCE Athens, celebrations of the cult of the male-female god Aphroditus (later known as Hermaphroditus) were characterized by men and women exchanging clothing because the revealing of genitals in travesty was thought to avert evil influence and bring good luck. In South Asia, *hijra,* trans women, often eunuchs, have, since 2nd century CE, both worked in the sex industry and attended weddings and birth ceremonies to bring good luck. In India, Pakistan, and Bangladesh the government has recently recognized *hijra* as a third gender. [9] See p. 238 for a discussion of the Takarazuka Revue in relation to the work of Miwa Yanagi. Sada Yakko (1871–1946) formed an acting troupe that from 1899 toured widely in the US and Europe. See p. 67, fig. 14. Tokuko Nagai Takagi (1891–1919) was the first Japanese female cinema actor, appearing in four shorts produced in Hollywood between 1911 and 1914. Aaron M. Cohen, "Tokuko Nagai Takagi (1891–1919) Japan's First Actress," *Bright Lights Film Journal,* June 27, 2014, http://brightlightsfilm.com/tokuko-nagai-takagi-1891-1919-japans-first-actress/#.VwooRpN94UE [Last retrieved October 4, 2016].

5

6

7

Spring Dream of an Old Capital came four years later. The pressures on her, however, were immense and she committed suicide at the age of 24, provoking national mourning. [10] **(fig. 5)**

In the traditional Chinese story of *Hua Mulan,* adapted for Chinese opera, a legendary woman warrior from the Southern and Northern Dynasties (420–589) dressed like a man to defend China from its enemies. Until 1949, when Mao "liberated" the country, this and other female figures had always been played by men, and for the classic actor Mei Lanfang this proved to be one of his most testing and gender-fluid parts. Not only did he have to be convincing as a man acting as a woman, but also as a woman who, herself, was playing a man. During the 1920s and 1930s, Mei's fine rendition of this role provided a platform for sentiments of both patriotism in the face of foreign aggression and of support for women's rights at home. [11] **(fig. 6)**

Following in the steps of the Amazons, the Old Norse "shield-maidens," Hua Mulan, Joan of Arc, the *onna-bugeisha* of Japan (like Takeko Nakano who fell in battle), the Mongolian warrior princess Khutulun, or the Rani of Jhansi, [12] women had often cross-dressed for ideological, military, or economic purposes—as well as out of personal predilection. **(fig. 7)** Their sacrificially romantic roles as soldiers, seamen, or pirates have also been immortalized in numerous popular ballads and broadsheets. [13] But in Paris during the 1840s and '50s, at the height of *la vie bohème,* novelist George Sand (actually Amantine-Lucile-Aurore Dupin) dressed and called herself a man for different reasons: a capricious beauty, well-known as the lover of composer Frédéric Chopin and writer Alfred de Musset, she assumed male attire, and scandalously smoked tobacco in public, not only in protest against the hypocritical rigidity of male bourgeois society but also to get access to places and do things from which women were barred. [14] **(fig. 9)** In the trouserly spirit of Brummell, along with such fellow French writers and poets as Barbey d'Aurevilly, Charles Baudelaire, and Gustav Flaubert, she was inventing, and living, a new kind of hybridized modern existence, populated by the *flâneur:* a reactive wraith who surfed the sounds, sights, and smells of the city in celebration of a fluid, "unnatural," darkly romantic sensibility, consciousness, and art. **(fig. 10)**

As prostitution of all kinds flourished in the dark streets of Europe's rambling cities, women's fashions paid lip service to propriety while mixing a heady cocktail of salacious prudery. In unconscious echoes of the deformational practice of foot binding in China, tight-laced corseting, crinolines, and bustles created unnatural, fetishistic carapaces covering the female body that, by exaggerating form while limiting movement, encouraged fantasies of ripe submissiveness. [15] From the 1880s, when long dresses with high necks made the female silhouette sleeker, movement was still restricted by the tightness of the skirt. In reaction to this, and the patriarchic control it symbolized, the campaign for women's rights in Britain began to mobilize politically. The Women's Social and Political Union (WSPU) was formed in 1903, with Emmeline Pankhurst as its leader, and the popular press rapidly labeled its members as "Suffragettes." Women now not only demanded equal suffrage and legal rights but also freedom of movement and action such as being able to ride the increasingly popular bicycle. This created a demand for "bloomers," female trouser-like garments that would allow them to do so. [16] **(fig. 4)**

While British suffragettes were trying to liberate themselves from fashion so that they could ride bikes and vote, in Paris the trouser was being nudged in a more erotic direction. In 1911, couturier Paul Poiret, fanning the flames of the continuing French predilection for orientalism, as well as responding to the brouhaha caused by the exotic costumes and production designs of Sergei Diaghilev's *Ballets Russes* that had taken the city by storm during the two previous years, launched *Le Style Sultane* in which harem trousers emphasized, in an unprecedented way (in the West), the naturally sensuous lines of the lower female body. **(fig. 11)**

Throughout the Qing Dynasty (1644–1912), Chinese fashion had little place for trousers; these were worn as work clothes only by the poor. For both sexes,

8 9

[10] The first Chinese Hollywood female star was Anna May Wong (1905–1961), whose earliest film *The Red Lantern* appeared in 1919, but she had been born in Los Angeles of second-generation Chinese immigrants. Wang Yiman, "The Art of Screen Passing: Anna May Wong's Yellow Yellowface Performance in the Art Deco Era," Catherine Russell (ed.), *Camera Obscura 60: New Women of the Silent Screen: China, Japan, Hollywood,* Durham, North Carolina: Duke University Press, 2005, pp. 159–191. Ruan Lingyu (1910–1935). See Richard J. Meyer, *Ruan Ling-Yu: The Goddess of Shanghai*, Hong Kong, Hong Kong University Press, 2005. [11] The *Ballad of Mulan* was first transcribed in the 6th century. Mei Lanfang (1894–1961) was an internationally recognized actor in both the Peking opera and modern Chinese theater who, during the 1920s and '30s, performed widely in the West. Even after the Liberation (1949), when women were given the vote and other basic rights, he was still exclusively known for his female lead roles. Echoing the life of the militant feminist revolutionary Qiu Jin (see fig. 8), Mei first appeared in the play *Hua Mulan Joins the Army* in 1917, a story subsequently filmed in a three versions, becoming, in 1939, a Chinese propaganda epic without Mei, who refused to perform during the second Sino-Japanese War (1937–45). In 1998, the *Mulan* story was made into a Disney animated feature, with a sequel in 2004, and different versions of this story still continue frequently to appear. (With many thanks to Drew Hammond for pointing out the link between Mulan and Mei Lanfang). [12] Amazons, see pp. 292–293. In Scandinavian folklore and mythology the *skjaldmær* (shield-maidens), forerunners of the Valkyries, are women who have chosen to fight as warriors. Jeanne d'Arc (1412–1431) fought for the French King against the British in the Hundred Years' War, was accused of heresy for cross-dressing as a soldier, and burnt at the stake. Warrior and athlete, Khutulun (c. 1260–c. 1306), a daughter of Kaidu the Mongolian potentate of Central Asia, fought in many campaigns against the Chinese Yuan dynasty ruled by her cousin Kublai Khan; she insisted that any suitor in marriage would first have to defeat her in wrestling and is thought to be the basis for the character of Turandot in western literature and opera. The Rani of Jhansi (1828–1858), the queen of the princely state of Jhansi in north India and one of the leading figures of the Indian Rebellion in 1857, died heroically fighting the British; for Naiza Khan's homage to her see p. 190. (Thanks to Rachel Rits-Volloch for drawing my attention to the *skjaldmær* and to Khutulun). [13] As in the English ballad *The Female Rambling Sailor,* an early version of which was printed in Newcastle by W. Fordyce, c. 1830 and reproduced in David Elliott (ed.), *The Beauty of Distance: Songs of Survival in a Precarious Age,* catalogue of the 17th Biennale of Sydney, 2010, p. 126; see also Rudolph Decker and Lotte C. van de Pol, *The Tradition of Female Transvestism in Early Modern Europe,* New York, St. Martin's, 1989; David Cordingly, *Seafaring Women: Adventures of Pirate Queens, Female Stowaways, and Sailors' Wives,* New York, Random House, 2007. [14] George Sand (Amantine-Lucile-Aurore Dupin, 1804–1876), female French novelist. See George Sand (ed. Thelma Jurgrau), *The Story of My Life*, New York, State University Press, 1991. Published originally as L'Histoire de Ma Vie in Paris in 1855, this covered her development until the end of the Revolution of 1848. [15] In 10th-century China, the erotically stimulating "lotus foot"—created by breaking and binding the bones of the growing foot—first appeared in the Imperial court and then extended to the elite. By the Qing dynasty it had spread to all social classes and signified wealth and status in that the woman did not need to work. In the 19th century, it is estimated that 40 to 50 percent of all women had bound feet. In Europe, the corset first became popular in the 16th-century French court as a tightly laced, elongated bodice worn underneath the clothing to push up the breasts and emphasize the waist. The garment evolved according to different fashions but, by the mid-19th century, had changed its shape to create, with whalebone or steel spiral stays, an hourglass silhouette in which the breasts were supported over a tiny waist. By the end of the century there was concern that corsets were injurious to health and this stimulated a movement for rational dress. [16] In 1851, American temperance campaigner Amelia Bloomer publicly announced that she would adopt the new "Turkish dress"—a form of *shalwar* (for a discussion of this garment in context see pp. 294–296) that had made its way to New York State—because it allowed unrestricted movement and greater freedom. By the end of the year, the American Press had renamed this "outlandish" dress "bloomers." Although these garments and their wearers attracted much attention and mirth, they were not widely worn until the "bicycle craze" of the 1890s. Now "bloomers" refer to voluminous, long-legged female underwear. See fig. 4.

10

11

12

clothing was based on traditional northern Manchu styles of dress —a *changshan* (male tunic shirt) and *qipao* (a tight one-piece dress). These, along with the *queue* ("pigtail") for men and foot binding for women, were encouraged among Han Chinese as both a form of control and proof of loyalty and nationhood. Yet, during the time of social ferment that characterized the twilight of the Qing, Qiu Jin, writer, activist, and early martyr of revolutionary feminism, was one of the first violently to question this rigid sartorial pattern. [17]

Driven to distraction by patriarchal ridicule, national humiliation, and boredom, she decided, aged 28, in 1903 to unbind her feet, leave her husband and children, sell her jewelry, and travel alone to Japan. Meiji Restoration Tokyo had become a magnet for disaffected intellectuals from all parts of Asia. Qiu joined them, studying Japanese while setting up the first association of Chinese Woman Revolutionaries and being the first woman to join the *Tongmenghui* (Chinese Revolutionary Alliance), a secret society and underground resistance movement against the Qing government, formed by Sun Yat-sen, Song Jiaoren, and others in August 1905. [18] Convinced of the need for female heroes, and modeling herself consciously, and eclectically, on Hua Mulan, Joan of Arc, the French revolutionary feminist philosopher Madame Roland, the American abolitionist Harriet Beecher Stowe, and Russian revolutionary activist Sofia Perovskaya, Qiu learned riding, fencing, and martial arts. [19] She moved around Tokyo as if she were a man, drinking wine in public and, invoking the shade of George Sand, caused uproar by regularly wearing male western-style clothes with trousers. **(fig. 8)**

In 1906, she returned to China as the Zhejiang area representative of the *Tongmenghui* and assumed the post of principle of the Datong Sports Teachers' School in Shaoxing, Zhejiang—a muscular new institution founded by Xu Xilin, her male cousin, that in spite of its innocuous name was actually a training center for revolutionary military leaders. [20] In July 1907, Qiu was apprehended by the authorities following the arrest, torture, and execution of Xu in connection with an abortive attempt at nationwide armed uprising. Under torture, she refused to confess and was sentenced to death. On July 15, 1907, she was beheaded in her ancestral village of Shanyin, not far from the school.

Early in 1912, after the Xinhai Revolution had overthrown the crumbling Qing Dynasty, Sun Yat-sen, the short-lived, first provisional president of the newly formed republic, was to set his own sartorial standard. [21] At this time, he first wore the *Zhongshan zhuang*—a round-collared, quasi-military, four-pocketed tunic with trousers that was named after him, which was quickly adopted by other men associated with politics or the military. In its design he had decided against western dress because of its whiff of much-hated colonialism and opted, instead, for an adaptation of the Japanese cadet uniform which, ironically, had been first introduced there from Germany during the early years of the Meiji Restoration. [22] Sun's new, modern, not exactly western, form of clothing, signified fundamental change. **(fig. 12)**

After continuing civil war and the extensive ravages of the second Sino-Japanese War (1937–45), a version of this was adopted, in a limited range of colors, as the Mao Suit—in honor of the new leader—after the foundation of the People's Republic in 1949. [23] By the time of the Cultural Revolution (1966–76), this egalitarian dress, in an even more simplified form, had become the approved uniform for both sexes, as Red Guards orchestrated new forms of "barbarism" in their ruthless campaigns to destroy the "Four Olds"—customs, culture, habits, and ideas—in order that a "true" proletarian society could flourish. **(fig. 13)**

In Europe during World War I, attitudes towards female dress had also changed irrevocably. With a large part of the male population fighting abroad, women were enlisted to work on the war effort. Heavy labor, and the fact that they were executing what was previously "men's work," meant that many women felt comfortable in trousers. Once hostilities were over, life reverted to "normal" but, in the spirit of modish iconoclasm that characterized the 1920s and '30s,

10 | Nadar's 1855 portrait of Charles Baudelaire captures the mood of the avant-garde poet who coined the term **flâneur** and who refined, throughout his work, this particular reflection of urban emotion and anti-naturalist sensibility

11 | By 1911, Paul Poiret's harem trousers and skirts had become the rage in Paris in the *style sultane* | fashion plate from L'Illustration

12 | Sun Yat-sen in his typical suit, walking with John Cornelius Griggs followed by his bodyguard Morris (Moishe) "Two Guns" Cohen | Shanghai 1919–22 | Courtesy John and Diane Thompson

13 | **Shining Path, Glittering Future: Stride Triumphantly Forward Along the Revolutionary Path of Chairman Mao** | poster designed by Workers Art Studio of the Shanghai Office for Mechanical Engineering and Electronics | 1975

[17] Qiu Jin (1875–1907). Her biographies are inconsistent in detail but see Kumari Jayawardena, *Feminism and Nationalism in the Third World*, Verso, London, 2016, pp. 179–181; Kazuko Ono, *Chinese Women in a Century of Revolution 1850–1950*, Stanford, Stanford University Press, 1989 and Lionel Giles, *Ch'iu Chin: A Chinese Heroine* (a paper read before the China Society in London in March 1917), London, China Society, 2009. [18] The *Tongmenghui* was the forerunner of the Kuomintang (KMT, or Chinese Nationalist Party). Sun Yat-sen (1866–1925) was a Chinese medical doctor, republican revolutionary and, in 1912, co-founder of the KMT who played an instrumental role in the overthrow of the Qing dynasty. Song Jiaoren (1882–1913) was also a republican revolutionary and co-founder of the KMT who led the party to victory in 1912 in China's first democratic elections. In 1913, he was assassinated. [19] Madame Roland (1754–1793) was a Girondist supporter of the French Revolution who perished on the guillotine during the Terror; Harriet Beecher Stowe (1811–1896) is best known for her novel *Uncle Tom's Cabin* (1852) that energized the anti-slavery cause in the US but she also published widely on other social issues; Sofia Perovskaya (1853–1881) was a member of the Russian revolutionary socialist group *Narodnya Volya* (The People's Will) who, in 1881, helped orchestrate the assassination of Tsar Alexander II for which she was executed by hanging. Jaywardena, op. cit., p. 180. [20] Lionel Giles, *Ch'iu Chin: A Chinese Heroine*, London, 1913. [21] After the Xinhai Revolution in 1911, Sun Yat-sen became the first Provisional President of the Republic of China, but in the ensuing chaos, during which the military seized power, he relinquished this post. In 1913, he organized a Second Revolution that was unsuccessful and was forced again to flee to Japan for safety. China was then partitioned and fell under the power of different warlords. Sun returned to China in 1917 to advocate reunification and, from 1919 until his death from cancer in 1925, was the prime minister of the KMT from his base in Guangzhou. [22] Sun had become familiar with this form of dress during his earlier ten-year exile in Japan from 1897 to 1907; it was based on the uniforms worn by Prussian cadets and is still worn in Japan by senior male school children. See pp. 60–81, for German influences on Japan during the Meiji Restoration. [23] This was named after Mao Zedong (1893–1976), the new national leader and became the proletarian uniform worn by party leadership and workers alike. Few other types of clothing were mass-produced in China at this time. During the 1960s and '70s in Western Europe, the "Mao Suit" was also worn as both fashion statement and badge of affiliation by some socialists and intellectuals.

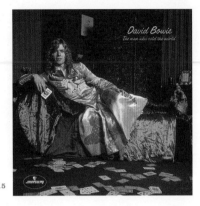

trousers or slacks became fashion. Initially sported by such performers as Marlene Dietrich and Katherine Hepburn, they were posed in both coquettish emulation of, and challenge to, male power. **(fig. 16)**

During the aftermath of World War II, it was not until the 1960s that, in Europe and the US, a younger generation began to question the beliefs, prejudices, and politics of their parents. As part of a widespread impetus to relax sexual mores and expand egalitarian rights, the Civil and Women's Rights movements, in particular, made significant legal gains although now, in a worldwide context, their progress still seems limited. In dress, workers' blue jeans became a nonconformist uniform for affluent western youth of both sexes, while some people championed the cause of the trouser suit (the "pant suit" in the US and Australia)—in fine cloth or denim—as the apogee of women's sartorial liberation. In conservative male circles they were thought, at the time, to be "unfeminine." Now, not even the most Neanderthal male would look askance at them.

In recent fashion, androgyny has become the rage. From the early 1970s, Japanese designers such as Comme des Garçons and Yohji Yamamoto were inspired both by early Russian revolutionary design and by contemporary British Street Style to create a baggy monochrome look for both sexes. [24] **(fig. 14)** While, in Europe, responding to the colourful androgynous dandyism of such pop stars as Mick Jagger, David Bowie, **(fig. 15)** and Marc Bolan, this look was disseminated by French designer Jean-Paul Gaultier, who in 1985 included skirts for men as part of his collection. [25] Throughout the 1990s, this motif reappeared in the work of such designers as Ann Demeulemeester, Martin Margiela, and Helmut Lang to such an extent that androgyny was confirmed as a significant element within contemporary fashion.

The androgynous impulse, however, has taken many different forms. On the catwalk, lithe supermodels, with the bodies of young boys, regularly display high fashion in a brutal paradox that implies that such clothes will be unwearable by the vast majority of women. But within this floating world of elitist irony and symbol, practicality is rarely the point. Distinctions between male and female silhouettes have often blurred in "unisex" or gender-neutral formats in which the trouser, for instance, symbolizes nothing but itself. Cross-styling creates a different impression as men wear soft fabrics, bright colors, and skirts or dresses; and women return to a more masculine look. In contemporary fashion it has ceased to matter "who is wearing the trousers" because the stereotypical symbolism of both sexes has been undermined. Yet still the question of who holds power remains.

* * *

The essays gathered below, in "Stories," the second part of this book, focus on the relationship between artists—and the work they make—and power, in the many different forms it takes, by examining it within a fluid temporal, cultural and political matrix. In Asia, as elsewhere, the rhetorical question of "who is wearing the trousers?" has often been, besides a patriarchal tease, an assertion that the only power worth bothering about is male, political, and financial, all of them being "naturally" interdependent. Natural skepticism, along with knowledge of the history of art and its contemporary manifestations, has led me to reject such a preposterous idea.

Art, if good, has a subtle autonomy, conscience, and devotion to different kinds of truth that constitutes a non-gendered, but no less influential power. As we have seen from the cataclysms of the 1930s, '40s and '50s in Europe, the USSR, US, and Japan—as well as from not so dissimilar events that unfolded throughout Asia from the 1950s to the '90s—art has maintained the possibility of constituting a difficult-to-define but incorruptible power that unsettles dictators to such an extent that if it cannot be co-opted, they feel that it should be destroyed.

Only recently in Asia have a larger number of artists who happen to be women, asserted themselves against this closed patriarchal system by strenuously and successfully asserting their desire for excellence, free action, and equality. ●

14 | Yohji Yamamoto's Winter 2003–04 Collection show in Paris with the British pop group Madness modelling the clothes

15 | David Bowie in a dress designed by Michael Fish for the cover of the UK release of his album **The Man Who Sold the World** in 1971

16 | After creating a scandal by wearing male evening dress at the premiere of Cecil B. DeMille's raunchy religious epic **The Sign of the Cross** in 1932, Marlene Dietrich sparked a "trousers craze" in Hollywood and the US. Here she models the new style in January, 1933

[24] The British group Madness's song *Baggy Trousers* (1980) is an anthem to this look. In his 2003–04 collection Yohji Yamamoto made a direct stylistic tribute to Madness, also including the band in his Paris catwalk show. [25] London fashion designer Michael Fish had famously produced a one-off man's dress for Mick Jagger, lead singer of the Rolling Stones, for a Hyde Park concert in 1969 as well as a dress for David Bowie that he wore in 1970 for the cover of his album *The Man Who Sold the World*.

KG Subramanyan
An Indian in Oxford

This essay was first published in the catalogue **KG Subramanyan: Fairy Tales of Oxford and Other Paintings** (1988), an exhibition that marked the end of the artist's residency at the Museum of Modern Art and St. Catherine's College, Oxford, where he was a Christensen Fellow (1987–88). KG Subramanyan (1924–2016) was born in Kerala, and had initially studied economics at Kala Bhavan in Santiniketan from 1944 to 1948. I first met him in Delhi in 1981 durng research for the exhibition "India Myth and Reality: Aspects of Modern Indian Art" (Museum of Modern Art in Oxford, 1982), for which I had selected a series of terracotta reliefs he had made in response to the atrocities of the Bangladesh Liberation War (1971) and the displacement of over 30 million refugees (See pp. 30–31). He had just moved from being head of the influential School of Fine Arts in Baroda to work as professor of painting at Kala Bhavana in Santiniketan. In both his art and his copious writings about it, he has struggled tirelessly to synthesize Indian traditional and folk forms with those ideas of modernity he felt were appropriate for a newly independent state. [1] His new "folk" paintings on Perspex, rather than on the traditional support of glass, that he made during his Oxford residency and shown in this exhibition, reflected ambivalent feelings about his position and experiences there by combining ironical humor with a deft appropriation of Kalighat painting, a rich Bengali strain of religious folk art.

2

The ugly vulture eats the dead,
Guiltless of the murderer's taint,
The heron swallows living fish,
And looks like an ascetic saint.

– Sanskrit poem, 5th–6th century

1 | **Ethiopian Nativity** | 1987 | gouache and oil on Perspex | 81 x 61 cm | courtesy Art Heritage, Delhi

2 | KG Subramanyan working in his studio in the tower of the Museum of Modern Art Oxford during his residency | 1987

[1] KG Subramanyan, *Moving Focus: Essays on Indian Art,* New Delhi, Lalit Kala Akademi, 1978; *The Living Tradition: Perspectives on Modern Indian Art,* Calcutta, Seagull Books, 1987. [2] In the *Harivamsa,* a supplement to the epic *Mahabharata,* we are told about the childhood of Krishna, an incarnation of the Indian god Vishnu. He grew up as the foster child of cowherds and first showed his divine nature by conquering demons through the music of his flute. He also conquered the affections of many milkmaids (*gopis*) to whom he also played his flute while he danced and bathed with them in the moonlight. This amorous relationship is regarded in Hinduism as an image of the soul's relationship with God. The physical and ideal love of Krishna with Radha, his favorite *gopi,* is celebrated throughout Sanskrit and Bengali love poetry and art. The cautionary tale of Susanna and the Elders in *The Book of Daniel,* in the Old Testament of the Bible, regards sex in a different way, using it as a vehicle to warn against the evils of hypocrisy, mendacity, and voyeurism. Many artists have taken this allegory of the protection of female virtue as an opportunity to focus on the act of voyeurism. The story is as follows: after spying on Susanna while she was bathing, two elderly men propositioned her, threatening to concoct a story about an illicit tryst in the garden if she refused to have sex with them. She resisted the two men, and was subsequently arrested and sentenced to death for promiscuity. Daniel successfully defended her by pointing to conflicting facts in the two lechers' stories. [3] In 1865, Matthew Arnold, then professor of poetry at the University of Oxford, in the preface to his *Essays in Criticism: First Series* had famously described the city as "home of lost causes, and forsaken beliefs, and unpopular names, and impossible loyalties!"

Appearances, as this unknown Sanskrit poet pointed out, may be deceptive: respectability can cloak hypocrisy, absurdity could overshadow truth, and poverty may conceal great riches. In the West, our intellectual dualism has polarized our way of looking at the world. In India, the fetishization of polarities does not exist, in that all oppositions are subsumed within a greater whole. All that has breath has worth, and this gift may appear in many different forms.

Wit, like sex, is to be relished; both lie at the root of knowledge. They are found in the tales of Krishna and the milkmaids, a life-affirming reversal of the guilt-ridden Christian story of Susanna and the Elders. [2] They are also seen in the joint-wrenching sexual acrobatics of the temple carvings at Khajuraho—the sweet-nabbing escapades of Ganesh, the elephant god—and in the downright naughtiness of Hanuman, the monkey god and Krishna's messenger. In India, the life of fantasy is out on the streets—where it often seems more real than reality itself.

Absurdity is no stranger to Oxford—is ever a cause wholly lost as long as someone believes in it? [3] Lewis Carroll could be an honorary Indian. Over the past two terms KG Subramanyan has, in reciprocation, become an honorary Oxfordian—as Christensen Fellow at St. Catherine's College. This is not to imply that Subramanyan is a purveyor of absurdity for its own sake but rather that his intelligent appreciation of its potency gives his work meaning. Over the past five months he has been working on a series of gouache and oil paintings made on perspex sheets in which his mastery of the languages and traditions of modern Indian art are conflated with experiences of living in Oxford—the heartland of the old empire.

In that no-man's fantasyland, which he has created in the cultural space between Oxford and Santiniketan—his *alma mater*—Subramanyan has presented us with a series of tableaux, of moral tales. He tells us the story of an Indian in Oxford—but an Oxford inhabited by strange creatures, flying horses and men, tigers, cats and elephants, palm trees and luxuriant vegetation—a world of innocence lost and found, a *fête champêtre,* set against the 19th-century villas of suburban North Oxford. Subramanyan's use of "Indian" motifs in these paintings is not evidence of any cultural insecurity— fantasy as an escape. It is an ironical subterfuge that implies the ingenuousness of the child but shows the teeth of the tiger.

As a student in Madras, Subramanyan first trained as an economist and for a time was actively involved in the movement for Indian independence. In a

3

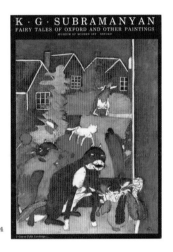

4

sense, his connection with politics and economics continued long after his decision to become an artist through his involvement in national planning for the All India Handloom Board, where he argued not only for better craft education but also for a careful husbandry of a national market for the crafts. India, he felt, had to become self-sufficient in art as well as in food.

When in the early 1940s Subramanyan decided to train as an artist, he traveled northwest to Santiniketan, Rabindranath Tagore's university in Bengal, where the painters Nandalal Bose, Binod Behari Mukherjee, and the sculptor Ram Kinkar Baij were working. [4] Here Subramanyan came into direct contact with Tagore's ideas about the synthesis of eastern and western cultures and became more fully aware of a national identity through an appreciation of the traditions of Asian art.

For Indian artists in this century, as indeed has been the case for many artists in the developing world, [5] the fine art tradition has been essentially an alien phenomenon—an import from the West. The princely courts, which in the past had supported schools of artists, had withered away. They had yet to be replaced by either an art market or an art public.

Like his colleagues at Santiniketan, Subramanyan looked back to the golden heritage of classical Indian art for inspiration—to the cave paintings of Ajanta, to carved stone and cast bronze. But, he realized, no direction for the present could lie in revivalism or pastiche; art has to live now. It has, in this sense, to be modern. He was faced by a problem: India had no established tradition of modern art. The rapidly successive styles of modernism had all originated in the West, and, within India itself, energy and conviction quite clearly lay in the fertile production of folk arts and crafts—traditions of work, style, and imagery which had evolved slowly according to need and unconscious consensus, oblivious of the world outside.

For an artist faced by the apparently opposed forces of modernism and folk art, artistic integrity alone can ensure survival. The demarcation between the two, however, has never been as clear-cut as many in the western art world have implied. Even in the earliest years of modernism, the traffic of influence was not only in one direction; Picasso and Matisse appropriated imagery from non-western art, transforming these influences in the process. Now in the developing world, as it was in the old empires, the direction is reversed and the pressure is on for the non-western artist to appropriate or, in some cases to re-appropriate, imagery from the West. In India, with its long perspective on history and necessary practices of bricolage and recycling, such a two-way flow seems sensible, even fair play. A culture that believes in the reincarnation of the soul finds it difficult to take seriously the western obsession with the chimera of originality.

One of the features of imperialism, cultural or economic, is that the center leeches the provinces. This process of systematic marginalization derives its authority, in art, from the power of the market, which is primarily concerned with the bankability of an artist's work. An artist's validity, on the other hand, depends upon the aesthetic quality of his or her work —not a matter of pounds, dollars, or rupees, but a part of the symbiotic relationship of the art to the culture from which it has sprung.

Subramanyan, preeminently of all living Indian artists, has effected his own synthesis of modern with traditional art. Just as modernism itself has many different faces, so do the traditional arts, and Subramanyan has become a master of manipulating the media and genres of both in work that is intensely personal and also intelligible to a wider public. He gained the confidence to do this from the intellectual climate of Santiniketan where the formal distinctions between fine art and crafts were broken down in an educational program which sought to liberate creativity and imagination by tapping resources that were already there, rather than by imposing standards and expectations which were largely alien.

5

For me, Subramanyan's most successful works are those which appropriate and transform the languages of folk art: the terracotta plaques of the 1970s, for instance, the earliest of which were born out of the atrocities of the Bangladesh Liberation War (1971). In these, which are reminiscent of unpainted wayside shrines, grids of clay are covered by the excrescent forms of the generals with their "trophies," the victims of war. (p. 31, fig. 5) The grotesqueness is continued in later works—bas-relief portrait heads or *mudras* (hand positions adopted in meditation). In their worn, powdery surfaces and contorted expressions they are far from presenting an image of a benevolent universe.

Since 1979, Subramanyan has been focusing his energies on a series of reversed paintings on glass, or more recently, Perspex. This medium relates to 18th- and 19th-century traditions of glass painting throughout different parts of India, as well as to the popular *kalighat* paintings of the Calcutta bazaar, but the imagery and narratives are his own. In many pictures, which share a flattened, tilted space with both Matisse and Mughal miniatures, an elderly man looks on from the foreground; the scenes refer to the traditional iconography of both eastern and western art—to nativities, annunciations, to scenes in the princely courts, to the Arcadia of Virgil's *Georgics.* East meets west in a burst of color and subversive laughter in images that depict both sexual ebullience and irony; desire under the aspidistras.

Diffident in talking about his work—or in naming particular pictures—Subramanyan can, on occasion, be pressed into leaking some information about their origins. A chance meeting, a newspaper article, or conversation on a train starts off an idea, which is then refined and developed. Tortured figures pushing their fists into their eyes are a response to the industrial catastrophe at Bhopal; the fighting cats painted in Oxford (in *kalighat* paintings, the yellow cat is a symbol of false holiness) are partly a response to the recent tragic events in the internal politics of the Church of England.[6] A madonna with a dead child echoes the threat of famine in Ethiopia; a long-tongued monster and a crying infant were triggered by recent publicity over child abuse.

In showing us a world that is in part fantastic, tragic, and absurd, Subramanyan, with characteristic vigor, creates an image of the present. In Subramanyan's Oxford, expectation and wonder are, with wisdom and gentle irony, fashioned here into potent fables of our time. •

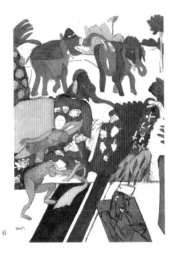

6

3 | **Inayat Khan against Moonlit Landscape** | 1988 | gouache and oil on Perspex | 81 x 61 cm | courtesy Art Heritage, Delhi

4 | Catalogue for "KG Subramanyan Fairy Tales of Oxford and Other Paintings," 1988 showing **Cats on Table, Landscape** | 1987 | gouache and oil on Perspex | 81 x 61 cm

5 | **Inayat Khan looks at Oxford No.3** | 1987 | gouache and oil on Perspex | 81 x 61 cm | courtesy Art Heritage, Delhi

6 | **Lotus Pond and Elephants** | 1987 | gouache and oil on Perspex | 81 x 61 cm | courtesy Art Heritage, Delhi

[4] Rabidranath Tagore (1861–1941), Bengali polymath, writer, musician, artist, and educator, who in 1913 was the first non-European to win the Nobel Prize in Literature, see p. 36. Nandalal Bose (1882–1966), influential Bengali painter and teacher at Santiniketan, pupil of Abanindranath Tagore (1871–1951), nephew of Rabidranath, and founder of the Indian Oriental Society of Art. Binod Behari Mukherjee (1904–1980), Bengali painter who taught at Santiniketan and continued to work after he lost his sight in the mid-1950s. Satyajit Ray made *The Inner Eye,* a documentary film on his work, in 1972. Ram Kinkar Baij (1906–1980), Bengali sculptor and painter. [5] Ed.'s note: The term "developing world" was commonly used as a replacement for "third world" after the collapse of the USSR in the early 1990s, though it has also fallen out of favor. While acknowledging its inadequacy as a term and its implicit bias, we have left it in place, as it appeared in the original text. [6] The Church of England, traditionally a conservative body, was finding itself increasingly at odds with the social effects of the policies of the Thatcher government, particularly in the north of England, but it also feared that it was becoming increasingly irrelevant to social debate and had launched an offensive against the BBC for its "marginalization of religion." This crisis of role, direction, and purpose has still to be fully resolved.

Jitish Kallat
Fugitive Monuments of an Unacceptable Present

Sweatopia (The Cry of the Gland) 2

This essay, published in both Hindi and English in 2016, first appeared in **Jitish Kallat: Covering Letter**, a booklet published by the Jehangir Nicholson Gallery and the Chhatrapati Shivaji Maharaj Vastu Sangrahalaya in Mumbai to coincide with an exhibition of the same name and was subsequently reprinted in the exhibition catalogue for "Here After Here by Jitish Kallat," which was shown at the National Gallery of Modern Art, New Delhi, in 2017. **Covering Letter** (2012) was first shown in the 1st Kyiv International Biennale of Contemporary Art, 2012. (See p. 137) Jitish Kallat was born in Mumbai in 1974 and continues to be based there.

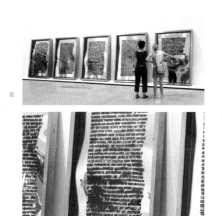

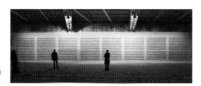

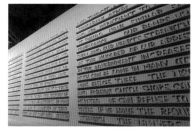

1 | Sweatopia (The Cry of the Gland 2) | 2011 | acrylic on canvas | 213 x 518 cm | Birmingham Museums Trust and the New Art Gallery Walsall collection

2 | Public Notice | 2003 | burnt adhesive on acrylic mirror, wood, stainless steel | 54 x 78 x 6 in (x 5 parts) | installation view | Gallery of Modern Art, Brisbane

3 | Public Notice | 2003 | detail

4 | Public Notice 2 | 2007 | resin | 4,479 sculptural units | display dimensions variable | installation view at Art Gallery of New South Wales, Sydney

5 | Public Notice 2 | 2007 | detail

In the megalopolis of Bombay, rightly renowned for its imposing Victorian monuments, little of monumental note has appeared since Independence; in the modern, decolonized era such structures seemed out of date, pretentious, irrelevant. Paradoxically, the exhibition now in Bombay of Jitish Kallat's *Covering Letter* (2012), a projection of flickering words on a screen of light and mist, responds to this void by creating a kind of "anti-monumental" monument. It follows on from three previous works that together comprise *Public Notice* (2003–10), only one of which has been seen in India so far. In this suite of "conceptual monuments" Kallat has contrived a specific collision of Indian art, history, and politics that casts a weather-eye on the formation of India's identity, independence, and nationhood. Subtly and non-judgementally, he has cut to the core of the realities of the region, but has also extended beyond this to frame a fragility, precariousness, and fear of moral bankruptcy that may be discerned almost everywhere.

In their denunciation of violence, as well as in their critical spirit and scepticism, these works embody a wide range of emotions and perspectives. Visual tropes fade in and out of focus like steps, moves, twirls, and slides in a carefully choreographed dance that, while transfixing in itself, also constitutes an allegory of a political life that has promised much but delivered little. *Public Notice* prefigures and also informs *Covering Letter* (2012): a fugitive screen of mist and light onto which Mahatma Gandhi's vain plea for peace, written in July 1939 on the eve of World War II, is projected. Approaching and walking through it, an observer becomes, literally, absorbed by these words while, at the same time, acting as an agent for the dissipation of their legibility. (figs. 9, 10)

Such involvement may seem like "interactivity" but, from a different perspective, it could also amount to a casual act of destruction, callousness, or violence. In these works, Kallat has given moral ambiguity form in a genre of political and social portraiture that reveals the evident yet convoluted viciousness, inequity, and compromise of present circumstance in stark contrast to the concentrated idealism of the past. He focuses particularly on events that led to the formation of an independent Indian political identity both before and immediately after withdrawal by the British. In this way, he has extended the social and causal references of such large, almost mural-like, paintings as *Sweatopia (The Cry of the Gland II)* (2011) into a more abstract, conceptual field by shifting from literal images of working-class urban alienation to a no-less disturbing summation of moral and political entropy. (fig. 1)

The specter here is "religious," ethnic-, and gender-based violence that through cynically manipulated mass paranoia has ignited successive waves of riots that have culminated in mass murder. Kallat has, in these works, chosen to concentrate on the "fault line" between India's founding principles and the blind perpetuation of hidebound tradition through enmities fanned by Partition.

India is hardly unique in this respect; the world has shuddered under similar threats before. As the recent massacre in Paris[1] has made horribly clear, confronting the cynicism and bigotry that leads to such violence is

like treading on eggshells. When disaster will occur is difficult to predict, but once it has it is almost impossible to contain as each action provokes chains of reaction. Not to challenge it, however, is to submit to its power. Remaining silent opens the door wider to continuing and greater violence as non-conformists and "unbelievers" are silenced or murdered. The question that Kallat addresses in these works is *how* to expose and delimit these new forms of bigotry so that their harmful, cyclical nature is revealed and may be confronted at its root.

He sets about this challenging and daunting task by invoking his autonomy and judgement as an artist; his bleak, almost playful, irony lays bare the mendacious, vain stupidity of power, past and present.

In his "Public Notice" works, Kallat approaches this responsibility variously, by revisiting the positions of three different Indian thinkers and leaders—Swami Vivekananda, Mahatma Gandhi, and Jawaharlal Nehru—highlighting their actions, ideas, and stories in contrast with the present state of things. As a result, these works may also be understood as implicit indictments of the current failure of politicians and governments worldwide to take responsibility for ensuring and protecting the public good. He views this state of affairs pragmatically, from a human rather than ideological perspective, aware that at a time of rampant commodification, people are often reduced to little more than commodities themselves.

Kallat frames here the historical words and acts of great men, sanctified by legend, document, and rhetoric, within a brute symbolism of fire, bone, and light. With surgical finesse, he builds out of this a much larger picture of the world by the excision of text from iconic political utterances. Through art, he restores the word as a vehicle for the ideals embodied within these texts, "born again" as godhead, good, and objects in themselves. Recast in the present, projected into the future, these words become reenergized as both portraits of decay and pin-pricks of conscience.

In *Public Notice 2* (2007), teetering between the animist and the minimal, Kallat employs the Shklovskian mechanism of *ostranenie* ("estrangement"), spelling out against a bright-yellow background, in archival, shelved regularity, the "bones" of the iconic self-sacrifice of Gandhi in the words he used so eloquently on the eve of his historic Dandi March (March 11, 1930). This inaugurated a nationwide campaign for civil disobedience but, as Gandhi unwittingly implied on that day, this moment would lead as inexorably to his own violent death as it would to independence. As if it were a wordplay, Kallat sets the sacred, perhaps prehistoric, bones of "oxen" in resin "stone," knowing that they will never be the law; freedom has been traduced, and obstacles have only apparently been removed as others, far more invidious, have taken their place. (figs. 4, 5)

Gandhi's words predated by seventeen years those of Jawaharlal Nehru that Kallat had already appropriated in *Public Notice* (2003), the first work in this series. (figs. 2, 3) These were extracted from his equally historic "Tryst with Destiny" speech that marked, on August 14, 1947, the fateful-midnight-moment of India's independence before the conflagration of Partition. Here Kallat has avoided monumental and archaeological reference, choosing rather to "brand" the words onto large buckled mirrored tablets. As in a hall of mirrors in a cosmic freak show, onlookers' distorted, reflected shadows cast monstrous overlays onto these fine sentiments. Inevitably, these "words of fire" also echo the torching of people's ideals, bodies and homes.

Public Notice 3 (2011) employs the earliest of Kallat's thought-provoking texts—Swami Vivekananda's address in 1893 to the World's Parliament of Religions in Chicago—in a site-specific installation spelled out in differently colored LED lights set into the risers of the grand staircase of the Art Institute of Chicago, the same building in which the speech was originally delivered. (figs. 6, 7) An impassioned plea against fundamentalism, bigotry, and sectarian violence, serendipitously delivered on September 11, exactly

6 | **Public Notice 3** | 2011 | LED bulbs, wires, rubber | installation view at Art Institute of Chicago

7 | **Public Notice 3** | detail | courtesy the artist

8 | **Letter from MK Gandhi to Herr Hitler** | July 23, 1939 | the text of the projection in **Covering Letter** | 2012

9 | **Covering Letter** | 2012 | fog-screen projection | dimensions variable | courtesy the artist

10 | **Covering Letter** | 2012 | detail | courtesy the artist

[1] Ed.'s note: On November 13, 2015, attackers affiliated with ISIS killed 130 people at six locations in central and northern Paris. [2] See Srdja Popović and Matthew Miller, *Blueprint for Revolution. How to Use Rice Pudding, Lego Men, and Other Non-Violent Techniques to Galvanise Communities, Overthrow Dictators, or Simply Change the World,* London, Scribe, 2015.

108 years before the 2001 attacks in New York, Kallat transforms this into an embodiment of how politicians now pay lip service to such ideals while stoking up fear of "terror" to create an atmosphere of docile, unquestioning obedience. Mocking the cultist conspiracy theories that proliferated after 9/11, Kallat links Vivekananda's words with contemporary western paranoia about religious fundamentalism as the colors of the lights in which these words are expressed echo the codes issued by US Homeland Security to denote different levels of external threat. Inevitably, this work also ricochets against other unacknowledged "threats" by touching on the confluence between the legendary Chicago Race Riots of 1919 and the racism still widespread in the US. The current demographics of poverty, unemployment, and crime throughout the country are a chronic and tragic testimony to a state of affairs that only becomes visible as "news" when violent protest is sporadically triggered. The events in Ferguson, Missouri, during summer 2014, after a white police office officer shot an unarmed young black teenager, Michael Brown, is only one of far too many examples of inbred, institutional racism.

Throughout the "Public Notice" works Kallat makes it clear that the brave thoughts and words of others expressed in the past, now often serve as little more than symbolic pretexts for cowardly mendaciousness. Once spoken with conviction, but now silently shimmering on the page, they become mute witness to the deadening effects of branding and entropy. The problem is not historical but moral: with rare sleight of hand, we make saints of people who tried to change the world in order that we may forget the meaning of their words and ignore the far-reaching implications of their actions. For Kallat, the primitive sentimentalizing of "fine words" into fetish or commodity is like a malevolent, dissembling form of politics and "magic."

Awareness of mortality is unavoidable, yet it only has any value in relation to respect for life. Such a sentiment underlies Gandhi's advisory letter to "Herr Hitler," written on the eve of the outbreak of World War II, of which a facsimile projected onto a mist screen comprises Kallat's work *Covering Letter*. (fig. 8) Gandhi wrote: "It is quite clear that you are today the one person in the world who can prevent a war which may reduce humanity to the savage state." And then he asks, "Must you pay that price for an object however worthy it may appear to you to be? Will you listen to the appeal of one who has seliberately [*sic*] shunned the method of war not without considerable success?" Yet, for the artist, this letter, transformed in his work, not only stands as a historical document, but also acts now as a meniscus between a contemplation of the inner depths of selfhood and the state of the world beyond. (figs. 9, 10)

Before this letter arrived at its Berlin destination, a cataclysmic world war had been triggered by the Nazi invasion of Poland, and still today the doctrine of nonviolent confrontation propagated by Gandhi almost seems quaintly old fashioned. Too often, modern politics has been born and bred out of violence and depends on it to survive; yet how many times may we repeat the same mistakes before the cycle of destruction is broken?

But there is hope. Rising out of the ruins of the Yugoslav Wars at the beginning of this century, introspection, irony, and sardonic humor have been part of the arsenal of such international NGOs as the Center for Applied Nonviolent Action and Strategies (CANVAS) that have invoked the doctrine of nonviolence to effect fundamental political change in many developing states in other parts of the world.[2]

The revival of nonviolence as a viable form of political action repudiates the idea that humanity has no place in politics. Jitish Kallat's work *Covering Letter* shown here, as well as a wider awareness of what this represents, deftly joins the world's present with India's past in again embodying a situation in which violence should have no place. ●

Rashid Rana
The Machinery of Truth

This essay was published in the book for the exhibition "Rashid Rana: Everything is Happening at Once," Manchester, Cornerhouse, 2011. I included his large composite work **Desperately Seeking Paradise II** (2010) in the 1st Kyiv International Biennale of Contemporary Art, 2012. (p. 136). Rashid Rana was born in Lahore, Pakistan, in 1968, where he is still based.

Go and catch a falling star,
Get with child a mandrake root,
Tell me where all past years are,
Or who cleft the Devil's foot,
Teach me to hear mermaids singing,
Or to keep off envy's stinging,
And find
What wind
Serves to advance an honest mind . . .

– John Donne

In a recent interview in *Art India*, Rashid Rana made a subtle but revealing point which provides a key to understanding both the development of his work and also how it relates to the different experiences, cultures, and traditions which have contributed towards its form, content, and context. Reflecting on modern American painting when talking about his use of a grid as a formal, flattening device, Rana put his finger on the central paradox around which his work revolves. His use of two dimensions not only made reference to his own and other traditions but also "remove[d] a sense that I am somehow representing reality," and this enabled him "to stake my right . . . to work with fictional spaces, impossible spaces, with the machinery of truth rather than with truth [itself]."[1]

The idea of a single truth, rather like there being just one manifestation of reality, is clearly a fallacy, although one which many cling to. Perception and thought depend upon the position, or perspective, of the individual—in art, the viewer—and there may be an infinite number of positions for a person to adopt, limited only by the field within which he or she is "standing." When thinking about art, this field must ultimately be aesthetic—even in the case of professed "non-art" art movements—and, by extension, also ethical, because the perception of aesthetic quality within the field of art has an unavoidable moral dimension.[2]

In a practical, material world in which power is often untrammeled, action ill-considered, and atrocities un-propitiated, multiple perspectives and morality may seem like uneasy bedfellows. Yet, unless one is a hidebound fundamentalist, an understanding of what is moral is not just a simple matter of deciding what is right or wrong, as this too depends on perspective. For morality to approach truth, rather than just being a matter of following orders, it is necessary to embrace self-doubt and be at times self-confounding, ambiguous, far from absolute. These are all aspects of the machinery of truth.

In addition, when looking at such matters collectively, according to the newspaper you read or the television station you watch, one person's insurrection may be described as another's civil war, and even the damaged mind of a terrorist may to others conceal a "true warrior" for "freedom," religion, or a national cause.

But the point here is that the hazy, iconic outlines of Rana's impossible, fictional spaces are recognizable to us all and demand to be interpreted in a number of ways. The skill of the artist is in using what he describes as the machinery of truth to point the viewer in the "right" directions.

1 | **Dis-Location** | 2007 | c-print and Diasec | 223.5 x 294.6 cm | courtesy of the artist and Pierre Huber, Switzerland | Rana's depopulated icon of an old villa in Lahore is composed of a mosaic of thousands of smaller photographs showing the bustling life of the same place through a 24-hour period.

2 | **Dis-Location** | details

[1] Interview with Quddus Mirza, Art India, No. III & IV, 2008–09, p. 65. [2] This should not be confused with art having to take a moral or moralizing viewpoint. After all, amorality or immorality can only have meaning within an overall context and sense of what the moral may be. See D. Elliott, "The Battle for Art in the 1930s," History Today, London, Vol. 45 (11), 1995, pp. 14–21. (Reprinted in shortened form in "The Battle for Art" in Art and Power: Europe under the Dictators 1930–1945, London, Thames and Hudson, 1995) and The Beauty of Distance. Songs of Survival in a Precarious Age, catalogue of the 17th Biennale of Sydney, Sydney, 2010.

3 | **The World Is Not Enough** | 2006–07 | c-print and Diasec | 221 x 294.6 cm | courtesy the artist and CC Art Ltd, Jersey | The "all-over," Abstract Expressionist appearance of **The World Is Not Enough** is composed of multiple, tiny close-up images of trash from urban landfill sites

4 | **The World Is Not Enough** | detail

[3] Some South Asian critics such as Apinan Poshyananda in Thailand (which was never colonized) and Redza Piyadasa in Malaysia have ironically claimed that they had always been "postmodern." See Apinan Poshyananda, *Modern Art in Thailand Nineteenth and Twentieth Centuries,* Singapore, Oxford University Press, 1992, Chapter 8, "From Modern to (Post?) Modern Art in Thailand." Redza Piyadasa (1939–2007), who was an artist as well as a theorist, also frequently lectured and wrote about the irrelevance of western models of postmodernism for the heterogeneous cultures of Southeast Asia. See TK Sabapathy, *Piyadasa. An Overview, 1962–2000,* Kuala Lumpur, National Art Gallery, 2001. [4] Different manifestations of language have been a recurrent theme in Rashid Rana's recent work, for example the "Language Series," 2010–11. [5] See, for example, Rashid Rana, "Interview with Hans Ulrich Obrist," in *Perpetual Paradoxes* (exh. cat.), Paris, Musée Guimet, 2011. [6] As shown in his inclusion in the modern/contemporary exhibition "Grid←→Matrix" at the Mildred Lane Kemper Art Museum, Washington University in St. Louis, in 2006. [7] At Sotheby's New York auction in 2008 *Red Carpet 1* (one of an edition of five cibachromes) sold for USD 623,000, setting a record for contemporary art from Pakistan. [8] See for example the essays on his work by Adnan Madni, Girish Shahane, and Kavita Singh in *Rashid Rana,* Mumbai, Chatterjee & Lal and Chemould Prescott Road, 2010. [9] The minimalists set out to produce serial industrial-looking objects that had no reference to anything else. These objects had to be *non-specific,* in that they could not be anything other than themselves and *non-hierarchical,* a political and aesthetic idea, which required that no single part of the object should have more importance than any other part. [10] The pixel is the individual unit out of which a digital image is built up. Pixelation occurs when these units are disrupted, often for the purpose of censorship. [11] Girish Shahane, "Seeing Double," in *Rashid Rana,* Mumbai, op. cit., pp. 90–91. [12] Adnan Madni, "Thinking Inside the Box: 6 Short Notes on Rashid Rana," ibid., p. 20.

Such a relative approach may seem like warmed-up postmodernism, yet in the unlikely event that Pakistan, the country in which Rana happened to be born, or other countries in the so-called non-western world, were in fact prematurely postmodern, I should emphasize that here I am referring to a very different set of cultural perspectives—one that is not dominated by the cultural entropy of the West but which is now being constantly negotiated by "non-western" artists in a vast number of ways. [3] Yet writing this, by using such terms, even parenthetically, as "western" and "non-western," I inevitably reveal my own western origins. And it is only by going beyond these, by laying bare the machinery of truth as I see it, am I able to think and see further. You could say that this process of interrogation challenges the hierarchical frameworks or languages through which the world is usually perceived, or at least rocks the dominant paradigms that form them. [4]

In conversation with some critics Rana has been keen to emphasize the less obvious, formal aspects of his work. [5] Perhaps this is partly out of a wish to highlight his interest in converting formal ideas into conceptual concerns, or a wanting to be seen alongside particular aspects of historical western discourse, [6] or, equally likely, from a desire not to be typecast as the successful, "price busting" "Pakistani artist" who feels bound to highlight the brutal realities of his point of origin. [7] Yet when interviewed or discussed by many critics from his region, context, content, and history have inevitably played a much larger role. [8] But I cannot help but suspect that the linked tropes of surface and concept are merely aspects of Rana's elaborate machinery as he reflects on the different forms of traditional Asian art and western modernism (so far, abstract painting or minimalism) in a spirit of both co-option and subversion. Almost oblivious of the world outside, the classic narratives of western art history have maintained that emulation of, as well as reaction to, previous art is the driving force for change and development in the present. Only relatively recently has this style-based system been penetrated by a need for ontological truth.

Educated in both Pakistan and the United States, Rana has acquired the ability to combine and shift between levels, traditions, and time scales and made this a central facet of his work. *Red Carpet 1* (2007) generically emulates the garden-of-paradise designs of oriental carpets but within its intricacies are myriad small shots of the assembly-line slaughter of goats in a Lahore abattoir. (figs. 11, 12) In the series *What Lies Between Flesh and Blood* (2009), the shade of Mark Rothko is invoked in painting-like works that encompass extreme close-ups of the interior of the human body taken from medical photographs, documentaries, or pornography, thereby creating an almost unbearable tension between the "spirituality" of the large images and all too evident, corporeal fragility of the small images out of which they are composed. (fig. 5)

Yet when, in a series of minimalist-inspired objects, Rana moves from two dimensions into three, the dialogue between the interior and exterior changes radically. Flouting the minimalist requirement for non-specificity in its objects, the image of *Plastic Flowers in a Traditional Vase* (2007) is obviously referential and only aspires to objecthood by being squared up like a block with its image disrupted by both its geometric shape and the effect of pixilation. [9] (fig. 6) In this playful process of deconstruction, a highly specific depiction, a 3D photograph of plastic flowers in a vase, is made generic and quotes the 1960s object language of Carl Andre or Sol LeWitt. In *The Step* (2010–11), Rana pushes this approach further. He photographed a low brick structure in front of a roadside stall in Lahore complete with a discarded cigarette packet and then rendered this in pixilated form in three dimensions. (fig. 7) The finished work is reminiscent of a fragment of Carl Andre's "Equivalent" series (1966), which are composed of different shaped piles of fire bricks that all have the same mass and volume. But in Rana's work the ironic twist is that the equivalence is not that of art with mass and material, as in Andre's work, but with the

5

6

7

original source from which the image was taken. Here it appears that reality has raised its ugly head only for its image to be symbolically sanitized and codified within the constraints of style.

Throughout his now-substantial career the decisive moments in Rana's art have been beholden neither to theory nor to the expectations of audiences—either in the East or the West. From 2002, the time of his first foray into photographic mosaic with *I Love Miniatures,* he has held to the same approach. Ostensibly this work is a traditional portrait of Shah Jahan, the 17th-century Mughal emperor, but, on closer inspection, is also a concatenation of hundreds of small images of popular billboards taken in the streets of Lahore. Not only a deconstruction of painting through the reconstruction of the possibilities of pictorial space, it is also a purposefully self-contradictory statement within which a number of potential readings are embedded. Although the surface of this work was not actually pixelated as in *The Step,* at a certain middle distance it appeared to be and, as a result, cites pixelation as a reference in contrast to the clear, flat spaces of traditional miniature painting. [10] The august subject matter of the main portrait is similarly undercut by the popular street imagery of the miniature billboards, each of which, through its contradiction of scale and context, questioned the idea of what miniature really means. Lastly, the National College of Arts in Lahore, where Rana had studied was, and continues to be, the fountainhead of the neo-miniature school of painting popularized in the West by such artists as Shahzia Sikandar, Saira Waseem, and Nusra Latif. Mistrustful of a picturesque national re-emergence in a country that had only existed since 1947, Rana distanced himself from it by reversing notions of medium, scale and importance in a *trompe de l'oeuil* "painting" that replicated a panoply of contemporary micro-photographs of popular and relatively poor culture within the authoritative lines of the macro-historical imperial portrait.

Although he has often used popular imagery within his work, a similar desire to create aesthetic and critical distance led Rana to take a very different path from the Karachi-based folk-pop artists such as Durriya Kazi, David Alesworth, and Iftikhar and Elizabeth Dadi, who employed and transformed traditional folk and industrial art motifs in their handmade installations. Rana's surfaces, however, were obviously digitalized and could therefore be reduced to pixels, yet he was determined to ensure that each individual unit acted as both control and counterpoint to the key image.

This approach appears to have been rooted in a consistent desire to make something new in a way that could be limited by neither tradition nor convention and could therefore respond to different levels and perceptions of actuality. In doing this, Rana seems to be playing many worlds off against each other, modifying the flow whenever he changed perspectives.

Girish Shahane has remarked on Rana's dialectical use of binary ideas and images throughout his work, yet this is not a method in itself and reveals only one aspect of his way of working. Certainly "oppositions of time versus space, two dimensions versus three, conceptual versus political, wholeness versus fragmentation, handmade versus machine-made, abstraction versus pop and artifice versus illusionism" can all be found in profusion, to which one could also add oppositions of "high" and "low," vertical and horizontal and of local and cosmopolitan. [11] This, however, is not a simple dialectic of contradiction but, rather, a marking out of different critical aspects of reality in what Adnan Madni has described elsewhere as "a politics of style." [12] Throughout the whole of Rana's artistic development this self-reflexive politics has provided the moving parts to construct the machinery through which he can approach an intuition of the truth.

This politics is based on Rana's manipulation and layering of different pictorial conventions that encompass as diverse a range of conventions as simple grids (not purely based in western aesthetics, in that they were also used to measure out the spaces of Mughal miniatures), bar codes,

8

9

10

documentary photography, miniature painting, photorealism, film stills, poster art, pin-ups, pornography, exotic views, Lahore street scenes, western cityscapes, Islamic rugs, minimal art, color field painting, and painterly abstraction. Within this polyphony of influences and ideas it is not surprising that Rana wears many hats: teacher, collector of young artists' works and curator, as well as artist. Yet it is in his art that he achieves his greatest complexity with the effect that any idea or leitmotif one may extract from his work immediately branches off to splinter into what seems to be an infinite number of other concerns.

Nowhere is this more clearly seen than in the structure he devised with Alnoor Mitha and Sarah Perks for "Everything is Happening at Once," his exhibition at the Cornerhouse in Manchester in 2011. Not intended as a rigid armature for any understanding of the work, the show was organized intuitively around three non-exclusive hub ideas that relate to each other and each suggest starting points for thinking about the whole of the show. *Dislocation* (2007) provides a keynote for the opening section, yet could almost describe the principle influence that drives Rana to question the world around him. A large, imprecise image of a colonial villa in Lahore at a nondescript time and period is actually composed of hundreds of small images taken over the same 24-hour period. Here the image confronts the subject of time, timelessness, and what, in the face of modernity, is sometimes seen as belatedness, or lack of development.[13] (figs. 1, 2) From issues of time and place, Rana progresses to those of waste, ecology, and poverty. *The World is Not Enough* (2006–07), ironically echoing the title of a James Bond film, shows montaged, decontextualized images of mountains of trash from landfill sites, celebrations of consumption and waste that have no further possibility or use except by the very poor. (figs. 3, 4) The dislocation continues into his minimal objects, photographs recycled as the reality of art in an absurd economy of exchange, which not only turns modernist aesthetics on its head but also subverts the whole idea of representation and value.

"Between Flesh and Blood," the second section of the exhibition, is Rana's meditation on violence, bringing together the slaughter of animals with the fear and oppression of terror and, in the "Veil" (2004) series, highlighting the ways in which many women suffer the double indignities of being made invisible through religious or social pressure while being completely exposed by pornography—all under a male-dominated gaze, which has the same ultimately dehumanizing force. (figs. 8, 9)

"An Idea of Abstract," the final section of the exhibition, takes modern art as its starting point, moving from hand-drawn grid to pixelated matrix and from the sublime expression of abstract painting to the vagaries of expression in different languages, alphabets, and scripts. The show is brought to an apt climax in *Desperately Seeking Paradise II* (2010–11), a stainless steel, wedge-shaped structure more than three meters high that throws back a bland reflection of the world and people around it. (fig. 10) Yet, when looked at from an angle, two embedded images become clear: the tall, generic, skyscraper skyline of a modern city, and the many small cells of which the larger image is comprised that show the wildly variegated buildings and vital street life of contemporary Lahore.

According to one's perspective, the artist seems to be saying, the images may be opposites, parts of the same thing, or representations of another. Yet, however one may see them, in the final event they are all minuscule aspects of one creation. For Rana, like the falling star, the mandrake root or the past years in Donne's *Song,* they create the poetic machinery for an intuition of truth—paradoxes, parameters, images, and ideas—that may be used and enjoyed by us all to appreciate art, things, and the world more clearly. ●

8 | **Veil VI** | 2007 | c-print on diasec | 136 x 177.8 cm | courtesy of the artist and Pierre Huber, Switzerland | Rana began his "Veil" series in 2004. In these different pictures, the embracing gestalt of women in burkas is composed out of minuscule, out-of-focus pornographic images.

9 | **Veil VI** | 2007 | detail

10 | **Desperately Seeking Paradise II** | 2010–11 | UV print on aluminum and stainless steel | 386.4 x 386.4 x 332.1 cm | courtesy the artist and Tiroche DeLeon Collection & Art Vantage PCC Ltd | See also p. 136, fig. 9

11 | **Red Carpet 1** | 2007 | c-print and diasec | 221 x 294.6 cm | courtesy the artist and the Pallack Seth collection | The lush form of an antique oriental carpet is made up of multiple small images of animals in slaughterhouses.

12 | **Red Carpet 1** | 2007 | detail

[13] On the question of belatedness, Rana has been careful to point out that while living in a polarized and uneven world is not a new phenomenon, even in ancient times some civilizations or places were much more "advanced" than others, this polarity offers more threats than ever before because of the "shrinking" effect of new media and internet. Conversation with the author, Manchester, October 1, 2011.

Naiza Khan
Image and Revelation

This essay was published in conjunction with the exhibition "Naiza Khan: Undoing / Ongoing," held at Rossi & Rossi gallery, London, in September 2015. I did not meet Khan when she was an art student at the Ruskin School in Oxford (1987–90), although I was head of the Museum of Modern Art there at that time, but working on this I was fascinated to reconstruct her work and influences from those years. Naiza Khan was born in Karachi, Pakistan, in 1968; she currently works between there and London.

2

3

Manora seems to be undergoing a different form of aggression this time, not a whale that would consume the fishermen but something far greater and uncontrollable.

– Naiza Khan [1]

I. Leviathan

Although the multidimensional quality and slow, at times errant, unfolding of Naiza Khan's work, along with her unfashionable insistence on "the importance of gesture [with] a certain level of randomness," [2] creates a sense of being out-of-time, or at least of standing on the edge, outside the current concerns of either daily life or the art world. Actually, her choice of the city of Karachi (and the small island of Manora, just off its coast), as subjects for her work is far from peripheral and very much engaged with the world around around her. The stories of both places, developed over the past seven years and amplified to a global scale, appear in this exhibition. Her words describe, rather, an attempt to establish a non-prescriptive way of working that opens itself by allowing unpredictable things to happen. If Khan resides on the edge, it is because she wants to create a space of her own, free from the banality of power—a place where things can be seen and show themselves more clearly.

The oil painting *Between the Temple and the Playground* (2011), her first after an interlude of sixteen years, is a poetic documentation of a rapidly changing, increasingly violent, divided city that is actually and allegorically built on sand. [3] (fig. 3) In a note on the surface of the painting she describes this baldly as "a space at the brink of erasure," but while sand may be intrinsically unstable, or used aggressively to blast away detail, as William Blake, the English poet, painter, and printmaker once pointed out, it may also reflect the whole world in one single grain. [4] Since 2008, Khan has been looking at the land around her as both material and body, as a repository of basic forms that she sees, feels, witnesses, and then reveals in her work as "a kind of materialistic historiography." [5] Since encountering the small depopulated island of Manora, a once-bustling colonial outpost in Karachi's former harbor, the body of her work has experienced a distinct shift: she has moved away from a consideration of the politics and aesthetics of the female self—and, by extension, of the selves of others—to an even more unruly body politic not unlike that of the *Leviathan,* described by the 17th-century British philosopher Thomas Hobbes in a book first published at the climax of the English Civil War. [6] The visual leitmotifs of debris, bare survival and waves of migration that have surfaced in her most recent paintings, objects, videos, and watercolors are the defining elements of this "island state."

For Khan, this old-new "body" has been expressed particularly through her research of Manora's topography, history, and fate—in the things she finds there and in her enquiries into the lives, and deaths, of its remaining inhabitants. She has mined, pillaged, and created a lexicon of images about this land and its waters and, within this *commedia,* a number of motifs have surfaced as "characters": the recurrent dead whale and the wreck of the *Futh-e-Mubarak (Blessed Conquest),* in particular, a 100-foot-long steamboat that worked the Indus River around the time of the 1843 British annexation of Sindh, that suddenly reappeared after the severe floods of 2011. She has described this hulk as "stuck in the mud flats of the Indus Delta, almost like a beached whale" [7] and its morphed skeleton appears in her watercolors, broken up on a vast splurge of sand bank or, prefigured, in the form of an

1 | The Streets are Rising | 2013 | oil on canvas | 200 x 256 cm

2 | Henna Hands | 2002 | detail | henna pigment stamped on walls | site-specific project near the Cantonment Railway Station, Karachi

3 | Between the Temple and the Playground | 2011 | oil on canvas | 270 x 200 cm | all images courtesy the artist and Rossi & Rossi , London/Hong Kong

[1] Quoted from the soundtrack for her video *Restore the Boundaries,* 2009. [2] Naiza Khan, email to the author, July 7, 2015. [3] *Between the Temple and the Playground,* 2011, oil on canvas, 270 x 200 cm. The city of Karachi is largely built on sand. [4] William Blake (1757–1827) from *Auguries of Innocence* (1803): "To see a world in a grain of sand / And a heaven in a wild flower / Hold infinity in the palm of your hand / And eternity in an hour." [5] Naiza Khan, email to the author, July 28, 2015. [6] Thomas Hobbes (1588–1679), *Leviathan: Or The Matter, Forme & Power of a Common-Wealth Ecclesiasticall and Civill,* London, 1651.

antique sailing ship, miniaturized, merged with the jaws of a whale and a small shelter made of shells, in a painting of an improbable snow dome, an imaginary souvenir of this sad, almost forgotten island.[8]

Whales, mythical and actual, populate the waters that lap the island's desolate shores and reappear, always dead, sometimes decomposing, in Khan's paintings, as well as in the watercolors and small objects she also makes. Every year, confused, dying whale sharks are beached in the old harbor leaving the formidable task of disposing of their remains. This is mixed in her mind with the traditional story of *Morriro and the Treacherous Sea,* as related by the Sindhi poet Shah Abdul Latif Bhittai (1689–1752) in *Risalo,* a compilation of local Hindu and Muslim legends. In this Sufi tale of self and the world, handicapped Morriro stays at home while his six bothers go fishing until, one day, they are swallowed by a giant whale. To take revenge Morriro asks blacksmiths to build him a giant cage of steel and glass, with hooks and blades on its outside, into which he climbs to be lowered into the treacherous straight between Karachi and Manora. The whale swallows the cage and the blades hook into its mouth; the fishermen reel in the monster to meet its end. Morriro climbs out of the whale unharmed and cuts open its belly where, deep inside its guts, he finds his brothers' bones. As Iftikhar Dadi has pointed out, "Morriro's myth emphasizes self and community in the face of larger predatory forces" and, extending this idea, Khan also feels the compulsion to delve into the guts of the whale as an act of honor and revelation.[9] Her versions of this story surface in images of these monsters and in incongruously anachronistic imaginary structures, described as *Drawings for Morirro's Fossil* (2009).[10] One of these reveals a conglomerate of architectural debris at the core of the "fossil" (like a giant pebble picked up on a beach), the other has TV monitors encrusted on its surface, streaming news, along with the fatuous flickering of everyday media.

The first sighting of a whale in Khan's work was in 2012 as a small brass cast, ironically reminiscent of a toy or souvenir, undoubtedly seen by the artist as a fragment of a much larger body.[11] (fig. 4) Its maw is split to bisect its length, supported by a chaotic brass scaffold just as if it were a jerry-built shanty. Small, diverse, sometimes inconsequential stories and images all feed into Khan's once noble and threatening Leviathan. She is determined to locate and expose for us its fractured bones and bloody guts as well as the remains of those it has consumed. This process of revelation concerns knowledge and beauty: we too may marvel at what she finds in that dark place—along with the iridescent colors of its entrails and beautiful textures of its skin.

The same kind of viscous visual matrix also appears in *On the Frontline* (2007), a photograph made of Khan's objects beached like spectral presences in an uncertain wasteland between city and sea. These echo for me the bleak figures and shadows of Giorgio de Chirico's metaphysical paintings or the poetic estrangement of magical-realist literature.[12] (fig. 5) Her hand and mind shape history, myth, and memory as a way of fixing the present to prompt the future.

II. Beginnings

The path that eventually brought Khan to Manora has been far from straightforward and this has influenced the directions in which her work has developed. She was born in 1968 into an educated middle-class family in the Pakistani city of Bahawalpur, where her father was posted as a civil engineer; her mother, who had been a gifted student of painting at the Lahore College of Arts & Sciences—then the country's most established and prestigious art school—did not work after marriage. When Khan was five, her father's business took him to Lebanon and the family moved to Beirut. She lived there happily until 1976, when the bomb blasts, rocket fire, and gun battles of opposing groups in the encroaching civil war meant that normal life was no longer possible. Her father's company moved to Saudi

[7] Naiza Khan in Iftikhar Dadi and Naiza Khan, "Manora to Karachi: A Conversation," *Naiza Khan: Works, 1987–2013,* Hong Kong, ArtAsiaPacific, 2013, p. 136. [8] *Fath-e-Mubarak (Blessed Conquest) 1843,* 2011, ink and watercolor on Arches, 36 x 51 cm; *Snow Globe,* 2009, watercolor, digital print and ink, 40.5 x 51 cm. [9] Iftikhar Dadi, "Manora's Fraught Trajectories," *Naiza H. Khan – Restore the Boundaries: The Manora Project* (exh. cat.), London, Rossi & Rossi, 2010, pp. 7, 8. [10] *Drawings for Morirro's Fossil,* 2009, ink on paper, 21 x 15 cm (two drawings made for installations [11] *Whale Under Construction,* 2012, brass, 12 x 13 x 12 cm. [12] *On the Frontline,* 2007, silver gelatin print, 51 x 61 cm. Photo by Arif Mahmood. [13] Naiza Khan, email to the author, June 27, 2015. [14] *Where Is the Shadow of Conscience: February 25th,* 1989, woodcut on paper, 163 x 69 cm. [15] Naiza Khan, email to the author, August 6, 2015. She recalls that this work was exhibited in the Oxford Union, but was removed after one day because of a complaint about its content. [16] *Look at the City,* 1987, woodcut and collage on handmade paper, 91.4 x 61 cm. [17] The title of this work comes from the poem of the same name by Faiz Ahmed Faiz.

7

8

Arabia, the family followed; after a year in Riyadh, they moved to the UK, firstly to Bristol and then to London, where they stayed.

Khan shares a common experience with many emigrants by remembering that wherever her family lived, they preserved the traditions and customs of home. Furthermore, she recalls that these were nurtured within as an unselfconsciously "secular" rather than religious household at a time when, before the fundamentalist polarization of Islam in the 1980s and '90s, such a description would not have been necessary.[13] From the time she left Pakistan in 1973 until she returned there in 1991, her direct knowledge of the country was through holiday visits to her maternal grandmother in the historic city of Lahore or to other relatives spread between Rawalpindi, Islamabad, and the southern port city of Karachi, where she herself was eventually to settle.

Fluent in English and Urdu, as well as in French and Spanish, as an art student, Khan had access to many different worlds. Between 1987 and 1990, the Ruskin School of Drawing and Fine Art (a department of the University of Oxford) provided physical and mental space in which she could work, read and try out new things. It was in this cloistered, relatively conservative atmosphere that she learned how to make engravings, etchings, lithographs, woodcuts, silkscreens, and watercolors; to draw the human body (from life and in death); and to make collages, oil paintings, photographs, videos, books, and objects. She had to read art history and critical theory, the latter administered in smaller doses at Oxford than elsewhere, and also immersed herself in a catholic range of poetry that included the works of Ezra Pound, Pablo Neruda, John Ashbery, the Palestinian national poet Mahmoud Darwish and the Pakistani modernist and communist, Faiz Ahmed Faiz. Artists that visited the school or showed at the Museum of Modern Art Oxford nearby (where she often sketched and made notes) also made a strong impact: the performance artist and sculptor, Mona Hatoum, who had been born in Beirut; Helen Chadwick's exhibition "Viral Landscapes" (1988–89); Shirazeh Houshiary's organic sculptures of mud, metal, and rose quartz; Krishna Reddy's virtuoso printmaking; or Ana Maria Pacheco's carved wooden tableaux that showed scenes of torture, exile, and wandering. (see fig. 52, p. 156) She was also an active member of the university's Middle Eastern Society, and many of her student works evince a continuing concern for the catastrophic events that continued to engulf the region that had once been her home.

Works from this time, such as *Where Is the Shadow of Conscience: February 25th* (1989), then her largest woodcut, refer directly to the violence that had become an everyday occurrence.[14] (fig. 6) Khan had been prompted to make this work by a widely publicized incident that had taken place in Palestine during the previous year, in which a boy had been brutally beaten by an Israeli soldier. Based on photographs she had seen in *The Guardian,* and pasted as reference in her notebooks, it was developed out of several life drawings: a hooded figure abjectly kneels on a bleak mountainside onto which the date of the atrocity and the title of the work are repeatedly engraved.[15] *Look at the City* (1987), a woodcut combined with collage, is an early reference to alienation, even violence, in the city, a theme central to Khan's current work.[16] Tension stalks in the void at its core: a man in front of an opaque curtain on one side and a woman, further back opposite, her voluminous hair covered by a veil, stands behind a semitransparent curtain; they make no connection. Their ambiguous self-absorption seems to mask the city, but could just as easily typify it. These two people *never* look at each other; they exist neither as individuals nor as a couple. (fig. 7)

The precarious, predatory violence of the city is also suggested in *Yahaan Se Shehr Ko Dekho (II) (Look at the City from Here)* (1987), a two-meter-high drawing, painting, and collage on paper, in which men and women emerge and disappear as fragmentary elements in a cityscape of almost obliterated photographs of time-worn buildings.[17] (fig. 8) In 1988, Khan made her first

4 | Whale under Construction | 2012 | brass | 12 x 30 x 12 cm

5 | On the Frontline | 2007 | gelatin silver print | 51 x 61 cm | photo by Arif Mahmood

6 | Where Is the Shadow of Conscience: February 25th | 1989 | woodcut on paper | 163 x 69 cm

7 | Look at the City | 1987 | woodcut and collage on handmade paper | 91.4 x 61 cm

8 | Yahaan Se Shehr Ko Dekho (II) (Look at the City from Here) | 1987 | charcoal, acrylic, and collage on paper | 202.3 x 149.5 cm

9

10

11

video (her second was not produced until 2009 on the island of Manora),
which was shot moving between the mosque and the bazaar in the walled
city and Red Fort of Lahore. She describes it today as "quite abstract, mainly
about space, the body, and architecture."[18] Such an assertion begs the
obvious questions, "What kind of space?" and "Whose body?"

III. Return

The works that Khan began to produce after 1991—when, after an interval
of eighteen years, she moved from the UK to settle as an adult in Pakistan—
provide a range of answers to the questions above. She lives and works in
Karachi, the country's largest, most populous city and its industrial and
financial powerhouse. Compared to London or Oxford, her lifestyle there
changed radically, but art proved to be the constant element, and she quickly
became established there as a faculty member of the Indus Valley School of
Art and Architecture. The city already supported a thriving artist community
best known at that time for its appropriation of folk art and advertising into
a unique form of "Karachi Pop" and, in this context, the formal grounding of
her work must have seemed out of step. By the beginning of the millennium,
however, a workshop-based practice involving writers, urban planners, and
architects was beginning to evolve that has strongly influenced her current
work. Between 1998 and 2009, she became a leading force in the Vasl Artists'
Collective which, initially supported by the Triangle Network in London,
instigated a new kind of cultural platform and ecology in the city. [19]

Khan's earliest Karachi works build on concerns that had already become
evident in Oxford. The three charcoal drawings that comprise *All the World's
a Stage (Hali Triptych)* (1993) were rooted in her experience of a gathering of
women in a Shia *majilis* at the house of one of her friends. [20] After religious
stories had been narrated, women shrouded in black mourned the martyrdom
of Hazrat Imam Ali (607–661) and, finally, an elderly stateswoman gave an
address about the refugee crisis in war-torn Bosnia, asking for goods or aid.
For Khan, the most vivid parts of this speech were quotations from Maulana
Altaf Hussain Hali's (1837–1914) epic Urdu poem *Musaddas-e-Hali,* about the
social and moral disintegration of Muslim society in India during the late
19th century that extended across time to refer to the contemporaneous
situation in Bosnia because they "were so visual. The images that I produced
[in response] were not describing the poem in any way, but [were] a result
of the confluence of images and emotions that knocked against each other
during those few hours."[21] The resulting drawings have a nervous, sketchy
quality; the quotation from Shakespeare in the title suggests sardonically
that fate rather than will governs our actions, and the images, with their
intimations of loss, suffering, and atrocity, serve as testimony to the eternal
viciousness of human nature.

One of these drawings, of humped, dark forms, suggests the black-shrouded
women keening in the *majilis*; in another, a row of female bodies lies slumped,
face downward, over what appears to be a platform or stage in an unstated but
visceral response to those sexual crimes of the Bosnian War in which Muslim
women were targeted. (fig. 9) In the third drawing, these "figures" have
become disembodied, abstract, and could almost suggest mountain peaks in
a classical Chinese landscape painting. Here, Khan preserves an aesthetic and
critical distance between the female body and herself, as is also clear in *Burnt
Torso,* two dense charcoal drawings from 1994. Taking a prompt from its
title, these latter images of a dark, isolated woman's body may be read as a
figure that has been decapitated, dismembered, and torched; however,
just as easily, Khan insists, they could be fragments of a nude figure. (fig. 10)
She recalls that she was then particularly interested in the formal qualities
of drawing, partly influenced by the work of Georgia O'Keeffe.[22] For her,
both interpretations are equally valid but these works were made at a time of
rising political violence in the streets of Karachi when, increasingly, hitmen
ran amok, terrorizing the general public while murdering their opponents.[23]

12

13

Her Body in Four Parts (1995), an eight-panel diptych divided between a dominant ground of twisted silk organza on one side and charcoal drawings of a woman's body on the other, is a personal exploration of gender and place.[24] While not devoid of political intent, the artist's gaze has shifted away from the city and its streets—populated by the bodies of others—to the female self and, by extension, to its signification and representation within culture. Echoing the custom in which two women prepare a veil out of a sheet of cloth by starching and twisting its fabric by hand as if it were a length of rope, the diaphanous, pale-almond, organza fabric laid on four of the canvas panels in this work bears the imprint and rhythm of this process. Through it, barely perceptible solid forms have been stitched with silver-wire thread that relate to the parts of the body drawn on the other four panels.[25] These charcoal images range from an intimately realistic nude torso or a long shank of black hair to dark, abstract whorls and clefts that are less easy to figure out. "*The weight of something,*" a text drawn on one of them, gives a clue, suggesting that these "black holes" are voids that are both positive and negative, resounding with sex, reflection, density, fear, foreboding, hope, and guilt.

Khan's long-standing concern with fragments of the body and their significance is further developed in *Hair Falls as Night* (1996), a series of four diptychs depicting hair, made in graphite on canvas, and a handmade illustrated book of poetry.[26] In the drawings, dark, disembodied hair swirls seductively on a light background from a head that seems to have no skull to define it; ultimately, the tresses appear like traces of light picked out on a dark canvas. These animated forms could also represent veils or wraiths but, for Khan, their translucent textures clearly offer a platform for virtuoso drawing, as suggested by the title of the last of these works, *Homage to Utamaro* (1996). **(fig. 11)** The book, manually typed on Japanese paper, however, is more complex, and combines two parallel texts running alongside separate visual strands. The first, a "cerebral dialogue" written by Khan, is linked to a series of images she had based on the classical Greek sculpture *The Victory of Samothrace.* The second strand, text and image, comprises a news report about two women who immolated themselves in front of the Hyderabad court in protest against the inaction of the judiciary in prosecuting the murderer of nine members of their family, nine years previously. The news photographs of the women in flames reminded Khan of the Greek sculpture's form.[27]

Khan's works from this time reveal an acute desire to express a concern for common values that relate not only to basic human rights, but also to the position and rights of women in particular, especially in the Muslim world. Yet she also regards them as "autobiographical." The prescriptive rules of *Bahishti Zewar* (*Heavenly Ornaments*)—a popular eight-volume handbook especially for the education of girls and young women compiled by the Islamic revival scholar Ashraf Ali Thanwi (1863–1943)—which one of her students introduced to her at this time, were catalysts for this development and the book provided the title for a series of drawings made in 2005.[28] Often gifted to a woman at the time of marriage, this tome provided, along with the author's interpretation of Muslim law, a detailed guide on how to behave—even in the most intimate ways. Fascinated by the restrictiveness of its detail, Khan's studies of this book became part of her work which, paradoxically, became more sexually explicit as she "suggested an alternative reality to the one [that was] prescribed."[29]

IV. Stamps and Carapaces

Within this ever-shifting dialogue of prescription and possibility, the polemics of western feminism seemed out-of-place and its blanket assumption of belatedness seemed offensively colonial.[30] As a result, Khan was concerned with both excavating texts and myths from South Asian, particularly from Urdu culture, and also with making a stronger,

[18] Naiza Khan, email to the author, July 27, 2015. [19] Iftikhar Dadi had previously attended a Triangle Workshop in Delhi, and in 1998 invited Robert Loder, the London-based chairman of Triangle, to visit Karachi with a view to organizing a similar development. After a year, Dadi moved to take his PhD at Cornell University in upstate New York and Khan became the main organizer of the Vasl Artists' Collective. The collective's first International Artists' Workshop took place in 2001. In Urdu, *Vasl* means "meeting point." [20] *All the World's a Stage (Hali Triptych),* 1993, charcoal on paper, 100 x 70 cm (each). [21] Naiza Khan, email to the author, August 6, 2015. [22] *Burnt Torso (I)* and *(II),* 1994, charcoal and Conté on paper, each 100 x 70 cm. [23] Naiza Khan, email to the author, August 6, 2015. [24] *Her Body in Four Parts,* 1995, diptych of eight panels, silk organza, silver-wire thread on stretched canvas (four panels), charcoal on stretched canvas (four panels), each panel 61 x 61 cm. [25] Naiza Khan, email to the author, July 27, 2015. [26] *Hair Falls as Night,* 1996, pencil and acrylic on canvas, 61 x 121.9 cm (two panels out of four). Artist's book: acrylic, typewriter, and inkjet print on kozo paper, 25.2 x 20.5 cm. [27] Naiza Khan, email to the author, July 28, 2015. [28] *Heavenly Ornaments (I)* and *(II),* 2005, charcoal, Conté and acrylic on Fabriano paper, 275 x 153 cm (each). [29] Naiza Khan, email to the author, July 27, 2015. [30] Iftikhar Dadi, "Allegories of Encounter" in Naiza H. Khan, *The Skin She Wears* (exh. cat.), London, Rossi & Rossi, 2008, pp. 12–23, gives the background on recent discussions about women's rights in Pakistan.

multilayered contact with the city in which she lives and the people who reside there. One of the main ways in which she accomplished this was by working outside the studio.

The project *Henna Hands* (2003–06) used henna, a medium traditionally associated with female ornamentation, to create, by means of hand-shaped templates that inevitably evoked the image of the *Hamsa* (Hand of Fatima), which she used to stamp out a series of different graffiti-like "paintings" of fragmented female nudes on the walls of old buildings in areas of Karachi that were undergoing demolition and reconstruction.[31] The women's bodies were realistic and imperfect, yet these "naked" figures were, to some people at least, a provocation, particularly if they were situated near a poster for a religious event—such as a march for jihad sponsored by an Islamic students' organization.[32] Retribution was swift and the "offence," like the women it exposed, was covered and "punished." But other examples of these works were left alone to fade slowly. **(figs. 2, 14)**

During 2006 and 2007, Khan returned to work in her studio on assertive images of the female body and its imprint that had had virtually no relation to traditional South Asian representations of women in painting, sculpture, or literature. In drawings, watercolors, and objects, she collided the "forbidden" feminine realm of lingerie and corsetry with armored, galvanized steel carapaces of different shapes and states that "all seemed to represent some part of myself or how the body is felt." **(figs. 12, 13)** These were "armor works with spikes on the outside, spikes inverted, sort of cradle-pouch-belly, the pregnancy armor . . . chastity belts, bulletproof vests."[33] The work is equivocal in that, through the spirit of one of her subjects, the Rani of Jhansi (a warrior heroine of the Indian Rebellion of 1857)[34], it expresses the aggression of "male" armor while, at the same time, also suggesting the sadomasochistic pleasures of domination, submission, and confinement. As perversely attractive as these objects and the works related to them may seem, the sense of confinement they both express and generate also communicates the conceptual and physical constraints of the artist. Khan soon needed a different kind of body—a parallel body—on which to work, and stumbled across this while walking on the island of Manora. She was trying to find a quiet, uncrowded environment, near but separate from the city, where she could reflect on her work.

V. Borders

Once a proud bastion of empire, now made obsolete by the booming container port along the coast, the once-flourishing island of Manora is, bar its naval base and academy, almost deserted—but still vigilantly patrolled by the naval police. In the seven years she has been going there, Khan has noticed an increased level of surveillance, a symptom of endemic paranoia about terrorism, but it was of particular interest to her because its empty, marginal spaces could be employed to reflect and portray change clearly, quickly, and symbolically. Although a small ripple would be harmless there, if it were amplified over the whole coast, it could soon become a crashing tsunami. And such chaotic reflection dramatically extended into reality when, in September 2008, four children on the island were crushed to death by a falling wall on the site of a former public school.[35]

The island became for Khan both a sounding board and a place where she could incubate ideas and feelings about a much larger social and political body. One of her first works referring to the island, the thinly painted, multilayered oil painting *In This Landscape There Is No Certainty* (2011), foregrounds its bleakness with concrete pylons, scrawled texts, and a failed luxury housing development set against the behemoth of the teeming city of Karachi on the other side of the narrow straight.[36] By the time she painted *The Streets Are Rising* (2013), a sarcastic riposte to Umberto Boccioni's Futurist paean to human and mechanized construction *The City Rises* (1910), the island's void had been filled and littered with debris and barracks; smashed, upturned cars; another beached whale; submerged notations; threatening, nondescript,

14 | Henna Hands | 2002 | henna pigment stamped on walls | site-specific project near the Cantonment Railway Station, Karachi

15 | Whale Under Construction | 2015 | oil on canvas | 132 x 203.5 cm

16 | Shoreline | 2015 | oil on canvas | 137 x 162.5 cm

[31] The Hand of Fatima, the prophet Mohammed's daughter, represents purity, loyalty, truth, and faith. [32] Karin Zitzewitz, "Life in Ruins: Materiality, the City, and the Production of Critique in the Art of Naiza Khan," in *The Journal of Asian Studies*, March 2015, p. 6. [33] Naiza Khan, email to the author, July 27, 2015. [34] *Armor Suit for the Rani of Jhansi*, 2008, galvanized steel, feathers, and leather, 90 x 45 x 35 cm. [35] This incident triggered and was referred to in Khan's video *Homage*, 2010. [36] *In This Landscape There Is No Certainty*, 2011, oil on canvas, 122 x 180 cm. [37] *The Streets Are Rising*, 2013, oil on canvas, 200 x 256 cm. The painting by Umberto Boccioni is in the collection of the Museum of Modern Art in New York. [38] *The Structures Do Not Hold*, 2011, ink and watercolor on Arches paper, 51 x 36 cm. [39] The examples shown in the exhibition are *Whale Under Construction*, 2012, brass, 12 x 30 x 12 cm; *Whale*, 2014, watercolor on Fabriano paper, 41 x 61 cm; *The Layers of the City*, 2015, oil on canvas 137 x 162.5 cm; *Whale Under Construction*, 2015, oil on canvas, 132 x 203.5 cm. [40] *Breakage*, 2015, oil on canvas, 120 x 150 cm. Naiza Khan, email to the author, July 28, 2015. [41] Ibid. [42] Ibid.

concrete structures; and then, zooming the eye towards the horizon, the line of the Indus River with the hungry city throbbing beyond it.[37] Within this desolation, objects, streets, and buildings seem to have taken over the world; no place for humanity remains. (fig. 1)

We have entered the world of WB Yeats's apocalyptic poem *The Second Coming* (1920)—"Things fall apart; the centre cannot hold . . . "—a work that Khan unconsciously references in the title of her drawing *The Structures Do Not Hold* (2011), which reveals the fragmentariness of the constructed city with its half-finished buildings, scaffoldings, collapsing bridges and flyovers, and temporary barracks.[38] Yet, the city, or the life that should exist within it, continues as a threatened, organic structure in the body and guts of the whale, a creature that, in one form or another, continues repeatedly to appear.[39]

In a number of Khan's larger new paintings, Karachi appears as a dark, oily shadow or reflection, inverted at the bottom of the canvas. Against this background, *Breakage* (2015) depicts the island as a fractured, bisected plan, overlain and "unified" in red paint by what seem to be the scattered footprints of unknown red buildings. Flickering between plan and silhouette, the central form of this work suggests to Khan "a large pylon under the ground. Something floating, contained and yet rooted."[40] Like people, objects, she implies, have lives and memories of their own because they are interwoven into the same flux, force, and pattern. The island, its form, and the things on it, operate therefore as both a beacon and a mirror in which past, present, and future connect and flow together backwards and forwards in time. This inexorable sense of flux is made explicit in "Undoing / Ongoing," the title of this exhibition, with the intimation that any sense of hope or progress is immediately pushed back—"undone"—in a constant Sisyphean labor.

A similar tension is also evident in *Layers of the City—Do They Stick?* (2015), an ominous painting in which the bleeding carcass of a whale foregrounds tents, shanties and a pylon with the ever-present city beyond. If the inequities of both past and present are fixed in a constant state of churning, exacerbated by successive waves of migrants due to war, urban strife, or natural disaster, what stability or kindness, Khan asks, will ever be achieved?[41] The ghosts of classical columns in one study, *Whale Under Construction* (2015), reinforce the metaphorical sense of desperation and decay. (fig. 15)

The present, seemingly insoluble, refugee crises in Syria, Africa, the Middle East, and Europe, as well as Pakistan's own chronic tragedies since the 1947 Partition, both test the international capacity to help, and present a constantly nagging indictment that it is impossible for any humane person to ignore. In Khan's work, this concern has come together in paintings such as *Shoreline* (2015), a "nightscape" in which vast crowds hover spectrally in a vast tent, and in other repeated images of shanties and tents. She feels that these flimsy structures, of a kind that may be seen in refugee camps anywhere in the world and which have become part of the daily global newsfeed, insist, like the people who have to call them home, on the necessity for a shift in borders. (fig. 16)

"There are no borders here," the accusatory motto of those who occupy the "Jungle"—the derogatory name given to the overcrowded refugee camps in Calais, France—has resounded across the world, not only as a statement of desire by people who, for reasons of war or poverty, are unable to live where they were born, but also as a challenge to us, the silent majority, who accept, and reinforce, the authoritarian impermeability of borders so unquestioningly.

Disregarding strictures of politics, sociology, cultural studies, or propaganda, these recent works, have become "about" the need for such a shift. Their content, along with the ways in which they have been conceived and made, are an embodiment of what Khan has described as a "realignment, a negotiation of new boundaries."[42] The desire to attain this state has fueled all her work; by digging into the belly of the whale she has extended the power of image and imagination. ●

Xu Bing:
Tradition, Representation
and Language

This essay was published in **Xu Bing**, London, Albion, 2011. I had been impressed by Xu Bing's work since his series of large installations "Book from the Sky," made in the late 1980s, but had only more recently got to know him personally when I showed his work in Tokyo. During my research, I learned about his early facility in calligraphy, the profound impact of the Cultural Revolution on him and his family, and how, like many others, he had been sent to the countryside to be "re-educated" as a peasant—in his case on a pig farm, where he learned husbandry skills that would later be put to good (and scandalous) use in such works as his video **A Case Study of Transference** (1993–94). The world financial crisis of 2008–09 delayed the book's production but it appeared finally in 2011, updated and magnificently designed in hardback by Herman Lelie. Xu Bing was born in Chongqing, China, in 1955; since childhood he has lived in Beijing.

2

We should take over the rich legacy and the good traditions in literature and art that have been handed down from past ages in China and foreign countries, but the aim must still be to serve the masses of the people. Nor do we refuse to utilize the literary and artistic forms of the past, but in our hands these old forms, remoulded and infused with new content, also become something revolutionary in the service of the people.

– Mao Zedong, 1942 [1]

Mao Zedong made this revolutionary statement about tradition and its relation to representation in a series of talks on art and literature given in May 1942 in what was then the Communist stronghold of Yan'an. **(fig. 4)** After the end of the Chinese War of Liberation in 1949, these ideas gradually solidified into the official cultural doctrine of the Chinese Communist government. There was little in Mao's words that had not been previously addressed by his hero Lenin (1870–1924), or by the Russian realist writer, Maxim Gorky (1868–1936), by the Soviet ideologue and son-in-law of Stalin, Andrei Zhdanov (1896–1948), or by the Chinese writer and critic Lu Xun (1881–1936), who posthumously became the "patron saint" of the art of the New China. **(figs. 2, 3)** What was significant here, though, was the importance that Mao gave to the matter of art and culture at such a chaotic time. However, the battle against the Chinese Nationalists (Kuomintang) and the Japanese occupiers, was far from won. It would be seven violent and tumultuous years before the Communist Party took control of the whole country.

Being a politician like any other, Mao referred to tradition when he wanted the best of all possible worlds, desiring to stake a claim as the legitimate heir of an illustrious history. His ideological beliefs, however, entailed that this could not be limited only to the traditions of China, nor restricted to an elite; it had to be "infused with new content" so that it could play a revolutionary role in service of all the people. Like everything else, after 1949, tradition had to become a tool of the revolution. In spite of Mao's later exhortation, during the Cultural Revolution (1966–76), "To Smash the Four Olds" (habits, customs, culture, and ideas), he always stayed in touch with the traditions of Chinese art: he was a passable calligrapher and poet, and incorporated these traditional forms into various editions of *The Little Red Book* and, in 1973, published a volume of his poetry, bound in a traditional string format [2].

As a child of the Cultural Revolution, Xu Bing was acutely aware of the persistence of tradition as well as of Mao's ambivalent attitude towards it. Inevitably this has influenced his own work: "While Mao broke with tradition, he also reformed tradition and returned it to the people. For example, Mao enjoyed citing classical Chinese literature, and Chinese cultural traditions had a significant influence on his thinking. In his writing there are many references to classical texts … Traditional culture is not necessarily learned, but innate to the character of Chinese people … Even if Mao tried to cut people off from tradition, it is an inescapable part of the Chinese character." [3] Tradition it would seem is genetic.

Looking back further, to the decaying world structures of the late-19th and early-20th centuries, China had much more in common with the

1 | Xu Bing | **Book from the Sky** | 1987–91 | as installed in the exhibition "China/Avant-Garde" at the China Art Gallery, Beijing, 1989

2 | Li Hua | **Roar China** | 1935 | woodcut on paper | 20 x 15 cm | Art Museum of the China Central Academy of Fine Arts, Beijing

[1] Mao Zedong, "Mao Tse-tung [talks at the Yan'an Forum 1942] on Literature and Art," Beijing, 1967, pp. 11–12. [2] Perry Link, "Whose Assumptions Does Xu Bing Upset and Why?" in J. Silbergeld and D. Ching (eds.), *Persistence/Transformation: Text as Image in the Art of Xu Bing*, Princeton, Princeton UP, 2006, p. 55. Link also comments on how traditional poetic syllabic forms were, no doubt unconsciously, incorporated into revolutionary propaganda. [3] Xu Bing, "Trans-boundary Experiences: A Conversation Between Xu Bing and Nick Kaldis," *Yishu: Journal of Contemporary Chinese Art*, June, 2007, p. 83.

entropy of the Russian and Ottoman empires than with its more vigorous neighbor (and enemy) Japan. Like the St. Petersburg Court or the Porte in Constantinople, the Forbidden City was a hotbed of violent intrigue, isolationism, and mysticism, characterized by complete aversion to the encroachments of modernity. From this perspective, modernity seemed little more than the wolf of western imperialism in the sheep's clothing of economic development when it was actually a premonition of death for the unreconstructed empires of the East. As the Chinese imperial structure began to decompose, tradition, in its many aspects, was regarded by many, both inside the country and abroad, as an obstacle, synonymous with feudalism, hierarchical Confucian beliefs and backwardness.

But what could be put in its place? Traditional art, aesthetics, and means of expression were embedded in the culture but, rather than being central as before, were now sidelined. Beauty as it had been appreciated for centuries suddenly seemed empty. The intelligentsia began to search for new forms of expression. The enlightened national culture engendered by the new Republic (1911) and May Fourth Movement of 1919 started to lead art down a path of social concern and populism that was later to dovetail with the aesthetic ideology of communism.[4]

As Arnold Chang makes clear in his study of the politics of style in the People's Republic of China, traditional painting was far more problematic for this regime than more easily accessible folk art or revolutionary graphics.[5] Yet, unlike in the Soviet Union where aesthetic ideology was based on the tenets of *partiinost*, *klasovost*, and *narodnost*,[6] even at the very beginning, in Yan'an, Mao made a firm distinction between what he described as *puji* ("popularization," something like what the Soviets would call *narodnost*) and *tigao* (the raising of aesthetic standards—a concern not much discussed in Soviet aesthetics). For Mao, both these ideas had to be present in any worthwhile work of art.[7] In the event, the inherent contradiction between popularization and aesthetic improvement caused great tension, the former predominating over the other. In spite of this, *puji* has been a constant impulse in the development of Xu Bing's work, even from the beginning.

For Xu Bing, the dilemma of tradition—what it is and how it could be expressed—was just as vexatious a subject as it was for Mao. Nor was Xu Bing alone, as the appropriation, or rediscovery, of tradition in one form or another has affected the work of most of the New Wave Chinese artists of his generation. Yet, although the crucible of Mao's Communism and the Cultural Revolution had been experienced by all, the consistent and reflective way in which Xu Bing confronted and digested the many aesthetic and ethical dilemmas raised by these experiences is extremely particular.

Since the end of the 1980s, and throughout the whole subsequent body of his work, Xu Bing has, using many different media and forms, addressed both the necessity and the impossibility of the continuity of history and tradition at times of violent social and political change. His experiences in the Cultural Revolution were critical to this. In Mao's China there was little possibility of withdrawal from everyday life, as the *literati* had done in historical times; engagement was mandatory. The problem was, and continues to be, how meaning and value could be conveyed from one time to another while, at the same time, not being irrevocably altered by the changes in ideology they had been forced to endure. This was particularly highlighted in the dichotomy between language and meaning at a time when traditional forms were under attack. Language had been reduced to a vehicle of ideology, and all ambiguity had been bleached out of it.

This short essay, therefore, is not only about tradition and *how* it is represented in Xu Bing's work. Such a focus would tell only a small part of the story. It is more about the tension between tradition and *what* is represented in Xu Bing's work and how this relationship has evolved over the past twenty years. During this process the artist has, sometimes ironically, addressed existential issues on a global scale, working out of

[4] Michael Sullivan, *Chinese Art in the 20th Century*, London, Faber & Faber, 1959, pp. 23–30. The Republic of China was founded in 1911, and Sun Yat-sen became its first provisional president in the following year. The May Fourth Movement (1919) was a student protest, initially against the terms of the Treaty of Versailles (1919), that became a mass movement and marked the rejection of Confucian values, the birth of modern Chinese nationalism, and the desire for new forms of culture. [5] Arnold Chang, *Painting in the People's Republic of China: The Politics of Style*, Boulder, Colorado, Westview Press, 1980. [6] *Partiinost*—harmony with the aims of the Communist Party; *klassovost*—awareness of the class struggle; *narodnost*—awareness of national destiny and of the importance of the masses. See C. Vaughn James, "Soviet Socialist Realism. Origins and Theory," in D. Ades. T. Benton, D. Elliott and I. Boyd Whyte (eds.), *Art and Power: Europe Under the Dictators 1930–1945*, London, Thames & Hudson, 1995. [7] Chang, op. cit., pp. 7–8, 73–77. [8] Britta Erickson, *Words Without Meaning, Meaning Without Words: The Art of Xu Bing* (exh. cat.), Washington, DC, University of Washington Press/Smithsonian, 2001, pp. 34–35. Xu Bing's father, Xu Huaming, had, as a student, originally enrolled at the Shanghai Painting Institute. At Beijing University he became professor of history. See also Karen Smith, *Nine Lives: The Birth of Avant-Garde Art in New China*, Zurich, Scalo Verlag, 2005, pp. 318–322 for Xu Bing's family background. [9] Erickson, op. cit., p. 16. [10] "My generation, however, was irreparably affected by the campaign to simplify characters. This remoulding of my earliest memories—the promulgation of new character after new character, the abandonment of old characters I had already mastered, the transformation of new characters and their eventual demise, the revival of old characters—shadowed my earliest education and left me confused about the fundamental conceptions of culture." Xu Bing, ibid., p. 14. [11] Ibid., p. 34. [12] This was orchestrated by Jiang Qing, Mao's wife, and "The Gang of Four." [13] A number of Xu Bing's installations in the 1990s entailed the use of live farm animals. [14] Xu Bing in Erickson, op. cit., p. 17, 18.

3 | Li Hua | **Lu Xun Giving a Woodcut Class in Shanghai in the Early 1930s** | 1957 | woodcut

4 | Luo Gongliu | **Mao Reporting on the Rectification in Yan'an in 1942** | 1951 | oil on canvas | 164 x 236 cm

5 | Xu Bing | at age 19 in the peasant commune of Huapen | 1974

6 | Xu Bing | **Zhao Cai Jin Bao (Bringing in Wealth and Riches)** | 1976 | ink on paper | calligraphy drawn by Xu Bing to bring good fortune to the commune of Huapen

7 | Cover of **Lanman Shanhua (Brilliant Mountain Flower) No. 4** | December 1975 | mimeograph on paper, staple-bound | 26.7 x 19.5 cm

formative experiences in revolutionary China by tempering them with what he has subsequently learned.

Xu Bing was born in 1955 and was eleven years old at the start of the Cultural Revolution. His parents were academics at the University of Beijing and as the Cultural Revolution violently progressed both were dismissed from their work; his father was denounced and arrested. In these dangerous times the families of all the intelligentsia were at risk, but Xu Bing's precocious ability for calligraphy, initially learned from his father, became his redemption.[8] He described this painful time as follows: "My father was a reactionary. No one spoke of 'tradition' during the Cultural Revolution; instead we spoke of 'blood relationships.' I was labeled 'the bastard son of a reactionary father.' My family background was polluted."[9]

Part of this "pollution" was the fine education he had received from his family and their friends, which was based on the traditional belief that painting, calligraphy and poetry were created out of the same aesthetic impulse. Such a grounding was to prove fundamental for his later work. Xu Bing has always acknowledged the importance of the written character or symbol but, as he was growing up, experienced the unsettling phenomenon of it actually changing just as he was learning it. From the late 1950s through to the 1970s, as part of a widespread drive for literacy, the government ordered that many traditional pictographs had to be recast in simplified forms. This meant that Xu Bing had to unlearn what he had already been taught so that he could write and understand the new language.[10] This was part of a traumatic and widespread process of re-education that reached its height during the Cultural Revolution. Mao's aim at this time was to strengthen his position as party leader by mobilizing teenage Red Guards to attack established party cadres, the professional classes, and the intelligentsia and their families, by forcing them to renounce their previous ideas and affiliations to replace them with an unquestioning and child-like ideological purity. Xu Bing later described how, when still a pupil at upper-middle school, he had learned of his father's imminent arrest from a large handwritten poster that abused and denounced him.[11]

From 1969, the time of his father's arrest, his family was broken up, his mother forced to undergo re-education, and rooms in his home were assigned to workers. The school system itself also began to break down as teachers were openly criticized by their pupils who were now Red Guards. In such a dire situation the only way that Xu Bing was able to avoid severe bullying and cleanse himself of the "pollution" of his family background was by using his talent as a calligrapher in the new style, working as a Red Guard, producing big character posters for the school propaganda office, as well as slogans for public discussions and criticism meetings. As for many others, the stress on him was immense.

In 1974, a time of particularly intense political polemic even by the standards of the Cultural Revolution,[12] Xu Bing was sent, with three other students, to the small, 39-household commune of Huapen, a remote mountain region on the border between Beijing and Hebei, where for almost three years he was to work with the peasants in the fields and tend their livestock. (fig. 5) The lack of pressure in the countryside was more than literally a breath of fresh air, as no one there either knew or cared about his family background. What was important was how well he performed his duties on the land and his personal relationship with the peasants. The work was hard and the physical conditions severe yet this was undoubtedly a profound experience for Xu Bing.[13] Also, because he knew calligraphy, local people asked him to create different kinds of visual word play for decorative banners for special occasions that combined the characters of a significant phrase within a single auspicious figure.[14] (fig. 6) Such composites were thought to have a shamanistic power and were an almost lost tradition in Chinese folk art. Their rectilinear, hybridized forms were later to have a strong impact on the development of Xu Bing's *Square Word Calligraphy*.

8

9

Once they had settled in, it was not long before Xu Bing and his colleagues began to collect news, poems and songs from people in the commune and to display them at the local County Cultural Palace in Yanqing. They also put together a local newsletter that, being responsible for propaganda, Xu Bing designed and illustrated.[15] (fig. 7) He recalled from this time that "in the countryside almost no one could read, so part of the revolutionary youth's job was to read aloud the news and teach characters ... We worked hard, promoting the required ideas clearly in a hand-produced newsletter."[16] At this particular stage of the Cultural Revolution, the idea of peasant art was being strongly promoted as the authentic art of the New China, and an international touring exhibition of "Peasant Paintings from Huhsien County" was being widely circulated.[17] (fig. 8) In this climate, Xu Bing's newsletter became such a local success that it was quickly noticed in Beijing and brought to the attention of the Minister of Culture, the revolutionary painter, Liu Chunhua (b. 1944).[18] As a result of this introduction, Xu Bing started to receive a number of special assignments, including the production of a print to support the 1976 campaign against Deng Xiaoping, who had been strongly critical of the Gang of Four. The print was a great success and Xu Bing was asked to make it on a larger scale for a national exhibition.[19]

Xu Bing was now "cleansed" and reformatted as a peasant artist rather than as a child of reactionaries, and was therefore eligible to study art at the elite May Seventh College of Arts, in Beijing, which was reserved only for workers, peasants and soldiers. However, before he could take up his place Mao died, the Cultural Revolution came to an end, and the Gang of Four was denounced, Deng Xiaoping was rehabilitated, and the college dissolved. Instead, no doubt because of his recently acquired peasant credentials, he was offered a place in the printmaking department of the newly reinstated Central Academy of Fine Arts in Beijing, although he would have rather studied western-style oil painting.

Ever since the end of the 1920s, the medium of woodcut, the form to which Xu Bing now gravitated, had become strongly associated in China with the struggle for national sovereignty and for the social betterment of peasants and workers. Lu Xun was one of the greatest protagonists of this movement and his seminal series of books *New Glories in the Realm of Art* (1929) showed important developments in the medium from England, Germany, America, Japan, France, and the Soviet Union. German expressionist prints, the socially engaged work of Käthe Kollwitz (1867–1945) in particular, became a strong influence on Chinese art at this time. Lu Xun realized that the woodcut could be a medium of mass education as well as a spur to social action and, accordingly, encouraged the foundation of many wood-engraving clubs across the country. (fig. 3) The aim of this new movement was, in his own words, "to accept the historical legacy of Chinese traditional art; to absorb the best in style and technique from foreign art; and thus to establish a new national art in accordance with the demands and tastes of the masses."[20] Lu Xun was subsequently adopted as one of the cultural heroes of the People's Republic, although his ideas were often misrepresented or disregarded.[21]

Xu Bing's first series of works, made in the late 1970s and early 1980s while first a student and then an instructor at the Central Academy of Fine Arts, were over 120 prints of village life, his *Shattered Jade Collection* (1987–88). Derived from his experience in the countryside, these were made in a direct, sometimes purposefully crude, style. In their modest size and limited use of color they were a far cry from the shrill didacticism of revolutionary peasant art. (fig. 9) Xu Bing remembered the mental turmoil of the time of relative openness that followed the Cultural Revolution: "Our lives and cultural background are a jumbled knot of socialism, the Cultural Revolution, the Reform Period, westernization, modernization."[22] And tradition too. In the university library he now had access to books about religion, philosophy, and culture long banned by Mao, but these were written in a script that he could now barely decipher. The "pollution" was now not of bloodline but of memory and language.

10

11

Xu Bing now frankly admits that he was overwhelmed by new impressions, information, and ways of thinking. In the library, he began to read about the riddles of Chan (Zen) Buddhism—ways in which spiritual enlightenment could be reached through the shock of realization—and about Taoism also. In the face of a reality that had been subjected to such torment he realized that language was hollow and that meaning could only be sought through action. And for Xu Bing that action was art.

New western ideas were also penetrating China. The existential puzzles, or *aporia*, of such deconstructionist and postmodernist philosophers as Jacques Derrida and Jean-François Lyotard were being translated into Chinese.[23] Western art, particularly American, was also being seen and openly discussed for the first time. Robert Rauschenburg (1925–2008) visited and exhibited his work in China; Andy Warhol's (1928–1987) repeated silk-screen paintings, in particular, made a strong impact on Xu Bing, as did conceptual art typified for him by the work of Marcel Duchamp (1887–1968) and that of Joseph Kosuth (b. 1945). **(fig. 10)**

In this climate, while still an instructor at the Beijing Academy, Xu Bing began to move away from figurative images of farm life by concentrating on the serial nature of printmaking itself and reflecting on how the process of making the print was, in fact, its most important content. This was a far cry from the propagandistic or illustrative orthodoxy that still prevailed.[24] In an article "A New Exploration and Reconsideration of Pictorial Multiplicity" published in *Meishu*, the leading art magazine in the Chinese mainland, Xu Bing contrasted the repeated, and repeatable, image of the print with the cathartic, dynamic beauty of the handmade work because it followed "the normalization and standardization of modern society . . . [and has] a deeply spiritual, incredibly rational, man-made beauty that comes when emotion has been eliminated or controlled."[25] Here he explained the new ideas behind the two series of woodcuts, one of which he had submitted for his MFA thesis. In the first series that comprised eighteen works,[26] he had focused on formal, rhythmic, abstract possibilities by using different inking and printing techniques. In "Five Series of Repetitions," the second series of eleven prints, he tells the story of a printing block from its untouched dark state in the first print to the gradual formation of an image by the sixth state, to its removal to a blank void in the last work. Using this openly deconstructive approach, Xu Bing embarked on what he describes here as "an artistic death course" which expressed the "aggressive meta-consciousness" of the artist.[27]

These relatively small works provided the platform from which Xu Bing could embark on a much larger and longer-term project, his seminal work *Tianshu* (*Book from the Sky*), the first version of which was exhibited in 1989. **(fig. 1)** The word of this title has a long history and has many meanings, from "word from the Emperor" to "word from heaven's spirit" but, most significantly, it was also used as a warrant of moral authority in the case of peasant revolt—as a document to show that heaven was on the insurgents' side.[28] The title, therefore, had both reactionary and revolutionary connotations, an ambiguity that Xu Bing must have relished as he hand-carved 1,250 invented, meaningless Chinese characters in both large and small formats that he then printed and made up into books, scrolls, and wall panels. **(fig. 11)** The final format of the installation is on an architectural scale, its long scrolls of paper delineating a powerful, numinous space —it is almost as if Xu Bing has built a temple in honor of the purposelessness of meaning.[29]

The question of reality and meaning were indivisibly linked for Xu Bing. Having been brought up in a world in which language was meaningless in that words could be manipulated to signify their opposite, what was real? In a reality full of confusion between past and present, western and eastern ideas, what was real? In *Book from the Sky*, the answer lay not in any narrative, actual or implied, but in a collection of meaningless

8 | Liu Chih-kuei | "Party Class" from **the Peasant Paintings from Huhsien County** exhibition and book | 1974

9 | Xu Bing | **A House in Shanbei** | from "Shattered Jade" series | 1982 | woodcut on paper | 14.6 x 15.2 cm

10 | Xu Bing, Zhang Jun, Chen Qiang and Chen Jinrong | **Big Tire** | 1986 | installation with a large industrial tyre and its imprint on canvas | approx. 1000 cm | CAFA Museum, Beijing

11 | Xu Bing | books of **Book from the Sky** | 1987–91 | 100 boxed sets of four-volume woodblock printed books

[15] Ibid., pp. 22–23. [16] Smith, op. cit., p. 325. [17] *Peasant Paintings from Huhsien County*, Peking, People's Fine Arts Publishing House, 1974. Quoting Mao's words, the foreword stated that these untutored artists used revolutionary art for "uniting and educating the people and for attacking and destroying the enemy." [18] Liu Chunhua made many famous paintings of Mao during the Cultural Revolution, most notably *Chairman Mao Goes to Anyuan* (1968). See his article "Singing the Praises of Our Great Leader is Our Greatest Happiness," *Chinese Literature*, September, 1968, pp. 32–40. [19] Smith, op. cit., p. 325. [20] Michael Sullivan, op. cit., p. 61. [21] See Merle Goldman, "The Political Use of Lu Xun in the Cultural Revolution and After," in Leo Ou-Fan Lee (ed.), *Lu Xun and His Legacy*, Berkeley, University of California Press, 1985. [22] Erickson, op. cit., p. 13. [23] See Jing Wang, *High Culture Fever: Politics, Aesthetics and Ideology in Deng's China*, Berkeley, University of California Press, 1996, passim. [24] For examples of propagandistic woodcuts of this time see J. Haas, C. Hartz, G. Sievernich, H. Spreitz, T. Ulbrich (eds.), *Holzschnitt im Neuen China*, Berlin, GVFC, 1976. [25] Xu Bing, "A New Exploration and Reconsideration of Pictorial Multiplicity," *Meishu*, No. 278, Autumn, 1987. Translated by Jesse Coffino-Greenberg. [26] Called "Woodcut Group One." [27] Ibid. [28] Link, op. cit., p. 51. [29] For a description of the composition of the different states of this work see Erickson, op. cit., pp. 33–50.

12

13

14

and unpronounceable words, and in the artist's repetitive, concentrated experience of cutting the characters out of wood, by hand, day after day, working manually, almost like a farmer. Xu Bing regarded this as a virtually redemptive spiritual activity that could be related to Zen or the Tao: "The highest achievement comes from knowing it is meaningless but you still put in all your effort."[30] Beauty had to be found beyond "meaning" and that was the meaning of beauty.

Not surprisingly, this work attracted great criticism as still, within the official mentality, beauty was *nothing but* meaning, and the answer to any question was either correct or wrong. For many, the fact that Xu Bing's "books" could not be read, although they looked as though they should be, was not so much a puzzle as an insult.

Book from the Sky marks what could be described as the first of Xu Bing's popularist *puji* works—a line that continues to the present. It is an ambiguous path that rejects easy solutions, sloganeering, and propaganda, yet also is widely accessible to those with the eyes to see it—even to those who are unable to read. But the ideologues did not regard his work in this way. In the official backlash against the whole generation of New Wave artists of the mid-1980s who, like Xu Bing, had exhibited in the seminal 1989 Beijing exhibition "China/Avant-Garde" and who had, either actively or tacitly, supported the Students' Democracy Movement, this was one of the works that was singled out for particularly harsh criticism after the students had been brutally suppressed on June 4, 1989. In the June 1990 edition of *Literature and Art Newspaper*, Yang Chenyin, a professor at the Central Academy, wrote, "If I am asked to evaluate *Book from the Sky*, I can only say that it gathers together the formalistic, abstract, subjective, irrational, anti-art, anti-traditional . . . qualities of the Chinese New Wave of Fine Arts, and pushes the New Wave towards a ridiculous impasse. I am reminded of a Chinese idiom, 'ghosts pounding the wall.'"[31]

The vitriolic tone of this article hearkened back to the denunciations of the Cultural Revolution in naming Xu Bing as an "enemy." In response, he entitled his next work, a monumental 32-by-15-meter ink rubbing of a section of the Great Wall of China, *Ghosts Pounding the Wall* (1990–91). **(fig 12)** Bypassing the criticism and throwing it mutely back to its source, this process work not only refers to the contemporary state of China but also to its whole attitude to history, implying that the past, particularly its dead, would not now be quietened. At this time Xu Bing moved his base to the United States, but periodically returned to China to work.[32]

Xu Bing's subsequent works have shown no consistent style but have manifested a persistent concern for the framing of social interaction as a means of reflecting on human behavior, usually on a global scale. One of the earliest and most humorous of these, *A Case Study of Transference* (1993–94), reemployed his experiences from the collective farm in setting up two live pigs as the protagonists. It was staged for a short time in a small alternative Beijing gallery and can now be experienced as a video. The title of the work puns on the idea of intercultural relations, Freudian psychoanalysis, and the physical exchange that constituted the "performance." As energetic, riveting and noisome as the pigs' coupling was, in a pen strewn with books, the true subjects of this work were the audience and their reactions to such "uninhibited" behavior. As observers of the final work in the form of a video, we now have the privilege of "measuring" the distance between the people and the animals. **(fig. 13)**

In *Wu Street* (1993–94), working with Ai Weiwei, with whom he shared a studio in New York at this time, Xu Bing began to study the idea of transference in an even more culturally subversive way. He had found a group of abstract paintings left as trash on Fifth Street in "Chinatown" and commandeered them as part of a complicated word-play and art-world hoax that reflected not only on questions of interpretation and meaning in contemporary art but also on ideas of truth and falsehood.[33]

[30] Quoted in Gao Minglu, *The Art and Methodology of Xu Bing*, Taipei, Eslite Gallery, 2003, p. 14. [31] Erickson, op. cit., p. 41. [32] In 2008, Xu Bing returned to Beijing as vice president of the Central Academy of Fine Arts, where he had originally studied. [33] Reiko Tomii, "The Slow Formation of Ice in Fourteen Phases: An Art-Historical Biography of Xu Bing," *Xu Bing*, London, Albion, 2011, pp. 188–191. [34] K. Smith, op. cit., pp. 351–2. [35] This book was published by Xu Bing in Beijing in August, 2012 in an edition of 3,000 copies. ISBN: 978-986-87860-1-1. For other work by Ai Weiwei, see p. 144, 145, and 202–205.

15

16

17

The Chinese sound *wu* has various meanings—*five* (echoing where the paintings were found), Zen *enlightenment*, and *misunderstanding*—ideas that were interwoven throughout the work. With her permission, Xu Bing also appropriated an essay that curator Melissa Feldman had written on the work of Jonathan Lasker, a well-known New York painter, because they looked rather like the paintings he had found. He then invented the twin personas of Jason Jones, "a painter," and Harold Phillips, "a critic," and published a fake article in English that reproduced two of the trash paintings as those of Jones along with "Philipps's" essay, that was actually Feldman's about Lasker's work. In an accompanying portrait, Ai Weiwei and Xu Bing were photographed together posing as the fictitious painter and critic. (fig. 14) The article was then professionally translated into Chinese and the whole package sent to the leading Chinese art magazine *Shijie Meishu* (World Art), in which, without question, it was published in the February 1994 issue. In this serious jape, as well as cocking a snook at the pretentiousness of the art world, Xu Bing and Ai Weiwei seem to have asking themselves whether "communication" was often the opposite of what it claimed to be and was rather obfuscation or manipulation.

Living as a foreigner in the West, and fully aware of the slipperiness of both meanings and value systems at home and abroad, Xu Bing's next monumental work, *An Introduction to Squareword Calligraphy* (1994–96), followed an inclusive rather than confrontational approach to social interaction. Centered on the idea of translation by concentrating on the invention of a "new" language system—Roman letters written in Chinese calligraphy—the work's meaning (or lack of it) depends on the perceptual abilities of the individual and the country in which it is exhibited. The work takes the form of a school classroom in which visitors are encouraged to sit and follow the exercises in a primer so that they can practice not only writing but also reading *Squareword Calligraphy*. A computer program has now been developed that automatically translates Roman script into square word calligraphy, which can then be copied using traditional brush and ink. (fig. 15) Xu Bing likens this project to the large-scale mass literacy campaigns after the Liberation yet, in China, where calligraphic exercises are still part of education, the "meaninglessness" of the scripts was seen as an affront rather than a potential tool for learning English, or any other Roman-script-based language.[34] For people who were not Chinese, *Squareword Calligraphy* became a way of approaching the logic of Chinese script without having to learn its characters. Yet, for Chinese and non-Chinese alike, the focus of this work is on process rather than on end but by combining painting with different kinds of non-verbal meaning, it ran the risk of ending in frustration because in terms of conventional translation it led to a dead end.

In *Book from the Ground* (2006), Xu Bing readdressed the idea of translation by creating a completely new nonspecific "language" out of commonly used pictorial symbols, icons, and isotypes (some of which he had invented) that could, in theory, be understood and used by anyone, regardless of their origin or language. He has developed a computer program that converts Roman script into this language and has recently published · → 👤 → · a "novel" written entirely in this form.[35] When the work is exhibited in a gallery the symbols are configured on the walls in different narratives that visitors are encouraged both to enjoy and to "interpret"; they are then able to explore the grammar of the language by creating stories of their own by using the conversion program on specially provided computers. (fig. 16)

Xu Bing continues to make works that fit into larger social and technological projects and is committed to make his writing systems as widely accessible as possible. As before, the social element in his work is of vital importance, and, perhaps because of this, he finds it difficult to take an interest in the more hermetic ideas of western contemporary art, because he believes they are irrelevant to lived experience: "At this point I am actually quite tired of contemporary art ... The field is getting really boring ... and narrow. In particular, contemporary art has increasingly lost touch with the times and

12 | Xu Bing | **Ghosts Pounding the Wall** | 1990–91 | ink rubbings on paper made of the Jin Shan Ling section of the Great Wall and mounted on paper; rock, soil | 32 x 15 m | installation view | Elvehjem Museum of Art, University of Wisconsin-Madison | 1991

13 | Xu Bing | **A Case Study of Transference** | 1993–94 | installation, performance and video with two live pigs inked with fake English and Chinese characters; discarded books and barriers | presented at the Han Mo Arts Center, Beijing | January 22, 1994

14 | Xu Bing and Ai Weiwei | **Wu Street** | 1993–94 | paintings picked from trash | East Village, New York | 1993

15 | Xu Bing | **Square Word Calligraphy Classroom** | 1994–96 | classroom installation with instructional video | model books (**An Introduction to Square Word Calligraphy**), copybooks, ink, brushes, brush stands, blackboard and framed student work

16 | Xu Bing | notebook for **Book from the Ground: from Point to Point** | 2012 | MIT Edition

17 | Xu Bing | **The Living Word** | 2001 | installation with approx. 300 painted acrylic Chinese characters for "bird" | fishing line, wooden plinth | Arthur M. Sackler Gallery, Smithsonian Institution | Washington, DC

18

19

social context. In truth I feel that it is inferior to advertising art and commercial art and design, which better reflect the intellectual trends of contemporary society . . . For myself as an artist, the most important thing is to be very clear about my own place within the art system. It is impossible to find anything new in that system itself, and nothing original can be brought into it."[36] This sense of constriction has led him to look in different directions as, for instance, *The Forest Project* (2005/09), a system set up through the internet to promote visual literacy and creativity among young people. An important aspect of this was the facilitation of an automatic and uninterrupted flow of funds from the developed world to a threatened forest reserve in Kenya.[37]

Within this social-visual-linguistic framework, the traditions of Chinese painting have again begun to play a role. During a trek in the Himalayas in 1999, Xu Bing started to make small landscape sketches in which natural features were delineated with Chinese characters that described what they were. The resulting work, *Landscript* (1999), went back to the rhythms of poetry and nature that lie at root of calligraphy by unifying word and image within what was effectively a large composite text. A similar impulse can be seen in his installation *The Living Word* (2001), which, starting on the floor with a Chinese dictionary definition of the word "bird," opens up into the space with a suspended "flock" of over 400 variants of the same Chinese character, starting with the simplified Maoist form on the floor and evolving high into the air with the most ancient pictograph for "bird." (fig. 17) This idea was further developed in *Monkeys Grasp the Moon* (2008), a twenty-meter-high installation over water that alludes to an ancient Chinese folk tale in which monkeys mistake the reflection of the moon for the real thing and, when they link arms and tails to touch it, it disappears. Constructed out of Baltic birch wood, each "link" of Xu Bing's chain takes a stylized form of the word for "monkey" in a different language, the sardonic implication being that what we strive for the hardest may be, in fact, an illusion and that, as a result of our short sightedness, we may all be "monkeys."[38]

Recently, in *Magic Carpet* (2006), Xu Bing has returned to the word plays of traditional Chinese art, adding his own inimitable twist of humor. The basis for the work is the acrostic form of Hui Su's Eastern Jin Dynasty carpet, *Xuan Ji Tu*, from the late 4th century, in which a grid of 841 characters was woven in such a way that it could be read in any number of directions and combinations, making it into a total of nearly 4,000 separate poems. (fig. 19) Xu Bing's version of this uses square-word calligraphy to transcribe into English four different texts (Buddhist, Gnostic, Jewish, and Marxist), all based on the idea of belief, which the artist then synthesizes into a single text. In their interwoven form, both a historical and contemporary model of cultural, religious, and ideological interaction is proposed as these texts shift in and out of meaning as the words of one "belief" inevitably interact with another. (fig. 18)

In *Background Story* (2004–06), Xu Bing has again returned to the language of classical oriental art. Originally shown at the Museum of East Asian Art in Berlin, this work "recreates" a number of Chinese and Japanese paintings that had been removed from the museum's collection by the Soviet Red Army as reparations at the end of World War II. This illusion was created in an elaborate series of shadow plays in which diverse materials such as twigs, leaves, modeling clay, lumber, and cotton wool were placed and lit behind opaque glass so that, from the front, the image of the lost painting could be seen. The artifice was then exposed by allowing the visitor to look behind the image and discover the ways in which it had been created. In their visual impact and ingenious handmade construction these are masterpieces, yet, as with so much of Xu Bing's work, one is never really sure of the extent to which he is imbuing old images with new life or demystifying them by stressing the aesthetic *bricolage* which contributed to the original works' creation, their formulaic nature and lack of interest in uniqueness. (figs. 21, 22)

A similar impetus fueled his *Mustard Seed Garden Landscape Scroll (Jieziyuan Huazhuan*, 2009), which is based on the eponymous popular painting

[36] Xu Bing, "Trans-boundary Experiences...," op. cit., p. 88. [37] http://forestproject.net [38] This work was commissioned for the American Embassy in Beijing. The languages represented by the "monkeys" include Hindi, Japanese, French, Spanish, Hebrew, and English. [39] Erickson, op. cit., p. 19.

manual first published in 1679 and still in use as a student primer today. Comprised of annotated motifs of rocks, trees, and water taken from the work of old Chinese masters, these templates are intended to be copied repeatedly so that, with experience, the student may join them together to make a coherent landscape. Xu Bing amplified the repetitive, mechanical nature of this tradition in this vast woodblock scroll, which was made by photocopying the contents of the manual (including the notes), onto transparent sheets, then cutting them out and collaging them into a panoramic landscape of his own design. These different elements were then pasted onto dozens of wood blocks to be cut by hand so that the final scroll could be printed from them. Like *Background Story, Mustard Seed Garden Landscape Scroll*, a simulation of brush painting, has been deconstructed, rescaled and re-orientated in a painstaking, even redemptive, process. Echoing the production of much earlier works like *Book from the Sky* or *Ghosts Pounding the Wall*, this emphasis on process highlights the tyranny and futility, as well as the potential creativity, of repetition.

A continuing cycle of image, language, time, and event runs throughout the whole of Xu Bing's work which, according to the point at which one stops to examine it, may bear a completely different significance and meaning according to its context. This is what the artist himself describes as "fate." The twelve-ton, 28-meter-long, fifteen-meter-high, eight-meter-wide *Phoenix Project,* shown in Beijing and Shanghai in 2010, and at the Venice Biennale in 2015, refers generally to the continuing cycle of rebirth and death, but, typically, with sideways glances at the impact of the 2008 global financial crisis as well as at the unchecked urbanization that is wreaking havoc in so many Chinese cities. The phoenix, a brilliant, fiery bird endlessly reborn out of its own ashes, is an archetypical symbol in Chinese mythology that expresses nobility, femininity, and eternity. Xu Bing's version encompassed this but it was made out of the building rubble and construction equipment that remained after Beijing's World Financial Centre had been completed. The first backer of the work had withdrawn from the project because the materials seemed too rough, but, for the artist, this completely missed the point: we live in rough times that must have beauty in them. He triumphantly proved his point by ensuring that two vast firebirds rose high in the sky, illuminated by fiery, twinkling lights. (fig. 20)

For Xu Bing, art is a remedy as well as an expression of self: "Art has value because it is genuine, not false. If you create art, the material 'you' will mercilessly reveal you in all your complexity. Perhaps in life you can hide, but in art it is impossible. Regardless of whether you hope to hide or to flaunt an idea, it will all be recorded . . . All of this is decided by fate . . . In reality, this 'fate' is what you experience: it is your cultural background and your life. It determines the inclination and style of your art. Your background is not of your own choosing . . . As far as I am concerned, artistic style and taste are not manmade; they are heaven-sent."[39]

This, too, is the energy, spirit, and significance of the heavenly sent phoenix. ●

18 | Xu Bing | **Magic Carpet** | 2006 | preproduction digital rendering | 676-square word calligraphy characters representing four religious and quasi-religious texts | designed as a prayer carpet for Singapore Biennale 2006 | This first version was rejected by the Kwan Im Thong Hood Cho Temple, which objected to visitors stepping and kneeling on sacred texts.

19 | Xu Bing | study of Su Hui's **Xuan Ji Tu** armillary woven brocade poem for **Magic Carpet** | 2006 | ink on paper | 20 x 19.5 cm | annotation by artist reads "This is the work of woman of genius Su Hui from 1,600 years ago"

20 | Xu Bing | **Phoenix Project** | 2007–10 | construction-site debris and materials | 27/28 x 8 m each | installation view | Today Art Museum, Beijing

21 | Xu Bing | **Background Story: Misty Rivers and Layers Ridges** | back view | 2014 | trash and natural debris attached to frosted glass panel | 520 x 2,185 cm | installation made at Taipei Fine Arts Museum

22 | Xu Bing | **Background Story: Misty Rivers and Layered Ridges** | front view |2014 | mixed media installation, natural debris attached to glass panel, light boxes | 520 x 2,185 cm | installation view at Taipei Fine Art Museum, Taiwan, 2014

Ai Weiwei
The Seeds of Time or
Sands of the Desert?

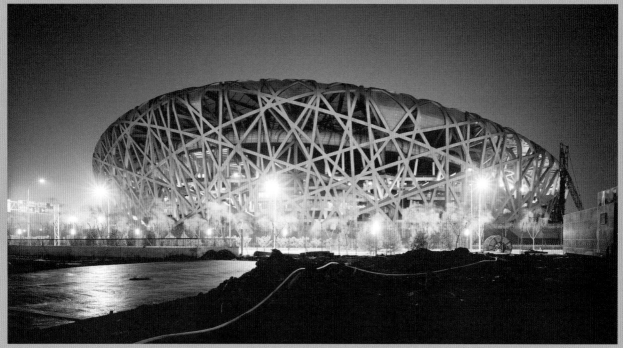

This text appeared in the **ArtAsiaPacific Almanac** 2011, New York, Vol. VI, January 2011. I have always been interested in Ai Weiwei's work as an "art strategist" and curator but have been skeptical about some of his art. In 2000, I had been deeply impressed by the unofficial "Fuck Off" exhibition he curated, with Feng Boyi, for the Eastlink Gallery Warehouse in Shanghai at the same time as the 3rd Shanghai Biennale. Closed prematurely by the police, it brought together the most radical Chinese artists of two generations, and although the exhibition's title in Chinese (translated as "An Uncooperative Approach"), seems less inflammatory than its version in English, it obviously made a strong impression on the Chinese authorities who favored unanimity in all things. I included Ai's large bronze **Circle of Animals (Zodiac)** 2010 in the 1st Kyiv International Biennale of Contemporary Art in 2012 (see pp. 144–145). This essay started as meditation on Ai Weiwei's large bed of porcelain sunflower seeds that was presented in the Turbine Hall of Tate Modern during 2010–11. Instead of being a relaxing, tactile experience that you could walk or lie down on, as intended, rather in the same spirit as Olafur Eliasson's **The Weather Project**, staged in the same space in 2003–04, this work rapidly became a hermetic object of contemplation because, soon after its opening, the public were denied access to it on grounds of health and safety. Thereafter they had to just walk around and look at it. I wondered: in the context of his previous work, did Ai Weiwei really care about this? Perhaps rightly, his sympathies were more with the imminently unemployable traditional porcelain hand workers in China, who had produced the seeds, whose labor was in danger of becoming obsolete. Ai Weiwei was born in Beijing in 1957 and lives in Europe.

2

1 | Herzog & de Meuron, Ai Weiwei, and CADG | National Stadium, "The Bird's Nest" | Beijing | jointly designed for the 2008 Olympic Games

2 | **Template** | 2007 | wooden doors and window frames from Ming and Qing Dynasty houses | 422 x 1106 x 875 cm | on display at Documenta 12 in Kassel before and after the storm | courtesy the artist

[1] "Stadium designer blasts China Olympics," Al Jazeera, August 12, 2007. [2] Reported in www.artforum.com/news/week=200727 [3] Sun Tzu, *Art of War*, Oxford, Westview Press, 1994. Trans. Ralph D. Sawyer. Artists as diverse as Cai Guo-Qiang (see pp. 298–309) and Mario Merz have been influenced by Sun Tzu's thoughts. [4] The Stars Art Group (Xing Xing) was founded in Beijing by Ma Desheng and Huang Rui in 1979. As they were not approved by the police, their first exhibitions were held in a park.

Over the past couple of years it has been hard to avoid the work of Ai Weiwei. Conscientiously ubiquitous, it popped up in Beijing in the design for the famous "Bird's Nest" stadium for the 2008 Olympics, only to be disowned by the artist as a symptom of the "pretend smile of bad taste." [1] (fig. 1) Or, the previous year in Kassel at Documenta 12, it hit the ground when his 39-foot-tall *Template* (2007), a monumental structure of doors and window frames—aged victims of the current Chinese building boom—collapsed in a freak storm. "It's better than before," the artist informed *Der Standard:* "Now the force of nature becomes visible. And art becomes beautiful . . . Now the price has doubled." [2] (fig. 2) There is a natural irony here that we can all appreciate, yet the means by which it is achieved: the strategy of reversal—a thing being the opposite of what it seems—reminds me of the ancient military writings of Sun Tzu that have influenced so many generals, and indirectly some artists. [3]

As architect, designer, artist, writer, blogger, and activist, Ai Weiwei has marshaled his works as if he were a general. After the Cultural Revolution, he exhibited with the Stars Art Group, a spearhead of the growing democracy movement. [4] Since then he has always pitched himself against the power of the establishment. From 1981 to 1993 he studied and worked in the United States, then moved back to China where, in a series of destructive and transformative actions, symbolic reversals of Confucian respect for harmony and age, he reduced ancient pottery to scattered shards or jars of conceptual dust. In 2000, he co-curated the unofficial "Fuck Off" exhibition in Shanghai that brought together installations and actions that seemed to be rooted in such a sadistic, disillusioned cynicism that for many they tested the limits of what art could be. Again the strategy of opposites kicked in: what seemed to be violence could, perhaps, actually be intense emotion, even sentiment.

At Documenta, though, *Template* was dwarfed by *Fairytale*, a homage to the Brothers Grimm who lived nearby, in which Ai Weiwei invited 1,001 laid-off Chinese workers, street vendors, students, performers, farmers, members of ethnic minorities, and others to travel to sleepy little Kassel —a town never renowned for its appreciation of ethnic diversity—to see the show. The impact of this work depended literally on where you were coming from. Was this sudden influx of people a dream or a nightmare? Was it a vehicle of happiness for those that traveled, or a Trojan horse threatening the heart of Europe?

Ai Weiwei weaves such ambivalence into the very fabric of his work. Recently, he has openly criticized the Chinese government for its corruption in suppressing the scale of the 2008 Sichuan earthquake and systematically flouting building codes that led to widespread carnage.

Last year, the mega-work *Remembering* (2009), spread across the facade of Munich's Nazi-built Haus der Kunst in which 9,000 children's rucksacks in five different colors formed, in Chinese characters, the words of a bereaved mother: "She lived happily on this planet for seven years."[5] (figs. 3, 4)

This month alone [October, 2010], three exhibitions of Ai Weiwei's work are on show in Europe. In a "commercial" gallery in Berlin: plangent strings back *Barely Something* (2009), a video of the scrolling names of the 4,851 schoolchildren who died in Sichuan, crushed under sub-standard buildings.[6] Switch to Vienna: another gallery shows his activist documentary works: photographs that capture the undercover police who dog his steps, as well as his fateful trip to Chengdu in August 2009 to attend the trial of his friend Tan Zuoren, who had also spoken out against the cover up of corruption.[7] One of these pictures shows the artist in a lift just after police had broken into his hotel room and seriously beaten him up. In both the Vienna and Berlin exhibitions were versions of the artist's brain scan made afterwards in a German hospital indicating cerebral hemorrhage —a result, it is implied, of the attack in Chengdu. (fig. 5)

Cut to London: in the Turbine Hall of Tate Modern, *Sunflower Seeds,* a large sculptural installation of "over 100 million individually handmade objects . . . that weighs over 150 metric tonnes, covering 1,000 square mets" has just opened.[8] During the Cultural Revolution, sunflowers symbolized the Mao-adoring masses, but Ai Weiwei also remembers that common sharing of sunflower seeds as a source of nourishment provided a rare space of friendship and pleasure in that paranoid, divisive time. This vast installation of Chinese-produced, hand-painted, porcelain simulacra, with its educational "making of" video, was intended to be "a sensory, immersive installation which visitors can touch, walk on and listen to as the seeds shift beneath their feet."[9] (figs. 6, 7)

Yet beyond this touchy-feely, urban-beach-bar dream, other impressions quickly make themselves felt. The mechanical impersonality of the statistics alone opens up contemplation of the place of the individual within the mass —and perhaps also of where power actually lies. As with *Fairytale*, there was a massive transfer of funds from Europe to China to produce the work, and I felt relieved that the workers in this age-old but rapidly shrinking cottage industry were gaining brief respite from destructive economic forces that are obviously far beyond their control.[10]

In this context, Ai Weiwei is quoted as saying, "Your own acts and behavior tell the world who you are and at the same time what kind of society you think it should be." An October 22 update on the Tate website embellishes on this: "Although porcelain is very robust . . . the interaction of visitors with the sculpture can cause dust which could be damaging to health following repeated inhalation over a long period of time."

Playtime is over. The pabulum of "experience" has been forcibly replaced by the contemplation of a more remorseless impression: art can obviously be dangerous as the barriers and guards of the museum separate the public from this work for their own good. But what do we really see in the Turbine Hall now? Is this huge, static, glowering rectangle really sculpture in an extended field, a younger brother of American minimal or conceptual art? Or is it more about the mass of its units—are these replicas of seeds, or just dry husks?

As ever in the art of Ai Weiwei, this work conveys both good news and bad news. Perhaps, in time, the seeds will germinate, feed the masses and fertilize the earth—or their inert mass may just smother us, like the ever-flowing sands of the desert. ●

3 | **Remembering** | 2009 | 9,000 children's backpacks each representing a life lost in the 2008 Sichuan earthquake | 10 x 100 m | on the facade of the Haus der Kunst, Munich

4 | **Remembering** | detail

5 | MRI scan showing Ai Weiwei's cerebral hemorrhage as a result of police brutality in Chengdu | August 12, 2009

6 | Ai Weiwei in his **Sunflower Seeds** installation

7 | **Sunflower Seeds** | 2010 | 100 million handmade porcelain objects | 1,000 sq m | Tate Modern, London

[5] Ai Weiwei exhibition, "So Sorry," Haus der Kunst, Munich, 2009. [6] "A Few Works from Ai Weiwei," Alexander Ochs Galerie, Berlin, Oct 7 – Nov 11, 2010. [7] "Ai Weiwei Hurt Feelings," Christine König Galerie, Vienna, Sept 18 – Nov 6, 2010. [9] Tate Modern press release, October 11, 2010. The exhibition ran Oct 12, 2010 – May 2, 2011. [9] Ibid. [10] *Fairytale* cost 3.1 million euros to produce, raised from Swiss foundations. Mu Qian, *China Daily, Beijing,* May 29, 2007, p. 18.

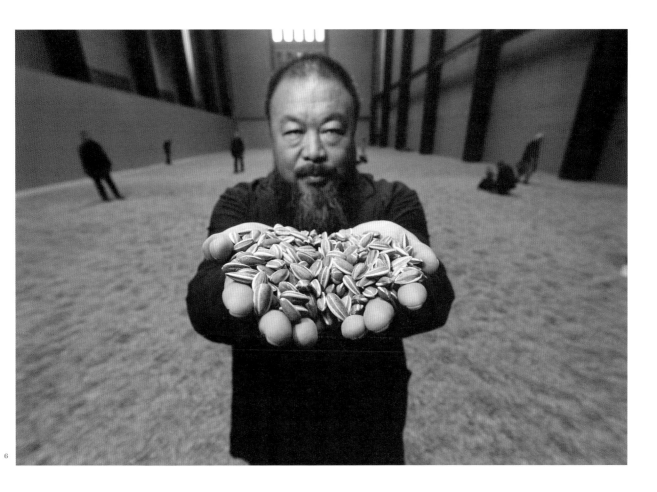

6

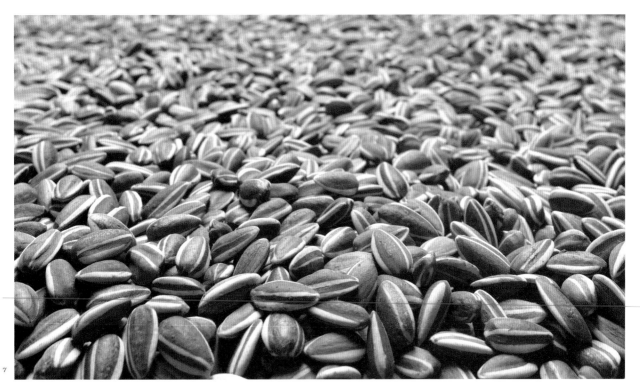

7

Song Dong
"Art, My Last Hope"

This essay appeared in the exhibition catalogue **Song Dong: Dad and Mom, Don't Worry About Us, We Are All Well**, San Francisco, Yerba Buena Center for the Arts, 2011. I had first seen Song Dong's work in "Fuck Off" (Shanghai, 2000) but met him in Tokyo in 2005 when he took part in "The Elegance of Silence: Contemporary Art from East Asia" that Sun-Hee Kim curated for the Mori Art Museum. When, the following year, he showed his large installation **Waste Not** (2005), made with his mother Zhao Xiangyuan at the 6th Gwangju Biennale (2006) I was completely blown away. Since that time we kept in close touch, and I was very happy to write this essay for his San Francisco show. In 2012, both he and Yin Xiuzhen, his wife, contributed major works to the 1st Kyiv International Biennale of Contemporary Art. See pp. 132–133, 152–154. Song Dong was born in Beijing 1966 where he still lives.

1 | **Another Lesson. Do You Want to Play with Me?** | 1994 | installation and performance | Central Academy of Fine Arts, Beijing | all images courtesy the artist and Pace Gallery

2 | **Breathing** | 1996 | performance | New Year's Eve | Tiananmen Square, Beijing

3 | **Jumping** | 1999 | performance | New Year's Eve | Tiananmen Square, Beijing

[1] Gao Ling, "A Survey of Contemporary Chinese Performance Art (1999)," in Wu Hung (ed.), *Contemporary Chinese Art. Primary Documents*, New York, Museum of Modern Art, 2010, p. 183. [2] Song Dong in *Song Dong* (exh. cat.), Shanghai, Zendai Art Museum, 2004, p. 42. [3] Song Dong, *Waste Not: Zhao Xiangyuan and Song Dong*, personal statement by the artist. [4] See Song Dong's work *Reading the Book Without Words*, 1994, in Zendai Art Museum, 2004. Xu Bing's vast installation *Tianshu* ("Book From the Sky") (1988) had previously focused on the question of "wordless text" through the invention of meaningless pictograms. See pp. 192, 197–198. [5] This "curse" may well not be of Chinese origin but in the West is popularly believed to be so. The form in which it most frequently appears is "May you live in interesting times."

"Frivolous, agitating, and destabilizing . . ." What an inspiring testimonial for any artist! Song Dong earned this treble whammy on the opening day of his new installation and performance *Another Lesson. Do You Want to Play with Me?* that took place in the gallery of the Central Academy of Fine Arts in Beijing in 1994. Not only was it summarily closed within 30 minutes of the doors being thrown open, but also the authorities gave this fine description of his work as the reason for their action. [1]

Little did they realize they had hit a much larger nail on the head. The "frivolous" experiment, "agitational" flux, and "destabilizing" openness that have characterized Song Dong's works since the mid-1990s were all there, products of his desire to create a new kind of personal and aesthetic freedom, untrammeled by censorship, self-censorship, or the past.

As an integral part of this development Song Dong cultivated multiple artistic personalities both to spotlight and broach the callous mediocrity that had become such a marked institutional and national feature. The impulse for this was a sense of claustrophobia that had led him to realize: "The most frightening thing in the world [for me] is being boxed in. It is even more frightening if it is by your own doing . . . People basically have many selves. Why strangle one of them?" [2] For him then, as it still is now, "'Art' was my last hope." [3]

In a clear satire of the rigidity and emptiness of the Chinese education system, Song Dong's political self had transformed the Academy's gallery into a surrealistic school room, in which exam papers smothered the walls and floor in bizarre heraldry while, throughout the center of the space, a bank of taps and sinks, amplified by a row of seven television monitors beneath them, served as lumpen metaphors for the influx and flow of information. The artist himself played the role of teacher, instructing the young people to read, with the help of magnifying glasses, "wordless textbooks," just as if they actually meant something. For Song Dong, the idea of the "wordless text"—an echo of Xu Bing's work from the 1980s—is both sarcastic and transcendent. [4] In this case, as in other works, his different selves overlap: the political merges with the existential self, before mutating into the Zen and finally becoming the Tao. (fig. 1)

Born in Beijing in 1966, Song Dong had graduated in oil painting from the Visual Arts Department of the Capital Normal University in Beijing in 1989, the same tumultuous year that the "Iron Curtain" was demolished in Berlin and with it the by-then moth-eaten dream of a European Communist utopia. Yet in Tiananmen Square in Beijing, only a few months earlier, the same threatened dream had been dragged back from the dead and galvanized into life by the blood of violently suppressed students. In the words of the apocryphal Chinese curse, we were, indeed, "living in interesting times." [5]

Even before his graduation Song Dong had been spotted as a talented painter and continued to exhibit as such through the early 1990s, while supporting himself as a middle-school teacher. But his heart was no longer in it. The destabilized, de-motivated, rootless world he now saw in front of himself could not be represented in the same way as before and, like many other members of his generation, both in China and overseas, his art increasingly moved towards a less rhetorical, quieter, more conceptual approach, laced throughout with a critical, at times satirical, sense of humor.

4

5

Art in Europe during the early 1980s had been characterized by a historicist revival of neo-expressionist painting, whereas in China the isolation of the years of the Cultural Revolution (1966–76) and before had crumbled, and influences of all kinds—historical and contemporary, philosophical, artistic, religious, and scientific—had flooded in. These were the years of hope, openness and learning, but there was little time for digestion. In June 1989, the door seemed again slammed shut. Many young people left the country, others retreated into cynicism. The question for Song Dong was how to pry the door open again.

But a similar sense of urgency and disquiet seems also to have grasped artists throughout Asia and the West. The Asian response to the 1990s can be identified with a general feeling that traditional patriarchal societies had become corrupt, which led to the desire to break free from their stultifying, controlling influence. To this was added the vague conviction that western modernity, whether it had been imposed or embraced, had robbed society of its warmth and capacity for human contact by creating an inhuman paradigm of progress that, in the headlong rush towards prosperity, many had sought to surpass. The reaction to this embodied cynical violence on one hand, and a desire to return to the values of the village or commune on the other. In this latter approach such "old fashioned" characteristics as discretion, kindness, friendship, humor, family ties, and respect were again valued. As we shall see later, such ideas were to surface during the latter half of the 1990s in what I describe as Song Dong's "Tao self."

Perhaps because there was no one else to blame, the western artistic response in the 1990s was more straightforwardly oedipal and directed wholly at the fathers or their surrogates. The art of the previous decade was regarded as overblown, overpriced, even corrupt, and therefore wholly in keeping with the authoritarian neoliberal spirit of the decade. In the United States, "abject art" became the critical buzzword to be followed by the less high-octane currency of "the everyday," while in the United Kingdom, the YBAs began to vent their spleen against the prevailing free-range inhumanity. [6]

[6] Jack Ben-Levi, Craig Houser, Leslie C. Jones, Simon Taylor, *Abject Art: Repulsion and Desire in American Art*, New York, Whitney Museum of American Art, 1993. "Every Day" was the title of the 11th Biennale of Sydney organized in 1998 by Jonathan Watkins. The YBAs, or Young British Artists, were a loose group of British artists born in the mid-1960s, who emerged after the London "Freeze" exhibition in 1988 and were known for both their oppositional and entrepreneurial stances. [7] This generation included, among many others, Chen Zhen, Xu Bing, Huang Yong Ping, Gu Wenda and Cai Guo-Qiang. [8] Wu Hung adumbrates the symbolical importance of Tiananmen Square in *Transience: Chinese Experimental Art at the End of the Twentieth Century*, Chicago, David and Alfred Smart Museum of Art, 1999, pp. 54, 57. But most importantly within Song Dong's lifetime, in 1976, it had been the site of the public demonstrations at the time of the funeral of Zhou Enlai that led to the end of the Cultural Revolution and the demise of the Gang of Four, as well as the events of June 4, 1989, that marked the violent suppression of the Student Democracy Movement. [9] Song Dong in Leng Lin, "Catching Moonbeams in Water," *Song Dong*, Shanghai, Zendai Art Museum, 2008, p. 18. [10] In their finally assembled form this collection amounts to 12 volumes, totaling 4,740 pages. A limited edition of 90 copies of this work was published in 2007 by MFC-Michèle Didier, Brussels. A similar edition of *I Met* was produced by the same publisher in 2004 and of *I Got Up* in 2008. [11] The exact dates for both *I Met* and *I Got Up At* are May 10, 1968, to September 17, 1979. [12] See pp. 22, 24, 40 for further discussion of On Kawara's work. [13] Gillian Wearing, *Dancing in Peckham*, 1994, video, 25'. [14] Tracey Emin, *Why I Never Became A Dancer*, 1995, video, 6'40". [15] This can be compared also to Song Dong's still continuing activity, started in 1994 in *Another Lesson: Do you Want to Play with Me?* and *Reading the Book Without Words*. See footnote 4. [16] In Greek mythology Sisyphus was a bad king who was punished by the gods by being repeatedly compelled to roll a huge boulder up a hill only to watch it roll down again. See also Albert Camus, *Le Mythe de Sisyphe*, Paris, 1942.

In Song Dong's case, however, at the beginning of the 1990s, his experience of the '85 New Wave movement of Chinese artists led him to rethink his own position and to move away from painting. [7] The other significant influence was the impact of June 4, 1989, and the subsequent closing down of cultural debate. At this time his "existential self" merged with his "political self" in two modest but definitive performances, *Breathing* (1996) and *Jumping* (1999), both of which were staged against the historic backdrop of Tiananmen Square. [8] *Breathing* was made on New Year's Eve when the temperature was -9° Celsius. The artist lay face down for a period of 40 minutes while his breath condensed on the brick paving and froze, leaving a small thin film of ice around the spot where his mouth had been. Shortly after, he made the same performance on Hou Hai, a frozen lake in central Beijing, where, even after 40 minutes, his breath had made no impact on its glassy surface. **(fig. 2)** *Jump* (1999), a sixteen-minute video of a performance, shows the artist jumping randomly among the crowds of tourists that throng the square, creating an anomalous vertical disruption to the horizontal forward movement of the mass. "Not jumping is pointless," the artist wrote, "but jumping is also pointless; even if it's pointless jumping is still necessary." [9] Both these works also obviously channel into Song Dong's "Zen self," but I will write about this later . . . **(fig. 3)**

The necessity of breathing, of jumping, of performing random actions that signify self, will, or life, echoes the conceptual art of the Japanese artist On Kawara (1933–2014). When, in 1965, he turned his back on Tokyo to settle in New York, he embarked on a series of works that itemized the basic actions that he had carried out on particular days. *I Went* started on June 1, 1968, and continued until September 17, 1979, and comprises a collection of marked maps showing where the artist had traveled. [10] This is mirrored

by *I Met* and *I Got Up,* which cover more or less the same period, the latter comprising two postcards rubber-stamped with the same message that he sent to different friends every day letting them know the exact time he got up.[11] But perhaps the most relevant of Kawara's works in this context is the series of telegrams he sent to friends from the beginning of the 1970s that were an inversion of the deadly news that this now outmoded medium so often conveyed. They all bore the same eloquent legend: I AM STILL ALIVE. [12] (see p. 24)

The assertion and dissemination of the uncompromising fact of continuing existence, and of survival, has been of great importance for the understanding not only of the work of Song Dong and his generation of artists in China, but also of many others working in very different contexts. In relation to jumping, I think immediately of Gillian Wearing's (b. 1963) video *Dancing in Peckham* (1994), (fig. 4) in which she solitarily gyrates to unheard music in a shopping mall in a depressed London suburb [13] or, at a symbolic remove, of Tracey Emin's (b. 1963) autobiographical video *Why I Never Became A Dancer* (1995), in which she masochistically attributes a lack of secure sense of self to brutal events from her childhood in the dowdy seaside town of Margate.[14] Jumping, dancing, almost anyone can try it and, at the very end of the video, Tracey Emin starts to dance.

In Song Dong's "Zen self," the force of existence is tempered by an almost comic feeling of inevitable evanescence. In 1995, after he had just decided to give up oil painting, his father suggested that, to save money on expensive ink and paper, he should practice traditional calligraphy by using water on a stone. Unwittingly, this set in motion *Water Diary,* a continuing series of activities, encapsulated and recorded by just four photographs, which Song Dong has continued every day to the present.[15] This action, or perhaps one should say discipline, has been amplified by other more public actions such as *Writing Time with Water,* which has been staged in different cities round the world, as well as, more indirectly, by *Stamping the Water* (1996), a one-hour-long performance recorded in 36 photographs, in which, standing in the Lhasa River in Tibet, the artist repeatedly impresses a seal carved with an archaic character for the word "water" (*shui*) onto the surface of the fast-moving current. (fig. 5) This labor of Sisyphus, appropriated by Albert Camus as an existential expression of the absurd, could on one level be regarded as a masochistic representation of the futility of existence, yet on another it becomes heroic.[16] The "washed clean," Zen-like purity of its gesture combines elegance with beauty by rejecting both the clutter and weight of history and matter.

A more iconoclastic Zen impetus is evident in the installation *Cultural Noodles* (1994), in which Song Dong uses a noodle-making machine to transform the spiritual and intellectual nourishment of books, one of the main sources of new knowledge in China during the 1980s, into a more recognizably digestible form. (fig. 6) Certainly when he made this he would have known Huang Yong Ping's self-explanatory action and work of 1987, *"A History of Chinese Painting" and "A Concise History Modern Painting" Washed in a Washing Machine for Two Minutes,* which reduced both books to pulp, (fig. 7) but he may not have been aware of British artist John Latham's (1921–2006) equally seminal *Spit and Chew: Art and Culture* (1966), in the collection of the Museum of Modern Art in New York. This consists of a leather-encased glass vial that contains Clement Greenberg's once-influential book *Art and Culture* (1961) after it had been masticated by Latham and his students at London's Saint Martin's College of Art. (see also p. 131, fig. 19)

4 | Gillian Wearing | **Dancing in Peckham** | 1994 | video | 25' | courtesy the artist and Maureen Paley, London

5 | **Stamping the Water** | 1996 | performance in Lhasa River, Tibet

6 | **Cultural Noodles** | 1994

7 | Huang Yong Ping | "A History of Chinese Painting" and "A Concise History of Modern Painting" Washed in a Washing Machine for Two Minutes | installation | 1987

8 | **Facing the Wall** | 1999 | performance and installation

9 | **Supermarket: The Art Guide and Art Salesman** | 1999 | performance

Unlike the notorious edicts to destroy books issued by Nazis and Stalinists before and during World War II and the Cold War, by Mao during the Cultural Revolution, or by fundamentalists of all kinds, before and after, the destruction of books in these works is not so much a restriction of knowledge but an assertion that there are kinds of knowledge and

experience that cannot be transmitted by words. The implication is that, being tied to a specific language, with its accompanying ideological baggage, criticism becomes inevitably inadequate or pretentious because it is unable to express either the complex nature or the essence of the experiences that art generates.

The performance and resulting installation *Facing the Wall* (1999) consolidate this Zen aspect of Song Dong's work. Here he invokes the story of Bodhidharma, the 5th- or 6th-century Indian monk credited with bringing Zen Buddhism to China, by sitting in silence on a bed facing a wall. However, as the accompanying text makes clear, the reason the saint came to China for ten years was to propagate "Zen," and he left his image (or influence) behind him—whereas the reason Song Dong visited India for only ten days was "art," which he also left behind him, equally invisible, in the form of this action.[17] (fig. 8)

Song Dong's deployment of different kinds of self strongly influenced his search for new, experimental ways of working. His "Tao self" centers on different ideas of community—the cadre, the corporation, or the family—all of which are dealt with equivocally by using both humor and the absurd to make a serious point.

A workshop in which he had participated in Hong Kong in 1996 had opened his eyes to the possibilities of making site-specific installations on a large scale. As a result, for the period of one year, from March 5, 1997, in the seven centers of Beijing, Shanghai, Chengdu, Guangzhou, Luoyang, Yangjiang, and Haikou, he co-organized, with Guo Shirui, an experimental art project on a scale previously unparalleled in China. This involved 27 artists and had the following self-explanatory title: "Wildlife: An Experimental Art Project Held Outside Conventional Exhibition Spaces and Devoid of Conventional Exhibition Forms. Commencing Jingzhe Day, 1997, One of the Twenty-Four Divisions in China's Traditional Calendar, Which Marks the Moment in a Year When Animals Wake Up from Hibernation and When All Creatures Revive."[18]

Three primary aims had led Song Dong to take this on. The first was to get away from the "regulated system" of exhibition spaces, which was becoming increasingly restrictive as, at the time, a greater number of contemporary art exhibitions were being closed by the authorities.[19] The second was to undermine the centralized hegemony of Beijing and to stimulate contemporary art activity elsewhere; the third was to discover new and unpretentious ways of showing contemporary art that encouraged "unpremeditated meetings" (*bu qi er yu*) between a work and a wider audience.[20] The inspiring metaphor of animals coming out of hibernation is strengthened by the wordy, ironically proclamatory style of the artist's title for the project, which conjures the collective, campaigning, *yundong* spirit of the Cultural Revolution but with the opposite aim of highlighting experimentation and individual creative discovery for both the artist and public.[21]

Song Dong's ironical approach to the collective becomes even more broad in such works as *Supermarket: The Art Guide and Art Salesman* (1999), a performance in Shanghai in which he set up an "Art Travel Agency" and, wearing a bright-yellow tracksuit and baseball cap, acted as "a professional artguide and salesman for the entire exhibition, wearing a special outfit, using a loudspeaker and a supermarket-flag [sic]."[22] As part of this, under the heading of *Making Something out of Nothing*, he created the *Win Without Work (Bulao Erhuo) Award*, stamped with evocative Cultural Revolution graphics, in which he re-congratulated in person the expatriate Chinese artist Cai Guo-Qiang (b. 1957) whose re-presentation of the anonymous didactic sculptural masterpiece of the Cultural Revolution, *Rent Collection Courtyard* (1999) had just won him an award at the 48th Venice Biennale. The point, Song Dong explained, was that Cai had gained fame by doing nothing. "Though 'Bulao Erhuo' is derogatory, this award

[17] See Song Dong's text for this work in *Song Dong*, Shanghai, Zendai Art Museum, 2004, pp. 19, 80–81. [18] The main form of documentation was a specially produced catalogue in which each artist's contribution was fully illustrated. [19] See Wu Hung, *Canceled: Exhibiting Experimental Art in China*, Chicago, Smart Museum of Art, University of Chicago press, 2000, for a discussion of works that had been closed down in China during this time. [20] Song Dong in ibid., pp. 143–147. [21] *Yundong* was an official term used to describe organized popular campaigns for different kinds of social, economic, or political change. For the continuing impact of this mentality on the art of the 1980s see Wu Hung, *Waste Not*, pp. 55–57. [22] Flyer for "Supermarket, Art for Sale" exhibition, Shanghai, 1999, in Song Dong, Yin Xiuzhen, *Chopsticks* (exh. cat.), New York, Chambers Fine Art, 2002, pp. 36–37. [23] Ibid, pp. 38–39. For a discussion of this and other works by Cai Guo-Qiang, see pp. 307–308. [24] Shimabuku, *I Gave an Octopus from Akashi a Tour of Tokyo*, 2000, video. Tsuyoshi Ozawa, *Museum of Soy Sauce*, 1998–2000, installation. [25] Rikrit Tiravanija, *Supermarket* (exh. cat.), Zurich, Migros Museum für Gegenwartskunst, 1998, p. 22. As the title of the exhibition implies it was, among other things, a parody of consumerism taking place in a space sponsored by one of the leading Swiss supermarkets. [26] *Chopsticks*, 2003, pp. 32, 33, 44–47. [27] Song Dong, Zendai Art Museum, p. 88. [28] "Chopsticks," New York, Chambers Fine Art, 2002, 2006, Beijing, 2007. The third chapter in this series, "The Way of Chopsticks III" was held in 2011 at Chambers Fine Art, New York and Beijing. [29] Song Dong, *Waste Not: Zhao Xiangyuan and Song Dong*, personal statement by the artist, 2009.

12

10 | Tsuyoshi Ozawa | Inside the Museum of Soy Sauce Art | 1999 | mixed media | dimensions variable | photo Yuji Shimomiya | courtesy Fukuoka Asian Art Museum

11 | Rikrit Tiravanija | Supermarket | 1998 | p. 183 from the catalogue for his exhibition Supermarket at the Migros Museum für Gegenwartskunst, Zürich

12 | Eating, Drinking, Shitting, Pissing, Sleeping | 1999 | color photographs | 30.5 x 10.8 x 10.1 cm

isn't necessary [*sic*] derogatory. It's very Taoist to win an award without doing anything."[23] (fig. 9)

In this ironical, even absurd, search for new value in every day actions or materials, Song Dong not only picks up on Fluxus actions from the 1960s but also amplifies the approach of contemporaries, such as Japanese artist Shimabuku (b. 1969), who in one video took a live octopus from the small provincial seaside town of Akashi on a sight-seeing trip to Tokyo, somewhat insensitively culminating the trip at the Tsukiji Fish Market before the long bullet-train ride home, or Tsuyoshi Ozawa (b. 1965) who constructed a Museum of Soy Sauce containing replicas of works by famous artists all skillfully painted in the same fragrant brown hue.[24] (fig. 10) But for Song Dong's "Tao self" the work of Thai artist Rikrit Tiravanija (b. 1961) is perhaps most relevant—his 1995 statement "You have to think about how to undermine the situation before it undermines you," can also be applied to much of Song Dong's work.[25] (fig. 11)

As well as following a strategy of what in China would be called "destabilization," and fired by the burgeoning spirit of the age of digitalization, many artists of the 1990s were committed to introducing dialogue, interaction and communication as essential elements in their work. Tiravanija, in particular, was intent to both convert and subvert the formerly pristine white cube of the gallery or museum into a social space where he cooked and people ate, or into a sound studio where he and they could make music, or just a place to chill out—where literally anything could happen.

In Song Dong's case this started with an appropriation of the Beijing family space in such self-explanatory photo-installation works as *Eating, Drinking, Shitting, Pissing, Sleeping* (1998), (fig. 12) which extended, two years later, in his temporary studio at London's Gasworks, into a series of edible miniature Chinese landscapes (*Penjing*)—images of classical ideals made out of local food products—that were to be consumed by visitors.[26] He then developed this idea to comment on profound urban change in a series of large-scale site-specific installations "Eating the City" (2003–06) that were staged in Hong Kong, London, Beijing, Shanghai, Barcelona and Oxford. In these works, tabletop scale models of each city were constructed out of biscuits, sweets and cakes to be greedily devoured as soon as the visitors arrived. For Song Dong, the implication of the digestion of desire was the point: "The purpose . . . is for the city I build to be destroyed . . . As cities in Asia grow, old buildings are knocked down and new ones built, almost every day . . . My city [is] . . . tempting and delicious. When we are eating the city we are using our desire to taste it, but at the same time we are demolishing the city and turning it into a ruin."[27] (fig. 13)

The theme of consumption continued. *Eating the City* quickly escalated into *Eating the World* (2003) in the form of a globular map, which then quickly retrenched into the *Penjing* installation and event, *Sitting, Idling and Eating* (2004). But the underlying themes of *Eating, Drinking, Playing and Happiness* were rooted in domestic life and had inspired "Chopsticks," a series of three exhibitions he had jointly organized with his wife, the artist Yin Xiuzhen, between 2003 and 2007.[28]

There is a feeling of contentment, nurture, and even healing in this body of work, most eloquently expressed in the series of installations he made with his parents, which are the subject of this exhibition. Here, in Song Dong's quintessential "Tao self," the family unit becomes a central motif for the simple reason that, as was the case for the vast majority of Chinese families, the Cultural Revolution had stretched it to breaking point.

Long before the Cultural Revolution, during the "Eliminating Counter-Revolutionaries Movement" in 1953, Song Dong's maternal grandfather had been imprisoned for seven years for previous affiliation with the nationalist Kuomintang. The once-prosperous family now fell on

13

14

extremely hard times. During the Cultural Revolution, Song Shiping, Song Dong's father, was wrongly accused of being a member of an active counter-revolutionary cell and was sent to a "re-education through labor camp" for eight years as punishment. The immediate traumatic result was that until the age of 12, Song Dong hardly saw his father and as a young man felt strongly estranged from him. The performances, videos, and installations that focused on relationship with his father, *Touching My Father* (1997), *Father and Son* (1997–98), *Father and Son in the Ancestral Temple* (1998), *Father and Son Face to Face with the Mirror* (2001), and *Listening to my Parents Talking About How I was Born* (2001) were real attempts to heal this rift, as well as to mitigate the impact of former wounds by involving the whole family in creative artistic production. (figs. 14, 15) When, in 2002, Song Dong's father suddenly passed away, Zhao Xiangyuan, his mother, was inconsolable and retreated into a profound, obsessive depression.

At this time, "The most important thing," for Song Dong, "was to pull my mother out of her isolated world filled with grief, to give her a bit of fresh air to breathe."[29] Art was his "last hope" in that it allowed his mother both liberation and rehabilitation. In *Waste Not* (2005), a vast, museum-like installation of often worn-out objects she had hoarded during and after the Cultural Revolution, mother and son confronted, personalized, ordered, and digested their past to find a new way into the present. But the "last hope" can also be understood in a much broader, political sense. (fig. 16)

Since the end of the 1980s, there has been a widely recognized failure of politics to confront world change and the problems it brings, accompanied by a suspicion that its self-serving priorities and machinery merely make the situation worse. Art, on the other hand, "frivolous, agitating and destabilizing" in the eyes of some, has no pretension to be either useful or of service and continues, often unwittingly, to express abstract, disinterested human values. Song Dong's "last hope" for art, for its warmth, healing, spontaneity, openness, innocence, even truth, may have a much wider application than may first appear—not only for his many selves, and other artists of his generation, but also for us all. ●

13 | **Eating the City** | 2003–06 | site-specific eating installations

14 | **Touching My Father** | 1997 | two digital prints

15 | **Father and Son in the Ancestral Temple** | 1998 | six chromogenic prints, two photographs | dimensions variable

16 | **Waste Not** | 2005 | mixed-media installation | dimensions variable

Sun Yuan & Peng Yu

"Somewhere Beyond Rape and Adultery"

This essay was published in **Sun Yuan & Peng Yu: Hong Kong Intervention**, Hong Kong, Osage, 2011, and was written in Sydney, April 2010, during the run up to the opening of the 17th Biennale of Sydney of which I was curator. These artists were featured there by a major installation containing one hundred photo-panels of Filipino "guest workers" in Hong Kong, shown together for the first time. I had been following their work since they had exhibited separately in "Fuck Off" in Shanghai, 2000. Sun Yuan was born in Beijing in 1972; Peng Yu was born in Jiamusi, Heilongjiang province, in 1974. They live and work collectively in Beijing.

2

3

In the range, ambition and evolution of their work, Sun Yuan (b. 1972) and Peng Yu (b. 1974) have had, like many Chinese artists of their generation, to contend with the ethical vacuum of growing up within a deracinated culture that no longer really believed in itself. The heroic period of social transition from the end of the Cultural Revolution (1976) to a more intellectually open world was, for them, a *fait accompli,* turned to ashes by the events of 1989 and the prevailing cynicism that followed. In a critical, newly "liberated" culture in which ideas of tradition, history, or morality were no longer sustained by experience or consensus, ethics and the related question of aesthetics had been reduced to little more than a matter of opinion.

The development of Sun Yuan and Peng Yu's work has tested and reinvented established standards of ethics and aesthetics and is best understood within this environment. For them China in the 1990s was a twilight zone in which art must demand a human reaction. Provocatively, Sun Yuan has described the illicit, bittersweet response he seeks as: "rape mixed with adultery."[1] In making work to this specification, style is purely a mechanism through which different kinds of relationships—material, spiritual, social, economic, political, and others—are expressed. The inevitable lack of visual cohesion that results from this represents neither vacillation of intent nor a restless desire to discover a single "correct way" of making things but, in fact, the opposite: each work is made in response to a particular series of conditions and is provoked by two larger questions: "How is it possible to make art in a hypocritical and cynical post-totalitarian society?" and "How can an artist maintain integrity within an increasingly superficial and manipulative art world and market?" Both Sun Yuan and Peng Yu are artists who are engaged with these realities of life.

Such questions inevitably lead to reflections on the nature of power (or "force" as the artists sometimes refer to it), on how it is disposed politically, economically, and socially both in China and throughout the world, and on what role, if any, art may play in channeling, challenging, or deflating it. Here, the act of representation becomes both a tool and a weapon. Through the invocation of paradigmatic, metaphorical, or symbolic experiences, and models, Sun Yuan and Peng Yu create a series of worlds in which assertive meanings are reinforced through the ostensibly negative strategies of irony, paradox, and sarcasm.

Their work embraces a symbology and aesthetic that ranges freely over the traditions of both the western world and eastern Asia. The mimetic role of classical Hellenic art, as well as theories about the power embodied within it,[2] can be seen in both artists' predilection for the expression of latent, chaotic, or entropized energy. This is clearly expressed in their work by emblems of purity, power, or both, that are shown crushed, broken, or degenerated.

Civilization Pillar (2001) is a four-meter-high "classical" column made up from the surgically removed body fat of different people mixed with wax. (fig. 2) A related work, *One or All* (2004), comprises a column of human bone ash leaning against a wall. (fig. 3) More recently, a consciously more "accessible" *Dying Angel* (2009), shows a "life-sized" fiberglass and silica-gel model of an elderly angel who had crashed to earth, (fig. 1) while the large installation *Old Peoples' Home* (2007), becomes a celebration of geriatric,

1 | **Angel** | 2008 | silica gel, fiberglass, stainless steel, woven mesh | dimensions variable | all images courtesy the artists

2 | **Civilization Pillar** | 2001 | human body fat, wax, metal armature | 400 x 60 cm

3 | **One or All** | 2004 | human-bone ash, metal underprop | 380 x 40 cm

[1] Sun Yuan described his work in this way in "Xu Tan Interview with Sun Yuan and Peng Yu," http://www.sunyuanpengyu.com/ article/other/xutan.html. Last accessed February 16, 2018.
[2] As in the writings of the German Enlightenment philosopher Gotthold Ephraim Lessing, *Laocoon: An Essay on the Limits of Painting and Poetry* (1766), to which they have referred.

almost disembodied, power in which thirteen generic political, military, and spiritual "leaders" perambulate aimlessly, confined to motorized wheelchairs, occasionally bumping into each other like dodgem cars in a fairground. (fig7) Ever-present disruptions in economic life are highlighted in the installation *Occasional Awakening* (2008), in which household objects are randomly thrown out of a window, presumably, as the artists imply, by "the invisible hand" of self interest [3]—a force that Adam Smith claimed governed both the acts of man and the movement of goods and money in the market.

Although there is no obvious orientalism in the potentially punitive reversals of power that characterize *Safe Island* (2003), in which the audience has to negotiate a tiger's cage to enter the gallery and is then surrounded and continually observed by the pacing beast, there is an inevitable reference to the form and representative power of the tiger in classical Chinese mythology, medicine, and art. (fig. 5) *Freedom* (2009) was conceived and exhibited in Beijing to coincide with the 20th anniversary of the June 4 Incident and the suppression of the Student Democracy Movement in Tiananmen Square. Here the libertarian ideological implications of the writings of Jean-Jacques Rousseau, Thomas Paine, the Marquis de Sade, and Mao Zedong collide when, under high pressure, water is pumped sporadically through a vast hose suspended in the gallery space, with the effect of making the hose move swiftly and jerkily and the water spurt in chaotic arcs. The force within this unpredictable water canon animates both the hose and the water's snake-like forms "calligraphically," with a painterly energy that, like a brush stroke, can be appreciated aesthetically—as long as one is neither being beaten nor soaked by it. (fig. 6)

A number of Sun Yuan and Peng Yu's earlier works presented dead animal and human remains in ways that have been thought both callous and sensational. Certainly, the inclusion of such material was intended to disorientate the viewer by confusing the borders between life, death, and art, but, more significantly, it also focused attention on what it means to *be* alive, a concern that is still very much at the center of their work. *Soul Killing* (2000) consists of a mounted "running" greyhound with smoking, scorching light from a high-wattage bulb focused through a magnifying glass onto its skull. In the performance *Linked Bodies* (2000), the artists sat on chairs linked by intravenous tubes to the aborted fetus of conjoined twins; as the blood spilled out of the tubes into the mouths of the unborn and then down their bodies, it seemed as if the artists were trying to propitiate death through their own combined life force. [4] (fig. 4)

By illuminating the rictus of oblivion, by using, and possibly abusing, now-empty containers of life, the artists privilege the whole notion of life force and its relation to the body. Is the body purely a transient channel where a spirit may temporarily repose to be reborn again, as Buddhists maintain? Or, according to the materialist beliefs in which they were brought up, is death final—and can the soul, if it exists, really be killed by a process of systematic obliteration? [5] One feels that the artists are posing these questions sincerely out of a sense of uncertainty, at times, even of anguish.

In *Dogs That Cannot Touch Each Other* (2003) (aka *Controversy Model*) four pairs of live pitbull terriers face each other tethered on treadmills. In a model of competitive capitalist society, running frenetically and barking furiously, unlike in life in spite of their strongest efforts, they are unable to reach or bite each other. When exhaustion sets in, they are separated. In this, as in the rest of their works, the artists are looking at "an order that is also an ecology." [6] (fig. 8) Acutely aware that this "order" may not fit with conventional hierarchies, but knowing that it is based on power and that power has an ecology of its own, they present it as a reflection of their fears or suspicions about what could actually be the case.

In *Hong Kong Intervention* (2009), first shown at the 17th Biennale of Sydney in 2010, the artists have turned their attention to the ecology of economic migration in an ostensibly more light-hearted, open, and participatory way.[7]

4 | **Linked Bodies** | 2000 | performance | medical samples, 200 cc blood

5 | **Safe Island** | 2003 | tiger, iron cage | 800 sq m

6 | **Freedom** | 2009 | metal plate, high-pressure hydraulic pump, fire hose, hydrant, electronic control system | dimensions variable

[3] Adam Smith suggested this in his influential book on world economy, *The Wealth of Nations* (1776). [4] This work was shown at the exhibition "Indulge in Pain," curated by Li Xianting at the Central Academy of Fine Art in Beijing in 2000. [5] See Joseph Ng, "With Animalistic Vividness," *Sun Yuan and Peng Yu: Can't Have it All* (exh. cat.), Beijing, 2009. [6] Ibid. [7] David Elliott, *The Beauty of Distance: Songs of Survival in a Precarious Age*, Sydney, Thames and Hudson Australia, 2010.

7

8

About four to five million Filipinos work as economic migrants in different countries and the remittances they send back to their families keep the home economy afloat. In Hong Kong, Filipinos comprise a large underclass of domestic helpers that during their few hours off on Sundays gather together in whatever public spaces they can find to play cards, chat, and picnic. To make this work, Sun Yuan and Peng Yu visited these different places and invited one hundred Filipinos to photograph a favorite scene at their place of work, giving them a disposable camera. There were, however, two conditions: each was supplied with a toy hand-grenade that should be included in the photograph, and Sun Yuan and Peng Yu took portraits of them that did not show their faces. Both the worker's own photograph and their portraits would be exhibited together as part of the overall work. No payments were offered to the workers, other than a copy of their portrait and the print they had made. (fig. 9)

Within this parody of subversion, potential terrorist threat, and anonymity—in images that mimic the style of anthropological and criminal photography—the true artists are the individual domestic servants. Through their wit and aesthetic sense they have composed domestic still-lifes that not only document the lifestyle and social mores of a cross-section of the Hong Kong middle- and upper-classes but also highlight discrepancies of economic and social power. But, significantly, there is humor rather than anger in these pictures. Again, the picture is of a whole ecology, and who can be blamed for that? Many a pet dog is confounded by the presence of the toy grenade, which also finds itself nestling on library shelves, toilet seats, coffee tables, play pens, mantelpieces, bedrooms, drinks cabinets, desks, and settees. It is as if this interloper has become a surrogate time bomb that can signal equally the effects of poverty or inequality, as well as the transformative power of aspiration in a world undergoing profound economic and social change.

In this, just as in Sun Yuan and Peng Yu's earliest works, the conventional world has been turned upside down with a sour-sweet taste of compulsion mixed with desire. As artists, aestheticians, and activists they trigger us both to think critically and enjoy the world for what it is. In *Hong Kong Intervention*, penetration (of ideas of home, privacy, social relations) has again definitely taken place but at least no one has been raped or has had to tell lies. Its coquettish lightness, even seduction, is just another way of thinking about truth. ●

7 | **Old People's Home** | 2007 | electric wheelchairs, fiberglass, silica gel | dimensions variable

8 | **Dogs That Cannot Touch Each Other (aka Controversy Model)** | 2003 | performance and video | eight pitbull terriers on non-powered treadmills

9 | **Hong Kong Intervention** | 2009 | 200 photographs mounted on aluminum | 100 photographs, 75 x 100 cm; the remainder 75 x 56 cm | courtesy the artists and Osage Gallery, Hong Kong

9

Xu Zhen
Chaos and Rectitude in the Face of History

This essay was published in Chinese and English in **Xu Zhen**, Berlin, Distanz, 2014. Although I would have seen Xu Zhen's work in "Fuck Off" (Shanghai, 2000), it did not really register until the research for "Follow Me! Chinese Art at the Threshold of the New Millennium," which we organized at the Mori Art Museum in Tokyo in 2005. From that time I followed his work and also made a major presentation of it at the 1st Kyiv International Biennale of Contemporary Art in 2012. See pp. 154–155. Xu Zhen was born in Shanghai in 1977 and is based there.

2

3

The concept of "great art" today is very doubtful, because we deeply feel that the situation we are facing now "no matter how much we do" [. . .] is never enough. New desires, requests, and fields of action are unceasingly produced and are always harsh, unsatisfied.

Creativity relates to a new reflection, discovering and creating new functions for "objects" [. . .]

— Xu Zhen, 2011 [1]

I. The House of Cards

Xu Zhen was born in 1977, one year after the end of the Cultural Revolution, and graduated from the Shanghai School of Arts and Crafts in 1996. He never directly experienced the excesses of Maoism but grew up with its legacy; neither did he benefit from the grounding in history and traditional painting provided by more established academies. A child of the digital revolution, he gravitated towards performance, video, and other new media, agglomerating different ideas and works into complex installations. His earliest work dates from 1999, and he is often described as a "conceptual artist." [2]

One of the youngest members of the so-called "Fuck Off" generation, he reflected, analyzed, and digested the anger and cynicism of the 1990s, a time of deep-seated unease among many artists. [3] But, in the spirit of Deng Xiaoping's apocryphal exhortation "to become rich is glorious," it also became a period of political recovery and economic boom. An intuitively satirical approach characterizes much of Xu Zhen's work from this time. Like many "avant-garde" artists before him, he began to question the ability of art, and himself as an artist, to express what he was feeling. His interrogation of art—its authority, competence, and limitations—was a fundamental part of this process. But even more important was his desire to examine the different inconsistencies and ambiguities that contributed towards his consciousness of the world.

In an interview published in 2010, Xu Zhen categorized his work in three chronological periods, almost as if someone else had made it: "The early ones were mainly instinctual. The middle period works [from around 2005] were also instinctual but at the same time had a kind of method informing their production [. . .] something that could relate to social issues like we now believe in 'facts.'" The third and current period, starting in 2009 with the creation of the MadeIn Company, is when he ceased to work as an autonomous artist. As he explains: "What MadeIn represents is a method and not content, although we can still insert content into the methodology." [4] This method is still Xu Zhen's current way of working. [5]

Xu Zhen's earliest "instinctual" works are an irreverent and consciously provocative continuation of the cynicism of the late 1990s, revolving around the ironical leitmotifs of power, pain, shock, and sex. In concordance with works made by contemporaries that incorporated parts of human bodies or fetuses, his first gallery work, *I'm Not Asking for Anything* (1999), a performance recorded on video, showed the artist beating an already dead cat against the wall and floor of a bare space. In addition to the obvious brutality of the scene, the Chinese equivalents of the English expressions "flogging a dead horse" and "having no room to swing a cat" were also invoked. [6] *Rainbow* (1999), a single-channel video projection of a close-up of a man's (the artist's) back beaten until raw, continued this idea, (fig. 1) as did *Shouting* (1999), a video showing the reactions of a startled public when it was infiltrated by a group who suddenly, repeatedly, and inexplicably shouted very loudly. (fig. 2)

1 | **Rainbow** | 1999 | single-channel video | 3'50" | All images courtesy the artist and MadeIn Company

2 | **Shouting** | 1998 | video | 4'00"

3 | **6th March** | 2002 | action with 100 performers wearing psychiatric hospital inmates' uniforms and slippers

[1] Xu Zhen interview with Chris Moore, "Made Up Interview" in *MadeIn Company: Action of Consciousness*, Shanghai, MadeIn Company, 2011, p. 21. [2] In his authoritative history of contemporary Chinese art, Lü Peng places Xu Zhen among the youngest generation of conceptual artists. See *Fragmented Reality: Contemporary Art in 21st-Century China*, Milan, Charta, 2012, pp. 270–74. See also Mami Kataoka, "Who's Leading, Who's Following? The Awakening of Contemporary Art in China," in *Follow Me! Chinese Art at the Threshold of the New Millennium*, Tokyo, Mori Art Museum, 2005, pp. 27–28. [3] Xu Zhen participated in the definitive and notorious "Fuck Off" exhibition organized by Ai Weiwei and Feng Boyi in Shanghai in 2000, as an unofficial riposte to the Shanghai Biennale of that year. The exhibition was closed by the authorities. The short-lived transgressive nature of the work by many of the included artists was a strong reaction to both the repressive cultural climate and the profound social and economic changes that characterized the 1990s. [4] Xu Zhen, interview with Andrew Maerkle, "The Path to Appearance is Always . . . ," Tokyo, Art-It, July, 2010, http://www.art-it.asia/u/admin_cd_itv_e/6Vsp7C1Zfl1CvDW0qublX/. Last accessed, April 21, 2015. [5] Since the time of writing Xu Zhen has decided that he will work in both the capacity of a private artist and as MadeIn Company. [6] "Flogging a dead horse" means to waste one's efforts. "Having no room to swing a cat" means to be confined in a small space.

Like a psychotic premonition of Tino Sehgal's (b. 1976) later relational pieces, the time-based performance/installation *6th March* (2002) also involved shocking an unwitting audience, or at least making it feel uncomfortable. One hundred volunteers, dressed in the blue-striped tunics and black slippers usually worn by mental patients, occupied a gallery space where they closely tracked the visitors as they looked at other works. **(fig. 3)** In *Earthquake* (2003), at the Duolun Modern Museum in Shanghai, the shock was literal rather than psychological, as an earthquake simulator was built into its top floor that would suddenly, without warning, kick in during the exhibition.

Xu Zhen's treatment of sex is funny, absurd, and masturbatory. Concerned with power—or the lack of it—this work creatively elaborates the reflexes of psychosexual dysfunction. Echoing the futility of human activity, while at the same time highlighting alienation from society and art, the three-screen video installation *From Inside the Body* (1999) presents the bizarre spectacle of a woman and a man sniffing themselves on two of its screens, while at the center they sniff each other. A padded, brown vinyl-covered sofa invites the viewer to indulge in the same animal-like activity. An exhibition tellingly entitled "A Young Man," held in the BizArt Gallery in Shanghai in 2002, featured two works that further elaborated the arcane rituals of onanism. *We Will Be Back Soon,* a black-and-white video, focused on a close-up of a couple in a rowing boat fumbling with their unzipped flies, **(fig. 4)** and the three-channel projection *Road Show*, a homage to Vito Acconci's performance *Seedbed* (1972),[7] that recorded male singers' karaoke-like simulations of female orgasms with the enthusiastic vocal response of large female audiences. The multi-screen video installation *Baba* (2002) introduced a post-revolutionary Confucian element into Xu Zhen's investigations of wanking, as two serious young girls implored their father to curb his ingrained habit. **(fig. 5)** The three-channel video *An Animal* (2006) interjected a banal note of patriotism into this theme when it showed three men joyously fluffing a panda-like creature (China's national animal)—it was probably a large, long-haired dog—so that it eventually ejaculated onto a plate glass table.

It was not by chance that around this time Xu Zhen was also turning his attention to the history and iconography of contemporary art. The installation *Comfortable* (2004), a heavily loaded Chinese minibus, the inside of which had been converted into a functioning washing machine to cleanse its passengers' luggage and clothes, recalls *The Pack* (1969), Joseph Beuys's spiritual survival kit for difficult times, a Volkswagen bus followed by 20 sleds covered with rolled up felt, leather, fat, and flashlights. **(fig. 6)** In *Just the Blink of an Eye*, first shown at Beijing's Long March Space in 2005, presented and documented the improbable positions of a group of performers, caught as if they were falling to the ground in slow motion. These seemingly frozen figures recall terrible accidents or *The Falling Soldier* (1936), Robert Capa's famous war photograph of a man who had just been hit by a bullet. **(fig. 7)**

The Starving of Sudan (2008) was a re-enactment through performance, photographic documentation, and video, of Kevin Carter's 1994 iconic, prize-winning photograph of a starving Sudanese child being closely observed by a hungry vulture. Xu Zhen's version recreated the bleak background of the photograph in a gallery; he hired an African child (with his mother offstage) and added a flapping animatronic vulture. **(fig. 8)** When it first appeared, Carter's image had created a shockwave of moral and ethical outrage that culminated in his eventual suicide. Because it was a news photograph, it had to be "true" and because the child's life was threatened by both starvation and the predation of the vulture, many argued that the photographer's duty should have been to save the child—and lose the photograph. Others claimed that the photographer's responsibility was to publicize the famine in an emotionally compelling way so that more funds could be raised for its alleviation and avoidance in the future. Yet, as a grisly *memento mori*, divorced from specific reality, this image had also established an independent life in both art and the media—free from ethical debate—that could be interpreted in any way the viewer desired.[8] It no longer mattered whether

[7] In *Seedbed*, Vito Acconci lay hidden, masturbating under a ramp, in an otherwise empty New York gallery. His amplified fantasies about the people walking above him were relayed into the main space. [8] Both Chilean artist Alfred Jaar (b. 1956), in *The Sound of Silence* (1995), and British artist Mat Collishaw (b. 1966), in *Prize Crop* (2013), have also used Kevin Carter's photograph and its impact as bases for their work. [9] Xu Zhen makes reference to military actions in a number of other works from this time.

8

9

10

this image was "real" or "fake"—and this was the territory that Xu Zhen now began to occupy.

Untitled (2007), a long, vertically bisected "dinosaur," in which its two halves were exhibited in separate display tanks, plays on a similar idea of morbidity. It is a parody of Damien Hirst's famous *Mother and Child Divided* (1993), in which four separate tanks display the two halves of a cow and her calf floating in formaldehyde. Xu Zhen's work is not so much a criticism of Hirst but of how images are transformed by media and commodified by the market. It also poses the open question: "Is not art which so obviously has become—in spite of the intention of the artist—a commodity, already as powerless and extinct as a dinosaur?" (figs. 9, 10)

Obsessive, unfruitful action appears repeatedly throughout Xu Zhen's work and purposefully engenders aggression as a response. Yet another metaphor for powerlessness, related not only to his condition but also to that of his generation, it may also refer to the current state of Chinese culture and society. In an obvious reference to the events of June 4, 1989, *12"91* (2005), a life-size model of a broken-down Chinese tank, was exhibited in a public park during "Archaeology of the Future," the Second Triennial of Chinese Art held in Nanjing in 2005.[9] (fig. 11) One of its tracks has unraveled and the barrel of its gun either droops un-phallically or points upwards in a ridiculously perky way; the scratch marks of unknown hands and feet are embedded in what appears to be its heavy steel carapace.

8848-1.86 (2006) re-enacts an imaginary expedition made by the artist and his team to the summit of Mount Everest. Not only is this the highest mountain in the world, but it also marks the border between China and Nepal. Here they removed and "repatriated" 1.86 meters of rock. (fig. 12) The work's numerical title indicates in meters the amount that was subtracted from the mountain's recorded height, but it also highlights the politicization of names. Everest, the widely recognized name of the mountain, was the name of the British Surveyor General in colonial India when the height of the mountain was first measured in the 1850s. The mountain already had Tibetan, Nepalese, and Chinese names but, oblivious of these, the surveyors wanted to record their own national achievement. The absence of a name in this context refers to imperialist ambition, historical and current, and to the way that language is power. The finished artwork ostensibly documents the process of the removal of the rock on film, also showing the equipment used to do this, together with the chunk of removed mountain preserved in a refrigerated glass cabinet. Xu Zhen stalwartly maintains that this expedition actually took place, and this, in turn, provoked much discussion about whether what the work represented was "real" or "fake."

A similar concern with borders and territorial ambitions underlies the video and installation *18 Days* (2006–07). In the video, a parody of television news, Xu Zhen documents another "expedition" but this time traveling with his team of four assistants to three different border areas in China: "strategic points" on the frontiers with Russia, Mongolia, and Myanmar where, using remote-controlled toy tanks, helicopters, airplanes, or warships, he tried to "invade" the neighboring country before finally returning home to the safety of the motherland. The mock-heroic style of this work was further heightened by the addition of an unreliable, beat-up van in which the artist and his "comrades" traveled to the edges of China. With such terrifying weapons of mass destruction, Xu Zhen parodied the vainglorious militarism and saber-rattling manifested by all great global powers.

In *Untitled* (2009), the last work the artist made in the persona of Xu Zhen, he presents a vast house of cards, a redolent and fragile symbolic structure, laid out on a tabletop. But the reference to borders—physical, mental, religious, moral, historical, geographical, national, and personal—again emerges. The house formed by the cards is not just any building, but clearly the Potala Palace in Lhasa, Tibet, the former chief residence of the Dalai Lama before he escaped into exile. Like biting on a bad tooth, the question of Tibet is sensitive

4 | **We Will Be Back Soon** | 2002 | black-and-white video | 3'22"

5 | **Baba** | 2002 | multi-channel video installation | 7'32"

6 | **Comfortable** | 2004 | installation | Chinese minibus, clothes, water, circulation system

7 | **In Just the Blink of an Eye** | 2005 | performance | Long March Space, Beijing

8 | **The Starving of Sudan I** | 2008 | performance, photography, video

9 | **Untitled** | 2007 | installation | mixed media, iron, formalin | 10 x 2 x 3.1 x 2 m

10 | Damien Hirst | **Mother and Child Divided** | 1993 | glass, painted steel, silicone, acrylic, monofilament, stainless steel, cow, calf, and formaldehyde solution | two parts each (cow): 1900 x 3225 x 1090 mm, two parts each (calf): 1029 x 1689 x 625 mm | Photo by Prudence Cuming Associates | Damien Hirst and Science Ltd | all rights reserved | DACS 2012

in China and, like any matter of national sovereignty, is not for public debate. By presenting a symbol of the desire for Tibetan independence in this way, Xu Zhen not only draws attention to the whole question of Tibet and other "minorities" in China, but also implies that the apparatuses that both support and suppress them could just as easily collapse of their own weight as be destroyed by the smallest of external movements. (fig. 13)

The fragile structure of Xu Zhen's whole work could also be regarded as such a house of cards. Yet, in fact, it is a plant with deep roots running in many directions. Its chaotic matrix of intuitive intelligence, randomness, delight in provocation, and concern with social, sexual, political and ethical borders has many precursors. It is firmly rooted in conceptual art . . .

II. What is Conceptual Art, Anyway?

When an artist uses a conceptual form of art, it means that all of the planning and decisions are made beforehand and the execution is a perfunctory affair. The idea becomes a machine that makes the art. This kind of art is not theoretical or illustrative of theories; it is intuitive, it is involved with all types of mental processes and it is purposeless. It is usually free from the dependence on the skill of the artist as a craftsman [. . .]

Conceptual art is not necessarily logical. The logic of a piece or series of pieces is a device that is used [. . .] only to be ruined. Logic may be used to camouflage the real intent of the artist, to lull the viewer into the belief that he understands the work, or to infer a paradoxical situation (such as logic vs. illogic). Some ideas are logical in conception and illogical perceptually.

– Sol LeWitt, 1967 [10]

In the short statement, published in 1967, from which these words are extracted, New York-based artist Sol LeWitt crystallized a debate that had been consuming contemporaries on both sides of the Atlantic throughout the previous decade. This had been prompted by the much earlier readymades of Marcel Duchamp (1887–1968) and, although not many people realized it when they were produced, these works had gone far beyond Dada *épatage*, or making fun of tradition, to propose a fundamental alterity in ways of thinking about and looking at modern art. [11] In the confrontation that Duchamp had initially provoked, the traditional idea of an artwork as a hermetic object—a painting or sculpture crafted by the individual creative vision of an artist—is set against a more strategic view of art in which the artist develops, and in the process changes, ideas about art, the world, or both, according to the manipulation of context, means, and ends. This latter approach was not only concerned with concentrating on art as an institution—those qualities that made art separate from other activities—but also with reflecting on how the inevitable limitations that bind art can be perceived so that they may be transcended. This tentative, ironical, research-based approach provided a matrix for the work of Xu Zhen and many other artists of his generation.

* * *

Looking back, we can clearly see that conceptual art emerges out of the social and political turmoil of postwar Europe and America, and encompasses a whole range of different aesthetics and approaches: the Merz-like combines of Robert Rauschenberg (1925–2008) from the 1950s, for instance, which in a watered-down, later form were shown in 1985 in Rauschenberg's solo exhibition at Beijing's National Museum of China, where they made a great impact on the 1980s generation of young Chinese artists. The ironical or critically symbolic objects, gestures, or actions of such artists as Yves Klein (1928–1962), Piero Manzoni (1933–1963), Marta Minujin (b. 1943), or Wolf Vostell (1932–1998) suggest a more surreal or absurd lineage for conceptual art, while the influential "instruction works" of John Cage (1912–1992), Yoko Ono (b. 1933), and Sol LeWitt (1928–2007) collide covert authority and the matter-

[10] Sol LeWitt, "Paragraphs on Conceptual Art," New York, *Artforum*, June, 1967. [11] Duchamp's readymades were ordinary manufactured objects, produced between 1913 and 1921, which the artist had selected or modified to become art. [12] Art & Language was founded in the United Kingdom during 1967/68 by artists Terry Atkinson (b. 1939), David Bainbridge (b. 1941), Michael Baldwin (b. 1945), and Harold Hurrell (b. 1940). Many others became associated with the group during the 1970s. [13] "Sensation" was the name of a seminal exhibition of Young British Artists (YBAs) from the collection of Charles Saatchi, their main patron, held in the Royal Academy in London in 1997. The YBAs included such artists as Damien Hirst (b. 1965), Sarah Lucas (b. 1962), Mat Collishaw (b. 1966), and Tracy Emin (b. 1963). [14] The key art event to mark this change was the 1989 exhibition "Les Magiciens de la Terre," organized by Jean-Hubert Martin at the Centre Pompidou and Grande Halle at the Parc de la Villette in Paris. Its concept, however, was still colonial as it exoticized nonwestern art along with selected examples of contemporary western art on the grounds that they all expressed some kind of primordial "magic." See p. 28.

11

12

13

of-fact-ness of minimalist materialism with the unpredictable transcendence of Zen. There is a similar tension in the existential date paintings, telegrams, and postcards of On Kawara (1933–2014). (see p. 24, fig. 11)

Much of this work has a strong relationship to Fluxus, an international, vitally chaotic, cross-media network disrespectful of established authority. The text-based installations of such artists as Lawrence Weiner (b. 1942), Joseph Kosuth (b. 1945), or the Art & Language group test barriers of language, text, understanding, and embodiment in a similarly anarchic spirit, yet remain hermetic in their terms of reference. [12] Other works focus on the human body as both symbol and representation, some expressing feminist or gay identities. As diverse a range of artists as Marina Abramović (b. 1946), Vito Acconci (b. 1940), Gilbert and George (b. 1943 & 1942), Eva Hesse (1936–1970), Valie Export (b. 1940), Mary Kelly (b. 1941), Yayoi Kusama (b. 1929), Robert Mapplethorpe (1946–1989), Carolee Schneemann (b. 1939), Nancy Spero (1926–2009), Paul Thek (1933–1988), and Hanna Wilke (1940–1993) were all working within this broad framework.

The desire to construct a counterculture, to make works that protested against institutional power and analyzed its weaknesses, had been a strong motivation for the whole of the European post-World War II avant-garde. The anti-capitalist actions of the Situationist International (1957–72) were closely associated with the 1968 Students' Movement in Paris and elsewhere, but the diverse production of such artists as German sculptor, performance artist and Green political advocate Joseph Beuys (1921–1986); the American painter and anti-Vietnam War activist Leon Golub (1922–2004); the German-American installation artist Hans Haacke (b. 1936), who critiqued the pervasive effects of corporate power both in America and multi-nationally; and the German "capitalist realist" painter and chronicler of recent German history Gerhard Richter (b. 1932), all fit within this frame.

At the end of the 1970s in the West, the political and cultural climate changed profoundly. Newly adopted neoliberal ideologies in both the UK and USA veered away from state control and patronage in favor of free markets. This increased surplus wealth, allowing the taste of those who possessed it to impact radically on a suddenly fashionable art market. Whatever form it took, conceptual art, with its subliminal social concern and conscience and need to deconstruct in order to build, seemed insubstantial, or needlessly intellectual, when compared with paintings and objects that could be quickly described and evaluated by the art market.

But conceptual art continued under other guises and, in a not-unexpected manifestation of the reflexivity of both postmodernism and contemporary art itself, the avidly post-Duchampian appropriation art made by such artists as Barbara Kruger (b. 1945), Louise Lawler (b. 1947), and Sheri Levine (b. 1947), threw the art market's new obsession with historicist originality back in its face. But the '80s was, above all, the "Me Generation" and the Darwinian ethics of turbo-capitalism also encouraged a widespread obsession with identity at many levels—particularly of gender, sexual orientation, and ethnicity, although no longer with class.

In the transformed geography of the 1990s when, owing to political change and revolutions in communication, national barriers suddenly seemed much less important than before, the term "conceptual art" lost its historical specificity and was used to describe a new generation of angry young British artists, the YBAs, whose pickled sharks, trampled beds, and laddish feminism caused literally a "sensation" both within the UK and much further afield. [13]

All this took place within the goldfish bowl of the Atlantic rim; it was not until the end of the 1980s that "others" began to be admitted. Multiculturalism had come to stay, but it still had to know its place . . . [14] The questions now to be asked were, "Where is that place to be situated? Who would decide? What would be shown?"

* * *

11 | 12"91 | 2005 | HDF, steel, resin, paint | 2.6 x 4 x 10 m

12 | 8848-1.86 | 2005 | photographs, video, mountain climbing equipment, tents, refrigeration box | dimensions variable

13 | Untitled | 2009 | installation of playing cards depicting the Potala Palace in Lhasa, Tibet | 430 x 130 x 120 cm | James Cohan Gallery, Shanghai

In Asia, conceptual art had developed its own trajectory. Also rooted in ideas, texts, actions, and performances, it drew strength from completely different aesthetic traditions and cultural contexts. Japan had been the first to moderniz during the Meiji Restoration (1868–1912) when western art, *yōga,* a newly invented genre and discipline, was isolated from *nihonga,* an equally newly invented version of traditional-style Japanese painting. Accordingly, Japan had its own versions of realism, Impressionism, Fauvism, Cubism, Dada, and so on, and, by the early 1960s, two overlapping groups, Hi Red Center and the Neo-Dada Organizers, working very much in a conceptual spirit, initiated a wide range of different art actions that were an active part of Fluxus.[15]

At this time art in China had been slumbering under the mantle of Maoism. It was not until the end of the Cultural Revolution (1966–76) that a decade and a half of rapid assimilation of developments in western philosophy, religion, cultural theory, science, and art progressed at breakneck speed. This also incorporated a reassessment of China's history and place in the world that had previously been proscribed by the Communist Party. Throughout the 1980s, Chinese culture was radically reformed as the work of previously unknown western philosophers, theorists, writers, and artists was absorbed, discussed, and synthesized, along with recently rediscovered Chinese traditional and modern culture.

A number of artists, such as Xu Bing (b. 1955), Gu Wenda (b. 1955), and Yang Jiechang (b. 1956), who had been Red Guards as teenagers, now built on their childhood talent for traditional Chinese calligraphy, later refined in propaganda posters, to invent new, "nonsense" forms of working with text and signs. (see p. 48, figs. 34, 35; pp. 192–201) Impressive objects in their own right, these works coulc also be understood as a reflection and critique of contemporary society. All thes artists had problems with the authorities when they exhibited their work.

The work of Marcel Duchamp and John Cage, as well as the writings of Ludwig Wittgenstein, also had a strong impact. This was evident in the work of Huang Yong Ping (b. 1954) and the artists of the Xiamen Dada group who, in a declaredly postmodernist synthesis of western influence with Chinese Tao and Chan Buddhism, created "anti-art" by destroying their own work.[16] This was equally controversial. An early victim of this process of destroying in order to cleanse and synthesize was Herbert Read's classic, but Eurocentric, book, *A Concise History of Modern Painting* (1959). This was thrown, along with Wang Bomin's authoritative *A History of Chinese Painting* (1982), into a washing machine to be reduced by Huang Yong Ping into a balanced and "politically correct" unified slurry. (ee p. 209, fig. 7)

The cultural and artistic ferment of the 1980s was mirrored in politics and, as had happened in both Paris and Prague in the mid-1960s, this became associate with students' demands for greater freedoms and democracy. "China/Avant-Garde," the first large exhibition of the post-Cultural Revolution generation of Chinese artists, which opened at the National Art Gallery in Beijing on February 5, 1989, adopted as its poster a sign for a U-turn canceled by a large red stripe. It was closed twice because of what the authorities described as "provocations," but reopened and lasted as advertised until February 19.

Supported by Hu Yaobang, then the General Secretary of the Chinese Communist Party, the Student Democracy Movement had been increasingly active since the summer of 1986. Although Hu was forced to resign in January 1987, he still retained many adherents both within the Party and outside. On April 15, 1989, however, he died unexpectedly of a heart attack and students began to gather in large numbers on university campuses across the whole country to pay their respects.

Spontaneous gatherings to mourn Hu centered on the Monument to People's Heroes in Tiananmen Square; this led to a student occupation of the square in demand of greater freedoms. Some students went on hunger strike, the government declared martial law. For over three weeks there was a stalemate. On June 4, 1989, the People's Liberation Army were instructed to clear the

14 | Made In Company | **Seeing One's Own Eyes, Middle East Contemporary Art** | installation view of Madeln exhibition | 2009

[15] The name Hi Red Center—in Japanese read as the characters *taka, aka, naka*—stood for the names of its protagonists: Jiro Takamatsu (1936–1998), Genpei Akasegawa (1937–2014), and Natsuyuki Nakanishi (1935–2016). The Neo-Dada Organisers included Genpei Akasegawa, Shusaku Arakawa (1936–2010), Ushio Shinohara (b. 1933), Masanobu Yoshimura (b. 1932). [16] The Xiamen Dada group was formed in 1986 by Huang Yong Ping with Cai Lixiong (b. 1960), Liu Yiling (b. 1958), Lin Chun (b. 1960), and Jiao Yaoming (b. 1957). [17] The "Fuck Off" exhibition in Shanghai in 2000, in which Xu Zhen participated, was one of the climaxes of this series of unofficial exhibitions. See note 3. [18] In the art world, at least, this check was relatively short-lived. In October 2013, Zeng Fanzhi's painting *The Last Supper* (2001) sold at Sotheby's Hong Kong for a record-breaking USD 23.3 million. [19] The BizArt Art Center was one of China's first nonprofit art spaces. It was dissolved in 2009. [20] George Orwell, *1984*, London, Secker & Warburg, 1949.

14

square with tanks, firing live bullets at the protestors, killing many. The students retaliated and after a brief, unequal struggle, they were removed from the Square and the government crackdown began. A number of artists left China; the style described as "cynical realism" followed. (see also pp. 44–47)

Yet as the 1990s progressed and the Chinese economy grew rapidly, previous polarities began to evaporate, with avant-garde artists finding their own ways of making and exhibiting work outside the official system.[17] After a short period of isolation, the world spotlight was again thrown on China as part of the desire to develop Chinese markets for western goods and services. By way of reciprocation, it also triggered an interest in the market for contemporary Chinese art, initially supported by foreign buyers but gradually also by newly rich Chinese. By the beginning of this century the market in Chinese contemporary art, particularly figurative "western style" oil painting, was extremely strong. In May 2008, Zeng Fanzhi's (b. 1964) oil painting *Mask Series 1996 No. 6* fetched USD 9.7 million at a New York auction, a record for a contemporary Asian artist. Beginning in September of the same year, the world economic crisis checked the art boom in China—and elsewhere.[18]

III. From Individual to Company and Brand

In the face of this unruly and complicated history, in which, in market terms at least, the West still plays the role of Big Brother, Xu Zhen has been acutely aware of potential symmetries between ideas, art, and events as well as of the tensions and discrepancies that result from differences of power and perspective. As a basis for his activities in the MadeIn Company, the new legal entity he created in 2009, he has taken the recent history of the contemporary art market and folded this, along with political and economic analysis and some interventions of his own, into what he has described as a "method" for artistic production.

Through the course of his work, Xu Zhen's evolution from the persona of an individual artist to that of MadeIn Company can be read in a number of ways. The reference to business was present from the beginning. In 2000, with curator and producer Davide Quadrio, he co-founded the BizArt Art Center in Shanghai. At one level, MadeIn Company may be seen as a work of art in itself—a corporate readymade worthy of Duchamp—as well as a child of the BizArt satire of the corporatism that typified the new China.[19] Yet MadeIn could just as easily be regarded as a more serious version of Takashi Murakami's production company Kaikai Kiki in Tokyo, or as a lampoon of the kind of Asian artists' collectives much beloved by western critics, or even of the bumbling cadres and "artists' brigades" of Maoist China. Looking in a completely different direction, what springs to mind is a parody of the self-conscious bohemianism of Andy Warhol's famous New York studio, the Factory (1962–84).

In recent work, Xu Zhen has continued to expand the boundaries of what art can be, referring to previous art while working with "hub concepts" of ideology, power, poverty, race, and religion that all exert a painful presence in the world. Aware that hypocrisy vaunts insincerity, duplicity, and self-interest in the name of political correctness, while society remains just as cruel and unequal as before, he had started to work with these subjects while still an individual artist, but has now suborned them to the different "methods" of the MadeIn Company. This awareness, the source of chaotic rectitude referred to in the title of this essay, is the machine by which Xu Zhen's work is driven. Within this approach, there is a universe of contradictions—still present embodiments of George Orwell's dystopia where, "War is peace. Freedom is slavery. Ignorance is strength."[20]

In Brechtian fashion, Xu Zhen invokes alienation, or distancing, between art and its observers to allow the work to be "read," rather than viewed, so that it may be seen more clearly against its social, cultural, and political context. Underlying this is the conviction that within art is a concern for ethical value, yet this also has to be subjected to the same inquisitorial method. "[Ethics]

15

should be somewhere. [It] evolve[s] along with your experience, or as you gain more experience you discover new perspectives on the issues you thought affected you . . . It's not about fundamental values, it's about questioning the nature of ethics."[21]

"Seeing One's Own Eyes, Middle East Contemporary Art" (2009), one of MadeIn's first exhibitions, comprised diverse series of paintings, objects, and installations that were produced in response to the puzzles posed by its long title. (fig. 14) How can one "see one's own eyes" when we are trapped inside them and unable to dispense with our subjectivity, however objective we would like to be? The idea of presenting a version of the newly fashionable "Contemporary Art from the Middle East" that has been entirely conceived and fabricated by a small company in Shanghai, was also absurd. Yet, if quality in art depends on creativity, why should this version of Middle Eastern art not be as "good" as the real thing? Here we are returned to a question that Xu Zhen has already posed in other contexts: what is real and what is fake, and how are such distinctions depicted by the media? MadeIn's choice of the Middle East as a point of interest was influenced by it being a flashpoint for world conflict, by its oil wealth, and by the (correct) premonition that its contemporary art would soon be fashionable in the market.

The works in this exhibition made iconic rather than stylistic reference to the Middle East and ranged from large, Pollock-like abstracts, cartoon-like figurative paintings, Calder-ish mobiles made out of prosthetic limbs, a "perpetual motion machine" constructed out of razor wire in the form of an oil pump, a black-painted fairground whirligig swirling around equally black chadors, and a sand model of destroyed desert buildings installed on the top of a sand-covered pool table. In the overwhelming chaos displayed here, what can we see: banality or truth?

The "True Image" series (2010) picks up this question in installations, paintings, and statues made for "Don't Hang Your Faith on the Wall," an exhibition whose title reflected the fact that all the works were inspired by found concepts and ideas named after an historical quote: a photograph of a man looking at a fabricated model of a classical tower bisected by a large iron spring was entitled *"Democracy is our goal, but the country must remain stable" (Deng Xiaoping).* A large photo-panel of a muddy, pseudo-socialist realist public sculpture in which heroic workers were replaced by Neanderthals, was accompanied by Czech-born writer Milan Kundera's aphorism "The struggle of man against power is the struggle of memory against forgetting."

In *The Physique of Consciousness* (2011), MadeIn moved its sights from ideology to religion. This work presents a lexicon of different bodily gestures and physical exercises rooted in the imagery, rituals, and beliefs of different world faiths. These references were presented in an encyclopedic, pseudo-scientific way as if they were illustrating bland clichés of lifestyle improvement. [22]

Prey, *Play*, and *Divinity*, three groups of work exhibited together in 2012, touch respectively on issues of poverty and excessive wealth; bondage, multiculturalism, ethnicity, and racism; and the fetishization of politics and religion. *Prey* began with a research trip to the poor, rural province of Guizhou. Recording each spot on Google Earth, the artists photographed scenes of severe but picturesque poverty inside the dwellings they found there, which, back in Shanghai, were transformed into large oil paintings in the style of Spanish or Dutch classical still-lifes. These were then expensively framed, photographed, and—in the exhibition catalogue—photoshopped into the opulent environments of art collectors' homes. (fig. 16) Not far away, suspended from the ceiling, were the sculptures that constituted *Play*. These silicone figures combined "exotic" images of naked black women, ethnographic concerns with "primitive" head dresses and body piercings, and motifs from pornography, BDSM, and the Japanese rope bondage art of

15 | Made In Company | **Play 1** | 2011 | silicone, feather, wood, stone, leather, hemp rope, chalk powder | 80 x 80 x 170 cm | courtesy the artist

16 | Made In Company | **Prey: 7S Miao Residence, Malin Village, Xishui District, Guizhou Province, China** | 2011 | oil on canvas | 126 x 190 cm

17 | Made In Company | **Divinity: Marx** | 2012 | PU foam, cow leather | 450 x 205 x 130 cm

18 | Xu Zhen ® | Exhibition view of **Movement Field** | 2013 | earth, grass, stones, trees | dimensions variable | installation at Sifang Museum, Nanjing, China | courtesy the artist and Sifang Museum

[21] Xu Zhen, Maerkle, op. cit. [22] MadeIn Company, *Action of Consciousness*, Shanghai, MadeIn Company, 2011, p. 103. [23] MadeIn Company, press release for "MadeIn Company Spring 2013 New Works Exhibition," Beijing, Long March Space, April, 2013, and email from MadeIn Company to the author March 31, 2013. [24] Xu Zhen, ibid. [25] Xu Zhen, interview with Chris Moore, op. cit., p. 20.

kinbaku. **(fig. 15)** Politically incorrect as these objects obviously set out to be, the question arises as to whether what they represent in terms of the position of women in general, and that of non-western women in particular, is true or false. The hyperbole of the MadeIn method exposes the hypocrisy of a situation in which the gilded cage of the museum, gallery, social group, or nation may conceal the sexual, economic, and ethnic bondage of the subject. The propensity to think of others as "exotic" in order to discount their common humanity is as prevalent in China as elsewhere. (see p. 155, fig. 50)

In its program of overseas development, China is now a major presence in Africa, providing aid and deriving economic benefit and political influence in return. *Divinity*, the third part of this group, a series of large figures cut out of polyurethane foam covered with low-temperature wax, refers to this by anthropologizing the monumentality of Socialist Realist sculpture within an imaginary African context. The black, roughly hewn, 4.5-meter-high *Divinity-Marx* sits on a throne with his mate (presumably Engels), his large manhood represented by a rolled leather biker's jacket. **(fig. 17, p. 154 fig. 49)** This reinvention of African sculpture in terms of monumental ideology indicates how blind political belief is not dissimilar from fundamentalist religion or superstition, in that all are dependent on the uncritical acceptance of monolithic power. This idea is pushed further in *Divinities Community – 01* (2011), in which a hierarchy of neocolonial power relations is suggested, based on size, as smaller gods are enthroned and subsumed within the vast volume of a much larger divinity.

* * *

In MadeIn's exhibition, "Movement Field" (2013), held at the Long March Gallery in Beijing, Xu Zhen has resurfaced as the author of "his" works. Still a family business rather than a multinational corporation, there is, however, a subtle difference from the way he worked before. Xu Zhen now appears neither as a company nor as a personality, but as a brand name, subsumed within and promoted by his company. **(fig. 18)** This, the most recent in a series of transformations that echoes the avatars of Tao or Buddhist deities, is part of a calculated and continuing provocation that is intended to impede the viewers' unconsidered reaction to both his work and biography. The merchandise of Xu Zhen/MadeIn Company/Xu Zhen (Brand) should not be taken at face value as art but as a "product" that swims against the stream of both the art world and art-market conventions while pretending to be part of them. The consistency, easy identification, and pervasive style usually associated with a brand are in this case turned on their heads in series of complex, seemingly self-contradictory, paintings, objects, images, installations, and products.

In this exhibition, the space of the gallery has been turned into a garden, a combination of human scale and miniature landscape crossed by numerous paths based on routes taken by demonstrators in riots in different parts of the world. Large cut-out images placed by the side of the paths seem to have no relation to each other but hint, more subtly than in earlier works, at themes of violence, shock, sex, tradition, and religion. This garden comprises the *Movement Field*, a longterm project that will eventually expand out of the gallery to bring together actual movements and movements of ideas from the past in order to project them into the future. The artist regards this as "a memorial which questions past and future commemorations . . . [as] a place for infinite spiritual quests . . . [as] a form of media based on media diffusion." [23] In the future it will also serve as a platform for the work of other curators.

These different possibilities contribute to this new idea of "business." The MadeIn Company currently operates as a collection of like-minded, salaried individuals, working under the artistic direction of Xu Zhen, who use the idea of artistic production as a framework for activities that also include "discussion, curating exhibitions, making publications" in addition to the production of art works. [24] Xu Zhen has described the "model of this company as a certain 'limited democracy,'" adding as an afterthought "[it] isn't perfect." [25]

If ever it were to be perfect, he would set his mind on something else. ●

Makoto Aida
The Surface of Things

This essay was published in **Aida Makoto Tensai de Gomen Nasai (Monument for Nothing)**, the catalogue that accompanied his retrospective exhibition at the Mori Art Museum, Tokyo in 2012. Aida's iconoclastic attitude towards Japanese tradition, coupled with his clear disdain for modernity, had previously encouraged me to show him in 2011 in New York as one of the lead artists in "Bye Bye Kitty!!! Between Heaven and Hell in Contemporary Japanese Art" as well as previously in the 17th Biennale of Sydney (2010), and later in the 1st Biennale of Kiev (2012) (see pp. 87–90, 145–146). Makoto Aida was born in Niigata, Japan, in 1965 and lives in Tokyo.

2

3

1 | **Giant Member Fuji Versus King Gidora** | 1993 | acetate film, acrylic, eyelets | 310 x 410 cm | A-manga homage to Hokusai's famous erotic print **The Dream of the Fisherman's Wife** (1814) | all images courtesy of the artist and Mizuma Art Gallery, Tokyo | see p. 87, fig. 6

2 | **Blender** | 2001 | acrylic on canvas | 290 x 210.5 cm | Takahashi Collection, Tokyo

3 | **Blender** | detail

[1] A *ronin* was a wandering *samurai* with no lord or master. [2] Aida, *Monument for Nothing*, p. 24. [3] This exhibition was curated for Art Tower Mito by Noi Sawaragi and ran from November 20, 1999, to January 23, 2000. Aida showed his series of paintings *War Picture Returns*, 1995–99. [4] Aida, *Monument for Nothing*, p. 9. [5] Ibid. [6] From an interview between the author and Aida in *Tokyo Visualist*, Tokyo, DD Wave Co. Ltd., 2009, p. 33.

Makoto Aida is no longer a rebellious young artist. He is 47-years old, and his work is still well known for its contrary and awkward character. Nothing seems to add up—on purpose! He has a predilection and obvious natural talent for painting but also makes performances, videos, installations, *manga*, drawings, objects, and collaborative works that have no discernible common style or approach. He is not particularly bothered, it seems, either by the finish or appearance of a work; his oeuvre purposefully includes items that are immaculately made, as well as those that are intentionally crude, rough or incomplete, sometimes colliding such opposing qualities in a single work. As lean and hungry as a *ronin* in a Kurosawa film, [1] he goes, acts and makes art where the wind of fate takes him. At least that is what he wants us to believe.

The truth is that there is a structured way in which he views the world. There is a quixotic logic to his "perverted path of being a painter." [2] The persona that Aida has created in the characters of artist, *ronin*, jester, and holy fool, reinforces but also partly obscures this fact.

In 2007, he went out of his way to reinforce this image of willful eccentricity in *Monument to Nothing,* a book with detailed notes about his works to date. Its nihilistic title, and the series of works he made with the same name, implied that heroism was impossible in a materialistic, soulless culture that had long lost its way. Such feelings were common throughout this generation of young artists. The nadir had already been sensed and celebrated in "Ground Zero Japan," a seminal exhibition, in which Aida participated, that had prophetically bridged the end and beginning of the old and new millennia. [3]

In his book Aida had decided to order his works by their predominant colors rather than by the more usual conventions of date, series, or theme: "I think that there is no point in seeing my works in chronological order, as my practice is different from the 'evolving' kind of practice of painters such as Mondrian. I gave up arranging works according to subject as well, since my interests were so diffuse that it was difficult [to understand]." [4] Instead Aida actively wanted "my living space, the inside of my brain, and works that I have made, to be in a "disorganized state."' The arrangement by color had "no profound meaning at all." But he was happy with this book-artwork because it had "successfully achieved a formation similar to [my] mental structure, . . . [as one] who has never exactly known, nor wished to know, what he wanted to make throughout his life." [5] In spite of editorial insistence that a chronological glossary should be provided at the end of the book, the official line was that both the artist, and his work, followed no official line; they were creatures that were governed almost wholly by impulse.

The (probably truthful) way he describes his early years also contributes to this chaotic myth. Brought up in a "normal" family in Niigata, in the rural north of Japan, at the age of ten, like many young Japanese, he had become enraptured by Osamu Tezuka's *Atom Boy* cartoons; by the age of thirteen he had moved to oil painting as a hobby, starting with a version of French style impressionism and then "moving into surrealism and avant-garde-like painting." [6] He remembers that he had "a great time" doing this but did not take a concrete decision to devote himself wholly to art until 1991, his last year in the masters class (western-style painting) at Tokyo's National

University of Fine Arts and Music [GEDAI]: "I guess that I was ADHD . . . an eccentric child who developed in a rather unbalanced way. I wet my bed until the second grade of junior high school [14 years old] but was excellent in making realistic paintings and drawings."[7]

Elements of such autobiography run throughout his work, as the awkward, slightly displaced child-adult tries to digest memory and make sense of the actual world. Following the spirit of one of the cruder stock figures from the European *commedia dell'arte,* in the video loop *Ueno Pantaloon Diary* (1990), Aida pisses himself repeatedly while pretending to be mentally disabled in front of a group of junior-school students in a public park. You could never accuse Aida of being "politically correct"; in fact, such a concept would never occur to him. (see p. 13, fig. 2)

His memories of geeky shyness, particularly when confronted by members of the opposite sex, come through in countless, often seductively gruesome works. The hypnotically attractive cuteness of young (school) girls who had just been brutally violated, dismembered, were about to commit *harakiri* or meet another very sticky end, is a striking and continuing motif. Yet admiration of women rather than misogyny motivates these works.[8] They are fueled by a humorous, sadomasochistic imaginative power that makes fun of the sneaky male arrogance that still prevails throughout Japan. Aida's works expose male desire to ridicule by pushing it to absurdly baroque conclusions.

According to Aida, the image in *Blender* (2001), a painting of the writhing, naked bodies of thousands of minuscule young girls, looks rather like lost souls in an inferno painting by Michelangelo or Rubens. The girls are in the process of being liquidized, a vision which Aida remembers, "came to me when I was 14. Originally the image had all 1.8 billion women of the human race in the blender. If you are a delicate, shy . . . adolescent boy, I'm sure that there are a number of people who would imagine this sort of image without [being] perverted or brutal. Men are such animals."[9] (figs. 2, 3)

As a now adult male himself, with a wife and young family, it is for men, particularly Japanese salarymen, that he reserves his particular sarcasm, mistrust, and ire. He stands with a megaphone in a street performance making fun of them for their limp conformism, drunken boorishness, dead-hand conservatism, and lubricious sexlessness.[10] He paints parodies of *nihonga* and *bijinga,*[11] submissive, amputee moppets fit for the wettest salaryman dream. Most recently, he has revealed their apocalypse on a gargantuan scale, as millions of salarymen lie dead, slumped in massive piles over their computers and desks, as minute, faceless units in a misty, Chinese-style landscape painting of mountains and water.[12] (figs. 4, 5)

As the word *makoto,* Aida's given name, prophetically suggests, such an approach to art could be related to his profound examination of the cardinal virtue of sincerity. *Ma* is the character for "true" or "genuine," *koto* means "words" or "conduct"; together they suggest truthfulness, an honest desire to penetrate beyond the mask of reality to get to the heart of things. This might seem a tall order in a culture that makes such a firm distinction between *tatemae,* the stated reason for an action governed by the need to preserve a smooth, unrippled surface in society so that life glides smoothly, and *honne,* one's real but concealed intention or motive, inevitably self-interested but perhaps also controversial or even disruptive. The difficulty of breaking through this mould perhaps explains the rumbustious, Rabelaisian energy of Aida's work.

And then there are the traditional warnings about estimating people or things by their surface qualities. The Japanese expression is "you cannot judge a person by his looks," and such admonitions are expressed in English by "beauty is only skin deep" or "you can't judge a book by its cover." But the essential paradox at the core of Aida's work, and the key to understanding his approach to it, is the realization that his surfaces are not

4 | **Ash Color Mountains** | 2009–10 | acrylic on canvas | 300 x 700 cm | Taguchi Art Collection

5 | **Ash Color Mountains** | detail

6 | **Your Pronunciation is Wrong!** | 2000 | c-type print | language demonstration in Washington Square, New York

7 | **A Picture of an Air Raid on New York City (War Picture Returns)** | 1996 | six-panel screens, hinges, Nihon Keizai Shinbun, black-and-white photocopy on hologram paper, charcoal pencil, watercolor, acrylic, magic marker, correction liquid, pencil | 169 x 378 cm

[7] Ibid. ADHD: Attention deficit hyperactivity disorder. [8] In 2009, Aida said the following about the representation of sexuality in his work: "Regardless of any sexual issue, my work is quite distinct from my private beliefs or personality. You could say that [they] are in an ironical relationship." Ibid. [9] Aida in Ethel Ong, *Genius Misunderstood?: Makoto Aida*, iSh, No. 6.1, 2005, p. 100. See also Aida, *Monument to Nothing*, op. cit., p. 229: "[M]y intent was to make a contemporary version of an 'inferno painting' with the brightness of the white color reforming the stereotypically dark-colored inferno painting . . . Moreover what I tried to put into this work was my adoration of western [Baroque] paintings typified by Rubens." [10] Aida Makoto, *Demonstration Machine for One Person (Against Salaryman)*, 2005. [11] *Nihonga*: contemporary, often kitsch, Japanese-style paintings observing traditional classifications, media and genres. *Bijinga*: a traditional genre denoting images of beautiful women. Aida's parodies of both these forms can be clearly seen in the still-continuing "Dog (Snow Moon and Flowers)" series that started in 1990. [12] Aida Makoto, *Ash Color Mountains*, 2009–11, acrylic on canvas, 300 x 700 cm, Taguchi Art Collection, Tokyo. [13] During the 1950s and '60s, at the same time as Marshall McLuhan's writings about the medium being the message, the traditional dichotomy between form and content was strongly challenged in western art by non-objective abstraction, minimalism, conceptualism, and some performance art. [14] Aida, in an email to the author, July 17, 2012. [15] See pp. 88–90. [16] Aida in *Monument to Nothing*, op. cit., p. 160.

superficial at all and express, perhaps in spite of themselves, essential truths about what lies behind.

The emphasis on individual style that characterizes western aesthetics has led to notions of form and content within art being regarded as separate, yet in Japan, and in Aida's work specifically, no such distinction is made.[13] Content and stylistic genre are intimately linked. The cloak of chaos Aida so carefully weaves around his work adds to this by ignoring or dismantling traditional genres, and acts as a unifying mantle that elides any dialectical distinctions, such as form and content, subject and object, image and genre, so that they are all subsumed under the shimmering banner of surface.

In writing about the differences between western and Japanese attitudes towards making contemporary art, Aida felt that "a latent sense of 'revolution' is central to western thought [that is] based on a progressive view of history. This regards the French Revolution or the American War of Independence as expressions of some kind of virtue."[14] The experience of modernization in Japan during the time of the Meiji Restoration (1868–1912) was radically different from this experience in that, although there were many fundamental changes, the new was, for the most part, able to co-exist with what had been there before. As a result of this interpenetration of new and old, he finds it difficult to fully understand or share many western attitudes. So when Aida brings different images, styles, and subjects together in the same work his motive is far from the didactic, avant-garde ideas of the "montage of attractions" or *Verfremdungseffekt* that brought together different "opposing" ideas and images in a constructive way. He tries rather to bring together in a straightforward but often chaotic way truthful, but sometimes unsavory, aspects of the same reality about which no easy conclusions should be drawn.

It may seem to some non-Japanese people in the art world that Aida and his work are just extreme examples of a sclerotic culture that has become increasingly inward looking, self-satisfied, and provincial. Yet nothing could be further from the truth. Aida's work, like that of much of his generation, is extremely critical not only of an increasingly elderly and complacent Japan but also of the power politics of the world at large—naturally, as they see it, from their perspective.[15]

Aida himself has been the first to make fun of the obvious gap in communication between East and West. During a residency in New York during 2000, he organized *Your Pronunciation is Wrong!*, a fake demonstration immortalized as a photo work. The piece resulted from his "pent up frustration in NY, after several months had passed without seeing any sign of becoming fluent in or even seeing any desire to speak English."[16] The venue was Washington Square, a popular gathering point. Wielding such revolutionary placards as *Cut Down Vowels! Be Based on KATAKANA, Stop Speaking with Trilled R's!, Pronounce* [sic] *SIMPLY and SHAPLEY as JAPANESE do!!!!* a small Japanese mob, including the artist, assembled to shake their fists and be photographed. (fig. 6) Although few passers-by stopped to sympathize, Aida was making the serious point that many non-Anglophone artists feel almost invisible, as well as totally inaudible, because the western art market, and a large part of the art world, all use English. A similar point had been driven home by Croatian artist Mladen Stilinović in a series of installations made between 1992 and 1996 simply called "An Artist Who Cannot Speak English is No Artist."

Aida's next encounter with New York was in 2004 as a participant in Lawrence Rinder's Whitney Biennial, "The American Effect: Global Perspectives on the United States, 1990–2003," which was conceived as a reaction to the conservative backlash of American opinion after 9/11. Rinder chose *A Picture of an Air Raid on New York City* (1996), one of the largest from the series "War Picture Returns." (fig. 7) It certainly made an impact. In an evocation of the conflagration that consumed Tokyo after the firebombing in 1945, this immaculately painted, nearly four-meter-wide work on six

8

sliding-screen panels, showed over two hundred ghostly outlines of World War II Mitsubishi Zero fighter planes circling endlessly in a figure-eight over the bombed, burning skyscrapers of downtown Manhattan. Asked to explain himself, the artist made it clear that the work had been made five years before the Twin Towers attack and was not an expression of misplaced nationalism. Yet the strength of the image, and the slur of anti-Americanism that some critics associated with the whole exhibition, drowned out his words.

Aida's series of war paintings had been started exactly 50 years after the end of World War II and was intended to reflect the style of Tsuguharu (Léonard) Foujita (1886–1968), a Japanese modern artist who was well known in Europe before the war but who, on the outbreak of hostilities, had returned to Japan and enlisted as a war artist. But the main point for Aida was to "paint the biggest cause of cultural degeneration today ... the Pacific War. The true theme of this series is not the past ... but the present age in which I live."[17] The tragedy for him was that, in spite of its boom-and-bust economy, Japan had still basically not changed. In 1945, the baby of culture had been thrown out with the bathwater of defeat, as economic success at any cost had become the new all conquering mantra. Aida also seems to have been implying that, for him, America's material ambitions of aggrandizement in the world today are not so different from those of Japan during its nationalist expansion before and during World War II.

In spite of its obvious quality, outside Japan and other parts of Asia, Aida's work has been gaining only slow acceptance among western museums, collectors, and gallerists.[18] It is difficult to understand why. Aida's "controversial" or "problematic" subject matter should hardly be an issue in the "free" West. His relative invisibility, it seems, can only be explained by endemic conservatism, prejudice, and ignorance—distressingly common characteristics that are reducing the idea of globalism to little more than a fashionable slogan. It should be evident that Aida has neither worked nor developed in a closed cultural bubble but has studied western and other art, and uses these influences in many different ways in his work. Yet maybe the problem of not knowing how to look at Aida's work has been compounded by his anti-commercial reluctance to see large works suddenly disappear into the art market. In this respect Aida has been his own worst enemy; for similar reasons, very few contemporary Japanese artists have been a commercial success outside Asia.

This is illustrated in the background to *An International Discord*, a large painting completed for the Madrid ARCO Art Fair in 2006. He described his feelings at that time: "I started to be asked to premiere new works in foreign countries before showing them in Japan. I had a strong sense of discomfort about this ... if a new work is sold there the probability that the work will never be seen by a Japanese audience becomes very high. Thus, I was propelled to make this work with an aim to achieve 'emptiness.'"

This roundabout strategy for creating a work that was so empty that it could not be sold, which can hardly have delighted his dealer, is reminiscent of the plot of Mel Brooks' 1968 film *The Producers,* about two impresarios who sought to benefit by staging "Springtime for Hitler," a musical that was so offensive that it would close immediately, leaving them with their backer's money. Although Aida had no such financial incentive, this work was a roughly painted close-up of a gigantic Big Mac, "a representative of meaninglessness that both Japanese and Spanish people would know." Across the middle of the painting he wrote in large Japanese and roman letters "ETA vs GAL," a crude translingual pun that had different references in Spain and Japan. In Spain, the work seemed particularly inflammatory, in that it staged a match between two competing terrorist organizations: ETA, the separatist Basque Homeland and Freedom movement, and GAL, Antiterrorist Liberation Groups, death squads illegally set up by officials of the Spanish government to combat ETA. To Japanese viewers the references were equally political but related more to social hierarchy: ETA is a

8 | An International Discord | 2006 | canvas, acrylic | 145.5 x 227.3 cm

9 | I-DE-A | 2000 | video | 62'03"

10 | Azemichi (a path between rice fields) | 1991 | panel, Japanese paper, acrylic, Japanese mineral pigment | 73 x 52 cm

[17] Aida, "Close Up: Makoto Aida," *Design Plex*, Tokyo, no. 17, Sept. 1998, p. 14. [18] See Adrian Favell, *Before and After Superflat: A Short History of Japanese Contemporary Art 1990–2011*, Hong Kong Blue Kingfisher, 2011, pp. 109–121. [19] Aida, *Monument for Nothing*, op. cit., pp. 50–52. [20] Aida has recently written, "In Japan, there are many people who hate contemporary art. I always want to know the reason [for this] because I think I partly share this mentality." Email to the author, July 17, 2012. [21] For text-based works by Aida see also, for example, *Poster* (1994), *Performance (Somewhat Patriotic)* (1995), *PANCHIRA – HAIKU* (2001), *Translator* (2005), *My Peace Pole* (2005), *Princess MASAKO SENPAI!* (2006), *Discover the Element of New Taste,* (2006), *Calligraphy* (2007). [22] Frank Wedekind (1864–1918), avant-garde German playwright. Vito Acconci (1940–2017), New York-based performance and installation artist. [23] Félix Gonzáles-Torres (1957–1996) was an American, Cuban-born artist working in New York. Many of his works are metaphors for dying. Aida, *Monument for Nothing*, op. cit., p. 224. See p. 220, figs. 4, 5, for Xu Zhen's works relating to masturbation. [24] Ibid. [25] Email to the author, July 17, 2012. [26] Joseph Beuys (1921–1986) was an influential German avant-garde artist. [27] Aida, *Monument to Nothing*, p. 165. [28] Aida remembers that while at school his favorite Surrealist artists were Salvador Dalí and René Magritte. He got to know about Dada only later through *Eureka*, a Japanese literary and philosophical magazine, and was attracted particularly by the youthful rebelliousness of this group. Email to the author, July 17, 2012. [29] See footnote 9. Hans Bellmer (1902–1975), German-born Surrealist artist known for his sculptures and photographs of dismembered or bound pubescent female dolls. [30] Henry Darger (1892–1973) was a reclusive, Chicago-based artist whose work was not publically recognized during his lifetime. Shōzō Numa (1926–2008) was the *nom de plume* of Tetsuo Amano.

9

10

derogatory term that refers to *burakumin*, an ostracized social minority not unlike the *dalits* ("untouchables") in India and Pakistan; GAL, on the other hand, is a neologism that refers to teenage girls with a bizarre fashion sense and make-up who hang around in shopping centers. **(fig. 8)**

Aida was surprised by the extent and violence of the Spanish response to his work—which resulted in an armed, plainclothes policeman being posted by the exhibition booth. Not at all surprisingly the work did not sell, but even when it was returned to Japan the artist was still not happy, as he felt that it could only be considered a success if he regarded it "as an event-based work, not a painting."[19]

Although this is a particularly dramatic example of the contrived collision of East and West in Aida's work and, in spite of his dislike of it, of the importance of categorization in making art, *An International Discord* is also related to his skepticism about contemporary art, in general, and about both his interest in and unease with conceptual art in particular.[20] It can also be understood as part of his ongoing examination of text-based works that he often bridges with calligraphy in his own work. A good example of this is *I-DE-A* (2000), a more than one-hour-long video of the artist masturbating while looking at large cut-out Japanese characters spelling "beautiful girl" mounted on a wall.[21] **(fig. 9)**

The subject of masturbation had been opened up long ago in theater in German writer Frank Wedekind's 1891 revolutionary play *Spring Awakening*; it had burst upon the New York art world in 1972 with Vito Acconci's literally seminal performance *Seedbed*, in which the artist lay under a ramp in a gallery while he vocalized into a loudspeaker his fantasies about the people walking above him.[22] Aida had first broached this topic in his installation *Safety GONZALEZ* (1998), both a transformation and a parody of Félix González-Torres's "minimal, sensitive, and sentimental masterpiece *Untitled (Placebo)* (1991) [in which] several thousand candies in silver wrappers cover the floor and the audience can take one each."[23] Aida's work consisted of a square of about 6,000 paper tissues, each containing fake traces of sperm symbolizing the approximate number of times he had masturbated since his first ejaculation. He saw this work as the complete opposite to that of González-Torres, as "a self portrait mingling my self-confidence and self-deprecation."[24] Aida's work was a record of the *petits morts* regularly experienced, rather than Gonzáles-Torres's more elegiac theme of the eternal presence of death.

Perhaps resulting from his conviction that other artists are "a potential rival . . . I tend to use them as a reference or to steal from," in the project *Discover the Element of New Taste* (2006), Aida laid out a similar challenge to Joseph Beuys's idea of social sculpture.[25] This set out, unsuccessfully, to discover a new form of fermented food.[26] Other than having a good time with the group of students who helped him, his main concern in making such work was its usefulness: he feels that many art projects are diminished by the fact that they "end up only satisfying artists and art appreciators themselves."[27] Aida's constant interrogation of the efficacy or necessity of contemporary art is an essential part of his work. This often results in a carefully contrived and critical banality, as is the case with *Shit by Jomon-type Monster* (2003), a massive installation of terracotta facsimiles of turds purporting to be ruins of early Japanese culture, over which lovely young girls drape themselves. But this also throws darts at the Japanese predilection for fetishizing and prettifying its past.

As another part of his practice, Aida has habitually brought together western influences with Japanese ideas to make completely new hybrids. A number of these works could be regarded as contemporary responses to Dadaism or Surrealism.[28] *AZEMICHI (a path between rice fields)* (1991) shows, with a Magritte-like strangeness, the center parting of a schoolgirl's hair receding into infinity by extending along a pathway through rice fields. **(fig. 10)** The "Dog" series paintings surpass even Hans Bellmer in the

11

12

11 | **Dog** | 1989 | panel, Japanese paper, acrylic,
Japanese mineral pigment | 100 x 75 cm

12 | **Encounter of the Fat and the Slim with
Ten Thousand Yen Bill Background** | 2007 | canvas,
inkjet print, acrylic | 450 x 1000 cm

13 | **Louis Vuitton** | 2007 | oil on canvas | 194 x 112 cm

14 | Left panel (Japanese Girl); right panel (Korean Girl)
from **Beautiful Flag (War Picture Returns)** | 1995 |
a pair of facing two-panel screens | hinges, charcoal,
paint with Japanese glue medium, acrylic |
169 x 169 cm each

[31] Norman Rockwell (1894–1978), an American painter
and illustrator whose works enjoyed a broad popular appeal.
Aida, *Monument to Nothing*, op. cit., p. 229. [32] Ogata Kōrin
(1658–1716), Japanese painter and lacquer artist, founder of
the Rinpa School. Ibid., p. 221. [33] Kumi Sugai (1919–1996),
Japanese abstract painter who was affiliated the School of Paris,
well known for his "heraldic" paintings of the 1960s. [34] Aida,
Monument to Nothing, pp. 52, 210. [35] Kazuo Shiraga (1924–
2008), action painter in the Gutai Group. In 1971, he became
a Buddhist monk. [36] Aida, *Monument to Nothing*, p. 224.
[37] Diego Velázquez (1599–1660), Spanish court painter; Peter
Paul Rubens (1577–1640), Flemish Baroque painter. [38] Aida,
Monument to Nothing, p. 224. [39] Eitoku Kanō (1543–1590),
one of the patriarchs of the Kanō School of painting. Ibid., p. 241.
[40] "Donki – Hôte (Man in the Holocene)" was the title of Aida's
solo exhibition at Ibid Projects in London in 2005. [41] Email
to the author, July 17, 2012. In answer to the question, "What
has been the best time and the worst time in your life?" Aida
answered: "I think that it has been the best time almost all the
time. I am basically an optimist."

potential cruelty of their fantasy but, unlike those of his predecessor,
were not expected to be taken at face value.[29] (fig. 11) *Mi-Mi Chan* (2001),
an imaginary series of harvestable edible artificial girls, cultivated from
the DNA of colitis bacteria intended to alleviate worldwide food shortages,
are similarly light-hearted. Thinking also about American outsider artist
Henry Darger and cult Japanese author Shōzō Numa,[30] Aida declared his
"affection for this [latter] series, not as profound works, but as tiny loving
illustrations, perhaps in the way that Norman Rockwell drew."[31]
A similar dream-like clarity to that which, perhaps incongruously, is
related to monumental Soviet-style Socialist Realism, can be discerned
in the stance of the determined Korean school girl in *Beautiful Flag* (1995),
the first painting in the series "War Picture Returns," (fig. 14) as well as
in the gigantic, naked young woman who heroically stands astride
a mountain of rubble in *Monument to Nothing* (2004), the first in the
continuing series of the same name.

In the four-part work *GUNJYO-ZU '97 (Young Girls)* (1997), painted
over Sanrio wrapping paper with the popular "girly" Hello Kitty and
Kerokero Keroppi characters printed on it, Aida layers the kind of classical
composition seen in a screen of flowers by Ogata Kōrin with the "pop realist"
style of Norman Rockwell in his depiction of an imaginary encounter
between a group of Tokyo high-school girls and an excursion of female
junior high school students from the countryside on a metropolitan station
platform.[32] These three layers come together in the surface of the work
and any appreciation of it must entail a recognition and exploration of each,
as well as of the cultural spaces around and between them.

Western art styles have continued to appear and reappear throughout
the whole of Aida's work. At the very start of his career, his installation
LET'S GO ANFORMERU (1988) was a willful misunderstanding of French
art informel but looked more like a piss take of the 1960s paintings of
Kumi Sugai.[33] He regarded the sixteen-part work *Pavement of Yukiko
Okada* (1992) as "an insolent attempt to grab back the primary vital spirit
of Impressionism which had fallen to the level of being one of middle-
aged madams' favorite safe playthings."[34] *Vanishing Point* (1998) was
an "endless column" of Japanese cushions reminiscent of Brancusi.
Untitled (2001) reprised action painting, a form that had been naturalized
in Japan during the late 1950s by Gutai artist Kazuo Shiraga.[35] Yet in
his curiosity for what could be described as the "other," Aida has not
only been interested in romping through different tendencies in modern
and contemporary art but has also been fascinated by the Gothic—most
recently, in *Monument for Nothing II* (2008–), the result of two years of
workshops held in collaboration with art students throughout Japan
in which the participants have created "altar pieces" using nothing but
cardboard. The intention of the project is a reconsideration of the position
of contemporary art from a number of different angles as well as the way
that art history is taught in Japan.

The dynamic spaces and dramatic lighting effects of Baroque painting
have also strongly attracted Aida, although it is hardly surprising that he
"seldom feel[s] the necessity of taking into account the orthodox history of
painting."[36] Even though the large sci-fi oil painting *Space Shit* (1998) is
part homage to the work of Velazquez and Rubens, there are no angels to be
seen—just a very large 3D turd floating in space.[37] Aida believes that these
old masters are relevant to this work because they have a much "closer
affinity with ILM [a special effects group in Hollywood] than Picasso or
Rothko" and it is the way in which they render space within a carefully lit
and modulated surface that is important.[38]

The radically different structure and imagery of the painting *Encounter
of the Fat and the Slim with Ten Thousand Yen Bill Background* (2007) was
also fueled by a similar historical élan. What seems to be a vast graffiti-
style showdown between brightly colored representations of fatty cells

13

and neurons was "made with the sentiment 'I love Eitoku Kanō!' . . . I adore those magnificent heroic painters like Kanō or Rubens with the feeling of a henchman, as I sense in them something that I do not have."[39] The ten-thousand yen notes that cover the surface of Aida's work echo the regular patterning of gold leaf, a strong decorative feature in Kanō's work and the artists who followed him. (fig. 12)

Aida sees himself as both an international and extremely local artist. He has even professed regret at leaving his native Niigata to be living now in a Tokyo suburb. A sense of guilt, dissatisfaction, or unease has been a driving force through his work. Like a tongue that repeatedly and painfully explores a cavity in a rotten tooth, he naturally gravitates towards that which he either does not understand or like, towards ideas that are usually deemed "unthinkable," towards artistic and social taboos that are obeyed and never questioned. He does this dispassionately by jumbling together the pure with the impure, the beautiful with the ugly, the old with the new, the fashionable with the totally uncool, the skillful with the clumsy, and then, to top it all, by gleefully employing cockroaches and shit to besmirch the cuteness so idolized by bourgeois Japanese taste. Everything is subsumed in surface —by the same clinically observed, iridescent carapace. (fig. 13)

For the burning curiosity and restless spirit of Aida Makoto, the surface in art is a constantly changing reflection of life as well as how he reacts to it. If like Don Quixote, Cervantes' hero—a down-at-heel Spanish knight with an antiquated sense of chivalry and a clapped-out charger—he occasionally finds himself tilting at windmills, this is only to be expected.[40] In an increasingly prosaic, instrumental, and materialist world someone has to carry out this work.

Who said making art was easy? The finding and fixing of truth has never been a straightforward matter—in any place, at any time. Making things "difficult" is all part of Aida's work. In spite of, or perhaps because of, this instinctively masochistic predilection, he remains an optimist about his work and life.[41] ●

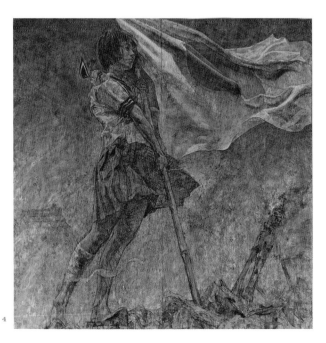

4

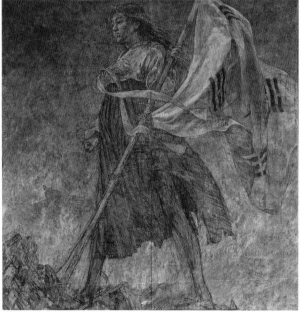

Miwa Yanagi
The Four Ages of Woman

1

2

This essay appeared, in Japanese and English, in the book **Miwa Yanagi**, Tokyo, Tankosha, 2009, published to coincide with a large retrospective of her work at the Tokyo Metropolitan Museum of Photography in the same year. Yanagi is one of Japan's strongest women artists and became a key figure in my large exhibition "Bye Bye Kitty!!! Between Heaven and Hell in Contemporary Japanese Art" at the Japan Society in New York.[1] Miwa Yanagi was born in 1967 in Kobe, Japan, and works in Kyoto.

3

4

1 | **Looking for the Next Story II** | 1994 | chromogenic print | 180 x 720 cm | all images courtesy the artist

2 | **Elevator Girl House 1F** | 1997 | chromogenic print | 240 x 200 cm

3 | **My Grandmothers: Hyonee** | 2007 | chromogenic print, plexiglass, text panel | 130 x 100 cm

4 | **My Grandmothers: Shizuka** | 2004 | chromogenic print, plexiglass, text panel, 140 x 100 cm

[1] See pp. 88, 90–91. [2] *The Old Girls Troupe: Windswept Women*, a work presented in the Japan Pavilion at the 53rd Venice Biennale in 2009, touches on the previously taboo topic of middle age as represented by the collision of extreme old age and youth within the entity of one body. I subsequently presented this work in 2012 at the 1st Kyiv International Biennale of Contemporary Art, see p. 156.

When approaching the imagery and range of personal references that appear throughout the extensive work of Miwa Yanagi, I cannot help but be reminded of the traditional subject of the Four Ages of Man that, from the early Middle Ages, has been a recurring motif in western art and literature. These ages—childhood, youth, maturity, and old age—each represent a symbolic stage in the journey of the soul from the innocence of childhood to the salvation or oblivion of death. They are often interwoven with the Christian ideology of original sin and redemption from it by faith. The Four Ages of Man are sometimes identified with the four seasons—spring, summer, autumn, and winter—subjects which have an analogous significance in traditional East Asian art. In the West, however, this convention was often, somewhat dyspeptically, regarded from a middle-aged perspective to make a moral reference to the carefree follies of the past (childhood/youth), the stability of the present (maturity), and forebodings of the future (old age). In her work, Miwa Yanagi turns this structure completely on its head: middle age, the traditional expression of "normality," establishment, and power has, so far, been a void in her work.[2] It has never been even mentioned.

Furthermore, Yanagi is definitely referring to the Four Ages of *Woman*, not Man. This is not purely a feminist inversion, but is rooted in her desire to uncover and explore certain psychological undercurrents that characterize Japanese and other modern societies. In doing this, Yanagi has conducted vital research, but her intuitive response as an artist to the world in which she has grown up has been of most significance.

Since the early 1990s, Yanagi has been engaged in developing four complex series of works that reflect different facets of her particular idea of the Ages of Woman: "Elevator Girls" (1993–1999), "My Grandmothers" (1999–ongoing), "Granddaughters" (2002–ongoing), and "Fairy Tale" (2004–2006). Reflecting on women's actual and potential roles, and on the psychology that underpins them, these works move from the anachronistic and hidebound society of her childhood and youth towards the yet-to-be experienced freedom and ambivalence of old age. Japan in the 1970s and 1980s is reflected here in the pert uniforms and marionette-like, fixed grimaces of the "Elevator Girls" whose seductive youth is cruelly and allegorically cut short by the different forms of violent oblivion Yanagi devises for them in her large, glossily sleek, colored-photo panels. (figs. 1, 2)

The "My Grandmothers" series is based on the fantasies and fears of a group of young women whom Yanagi asked to imagine what they wanted to be 50 years in the future. Working closely with her subjects, and employing makeup and digital manipulation, Yanagi photographed a staged visual set of their imagined futures and exhibited this alongside a written description of their future lives. (figs. 3, 4) This new way of working was an apotheosis rather than an apocalypse. The demise of the "Elevator Girls" had created a *tabula rasa* in which past and present no longer mattered. The optimism, or pessimism, of youth is now given an outlet by being telescoped into a future fantasy of old age.

In the videos of the "Granddaughters" series, which include testimony from women both in and outside Japan, the compression of time is even more dramatic. In this series, elderly women look back over their lives to describe

9

[3] Miwa Yanagi, correspondence with the author, December 26, 2008. [4] I am thinking here of the strongly gendered work of such artists as Makoto Aida (b. 1965), which touches on issues of sexuality and power from a male perspective in a violent and disturbing way, as well as of Takashi Murakami's focus on infantilism (see pp. 85–86). Similar attitudes can also be seen in the same generation of YBAs (Young British Artists) in the UK. [5] Feminism first made an impact in Japan during the years following the Meiji Restoration of 1868, but it had no political voice until after the World War I. Universal female suffrage was only granted in 1946. From the mid-1950s a number of women artists, such as Atsuko Tanaka (1932–2005), Yayoi Kusama (b. 1929), Yoko Ono (b. 1933), and Shigeko Kubota (1937–2015) played important roles in the avant-garde but often had to live or work abroad to make an impact. Feminist ideas have only relatively recently started to make a significant impression on the Japanese art world. See Michiko Kasahara, "Contemporary Japanese Women's Self-Awareness," *Global Feminism* (exh. cat.), New York, Brooklyn Museum, 2007. [6] See, for example, Tomoko Otake, "Japan's Gender Inequality Puts it to Shame in World Rankings," *The Japan Times*, February 24, 2008; Dolores Martinez (ed.), *The Worlds of Japanese Popular Culture: Gender, Shifting Boundaries and Global Cultures*, Cambridge, Cambridge University Press, 2008. [7] "Dominique Gonzalez-Foerster, Hans Ulrich Obrist, Miwa Yanagi: Interview," *Miwa Yanagi*, Berlin, Deutsche Bank Art / Frankfurt am Main, 2007, p. 48. [8] Miwa Yanagi, correspondence with the author, December 26, 2008. [9] The Takarazuka Revue was founded in 1913 in the city of Takarazuka, Hyogo Prefecture, and also subsequently opened in Tokyo. Annual attendance is estimated at around 2.5 million. Plots of some Takarazuka plays have also spawned a genre of similarly androgynous *manga* for girls. See Jennifer Robertson, *Takarazuka: Sexual Politics and Popular Culture in Modern Japan*, Berkeley, University of California Press, 1998; Erica Stevens Abbitt, "Androgyny and Otherness. Exploring the West through the Japanese Performative Body," *Asia Theatre Journal*, vol. 18, no. 2, 2001, pp. 249–56. [10] Gonzalez-Foerster et al., p. 48. [11] According to the *CIA World Factbook*, the projected fertility rate in Japan for 2008 is 1.22. This is mirrored by a rapidly decreasing marriage rate. Conversely, Japan also has one of the longest life expectancies in the world—according to AP/Kyodo, 85.99 years for women and 79.19 for men—which, unless there is a marked change soon, implies a rapidly ageing and increasingly less productive society. [12] Chizuko Ueno, "Miwa Yanagi," *Miwa Yanagi*, Berlin, Deutsche Bank Art/ Frankfurt am Main, 2007, p. 65. Similar phenomena, particularly relating to the taboo and prevalence of child abuse, can also be seen in the rapidly ageing societies of Western Europe. [13] In the "My Grandmothers" series *ERIKO*, *ESTELLE*, and *RYUEN* are played by men who imagine their own deaths as part of their scenarios. As far as Yanagi is concerned "Anyone who wants to represent themselves as a grandmother 50 years later is OK, without age limits (presently there are 'grandmothers' from 12 to 45 years of age), of any nationality. They can even be men, as long as they imagine themselves as a grandmother." Letter to the author, December 26, 2008. [14] Gonzalez-Foerster et al., p. 58.

memories of their own grandmothers when they were young girls and, in the process, "naturally slip back to the time when they were granddaughters themselves." [3] These individual videos are projected in the same space so that the words of the speakers overlay each other. Conventional notions of distance and time are further displaced by the devices of putting each woman in front of a backdrop of the city in which they live, as if she were a newscaster, and by replacing the speakers' voices with those of completely unrelated young girls, the age that their own granddaughters would be. Here, in a scenario that covers three generations, Yanagi has created a compelling paradigm of the mechanism of history itself, in which the voices of both present and future constantly reshape the impression of the past.

Her next series, "Fairy Tales" (2004–06), mainly consists of large-scale images printed in delicate gradations of black and white. In these works, she moves completely away from the context of Japanese culture toward a consideration of collective imagination or fantasies. Dichotomies of youth and age are here expressed in idiosyncratic re-stagings of scenes from fairy tales. Although a part of collective literature, these tales have usually been written down by men and have, in the process, often acquired a strongly misogynistic bias. But again Yanagi turns convention on its head. In a grotesque juxtaposition and inversion of youth and age, all the parts are played by young girls, some of whom wear latex masks to make them appear old. In this festival of ambivalence, the archetype of the "evil old witch" is potentially reversed in series of mises en scène, in which both young and old are shown as being capable of the utmost cruelty. By adopting an iconoclastic approach to the fetishized "innocence" of traditional children's literature and, by extension, to that often bestowed on children themselves, Yanagi has begun to approach the actual state of the world in which innocence or evil cannot be taken for granted. (figs. 5–9)

She was born 1967 in Kobe, and Yanagi's formative years were marked by the frenetic economic bubble and infantile overconsumption of the 1980s, followed, at the beginning of the 1990s, by the cold shower of severe economic recession. This dramatic reversal of national fortune fostered in her generation a cynicism about the values, attitudes, and arrogance that had encouraged the earlier hubris, as well as a desire to explore how and why this reversal had occurred. As a result, a more realistic, critical, and at times even brutal view of the world, and the unhealthy gender relationships that characterize it, can be clearly seen in the art of Yanagi's generation. [4] But this is only one part of the story. She has also obviously been strongly influenced by the deeply rooted social pressures on women to behave in specific, time-honored ways that were considered "proper" and acceptable in a still largely male-dominated society. [5]

Much has been written on the rigidity of gender roles in patriarchal Japan, as well as on their recent blurring and breakdown. [6] Yet, as is so often the case, this reflects only a part of the picture; within their own spheres of influence, particularly the home, women have always wielded power, although within strictly defined limits. Women also gained a degree of independence in the glamorous worlds of modern theater and film, and Yanagi has spoken of how both her grandmother and mother were frustrated actresses, a desire which they projected onto her. [7]

In traditional *noh* and *kabuki* theater, female roles are played by men; however, in the modern, romantic, western-style Takarazuka musical theater, much loved by the women in Yanagi's family, the reverse is true. [8] All parts in Takarazuka, including male roles, are played by young, unmarried women. (fig. 10) Surprisingly perhaps, the main audience for Takarazuka is women—of all ages. There are varying interpretations of the attraction of Takarazuka for female audiences: the barely concealed lesbian subtexts of the plots; the empowerment of audience members' experiences in seeing women as "supermen"—beautiful agents of action and desire; or, more innocently (or perhaps naively), simply the pure fantasy and escapism of the genre. [9] Most

10

11

female audience members do not seem to be aware that Takarazuka actually presents a proscribed, even perverse, view of womanhood that enshrines outdated patriarchal ideas, emphasizing the qualities needed to be a "good wife and wise mother."[10] There is no real time or space in the Takarazuka world where women can make decisions or act and live for themselves.

Such phenomena are expressive of a much broader malaise that Yanagi's generation feels concerning the established social order. This is most dramatically reflected in the plummeting fertility rate of Japanese women.[11] The frightening truth is that in an ageing society obsessed by youth, fewer and fewer babies are actually being born. The ideal of childhood is rapidly and increasingly becoming both virtual and detached in Japanese society, where growing levels of bullying, abuse, and the murder of children, as well as an increasing number of violent acts committed by children themselves, are much reported in the press.[12]

Although Yanagi was adamant in rejecting a career in the theater, some of her earliest works were in fact performances, and the idea of staging has strongly influenced the series of large-scale photographs she has produced. In these she presents an alternative dramaturgy of gender and age in which, like the Takarazuka theater, little girls or young women play the critical roles (although, in a few cases, these are played by men *en travesti*), projecting futures onto lives left behind after their own deaths.[13]

The reason that Yanagi gives for this is that men, no doubt because of the position of power they enjoy, tend to have more concrete, earthbound attitudes towards the future. For women, on the other hand, who have little to lose, the future is both their playground and their hope. When recently asked about this discrepancy, Yanagi explained: "When I interview men . . . they often think realistically about the generation that follows them. They also tend to think about dying. But for women their thoughts often depart from reality. When I observed this I began to think that women don't feel death, or rather, they don't feel time passing; they almost disregard the existence of time."[14] For Yanagi, timelessness not only offers a liberating possibility of freedom from past and present, but also becomes a kind of stage on which actors can play out different scenarios of enlightenment or desire.

As Yanagi herself approaches the empowered oblivion of middle age, by looking both back and forward in her life, she has increasingly penetrated the psychopathological hinterland of a universal unconscious. Her fragmented versions of traditional fairy tales or of the ageless, god-like "Windswept Women" reflect the "Four Ages" of innocence, desire, oblivion, and enlightenment. (fig. 11) Yet, as is so often the case in her work, the plots are turned on their heads: the seductively evil twin battles it out with the ugly sister, the wicked stepmother is tortured by the virginal girl, the beautiful princess stomps on the vile old witch, the belly of the wolf replete with little girl becomes transformed into a womb.

Yanagi's fertile imagination reflects the world as it is: the wiliness of old age triumphs over youth only to be itself called to account by death. ●

5 | **Fairytales: Rapunzel** | 2004 | gelatin silver print | 100 x 100 cm

6 | **Fairytales: Sleeping Beauty** | 2004 | gelatin silver print | 100 x 100 cm

7 | **Fairytales: Little Red Riding Hood** | 2004 | gelatin silver print | 100 x 100 cm

8 | **Fairytales: Erendira II** | 2006 | gelatin silver print | 100 x 100 cm

9 | **Fairytales: Untitled IV** | 2005 | gelatin silver print | 140 x 100 cm

11 | **Donburako** | the first performance in 1914 of the all-female Japanese theater group, the Takarazuka Review

12 | **Windswept Women I** | 2009 | framed photograph | 400 x 300 cm | from a series of four works

6

7

8

Chiharu Shiota
Time and Distance, Absence and Silence

Chiharu Shiota contributed an installation to "Bye Bye Kitty!!!" and a much larger work to the 1st Kyiv International Biennale of Contemporary Art in 2012. As she lives in Berlin, where I have also spent some time, I often bumped into her; when she told me about **Other Side**, a site-specific installation she was making for the newly built Towner art gallery in Eastbourne, I was delighted to write this piece. The essay appeared in the catalogue: **Chiharu Shiota**, Other Side, Eastbourne, Towner, 2013. See also pp. 101, 134–135. Chiharu Shiota was born in 1972 in Osaka, Japan; during the 1990s, she studied art in Kyoto, Canberra, Braunschweig, and Berlin.

2

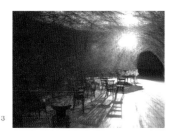

3

It was often Obon season when we went there [Kōchi], which invariably entailed a trip to my grandmother's grave, where we pulled up the grass growing over her, all the while fending off vicious bush mosquitoes. I remember being frightened doing this, because it seemed as if I could still hear my grandmother's breathing coming out of that ground. Here in my child's mind was planted my first fear of death. I still remember, even at this age, how my hands felt plucking the grass, and sometimes at work in the studio can still feel the sensation on my palms. [1]

– Chiharu Shiota

Chiharu Shiota has lived and worked in Berlin since 1996 and, although she has often been drawn back to Japan, her geographical displacement has been a vital element in distilling, even intensifying, the dense mesh of poetic imagery that has fed into her work. Time and distance, absence and silence, have allowed her both to triangulate and digest vivid, poignant memories of childhood and youth that still provide an important creative mainspring. Yet, even during the early 1990s, when first she had began to study art at the Seika University in Kyoto, such works as *From DNA to DNA* (1994) and *Becoming Painting* (1994), constructed out of woolen yarn, paint, and other materials, were already frameworks for future actions. **(fig. 1)** Even then she had started to break down the barriers between performance, painting, and sculpture by using her body as both the subject and the object of her work.

By the mid-1990s she had moved to Germany, initially working under Marina Abramović at the Hochschule für Bildende Künste in Braunschweig and then at the Universität der Künste in Berlin. These experiences undoubtedly reinforced her concerns with the importance of duration in performance, as well as with the intense power of the body —even when its presence is suggested rather than present. As a result, many of Shiota's works began to take on the monumental appearance of sites where some momentous event had either just passed or is in nervous anticipation of something yet to materialize. [2]

Her installations contain objects—lamps, dresses, chairs, beds, shoes, suitcases, or window frames. The yarn she uses may be black or red, or replaced by thin plastic tubing through which blood-like liquid pulses viscously as if the whole work were a body, an umbilical support of vessels and nerves that link, feed, and nurture the objects found within them which then, suddenly galvanized, begin to take on new life.

Such works suggest a dream-like, unconscious state of anxiety in which actual and imagined barriers surround both the artist and observer. In relation to this, Shiota has described two early memories that reappear throughout her work. The first image is of a fire set by an arsonist in a neighbor's house and of her hearing the sound of a grand piano inside being consumed by flames, an impression confirmed shortly after by seeing the piano's blackened skeleton within the burnt-out hulk of the building. She realized that she had been awakened by the "music" of the burning piano and continued to relive this uncanny moment in her work *The Way into Silence* (2002–03). [3] **(fig. 3)** Here the instrument had been

1 | **From DNA to DNA** | 1994 | performance, installation | mixed media | all images courtesy the artist | photograph by Kayoko Matsunaga

2 | **During Sleep** | 2004 | performance with sleepers during the opening | beds, black thread | Kunstmuseum Luzern, Lucerne, Switzerland | photograph by Sunhi Mang

3 | **The Way into Silence** | 2003 | Württembergischer Kunstverein, Stuttgart, Germany | burnt grand piano, burnt chairs, black thread | photography by Sunhi Mang

[1] Chiharu Shiota writing about childhood summer visits to the island of Shikoku in Japan from where her parents came, in "Letters of Thanks – About the Exhibition in Kōchi," *Letters of Thanks*, The Museum of Art, Kōchi, 2014, p. 8. [2] The event itself takes center stage in her sets for theatrical performances. See, for example, her work for *Oedipus Rex*, Dresden, Festspielhaus Hellerau, 2009; Berlin, Hebbel am Ufer Theater, 2010; and for *Tattoo*, New National Theatre, Tokyo, 2009. [3] She later extended this idea into a series of installations with the name "In Silence."

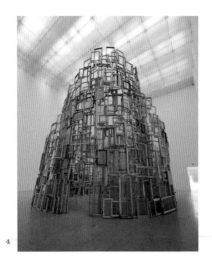

4

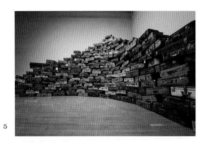

5

6

7

silenced forever. Extending this analogy into a paradox about finality of death, Shiota subsequently wrote:

I always carry this silence within me. Deep in my heart. When I try to express it I lack the necessary words. But the silence lasts. The more I think about it, the stronger it gets, the piano loses its voice, the painter does not paint any more, the musician stops making music. They lose their function but not their beauty. They even become more beautiful. My true word has no sound. [4]

The second recurring memory is of a near-death experience when, as a young woman, she was confined to bed in hospital with cancer. This has been alluded to in many works, such as "During Sleep" (2001–07), a series of installation/performances in which a number of young women in white nightgowns lie motionless, as if in sleep, in hospital beds enmeshed by skeins of yarn. (fig. 2) This motif was further developed in the installation *Flowing Water* (2009) in which water rains down over 35 bare, metal-framed hospital beds that rise from the floor, high into the cavernous vault of the Nizayama Forest Art Museum in Toyama, Japan. (p. 103, fig. 33) The absence here of the human body implying, in this case, physical transcendence is, in other works, made all the more poignant by symbols of its former presence: girls' and women's dresses or nightgowns, worn-out shoes, beds, chairs, pianos, all suspended within the separate worlds that Shiota has created for them, wrenched away from their previous lives.

Rites of memory become acts of exorcism that transfer the unavoidability of the past into seeds of future hope. *A Room of Memory*, a large circular tower, twelve meters high, made in 2009 for the 21st Century Museum of Contemporary Art in Kanazawa, creates another shrine to absence and silence. Constructed out of window frames from demolition sites in East Berlin, its dejected parts suggest the torn history of the formerly divided city, as well as the hopes of the people who once had peered out of them. (fig. 4) As with all the materials Shiota uses, her engagement with them is compulsive: "I go on searching because the windows are in my eyes like a skin. They are like the boundaries of my self that I cannot cross. I have the impression of being in a forlorn abyss of, not inside but outside neither." [5]

In *Accumulation for the Destination* (2012), a recent site-specific installation of over two-hundred antique suitcases stacked in a rising mass against a wall, Shiota has reanimated everyday symbols of transit by acknowledging their status as repositories of memory that obviously once belonged to other people. (fig. 5) With her Berlin background, reference to the Holocaust is unavoidable, yet the redolence of the work goes far beyond this tragic history to remind us of the hopes, ambitions, and fears of all people who have been forced into such physical upheaval—including the artist herself. The constant, at times impossible, search for "home," is something we can all recognize as endless waves of economic, political, and psychological migration continue to shape the world.

A similar sense of questioning informs *Where Are We Going?*, a related work from the same year. Two small wooden boats are fixed in a long shallow pool, their sterns facing in the same direction. (fig. 6) Water pours on them from above. According to one's viewpoint, this may give the impression of movement, although there is none, or it could seem that the boats have become broken, derelict, obsolete. The abiding impression, however, is of the beauty of a particular moment: the sound of falling water as it glitters in the spotlights, the patina and grain of the wet wood, the numinous hulks of the old boats. Faced by such a captivating ambience, ideas of physical progress or progression become irrelevant.

As Shiota's work has developed, a sense of dislocation has become increasingly evident but this has also been accompanied by the feeling that the making of the work itself, the painstaking manual process by which it is "woven," is a form of propitiation for this. In *Letters of Thanks* (2013),

[4] Chiharu Shiota, *Raum* (exh. cat.), Berlin, Haus am Lützowplatz, 2005, p. 33. [5] Ibid., p. 14. [6] See note 1.
[7] Andrei Tarkovsky (1932–1986), Soviet and Russian filmmaker and film theorist.

one of her most recent installations, she has brought together nearly 2,500 "thank you" letters written for different purposes by Japanese children and adults. (fig. 7) These have then been inserted into skeins of dark woolen yarn that tightly define the exhibition space, obscuring, confining, and centering it, rather like a spider's web. As if they were insects awaiting their doom, these small, innocent sheets of paper seem transfixed as they shine out of the darkness but, in their directness and naiveté, they are reminiscent of the messages tied to the branches of wish trees outside Shinto temples on which supplicants write their hopes for the future. Linked together in this work, the sentiments expressed within these letters become a reservoir of positive energy to be shared and enjoyed by all, as well as, in the artist's mind, a surrogate "thank you" to her parents who have cared for her, particularly to her father who, although still alive, is unable to communicate.[6]

In *Other Side* (2013), the installation Shiota completed for the Towner gallery in Eastbourne, the viewer is also invited to become a part of the webs and labyrinths of her immersive interiors. (fig. 8) But here there are no messages to read. Doors open onto five different, dimly lit spaces in a Kafkaesque architecture of shadow and light where visitors are invited to project their own memories, hopes, or fears. Each threshold defines a different character or sense of possibility; the yarn becomes a semi-transparent membrane between the fantastic and the real. Imagining a space like "The Zone" in Andrei Tarkovsky's memorably unsettling film *Stalker* (1979), Shiota has woven five "rooms" of memory, silence, self-discovery, and desire.[7] They will only become active when a body is present, filling their webs with different thoughts and dreams. ●

4 | **A Room of Memory** | 2009 | 21st Century Museum of Contemporary Art, Kanazawa | old wooden windows | photograph by Sunhi Mang

5 | **Accumulation – Searching for the Destination** | 2012 | Marugame Genichiro-Inokuma Museum of Contemporary Art | Installation: old suitcases | photograph by Sunhi Mang

6 | **Where Are We Going?** | 2012 | Marugame Genichiro-Inokuma Museum of Contemporary Art | installation: old wooden boats, rope, water | photograph by Sunhi Mang

7 | **Letters of Thanks** | 2013 | Kōchi Art Museum, Japan | installation: thank you letters, black thread | photograph by Sunhi Mang

8 | **Other Side** | 2013 | Towner Art Gallery, Eastbourne, UK | installation: doors, light bulbs, black thread | photograph by Alison Bettles

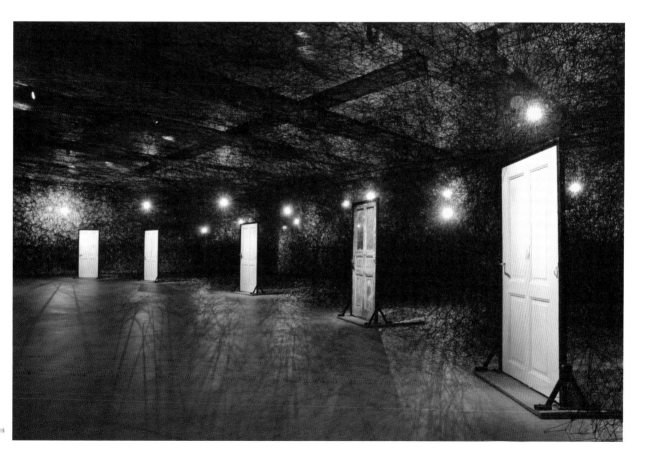

Tomoko Kashiki
A Floating World

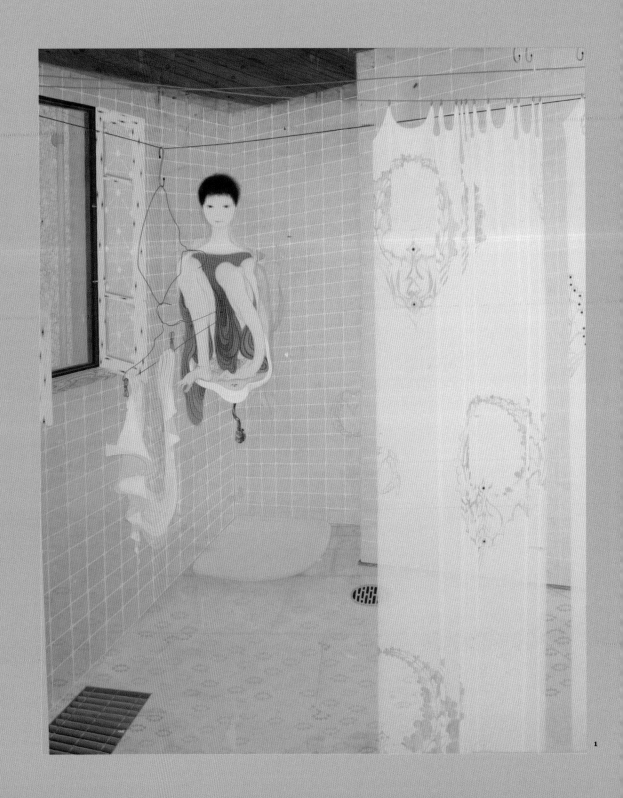

This essay, written in Moscow in December 2013, was published in Japanese and English for the exhibition catalogue **Tomoko Kashiki**, Tokyo, Ota Fine Arts, 2014. Kashiki is one of the youngest, most poetic and silent artists shown in "Bye Bye Kitty!!!" Here I have attempted to enter the imaginative world she rarely talks about and only intimates in her work. In this I may have taken some liberties but, to date, she has made no objection. I also included her paintings in the 1st Kyiv International Biennale of Contemporary Art (2012) and in the 4th Moscow Biennale of Young Art (2014). See pp. 102–104. Tomoko Kashiki was born in Kyoto, in 1982, where she still lives today.

1 | **Morning Glory** | 2009 | acrylic and linen on wood panel | 227.3 x 181.3 cm | Museum of Old and New Art, Hobart, Australia

2 | **Drawing Person** | 2008 | acrylic, charcoal, ink and tracing paper on cotton, mounted on wooden panel | 180 x 200 cm | Images courtesy the artist and Ota Fine Arts, Tokyo

3 | **In a Box** | 2008 | acrylic, charcoal, ink, and collage on cotton, mounted on wooden panel | 130.3 x 162 cm | private collection, Tokyo

[1] In some recent works she has painted directly onto the wooden panels. [2] See Kendall H. Brown & Sharon Miniciello, *Taisho Chic: Japanese Modernity, Nostalgia and Deco*, Seattle, University of Washington Press, 2002. [3] Kashiki: interview with the author, Tokyo, December 7, 2009.

Tomoko Kashiki's beautifully crafted paintings are concerned with an intimate dream of art, life, and desire that teeters between hesitant self-confidence and a compulsive fear of obliteration. Reiterating a multiple self-image in different manifestations, appearing in the personae of willowy, sometimes etiolatedly deformed, young women, she has created a contemporary equivalent of *ukiyo-e*—the transient and ultimately un-gratifying Floating World of the pursuit of pleasure and desire, derived ultimately from Buddhist notions of temperance. This rejects the uncritical, male-dominated gaze of Edo and Meiji Japan, and is an honest view, fit for its own times, that brings together a primal sense of wonder with a joy in the uncanny that enables Kashiki to distance, objectify, and propitiate the most fundamental of human anxieties.

First sketched out in pencil, her works are painted in acrylic, to which she sometimes adds pastel, charcoal or Chinese ink onto a fine linen cloth mounted on large, chamfered wooden boards.[1] She has invented this fluid form of presentation, in which the edges of the works are softened by shadow, to ensure a subtle separation of image and surface from the environments they depict, as well as in those usually more uniform and rectilinear spaces in which they are shown. Disembodied, Kashiki's paintings seem to float over the wall and their estranged, sensual impact seems to stop time while reverberating far beyond the painting itself.

Born and educated in Kyoto, she has made drawings continuously from childhood but only during her time at art school did she begin to take an interest in the work of other artists or the history of art. Certainly images of women have affected her work greatly, particularly the *ukiyo-e* genre of *bijinga*, paintings and woodblock prints of beautiful women in which the abstract qualities of the face or kimono are reflected in both the texture and iconography of their interiors or landscape. Through its combination of sophisticated icons of modern life with the elegant brushwork and aristocratic taste of an earlier age, the poetic romanticism of traditionally painted *taishō* (art deco) screens and scrolls also made a strong impression.[2]

She has never questioned why she paints, or why she produces only images of women, but is aware that since her earliest works she has progressed from presenting featureless or fragmented figures, as in *Sambucus Sieboldiana* (2007), to a point at which she feels the need to be more specific, depicting the facial features, hairstyles, painted nails, and other details of her characters.

In two related works from 2008, *Drawing Person* (fig. 1) and *Painting Person,* Kashiki concentrates on the act of making art. *Drawing Person* depicts an artist applying the finishing touches to a painting, for her, a powerful moment of transference that she makes clear has attendant risks of losing identity to, or within, the work. She is showing, and being, here someone who "concentrates so much on creating everything around her that her body literally melts away."[3] *Painting Person* (2008) captures the beginning of this process, when an artist makes the first marks on the canvas. A hunched, Narcissus-like pose characterizes the protagonists of both works. By quoting the figure of the self-regarding youth from Greek mythology who became fatally fixated by his own reflection in many of her works,

4

5

Kashiki has stressed the intense, inwardly directed gaze that being an artist requires, as well as the danger of loss of outer consciousness that such concentration demands.

In spite of the confinement suggested by its title, *In a Box* (2008), expressed both by disorientating perspectives and close-up details of decorative textures, this work shows a young woman at rest—in a reverie or dream—lying on her back to enjoy the comforting arabesque of fine white curtains as they billow languidly above her, moved slowly by a warm summer breeze. **(fig. 3)**

The more tense subject of *Roof Garden* (2008), in which a young, fashionably dressed, wind-blown girl teeters dangerously on the parapet of a high building, could be regarded as the knife edge on which all good art has to be judged; equally, it could have the added connotation of a figure disappearing, "evaporating into the landscape" to which she has often referred.[4] **(fig. 4)** This need, or desire, for absorption and obliteration into the universal space of art is strongly felt and echoes a similar compulsion in the work of Yayoi Kusama, her eminent and much older Japanese colleague.[5]

Yet even within the comfort zone of art, dream is countered by nightmare with threatening notes of alienation and anxiety. In the densely intertangled forms of *Shadowplay* (2009), two elegant, willowy-limbed young women, reflective images of each other, seem more interested in clawing combat than in participating in an innocent children's game. In *Wind-Bell,* a pair of paintings from 2009, a young woman hangs as if she were a bell, "swinging in the breeze," in an aesthetic mockery of an execution by hanging. In the ironically titled *Morning Glory* (2009), she is hunched in the corner of a bleakly tiled bathroom, staring ahead, alone, legs pulled up, tightly crouched in a male urinal. **(fig. 1)**

Kashki's most recent paintings show an interest in *yūrei,* traditional, sometimes humorous, but always horrifyingly grotesque, depictions of ghosts and other monstrous creatures that inhabit the Japanese netherworld. *Reverberatory Furnace* (2012), a tall scroll-like painting, imagines the crumbling Gothic architecture of an ancient kiln emerging out of a misty raft of different textures. In the foreground, with feet submerged, stands a tall, windblown young woman, her face almost covered by the pink umbrella she carries, the hot color of which creates a source of energy and pictorial focus that reverberates throughout the work. Behind the kiln grows a shadowy, ghostly tree, its white leaves and branches spreading against the flux of what looks like a river that stretches across the painting's width. This "river" also flows down the work to just behind the base of the kiln where it morphs into the watery bed of pebbles in which the young woman stands. The interpenetrating tissues of texture, pattern, planes, and color in this work, referred to in the "reverberation" of its title, is made even more illusory by a long, uneven sliver of darkness that defines the painting's top edge. The illogical and shocking intervention of this dark space suggests that the whole work, and everything it represents, is little more than a projection or shadow. Perhaps everything that we see here is a mirage that, for a brief interlude, masks the reality of nothingness?

Echoing the two paintings *Drawing Person* and *Painting Person* (2008), *Room of This Person* (2012) suggests that the act of artistic creation is becoming even more risky. An interior—a studio perhaps—emerges out of a turbulent bed of water or clouds on which an amorphous, dark-brown "cumulus" serves as a kind of threshold. A tall wall, the exterior of which is decorated with sinuous, sperm-like motifs that are repeated more intensely in the interior, defines the front of the room. Access is gained through an oval frame suggestive of a very large mirror. **(fig. 5)** Here Kashiki presents both a spatial and ontological conundrum: are we

6

7

looking into the room or at a reflection in a mirror? Are we actually looking at the occupant of the room or at ourselves?

Inside the room, the scene reminds us of *In a Box* (2008), (fig. 3) but this space is more unsettling and claustrophobic. The floor is covered by a flowery carpet and beyond the far wall, defined by a large plate-glass window, a small courtyard, itself enclosed by a high stone wall, can be clearly seen. White curtains billow in the breeze by the window, a young woman lies beneath them, her small head and upper torso just visible through the diaphanous textile. Yet what seemed to be a rare moment of delight in *In a Box* has here been transformed into an experience of a quite different order. This poor person—the artist perhaps—appears to be drowning in what soon becomes clear is the residue of herself, her body melted into waves and folds of skin-like matter that ooze across the floor, gravitating towards the dark mass of the threshold/cumulus. In this ghostly world the slim chance of security and simple delight felt in Kashiki's earlier work appears to have completely evaporated. The live-in studio has become a cell, the body obliterated in a dark cloud of depression. We have moved from fantasy into nightmare.

Painting of Shells (2013) (fig. 6) marks a similar sense of dissolution, also transposed to the space of the artist's studio. The metaphor of protection, the subject of this work, is the shell that shelters the soft body of a mollusk, yet all defenses seem to have been breached. This scene of mayhem is drawn from a crazily tilted perspective: paintings are stacked carelessly against the wall or propped on easels, a vast sheat of paper cascades downwards, its folds marked like the eyes of a Japanese monster that focus with horror on the chaotic, patterned energy fields that move across the space. In the two visible paintings, different single seashells are depicted lying on sand by the side of an ocean. One of the paintings contains a glass, a quarter full. In the other, an empty glass has tipped over. But, maybe as a result of this, this shell is larger and surrounded by a halo of light.

Some rule has obviously been broken, a fragile balance destroyed. Like an upturned crab, the artist lies immobile on her studio floor, most of her body melted away. In horror, she stares at her hands, stained orange from a liquid consumed from a discarded glass that now splashes its way across the whole studio. Like a contemporary Alice who wanted to change the size of her body to enter Wonderland, or the Greek sculptor Pygmalion whose love for a woman he had carved brought her to life, Kashiki has entered a wormhole between parallel universes. The implications are far from comforting, desire has transgressed the borders between art, the unconscious, and life, and this has unleashed a terrible force.

In *Because the Dandelion Rock is Chasing After Me* (2013), one of her most recent works, Kashiki again confronts the unsettling, illusory nature of experience. The image suggests paranoia. (fig. 7) Who could be afraid of an innocent dandelion? Yet the unlikeliness of its title points to Kashki's hidden intention. Her motif is not now herself, nor even art, perhaps the best medium for showing the bizarre, *yūrei* attractions of the Floating World. In this pastel-gray painting, heightened only by the tortured pink flesh of the artist and the yellow heads of the floating dandelions, almost godlike, she has assumed control. Creating worlds of illusion to renounce the very same, balancing on a high windowsill entrapped within an inhospitable stone keep, abnormally human, the artist refuses to fall or disappear but floats, one hand held high, in benediction and condemnation of the world floating around her. ●

4 | **Roof Garden** | 2008 | acrylic, pencil and paper on cotton, mounted on wooden panel | 225 x 183 cm | Dai-ichi Mutual Life Insurance Company

5 | **Room of This Person** | 2012 | acrylic, pencil, tracing paper, charcoal and linen, mounted on wooden panel | 145 x 97 cm

6 | **Painting of Shells** | 2013 | acrylic, pencil, tracing paper, wallpaper, charcoal and linen, mounted on wooden panel | 180 x 230 cm

7 | **Because the Dandelion Rock is Chasing After Me** | 2013 | acrylic on wooden panel | 180 x 90 cm

[4] Ibid. [5] Yayoi Kusama (b. 1929) described one of her earliest memories as of being covered with points of color that also blanketed the things around her. This sense of "dissolution into the universe" impressed her strongly and was the origin of her dot paintings and installations, as well as of her many mirrored *Infinity Rooms*. Both artists were shown in close proximity in the 1st Kyiv Biennale.

Dono's Paradox
The Arrow or the Kris?

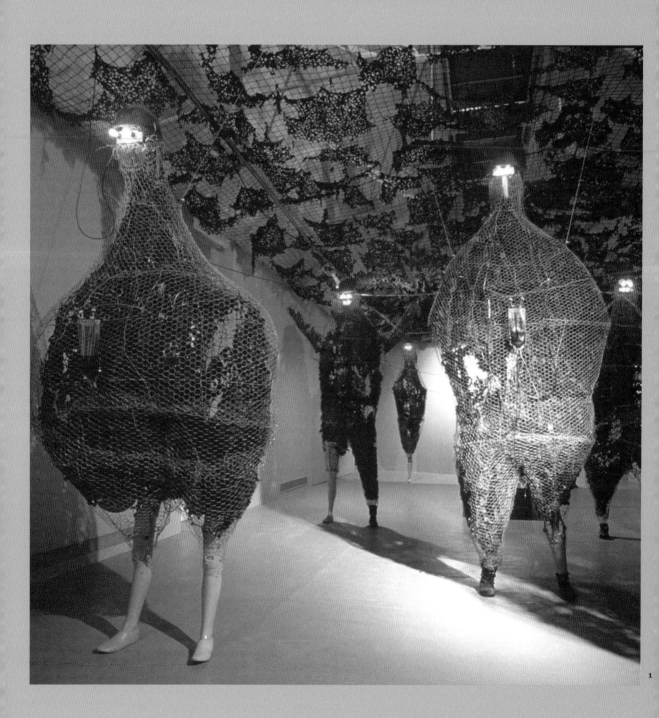

1

Henri Dono was born in Jakarta, Indonesia, in 1960; he lives and works in Yogyakarta. This essay, based on that in the exhibition catalogue **Heri Dono: Dancing Demons and Drunken Deities**, published by the Japan Foundation Forum, Tokyo, in 2000, builds on the introduction for **Blooming in Arms**, a catalogue that marked Dono's exhibition, at the Museum of Modern Art Oxford during 1995–96. My first encounter with Dono's work was at the 1st Asia Pacific Triennial of Contemporary Art (APT) in Brisbane in 1993 where I saw in his contemporary adaptations of the forms and stories of the traditional **wayang kulit** (Javanese shadow puppet plays) a strong critique of greed, military power, and environmental despoliation. In 1995, I invited him to Oxford as an artist-in-residence, with the view to his making an exhibition. [1]

Interest in, and knowledge of, contemporary Indonesian art or politics in the UK at this time was almost nonexistent, and both Dono and I were surprised to receive a favorable review of the exhibition in **The Times**. [2] This, however, attracted the attention of the Indonesian Embassy in London, which sent a detailed letter of outrage to the museum correcting the "misapprehensions" in the catalogue and demanding that we should withdraw it from sale because of its "discrepancies, inaccuracies, and misleading information . . . regarding the political situation in Indonesia." [3] Dono's response on hearing about this was of profound alarm, however, this was not initially communicated directly but via a telephone call from a third party who accused the museum of putting words into the artist's mouth. [4] The museum's position was that it could not be pressured by a foreign embassy to withdraw any publication which had prior approval of the artist, but, as the exhibition had closed, we would consider the temporary withdrawal of the publication from sale on receipt of a written request from him. We received this by fax from Basel on March 5, 1996. [5] The catalogue remained "in jail" until March 25, 2000, when Dono sent an email asking that, in the light of political changes within Indonesia, his catalogue should again be put on sale. [6]

2

1 | **Blooming in Arms** | 1995–96 | installation view | John Piper Gallery, Museum of Modern Art Oxford | 1996

2 | Heri Dono installing his sound work **Gamelan of Rumor** | 1992–93 | at the 1st Asia Pacific Triennial, Brisbane | 1993

[1] The exhibition was jointly sponsored by InIVA (Institute of International Visual Arts), an organization set up in 1994 with Arts Council funding which, at that time, did not have an exhibition space. [2] Sasha Craddock, "Speaking Out By Lying Low. The Indonesian Heri Dono Has Brought His Art—and His Protest—to England," *The Times*, London, Tuesday February 6, 1996. [3] Letter from (Mrs.) Hendrathi S. Munthe, Minister Counsellor and Head of Information of the Indonesian Embassy in London, to David Elliott and Gilane Tawadros (director of InIVA), February 12, 1996. Museum of Modern Art Oxford archive. [4] Internal memo: A. Bowron to D. Elliott, February 25, 1996. Museum of Modern Art Oxford archive. [5] Urgent Fax: Heri Dono to D. Elliott and G. Tawadros, March 5, 1996, Museum of Modern Art Oxford archive. [6] Email: H. Dono to G. Tawadros March 25, 2000. Museum of Modern Art Oxford archive. [7] Heri Dono, "The Game," in David Elliott & Gilane Tawrados (eds), *Heri Dono*, InIVA London/Museum of Modern Art, Oxford, 1996, p. 18. [8] M. Dwi Marianto, "Mainstreaming of *Ngeledek* in Indonesian Contemporary Art," *Awas! Recent Art From Indonesia*, Indonesian Arts Society, 1999, pp. 17–20.

Around 470 BCE, the Greek philosopher and mathematician Zeno made a series of propositions about how truth could relate to the infinite divisibility of time and space. One paradox in particular reverberates ontologically like a Zen kōan: why, when an archer shoots an arrow, can it never logically reach its target? For Zeno, this was for the reason that at each instant of its flight an arrow occupies only the amount of space that is equal to its length and volume. Therefore, motion—progress through space—was logically impossible and the object remained at "rest."

The trajectory of an arrow—a metaphor for swiftness and directness—was obviously far more complicated than it seemed but, in relation to the work of contemporary Indonesian artist Heri Dono, a slightly different paradox, also concerning truth, motion, and impetus, springs to mind: the movement of the deadly, undulating blade of a *kris*, the traditional dagger that Dono has described as expressing the logic of survival in contemporary Indonesia: "People find it difficult to confront and express the truth and the reality of their lives. Fear is the disease that prevents them from saying what they want to say. The word of truth cannot always run in a straight course but, like the *kris*, it has a wavering edge. Some people have to use a coded slang, or write graffiti, as the only means by which they can criticize authority and government." [7]

Dono's words are rooted in harsh experience as, over the past fifteen years [1985–2000], he has had to zigzag through the traps and pitfalls of a militarized, virtually totalitarian state from which he has derived so much creative energy, wisdom, and imagery.

Happily, over the past two years [1998–2000], the political situation in Indonesia has changed for the better. The oppressive, militaristic government of Suharto has been swept away, although the multiparty future is far from clear. This process of "liberation" has spawned a patois of its own, with words such as *ngeledek*, meaning to "tease, taunt, or ironize," which one art critic has recently applied to the work of those Indonesian artists who have emerged during the latter half of the '90s. [8] This neologism may also be applied retrospectively to Dono's entire work.

When I first saw Dono's work at the opening of the initial APT in Brisbane in 1993, his paintings alone, perhaps, would not have caught my eye. But his sound installation *Gamelan of Rumor* (1992–93), along with specially customized shadow puppets displayed on a rack and the *wayang kulit* (shadow play) performance, in which they were used, tipped the balance. **(fig. 2)** These

works were celebratory and humorous but with a bitter undertow of social and political criticism. Two years later, the Museum of Modern Art Oxford invited Dono to come to Oxford as artist-in-residence.

I have since wondered what I took away from my first impressions of his work: I had apprehended its essence and context but there was something missing—a lack caused by what Julie Ewington has described as the intellectual and perceptual filters that "outsiders" cannot avoid applying to the region.[9] This had little to do with the muscular patriarchy of Kipling's infamous interdict about "East" and "West,"[10] nor was it based on the condition of Dono being a citizen of a country that was both colonial and colonized (although parts of Indonesia had been colonized by the Dutch, this was not a dominant issue in its contemporary art). She was referring more to the blurred, partial view that may only be glimpsed fleetingly, as if between cracks in reality. For me, this was a territory that spanned the difference between the straight flight of an arrow and the wavering flash of the blade of a *kris*. Both are a means of attack as well as of self-defense, and they may also inflict a deadly wound.

The West blithely constructs worlds out of theoretical concepts—colonialism with postcolonialism, modernity with postmodernity, totalitarianism with democracy, late capitalism with globalization, traditionalism with modernization and so on—but these can easily be regarded by others as a new form of colonialism because there is no discussion about their governing perspectives or consensus about their significance. Is the verbal, publishing, academic West still attempting to suborn the rest of the world with the power of words at a time when meaning cannot be enforced and critical theory has no hegemonic discourse? Cultural flow moves as chaotically as it always has done and languages of whatever origins are defined, redefined, and massaged to fulfill necessary functions.[11]

Is the historical dimension of modernity in Southeast Asia the same as that in Africa, or as in Western or Eastern Europe? No.

Is "postmodernity" an irrelevance in Malaysia or Indonesia—countries that regard the wavy blade of the *kris* as an important element of their cultural and metaphorical heritage?

Yes, probably, unless these words and the ideas they express can be reworked in some way that would be locally useful. Not surprisingly, in the chaotic context of post-totalitarian Indonesia, critic Rizki Zelani ironically highlights the recent "loss of . . . faith in a number of meta-narratives of modernity" as part of a weakening desire, or hope, of ever becoming "modern."[12] At the same time he has tracked the intensification of an "art of revolt" to redefine and grasp hold of truth and its meaning for historical development.[13]

In the light of this discussion, two things particularly attracted me to Dono's work: its critical and dynamic relation to cultural tradition and its intense reflection about, and critique of, lived experience and reality. He has positioned himself at the margins of society, identifying both with the past and the poor, which a rapaciously modernizing state tends to regard as the same thing. He has also consistently shown sympathy for those who have been disempowered but typically, and of necessity, he has not regarded this as a political position: "I am not involved in political or social problems . . . but my paintings, maybe they are identical with politics or society. The main thing is that the social structure should be turned round by 180 degrees."[14] In this strategy Dono looks at the world upside down in order to see it more clearly.

This statement is also dangerously ambiguous: his work is a reflection of reality that also implies that reality (the social structure) should be upturned to match art. Dono's work is both parody and critique—waveringly balancing on a knife's edge and, until very recently, any negative political statement in Indonesia could be life-threatening. Fellow artist Dadang Christanto remembered in May last year [1999] [that] "while Suharto was in power,

[9] Julie Ewington, "Between the Cracks. Art and Method in South East Asia" [a review of the 2nd APT], *ArtAsiaPacific*, Vol. 3, No. 4, 1996, pp. 57–63. For this metaphor she credits William Henry Scott, historian of the pre-Hispanic Philippines. [10] Rudyard Kipling, The Ballad of East and West, 1889. The first quatrain: *Oh, East is East and West is West, and never the twain shall meet, / Till Earth and Sky stand presently at God's great Judgement Seat; / But there is neither East nor West, Border, nor Breed, nor Birth, / When two strong men stand face to face, tho' they come from the ends of the earth!* [11] For discussions of this topic see, for example, Jim Supangkat, "The Framing of Contemporary Indonesian Art," *Artlink*, Vol. 13, Nos. 3 and 4, Nov 1993 / Mar 1994, pp. 46–50. In particular the section entitled "Modernism in Indonesia: A Difference." Malaysian artist and critic Redza Piyadasa also has referred to the prescient multi-ethnic and multi-traditional postmodernity of Malaysian contemporary art in "Modern Malaysian Art 1945–1991: a Historical Overview" in C. Turner (ed), *Tradition and Change. Contemporary Art of Asia and the Pacific*, Brisbane, 1993, pp. 58–71. [12] Rizki A. Zelani, "Contemporary Art in Indonesia: Beware! After the Big Change," *Awas! Recent Art from Indonesia*, op. cit., pp. 85–89. [13] A similarly critical but distantly related attitude towards modernity, identity, truth, and power has also characterized the work of many eastern and western European artists during the 1990s. [14] Astri Wright, *Soul, Spirit and Mountain. Preoccupations of Contemporary Indonesian Painters*, Kuala Lumpur, Oxford University Press, 1994, p. 238. Dono made this statement between 1988 and 1992. [15] Dadang Christanto to Astri Wright, letter, May 25, 1999, published in A. Wright, "Thoughts from the Crest of a Breaking Wave," *Awas! Recent Art from Indonesia*, op. cit., p. 60. Even before Suharto established his "New Order" in 1966, death squads had murdered an estimated one million people during 1965–66 during the closing months of the previous Sukarno regime. See Joshua Oppenheimer's chilling documentary *The Act of Killing* (2012), based on interviews and reenactments with gangster members of the death squads. [16] A. Wright, *Soul, Spirit...*, op. cit., p. 236. [17] *South East Asian Art Today*, Singapore, Roeder Publications, 1996, p. 17. [18] The debt of early modernism to eastern and other non-western visual archetypes has long been acknowledged. By the middle of the 20th century, such "influences" had become fully absorbed within "indigenous" western cultures.

in general, political perspectives did not emerge in most artists' artworks. They also avoided discussing politics in daily life. If talking politics was taboo—how much more so was it to put political concepts into works of art. This matter is easily understood if we remember the terror created by the New Order, that is, how fear was created among the people."[15]

No doubt as a result of this repressive climate as well as out of personal conviction, Dono has stressed his orientation towards the "problems of humanity in general" and one of the ways he did this was by using humor as a threshold for further involvement: "I imagine a person who doesn't look deeply into my paintings will laugh and see my work as an expression of hilariousness. But someone who gets into it might cry . . . I am not only involved with problems of visual art . . . but with tragedy."[16] And not only with that of Indonesia: "The world is crazy and frightening. Look at the hunger in Africa: they need food but they've got bullets."[17] (fig. 3) Under pressure to work abroad for considerable stretches, Dono has transposed his Indonesian sensibility and experience into other climates. The painting *The Magician Who Cannot be Killed* (1990) refers to an argument with a Czech market trader in Switzerland within the context of the fantasy of a shadow-puppet play; *A Conductor Gets Shot* (1992) was triggered literally and metaphorically by another real event in the Netherlands. (fig. 4)

At this point we begin to apprehend the core of *Dono's Paradox* more clearly. Like Zeno's arrow, his work can only logically occupy its own space and therefore cannot move forward—yet we can see that it does. In this context, we may also understand that, under certain conditions, silence may be more eloquent than words and that the artist, like the *kris*, may occasionally have to move in one direction to strike in another.

Although he was born in Jakarta, the old Dutch colonial capital Batavia, he has been based for many years in Yogyakarta, the former capital of Java, which has a much slower pace. From 1980 to 1987 he studied painting at its Academy and obviously acquainted himself with the work of Miró and late Picasso, melding their cutout figures on flat grounds with elements of traditional Javanese art that also used silhouetted forms within different genres of non-naturalistic space.[18] A key painting at this time was *Eating Shit* (1983), an acrylic and collage mounted on a one-meter-square canvas. (fig. 5) Respect for elders is widespread in traditional culture through most of Southeast Asia but Dono's work expressed youthful rebellion against authority—perhaps against his art-school teachers—and also had a political dimension: he had heard reports that dissident prisoners were forced to eat their own excrement, so this work also became a record of a fact which could be neither talked about nor disseminated through the media. At this time Dono felt the need to develop more participatory and broadly based work and from 1987 studied *wayang kulit* with Sukasman, one of its masters. (see p. 21, fig. 7) He now began to make his own non-traditional puppets, which were often related to the characters that appeared in his paintings. These plays enabled the artist to use parable or pseudo-myth in a dynamic way. There had always been elements of comedy within the Hindu *Mahabharata* and *Ramayana* epics that provided the staple narrative of the traditional *wayang* and, as it was a popular art form, burlesque elements were often accentuated.

Even though Java is predominantly Islamic, as are most territories that comprise the Indonesian state, and has undergone severe changes owing to the pressure of fundamentalism, these stories are often combined with animist folk tales and other popular beliefs rooted in Buddhism that reflect a pre-Muslim past. Dono, accordingly, exploited the multicultural and multifaceted references and possibilities of *wayang,* with its proliferation of mythological monsters, in a contemporary context, often enlisting people from the poorest districts to participate in and enjoy his performances.

Kuda Binal ("Wild Horse," 1992) was one of these. Based on a traditional horse trance dance, it could be understood as an indictment of the "fossilization of traditional art . . . [and] . . . the systematic destruction of nature by human

3 | **Eating Bullets** | 1992 | synthetic polymer paint and collage on cardboard | 66 x 77 cm | collection of Queensland Art Gallery, Brisbane

4 | **A Conductor Gets Shot** | 1992 | acrylic and collage on paper | 65 x 80 cm | courtesy Tyler Rollins Gallery, New York

5 | **Eating Shit** | 1983 | acrylic and collage on canvas | 96 x 96 cm

6

7

6 | **Fermentation of the Mind** | 1994 | mixed-media sound installation, wood, plastic, metal, electronic circuits

7 | **Watching the Marginal People** | 1992–2000 | wood, electronic equipment, speakers, variable dimensions | courtesy Mizuma Art Gallery, Tokyo

8 | Scene from **The Drunkenness of Semar** | **wayang kulit** performance | FREUD (Café Bar) Oxford | December 10, 1995

9 | two preparatory pencil sketches for the installation **Blooming in Arms** | 1995 | MoMA Oxford Archive

[19] Program for Heri Dono, Kuda Binal, Alun-Alun Utara, Yogyakarta, July 29, 1992. [20] Since its formation in 1967, Indonesia has been a leading member of ASEAN (the Association of Southeast Asian Nations). [21] See footnote 19. [22] D. Elliott & G. Tawadros (eds), "Blooming in Oxford," op. cit., p. 13. See also footnote 15. [23] Heri Dono, "The Game," ibid., pp. 18–21. [24] Heri Dono in an interview with Tim Martin, ibid., p. 38. [25] This work was shown in the museum's large John Piper Gallery, while Dono's paintings and objects were exhibited in the smaller ground floor spaces. [26] These are vast, heavily forested areas of Indonesia [27] Heri Dono, "Blooming in Arms," ibid., p. 22. [28] See note 2. [29] See note 3. [30] Letter Astrid Bowron to HS Munthe, February 27, 1996. Museum of Modern Art Oxford archive. [31] See note 5.

greed and arrogance."[19] But its story line also suggests a more searching critique: concealed within traditional tales of dancing horses, warriors, tempted Gods, and ultimate destruction, Dono's massed armies are not the Hindu legions of ancient mythology but the steel-helmeted and gas-masked monsters of the present. Tellingly, he linked the premiere of this performance with the official ASEAN Year 1992:[20] "*Kuda Binal* is not presented to gather support for any cause, or to welcome visitors to visit ASEAN Year '92. But, of course, a visit to ASEAN Year '92 supports the concept of *Kuda Binal*," he declared cheekily.[21]

Three installations from the same time—*Watching the Marginal People* (1992), *Gamelan of Rumor* (1992–93), and *Fermentation of Minds* (1994) — further nail down its threatening and exploitative atmosphere by extending Dono's perception of how the state inflicted terror. (figs. 7, 2, 6) In these works we become not only the audience but also the actors in a much larger puppet play, one in which the state and its cronies are the puppeteers where "authority, marginalization, and rumor exist because a big system [had] already built them and we are included either as puppets or as the audience." All-seeing eyes revolve, teeth are bared, quiet whispering disseminates information with disinformation, rows of heads nod rhythmically behind school desks—these pervasive elements bridge a space between children's toys, third-world bricolage, props for a horror film and high technology. Together they reflect critically on the paradox of governance as well as on how power is enforced and resources exploited.

In Oxford during the winter of 1995/6, Dono organized a performance and a large exhibition resulting from his three-month residency. *The Drunkenness of Semar* involved local community groups, took place in a disused church, and examined, in a playful but powerful way, the impact of modernization and militarism on a developing society. (fig. 8) Semar, a priest, guru, and trickster who lived in low-class society, was a Hindu God with both male and female attributes and provided an anchor for a number of intricate word plays and parodies. Dono's contrived intervention of SuperSemar, a new character (and parody of Superman), keyed the protagonist back to the Batak Decree of March 11, 1966, the date of the military coup in which President Suharto had replaced President Sukarno.[22]

The broad humor was bolstered by wordplay: *Semar Mendem (The Drunkenness of Semar)* is also the name of a traditional Javanese sweet cake which, for Dono, became a metaphor for sweet-talking politicians: "The leaders of Government when speaking on TV may appease the masses with their wisdom and sweet charm but their abuse of power belies this sweetness. I used to eat the cake but now I perform it."[23] Dono's version of this story departs from the Hindu original in that he shows the god when he is drunk and can no longer impart wisdom to his people. "In this condition Semar can be appropriated by the authorities and turned into a devil, [and then] pretend to have Semar's sober wisdom. In this way a dictator can seem to be a man of the people."[24] Yet even if the audience was not aware of this political volte-face, the performance seemed like a violent and eccentric pantomime with a happy ending in which the devil into which Semar had been transformed was finally destroyed.

At this time Dono also constructed *Blooming in Arms*, a site-specific installation comprised of helmeted military figures (about five meters high) made out of chicken wire that loomed out of the dark, (the walls of the gallery had been painted khaki and camouflage netting draped the roof), standing on rough prosthetic limbs, dramatically lit with glowing red eyes; even the museum guard wore military battle dress.[25] (figs. 1, 9)

The title of this work also depends on a sardonic word play that contrasted the hypocritical absurdity of the Indonesian government's "well-meaning" ecological intentions in which every family was encouraged to plant a tree outside their home (*penghijauan*), with its destructive economic policy of allowing multi-national logging corporations to decimate the

tropical forests of Sumatra, Kalimantan, and Irian Jaya.[26] Under such circumstances, little that was really green could be said to "bloom"—except for the khaki uniforms of the young army cadets that sprouted in ever-increasing numbers. But the chain of associations did not stop at this point: the situation deteriorated as intensive militarization and the mining of vast areas of jungle against "terrorists" meant that, "Children lost their limbs. They are innocent but have to live with artificial legs for all their lives. Some have lost their families and their souls."[27] Here Dono has moved from the specifically Indonesian context to one widespread through the region; the land mine became a metaphor for a pervasive sense of hidden threat that could also be tied back to Indonesia, its point of origin.

There was considerable public interest in Dono's Oxford exhibition and a number of reviews appeared in the press. One in particular, "Speaking Out by Lying Low The Indonesian Heri Dono Has Brought His Art and His Protest To England" by Sacha Craddock in *The Times,* had an unforeseen impact in that it drew the attention of the Indonesian Embassy in London to Dono's exhibition.[28] On February 12, 1996, a five-page letter from the head of its Information Department landed on my desk. Reading through it the first time, it seemed to be like an arrow, but I subsequently realized that it may have been a *kris,* because it complained bitterly about "misrepresentations" of the political situation in Indonesia which had appeared in the catalogue.[29]

Of particular concern to the Embassy were allegedly false statements that President Suharto had come to power in a military coup, that Indonesia was ruled by a militaristic government and that the Indonesian government had failed to confront the despoliation of the tropical forests. It also maintained that there was full freedom of the Indonesian press and contested that the countryside was "politicized, militarized, mechanized, and territorialized." The letter terminated by demanding that the museum should withdraw the catalog from circulation "so as to avoid misunderstanding between our two peoples."

I was traveling abroad, and my assistant acknowledged the letter adding, after we had spoken on the telephone, that the catalogue would be temporarily withdrawn from sale pending my response on return.[30] As the exhibition had closed the previous day this was no hardship. Dono had already left the UK and it was vital that we had the chance to assess the situation together before any course of action was decided. The artist and the museum faced different dilemmas that time alone could solve. In the context of British culture and law, we had both been exercising the right of fair comment and free speech; it would have been both craven and unreasonable for the museum to accede to pressure from the Indonesian government.

Yet what was at stake was not purely a matter of principle. The potential problems for Dono and his family could, at best, prevent him either from returning to Indonesia or, if he was let back in, from working outside the country again and, at worst, they could take the form of serious and violent reprisals.[31] After discussion, it was decided that the best course would be one of masterly inaction. This seemed to make everyone reasonably happy.

The Embassy already had its "withdrawal" from my assistant, a letter from me would not have improved matters and was not again asked for, and Dono's position as an artist was not compromised. Furthermore, the catalogue was not on sale but was still available at no cost to anyone who was interested in it. In these *kris*-like maneuvers it almost seemed as if Oxford had become like a small part of Java, but the ease with which this was achieved suggests that this propensity had, perhaps, always been present.

And that is how the situation remained until the beginning of this year [2000]. Recent political changes within Indonesia have meant that the *kris* can be put back into its sheath. The catalogue is on sale again and for now, at least, it is possible directly to speak the truth. ●

Chatchai Puipia's Last Masque
A Funerary Oration

In spite of the elegiac tone of this essay, Chatchai Puipia is not dead, and the dreadful accident that I described did not occur. It was written in 2008 for his monograph **Chatchai Is Dead. If Not, He Should Be** (Bangkok, A Leg Up Society, 2010) which the artist decided should be presented in the form and style of a traditional Thai memorial volume just as if he had actually passed away. The style of writing reflects this. This version of the text has been slightly modified from the original. Chatchai Puipia was born in 1964 in northeastern Mahasarakham province, near Khon Kaen, and as a child moved to Bangkok, where he still lives.

2

1 | Two paintings from the series **Where Do We Come From? What Are We? Where Are We Going To?** | 1999 | oil on canvas | 130 x 270 cm | private collection

2 | **Better Than Ever?** | 2008 | patinated, gilded and painted bronze | 40 x 32 x 35 cm | P. Chirathivat Collection | See pp. 2, 22 fig. 9

Chatchai Puipia's short but brilliant life burst upon the world like a shooting star, and his passing has left a dark void and deep sorrow in its wake. Since his recent, tragic demise at the sculpture foundry, the breath crushed out of his frail body by one of his most recent works (the last of a toppling line of newly cast, oversized bronze buttocks), few of us have known how to pay him tribute.[1] Yet, in spite of our grief, we must absolve our pain by detailing here his unique development as an artist. (fig. 2)

I suspect that when he first decided to become an artist Chatchai never actually realized the immensity of the tasks that faced him—few do. Yet, through a self-lacerating resolution of his anxieties and limitations, by considering and re-evaluating his role in the world step by step, he managed, with great difficulty, to establish a platform of self-knowledge and wisdom through a progression of works which, when taken together, have the timeless quality of a shadow play—a theater of illusion and masque understandable by and applicable to all. These words of tribute may be considered as one of the scenes in a last celebratory masque for Chatchai, although the works he has left behind will continue to resound long into the future.

Like many of his contemporaries—artists living and working in India, Indonesia, Malaysia, Singapore, or Thailand—Chatchai Puipia was the citizen of a place that was structurally and endemically "postmodern" without ever being aware of the fact. But of all these countries, Thailand alone had never suffered the indignity of colonization—not officially, at least.[2] Perhaps for this reason he had little incentive, and even less compunction, to study abroad, attending instead Silpakorn University in Bangkok where, in 1988, he was awarded a Bachelor of Fine Arts in painting. From the very beginning, Chatchai became a master of those influences on which any young artist must depend for his development. Avowedly contemporary, yet also fascinated by the history of art, he followed an independent path that disregarded the temptations of power and fashion by criticizing them both.

Those of you who have come from afar may not be aware of the context and history of the art world that had nurtured Chatchai in Thailand. Indeed, in 1999, in his large frieze-like paintings *Where Do We Come From? What Are We? Where Are We Going To?* Chatchai provided an introspective and critical gloss on this very subject, as well as on the role of his *alma mater* in it.[3] (fig. 1)

Silpakorn was the school that had introduced western-style art into Thailand. Under the firm hand of the fascist-inspired Italian sculptor Corrado Feroci (1892–1962), who in 1924 had first set foot on the banks of the Chao Phraya River in Bangkok as the official sculptor for King Vajiravudh's government, this venerable institution took the national and public lead in the cultural transformation that followed the bloodless coup d'état of June 24, 1932.[4]

As we shall see, the tension between eastern and western ideas of culture that flared up at this time was a vital but painful part of Chatchai's development. As a student in the 1980s, he felt that western influence had predominated to such an extent that it had been to the detriment of both his country and its art. Pale fakes of the latest western art trends seemed to be just as debilitating as the swarms of western sex tourists who were looking for cheap thrills in the red light districts of the capital and south coast. As an antidote to this, he proposed greater self-scrutiny and reflection, as well as a deeper appreciation of the contemporary cultures of his own and neighboring Asian countries.[5]

3

[1] The title of this fatal edition of sculptures is *Better Than Ever?* (2008). [2] On the tension between Thai art and postmodernity, see Apinan Poshyananda, *Modern Art in Thailand Nineteenth and Twentieth Centuries*, Singapore, Oxford University Press, 1992, Chapter 8, "From Modern to (Post?)Modern Art in Thailand"; and *Playing With Slippery Lubricants: Selected Writings, 1993–2004*, Bangkok, Office of Contemporary Art and Culture, Ministry of Culture, 2010. See also the writings of Malaysian theorist and artist Redza Piyadasa (1939–2007), who also frequently pointed out the irrelevance of western models of postmodernism for the heterogeneous cultures of Southeast Asia in TK Sabapathy, *Piyadasa. An Overview, 1962–2000*, Kuala Lumpur, National Art Gallery, 2001. [3] See Steven Pettifor, "Art's Soldier," *Asian Art News*, 1997, Nov/Dec, pp. 89, 90. [4] This coup d'état, in honor of which Feroci designed the Democracy Monument, in 1939–40, in Bangkok, was the first of many. See Poshyananda, op. cit., pp. 31–41, 43–49. [5] "We are constantly comparing ourselves to western art rather than looking inwards. There's not enough pride. We know very little about, say, Chinese or Indian art . . . Our only experience is of American pop culture. Outside the art school there is very little to stimulate or arouse in the country's few museums and libraries." Pettifor, op. cit., p. 90. [6] Silpa Bhirasri. [7] Thailand had been informally allied with Japan during the Pacific War (1941–45), and Japanese troops were stationed there. This stimulated a strong resistance movement within the country as many people regarded this as a form of occupation. At this time the Thai government became involved in a series of border skirmishes, particularly against the French in Indochina. As part of the official policy of bolstering national identity and pride, a large number of heroic public monuments were produced under the supervision of Feroci. See Poshyananda, op. cit. [8] See John Clarke (ed.), *Modernity in Asian Art*, Sydney, East Asian Series No. 7, 1993, passim. [9] Three Japanese instructors taught at the School of Fine Arts and Crafts in Bangkok in the late 1930s and as late as 1941 Thai artist Chit Buabus studied the technique of French impressionist *plein air* painting in Tokyo. See Poshyananda, op. cit., pp. 41–43. [10] Pioneers of the idea of pan-Asian culture were the Japanese proponent of *nihonga* and founder of the National School of Fine Arts, Tenshin Okakura (1862–1913) and the Bengali artist Abanindranath Tagore (1871–1951). In his book *Ideals of the East* (1904), Okakura had maintained that Asia had been humiliated by falling behind the modernization of the West. [11] ASEAN (The Association of South East Asian Nations) is one of the obvious progenies of this idea. [12] Although it originates from different roots, this sense of responsibility may be equated with the social and political awareness that began to permeate art in Europe from the beginning of the 19th century as seen, for instance, in such paintings as Francisco Goya's *The Third of May* (1814), and in Théodore Géricault's *The Raft of the Medusa* (1819). [13] Robert Preece and Gridthiya Gaweewong, "Cracking Beneath the Surface. An Interview with Chatchai Puipia," *ArtAsiaPacific*, 1999, No. 22, p. 72. [14] These were in 1971, 1973, 1976, 1977 (March and October), 1981, 1985, 1991, 1992, 2006, and most recently, 2014. Since 1932 there have been 20 attempted or successful coups in Thailand. [15] Preece and Gaweewong, op. cit. [16] Shadow-puppet plays; see p. 253–255. [17] DDR = Deutsche Demokratische Republik (German Democratic Republic), also known as "East Germany," 1949–1990. [18] Sergei Mikhailovich Tretiakov (1892–1937) was a Russian Constructivist writer, playwright, and theorist whose idea of *ostranenie* ("alienation"), derived from the Russian formalists, greatly influenced Brechtian theater. Bertolt Brecht (1898–1956), German poet, playwright, and theater director whose theory of the non-empathetic *Verfremmdungseffekt* ("alienation effect") has had a huge impact on political theater and filmmaking throughout the world.

Yet, even in the 1930s, the designation of what was "East" or "West" had been no simple matter. As was necessary for the head of Silpakorn, Feroci had to adopt a Thai name [6] and, by 1943, he had transformed the previously sleepy school into a university with courses that combined a classical European beaux-arts education (with the addition of impressionism and its offshoots), with, in response to the government's demands for a national style, the possibility of researching Thai antiquities and making copies of traditional art. But in fact, the national revival chose neither of these paths: the bellicose spirit of that decade worldwide, as well as Feroci's natural inclinations, led to a plethora of heroic sculptural monuments which became the most visible products of this new institution and its national art. [7]

At the time, not all advanced art was coming directly from Europe. From as early as the 1870s, Japan had been absorbing and transforming European art, science, and culture for its own needs, which it synthesized with own "eastern" traditions in a new and militant form of specifically pan-Asian modernity [8] that was seen in opposition to the imperialism and overbearing racism of the West. [9] Fueled by a desire to stay separate, to celebrate difference rather than to acknowledge similarity, this new way of looking at the world opposed naked, materialistic western power with more subtle oriental spiritual force and rectitude. [10] In addition, it built on indigenous feelings, traditions, and sensibilities, molding them into new forms of specifically modern identity.

Although discredited by Japan's behavior and defeat in the Pacific War, something close to a pan-Asian feeling of independence and self-sufficiency can still be recognized within Southeast Asia. [11] In addition to certain shared political attitudes, there is also a strong sense of moral cohesion—even outrage—versus the West, as well as against the effects of the multinational capitalism that seems to be one of its most overbearing expressions. In the Thai context, it would be too reductive to regard this as a simple symptom of hippie idealism. Such feelings, sensed particularly among those artists who take Buddhist codes of behavior seriously, are based on the widespread conviction that the artist has a duty to make a positive, tangible contribution to the general good. [12]

When he was once asked about the artist's role and responsibility in this respect, Chatchai characteristically replied: "We need to stimulate society to seek imagination as an alternative. Usually, whenever there's a crisis in society, artists and writers always have important roles, and are always at the forefront. What else can we offer besides our rebellious souls? Artists should take the leading role in order to advocate people's spirits." [13]

In a country that has seen eleven military coups d'état since 1971, the most recent in May 2014, [14] and against the background of a violent social and economic transition between agriculture and industry, such sentiments have been keenly felt. Disparities in income and quality of life are vast and often tragic, corruption is endemic, and, in a country with a barely developed art market, there is the widespread sentiment that artists should play a decisive role in making things better for everyone, rather than just for themselves.

In the same interview, Chatchai contrasted the art world's self-centeredness and obsession with newness for its own sake with the standards of the rest of society: "In the art world, we talk about expression, new movements, new concepts, and extending the boundaries of art. How far can we go? For me, I try to think about sincerity, truth, honesty, and integrity— things respected in other parts of our society, which never seem to exist in the art world. I think that these values will enable our art community to contribute to society. Why is our self-indulgence, concern for advancement, activities, and presentation—which we consider as avant-garde—considered to be 'development'?" [15]

A preparedness to question the progressive holy cows of the western artistic canon (and, by extension, its social and political ideas) has distinguished

the whole of Chatchai's mature work. With his artist-and-activist friends Vasan Sitthiket (b. 1957) and Manit Sriwanichpoom (b. 1961) he shared a strong sense of disgust at the dishonesty, exploitation, and political chicanery he saw everywhere around him. Yet, unlike his friends, the ways in which he expressed such sentiments in his art were oblique rather than confrontational.

The central motifs that appear throughout Chatchai's mature work are his own face, his conflicted personality, and his body, out of which he has created a wide range of *dramatis personae* who play out different roles and significations within a 21st-century masque. Like its European brother, the *commedia dell'arte*, Chatchai's satirical theater of the world and its morals has revolved around archetypical characters—in this case such figures as the Thai everyman, the wounded lover and artist, the ironical commentator, the coyly hermaphroditic ladyboy, the drooling hypocrite, the subversive avant-gardist, the impotent old man, the infantile provocateur, and many others. From the beginning of the 1990s in different guises, alliances, and mutations, these characters have appeared repeatedly throughout Chatchai's paintings and sculptures.

From the few early works that have survived from the late 1980s, we can see that this approach emerged out of a wasteland of what seemed to be irreconcilable opposites—object and image, painting and sculpture, abstraction and engagement—and, for a time, Chatchai seemed unable to choose between the different paths that lay open to him. This impasse lasted until 1991 when, as was to become his regular habit, he broke off from making work for over a year, to emerge in August 1993 with a series of large, almost mural-like, paintings that criticized different aspects of Thai reality and identity. The curtain had been raised, the masque had begun: it was in this group of works that the theatrical figure of "Chatchai the artist" first began to appear.

These disparate manifestations of Chatchai are different from the more direct political caricatures that can be seen, for instance, in Vasan Sitthiket's installation *Shadow Play* (2007), or in the earlier performances of the Indonesian artist Heri Dono (b. 1968) that criticized local and international power politics through the medium of the traditional, popular *wayang kulit*.[16] **(see pp. 248–253)** Chatchai's quasi-pathetic, neo-expressionist, semi-autobiographical style, and large scale had more in common with German painter Georg Baselitz's (b. 1938) *Heldenbilder* ("Hero Pictures") from the mid-1960s—ironical riffs on the Romantic propensity for hypocrisy and self-pity, these works also targeted the false heroism of Socialist Realism, the proscribed official style of the German Democratic Republic (DDR) where Baselitz had grown up.[17] Like those of Baselitz, Chatchai's paintings referred to and incorporated the great traditions of western art in a continuing, critical dialogue with previous works of art.

Yet the omnipresent, similar but subtly different, figures that appear through his work as a cipher for "Chatchai" also had some of the characteristics of the Pink Man, the ubiquitous Thai figure in the pink suit pushing a supermarket trolley that snakes his way through Manit Sriwanichpoom's photo-works. With avuncular disregard, unchanging and unflappable, he stands at the margins while the atrocities, obscenities, and absurdities that characterize contemporary Thai society seem almost to engulf him. **(fig. 3)**

In the spirit of the political theater of Sergei Tretiakov and Bertolt Brecht,[18] who had both been strongly influenced by the easily identifiable theatrical types of the *commedia dell'arte*, the different "heroes" created by Baselitz, Chatchai and Sriwanichpoom act as triggers that intensify feelings of alienation from terrible events, actual or implied, by inducing the observer to forgo any empathy or sympathy by distancing themselves from the roles and situations which these actors play out. By looking at these worlds dispassionately, underlying causes rather than effects become evident and the harsh realities of power and force are revealed as universal perpetrators

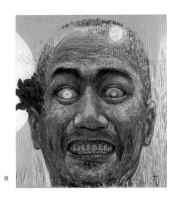

8

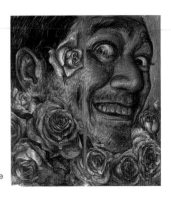

9

8 | **Self Portrait** | 1994 | oil on canvas | 240 x 200 cm | private collection

9 | **May I Come In?** | 1995 | oil on canvas | 220 x 200 cm | collection of the Museum of Contemporary Art, Tokyo

10 | **Siamese Smile: Siamese Intellectual** | 1995 | oil and synthetic polymer paint on canvas | 200 x 300 cm | collection of Queensland Art Gallery, Brisbane

11 | **Paradise Perhaps?** | 1997 | oil on canvas | 240 x 370 cm | private collection

12 | **The Sweetness of Life** | 1999 | oil on canvas | 200 x 850 cm | Kris Kasemsarn Collection

13 | **Hymn of Fire** | 1993 | oil on canvas | 220 x 620 cm | private collection | detail of exhibition.

[19] A Bodhisattva is an enlightened being who forgoes Nirvana to relieve suffering on earth. [20] For a particular account of this legendary phenomenon see the catalogue for the opening exhibition of the Bangkok Art and Culture Center, in 2008, *Traces of Siamese Smile*, curated by Apinan Poshyananda. [21] Chatchai Puipia in *Khao Nok, Oak-Nai: Selected Interviews and Thai Art Contemporary Articles, 2003–2005*, Bangkok, 20.05, p. 40. [22] About this work, Chatchai once said, "I'm not a good storyteller, and my story isn't clear anyway. But through my paintings I hope to find a path in life." Pettifor, op. cit., p. 88. [23] *Sweetness of Life* (200 x 850 cm) is over twice the length of Gauguin's frieze. [24] The critic and poet Charles Baudelaire (1821–1867) published his essay *Le Peintre de la Vie Moderne* ("The Painter of Modern Life") in Paris, in 1863.

of tragedy and suffering. The difference between Chatchai's and Manit's work, however, is clear, in that the Pink Man remains blandly the same whatever confronts him, whereas the figure of "Chatchai" morphs, adopting many different masks, attributes, and avatars, each with their own histories and iconography.

The imagery of Chatchai's paintings at the start of the 1990s was simple and almost consciously stereotypical. The large figure of an elephant (a national symbol) was taken over from earlier constructions to appear in a painting with a flaming lotus on its back. Fire dropped from the skies as if in an apocalypse, while also echoing the iconography of the peaceable descent of a Bodhisattva to earth in traditional Buddhist art. [19] But the overall impression is one of dislocation, disjuncture, and distress, as the artist gravitated towards a form of determinedly ambiguous conceptualism in which disparate objects, motifs, and spatial systems were collided together in order to create non-hierarchical networks of mythic intensity.

In these early paintings, as well as in his subsequent three-dimensional works, Chatchai created a conceptual distance between himself and his public in which his characters and objects are appreciated for their allusive incongruity rather than for any direct symbolism. At face value, they may seem banal yet, incorporated within the framework of this comedy of manners, they become both celebrations and indictments of folly. Such works characterized Chatchai's first solo exhibition "Hymn of Fire," held in 1993 at the Silom Art Space in Bangkok. **(figs. 4, 5, 13)** Together they created a self-doubting—even self-loathing—manifesto about the nature of art and its relation to life, as well as about how it expressed different forms of identity and even questioned set gender stereotypes.

The importance of this exhibition was attested to by the fact that Chatchai continued to develop ideas and motifs from it in his subsequent work. In one of these, the ironically entitled *Last Action Hero* (1993), he lies dazed, half naked on his back, his bed floating on a cloud. **(fig. 6)** The disembodied, isolated form of his raised, crossed legs was subsequently recycled as the main motif for his painting *The Sweetness of Life* (1999), **(fig. 12)** that in turn provided the idea for the large bronze sculpture of the same subject, *Wish You Were Here,* not made until 2007. **(fig. 15)** This image, now elevated to the status of an icon, also became the logo for The Leg Up Society, a group of artist-friends who gathered together for an exhibition at the 100 Tonson Gallery in Bangkok in late September 2008.

Both in his "original" painting and in his later bricolages of edited images and sculptures, Chatchai comments tartly on the indolence of "life in the tropics" and, by extension, on the inability of Thai people to organize themselves efficiently, either socially or in politics. The painting *Last Action Hero* may also conceal a kind of teasing Giorgioni-esque riddle: as shooting stars rain down above its mysterious central, prostrate figure, in the far distance another more threatening cloud approaches. Perhaps a storm is coming? This work, like many others made at this time, is an allegory of the difficulty, even the danger, of unbridled creativity. It also touches on the impossibility of netting reality as a specimen in art.

The ambiguities and difficulties of creation may also be sensed in *Hymn of Fire* (1993), another key painting from this eponymous exhibition. Here, the artist's naked alter ego squats, staring directly at the viewer, holding his back with one hand in an awkward expression of either discomfort or pain, and, not without a touch of comedy, looking as if he were about to defecate. His bent form occupies most of the considerable height of the canvas, the background is dark, nonspecific, and on the ground a small fire (referencing other works in this series) appears more to warm the artist's backside than to make a transcendent or metaphysical reference. **(fig. 13)**

The Game of White (1993), also shown there, collides the highbrow ambition of creating what could be described as a specifically Thai contemporary art with the reality of the inbred bias of the Greco-Roman aesthetic, beaux arts tradition

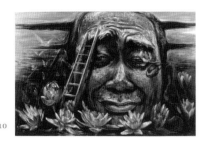

that was embedded in the art schools: half-naked in a sarong, the artist gazes moodily and uneasily ahead in a room full of Greek classical statues that appear to be generating their own divine creative fire. There is an ironical sense here of disappointment, of belatedness, of having missed the boat, even of the impossibility of progress itself. By focusing on the absurdity of historical pretence, Chatchai perversely challenges the necessity and relevance of the things he most admired but had also begun to detest. In essence, as the title of the work implies, it seemed as if contemporary art was implicitly racist.

Looked at together, these works may be understood as not only as idiosyncratic meditations on the powerlessness and insignificance of art and the artist when faced by the immensity of history and life, but also as comments on the fallacy of "otherness" and the perspectival chasm between Europe and Asia. Differences between histories, physiognomies, cultures, perspectives, and ideals of beauty were emphasized. Shown here under the artist's laconic gaze, everything seemed to be frozen by the seemingly insurmountable dominance of the past.

During 1994, Chatchai continued to explore these themes in works that were shown in his next large exhibition, "Take Me Somewhere, Tell Me Something." (fig. 7) Here the figure of the artist is sometimes drawn roughly over newspapers and advertisements, but it also appears painted on a large scale surrounded by comic workers and fallen angels who, under moonlit skies, gesticulate in bizarre or grotesque poses. The following year, Chatchai moved to Japan on a scholarship and started the series known as "The Siamese Smile."[20]

These expressionistically painted, super-sized, skull-like heads, showing the artist's physiognomy in different grotesque contortions, reinforce the idea that the "joke" that had occasioned the smile had been wearing considerably thin. Like the figure of the elephant that has appeared in his earlier work, the simpering, usually female, Thai Smile had become a kitschy national symbol that was aimed at tourists, but Chatchai discouraged the idea that these works should be regarded as a critique of Thai culture.[21] Rather, he regarded them as marking the beginning of a number of close-up self-portraits that have a much broader frame of reference and, as was the case with his citation of Gauguin when considering his own and other people's "otherness," they also were set in a long tradition of western "existential" self-portraiture that includes the paintings of Rembrandt, Frans Hals, Van Gogh, Cézanne, and Francis Bacon. (figs. 8–10)

In this respect, Chatchai's inverted, grudging admiration for Gauguin is critical, particularly in his conscious melding of different cultural influences, traditions, and motifs into a single existential question. The resulting works were, like Gauguin's own, a kind of open-ended pictorial *Bildungsroman*, as well as an ironical expression of his own sense of alienation, anguish, and desperation.[22] Gauguin's seminal Tahitian frieze, and intended last testament, *Where Do We Come From? What Are We? Where Are We Going?* (1898) provided the starting point for Chatchai's next important exhibition, "On the Way to See Buddha, Encountered Gauguin Passing By, I Think Twice," held at the Chulalongkorn University Art Center in 1999. (fig. 1) The works shown here mark a move away from his style of painting of the mid-1990s, when his image-making was still smooth and symbolically literal, towards a more anguished and acidic approach, using distorted, "illogical" close-ups, often with the artist's decapitated head as a central motif. In "homage" to Gauguin, he also started to use the form of the frieze in such vast equivocations as *Sweetness of Life* (1999) in which, again, he cannibalized motifs from his own previous paintings in order to recreate a dark and grotesque impression of the fragile interval from birth to death.[23] (fig. 12)

Echoing the piquancy of Gauguin's loneliness in the South Seas, Chatchai felt that he stood alone in Bangkok but, unlike the French interloper, he was the authentic native and therefore in a position to eschew and satirize the exotic. Both artists, however, had chosen to live their lives in a Baudelairean fashion,

14

15a

15b

like flâneurs—dandies—detached, yet commenting on the world at large, telescoping time, space, and cultural tradition for their own purposes into an interrogation of what it really felt like to be a painter of (post-)modern life.[24]

Yet, once we have been drawn into his world, Chatchai's grotesque, self-deprecating humor drives us back from the gilded halls of western art history to deposit us firmly in the here and now. The doppelgänger of Chatchai's heroic-pathetic self-portraits is a series of paintings begun in 1997 with the large work *Paradise Perhaps* (1997) **(fig. 11)** and continued in the large and small versions of the sculpture *Better Than Ever?* (2008). **(fig. 2)** The motif that dominates these works is no longer the now-familiar crossed legs of *Wish You Were Here* (2007) but a close-up of the artist's buttocks and balls with his face peering distantly between his legs. This humorous but shocking image encapsulates Chatchai's understanding of power, past, present, and future, as well as his irreverent relationship to the world in both Thailand and outside. Just as his earlier self-portraits communicate an ambiguous range of different personal, cultural, social, and geopolitical responses to the proposition "I have been shafted," so this series of works lays down both a challenge and an offer: "shaft me." If seen as a challenge, the mooning of the buttocks is an affront, a calculated insult that reflects the viewer's impotence. But if it is seen as an offer, this gesture becomes a self-lacerating license for the viewer to ravage. In true Bangkok-Brechtian style, Chatchai manipulates his body as both an icon and symbol—as a form of bait. Unsuspecting observers are quickly entrapped by being asked to contemplate not only the significance of his gestures but also the nature of their own positions and desires—both in relation to Thailand and the wider world.

Immediately before Chatchai's untimely demise, the image that dominated his self-portraiture had, like the crossed legs, appeared initially in painting and then subsequently surfaced in sculpture. It is based on Velázquez's famous *Portrait of Pope Innocent X* (1650), which during the early 1950s had been the inspiration for Francis Bacon's studies of screaming Popes. But in his works, Chatchai reveals himself with an oversized head and twisted dwarf-like body contorted within the confines of a papal throne. This character's first solo appearance was in the painting *Dedicated to the One I Love* (1999), and he was brought back in 2008 in a series of polychrome bronzes, with an enigmatic Buddha-like head, crab-like hands and scrawny legs. **(fig. 14)** This expressive figure is both arrogant and quizzical, although its grotesque form seems almost like a creature from a science-fiction film in which its humanoid head is too heavy for the alien life form that supports it.

This uneasy, again sadomasochistic, self-questioning gaze characterizes Chatchai's later work and expresses his awareness that the ultimate existential tragedy is an inability to transcend physical limitations to realize our ideals. Like a majestic dinosaur or an ancient king or pope, in his twenty-work series of oil paintings "The Heart is a Lonely Painter" (2006) he manifests the carnal attributes of his power and experience as if they were diadems. In these late works, he literally holds his bleeding heart in one hand, with either a cigarette, or his amputated penis, in the other ... **(fig. 16)**

Is this man damaged, bleeding, crushed by existence? *Perhaps.* Is he whining, daunted, afraid to look forward? *Never.* Is he humorous, ironical, terminally self-aware? *Always.* And what can we read in the artist's eyes: that self-pity is futile; that there is no such thing as the straightest path; that however twisted our route may be, we just have to smile and get on with it; that the biggest joke of all was the way Chatchai "died"? *Whatever they tell you, it can always get worse.*

Reveling in the primacy of the current moment, this guarded optimism is his final legacy. Although he may no longer be with us, the harshly disquieting, particularly Thai, balance of reality with possibility presented in his work provides us with a key, a plot, and a future for Chatchai's inscrutable but coruscatingly honest masque of experience and life. ●

14 | **Dedicated to the One I Love** | 1999 | oil on canvas | 180 x 150 cm | private collection

15 | **Wish You Were Here** | 2007 | a the large version is installed in central Bangkok | b the small version is shown with **Mr Puipia** (2007), three small self-portrait busts | 100 x 120 x 55 cm | private collection

16 | **The Heart is a Lonely Painter** | 2006 | oil on canvas | a 280 x 180 cm | b 280 x 180 cm | c 300 x 190 cm | private collection

16a

16b

16c

Rodel Tapaya
"The One You Feed"

Although I had been aware of the diverse rootedness of contemporary Filipino art since my first encounter with it at the 1st Asia-Pacific Triennial in Brisbane in 1993, this meditation on the work of Rodel Tapaya was the first time I had written about it and coincided with my reexamining the thoughts of Karl Marx in the light of current globalization. It followed an exhibition of Tapaya's work at Arndt Berlin in 2014 and was published in a monograph produced by Distanz Verlag in 2015. Rodel Tapaya was born in 1980 in Montalban, Rizal, Philippines; he lives in Bulacan, Central Luzon.

The need of a constantly expanding market for its products chases the bourgeoisie over the entire surface of the globe. It must nestle everywhere, settle everywhere, establish connexions everywhere...

The cheap price of commodities ... [compels] all nations, on pain of extinction, to adopt the bourgeois mode of production; it compels them to introduce what it calls civilisation into their midst, to become bourgeois themselves. In one word, it creates a world after its own image.

– Karl Marx and Friedrich Engels, 1848 [1]

Take up the White Man's burden—
Send forth the best ye breed—
Go bind your sons to exile
To serve your captives' need;
To wait in heavy harness,
On fluttered folk and wild—
Your new-caught, sullen peoples,
Half-devil and half-child.

– Rudyard Kipling, 1899 [2]

I. A Long Story, Not Yet Finished

It may seem eccentric, if not perverse, to preface an essay on the work of Rodel Tapaya, a 34-year-old artist born and living in the Philippines, with quotations from Karl Marx and one of Rudyard Kipling's most offensive imperial poems. Yet, there is a method here, and strong links can be established between all three. From vastly different perspectives, these texts and Tapaya's work are emblematic of still-unfinished stories of colonization, capitalism, and globalization that have contributed to a massive erasure of memory and sense of values. Firmly rooted in the present, Tapaya has grown up with, and reacted against, this relentless process—the impulse for destruction prophesied by Marx and lauded by Kipling. Touching on history, politics, psychology, economics, culture, ecology, and national identity, Tapaya's paintings not only question narratives that try to make everything the same, but also focus on the ways in which they have exerted a grip on how "we" (whoever "we" are and wherever "we" are situated) view the world. He does this—consciously and intuitively—by creating spaces for new myths and stories—and recycling old ones—in order to present different choices from those we are conditioned to make.

Tapaya's neo-traditional world of ghosts, allegories, and symbols is rooted in common experience and reflects values relating to "human" rather than "bourgeois" interests. Yet in a country as diverse as the Philippines, that for centuries has been subject to successive waves of migration and colonization, the nature of common experience is difficult to define and has too easily been compounded into opposing clichés of solidarity or otherness. The definition of a thing in the terms of what it is not is a familiar ruse by which power seeks to legitimize itself. Tapaya does the opposite by forging networks of associations and ideas that are built on his experience and critical perception.

1 | **The Magic Show of the Haciendero Magician** | 2007 | acrylic on burlap | 122 x 91 cm | courtesy the artist and Arndt Art Agency (A3)

[1] Karl Marx and Friedrich Engels, extracted from "Chapter 1. Bourgeois and Proletarians," *Manifesto of the Communist Party* (1848). Translated from German by Samuel Moore in co-operation with Friedrich Engels in 1888. [2] Rudyard Kipling (referring to the US colonial subjugation of the 1st Philippine Republic), first verse from *The White Man's Burden* (1899). This peon to western imperialism was written in acknowledgement of the US subjugation of the short-lived 1st Philippine Republic during the Philippine-American War of 1898–1902.

2

[3] In 1521, explorer Ferdinand Magellan first claimed the islands that comprise the Philippines for Spain. He was killed in a skirmish on the small island of Mactan near Cebu in the same year, and his second-in-command, Juan Sebastián Elcano, took over the expedition to complete his circumnavigation of the globe. In 1542, Spanish explorer Ruy López de Villalobos named the islands after Spanish king Phillip II, and in 1565 the first Hispanic settlements were formed in Cebu. By 1571, Manila, on the northern island of Luzon, had become the capital of the Spanish East Indies, a trade hub serviced from Mexico that dispatched Chinese porcelain, lacquerware, and later tea, to the Americas and Europe, in return for corn, chili peppers, tomatoes, potatoes, and pineapples. [4] The Philippine Revolution against the Spanish began in 1896. The Spanish-American War lasted for ten weeks during 1898 and was initially occasioned by American intervention in the Cuban War of Independence. It ended, to the benefit of the US, with the Treaty of Paris (1898) that allowed temporary American control of Cuba and indefinite colonial authority over Puerto Rico, the Philippines, and Guam. After defeat, the departing Spanish troops handed over power to the incoming American forces, ignoring the Philippine revolutionaries. [5] The Philippine-American War (1899–1902) took place between the United States and the revolutionaries who had independently declared the First Philippine Republic (sporadic resistance continued until 1913 by Muslim insurrectionists in the southern island of Mindanao). This guerrilla war was bitterly fought on both sides and the Americans used torture (including waterboarding), concentration camps, and indiscriminate massacres of civilians to intimidate the Philippine people and its army. In retaliation, Filipino soldiers also committed atrocities against US prisoners of war. Some historians have regarded this war as a defining moment in the evolution of US national identity and foreign policy that continues to have an impact on the present. See Matthew Frye Jacobson, *Barbarian Virtues: The United States Encounters Foreign Peoples at Home and Abroad*, 1876–1917, New York, Hill and Wang, 2000. [6] The title of this work in Filipino is *Ang Palabas ng Hacienderong Salamangkero*; the name of the exhibition is "Perya" ("Carnival"). [7] The title of the painting *Kinakawowee* is made up of a play on two words: *Kinakawawa*, meaning someone who is causing another person to look miserable or pitiful, and *Wowowee*, the name of a popular TV show. Rodel Tapaya, email to the author November 4, 2014. [8] The occupying American army regarded the Filipinos as "negroes." This unsettled many of the 7,000 African-American forces who had been sent to serve in the Philippines, as they felt that they had been enlisted in an unjust racial war. Some deserted to join the Philippine forces. Contemporary documentary accounts are available in Arnaldo Dumindin, *The Philippine-American War 1899–1902*, www.philippineamericanwar.webbs.com. [9] In 1946, after independence, it was planned to regenerate the economy by developing the country's largely unexploited mineral and natural resources. In 1965, such hopes were put on hold for the next twenty years by the corrupt autocracy of President Ferdinand Marcos and his flagrantly kleptocratic wife Imelda, who, while staunchly supporting US foreign policy, plundered the country for their own gain while imposing widespread censorship, violent suppression of political opposition, and violations of human rights. Once an increasingly disgruntled populace had restored the rule of parliamentary democracy, haltingly the country again began to right itself. [10] Out of a total population of 100,618,000 (2014), nine percent is Protestant and a further five to eight percent is Muslim. [11] In the 1987 Philippine Constitution, Spanish, along with Arabic, is categorized as one of two "Optional Languages."

II. Portraits of Malevolence, Power, and Fear

Within the pattern of the colonial development of Southeast Asia, the Philippine experience is particular: it is the only country in the region colonized in the 16th century, when the Spanish explorers first set foot on the islands, until it was "granted" independence from the United States as part of the new system of power and alliances that followed the end of the Second World War. [3]

Oblivious of, but none the less participating in, what Marx described as an expanding world market, the Philippines nestled within the bosom of an increasingly sclerotic Spanish Empire until the fading years of the 19th century when, unsettled by indecision in Madrid and revolutionary unrest in Havana and Manila, Spanish forces were defeated in a brief, relatively un-bloody war with an increasingly expansionist United States. [4] As a result in 1898, as one of the stipulations of the Treaty of Paris, Spain was forced to cede this territory to a new colonial master in return for the princely payment of USD 20 million dollars.

But the citizens of the Philippines thought otherwise. Revolutionaries who had supported the US in their war against Spain now rapidly declared an independent First Philippine Republic and refused to welcome the Americans whom they felt had turned against them. A bitter, bloody, and strangely prophetic guerilla war with the US ensued that, in its now familiar combination of superior firepower, blatant abuses of human rights, and violently self-righteous hypocrisy, still resonates in many present-day conflicts. [5]

Sometime in 1899, an American photographer snapped two Filipina women, one of them carrying a baby, "begging for food" at an American army encampment. An unusually ambiguous photograph for its time, it shows neither the rictus grins of phalanxes of winsomely posing troops, nor the piles of corpses that, according to their nationalities, could denote either an atrocity or rightful retribution. These small, poor, barefoot peasant women are obviously frightened and dwarfed by the armed soldiers who surround them. The soldier in control returns their gaze, leaning heavily on his rifle. Three others, standing behind, look sullenly on, waiting. It is an unsettling portrait of power and fear. (fig. 2; p. 160, fig. 1)

A gaze of malevolence characterizes the face of the tall young soldier who, unconsciously hogging the center of the photograph, stands directly behind the two young women. (fig. 3) It sticks in my mind because this look seems eternal, connected with neither place nor time, and derives its disquieting power from an unquestioning belief in its own entitlement. I recognized this gaze again in *The Magic Show of the Haciendero Magician* (2007), one of Tapaya's earliest paintings, first shown in an exhibition called "Carnival" as part of a series of works showing people "enjoying" themselves at a fairground. [6] (fig. 1) This work focuses on the rolling eyes and vulpine teeth of a magician—in fact, a wealthy landowner who abuses and exploits his tenants—who, accompanied by his gorgeous assistant, pulls not a rabbit out of his top hat but, with a malevolent flourish, a vampire bat—to the puzzled but obvious delight of his strangely masked, half-animal audience. In this neo-gothic scene, the moon, masked by scudding clouds, picks out a billboard with the legend *HORROR RIDE* painted on it. Not only does Tapaya present us here with his sardonic view of the "law of the jungle," pulling "out of his hat" contemporary society and politics in the Philippines, but also, using the allegory of the fairground or carnival (a convention deeply rooted in European *commedia dell'arte*), he transcends topicality to encompass human values that can easily be recognized in any place at any time. Tapaya's carnival presents an implicitly subversive, bottom-up view of culture and life that criticizes dominant structures of exploitation and power by turning them on their heads.

The sense of foreboding is intensified in *Airplane Ride* (2007), a painting from the same series of works, in which terrified figures whizz by in small metal planes on armatures high above the fairground. A man, his mouth gaping wide and hands thrown up in what appears to be real rather than vicarious horror, occupies the foreground while in the plane immediately behind him, decked in an American Stars and Stripes, another figure covers his eyes. The nose and propeller of a third plane hovers into view showing a fragment of a Japanese flag. It is difficult to judge whether Tapaya is making a reference here to painful histories or to the fact that both the US and Japan are currently key destinations for overseas Filipino workers. The likelihood, however, is that he is referring to both, as throughout Philippine history, as well as in his work, the present takes form as a surreal echo of the past.

Poverty with its obese doppelgänger—the empty dream of materialism—is the central subject of *Kinakawowee II* (2007), a painting in which an elderly woman, a winning contestant in a popular noon-time television show, dodders onto the center of the stage to receive her prize.[7] (fig. 4) The compère brandishes a wad of money, a vapid grin, and a microphone, but her family, also on the stage, seem alarmed and one appears to be praying. Placards with the names of different countries, along with familiar cartoon characters, pepper the enthusiastic audience: Mickey Mouse lurks in the background while Ronald McDonald has nabbed a ringside seat. This ship of fools, fueled by the brain-sapping benzine of globalized entertainment, in honor of which a poor, untalented grandmother is, like a circus animal, forced to dance pitifully for a pathetic cash prize, churns an overwhelming tide of perplexity in its wake. It is as if the voice of an unknown, unheard figure is drowned out by the roaring ocean: "Oh what on earth will become of us!"

III. The Filipinos' Burden

In *The White Man's Burden*, convinced of the West's duty to assert its moral superiority over others, Rudyard Kipling made an appeal for the US to temper its instinctive isolationism by extending its doctrine of Manifest Destiny (the justification for previous border wars against the Indians and Mexicans) into a more general mission to "civilize."[8] The Filipinos felt little need for such an offensive form of civilization yet they had little option but to endure it, rather as if it were a typhoon, an earthquake, or some other natural disaster.

An examination of what the Spanish left behind and the Americans brought with them in 1898 throws light on what kinds of "burden" that the Filipinos had no choice but to shoulder. Yet, since independence they have undoubtedly added much more weight to it of their own.[9] The Catholic religion is firmly placed at the top of the Spanish legacy; its festivals are still fervently observed by over 80 percent of the population and many others go along for the ride.[10] Through intermarriage this legacy was also encrypted in people's genes and names, as well as in the remnants of a feudal class system, and it is also still expressed in the colonial art and architecture that has survived. Occasionally, it is still revealed through an educated interest and sympathy for things Hispanic as well as in the use of the Spanish language.[11]

In addition to the Americans' insensitive ethnocentricity and English lingua franca (with Filipino, one of the two official languages), they presided over nothing less than the advent of modernity to the Philippines, including, in 1909, the building of a school of fine arts as an integral part of the new University of the Philippines. To this legacy, a taste for fast food restaurants and a continuing system of international security alliances should also be added. The near defeat of the US in the Second World War, along with the brutal disruption of the Japanese occupation, however, tarnished both the mystique and reality of colonial power of any kind and this, in 1946, culminated in the formation of an independent Philippine Republic.

2 | J. Tewell | American soldiers confront two Filipinas and a baby, begging for food, during the Philippine–American War | 1899 | courtesy the US Library of Congress | see also p. 160

3 | J. Tewell | American soldiers confront two Filipinas and a baby, begging for food, during the Philippine–American War | detail

4 | **Kinakawowowee II** | 2007 | acrylic on burlap | 152 x 183 cm | courtesy the artist and Arndt Art Agency (A3)

But when the US first took over, the ideal of political independence, once so close, did not completely dissipate but resurfaced in art and literature, although in an initially muted form. The Mexican muralists, particularly Diego Rivera and José Clemente Orozco, were a strong inspiration as, from the beginning of the 1920s, they had been charged by their government with a nationwide program for decorating public buildings along with the formidable task of synthesizing a visual history of revolutionary Mexico that extended far beyond the Spanish colonists to include the pre-Columbian Indian empires. The muralists cast a stern and critical eye on this rewriting of history, and, during the 1930s after the government had changed, Orozco in particular presented a strong critique of the corruption of the revolution's ideals.[12]

Victorio Edades's large mural *Rising Philippines* (1934), painted with Galo Ocampo and Carlos Francisco, was one of the first Philippine ripostes to the Mexicans. It echoed their allegorical approach but, in spite of its rousing title, had little revolutionary bite. The Philippines was represented as a "Greek" maiden in a flowing white dress presiding over the work, with Spanish influence benevolently symbolized on her right side while the US, on her left, was depicted, without irony, as the purveyor of liberty and democracy.[13]

Although the Mexican model of national myth-making was accepted as part of the discourse of modern Philippine art (and would resurface in the 1980s and 1990s in the work of such artists as Lazaro Soriano and Egai Fernandez), only very recently has it been realized by artists such as Rodel Tapaya that monumentality and clarity of message are only privileged to the detriment of complexity and ambiguity. The reduction of the Mexican approach to a form of heroic propaganda had made it a blunt and useless instrument.

The independent Philippines seemed trapped within a postcolonial time warp in which the worst things from outside were enthusiastically adopted while the few benefits were not widely distributed. Today, it is classed as a newly industrialized country, largely dependent on service industries as well as on the wages returned home by the ten percent of its population that lives and works abroad, often as maids or house servants.[14] Poverty, although slowly reducing, continues to be a critical social problem that plagues over a quarter of the population.[15]

Within the 7,107 islands and thousands of kilometers of jagged rocks and winding inlets that define the Philippine coastline, the "fluttered folk and wild" who live there still communicate through at least nineteen regional languages, often multiply, sometimes using the further 152 recorded living languages. In remote areas, many indigenous groups and tribes remain relatively undisturbed, their traditions largely unbroken by the effects of either colonization or globalization. In spite of predictions to the contrary, and of alarming attacks on its ecology, the diversity within the fragmented land mass, impenetrable jungles, and mountain ranges of the Philippines has enabled it to maintain a distinct but ungraspable image. But it took an artist like Rodel Tapaya to envisage this because the despoliation of nature on every level has started to seem "natural."

IV. Unfluttering the Folk

The sixth of seven children, Rodel Tapaya, was born in the small town of Montalban on the slopes of the Sierra Madre Mountains, an area deeply rooted in Philippine folklore. His parents prepared smoked fish for a living, and there was little talk of art at home. He first started making drawings at the age of ten but only four years later, after he had been attracted to the Old Masters through books and won a number of prizes in art competitions, did he realize he had a deeper interest in art. His mature work is informed by a constant sense of discovery that echoes his early years. It is as if he discovers his own feelings and relationships with the world outside through the regular daily process of working in his studio.

5 | **The Origin of Rice** | 2006 | acrylic on canvas | 183 x 152.4 cm | courtesy the artist and Arndt Art Agency (A3)

6 | **Cane of Kabunian, Numbered but Can't Be Counted** | 2010 | acrylic on canvas | 305 x 610 cm | The Tiroche de Leon Collection and Art Vantage PCC Limited

7 | **Cane of Kabunian, Numbered but Can't Be Counted** | detail

[12] See Orozco's different mural cycles made during the 1930s and '40s in Guadalajara in David Elliott (ed.) *¡Orozco!*, Oxford, Museum of Modern Art/New York Abbeville Press, 1980. [13] Ahmad Mashadi, "Some Aspects of Nationalism and Internationalism in Philippine Art," in TK Sabapathy (ed.), *Modernity and Beyond: Themes in South East Asian Art*, Singapore, Singapore Art Museum, 1996, pp. 45, 59. [14] These people are known as overseas Filipino workers (OFWs), and their remissions were in 2012 estimated to be at 8.6 percent of the national GDP. Doris Dumlao, "OFW Remittances to Increase by 8.5% in 2014—Standard Chartered," *Philippine Daily Enquirer*, January 13, 2014. This amount will surpass funds from foreign direct investment. [15] The current population of the Philippines is estimated at 100,617,000. According to the National Statistical Coordination Board, 27.9 percent of the population fell below the poverty line in 2012. Quoted in Justin Calderon, "How Feudalism Will Undo the Philippine Elections," *Inside Investor*, April 30, 2013. See also p. 217, fig. 9 for Chinese artists Sun Yuan and Peng Yu's work on Filipino domestic labor in Hong Kong. [16] "Rodel Tapaya Mines Filipino Folklore for 'Ladder to Somewhere,'" *Blouin Artinfo Southeast Asia*, April 3, 2013. [17] Ibid. [18] Geronimo Christobal, Jr., "Between Gods and Men," *Rodel Tapaya: Visions of Lore*, Galerie Caprice Horn, Berlin, 2011. [19] Damiana Eugenio, *Philippine Folk Literature – The Myths*, Manila, 1994. William Henry Scott, *Cracks in the Parchment Curtain and Other Essays in Philippine History*, Quezon City, New Day Publishers, 1982. [20] "Folkgotten: Myths and Tales," the first exhibition of this work, was held at the Vargas Museum in the University of the Philippines at Diliman in February/March 2008. [21] Alice G. Guillermo, "Folk Wisdom in Images," *Business Mirror*, Manila, February 16, 2011. [22] These works were shown in "Diorama," a solo exhibition at the Drawing Room in Makati City in 2009. [23] *Bastan ni Kabunian, bilang pero di mabilang Bastan ni Kabunian, bilang pero di mabilang* (2010), acrylic on canvas 340.8 x 609.6 cm. See also Lito B. Zulueta, "Rodel's 'Ladder': Tapaya Builds Intercourse Between Myth, Art and Reality," *Philippine Daily Enquirer*, Manila, April 15, 2013.

Akin to many Latin American authors, he has been described as a magical realist and, from 2006, began to take a strong interest in this literary genre, particularly the novels of Gabriel García Márquez. Yet he had to learn to compress a whole book within the scope of a group of interlinked images, joined together within a single pictorial plane. In response to this, he has described how when reading stories such as folktales or myths, "It makes my imagination explode with images. Since there is no specific archetype or image assigned to each tale, I have the liberty to imagine and give them form myself."[16]

This freedom he has also granted to his audience who, even if they are Philippine, may not be familiar either with the multiple stories that surface in his works or how they relate to each other, both integrally and across different paintings: "People can look at the works and make [up] their own stories . . . [They] need not be narrated literally but can be felt visually."[17] For these narratives there is no single "correct" reading, merely a range of pleasing or plausible ones.

By 2008, his dissection of contemporary Philippine experience had moved decisively from what had been described as the "fictionalized" approach of his previous work to a more magical, "fictional" vision as he began to focus on the illegal deforestation and mining that was beginning seriously to affect not only the land itself but also the communities who lived off it.[18] Fascinated by how plays on words could create multiple meanings that he could refashion into syncretic, surreal images, he started to research ancient myths, folk tales, and traditional sayings, initially around the area of Northern Luzon where he lived, but later expanding to other parts of the country. His inspirations for this were the extensive compendia of Philippine folklore assembled by the ethnologist Damiana Eugenio as well as the writings on the pre-colonial Philippines by historian and anti-Marcos activist William Henry Scott. Both served as starting points and continuing sources of reference for his work.[19]

Tapaya's paintings started to become larger—in some cases taking on the scale of murals—as he moved from using rough burlap as a support to a more finely grained canvas. This marked the beginning of an elaborate, gradually shifting, fantastic morphology that, moving between different stylistic and narrative forms, continues in his work to the present.[20] In his role of storyteller—of creation myths, cautionary tales, and the impact of everyday idiocies—he teeters between hubris and nemesis in densely layered tableaux that telescope time by bringing together long-forgotten myths with the actions of blackguards, buccaneers, thieves, and holy men, all composed within an intensely colored framework of arabesques—visual and mental.[21]

In 2008 and 2009, while making his first folkloric paintings, Tapaya was looking through books on illustration and design to see how strongly colored, simple patterns and motifs could be brought together in complex spatial combinations. He also started to make a series of "Story Houses," small three-dimensional tableaux, hybrids of domestic Catholic altars (*retablos*), museum dioramas and surrealist collages that explored ideas that were reiterated in larger paintings.[22] These are typified by such works as *The Origin of Rice* (2008), based on a myth from the northern Ibaloi tribe, (fig. 5) or *The Origin of Mountains* (2008), a story about Kabunian, the rice god, and Lumawig, his son, that have flat, planar spaces that bring together different textures and forms that, rather in the manner of Catholic ex-voto paintings (or altars), provide frameworks for fantastic and more or less coherent narratives. Other paintings like *The Banquet* (2008), depicting a ghostly, bloated profiteer tucking into a sumptuous feast in the depths of thorny, vine-smothered, smoldering jungle, hark back to the direct social criticism of his earlier "Carnival" paintings. The sense of carnival is developed further in the sinuous lines of his new mythological characters who, like spectral harlequins or wandering *saltimbanques*, flit nervously across his densely drawn surfaces.

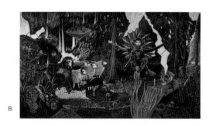

The climax of this body of work was the over six-meter-wide *Cane of Kabunian, Numbered But Can't Be Counted* (2010), (figs. 6, 7) his largest mythological painting to date, for which in the following year he won the coveted grand prize in the Asia-wide Signature Art competition.[23] Made at a time of devastating monsoon floods aggravated by illegal deforestation, Tapaya describes this work as "a riddle about rain." Its central figure is the giant dog who in Bontoc myth saved humans from the Great Flood, aided by the benevolent figure of Kubunian who formed mountains out of a piece of cloth that also warmed humanity. But within this chronicle of good deeds, Tapaya also issues an iconographic warning of which the greedy perpetrators of present-day disasters should be aware: a cautionary Tagalog fable tells the story about a glutton who was turned into a frog.

During 2010 Tapaya felt that he was becoming increasingly entrapped within the dense jungles of his own creation and wanted to "loosen up" his painting to allow for "more fluid and dark themes."[24] For a time, he moved away from myth and folklore in favor of an expressionist palette and orthogonal plunging perspectives in which monochrome, usually grey figures, tensely huddle. In their rhythmic line these characters recall both Orozco's drawings of Mexican peasant women and Edvard Munch's dancing Norwegian country girls. The hunched gray shadows in *Dancing in the Moonlight* (2010) conjure the melancholy angst of an enclosed rural nightmare, while the pink striations of the "El Greco" figures in *Hot Topic* (2010) reflect not only unbearable midday heat but also blistering political argument in the lead up to an election.[25]

These were followed in 2011 by paintings that returned to mythology, but with a new feeling of weightlessness. This fusion of "sky world" with human nature takes place over different, brightly colored, decorative grounds onto which the artist situates figures, scenes, and fragments of landscape as if they were in dialogue.[26] Some works, like *Foreknowledge* (2011) echo motifs from the early Italian Renaissance, particularly the works of Botticelli, while others such as *The King's Bridge* (2011) bring together quotations of passages from such post-impressionist artists as Van Gogh and Gauguin. Manama, the red, clown-like figure wearing what looks like a deep-sea diver's helmet sitting on the stump of a dismembered tree in *The Origin of the World* (2011) ironically enacts the creation myth of the southern Manuvu people. By rubbing two sticks together, he makes fire, creating the energy to transform parts of his body into the different elements of the universe. Tellingly, the dirt under his fingernails will become the world and its inhabitants.[27] In *Homecoming* (2011), a mural-like, over three-meter-wide panel, Tapaya imagines the complex journey of the gods from the sky as they track through the dark luxuriant foliage of the world of ancestors and mortals. But everything is floating, almost imperceptibly, on a golden ground of whirling flowers and stars.

Tapaya further extends the visual poetics of his spiritual, human, and natural pantheon by experimenting with different kinds of perspective. This enables him to express different worlds within the same work: "western" vanishing points find themselves juxtaposed with "Asian" layering of flat planes together with the "South Asian" *tabulae rasae* of decorative colored grounds. During 2012 he first read *Myth and Meaning* (1977) by the French structural anthropologist Claude Lévi-Strauss, which confirmed his own work process through its bringing together of pre-modern systems of knowledge and belief with changing perceptions of reality. In contrast with the unconnected, sometimes dysfunctional, symbologies of CG Jung's collective unconscious, Lévi-Strauss's view of myths as expressions of complex "bundles of relations" seemed to describe perfectly the "linguistic" approach of Tapaya's new work.[28]

Within the different spaces of increasingly anthropomorphic jungles, mountains, and plains that comprised the system of a single painting, he now began to articulate series of polyphonic, open-ended dialogues that could

8 | **Multipetalled Beauty** | 2011 | acrylic on canvas | 244 x 427 cm | private collection, Indonesia

9 | **Modern Manananggals** | 2013 | seven pairs, male and female | encaustic on fiberglass resin, wood, and engraved tin sheet | 33 x 33 x 147 cm (each upper torso); 23 x 20 x 147 cm (each lower torso) | installation view of "Rodel Tapaya: Bato-Balani" | Ateneo Gallery, Quezon City | 2014

10 | **The First Beings: The Ten Headed Creature, The Mediator, The Supreme Planner** | 2014 | acrylic on canvas | 213 x 152 cm each | Deutsche Bank Collection, Frankfurt

[24] Rodel Tapaya, email to the author, November 5, 2014. [25] This series of work was shown in the exhibition "Rodel Tapaya: Believe It or Not" at the Pintô Art Gallery, Antipolo City, Philippines, in 2011. [26] Many of these works were illustrated with detailed notes in the catalogue for the exhibition "Rodel Tapaya This Beast I Have Become," held at the Y ++ Gallery, Beijing, in 2011. [27] Rodel Tapaya, email to the author, November 5, 2014. [28] Claude Lévi-Strauss, *Structural Anthropology*, New York, Basic Books, 1963, p. 211.

be interpreted on many different levels. The idea of the journey or quest becomes an important leitmotif within this "language." In *Biag ni Lam-ang* (2012), he tells the story of one of the most popular epics in Philippine folklore: the deeds and travails of the superhero Lam-ang. Within the complexity of this image, which contains different scenes from the hero's life, Tapaya exercises a strong sense of humor that pivots on the discrepancies between the worlds he creates and the ones that are evident on a daily basis.

The large painting *Multipetalled Beauty* (2012) extends this track by intertwining legends and folktales with contemporary abuses in biotechnology. (fig. 8) In the Philippine version of the western fairy tale of "The Princess and the Frog" (in which the amphibian turns out to be a handsome prince), a monkey takes on the latter role. We see him here peeling back his skin in Buddha-like pose deep within a jagged, toxic, mythical forest. A flock of sheep has gathered (referring to Dolly, the first animal to be cloned), while underfoot a hybrid between a crocodile and a tree refers to corrupt officials who use stem-cell technology to appear younger. In mini-format, researchers with test tubes work intently on the forest floor. Here the artist has transformed the innocent narrative of the old fable: the new technology that upturns the previous rules of nature may be put to good use but, in the cause of vanity and personal gain, it may also be widely abused and create uncontrollable monsters.

V. The Two Wolves

Over the past two years, Tapaya's mind has continued to race as if it were a factory of images, and this, backed by a rigorous working routine, has enabled him to produce a vast number of paintings in different media and sizes. He has also started to work more in three dimensions, sometimes in the form of large installations, as in *Modern Manananggals* (2013), shown this year [2014] at his large exhibition at the Ateneo Gallery in Quezon City, as well as in super-sized, amulet-like-shaped canvases set within elegantly stamped tin-sheet frames. (fig. 9)

In Philippine folklore, the *manananggal* is a vampire-like creature that divides itself in two so that its head and torso can fly off to find prey; only then may it be killed by placing salt on the lower half of the body so that it cannot reform itself. Tapaya has used this desolate, divided figure as a metaphor for the fate of overseas Filipino workers who are forced to leave the country to support their families, many of them spending so many years away that they are unable to reintegrate themselves on return. These he presents in the form of fourteen large figures, seven of each sex, made out of encaustic and mixed media on fiberglass resin. Their winged torsos and heads grasp cheaply colored suitcases as they flutter desperately across the gallery while their legs and lower bodies remain abjectly behind. On the smoothly cut "table tops" of their leg-born bellies, Tapaya has painted different romantic landscapes of "home."

Rather in the way that earlier works echoed popular figures of speech and word plays, his shaped canvases reflect the different forms of charms that are still widely used to protect their holders from evil or just to bring good luck. In *Lucky Fight* (2013), Tapaya refers to the popular practice of cock fighting in a shield-like amulet shape designed to give protection in time of war. The subject of this painting is an allegorical struggle between good and evil that switches in reference between the Philippine tale of *The Origin of Birds* and the New Testament story of the cock that began to crow after St. Peter had betrayed Christ three times. The triangle of *Antidote* (2013), in the form of an amulet against witchcraft, reinforces its subject in a similar way: it is a composite, everyday folk story about the malevolence of gossip and how to counteract it.

A commission from the Deutsche Bank in Frankfurt triggered the production of his triptych *The First Beings* (2014), which, invoking the creation myth

of the southern Bukidnon people, illuminates the creativity and ingenuity of the contemporary Philippines workforce. The painting is assembled in three parts: *The Supreme Planner*, *The Ten Headed Creature,* and *The Mediator*, representing different approaches needed to achieve success. **(fig. 10)** In both its structure and subject this work could be seen as a response to the ideological hubris of *Man, Controller of the Universe* (1934), the monumental triptych fresco Diego Rivera made for Mexico City's Palacio be Bellas Artes in 1934. But there are neither heroes nor political creeds in the more nuanced, less bombastic, world shown here by Tapaya, merely moral choices governed by basic needs.

In *The Chocolate Ruins* (2014), a painting over seven meters wide, a cartoon-like element of parody indicates the extent to which natural balance has been disrupted by human intervention. **(figs. 12, 13)** Manaul, the bird protagonist of the Philippine's foremost creation myth, breaks open the trunk of a bamboo stem not to usher into existence the first man and woman as in the story, but to give birth to different processes for the production of chocolate. Such absurdity cannot hide the obvious fact that all is not well. People are in pain, homeless, as the country suffers three major—natural and man-made—disasters. [29] This is not a carnival but chaos, a free-for-all in which the rich get richer and the poor are left to drown. Chocolate here has become a metaphor for the corrupting attraction of kitschy sweetness—money, vapid beauty, entitlement, or hidebound tradition—all of them impediments in an epic battle for survival.

Tapaya is of the firm opinion that there are many more worlds than those we experience. "There are different forces; some good and some not; just like in society," but ultimately he believes that "there is goodness in everyone, in everything." [30] The path we decide to follow is a matter of choice. As a master storyteller, he weaves such elements throughout his work. Concerned with human relationships and values rather than with problems or their solutions, he shows how discord is nurtured through deep roots of ignorance, callousness, fear, and greed, and how this creates a toxic alternative to natural ecology that can only be repudiated once its true nature is recognized.

In his most recent paintings, Tapaya has started to tread a path between public and private identities, breaking off from shared mythologies and experiences to express more existential concerns. In recent works on paper, he has, on a more intimate scale, returned to the severity of his works of 2010. In a sense, within the accretive context of his development, these small paintings may be regarded as fragments of a much-larger whole in which stories and characters are constantly recycled and remixed. However, in such paintings as *Meeting with Self* (2014), the face, body, and desire of the artist appear alienated, a feeling accentuated by the figure's colonial pose and by the smothering, ghostly presence of its alter ego.

Mask-like faces, angular planes, and muted tones also delineate *The Two Wolves Inside* (2014), a dark, formal portrait of a grandfather with his grandson that echoes the enthronement of one of Francis Bacon's Popes. **(fig. 11)** It is based on a short story about the metaphorical battle between two wolves that struggle for primacy within the minds of us all. "One is anger, jealousy, greed, resentment, inferiority, lies, and ego," the grandfather explains. "The other is peace, joy, love, hope, humility, kindness, empathy, and truth." "But which wolf wins?" the boy asks. Oblivious of Marx or Kipling or any of their ideas, the old man quietly answers: "It is the one you feed," he says. [31] ●

11 | The Two Wolves Inside | 2014 | acrylic on paper | 77 x 57 cm | courtesy the artist and Arndt Art Agency (A3)

12 | The Chocolate Ruins | 2013 | acrylic on canvas | 305 x 732 cm | courtesy the artist and Arndt Art Agency (A3)

13 | The Chocolate Ruins | detail

[29] The disasters are a 7.2-magnitude earthquake, super typhoon Haiyan, and the scandal over the misuse of congressional funds that all took place in 2014. [30] Rodel Tapaya in Oliver Koerner von Gustorf, "The Spirit in the Forests. Rodel Tapaya's Magical Art" in *DB Artmag*, 2014. http://db-artmag.de/de/82/feature/der-geist-in-den-waeldern-rodel-tapayas-magische-kunst/. Last accessed, February 19, 2018. [31] Note by the artist in the archive of Matthias Arndt, Singapore, 2014.

Choi Jeong Hwa
Gangbuk Style

This essay was published in Korean and English in **KABBALA Choi Jeong Hwa**, Daegu, Daegu Art Museum, 2013. I first got to know the work of Choi Jeong Hwa through the Thai curator Apinan Poshyananda and then visited him in Seoul. For the public art program in Roppongi Hills around the Mori Art Museum in 2002, he designed **ROBOROBOROBO**, a children's playground, with slides and climbing towers, in the retro-form of 1950s robots; for "Happiness: A Survival Guide for Art and Life," the inaugural exhibition of the Mori Art Museum, he created **Flower Paradise** (2003), a long inflatable sculpture that followed the spiral stairs to the museum's ground floor entrance. Since then we have worked a number of times together: in site-specific works for the "cleavage" of the Sydney Opera House and a pond in the Botanic Gardens during the 17th Biennale of Sydney (2010) and at the foot of the Ukrainian national monument in Maidan Square during the 1st Kyiv International Biennale of Contemporary Art (2012) where, for three weeks before the opening, an 11-meter-wide golden lotus blossom slowly breathed in and out.

1 | **Hubble Bubble** | 2010 | commercial plastic containers | dimensions variable | site-specific installation | courtesy the 17th Biennale of Sydney

[1] Choi Jeong Hwa, email to the author, January 17, 2013. [2] Choi Jeong Hwa, Creators' Project interview, http://the creatorsproject.com/creators/choi-jeong-hwa . Last accessed February 19, 2018. [3] I would like to thank Kim Hee Jin, Lee Dongguk, and Park Samchoel for their kind permission to read and quote from their unpublished articles on the work of Choi Jeong Hwa. These were written in 2009 at the time of the Seoul Design Olympics. [4] See note 1. [5] Soen Buddhism in Korea is related in approach to the Chinese Chan and Japanese Zen schools of Buddhism. [6] At the beginning of the 1970s, German artist Joseph Beuys (1921–1986), echoing the sentiments of the German Romantic poet Novalis (1772–1801), stated, "Everyone is an artist." This idea was one of the founding tenets of Beuys's theory of social sculpture that, in the tradition of Swiss cultural historian Jacob Burckhardt (1818–1897), regarded the whole organism of society as one large artwork. [7] This expression was used by Lee Dongguk, curator of the Seoul Calligraphy Art Museum, when discussing how *Gather Together*, a large installation of plastic rubbish that Choi brought together to cover the surface of the Jamsil Stadium at the time of the Seoul Design Olympiad in 2009, created a strange harmony between seemingly disparate elements. A series of related exhibitions added to this impression. He said that Choi's approach "was perfectly matched to calligraphy," from an unpublished essay, 2009, Choi Jeong Hwa archive.

3 Questions:

Who refuses to use mobile phones, prefers to walk everywhere, likes "spectacularly trivial" things made of plastic,[1] and sees himself as an "intruder" and "meddler" with art?[2]

Who in his shaven head and eccentric fashion sense looks half way between a Buddhist monk and a pop star?

Who, through his energy and ability to bring people and ideas together, has inspired and animated a whole generation of creative people in Korea and beyond?

Answer: Choi Jeong Hwa, the Seoul-based artist, thinker, designer, facilitator, and producer.

I. Losing Art [3]

Long before chubby PSY (Park Jae-sang), in his virally popular YouTube hit, satirized the dorky fashions and high life of Gangnam, the affluent, aspirational "downtown" of Seoul's south bank, Choi had been working on a completely opposite style. This is based on the cheap, dazzlingly colorful, everyday materials found in the street markets of the working-class neighborhoods of Gangbuk on the north bank of the Han River.

In deciding to do this, Choi was not making an overtly political point, although his sympathies undoubtedly lie with popular culture and the people who create it rather than with the stultified, Americanized culture that many people believe typifies Korea. He was more concerned to establish a kind of truth through art that reflected his own thoughts and experience but was unable to do so with the methods he had been taught at art school. He discovered that he had to shed previous learning in order to break this impasse.

Choi was born in Busan in 1961 but frequently had to change elementary schools (eight times in six years) because his father's work as a career soldier meant that he was constantly on the move. His, however, was not the normal military childhood. His father and eldest uncle were devout Buddhists and he was the eldest of five siblings. Of this time he remembers, "My father always offered rice and soup to beggars . . . and I hung out with many monks. Everywhere we moved, I stayed in Buddhist temples and lived with the people there."[4]

His father also occupied the honorary post of chief secretary for the venerable Cheongdam, a highly regarded Soen monk who had been one of the reforming spirits within Korean Buddhism.[5] Choi was taught to live strictly according to the Buddhist code of ethics that included the belief that everyone had the potential to become Buddha. There is little doubt in my mind that such an inclusive idea of grace was, much later, strongly to influence Choi's conviction that everyone has the innate capability of being an artist. In Choi's case, the origin of this kind of thinking is rooted in Buddhism rather than in the path usually invoked in western contemporary art—the utopian romanticism of Joseph Beuys.[6]

Before Choi enrolled in the prestigious art department of Seoul's Hongik University in 1980, he had imagined embarking on a literary career and had studied classical Chinese calligraphy. The rendering of Chinese characters has been described as "the written form of divine sounds," and it seems that Choi has tried to express the same kind of feeling, visually and physically throughout his work.[7]

Choi had not yet traveled outside Korea, and his interests in art were primarily local: the rich, often shamanistic, imagery of folk art, or *jogakbo*, brightly colored traditional Korean patchwork cloths and quilts. His favorite artists at this time were the scholar, calligrapher, and ink painter Kim Jeong-hui (1786–1856), a man who contemplated the totality of relationships

273

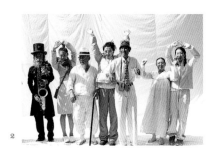

[8] Choi Jeong Hwa. See note 1. [9] Ibid. [10] Ibid. Choi wrote that although he was vaguely aware of the existence of such artists, they seemed irrelevant to his own situation, and for reasons of language and his lack of interest, he did not understand the ideas underlying their work. [11] Ibid. Korean artist Lee Ufan (b. 1936) was one of the leading figures of Japanese Mono-ha, which remains very popular in Korea. [12] Ibid. [13] Ibid. [14] Choi Jeong Hwa, ibid. [15] The interior design of OZONE still exists. [16] Yeesookyung, email to the author, July 14, 2012. [17] Takashi Murakami, *Superflat*, Maddora Shuppan, Tokyo, 2000. See also, pp. 85, 86. [18] *Otaku* describes the geeky, largely male, often violent and pornographic fantasy subculture propagated among Japanese teenagers since the end of the 1970s in *manga* [comic books], *animé* [animated films], computer games, and role-play. [19] Choi Jeong Hwa, interview with James B. Lee, "Flim-flam and Fabrication: an Interview with Choi Jeong Hwa," *ArtAsiaPacific*, vol 3, no 4, 1996, p. 66.

within the world as much as making art, rather in the same way that Choi now does; the painter Saeng-kwang Park (1904–1985), whose exuberant late works explored the fusion of shamanism and Buddhism in traditional Korean folk religion; and the Fluxus provocations, robotic combines, and video installations of Nam Jun Paik (1932–2006), a world-famous artist born in Korea who spent most of his time in Europe and the United States. [8]

As a student Choi remembers that he was "indifferent to all kinds of academic work and information about art . . . there was nothing more important [for me then] than to earn a living." [9] He regarded himself as little more than "a skillful art instructor" and started to become increasingly frustrated with the narrowness of what he was being taught. Although his lecturers talked eloquently about Robert Rauschenberg, Andy Warhol, or Joseph Beuys—artists who in their choice of materials and imagery or social ideas could be regarded as kindred spirits with Choi's later work—they seemed remote, historical, colonizing figures and he showed little interest. [10] Even the minimalist Mono ha group of Japanese artists, who were then all the rage, he simply "did not understand." [11] He supported himself by teaching students cramming for art college exams; in 1982, he left the university and did his national service in the army. This gave him the breathing space he so obviously needed to think things through.

In 1985, after coming out of the army, he made a first trip to Japan and was immediately attracted not by Tokyo's art, famous street-style, nor even by its *manga*, then at the highpoint of its quality and production. The radical innovations of such fashion designers as Issey Miyake, Yoji Yamamoto, and Comme des Garçons are what caught his eye. Design cannot exist without people to use it, and the new forms and uses he encountered in Japan changed the way the world looked to him. "They truly shocked me," he said. [12]

This trip to Japan was obviously an epiphany. Choi now started to feel related to the present. He realized that art was actually an important part of contemporary society, and began to engage with a broad swathe of culture from all over the world. But most critical for his development was the influence of what he saw around him as he walked every day from Hongje-dong, where he lived, to his studio at the university: "Going to college on foot, I discovered that art was not taught in school but outside it. I was impressed and excited by the different things I saw in back alleys, traditional markets, and construction sites, as well as by the lives of *ajumma*, ordinary middle-aged women who have survived hard lives. I admired their aggressive positivity"[!]. [13]

Returning to art school, Choi now seems to have made the decision to graduate as quickly and as painlessly as possible. He turned his back on the worthiness of his art instructors and started to make "illustrations" using crayons and acrylic in a hybrid style, somewhere between the then-fashionable Japanese minimalism and the new wave of European figurative painting. His description of why he decided to do this sounds calculated, even cynical: "The works I created in 1986 and 1987 were made to receive prizes." [14] He had by now fully understood how the art system worked and was prepared to exploit its weakness in order to create a more open opportunity beyond it. In 1987, he was awarded the prestigious JoongAng Fine Arts Prize.

Choi graduated from university immediately after this, burnt all his previous work, stopped making "art," and threw himself into interior design, working on outlets for Ssamzie, a new Korean fashion brand, as well as on designs for books, posters, theater, and dance productions. (fig. 2) This was all done under the umbrella of the Ghaseum Visual Development Laboratory; the neologism *ghaseum*, which he still uses, was derived from the Hangul characters for "mind," "heart," and "breath" that, when taken together, connote the source of feeling or emotion. For Choi, art now became the creation of a protective shell or framework within which people could develop their taste and begin to realize dreams and desires that they had never suspected.

5

6

7

II. Creative Spaces

At the beginning of the 1990s, Choi began to design his first creative spaces that immediately attracted a huge following of young people. The OLLO OLLO bar opened in front of the Ewha Women's University in 1990, where he staged series of talks and exhibitions on interior and exhibition design, as well as performances and informal courses on how to program them. This was followed in 1991 by the OZONE club and bar on Jongno 2-ga, which also offered a similar ambience and range of activities. [15] (fig. 3) SAL, the much smaller café and bar in the Daehak-ro district, that ran between 1996 and 2007, was also an important artists' hangout. Its versatile name denoted "living" but could also refer to "flesh," "sex," and "death."

With their imaginative combinations of cheap plastic, recycled wood, and market kitsch set within rough carapaces of raw concrete or brick, these spaces created a wholly new style of "shabby chic" which continues to the present in Ghaseum, his labyrinthine café, bar, gallery space, and meeting rooms that ramble over a whole block on Nakwon-dong. (fig. 4) Compared to the commercialized institutionalism of pre-existing spaces, the ambience and ethos of these different kinds of place had a decisive impact for emerging generations of young artists and creators working in design, theater, music, dance, film, performance, and installation. Choi had established himself as a thinker, facilitator and producer, as well as an artist and designer.

Painter, installation, and performance artist Yeesookyung remembers the excitement of this time when she herself was just beginning: "Lots of young artists used to gather in Jeong Hwa's place. He generously shared experimental films and up-to-date art books and magazines with younger artists. I think I learned about contemporary art not from school but from him." [16]

One of the first exhibitions at OZONE was a two-man show of the work of Takashi Murakami and Masato Nakamura, young Japanese artists of the same generation as Choi who were also dissatisfied with the blinkered artiness of what they had been taught and wanted to work with new materials and imagery. Over the next few years, unaware of how each other were thinking, both Choi and Murakami were both to experiment with plastic inflatables and trashy, generic images of flowers, yet their motives for doing so were radically different. At that time, Murakami was critical of the "Disneyfication" of Japanese culture and in the figure of *Mr. DOB* presented a super-sized inflatable of a hybrid somewhere between a self-portrait and a malevolent, Big-Brother Mickey Mouse. In the series of painted and plastic images of anthropomorphic flowers started in the mid-1990s, Murakami was exploring what he described as "Superflat," a conflation of the flattened spaces of traditional Japanese art with the undiscriminating commercialization of contemporary Japanese culture. [17]

Choi has always maintained a more celebratory attitude towards popular culture, and kept relatively clear of the dark taste of the Japanese *otaku* that strongly influenced Murakami. [18] His earliest inflatables in 1992 were based on floral advertising balloons seen on the street: he asked their manufacturer to produce a similar product but with an on and off timer so that the balloons would appear to breathe by inflating and deflating. Essentially, this is how all his inflatables have been produced to the present.

Choi's works seem playful, yet they also make strong comments about rampant materialism, unchecked urbanization, and the alienation from nature that results from this. "I feel strange," he once said, "when I see a real tree or flower. Nature as such is so rare in Korea these days that I'm actually afraid when I encounter it. I'm afraid of the 'real.' Maybe all I can deal with is an idea of nature immune to destruction, so I make an artificial one to look at and enjoy." [19] A different, but similarly ironical, sense of alienation intrudes in *Mother*, presented at the São Paulo Biennial in 2006, (fig. 5) where the inflatable is a found object, a life-sized naked woman sold as a sex toy

2 | Design shoot for **Ssamzie** | 1990s | courtesy the artist

3 | Interior of **OZONE** Club and Bar | Seoul | 1991 | courtesy the artist

4 | **Ghaseum Café** | Seoul

5 | **Mother** | 2006 | inflatable sex doll and Korean goddess

6 | **The Death of the Robot – About Being Irritated** | 1995/2018 | fabric, air blower, motor, timer, plywood | 800 x 400 x 350 cm

7 | **ROBOROBOROBO** | 2003 | a children's playground designed for the Roppongi Hills development, Tokyo | courtesy Mori Building Company

275

8

9

[20] See note 2. [21] Gu Kaizhi's theoretical books are *On Painting* (畫論), *An Introduction of Famous Paintings of Wei and Jin Dynasties* (魏晋勝流畫贊) *and Painting Yuntai Mountain* (畫雲台山記). The most fundamental of Xie's Six Principles (绘画六法) is *spirit resonance* or vitality. See Kim Hee Jin, "Choi Conveys the Spirit of Life," unpublished essay, 2009, Choi Jeong Hwa archive. [22] Park Samcheol, "I play 'well' therefore I am," unpublished essay, 2009, Choi Jeong Hwa archive. In this essay Park discusses Nietzsche's ideas on pleasure and taste in *Thus Spoke Zarathustra* (1883–85) and how this related to Choi's own concept of taste. Park also mentions Henri Lefebvre's ideas about how everyday life was becoming art, as set out in his book *Art and the Everyday World* (1968). [23] Ibid. [24] Choi has a large collection of such toys and objects, as well as a large photographic library of possible source materials. Part of this is available on his web site: http://choijeonghwa.com. Last accessed, February 19, 2018. [25] The title of this work is taken from Austrian film director Michael Haneke's Pinter-esque psychological thriller *Funny Games* (1997). [26] Choi Jeong Hwa, ibid. [27] Later this was to move to the entrance of the Mystetskyi Arsenal where, to mark the opening of the 1st Kiev International Biennale of Contemporary Art, it throbbed and bounced in sight of the glittering golden domes of the Kievo-Pechersk Lavra, one of Ukraine's most ancient monasteries. [28] Choi Jeong Hwa: "I like doing things outside art museums. I dislike that you have to pay to enter and prefer working and interacting with people outside." See note 2. [29] Ibid. [30] Choi Jeong Hwa, conversation with the author, October 2009. The Kimusa building is now the Seoul branch of the National Museum of Modern and Contemporary Art, and opened in 2013. [31] The music in question was *Shock Headed Peter* (1998) for The Tiger Lilies' version of the 19th-century German children's cautionary tale *Struwwelpeter*. For the 17th Biennale of Sydney in 2010, of which I was artistic director, they wrote and performed *Cockatoo Prison*, a grand opera of crime and punishment. Choi also participated in this exhibition with two large site-specific works.

who lies awkwardly spread-eagled on the floor. "She" is overlooked by the serene smile of the garishly colored figure of a Korean goddess.

III. Korean Beauty

Regarding himself as "an intruder" who "messes round with art," Choi remembers that he chose to use plastic "because it does not decompose and is recyclable."[20] Perhaps he found in this humble yet long-lasting material an equivalent to the Buddhist cycle of birth, death, and rebirth. He regards his work as an interactive process of inclusion and transmutation in which he is able to obliterate differences between nature and artifice, the real and the fake, while, at the same time, allowing others to project onto it feelings of insecurity, alienation, and beauty.

It is not so much the material of his work itself that is important to Choi but its possibility to resound clearly with simple spirit energy, untrammeled by pretension or "artfulness." In this approach Choi is hearkening back to the ethics of early Chinese painting—to the writings of Gu Kaizhi (c. 344–406), a celebrated artist who claimed that the spirit of a painting was more important than its appearance, ideas that were further developed 200 years later by artist Xie He in his influential manual *Six Principles of Chinese Painting*.[21]

Although Choi could never be described as gifted in his command of European languages, from the late 1980s he had begun to absorb influences and ideas from many different sources. Friedrich Nietzsche's mystical writings on taste, judgment, and feeling reinforced his own developing ideas on aesthetics, while Marxist sociologist Henri Lefebvre's revolutionary credo that everyday life was becoming like a work of art itself could also be adapted to his inclusive sensibility.[22]

In his quest for a contemporary form of Korean beauty based on the synergy between seemingly disparate ideas, influences, and objects, Choi has invented a completely new aesthetic vocabulary, exploiting the mimetic nature of Korean words to describe the particular characteristics he wants. In this, words such as *singsing* ("fresh"), *saengsaeng hwalhwal* ("lively and vigorous"), *bbageulbbageul* ("bubbling and boiling"), *jjambong* ("hotchpodge/mess"), *saeksaek* ("peaceful") and *wageulwageul* ("swarming"), occur regularly as both as titles and descriptions.[23]

Choi's earliest mature work used plastic and other cheap materials found in local markets and junkyards. He also employed toys or models as templates.[24] His affection for tin toys of the 1950s and '60s is an evident inspiration for the humorous jerky presence of his inflatable *The Death of the Robot – About Being Irritated* (1995), (fig. 6) as well as for *ROBOROBOROBO*, a children's playground with swings, slides, climbing frames, and an illuminated robot tower that he designed in 2003 for the newly built Tokyo district of Roppongi Hills. (fig. 7) *Funny Game* (1997), a dramatic example of Choi's playful appropriation of found material,[25] is a constantly transforming installation of recycled, just-over-life-size mannequins of traffic cops. (fig. 8) Choi exhumed these literally from the pits in which they had been buried after the police had decided no longer to use them. This work still continues to appear as part of much larger installations. The synthetic, at times syncretic, environments he now produces veer between the sinister, the threatening, the hilarious and the sublime. "Truth," an exhibition installed in the REDCAT Gallery, Los Angeles, in 2007, brought these cops together with different decorative elements of flowers, trees, furniture, chandeliers, masks, fashion mannequins, figures, vegetables, and gods, to create new forms of life, just as if Choi was some kind of crazy, contemporary Baron Frankenstein.

In Choi's persistent, bittersweet search for "how the natural and artificial can be combined in harmony," flowers made out of different kinds of plastic material have become established as a dominant motif.[26] They were the

topic of *Super Flower* (1995), his first giant balloon tulip, as well as the name of his first book for Ssamsie (1998). **(fig. 9)** They appear in his work as both inflatables and as large, cast-plastic objects. A long, slowly deflating, then expanding, multicolored wreath of flowers led the way up the entrance spiral of the newly built Mori Art Museum in Tokyo as part of "Happiness: A Survival Guide for Art and Life," its inaugural exhibition in 2003; large replicas of Roses of Sharon adorned Seoul's Gwanghwamun Gate in 2008 in commemoration of the 60th anniversary of the founding of the Republic of Korea; in 2012, an 11-meter-wide blossom *Golden Lotus* inflated and deflated in front of the phallic column of the National Monument in the Maidan, Kiev's historic central square.[27] **(p. 157, fig. 54)** Wherever they have been shown, these works have made such an impact on viewers because they appropriate within their orbit everything around them, natural or manmade. The context of the work is perceived and remembered as much as the object itself.

Humorous, reckless, and sometimes provocative, it was no surprise that Choi's work ruffled a large number of Korean feathers. Nothing quite like it had been seen before and its unpretentiously critical "anti-art" position was not so dissimilar from that of the Young British Artists (YBAs) who, at the same time, were starting to make an impact in the UK.

Increasingly, Choi has moved away from showing his work in dedicated art spaces and prefers to work outside.[28] Many of his works now need the participation of many people to help construct them, and this also has become an important element within the whole operation, and the process of making is often referred to in their titles. *Gather Together*, made out of about 1.7 million pieces of plastic garbage, transformed the outside of Seoul's old Olympic Stadium. **(fig. 10)** In *Time After Time*, produced in London to coincide with the 2012 Olympics, 5,000 plastic sieves covered the discolored concrete columns of the brutalist South Bank complex, and 2,000 balloons added a carnival atmosphere to the surrounding trees. **(fig. 11)** Choi often refers to the necessary transfer of energies between people that his work demands by asserting: "Your heart is my art! What you see, what you feel—that's my art. I help you feel and you find the art yourself. [You see] the same kimchi tastes different in different mouths."[29]

Contemporary writers, such as Jared Diamond, who have been rethinking the causes and effects of transcultural development, have also fitted into Choi's desire for synthesis. Diamond's 1997 Pulitzer Prize winning book *Guns, Germs, and Steel: The Fates of Human Societies*, which Choi once strongly recommended that I read, provided the title for a chaotic labyrinth of cheap, brightly colored plastic sieves and buckets that he constructed on the roof of Kimusa, the former Head Quarters of the Defence Security Command (the Korean "CIA"), a historic building with many associations with Korea's painfully divided present and past.[30] **(fig. 12)**

I remember, about 12 years ago, sitting, drinking, listening to music, on the top floor of Choi's narrow house in Seoul. What has stuck in my mind from that evening was hearing for the first time the plangent, sweet-sour falsetto of The Tiger Lilies, an English, Brechtian, post-punk group. I was so excited by their work that I searched them out and subsequently worked with them.[31] I, too, became a beneficiary of Choi's intuitive ability to create contacts and synergies that is an integral part of his work as an artist. Over the past four years Choi has been constantly on the move, presenting exhibitions and large, site-specific works in such diverse places as Sydney, Shanghai, Berlin, Helsinki, Hong Kong, Tokyo, Kota Kinbalu, St. Moritz, Brisbane, Los Angeles, London, Kiev, Krasnoyarsk, and Prague, as well as in different cities in Korea.

In its own way, Choi's "Gangbuk Style" has gone virally global. Brightly colored, hospitable, yet complex and always with a humorous and thoughtful edge, his work radiates a constructively critical liveliness that challenges conventional ideas about the boundaries of art. As Choi himself realized long ago, if his work is to be appreciated in all of its different manifestations, it will demand new ways of thinking about art, as well as new words to describe it. ●

8 | **Funny Game** | 1997 | installation of police mannequins | size variable | courtesy the artist

9 | **Super Flower** | 1995 | plastic inflatable | courtesy the artist

10 | **Gather Together** | 2008 | plastic waste | site specific installation | Seoul Design Olympiad 2008

11 | **Time After Time** | 2012 | site specific installation | Southbank Centre, London

12 | **Guns, Germs and Steel** | 2009 | site specific installation of plastic hardware | Kimusa, Seoul

13 | **COSMOS** | 2015 | site-specific installation | beads, mirror, wire, clips | Helsinki

Yeesookyung
Reflections on a Korean Urn

This essay appeared, in both Korean and English, in **Yeesookyung: Constellation Gemini**, one of four publications made for the Korea Artist Prize 2012, that coincided with the finalists' exhibitions at the National Museum of Contemporary Art in Seoul. I had first been introduced to Yeesookyung's work by Kim Sun-hee, a Korean curator who worked with me at the Mori Art Museum in Tokyo, and who also approached me about writing this essay. Yeesookyung's questionnaire work **The Very Best Statue** (2012) was included in the 1st Kyiv International Biennale of Contemporary Art. Yeesookyung was born in Seoul, in 1963, where she still lives.

Beauty is truth, truth beauty—that is all
Ye know on earth, and all ye need to know.

– John Keats [1]

John Keats's enigmatic, much-pondered, and often challenged words about the virtues of "beauty and "truth" as they are embodied in art—in this case an imaginary classical Greek vase—point to a fundamental dichotomy that has driven the work of Yeesookyung from the outset. This depends not so much on definitions of either "beauty" or "truth," as both are, to a large extent, relative; rather, it is rooted in a profound research of what these concepts mean when they are applied to new ideas, things, and contexts. In this respect her creative development may be understood as a moral progression towards an aesthetic goal that can neither be fully known nor recognized because of the simple fact that it is in a constant state of becoming. Integrity is never an easy path either to understand or follow. Ironically, Yeesookyung has described her work as an artist as a quest for "the paradise hormone."[2]

Echoing Keats's ode, *Translated Vases*, one of her major works, has become a medium through which the artist has been able to interrogate the world. Since its inception in 2001, this still-continuing concatenation of objects, installations, interchanges, and videos has provided a platform on which the traditional—in this case, Korean—vase acts as a metaphor for transition, difference between cultures, and reconciliation through its many fragmented, conflicting forms. The elegant curves and smooth surfaces of its fine white porcelain hint at the presence of a female body, yet the material is often fractured and awkwardly reconstituted, suggesting pain, adversity, and healing. (fig. 2) The implied balance of Keats's final aphorism—a motif of organic division and reflection that links antiquity with the present through an impossible desire for a simple, symmetrical world—runs also throughout the work of Yeesookyung.

"Getting Married to Myself," the title of her first solo show in Seoul and Tokyo in 1992, asserts, at the beginning, her belief in herself as an artist, as well as her need for an artist double. Circumstance had planted the seeds of this ironical love-affair in childhood. In Seoul, where she was brought up, absent, hard-working parents meant that she had to find courage to combat loneliness by creating another world and persona through drawing: "Around five years old I thought I would be an artist . . . as if this was my karma."[3] She grew up in a Buddhist family and was strongly influenced by this, although, as the ironical title of the continuing series of works "The Very Best Statue" (2006–12) implies, she is highly skeptical of organized religion.[4] (fig. 1)

As in all marriages, the road she has taken has sometimes been bumpy. And the journey on which Yeesookyung the person, guided by her trusty doppelgänger artist, is still passionately embarked has been a long path of trial and error, self-discovery, awareness of others, and revelation. As if she were Dante led by Virgil, art has enabled her to scrutinize and pass through the circles of hell, purgatory, and heaven, taking in what she needs to make her work.

Born in 1963, Yeesookyung belongs to the first significant generation of women artists and curators to have emerged in Korea. As in China, western

2

1 | **The Very Best Statue: Kyiv** | 2012 | FRP | 190 cm | courtesy the artist

2 | **Translated Vase: Nine Dragons in Wonderland** | 2017 | ceramic shards, stainless steel, aluminum bars, epoxy resin, 24k gold leaf | 492 x 200 x 190 cm | courtesy the artist

[1] The last lines of John Keats's poem *Ode on a Grecian Urn*, 1820. [2] The title of an exhibition of Yeesookyung's work held at the Mongin Art Center, Seoul, May–July 2008. [3] Email to the author, July 13, 2012. [4] In each version of the sculpture, the attributes of different religious luminaries were amalgamated according to the results of a survey sheet that the artist has circulated to the inhabitants of different places. This set out various options on physique, dress, and posture based on depictions of sacred figures from different religions. The recipients of the questionnaire were asked to express their preferences for these different options which, when analyzed, would provide instructions for the artist to create a hybrid figure of what the different groups of people felt would make the "very best statue." To date four versions of the statue have been made: in Echigo, Japan (2006); in Anyang, Korea (2008); in Liverpool, UK (2008); in Kyiv, Ukraine (2012). The series will be complete once twelve statues have been made.

3

3 | Snow White Revision | 1995 | detail | bubble gum, toy crown, beads | 61 x 45.7 x 12.7 cm | courtesy the artist

4 | Elephant Rescue Team | 1996 | acrylic on paper, water, bucket, ladder | 230 x 89 x 60 cm | courtesy the artist

5 | Nail Flower | 1996 | plastic nail extensions, wine glass, urine | courtesy the artist

6 | Color-blind Test to Blind Minnie Mouse | 1998 | performance | photo by Djin Suk Kim | This was a parody of Joseph Beuys's 1965 performance **How to Explain Pictures to a Dead Hare**

[5] This started with the Japanese annexation of Korea in 1910 and ended in 1945. [6] The arts projects around the 1988 Seoul Olympic Games were the apogee of this tendency. Many of them have been collected together by the Seoul Olympic Museum of Art and Sculpture Park. [7] The pro-democracy demonstrations, and their subsequent massacre by the military, in Gwangju in May 1980, became a fundamental element of the city's historical identity and was instrumental in its decision in 1995 to host an international biennial. [8] Email to the author, July 14, 2012. [9] See "Choi Jeong Hwa: Gangbuk Style," pp. 272–77. [10] Email to the author, July 14, 2012. [11] See the essay by Jung Hunyee, *Yeesookyung's "Fire Works",* Seoul, One and J. Gallery, 2006. Translated by Iris Moon. In this respect Yeesookyung echoes the classical story of the phoenix that dissolves in flames and rises renewed out of its own ashes. [12] *Wie man dem toten Hasen die Bilder erklärt,* Dusseldorf, Galerie Schmela, November 26, 1965. [13] Instruction works consist of a series of written instructions through which the public can realize an artwork for themselves. They were an early form of conceptual art pioneered by Yoko Ono in the early 1960s. For examples see Yoko Ono, *Grapefruit*, New York, self-published, 1964. [14] A handle on one side of the painting enabled it to be unrolled at will and extended by up to about five meters in width according to the size of the space.

modernity did not begin to make an impact until after the First World War, but it was strongly tainted by association with the colonial rule of Japan. [5] As a result, "modern" art was either based on an evolution of classical painting or on elaboration of folk art. After the Korean War (1950–53), the country was divided, China and the USSR gained influence in the North and the USA in the South. In both halves of the country, the military ran riot.

By the 1950s, the cultural scene in the South began to be challenged by "international" forms of abstract art originally from France, then from the United States or Japan, regarded by many as imperialism in disguise. [6] Some artists, like Nam June Paik or Lee Ufan, left the country to work but the domestic art world began to polarize between the hollow universalism of the international style, and the popular leftist agenda of the Minjung cultural movement, which had coalesced in 1980 after the declaration of martial law and the ensuing massacre in Gwangju. [7] Between these rigid, irreconcilable, essentially ideological extremes, there seemed little space for individual exploration, frank self-criticism, or reflection—in fact, neither truth nor beauty. The development and work of Yeesookyung, as well as that of many other artists of her generation, can be seen as a direct response to this deadlock.

In 1989, Yeesookyung graduated with an MFA in western-style painting from Seoul National University and firmly asserts that, "No professor ever influenced my work." Even when looking for avant-garde models she admits that she "never really liked the work of Nam June Paik. I could see its importance but none of it ever moved my heart." [8] The critical figure for her around this time was Choi Jeong Hwa (b. 1961), an installation artist, designer, and producer who often incorporates popular culture as part of his work. [9] She remembers, "Lots of young artists used to gather in Jeong Hwa's house. He generously shared experimental films and up-to-date art books and magazines with younger artists. I think I learned about contemporary art not from school but from him. He influenced so many young artists in the 1990s." [10]

And these were vertiginous times. The spinning, naked-wire armature of a bride-to-be doll that occupied center stage at her first exhibition testifies to this, as do the wall-mounted glass plates in which whirling interlace patterns imprison the same bride. Subsequent works explored further this sarcastic and almost too real fantasy of entrapment: fashionable, smartly tailored carapaces of aluminum-wire netting (*Armor*, 1993), or brightly decorated high heels that could never be worn (*Death of High Heels*, 1993), hinted at every day torture. In connection with her husband's work, Yeesookyung moved to New York for two years in the early 1990s where she gave birth to a child and made little art.

Returning to Korea in 1996, the cruel artistic fairytale of love, marriage, entrapment, and desire continued, but with a harder edge. *Snow White Revision* (1995) was a "jeweled" princess's crown filled with a violated membrane of smooth, pink bubblegum. (**fig. 3**) *Queen of the 21st Century* (1996) consisted of two flesh-pink silk tailored women's jackets, the kind of garments the Ugly Sisters would wear, placed on coat hangers attached to the wall. Equally unsettling was *Nail Flower* (1996), a threateningly surrealistic montage of beauty and abjection in which a "lotus blossom," made presumably out of some wicked queen's cosmetic nail extensions, is balanced on the rim of a wine glass half-filled with urine. (**fig. 5**) The more discursive *Story of Munkil (Long Journey)* (1997), an installation of small puppets thrown on the floor with a recorded story and chairs for the audience, provided no happy endings, nor even a moral: this hybrid, amplified amalgam of fairy tales was violent, sarcastic, ironical, and seemingly endless.

The Green Shoe Tribe (1998) told another kind of story—a parody of news media and pseudo-anthropology, as well as an essay in both sensory and

4

5

6

conceptual disorientation. It was installed in a virtually empty space, in which slides of violent, cartoon-like drawings the artist had previously made there were projected. In the background, a disembodied voice, sounding very much like a newsreader, "reported" the discovery of a diasporic tribe, who all wore green shoes, whose descendants could be found today among the indigenous people of North America and Alaska, or in a small town in Germany, or in the Green Shoe Tribe in Korea. Nothing was quite what it seemed. A window in the space appeared to look out onto a park but, on closer examination, was a large photograph showing the view seen out of the matching window on the other side of the space. Nothing was real, nothing of substance. There was no place here for truth or beauty.

And so the increasingly dyspeptic nightmare of the artist-woman-child continued. In a consciously clunky attempt to collide representation with reality, the installation *Elephant Rescue Team* (1996) consisted of a small painting of a baleful elephant consumed by flames hung high on a wall. A ladder reached up to the painting, at the foot of which were buckets of water, presumably to put out the image. **(fig. 4)** This installation was significant in that it was the first time that fire had appeared as a motif in her work, at first destructively—"I am drawing fire so that I can burn it all"—but ten years later in "Flame," a still-continuing series of drawings started in 2006, fire had become transformed into a consuming force of a different kind—one that purified and generated.[11] **(figs. 13, 14)**

Color Blindness Test for a Blind Minnie Mouse (1998), one of Yeesookyung's rare performances, was initially conceived as a parody of Joseph Beuys's 1965 seminal action *How to Explain Pictures to a Dead Hare*.[12] **(fig. 6)** While for Beuys the stuffed hare he cradled in his arms represented the romantic necessity of sincere imagination, and the honey that covered his head was a natural, healing, living substance, there was no such solace in the work of Yeesookyung. Minnie, an ersatz Disney character, wife of Mickey, whom she held in her arms, had been rendered purblind, her button eyes torn out. As mouthless Hello Kitty had already shown, such mutilations could be regarded as "cute." But by inventing the idea of a color-blindness test for a fantasy creature with no eyes, and re-enforcing this by performing with her own eyes closed but with large seductive, cartoon-like eyes painted over her eyelids, Yeesookyung railed not only against the absurd power of old male masters and the ways that women were still demeaned and discounted, but also implied that many young women were actually complicit in the debilitating culture of cuteness and willingly, sometimes seductively, embraced the bars of their cage. The fact that the performance was made sitting on a toilet pedestal, rather than in a gallery, added to the sense of outrage and disgust. For a time, it almost seemed to her that art had become too compromised for it to work. She felt lost in art space and had to find a way out.

At this time, the alien—for her a broad idea connected with the uncanny, the extraterrestrial, and the Other—becomes for Yeesookyung an important idea. She started off and still remains an outsider, yet her sense of otherness creates a source of both strength and regret to which she constantly returns. *Painting for Out of Body Travel* (2000–02) was conceived as a portal into a new artistic dimension and can be partly understood as a parody of conceptual instruction works of the 1960s.[13] Combining the figuration of a kitsch landscape painting she had found and cut in two, with the extendable abstraction of the attenuated lines of color that she had made to link land, shoreline, sea, horizon, and sky by joining together the two separated halves of the painting, she had created a machine for projecting oneself into another reality.[14] To view the work properly, the artist wrote the following instructions: "Relax and stare at the center of the painting until you feel dizzy . . . At some point it will appear to conjoin into one image and you will finally experience 'out of body travel' and land up in the painting itself. When you do this you may fall into a waterfall or lake

in the painting. Therefore, I have provided a helmet, life jacket, and elbow protectors and suggest you wear them."

A darker fate, however, awaited the unfortunate girl in *USO* (2004), an installation that could serve as a "memorial" to her own abduction by a UFO flying low over the capital. As soon as this had happened, "The beautiful buildings of Seoul begin to grow out like a fungus [from the surface of the ship] as if they were the halo of a martyr."[15] Only her clothes, watch, and a half-eaten chocolate bar were left behind. By absorbing the girl, the UFO had turned into a USO [Unidentified Seoul Object]; "time was frozen and the fabric of space had been torn." With a not-wholly-straight face, the artist had immortalized her own disappearance.

Yeesookyung describes her state of mind at this time as "negative and cynical" and she was obviously unhappy. As a result she resolved to analyze and strip back those elements in her work that expressed dissatisfaction—with art, with herself, with society—in order to concentrate on her own evolving feelings which had to be substantiated in a more positive, generative approach.[16] Partly influenced by the ideas of Rudolf Steiner, as well as by a psychoanalytical method known as mandala therapy (in which she had to complete at least one drawing every day that included a mandala image), she extended her practice of drawing into the making of objects that had a unique if often damaged character.[17] She had also been interested in the philosophical writings of Friedrich Nietzsche since her days as a student and these now clicked into focus, particularly his questioning of the value and objectivity of truth.[18] Embracing the ethos of *amor fati*, "love one's fate," Latin for the unavoidability of destiny or karma, Nietzsche had, at the age of 38, expressed the desire to see only "what is necessary in things and what is beautiful in them."[19] Although she did not yet fully recognize it, Yeesookyung was in the process of reaching the same conclusion: "I wanted to put my mind and body together. I wanted to be healthier and happier through my work. I wanted to be a positive person."[20]

Translated Vase Albisola (2001), the first in the continuing series of works called "Translated Vases," made between 2001 and now, was a critical step in reaching this goal. (fig. 7) While on a residency in the Italian ceramics center of Albisola, Yeesookyung contacted Anna Maria Pacetti, a potter who, under her instruction, formed and painted twelve white porcelain vases in the Josean style of the 18th century.[21] Pacetti knew nothing about the history of Korean art except for what the artist had told her and what she had read in a translated poem about a vase that she had been given.[22] With these clues Pacetti brought her sensibility, influenced of course by centuries of Asian influence on European porcelain, to bear on a cyclical process of dematerialization and embodiment: from vase to text, then translation, then transformation, re-materialization, and then finally its re-presentation as a vase.

In terms of their quality as ceramics, these hybrids can have satisfied no one, in that the artist was oblivious of the strict rules that govern Korea's traditional aesthetic. Their heaviness, not improved by being exhibited alongside a large "clearance sale" banner, indicated that neither were they a skillful pastiche of oriental art. But for Yeesookyung the process was the point, not the end product: "The twelve vases can be considered as a trace of a temporary encounter between virtual neighbors. This project is not a presentation of the synthesis of two heterogeneous cultures nor [of] a cultural exchange in the frame of late capitalism, but a presentation of interwoven regional stereotypes which could be valid or invalid according to one's viewpoint."[23] What could be seen, and apprehended, from this work would have to depend on the viewpoint and knowledge of the observer.

The temporary surrender of artistic control that this work implied seems to have been necessary for Yeesookyung at a time of personal transition

[15] Yeesookyung, notes on the work, 2004. [16] Conversation with the author July 15, 2012. [17] During 2004, Yeesookyung started a course of psychotherapy. [18] Friedrich Nietzsche (1844–1900), German idealist philosopher. Yeesookyung was also curious about the relationship between the development of Nietzsche's ideas and his changing states of mental and physical health. [19] Nietzsche in *Die fröhliche Wissenschaft*, 1882, section 276. Translated in Bernard Williams (ed), Friedrich Nietzsche, *The Gay Science*, Cambridge Texts in the History of Philosophy, CUP, 2001, p. 157, translated by Josefine Nauckoff. [20] See note 8. [21] The Korean Joseon Dynasty lasted from 1392 until 1897. [22] This poem *Baekjabu* had been written by Kim Sangok in 1947 and emphasizes the vase as a metaphor for a beautiful woman. This idea that is fundamental to all of Yeesookyung's work with ceramics, even though it is fractured and reformed. [23] Yeesookyung in Laurie Firstenberg, "Waiting and Seeing," *Catalogue of the 1st Biennale of Ceramics in Contemporary Art*, August, 2001. [24] Hans Bellmer (1902–1975), a German-born Surrealist artist, known for his sado-masochistic sculptures of bound female dolls. [25] In their proliferative respect, these works relate to the way in which the twelve drawings in *Breeding* (2005) were produced. The series starts with a schematic line drawing of a semi-naked woman, with a classical hairstyle, holding a balloon; in the second drawing, two figures, the first figure is flipped and copied symmetrically. In the third drawing, four figures are shown. This geometrical process of replication continues from one drawing to the next until twelve works have been completed. [26] These included "quoted" passages from Goryeo Dynasty (918–1392) temple paintings. Their syncretic quotation of motifs from many religions echoes Steiner's anthroposophic approach.

9

and was important because it is linked to her new interest in traditional Korean art. On one level this was part of her continuing search to establish an individual artistic identity. But it also related to the vast social, political, and economic shifts taking place as the previous 250 years of western cultural hegemony were being challenged.

It is still the case that regional aesthetic systems have to be integrated into creaking western meta-narratives of modernity and contemporaneity, although only rarely has this been satisfactorily achieved. Yeesookyung's response to this, like that of many other artists in Asia (and in other parts of the world too) was to start to examine her own aesthetic traditions more closely and to consider how these could be related to her own work.

Within Korea, and other parts of eastern Asia, traditional ceramics made today are not so different from those of centuries before. Master potters live in ceramic villages and take great care in maintaining traditional standards. As a result, they destroy a large part of what they make and the refuse—what Yeesookyung calls "ceramic trash"—is thrown on spoil heaps. The next step that Yeesookyung took in her series of "Translated Vases" was to visit these villages, collect the trash from the best masters, and use this to make completely new work.

The scale of these works varies from the minuscule to the vast in that, with the help of an aluminum armature, they can be made to any size. Epoxy resin holds them together, in strange, sometimes comic, often baroque montages and, following the traditional practice of mending precious ceramics, their seams are covered with 24-carat gold. Often these works allude to classical sculpture, but show the body in slightly skewed poses. Yet, at other times they seem to be based on cartoon characters with Mickey Mouse ears, Donald Duck beaks, or other absurd features protruding from their surfaces. (fig. 8)

It is a tribute to the range of reference in these works that Yeesookyung also manages to interject suggestions of Hans Bellmer's dismembered, violated, prepubescent dolls as well as a quotation of Yoko Ono's *Mend Piece* (1966), in which Ono had smashed ordinary pieces of pottery and then invited visitors to put the mixed fragments together in an act of propitiation and healing. [24] Yet what is most remarkable about these works is their awkward elegance, their organic proliferation, the feeling that they can continue to replicate and expand almost indefinitely. In spite of their obvious weight, they seem to be almost as light as soap bubbles and their composite structure is reminiscent of the division and multiplication of cells seen under a microscope. [25]

Some are tiny, others very large, yet they are all backed by a sense of fantasy and humor which not only rethinks the purity and balance of traditional Korean aesthetics, but also presents an ironical self portrait of the artist—not looking as we really think she ought, but nevertheless as strong, self-confident, and sure of her new direction.

The ceramic works are not based on drawings but are obviously closely related to them. At this time, Yeesookyung began to augment her previous cartoon-like drawings with the simplified line of late 18th-century Korean brush painting, bringing this together with traditional Buddhist art as well as with motifs from Christian and other religions. [26] "Flame," a series of drawing-like paintings begun in 2006, were made using cinnabar on Korean paper. (fig. 13) This crushed-stone, rust-brown pigment, mixed with glue, reputedly had medicinal properties and was often used for religious purposes, particularly for drawing shamanistic and Buddhist talismans. Describing them as "more traces than drawings," she worked methodically, with intense concentration, in a near meditative state, at the same time each day. Initially the flame seemed a metaphor for passion or energy emanating from a central core, but later, figures and other motifs randomly began to appear.

7 | Translated Vase Albisola | 2001 | installation view | Truco Museum, Albisola, Italy | courtesy the artist

8 | Translated Vases | 2009 | recycled porcelain | 90 x 90 x 160 cm | Orianenbaum, Dessau, Germany | courtesy the artist

9 | Mother Land and Freedom Is | 2009 | installation view at Kimusa, Seoul | courtesy the artist

10

11

As with the "Translated Vases," there is an unconscious element in the way that these images are compounded as they create waves, voids, and interlaces across the surface of the paper. They also begin to radiate an almost messianic quality, in that the artist takes on the role, literally, of a seer—one who is trying to excavate truth. These representations reflect many different spiritual traditions and particularly focus on the figure and fate of a crying woman—a syncretic amalgam of artist, bride, and saint.[27] It is perhaps best to regard these paintings and their related drawings as test beds for thinking and feeling, for remembering and dreaming, as a place where tolerances are measured and where she can become better acquainted not only with her conscious and unconscious self and the world with which she has to interact, but also with the direction that her art must take in response. Yet, her technique of montage—clear also in the unfinished series "The Very Best Statue" (2006–12) (fig. 1) and in individual works such as *Absolute Zero* (2008)—as well as her critical way of thinking, add an inevitable edge of iconoclasm, and humor, to this process. She leaves little doubt that she is not really willing to take herself so seriously, at least, not until, in the unlikely event, she feels entirely satisfied with her work.

Since 2009, the theme of purification, connected ultimately with the modification, even cleansing, of space by sound and movement, has for her become increasingly significant. Central to this has been an intense, newly found interest in deep-rooted traditions of Korean shamanism, as well as in traditional music. The installation *Mother Land and Freedom Is* (2009) was presented as part of an exhibition at Kimusa, the former headquarters of the Defense Security Command (DSC) in the capital. (fig. 9) Although it has since been converted into a branch of the National Museum of Modern and Contemporary Art, the memory of both this building and site is overwhelmingly negative. In colonial times it was a Japanese military hospital, and after liberation the headquarters of the secret military police; people were routinely tortured in its cellars and coups against the government were hatched there.[28] The title of this work is appropriated from the words of the DSC's military song that the artist has rescored and had performed as *jeongga*, traditional Korean court music. Using homeopathic principles and with the advice of a *feng shui* master, she sought to transform the negative male (*yang*) energy that for so long had dominated this site by creating "Infinite *Yin* [female] Energy Amplifying Furniture." To do this she framed an old military camouflage handkerchief she had found there, along with a large number of geomantic drawings that echoed the emblematic design at the center of the handkerchief; she then strategically positioned a simple wooden trestle that crossed the threshold between two rooms, on which she placed an irregular geometric object she had made using the iridescent "camouflage" texture of mother of pearl, and surrounded this with bowls of nickel silver. Sound recordings previously made at the site supplemented the female voice.

The performance, architecture, and resulting video of her new works, *While Our Tryst Has Been Delayed* (2010) and the dance, audio performance, and resulting video *Dazzling Kyobangchoom* (2011), have both amplified the significance of sound, particularly music, as a way of purifying and dematerializing space. Her discovery of *jeongga* and interest in other traditional forms of Korean music has been central to this development.

While Our Tryst Has Been Delayed was spurred out of Yeesookyung's sense of dissatisfaction on hearing a performance of court music amplified on a western proscenium stage. She had been particularly enraptured by how the pure voice of Jung Marie, a young performer, had energized and spiritualized this music and decided to preserve this by designing a stage as a pure, white sounding board, projecting away from the auditorium, that would amplify the notes and sentiments of the music by enabling the voice to be heard alone without the enhancement of instruments or loudspeakers.[29] Wearing a specially designed white *hanbok*, the singer

[27] Yeesookyung's essentially secular depiction of the figure of the artist, sage, and seer is reminiscent of similarly enigmatic figures in the paintings of Indian poet, writer, and artist Rabindranath Tagore (1861–1941). See pp. 36–37. [28] See p. 92 for a discussion of Tomoko Yoneda's images of this building. [29] *While Our Tryst Has Been Delayed* was accompanied by an installation on another floor of 176 of her daily drawings in an amplified soundscape based on musical settings of the hymn *Stabat Mater*, describing the sufferings of the Virgin Mary at the time of the crucifixion, sung also in the style of *jeongga* by Jung Marie. In contrast with the white, unamplified space on the ground floor, the loud speakers here, set back into the wall, took on the role of sound emanating minimalist objects or "paintings." [30] [31] The song was performed in *gagok*, a genre within *jeongga* that expresses desire, longing and unrequited love, and was written by Park Heesuh. [32] Shamanistic rituals and beliefs are still widely held in Korea and overlap with the other major religions of Christianity and Buddhism. [33] Conversation with the author, July 15, 2012. [34] Unpublished artist's statement, July 2012.

12

appeared to be immaterial, floating within a white void, sustained by
nothing but the power of her voice.[30] **(fig. 10)**

Dazzling Kyobangchoom, a dance performance in the style of *kyobang
salpuri* (a combination of two types of traditional music and dance), was
made to signify the opening and spiritual cleansing of Cultural Station
284, a controversial, newly restored art space also with a complicated and
painful history: it had formerly been the Central Railway Station, built
during the 1920s by Japanese architects. *Kyobang* is the house where
gisaeng, traditional female entertainers, sometimes regarded as prostitutes,
lived and worked during the Joseon Dynasty. *Salpuri* means the driving
out of evil spirits, a ceremony usually conducted by shamans, in which
a white handkerchief is used—such as the one held by Lee Jung Hwa,
the dancer in this performance.[31] Yeesookyung designed and directed,
recycling discarded chandeliers from the old station to throw a dazzling
light onto the small octagonal stage she had constructed, to accommodate
a performance that would bring together the ritual drama and music of
ancient shamanism with the timeless movement and secular traditions
of Korean dance.[32] **(fig. 11)**

Yeesookyung's installation *Constellation Gemini* (2012) moves away
from performance and music to return to ceramics, sculpture, and
painting. Comprised of thousands of pieces of celadon fragments laid out
in mandala-like patterns, these are surrounded by large, symmetrical,
pigmented "Buddhist" paintings on silk, drawings from her "Flame" series,
and 3D photographic renderings of a woman mediating, as if in prayer.
She describes this whole family of work as "more or less religious,"[33] yet
acknowledges that while "I work very slowly and repetitively, I keep on
working because I can never predict what a sudden idea that pops into
my head will turn into. While working, the process changes and my
beliefs. I work in order to change myself, to be more different from the
past."[34] **(figs. 12, 14)**

Such a process of change in Yeesookyung's work may seem random, even
self-serving, yet the motives behind it are always the same: truth and
falsehood are opposites, yet they both replicate themselves as different
forms of energy, one through virtuous, the other through negative,
spirals. Yet, as Keats's poem points out, truth alone retains an impassive,
crystalline beauty at its core—unpredictable, irregular, and sometimes
awkward—and Yeesookyung seeks to discover this each time for herself. ●

13

14

Part

Three

Migrations

A Short History of the Trouser

The ladies of the nobility and gentry in Badakhshan

[TODAY PART OF AFGHANISTAN]

WEAR TROUSERS ...

who in [them].... put anything

up to a hundred ells of cotton cloth, folded in pleats.

THIS IS TO GIVE THE IMPRESSION

THAT THEY HAVE PLUMP HIPS,

BECAUSE THEIR MENFOLK DELIGHT IN PLUMPNESS.

Marco Polo

THE TRAVELS OF MARCO POLO

c. 1280 [1]

1 | Hiroshi Sugimoto | **Cro-Magnon** | 1994 |
From **Dioramas** | gelatin silver print | 119.4 x 185.4 cm |
See pp. 316–325

2 | Cavalryman in the Qin Emperor's "Terracotta Army" |
early 3rd century BCE | Emperor Qin Shi Huang's
Mausoleum Site Museum, Xian, China

3 | Cherchen Man | the mummy of a c. 55-year old male
who died c. 1000 BCE | found in Tomb 2 near Qiemo
(Cherchen) in the Taklamakan Desert in northwest
China, he is wearing a red twill tunic, white deerskin
boots, woollen trousers, and felt leggings |
Xinjiang Regional Museum, Urumqi

[1] Marco Polo, *The Travels of Marco Polo* (translated by Ronald
Latham), London, The Folio Society, 1968, p.61. [2] Sarah
M. Nelson, "Gender in Archaeology: Analyzing Power and
Prestige," *Gender and Archaeology 9*, Altamira, Rowman,
2004, p. 85. Mal'ta-Buret' is in present-day Irkutsk Oblast, in
the Russian Federation. [3] For a visualization of these "suits,"
as well as photographs of the carvings which depict them, see
http://donsmaps.com/malta.html. Last accessed August 7,
2017. [4] Ötzi's frozen mummified body was discovered in a
retreating glacier in 1991. [5] JP Mallory, Victor H. Mair, *The Tarim
Mummies: Ancient China and the Mystery of the Earliest Peoples
from the West*, London, Thames & Hudson, 2000. [6] See Ulrike
Beck, Mayke Waqner, Xiao Li, Desmond Durkin-Meisterernst,
and Pavel Tarasov, "The Invention of Trousers and Its Likely
Affiliation With Horseback Riding and Mobility: A Case Study
of Late 2nd Millennium BC Finds from Turfan in Eastern Central
Asia," *Quaternary International*, vol. 348, October 20, 2014, pp.
224–235. [7] These terracotta figures were produced as burial
goods for the funeral of Qin Shi Huang (260–210 BCE) who,
through conquering other states, had by 221 BCE unified China
and proclaimed himself its first emperor.

The early history of the trouser is shrouded both in the mists of antiquity and in the profundity of common sense and, between its dim origins and the present, it has ricocheted around the world in many forms, functions, and symbologies. The first evidence of them found so far is incised on figurines found in Siberia, made of deer bone or mammoth ivory during the Upper Paleolithic period (c. 24,000–15,000 BCE) by big-game hunters living in the area of Mal'ta-Buret'.[2] **(fig. 1)** Not surprisingly, in that harsh climate, they were part of an encompassing hooded "suit" made out of animal pelts.[3] History to date, however, has revealed no further sightings until "Ötzi the Iceman," a Neolithic hunter who died painfully and violently around 5,000 years ago in the southern Tyrol, near the present Italian-Austrian border.[4] But he was wearing a leather loincloth and leggings, covered by a grass skirt, so these may be regarded only as "proto-trousers"—or chaps.

The earliest surviving actual trousers, excavated in the Yanghai cemetery near Turfan in the Taklamakan Desert in Xinjiang province, were made by a group of tall, blond-haired, blue-eyed people nearly 3,000 years ago in what is now western China. **(fig. 3)** Preserved, like the mummified bodies they covered, by the dry, salty atmosphere of this former sea, they were intricately woven in different geometric patterns out of wool, and sewn together out of separate pieces of cloth.[5] Links have been suggested between these and the weaving styles and patterns of Celts from eastern and central Europe, but other archaeologists have proposed Persian influence. Certainly in their DNA, physical appearance and choice of clothing, these people had nothing in common with their Shang "Chinese" contemporaries, who would never have dreamed of wearing wool, woven or felted, thinking it a coarse "barbarian" material. They preferred "civilized" fabrics made out of silk (cultivated, spun, and woven in China since the 3rd millennium BCE), hemp, and, later, cotton.

On the lookout for "causes," and taking into account that, over millennia, the climate has changed in the region and nearby Turfan once was an oasis situated on the trade routes and "information highways" of the Silk Road, some archaeologists have surmised that trousers were invented in response to the need to ride horses.[6] Maybe this was the case, but also adaptability and their wearers' need for warmth on cold nights could equally have made them a snug and convenient garment for both steppe and desert. And then, the archaeological record suggests, but does not prove, that blandishments of identity, adornment, "fashion," and style, could have been equally decisive in the creation and evolution of this garment.

It was only after the 6th century BCE that there is evidence of the trouser having become firmly established as one of many forms of apparel for both sexes throughout wide areas of Eastern and Central Asia. But in China, where the upper classes favored loose-fitting robes, they were adopted more slowly because they were associated with non-Chinese "barbarians." By the beginning of the 3rd century BCE, however, they had begun to take hold in the Chinese military: the "uniform" of the cavalry of Emperor Qin Shi Huang's underground terracotta army—lifelike portraits of the men who had recently unified China as an empire—clearly incorporated padded cotton trousers. **(fig. 2)** No doubt this idea had been "borrowed" from marauding "barbarian" horsemen.[7]

Yet although the cotton trouser was quickly absorbed into the panoply of the Chinese fighting force, woven wool, or felted trousers remained emblematic of the "barbarian" tribes. This is indicated by the clothing of terracotta tomb guardians made during the early years of the Northern Wei Kingdom (386–534 CE). Such robust figures clearly express the primitive energy of the Eurasian Steppe yet about 150 years later, during the short reign of their successors the Eastern Wei (534–550 CE), the sculptural style and subjects of Wei art, as well as the garments that were depicted, had been supplanted by delicately expressive stone carvings of Bodhisattvas in flowing robes (almost certainly made by itinerant craftsmen), that served

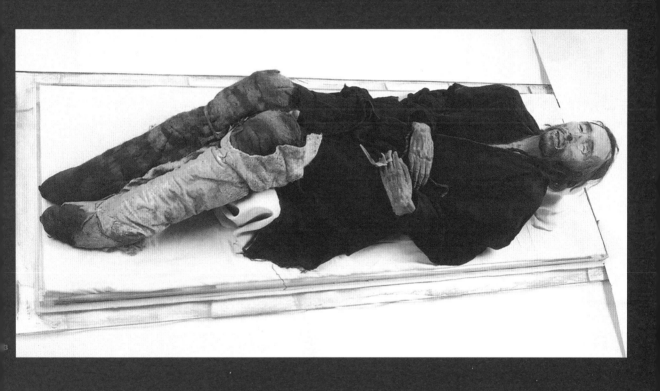

the newly adopted religion of Buddhism that was then entering China from the west.[8] The moral of this particular story was that as they became more Sinicized, and therefore vulnerable themselves to being overrun by "barbarians," the Northern and Eastern Wei abandoned their trousers. (figs. 4, 5)

Just as the Chinese had associated the trouser with lack of refinement, the ancient Greeks, who favored flowing, white tunic-like chitons covered by billowing, cloak-like *peploi* or *himatia*, also regarded them as uncivilized, ridiculous, and foreign; the "barbarian" appearance of this garment was even ridiculed by the leading Greek dramatists.[9] Also, as had been the case in China, the first recorded Greek encounter with trousers was military when, around 500 BCE, their armies fought against horse-riding Persian soldiers. By this time trousers of one form or another were *de rigueur* for the majority of both sexes across a wide swathe of central Asia (which is where the Persians must have first encountered and adopted them), worn by different nomadic groups that included the (perhaps mythical) Amazons as well as the substantiated, equally war-like, Armenians, Bactrians, Scythians, and Xiongnu.[10] As a token of strange, violent, exotic otherness, trousers, therefore, became a feature within 4th- and 5th-century BCE Greek art, adorning the barbarian shanks of both Scythians and bare-breasted female Amazon warriors.[11] (figs. 6, 7, 8)

While trousers were running riot in Asia, the Roman Republic, aspiring, in its turn, to be civilized, decided to emulate the draped tunics of the Greeks and early Minoans with their togas and, by extension and experience, also felt obliged to regard trousers as "barbarian." (fig. 9) Around the beginning of the first century CE, however, as the Roman Empire stretched away from the shores of the Mediterranean towards the colder, damper climes of northern and eastern Europe, an interchange took place that again mirrored what had previously happened in Greece and China. The Roman legions began to emulate the dress of the despised, but surprisingly resilient, Celtic and Gothic "barbarians" by adopting their trouser-like garments as an antidote to the inclement weather.[12] As a result, two different "trousers," the *feminalia*, snug and calf-length, and the oriental-looking *braccae*, loose and tied at the waist and ankles, made their way back to Rome where, shorn of its military function, the *feminalia* became a standard item of dress, produced in a variety of different materials.[13]

In the wake of the many ethnic groups from East Siberia and China who had, over millennia, first terrorized and then settled in Europe, the trouser became assimilated as a staple item of male European dress and, over the next centuries, would be recast in many different guises. For serfs and peasants it became a basic item of work clothing, but for nobles, merchants, yeomen, craftsmen, and retainers in the cities it was an item of fashion. "Trousers" battened slashed hose to doublets, supported ornate codpieces, or showed the line of a shapely leg in tights or breeches that were finished by fine silk stockings. Yet, although subject to vagaries of fashion, trousers not only became an expression of masculine style and male sexuality but also began to epitomize ideas of progress, dominion, and power.

In 1701, Peter the Great, the Russian Tsar, reified the symbolic empowerment of trousers when, returning from a fact-finding mission in western Europe, he immediately issued his Decree on Western Dress as part of a vast modernization program. The high point was the building of St. Petersburg itself, a completely new capital on damp, virgin lowlands in the far west of the country. In order to harmonize with the newly planned architecture, built mainly by Italians and Frenchmen, Peter decided that henceforth all the inhabitants of his empire, male and female (with the exception of clergy and peasants), should pack away their kaftans, Circassian coats, Russian long sheepskin cloaks, and traditional underwear of long johns, "bloomers," and drawers, to wear only western, especially French and German, clothes. For men, these included the "progressive," gentlemanly trouser.[14]

4 | Pair of guardian warriors | Northern Wei dynasty 386–534 CE | earthenware with pigments | left 39.5 cm, right 43.5 cm | Inner Mongolia Autonomous Region Museum, Hohhot, China

5 | **Bodhisattva from a Triad with Mandorla** | late Northern Wei dynasty or Eastern Wei dynasty | 534–550 BCE | limestone, 110 cm | Qingzhou Municipal Museum, China

6 | **Epiketos, Scythian archer** (in trousers) | 520–500 BCE | ancient Greek, Attic | red-figure plate from Vulci | 19.4 cm diameter | British Museum, London

7 | **Warriors in Battle** | early 4th century | Scythian gold comb | detail | probably made by Greek craftsmen to Scythian taste | from Solokha (eastern Ukraine) | Hermitage Museum, St Petersburg | see also p. 111, fig. 7

8 | Amazon archer in trousers carrying a shield and quiver | c. 470 BCE | ancient Greek, Attic | white-ground terracotta alabastron | height 15.24 cm | British Museum, London

9 | **The Wounded Amazon** | after a lost original by Phidias 4th century BCE | marble | 197 cm | Capitoline Museums, Rome | courtesy Jean-Pol Grandmont | here the Amazon has been Hellenised and is shown wearing Greek/Roman dress

[8] See James CY Watt, *China Dawn of a Golden Age 200–750 AD* (exh. cat.), New York, Metropolitan Museum of Art, 2005, pp. 137–173, for works of early Northern Wei, and *Return of the Buddha: The Qingzhou Discoveries* (exh. cat.), London, Royal Academy of Arts, 2002, for those of the Eastern Wei. [9] The ridiculous "barbarity" of the trouser was mentioned in the satires of both Euripides and Aristophanes. See: Euripides, *The Wasps* (BCE 422), 1087; Aristophanes, *Cyclops* (c. BCE 428), 182. [10] The Amazons appear as figures in Greek mythology but archaeological evidence from *kurgans* (burial mounds) in the lower Don and lower Volga regions of present-day Ukraine and Russia suggests that a matriarchal, war-like culture existed among Scythian-Sarmatian peoples that resided there. The Xiongnu were the East Asian ancestors of the Huns, the "barbarian" peoples who laid waste to large parts of Europe in the 5th century. See also Blanche Payne, *History of Costume*, New York, Harper & Row, 1965, pp. 49–51. [11] A Scythian archer in trousers is depicted on the under surface of an ancient Greek Attic red-figure plate, c. 520–500 BCE, from Vulci, and a similarly clad Amazon, carrying a shield, woven cloth, and quiver, is painted on the surface of an ancient Greek Attic, white-ground alabastron, c. 470 BCE. Both are in the collection of the British Museum, London. **(figs. 6, 8)** [12] The Roman Empire reached its greatest extent c. 117. [13] David J. Symons, *Costume of Ancient Rome*, New York: Chelsea House, 1987. See also http://www.fashionencyclopedia.com/fashion_costume_culture/The-Ancient-World-Rome/Feminalia.html. Last accessed March 1, 2021. The *feminalia* (related to the word femur or thigh bone) was adopted as part of the late Roman male wardrobe and, while not as popular as the toga or tunica, was used for travel and work; it was worn by both emperors Augustus Caesar (BCE 63–14 CE) and Nero (37–68). The *braccae* were never embraced as fondly by the Romans because their form denoted "barbarian" origins. [14] Peter the Great, *Decree on Western Dress*, 1701: "Western dress shall be worn by all the boyars, members of our councils and of our court . . . gentry of Moscow, secretaries . . . provincial gentry, . . . government officials, . . . members of the guilds purveying for our household, citizens of Moscow of all ranks, and residents of provincial cities . . . excepting the clergy and peasant tillers of the soil. The upper dress shall be of French or Saxon cut, and the lower dress . . . — waistcoat, trousers, boots, shoes, and hats—shall be of the German type." http://college.cengage.com/history/primary_sources/world/edicts_and_decrees.htm. Last accessed June 1, 2015. For the etymology of the Turkic "bloomer," see note 16 on p. 165 and fig. 4, p. 163 in "Who is Wearing the Trousers?".

10

[15] The *Table of Ranks* was created in 1722 and remained in operation until the overthrow of the Russian monarchy in 1917. [16] Peter the Great, *Decree on Shaving*, 1705. Failing to shave resulted in payment of a "beard tax" of 100 rubles. http://college.cengage.com/history/primary_sources/world/edicts_and_decrees.htm. Last accessed June 1, 2015. [17] Olympe de Gouges (1748–93), *Déclaration des Droits de la Femme et de la Citoyenne*, Paris, 1791. See Olivier Blanc, *Marie-Olympe de Gouges*, Paris, Editions René Viénet, 2003. The Reign of Terror lasted in France from September 5, 1793, to July 28, 1794. It has been estimated that 16,594 people were executed by the guillotine (2,639 of them in Paris) and another 25,000 perished in summary executions across France. It came to an end with the execution of its architect, the Jacobin leader, Maximilien Robespierre (1758–1794). See Marisa Linton, *Politics of Virtue in Enlightenment France*, London, Palgrave, 2001; Donald Greer, *The Incidence of the Terror during the French Revolution: A Statistical Interpretation*, Cambridge, MA, Harvard University Press, 1935; Hugh Gough, *The Terror in the French Revolution*, London, Macmillan, 1998. [18] Marianne was the French revolutionary goddess of liberty, wearing either a victorious laurel wreath or a red Jacobin cap. Her *sans culottes* supporters were *les tricoteuses*—the women who sit and knit—who positioned themselves in front of the guillotine. [19] Valerie Steele & John S. Major, *China Chic: East Meets West*, New Haven, Yale University Press, 1999, p. 44.

Peter's decision had practical as well as symbolic implications because it sidelined the shaggy, aristocratic boyars, whose loyalty was in doubt, in order to create space for a dapper new order of professionals that was set down in a "table of ranks," where social position was determined by talent and service to the Emperor rather than, as previously, by birth.[15] Four years later, in 1705, to curb further the power and credibility of both the church and the hereditary aristocracy, he issued an additional decree that ordered men to shave off their beards and other facial hair.[16] Peter's sartorial transformation of Russia became so complete that, by the last twenty years of his reign, the smoothly shaven man in trousers, the model inhabitant of his new capital St. Petersburg, was emblematic of his centralized, modernizing state.

Yet the "trousers" that Peter had imported from Europe were not the garment we would recognize as such today. They were breeches—worn with long stockings and ending with a buckle at the knee—of the same kind then worn by all western men of property and substance. But little did Peter realize that, before too long, both the blandishments of vanity and the impact of revolution would again completely transform its significance and shape.

During the European Enlightenment, rational *philosophe* ideals of personal autonomy, hygiene, and human rights culminated in a doctrine of virtuous rectitude that, when enacted politically in Paris, from the end of the 1780s, laid bare a dark underside to revolution: the Terror. Playwright, women's rights activist and passionate campaigner against injustice, Olympe de Gouges, one of its most eminent victims, was murdered by *sans culottes:* men without breeches. In 1791, she had published a *Declaration of the Rights of Woman and the Female Citizen* as a bitterly ironical riposte to blatant omissions in the *Declaration of the Rights of Man and the Citizen*—the Book of Genesis of the French Revolution, written by Thomas Jefferson with General Lafayette—that had been presented at the National Constituent Assembly in Paris two years previously.

By pointing out the obvious—that the universality of the rights of man excluded women—de Gouges had hoped to expose the failure of the revolution so far in not recognizing the equality of the sexes. Her views, however, fell on deaf ears and, because she was also associated politically with the denigrated Girondistes, and refused to compromise on any issue, she was condemned to death, one of three women executed by the guillotine in Paris during the Reign of Terror.[17] (fig. 10)

Under the supervision of Maximilien Robespierre's Committee for Public Safety and Revolutionary Tribunal, the vengeful lust of the *sans culottes*—the *nom de guerre* of the rural and urban poor, the "guardians" of the Revolution, was commandeered and spun out of control. In the name of virtue, tens of thousands of people were summarily executed. With inexorable logic the Terror accelerated; more and more people were murdered until, eventually, it consumed its own leaders—and then petered out. The name given to this bloodthirsty, unruly mob was based on the evident fact that the men did not wear *culottes*—the breeches of the hated aristocracy—but instead *pantalons*—the baggy, "egalitarian" workers' trousers they seem to have always worn. They defined themselves proudly by what they wore not.[18] (fig. 11)

With much less controversy, baggy unisex trousers, held up by some kind of drawstring, had been worn for centuries across large parts of China by both men and women workers, as well as by young unmarried women. Anyone with social standing, or pretension to it, however, would never have worn such a garment.[19] But further west, in South Asia, Persia, the Ottoman Empire and North Africa, baggy *shalwar* trousers of different designs were worn by both sexes, usually with a *kameez,* a shirt or tunic of varying length. From the first half of the 19th century, however, hand in hand with the expansion of colonization and travel for leisure, this

The Zenith of French Glory; — The Pinnacle of Liberty.
Religion, Justice, Loyalty, & all the Bugbears of Unenlightend Minds, Farewell!

adaptable and pervasive garment, when worn by women, became associated, in the Western mind, with the languorous exoticism of the harem. European orientalist writers and artists often depicted Turkish or North African women, wearing richly colored, revealing *shalwar*, as seductive denizens of a declining and decadent Ottoman Empire, fulfilling everyone's dreams of *luxe, calme et volupté*. [20] (fig. 12)

As the 19th century became increasingly consumed by the aggressive Western desire for more territory and raw materials to feed its expanding populations and industries, the balancing power of the Chinese Empire was also tested. In the unseemly rush to foreclose markets, grab land, and fill vacuums, the trouser, an expression of righteous, dominating, male power at home, when worn by soldiers, merchants, bankers, colonists, or missionaries abroad—rampaging, occupying, merchandizing, ruling, converting, or just trading opium—again revealed its original barbarian status and began to be regarded by many not-so-willing victims and subjects as just yet another token of arrogant, "long-nosed," Western imperialism. [21]

A mercurial garment, the trouser has always morphed and shifted across, and between, cultures according to desire, fashion, and need. Worn by colonists and fashionistas, peasants and workers, revolutionaries and conservatives, soldiers and city dwellers—and, of course, by men and women—it has become a staple garment of modern life.

Art, and sometimes the people who make it, have also moved backwards and forwards in similar ways. The contemporary artists in "Migrations," this part of the book, all share one characteristic: for various reasons, they have migrated to live and work (sometimes temporarily) in different continents and, inevitably, this has affected how they experience and show the world. The reasons for this are impossible to categorize, each are specific to the artist in question, and they cover a wide range of fundamental feelings, including love, hope, dissatisfaction, curiosity, and desire. A paradox of *la condition humaine*, however, is uniformly shared: separation from a mother culture creates a desire to know it better, made all the keener by an opposing impulse to join a wider flow. •

12 | Eugène Delacroix | **Les Femmes d'Alger dans Leur Appartement (The Women of Algiers in Their Apartment)** | 1834 | oil on canvas | 180 x 229 cm | Musée du Louvre, Paris

[20] There were many erotic imaginations of the harem as, for example, in *The Lustful Turk or Lascivious Scenes from a Harem*, the title of a pornographic novel published anonymously in London in 1828 (in which the harem was endowed with the role of erotic finishing school for deflowered western virgins), in writer, soldier, explorer, and linguist Sir Richard Burton's (1821–1890) scholarly, unexpurgated translations of *The Kama Sutra (1883), The Book of a Thousand Nights and a Night* (10 vols., 1885) and *The Perfumed Garden of Shaykh Nefzawi* (1886), and in countless orientalist paintings, one of the most memorable being Eugène Delacroix's *Les Femmes d'Alger* (1834) in the Louvre. *Luxe, calme et volupté* ("luxury, calm and voluptuousness") is an Arcadian passage from Charles Baudelaire's poem "L'Invitation au Voyage," from *Les Fleurs du Mal* (1857). In 1904, Henri Matisse appropriated this as the title of his most important and unconventional painting to date. [21] The two Opium Wars (1839–42 and 1856–60) violently secured concessions of trade and land from China for the western powers. The barbarous sacking of the Emperor's Summer Palace in Beijing in 1860 by British and French troops still remains a live issue in Chinese cultural politics, particularly in relation to the repatriation of Chinese national treasures. See pp. 144–145.

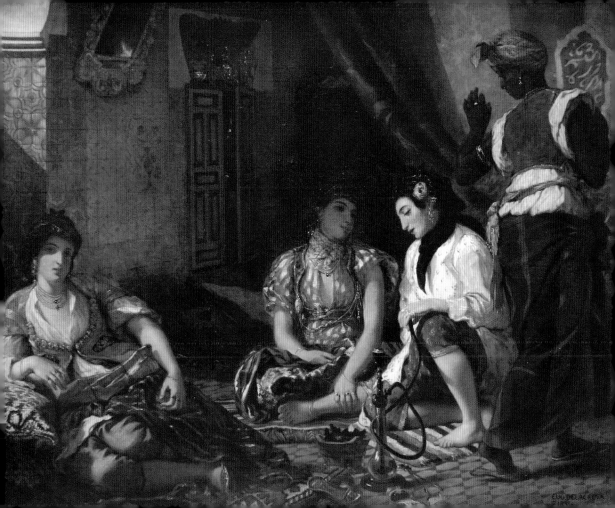

Cai Guo-Qiang
Earth, Air, and Fire

I first worked with Cai Guo-Qiang on the exhibition "Silent Energy: New Art from China," at the Museum of Modern Art Oxford in 1993 (see pp. 46, 47, 49), and then subsequently in "Wounds: Between Democracy and Redemption in Contemporary Art," the inaugural exhibition of the new building of Moderna Museet in Stockholm in 1998 and in "The Beauty of Distance. Songs of Survival in a Precarious Age," the 17th Biennale of Sydney, in 2010. This essay was published in **Cai Guo-Qiang: Fallen Blossoms**, Philadelphia, The Fabric Workshop and Museum, that marked an exhibition held both there and at the Philadelphia Museum of Art in 2010. Cai Guo-Qiang was born in1957, in Quanzhou, China, and lives in New York.

2

1 | **Human Abode: Project for Extraterrestrials No. 1** | 1989 | gunpowder on paper | 212.8 x 154.3 cm | all images courtesy Cai Studio

2 | Cai Guo-Qiang and Stephen Hawking | Centre Pompidou Paris | 1990

[1] The Latin title of this poem *Sic Vita* means "Thus is Life." Written in the 1630s, it compares cosmic with worldly events in order to reflect on the transience of human life. Only a part of it is reprinted here but the all-encompassing imagery of this passage is typical of English poetry of this time. Helen Gardner (ed.), *The Metaphysical Poets*, London, Penguin, 1985, p. 113. [2] Often heaven has been depicted or referred to as a circle and earth as a square. See below figs. 5, 6. [3] *Fengshen Yanyi* is set during the decline of the Shang Dynasty (1766–1122 BCE) and rise of the Zhou Dynasty (1045–256 BCE). The story integrates tales of many Taoist heroes and immortals, and various spirits (usually represented in avatar form as foxes, chickens, and even sometimes as inanimate objects) that take part in the struggle. Many of the gods and heroes prefigure ideas of extraterrestrials in that they fought their battles all over the universe, and some of the gods were named after planets. *Shan Hai Jing* was written over 2,000 years ago and contains a mythological and actual bestiary as well as accounts of fantastic Chinese geological features and medicines, gods and demons. Thanks to Chinyan Wong for this background information. Email to the author August 11, 2009. [4] Stephen Hawking, *A Brief History of Time: From the Big Bang to Black Holes*, London, Bantam, 1988. [5] Cai Guo-Qiang, email to the author, August 10, 2009. Carl Sagan, *Cosmos*, London, Macdonald, 1981. [6] Dana Friis-Hansen, "Towards a New Methodology of Art," *Cai Guo-Qiang*, London, Phaidon, 2002, p. 48.

I. The Geometry of Heaven and Earth

Like to the falling of a Starre;
Or as the flights of Eagles are;
Or like the fresh springs gawdy hew;
Or silver drops of morning dew;
Or like a wind that chafes the flood;
Or bubbles which on water stood;
Even such is man, whose borrow'd light
Is straight call'd in, and paid to night.

– Henry King [1]

The cosmological symbols of heaven and earth express the geometry of space and time; together, in graphic form, they encapsulate both the scale and intimacy of an impassive universe. [2] The origins of this, along with our own existence, started with one Big Bang, but, as with any large explosion, it was certainly the result of a series of chain reactions. As Henry King's short poem on mortality—the span of a single life—makes clear, the same pattern may also be applied to the world we know. We are only able to make sense of it by looking through a prism of closely knit cycles of real and symbolic relationships.

Cai Guo-Qiang's earliest understanding of the universe was, like that of many Chinese children, fashioned by epic classical tales such as *Fengshen Yanyi* ("The Creation of the Gods") and *Shan Hai Jing* ("The Classics of the Mountains and Seas") in which a panoply of Taoist heroes, immortals and spirits fought cosmic mythological battles through time and space against a backdrop of stars and planets. [3]

By the end of the 1980s, then a young artist working in Japan, his interest in astrophysics, the connections between time and space, and the possibility of extraterrestrial life, had become much more concrete. He had already read a translation of Stephen Hawking's *A Brief History of Time*, and in 1990 had even managed to pose with him in a snapshot in a chance meeting at the Centre Pompidou in Paris. [4] **(fig. 2)** He had also been strongly influenced by the popular American astronomer Carl Sagan's book *Cosmos,* which he has gone through many times and still takes with him on his travels. This has become a source of constant comfort to Cai because in the face of infinity, "it makes me believe that I am part of the universe and therefore can understand it." [5]

The kind of universe Cai began to apprehend in Japan was no longer a stage for superheroes, but a carefully balanced machine, both the origin and an integral part of all space and matter, and therefore also the starting point of time. He became convinced that an intuition, or memory, of original creation was embedded within the human psyche and may continue to guide it in a quest for survival: "The human spirit was born at the time of the creation of the universe, and actually contains vivid memories of the past. Therefore, at a deep level, it has insight into future direction, potential, and danger." [6]

In 2002, during an early attempt at a midcareer memoir, he readdressed his obsession with time and space as determining factors in his work:

3

4

When I came to Japan my encounters with the theories of twentieth century astrophysics were very significant to me. The concepts of the Big Bang, black holes, the birth of stars, what is beyond the universe, time tunnels, how to leap over great distances of space and time and to dialogue with something infinitely far away—these ideas were still not commonly in circulation in China at that time. They were an eye opener for me. [But], at the same time, many of these ideas have similarities with traditional Chinese views, with which I was familiar, of metaphysics and the universe. [7]

The "Chinese views" to which the artist refers here are not those of a curved, cone-like, space-time continuum of a kind that would be recognized by Einstein or Hawking, but one that takes into account the moral aspects of chaos, conflict, and contradictions, and relates them to life. In line with chaos theory, he emphasizes that all these elements are necessary and related parts of a greater unity:

Eastern philosophy says: "No law is the law, no method is the method, and all laws go back into one." Attempts today to discover the laws governing the universe or society through the concept of chaos are in line with my own thinking [. . .] This is a [. .] symbiotic way of looking at the world. Whether I use traditional Chinese medicine or feng shui, I always aim to find the symbiotic relationship between things and bring them together. You cannot use a purely analytical method to understand my working process because it's filled with contradictions." [8]

Embracing of contradiction—in the "rational" West a sure sign of chaos—could, he argued, be the foundation for a new way of thinking about how art related to lived experience because "the fundamental monastic tenet underlying all eastern culture [is] to accept contradictions and seek harmony and co-existence within them." [9]

One of the most striking of these contradictions is Cai's frequent use of the explosive, "destructive" medium of gunpowder in his work to echo the first moments of the universe. On one level this relates to a notion of "healing" through a process of shock, or realignment, rather like an osteopath or chiropractor. (The Chinese pictograph for gunpowder literally means "fire medicine.") But, on another level, it represents a willful search for a new and unorthodox artistic medium, an alternative to the materials and strict rules of Soviet-style Socialist Realist oil painting or the traditional brushwork of Chinese calligraphy, the two possibilities for making art that he had known since childhood.

The chaos-inducing role that Cai believes art must fill is not so much intended as a shock in itself, although since he moved from Asia in 1995 to settle in the United States he has not shied away from taking what could seem to be an unpopular or provocative stance. It is rooted neither in the *Sturm und Drang* of western neo-Dadaist iconoclasm, nor in the super-chic sashays of highly contextualized postmodernity. For him, it is a necessary part of the process of propitiation, of the promotion of healing or balance in a wounded planet through the realignment of individual, social, artistic, or aesthetic flows of *qi* (energy) that have become seriously out of kilter. Cai is approaching here a general theory of cultural relativity in which space and time play a key role: although the artists' intention remains more or less the same, the understanding of artworks is distorted according to the ideologies dominant both where and when they are made and seen. [10]

In such a connected universe, where one part reflects and reacts to another because they are glued together by a ubiquitous flow of *qi,* all activities—medicine, architecture, art, science, martial arts, law—follow the same principles. Sun Tzu, the 5th-century BCE military strategist, could have been describing Cai's approach as an artist, when he wrote about the qualities needed to make a good general: "In battle one engages with the orthodox and gains victory through the unorthodox. The one who excels at sending forth the unorthodox is as inexhaustible as heaven, as unlimited as the Yang

[7] "Octavio Zaya in Conversation with Cai Guo-Qiang," ibid., p. 34. [8] Ibid., p. 18. *Feng shui* is an ancient Chinese system of aesthetics that aligns the attributes of heaven and earth to create positive *qi* (energy) and thereby improve life. [9] Cai Guo-Qiang, "On Thought and Action," *The Potential of Asian Thought* (symposium report), Tokyo, Japan Foundation ASEAN Culture Center, 1994, p. 127, in Friis-Hansen, op. cit., p. 38. [10] I am not suggesting here an outdated, discussion of "intentional fallacy" versus "auteurism," but proposing, rather, that in the West there is a "universalist fallacy," in which it is assumed that the reception of an artwork should be the same from wherever it originates. Cai has reacted strongly against this both in his thinking and his work. [11] Sun Tzu, *The Art of War*, trans. Ralph D. Sawyer, Boulder/Oxford, Westview Press, 1994, p. 148. [12] Holland Cotter, "Public Art Both Violent and Gorgeous," *The New York Times*, September 14, 2003, in Alexandra Munroe, *Cai Guo-Qiang: I Want to Believe* (exh. cat.), New York, Guggenheim Museum, 2008, p. 274. [13] I am grateful to Chinyan Wong for her translation of the artist's notes in the preparatory album for this work. [14] See, for example, Jonathan Goodman, "Cai Guo-Qiang: I Want To Believe," *Yishu*, Vol. 7, No. 3, 2008, and Peter Schjeldahl, "Gunpowder Plots: Cai Guo-Qiang at the Guggenheim," *New Yorker*, February 25, 2008. Arguing from the critical base of American art theory of the 1960s and 1970s, both critics find it difficult to accept the different aesthetic and conceptual framework that underpins Cai's work. Some of it may be regarded as "spectacular" in a superficial sense, a "bad" thing in their eyes.

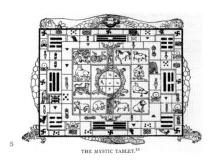

5

THE MYSTIC TABLET.¹³

A

6

Tze and Yellow Rivers. What reach an end and begin again are the sun
and moon. What die and return are the four seasons. In warfare, strategic
configurations of power do not exceed the orthodox and unorthodox, but
the [variations between them] can never be completely exhausted. [They]
mutually produce each other, just like an endless cycle."[11]

All creation myths begin with chaos, and perhaps this is the most basic
contradiction of all: if there had never been a Big Bang, no one would be
here. This point—the moment between being and non-being, what Cai
would call "the vague border at the edge of time/space"—has been such a
constant source of fascination for Cai that he constantly tries to emulate it
in his work. *The Vague Border at the Edge of Time/Space* (1991) was the first
of his gunpowder drawings to stand in its own right rather than being made
for an "explosion event." In the preparatory album of the same title for this
large, seven-panel folding screen—comprising seven life-sized projections
of his body expressing different states of vitality and consciousness—the
artist set out a series of paradoxes that strongly related to traditional Taoist
and Buddhist thought. He wrote about being buried deep in the circle of the
earth, where an all-encompassing darkness had ignited a light inside him
and he had entered a state of complete nothingness. When he reached a
spatial, temporal and physical "ground zero," a feeling that he has described
elsewhere as "an eclipse into oblivion"[12]—a void—his body became a
reservoir for self-reflection in which breath, desire, and matter evaporated.
Slowly, in harmony with the movement of the earth, his pulse began to
quicken and, in emulation of the Buddhist doctrine of making "nothing into
something fine" (*hua wu wei da you*), to absorb water and the sun's rays. In
this rite of passage, his consciousness had been transmuted from earth to
heaven, from time to space, so that it could enter "an eternal and defined
order . . . [where] one can understand clearly the details of distant planets,
beyond matter, time, and space."[13] Each panel of the large work
represents for Cai a particular stage in this development.

In Japan during the late 1980s and early 1990s, Cai began to move away
from an exploration and depiction of the self toward the idea of staging
"explosion events" (with related "gunpowder drawings") on a scale and
simplicity that could, in theory, be seen from outer space in a series of
works called "Projects for Extraterrestrials." The unorthodox idea of
inventing art made by humans for the denizens of another solar system
liberated the artist from the constraints of provincial Japanese art politics,
as well as from the more threatening specter of conservative political
retrenchment back in China. But, in the longer term, the geographical
scale of the resulting "explosion events," as well as the schematic,
map-like quality of his drawings, set out a universal, and arguably
intergalactic, symbology that has remained the basis of his visual
vocabulary to the present.

This way of working also subsequently enabled him to integrate the
design of popular, mass-appeal events (such as the impressive pyrotechnic
displays for the Asia-Pacific Economic Co-operation Conference, in
Shanghai, in 2001, or the Beijing Olympic Games in 2008) with the making
of reflective and much quieter art. In the clear-cut, dualistic world that
many western art critics inhabit, some have seen a possible conflict in
pursuing these two paths, yet for the artist they are simply different
aspects of the same activity.[14]

Human Abode: Project for Extraterrestrials No.1 (1989), the first and most
modest of "Projects for Extraterrestrials," was made in a western suburb
of Tokyo. It was one of the first times that he had used paper as a support
for a gunpowder drawing, and the explosion event that preceded it entailed
the destruction of a frail canvas structure, described as a "nomadic yurt"
but roughly rectilinear in plan and elevation. Its fragility also conjured up
the ghosts of the student tents in Tiananmen Square in Beijing that the
military had brutally demolished on June 4 in the same year. **(fig. 1)**

7

For the third in the series, *45.5 Meteorite Craters Made By Humans On Their 45.5 Hundred Million Year Old Planet: Project for Extraterrestrials No. 3* (1990), a metaphorical response to the passage of infinite time, Cai ignited man-made craters in the French countryside that looked from a distance like circles inscribed in the earth. He made *I Am An Extraterrestrial. Project For Meeting With Tenjin (Heavenly Gods): Project for Extraterrestrials No. 4* (1990), in the southern Japanese city of Fukuoka, and took as its motif the crop-circle patterns that had been discovered in Wiltshire, deep in the English countryside, earlier that year. Its ostensible aim was to create a dialogue with beings from another universe by projecting back into space what was thought to be their own "language." (fig. 3) The drawing for *Fetus Movement II: Project for Extraterrestrials No. 9* (1991), made in Japan, shows the artist meditating in the midst of a dark web or globe. During the explosion event for this, which took place in Germany the following year, Cai put himself—for the first and only time—in the middle of an explosion, monitoring his brain waves and heartbeat as part of the work. (fig. 4)

The most impressive and largest of these early works was *Project to Extend The Great Wall of China by 10,000 Meters: Project for Extraterrestrials No. 10* (1993). Gunpowder fuse was laid out at the northwestern end of the Great Wall, stretching ten kilometers out into the desert. The invited audience was given different Chinese medicines before and after the ignition to stimulate and calm their energy. (fig. 7) The Wall was long thought by the Chinese to be the only human-made feature that can be seen from the moon and is supposed to follow the ancient "dragon meridian" of *qi* across the earth and therefore to be an amplifier of it. This project was partly tongue-in-cheek, intended to both highlight and enhance this capability and, from a different viewpoint, had been prefigured two years earlier by *A Certain Lunar Eclipse: Project for Humankind No. 2* (1991), one of a reciprocal series of gunpowder drawings that had envisioned explosion events in outer space that could be observed by a human audience. In this proposal, Cai envisioned a line of fuses to be detonated across the moon during a lunar eclipse, with the resulting explosion echoing both the length and shape of the Great Wall.

The need to work on a cosmic scale, to reenact and re-fix these moments of elementary creativity, discharge of energy, and out-of-selfness is one of the most compelling motifs in Cai's work. But the continuing desire to capture and understand the synergy between the world and the cosmos within a single physical, philosophical, mathematical, ethical and aesthetic system can be traced back to times when philosophical, and ideological dichotomies between east and west did not exist—even back to the origins of art.[15] This submerged, and in some cases forgotten, symbology of space and time reemerges in many of his works.

A wide range of similar symbologies from different periods may be found in different parts of the world. Neolithic carvings,[16] discovered in Mas d'Azil, France—radiating lines with rectangular boundaries, or nine dots forming a square—are, for instance, close cousins of the Luo Shu square in Chinese cosmology, one of the most active emblems in *feng shui*, traditional Taoist geomancy.[17] (fig. 5) The circles, squares, spirals, and crosses of Celtic ritual symbols,[18] thought to depict the dynamic interfaces between the cosmos and earth, had already appeared, although in slightly different form, on Yangshao pots from the Neolithic settlements by the central Yellow River in China.[19]

In addition to this network of cosmic and earthly symbols, the ancient world also sustained an architectural geometry of heaven and earth in which, through an evocation of time and space, many different kinds of structure were erected on religious sites to provide points of contact between the energies of the living and the spirits of the dead: the burial mounds of the Boyne Valley in Ireland, the megaliths of Stonehenge, the pharaonic Necropolis of Giza, the Mayan Pyramids of Yucatan,

7 | **Project to Extend the Great Wall of China by 10,000 Meters: Project for Extraterrestrials No. 10** | 1993 | realized at the Gobi Desert, west of the Great Wall, Jiayuguan, Gansu Province | February 27, 1993, 7:35 pm | 15' | Commissioned by P3 Art and Environment, Tokyo

8 | **Borrowing Your Enemy's Arrows** | 1998 | wooden boat, canvas sail, arrows, metal, rope, Chinese flag, and electric fan, boat | approximately 152 x 720 x 230 cm | arrows 62 cm each | The Museum of Modern Art, New York | This work alludes to a legendary story about the Chinese general Zhuge Liang (181–234) considering the importance of resourcefulness and strategy in battle. The fishing boat was sourced from Quanzhou, Cai's home town.

9 | **The Century with Mushroom Clouds: Project for the Twentieth Century (Looking Toward Manhattan)** | April 20, 1996 | The project was realized at various sites in the United States, from February to April, 1996 | 1" each explosion | gunpowder 10 g each, and cardboard tubes

[15] Contemporary physics is still very much engaged in the search for a Grand Unified Theory (GUT). See Hawking, op. cit., passim. [16] The Neolithic period in Europe ran from c. 7,000–1,700 BCE. [17] Lars Berglund, "The Secret of Lao Shu: Numerology in Chinese Art and Architecture," Södra Sandby Sweden, Tryckbiten AB, 1990, pp. 13, 14. [18] The Celts were active across Europe during the period c. 1,200 BCE to c. 100 CE. [19] These were made between c. 5,000 and c. 3,000 BCE. [20] For the earliest examples of this kind of architecture, see Roger Joussaume, "Les Dolmens pour les Morts" (1985), published in 1988 in English by Batsford, London, as "Dolmens for the Dead." This examines the morphology of megalithic burial sites across the world, the earliest examples being built in the Iberian Peninsula during the 5th millennium BCE. [21] Berglund, op. cit., pp. 249–255. [22] Sun Tzu, op. cit., p. 167. [23] Holland Cotter in Munroe, op. cit., p. 274.

8

9

the Khmer temples of Angkor Wat, and many other tombs and ritual structures are now also recognized as sophisticated astronomical devices, primordial computers, tied to the measurement of distance, time, and season, that could predict solstices, comets, or eclipses. The meticulous observation of the movements of the stars and planets through the heavens was their common base.[20]

The Ming Dynasty (1368–1644) architects of Beijing constructed the Imperial City as a microcosm of the Taoist universe, revolving around the geometry of five altars: heaven, *Tiantan*, a circle, lay in the south; (fig. 6) yellow-tiled, square earth, *Ditan*, controlled the north; the altar of the sun, *Ritan*, rose in the east; while that of the moon, *Yuetan*, presided over the west. At the very center, the heart of the Inner City, was the altar of *She Ji*, the god of soil and grain, the sustainer of life.[21] The abstract architecture of circle and square, heaven and earth, energy and void is, through the moral philosophy of the Tao, strongly linked with the conceptual and structural geometry that Cai has developed in his work.

II. "No One's Child": A Politics of Time and Place

Heaven encompasses yin and yang, cold and heat and the constraints of the seasons.

Earth encompasses far or near, difficult or easy, expansive or confined, fatal or tenable terrain.

—Sun Tzu [22]

Although Cai has sometimes been criticized for playing the "Chinese card" too strongly in his work, he has, throughout his career, carefully modulated the spatial politics of east and west in ways that have negotiated obvious and creative contradictions through an active process of learning and self-discovery. (fig. 8) The fact that he has lived and worked in three different countries—Japan between 1986 and 1995, and the United States from 1995 until the present, as well as his formative years in China, from 1957 until 1986—has undoubtedly contributed to this. One of the main tensions and paradoxes that affected his development resulted from China's adoption of the western ideology of dialectical materialism after the Communist takeover in 1949. Once in Japan, the artist, who had to deal with the contradictions that resulted from this in his work, quickly became aware that "seen from the eastern perspective I am actually quite western. Since childhood my education has been based on dialectical training in Marxism."[23] Caught in a web between the traditions of east and west, between communism and capitalism, although he did not realize it, he was, and remains, "no one's child."

As a child and young man, Cai had been relatively insulated from the excesses of the Chinese Cultural Revolution (1966–76) because the southern port of Quanzhou, in Fujian Province, where he was born and raised, provided a relatively safe haven. His father, Cai Ruiqin, an amateur traditional brush painter, was the head of the local branch of the state bookstore and a member of the Communist Party. Unlike in Beijing, Shanghai, or other big industrial cities, the all-seeing eye of the Party was a little less sharp in Quanzhou, and his father was able to continue with the politically suspect art of calligraphy, at the height of the Cultural Revolution switching to painting the sayings of Chairman Mao instead of the traditional, "feudal" Tang dynasty poets. Young Cai was equally fortunate; he was able to avoid being sent to work on a collective farm, joining instead the municipal propaganda (theater) troupe.

Though unusual for this time, his father's profession allowed the Cai family to have clandestine access not only to banned classical Chinese literature, but also to translations of western books by such authors as Samuel Beckett

and Arthur Miller that were supposed to be read only by those critics who would be sure to denounce them. For a relatively short time at the height of the Cultural Revolution his father had to burn proscribed books at home to avoid being caught with them. Not surprisingly, this fiery image of cultural destruction is strongly engraved in the artist's memory.[24]

In addition to this relatively broad artistic and literary background for the time, the artist also recalled an educational stimulus of a completely different order through the Taoist beliefs of his paternal grandmother: "I would go to the temple with my grandmother and mother. That is why I have a lot of curiosity about unseen force[s] and invisible things. It is like a time tunnel [...] to go beyond the social systems and boundaries of nations to make you free."[25]

Cai's first steps along this tunnel took him on a student visa to Japan, in 1986, where he discovered, much to his surprise, the depth and range of a previously hidden Asian culture. Just as he had learned about the latest developments in astrophysics there, he now also began to learn about the depth and history of East Asian culture, something he could see that China had lost: "Japan and China have so many overlaps in cultural traditions, for example the Chinese and Japanese practices of traditional medicine, or the arrangements of objects in the home to emphasize balance and a holistic view of the world ... [U]nlike [in] Japan, the past 50 years in China have not created the stable conditions necessary for the modern Chinese to develop their own culture; there has been only turmoil."[26]

Other possibilities began to dawn as he realized that: "the Chinese are closer to westerners than the Japanese. I was interested to find many 'oriental' things still existing in Japan."[27] He learned "to look at things from a distance,' particularly "the distance to look back on eastern aesthetics."[28] Initially, he thought his stay in Japan would be temporary, but this comforting sense of distance, as well as the suppression of the student movement in Beijing on June 4, 1989, and the subsequent crackdown, meant that he would stay in Japan for nearly a decade.

During this time he befriended many members of the avant-garde Mono-ha group. Although he undoubtedly learned much from these associations, the dominant aesthetic and critical debate, both within this group and more generally, focused on the need to differentiate a specifically Asian aesthetic and ontology in opposition to the West, while still being bound by the same basic terms of reference. By the end of the 1980s he had realized that this had culminated in a dead end, which he had to confront in his work:

"[Artists and critics] wanted to achieve an internationalism and modernism. But, in the end, they only retained the result of westernization. The Japanese executed quite a profound self-examination. Nevertheless the Japanese problem became my problem. This is how the series 'Projects for Extraterrestrials' came about. I was thinking 'Would there be a way to go beyond the very narrow east and west comparison? Was there an even larger context or a broader approach?'"[29]

Cai now realized that he had to cut himself free. His understanding of chaos had to transcend the Big Bang, to focus on events on earth, rather than on extraterrestrials or the universe, and to go far beyond Mao's ideological paradox: "Construction is destruction." He needed to develop a working method that would enable him to move wherever he wanted and to break through the boundaries that others had tried to construct for him: "I am bringing chaos to time, to context, and to culture. I ignore the boundaries between different cultural heritages and freely navigate between Chinese, eastern, and western, or whatever world culture there is. I can take one out of context and put it in another, ignoring all boundaries and socially constructed constraints."[30]

In 1995, he moved from Japan to New York: "It was clear to me that the twentieth century was the American Century; I thought it would be a good place to stay and live in for a while ... Art is like an industry [there]. It's like

11 | **Shadow: Pray for Protection** | 1985–86 | gunpowder, ink, candle wax, and oil on canvas, mounted on wood | 155 x 300 cm

12 | **The Earth Has Its Black Hole Too: Project for Extraterrestrials No. 16** | 1994 | realized at Hiroshima Central Park near the A-Bomb Dome | October 1, 1994, 6:01 pm | 30" | explosion area: diameter c. 100 m, spiral length 900 m | gunpowder (3 kg), fuse (2,000 m), and 114 helium balloons

[24] Email to the author, August 11, 2009. [25] Arthur Lubow, "Cai Guo-Qiang: The Pyrotechnic Imagination," *The New York Times Magazine*, February 17, 2008, pp. 34–5. [26] Zaya, op. cit., pp. 19–22. [27] Yuko Hasegawa, "New Order Out of Chaos," Tokyo, Setagaya Art Museum, 1994, in Munroe, op. cit., p. 265. [28] Munroe, op. cit., p. 298. [29] Ibid. [30] Ibid., p. 25. [31] Zaya, op. cit., p. 22. [32] Holland Cotter, op.cit. [33] Zaya, op. cit., p.10. [34] Laozi, "Sheathing The Radiance" in *Tao Te Ching*, trans. Patrick M. Byrne, New York, Square One, 2002, p. 17. Some scholars claim that Laozi actually lived in the 4th century BCE, during the Warring States Period. [35] Concerning the void and the unpredictability of gunpowder as a medium for art, Cai has described his feelings as follows: "The momentary flash contains eternity. Its impact is both physical and spiritual." Munroe, op. cit., p. 34. For the Japanese idea of *Ma*, the void, see Sugimoto p. 325 and Ikemura p. 336. [36] See footnote 14. Goodman and Schjeldahl, op. cit.

the official army, whereas in China, art is like the underground guerilla forces, and in Japan it's more like the militia."[31] Paradoxically, the first works that he made in the United States moved away from the vast scale and semi-ironical mysticism of the "Projects for Extraterrestrials" to a lower-key examination of the threats and contradictions within society itself.

By now, in his own words, a "supranational" artist,[32] he had wholeheartedly embraced the military stratagem of unorthodoxy to break through, to "conquer," wherever he may find himself. In China at the beginning of the 1980s, he had remarked that, "the influence of western ideas and trends became a weapon for … artists to use against their own tradition, politically and socially."[33] Now in New York, at the beginning of a new millennium, oriental ideas would have to play a similarly pugnacious role.

III. An Enduring Universe of Memory, Hope and Loss

Heaven lasts, Earth endures.
Why is it that Heaven and Earth last and endure?
Because they do not live for self-interest,
They therefore live perpetually.

– Laozi, Taoist deity and sage, 6th century BCE[34]

Taoist beliefs, rooted in prehistory, bridge the spaces between chaos and order, discipline and humanity, folklore and philosophy. The Tao expresses the flow of the universe and is the force behind its natural order, including disorder. Within this structure, non-existence—the void—is not, as in western existentialism, a figment of terror or alienation but a silent space of liberation, somewhere between stability and chaos. In this sense, it is rather like the few seconds between the lighting of a fuse and the resulting explosion—a moment when control is lost, anything can happen, and time and breath seem to stop before the flux of life resumes.[35] After the Renaissance in the West, the belief in an essential unitary architecture of earth and cosmos, nature and culture, body and mind had been, for many reasons, superseded by religious, materialist, and positivist ideas based on the false doctrine of Manifest Destiny and the conviction that humanity and science could, in time, know, possess, and conquer everything. The question of balance no longer seemed to matter as the resources and appearance or the world were consumed and transformed. The only traces of unitary, holistic views that remained were submerged in the subculture of the occult; in folk art, music, and customs; in the religions and beliefs of so-called First Peoples whose cultures were, without fail, denigrated and decimated by ravaging colonists, or in recently introduced "Oriental mystical" thought.

As part of the process of healing that he regards as one of the functions of art, Cai has always been concerned with recuperating lost elements, bringing things together, and trying to see the world from different points of view, often in an unorthodox way. Memory and loss, both factors of time, have inevitably become part of this rare beauty.

Sometimes this approach has lead to the accusation of being morally ambiguous.[36] A holistic view, some claim, is too reductive in that good or bad are given equal weight, and all matters revert to a single law. Essentialist moral critique takes no account of historical, geographical, or cultural contexts, nor of the obvious paradox that value may sometimes be found within, or come out of, bad events. History has also shown the reverse: that short-term gain may lead to long-term loss. But where do we draw a line in coming to an opinion? Cai has clearly shown that he is prepared to confront this question in his work and to look for value in areas that have been often dismissed or condemned.

From his earliest years he had been both attracted and repelled by the specter of nuclear power. *Shadow: Pray for Protection* (1985–86), one of his earliest paintings, showed his face against a backdrop of the devastation cause by the atomic bomb in Nagasaki. (fig. 11) *The Earth Has Its Black Hole Too: Project for Extraterrestrials No. 16* (1994), the last explosion event he staged while still based in Japan and realized near the Atomic Bomb (*Genbaku*) Dome in Hiroshima, comprised a fuse suspended in the air that spiraled downward in concentric circles until it disappeared into a black hole in the ground. This linked the idea of the initial explosion of the atomic bomb that had devastated the city in 1945 with the gravity-defying power of a black hole in space. (fig. 12)

After moving to New York, he continued to explore this subject in *The Century with Mushroom Clouds: Project for the 20th Century* (1996), explosion events in which he detonated a small hand-held charge in front of famous landmarks across the United States. (fig. 9) In a laconic, almost humorous, way, atomic chickens were brought home to roost in the ostensibly innocuous puffs of miniature "nuclear" explosions set against a background of iconic American landmarks, including the World Trade Center and the original Nevada Nuclear Test Site. In these works, the horrors of nuclear warfare and arms proliferation were "domesticated" as if they were wholly benign benefits of advanced science and technology. The artist described how this contradiction was encapsulated in these images: "The mushroom cloud is one of the most tragic, beautiful, and powerful images and behind this there's also great contradiction and pain." [37]

The terrorist attacks of September 11, 2001, had a strong impact on his work, largely because of their explosive connection. The dramatic installation *Inopportune: Stage One* created and shown at Mass MoCA in 2004, the year in which terrorist bombs also killed 191 people in Madrid, referred to this directly through the image of nine "exploding" cars turning over in space, as if one of them had been caught on camera. "I make explosions, so I pay attention to explosions," he said about this work. "I can imagine the methods used and the mental state of the suicide bombers . . . Before igniting an artwork, I am sometimes nervous, yet terrorists face death unflinchingly. Along with the sympathy we hold for the victims, I also have compassion for the young men and women who commit the act. Artists can sympathize with the other possibility, present issues from someone else's point of view. The work of art comes into being because our society has this predicament. Artists do not pronounce it good or bad." [38] (fig. 13)

Here Cai is talking about the geometry of morality: there is no effect without cause. While the effects of terrorism are obvious and horrifying, its causes are by no means clear. Self-sacrifice in the name of an ideal may be misguided and cruel, but it is fuelled by a warped integrity that has a cause of its own. In such a literally vicious circle, an act of healing cannot take place unless both sides are brought together.

Cai's holistic approach has much in common with that of the postwar German artist Joseph Beuys (1921–1986), who adopted the anti-modern, ritualistic mythology, and persona of a Central Asian shaman, using the materials of fat and felt to help heal a culture that had been fractured and traumatized by both materialism and war. [39] In the process, he created art which was simultaneously regressive and futuristic, a metaphor and act of cultural, social and aesthetic healing that balanced and united a long-separated whole. [40] For Beuys, the re-integration of body with spirit was projected on personal, historical, social, and cultural planes, and the "dialectical" symbol of the cross that appears in many of his early installations and drawings was transmuted into the holistic figure of a Eurasian staff (*Eurasienstab*), an emblem of universal power and authority that reunified the long-sundered spirituality of both east and west. [41]

Beuys's later practice of social sculpture—remedial artistic actions that impact the apprehension, distribution, and use of power and resources

[37] James Putnam, "Interview with Cai Guo-Qiang," London, September 2002, www.jamesputnam.org.uk. [38] Cai Guo-Qiang, "I Wish It Never Happened," interview with Jennifer Wen Ma in *Cai Guo-Qiang Inopportune*, North Adams, Mass MoCA, 2005, pp. 54–69. [39] During World War II, Beuys had been a rear gunner in a Stuka dive-bomber and in 1944 was severely injured on the Crimean Front when his plane was shot down. He later claimed that he had been saved by Tartar nomads who had wrapped his body in felt and animal fat in order to heal it, although it appears that he was actually taken to a German field hospital. [40] Joseph Beuys, "I assume the role of shaman in order to express a regressive tendency, to go back to the past, in other words, back to the womb, but it's a regression in the spirit of progression, the futurological." In conversation with Erika Billeter, March 1981, in *Mythos und Ritual der siebziger Jahre* (exh. cat.), Kunsthaus Zürich, 1981, p. 89 (trans. Isabel Cole). [41] See Eugen Blume and Catherine Nichols (ed.), "Section 08: Wo ist Element 3?" *Beuys: Die Revolution Sind Wir*, Göttingen, Steidl, 2008, pp. 174–189. [42] See footnotes 11, 22. [43] The Fibonacci number sequence was first set out in the early 13th century by the Italian monk Leonardo da Pisa. Each number of the sequence should equal the sum of the two numbers that precede it: 1, 2, 3, 5, 8, 13 . . . [44] Cai was not aware that Smithson's interest in the physics of entropy and the duality of "sites" and "non-sites" mirrored some of his own aesthetic concerns until he saw the large solo exhibition of his work at the Whitney Museum of American Art in 2005. Email to the author, August 17, 2009. [45] A retrospective of Richard Long's work held at Tate Modern, London, in 2009 was entitled "Heaven and Earth." [46] See interview with Fei Da Wei in "To Dare to Accomplish Nothing," *Cai Guo-Qiang* (exh. cat.), Paris, Fondation Cartier, 2000, pp. 117–35. [47] From the late 1970s, Tadashi Kawamata (b. 1953) has infiltrated nature and architecture across the world with temporary, mainly wooden, structures and walkways built with the help of local people. [48] Zaya, op. cit. pp., 10, 11.

13

14

15

within society—as well as his conviction that everyone is an artist, find affinity with the healing impetus of Cai's social projects, such as *Bringing to Venice What Marco Polo Forgot* (1995), *Crab House* (1996), and the "Everything is Museum" series (2000–), which he started around the time he moved to the United States. These are similarly concerned with the questioning, recycling, and realignment of thought and action through social, often community-based, engagement.

The work of Mario Merz (1925–2003), a contemporary of Beuys and one of the protagonists of Italian Arte Povera, is, in its essential geometric simplicity, closer to Cai's work in Japan. In 1968, the year of student revolt in the West, Merz made *Igloo di Giap,* the first of a long series of archetypical structures with prehistoric, "tribal" or nomadic, features that were posed in stark opposition to consumer capitalism. The text that wound in neon around its rough surface reproduced a military paradox, *If the enemy moves his forces, he loses ground; if he scatters, he loses strength,* that had been articulated by the Vietnamese strategist General Vo Nguyen Giap (1911–2013), himself strongly influenced by the writings of Sun Tzu. [42] (fig. 14) Merz's interest in the form of the igloo was followed, in 1970, by his "discovery" and continuing use of the Fibonacci number sequence to represent universal principles of creation, association, and growth, in a sublime curved spatial geometry that both regulated and connected the human and natural world with the universe. [43]

Cai undoubtedly also felt an affinity with the Land Art he found in the West, yet this was mainly on account of its scale. When he first moved to the United States, Michael Heizer's (b. 1944) vast earthwork *Double Negative* (1969), in the Nevada Desert, and Robert Smithson's (1938–1973) iconic structure *Spiral Jetty* (1970), in the Great Salt Lake in Utah, were both sites for images from *The Century with Mushroom Cloud* series. [44] (fig. 9) But perhaps the time-and-place-based "sculptures" of British artist Richard Long (b. 1945), in which ephemeral traces of the artist's presence are recorded in a photograph of a landscape, or the circular, or meandering, routes he had walked are plotted on a map, relate most closely to Cai's engagement with the land. Long's early and seminal work *A Line Made by Walking England* (1967), a straight line in a grass field, is a silent and still prefiguration of Cai's later, longer lines of quickly burning fuses. [45] But on arrival in the West, Cai was understandably wary of, and even sarcastic about, art critics he encountered there who wanted to make his work "fit in" by focusing primarily on its interactive or participatory elements. [46] In order to survive in the West he had to learn to tolerate, and understand, this arbitrary, at times irritating, facet of time and space on the other side of the world.

In his desire to always view the "other side," Cai appears to have developed away from the platonic ideal of Mario Merz's igloos and number sequences, and Long's actions, walks, and maps, to move toward the more direct social engagement of Beuys or even toward the less dogmatic interactive social "structures" of Japanese artist Tadashi Kawamata. [47] In looking back, Cai neither discounts nor glorifies the art he experienced as a child; he merely wants to revisit and re-evaluate it as part of the changed context of the present.

The first work in which he actively confronted the art and traumatic memory of the Chinese Cultural Revolution was *Venice's Rent Collection Courtyard* (1999), presented at the 48th Venice Biennale. (fig. 15) This was based on a much circulated and replicated didactic clay sculptural tableau of the mid-1960s that vividly illustrated the capitalist exploitation of peasants and workers. "It was [. . .] of particular interest to me because I first saw the work as a young person in China and was very moved by it. [. . .] Often people would even cry. At that time I didn't understand the work's cultural strategy, or that the intention was propagandistic." [48] He tried to make as faithful a copy of this work as possible, using one of the

13 | Inopportune: Stage One 2004 | cars and sequenced multi-channel light tubes | dimensions variable | installation on Cockatoo Island, 17th Biennale of Sydney | 2010

14 | Mario Merz (1925–2003) | Igloo di Giap | 1968 | iron armature, plastic bags filled with clay, neon, transformers | 120 x 200 cm diameter | Copyright Philippe Migeat | Centre Pompidou, MNAM–CCI, Paris

15 | Venice's Rent Collection Courtyard | 1999 | 108 life-size sculptures created on-site by Long Xu Li and nine guest artisan sculptors, 60 tons of clay, wire, and wood armatures, four spinning night lamps, facsimile photocopies of documents and photographs related to the original Rent Collection Courtyard | 1965 | realized for "Aperto Over All," 48th Venice Biennale | This, like the former work, no longer exists.

16

[49] Ibid. [50] A modest, 24-page catalogue on Maksimov's life and work was made in Chinese for this exhibition, which was also shown in the Beijing Central Academy of Fine Arts and the Shenzen Art Museum. [51] Email to the author, August 8, 2009. [52] Munroe, op. cit., p. 23. [53] Mao Zedong, *On the Correct Handling of Contradictions Among the People*, Beijing, February 27, 1957, first pocket edition, pp. 49–50.

original artisans as part of the fabrication team, but insisted that it should be presented as a work-in-progress and not be completed in time for the opening. The Biennale Jury, no doubt impressed by its appropriative postmodernity, awarded it a Golden Lion, but the work was criticized in both China and the West, although for different reasons. The Chinese criticism, without any irony, revolved around the charge of plagiarism; in the West some felt that he was merely rehashing exotic communist kitsch. They all seemed to miss the point; as is typical, he was trying to heal a rift by bringing time, space, and place together; by not being pre-programmed by context; by being prepared to take the other side seriously. The original work continued to be popular in China as an icon of SocialistRealism, so Cai's work could not be shown there because it was regarded as disrespectful of the original. But for the artist, it, rather like the image of the mushroom cloud, expressed "the tragedy of time, of people, of artists who were once full of passion and conviction . . . the discrepancy between ideology and reality."[49]

The same impulse led him to collect and "rehabilitate" over 230 works by the Soviet oil painter Konstantin Maksimov (1913–1993) by exhibiting them with his own work at the Shanghai Art Museum in 2002.[50] (fig. 16) At the request of the Chinese, Maksimov had had been sent by the Soviet government to work as an instructor at the Beijing Central Academy of Fine Arts and stayed there between 1955 and 1957, where he trained many students and helped establish Socialist Realism as the dominant academic style. Despite the Sino-Soviet split in 1961, the style he had established remained influential, so Cai had first encountered Maksimov's work as a young child in the 1960s through his father and friends.[51] Although in China today his name and work have been forgotten, Maksimov is, in a sense, the buried "cause" of much art that is still fondly remembered and widely appreciated.

Cai's excavation of the memory and culture of his childhood continued in 2006, when he was asked by a Shanghai-based artists' group to participate in "The Long March: a Visual Walking Display." He chose Yan'an, the politically charged terminus of Mao's mythic Long March of 1934–35, to present a new discussion-curriculum for art education throughout China that stemmed from Mao's historic 1943 *Talks at the Yan'an Conference on Literature and Art.* By referring to the idealistic origins of Chinese Communist art, he wanted to offer young artists today opportunities that, through travel and self-criticism, he had been fortunate enough to experience: "To endow students with the power of self-discovery, the ability to understand the past, present, and future of contemporary art more fully."[52]

In Philadelphia, Cai Guo-Qiang presents three new works in a joint exhibition at The Fabric Workshop and Museum and the Philadelphia Museum of Art devoted to the memory of Anne d'Harnoncourt, former director of the PMA. Inevitably, these relate to his previous concerns and together constitute a finely woven tapestry of many different impressions and ideas. As his work has moved between the contemplation of eternity and a single moment, he has sometimes used water, as well as fire, as a medium. The motif of a river, in which water gradually washes away the presence of a drawing, just as time slowly softens and eventually eradicates the memory of a life, is a central part of the work *Time Scroll* (2009), exhibited at the FWM. Life may be short but, in the face of eternity, art, like the cycle of days, nights, seasons, and years, continues. (fig. 17)

Mao Zedong may have meant something entirely different when he famously called for "a hundred flowers [to] blossom and a hundred schools of thoughts [to] contend,"[53] but he was a poet as well as a leader. Although the reference to Mao's words is present, the poetry of Cai's *Fallen Blossoms: Explosion Event* is of an entirely different order. History, memory, nature, culture, space, and time are again joined together. Specially devised for the main entrance of the PMA, echoing traditional Chinese painting, this vast, bright, ephemeral flower lit up the whole museum. Its brilliance was temporary, but the fact that it once existed will continue to illuminate the world around. •

7

Zeng Xiaojun
Labyrinths

1

1

I had been impressed by Zeng's work when I saw it in a Beijing gallery and wrote this essay at the request of Angelika Li who was then running the new gallery Sotheby's had made as part of their Hong Kong office. Apparently, some of her bosses did not greatly appreciate my "labyrinthine" text but, fortunately, the artist and Angelika did, and it was published accordingly, in Chinese and English in **Zeng Xiaojun: Labyrinths**, Hong Kong, Sotheby's, 2013. Zheng Xiaojun was born in 1954 in Beijing, where he lives and works.

1

4

1 | **Wild Spirit Screen No. 7** | 2013 | ink on paper |
199 x 142 cm | images courtesy the artist

2 | **Wild Spirit Screen No. 8** | 2013 | ink on paper |
242 x 122 cm

3 | **Wild Spirit Screen No. 2** | 2013 | ink and color on paper |
216 x 318 cm

4 | **Wild Spirit Screen No. 4** | 2013 | ink and color on paper |
152 x 226 cm

[1] Zhuangzi (Chuang Tzu, 369–286 BCE), *Nanhua chenching (The Pure Classic of Nan-hua)*. Translated by Burton Watson in *The Complete Works of Chuang Tzu*, New York, Columbia University Press, 1968, p. 49. This Taoist strain of thought fed into Chinese *Chan* Buddhism, better known by its later Japanese nomenclature Zen Buddhism. [2] Confucius (551–479 BCE), a teacher, politician, and philosopher whose system of morality, government, and filial piety has had a vast impact on Chinese life and politics. Laozi (exact dates not known but probably 6th century BCE), was a writer, philosopher, and teacher who is credited as the founder of Taoism, a cosmological philosophy and religion based on the idea that an unknown energy drives the universe. The Tao itself is the way or path of this energy. [3] Ludwig Wittgenstein (1889–1951), Austrian-British philosopher of logic, mind, and language. [4] Edward Norton Lorenz (1917–2008) was one of the pioneers of chaos theory. [5] Jorge Luis Borges (1899–1986), *Labyrinths Selected Stories & Essays*, New York, New Directions, 1964. [6] Franz Kafka (1883–1924), Czech writer. In his novella *The Metamorphosis* (1915), the protagonist Gregor Samsa awoke one morning as a "verminous insect." [7] See, for example, Borges, *Nueva Refutación del Tiempo*, Buenos Aires, 1944–46, and, with Adolfo Bioy Casares, *Cuentos Breves y Extraordinarios*, Buenos Aires, 1986, p. 27. See also Beatriz Sarlo, *Jorge Luis Borges: A Writer on the Edge*, London, Verso, 1993, Chapter 4. [8] Borges, "The Library of Babel," *Labyrinths*, p. 78.

Once Zhuangzi dreamt he was a butterfly . . . fluttering around, happy with himself and doing as he pleased. He didn't know he was Zhuangzi. Suddenly he woke up and there he was, solid and unmistakable, Zhuangzi. But he didn't know if he was Zhuangzi who had dreamt he was a butterfly, or a butterfly dreaming he was Zhuangzi. Between Zhuangzi and a butterfly there must be some distinction! This is called the Transformation of Things.

– Zhuangzi [1]

Zhuangzi was one of the leading philosophers of the chaotic, unstable period known as "The Warring States" (475–221 BCE) that, in spite of its bellicose name, is regarded as the golden age of Chinese thought. Within this physical and intellectual crucible ethical, cultural, social, aesthetic, and philosophical ideas were cast that still impact on the present.

No sooner had the Analects of Confucius been digested than they were challenged, and satirized, by the less prescriptive, more unruly followers of Laozi, the sage of the Tao. [2] As we can see from his parable of the butterfly, Zhuangzi, a skeptic interpreter of Laozi, was particularly consumed by paradoxes of ontology and consciousness. Rather like Ludwig Wittgenstein over 2,000 years later, Zhuangzi wondered how one can possibly "know" things that one could neither perceive, nor understand? [3]

In 1972, the American mathematician and meteorologist Edward Lorenz presented a paper to the American Association for the Advancement of Science in Washington, DC, that considered Zhuangzhi's butterfly in a different way. As its title, *Predictability: Does the Flap of a Butterfly's Wings in Brazil Set Off a Tornado in Texas?* suggests, he was interested in causality within the context of chaos. [4] In this seemingly random version of "The Transformation of Things," Lorenz highlighted, in an unwittingly poetic way, how an infinitesimally small structure or movement could affect, and also reflect, the overarching dynamics of the universe.

But the butterfly fluttered in yet another direction. The eminent Argentine writer Jorge Luis Borges conducted his interrogation of the universe from a different but equally skeptical point of view. During the 1960s, a compendium of his short stories and essays in translation appeared under the title of *Labyrinths*. Aware that truth may elude capacities of human perception or reasoning, Borges decided to allude to it obliquely as if it were in a dream. [5]

As a critic, Borges admired the "labyrinths" of meanings and perspectives he could detect in the work of other writers such as Franz Kafka (for whom the butterfly was certainly a cockroach), [6] and used this idea himself as a central metaphor, referring on a number of occasions to Zhuangzi's "butterfly" parable. [7] A librarian himself, in his fictions the universe transmuted into the image of a meta-library "composed of an indefinite and perhaps infinite number of hexagonal galleries, with vast air shafts between, surrounded by very low railings." [8] Like the mirrored cells of a cosmic beehive, the vaulted cloisters of a scholar monk, or even the small ratty shacks of literati isolated in the grandeur of mountainous Chinese landscapes, the hexagonal folds of this extending web of knowledge, objects, experiences, and images had no perceptible beginning or end. Within these vast labyrinths of space and time, where could one find room to work or shelter? To fix anything, Borges implied, fiction had to be merged with reality.

5

6

[9] In China, the excesses of the Cultural Revolution (1966–76) made many people unwilling to look back to these unhappy divisive times, but also in Japan the militarism of the 1930s and '40s led many young people there to reject the past for fear of what they might find. [10] Yuan Yunfu (b. 1933) studied at the Hangzhou National Art Academy, the CAFA, and the Central Academy of Art and Design in Beijing, graduating in 1955. He made extensive sketching tours of the Yangtze River that provided raw material for a vast mural, *Ten Thousand Miles of the Yangtze River* (1973) installed in the historic Beijing Hotel. Yuan Yunsheng (b. 1937), Yunfu's younger brother, also studied at CAFA. During a brief time of cultural relaxation in the late 1950s, he rejected the prevailing epic style of Socialist Realism in favor of European post-impressionism. For this he was sent to a labor camp but returned to Beijing in 1963 to graduate. He continued working in an unorthodox way, concentrating on a series of elongated, expressive nudes. As a result, he was ordered for the next sixteen years to work as a local art teacher in Changchun, a remote town in the northeast. He was rehabilitated at the end of the Cultural Revolution but *Water Festival – Song of Life* (1979), his large mural for Beijing Airport on which Zeng worked, was censored, ostensibly for its inclusion of nude figures. He moved to the United States in 1983 and returned to China in 1996.

Since the middle of the 1990s, Zeng Xiaojun has set out to address such questions in his paintings, bringing together his deep knowledge and experience of Chinese culture with a broader global perspective. This may sound like a relatively simple matter yet, as was the case for many Asian artists of his generation, during his childhood and youth the past was forbidden territory and its stories and traditions had to be actively sought out and learned as an adult. [9]

Zeng Xiaojun's childhood was typical of many educated Chinese families. His parents were both editors in Beijing publishing houses but in 1969, at the height of the Cultural Revolution, they were relocated over 2,000 kilometers away to the rural depths of Hubei province where they had to "re-educate themselves" through hard physical labor. Fifteen-year-old Zeng went with them. With little experience of either art or nature before this time, he slowly began to realize that he was interested in art and wanted to study it. There was probably some association between art and free-thinking in his mind, but it could not be clearly formulated. Red Guards were desecrating temples and destroying museums, and any consideration of Chinese classical art was forbidden. Zeng's idea or experience of art can have been no greater than what he had seen or what was then permitted.

Then, after over 25 years of self-imposed isolation, following the death of Mao Zedong and the end of the Cultural Revolution in 1976, China experienced a new era of cultural openness. In science, the arts, and humanities, new ideas from outside flooded in and it also became possible again to study traditional Chinese culture. People were also allowed to travel overseas so that they could experience other ways of thinking and living.

In 1977, Zeng enrolled in the mural painting department of the Central Academy of Fine Arts (CAFA) in Beijing where he remembers being particularly influenced by the work of two professors, Yuan Yunfu, his class teacher, and Yuan Yunsheng, who was in charge of the small group of students (of which Zeng was a part) who were working on a controversial, large mural for Beijing's airport.[10] **(fig. 5)** At this time he was learning both Chinese and western painting techniques, in the latter using oil paint.[11] He graduated in 1981 and two years later moved to the United States, settling for fourteen years in Boston, where he lived and worked until his return to China in 1997. Paradoxically, this distance, along with the impressive collections of Chinese paintings and antiquities in many American museums, enabled him to see his own culture more clearly, and he began, slowly at first, to educate himself in its previously forbidden traditions.[12]

Supporting himself by teaching painting, art conservation and working as an art consultant, Zeng's main project was to educate himself as an artist, connoisseur, and collector by studying classic works of Chinese art and literature. For him these three activities became inseparable as each was part of a continuum of thought, morality, feeling, and experience that, by reaching back into the tangled web of history, enabled him to recuperate and begin to understand the complexities of the present. Out of this he could start to build a platform for the future.

This scholarly, contemplative approach was consolidated by the knowledge he had acquired about the techniques and ideas of traditional artists and particularly about the ways they related to what they saw in nature. He was particularly captivated by the monumental landscapes of the painters of the Northern Song Dynasty (960–1127) in which the rolling, twisted forms of mountains, clouds, and rivers exude patterns of dynamic, encompassing energy in which human presence is little more than a brush stroke. In such works, landscape becomes a metaphor for ideas of balance, morality, and power that radiate from them into the whole universe.

Such massive forms appear in miniature in the scholars' rocks that Zeng began to collect and which have provided inspiration for much of his recent work.[13] These aesthetically resolved fragments of the earth's crust, *objets*

7

8

trouvés, not only conjure the grottos and peaks of celestial beings but also encapsulate the modest tradition of amateurism that is at the heart of their appreciation. Objects of fantasy, conjecture, and imagination, they become miniature screens upon which desire and sensibility can be projected. **(fig. 9)**

The marks in Zeng's earlier brush paintings, made in ink on large sheets of white paper, are darker than in his recent works. They also express the physical integrity of particular objects against a clear white background. A sense of mass and depth is carefully portrayed that engages an almost balletic element in the twists and interlaces of their design. The "gothic" depiction of the interlaced "arms" in Zeng's *Ming Dynasty Vines Planted by Artist Wen Zhengming* (2004)[4] indicates virtues of strength and perseverance that are characteristic of classical paintings of trees. **(fig. 7)** Yet this is also a homage to the work of a particular Ming period painter, one of whose masterpieces, a hand scroll *The Seven Junipers (The Seven Stars)* (1532), is a depiction of seven juniper trees that had been planted in 500 in the grounds of the Zidao Guan, a Tao temple in Changshu, Jiangsu Province. The trees were thought to be manifestations on earth of the seven stars of the Plough constellation and, in a long inscription at the end of the painting, Wen compares them to Dragons and Cranes, Taoist symbols of immortality.[15] **(fig. 6)**

In this, and other works such as *Connected Trees from the Forbidden City No.1* (2004)[16] and the scroll-like, four-and-a-half-meter-wide drawing *"Qing," "Qi," "Gu," "Guai"* (2004),[17] Zeng is making his own transformations, bringing history, symbol, and anthropomorphism together in tableaux of nature that, in spite of their dense frames of reference, can be apprehended instinctively as complex objects of beauty and survival. **(fig. 8)**

A large, gnarled root ball of a camphor tree said to be over 1,500 years old presides over one of the empty spaces in Zeng's Beijing studio. Like the more compact scholar rocks, it suggests a wild natural beauty that in a drawing has to be distilled through depth, density, and color. He examines its surfaces minutely with a magnifying glass but he also takes in its general form, trying to establish the best viewpoint that can include simultaneity not possible to the eye.[18] As with earlier brush drawings, what he sees reminds him of previous works, in this case of two works by Wu Bin, a Ming period artist, but the painting that results is neither replica nor empty homage but a creation made new that resonates with the values of previous worlds while at the same time extending them.[19]

Zeng's most recent works have the quality of close-ups, screens or scrolls, yet others in their scale and length have an almost architectural impact. Nuances of texture and depth are expressed through gradations of gray with minute details carefully depicted so that viewers may move between a contemplation of the overall gestalt—literally the bigger picture in which the work's energy, rhythm, and speed can be clearly discerned—and immersion in its different labyrinthine fields of detail that, taken together, add up to the whole.

Zhuangzi's fascination with the transformation of things runs through all the works chosen for this exhibition. The objects and places on which Zeng has chosen to concentrate enclose serial references and levels of reality. Among the smaller works, a drawing of a suspended *lingbi* scholar rock from two points of view is shown alongside studies of ritual scepters and fly whisks, some from the artist's own collection. **(figs. 9, 13, 14)** These objects, miniature universes in themselves, in materials both hard and soft, rigid and pliable, bear multiple inscriptions not as statements but as unfinished conversations about the nature of the world. On the boxwood scepter *ruyi*, for example, Qing-era calligrapher Laotai once scratched the characters for "root of cloud," to which his colleague Qian Dan added "the sea of snow shimmers and hovers, the mountain of jade, trembles and fractures," an extract from a long Tang Dynasty poem.[20] **(fig. 13)** Both these accretions were made in response to the object and the time and environment in which they were writing.

5 | Yuan Yunfu and Yuan Yunsheng | **Water Festival – Song of Life** | 1979 | mural at Beijing Capital International Airport | This work was strongly criticised because of its inclusion of nude figures | Zeng Xiaojun worked as an assistant on this.

6 | Wen Zhengming | **Bare Trees in Winter with Reference to Li Cheng** | 1542 | hanqing scroll, ink, and light colors on paper | 90.5 x 31 cm | British Museum, London

7 | **Ming Dynasty Vines Planted by Artist Wen Zhengming** | 2004 | ink on paper | 211 x 179.7 cm

8 | **Connected Trees from the Forbidden City No. 1** | 2004 | ink on paper | 220 x 138.5 cm

Zeng consolidates these feelings in his drawing, a product of his own response to and thoughts about this object as well as another step in the conversation.

Similar chains of association can be seen in Zeng's two-meter-wide painting *Tang Poetry* (2011–12) that takes as its point of departure the intricate patterning of a marbled ceramic cushion of the Tang period made for taking the pulse. While retaining the feeling of marbling, the artist unpacks the compact balance of the pillow's floating cloud-like forms (which could also seem like cross sections of cells or tree trunks) into a cursive, "abstract" scroll of "mountains" and "rivers" unified by a single heart beat of rhythm, speed, and energy. (fig. 12)

This approach is expanded to dramatic effect in the two largest works in this exhibition, *Nine Trees* (2007) and *Ancient Vine Trees at the Villa Giulia in Rome* (2011). The former, 69 centimeters high by nearly ten-meters wide, has the character of a hand scroll. In a serpentine, almost Manichean, interlace of darkness and light, the trees are silhouetted against the light that surrounds them. While in the painting of the Roman villa, over two meters high and nearly nine meters wide, the ancient vines whip across its surface like lightning, creating a screen through which the villa and its gardens can be barely seen. (figs. 10, 11)

The idea and realization of depth is becoming increasingly important in Zeng's work as he begins to move between the *depiction* and the *realization* of space. Several drawings, key works in this respect, are shown here. These enlarge and expand the viewpoints of a carved dragon-wood screen from the Ming Dynasty that represents a physically impenetrable barrier of fallen branches, trunks, roots, and undergrowth. In this work, as well as in Zeng's version of it, there is little harmony and any rhythm is strongly syncopated. The emotions it evokes relate to age, overcoming difficulty, wonder, lack of symmetry, balance, skilfulness, beauty, and the realization that there might be light at the end of the tunnel. Zeng has not only extended this emblematic screen into a series of drawings but has also transformed it into freestanding "sculptures" in marble and bronze. (figs. 1–4, 15)

A more playful approach to the same "problem" of space can be seen in Zeng's transformations of unusual gourds collected by Qing scholars.[21] Knotted, duck-like, or twinned, these rather comic objects achieve an unexpected sensuality and gravitas when rendered in marble: their sinuous lines are accentuated as they reflect shadow and light in completely different ways. Like those imagined by Borges, Zeng's labyrinths continue to replicate and expand.

Talking about his work, Zeng has quoted the old Chinese saying, "a sparrow may be small, but it has all the vital organs."[22] This is the point—in the context of infinity size does not matter—each of his works is a staging post, a breath held between the microscopic and the infinite in a single unknowable universe. ●

9

9 | **Lingbi Stones** | 2011 | ink on paper | 158 x 89 cm

10 | **Nine Trees** | 2007 | ink on paper | 69 x 988 cm

11 | **Ancient Vine Trees at the Villa Giulia in Rome** | 2011–12 | ink on paper | 212 x 892 cm

12 | **Tang Poetry** | 2011–12 | ink on paper | 51 x 205 cm

13 | **Wood Ruyi and Fly Whisk** | 2011 | ink on paper | 58 x 90 | The *ruyi* is a ceremonial scepter or talisman symbolizing power and good fortune in Chinese folklore.

14 | **Wenge Wood Incense Stand** | 2011 | ink on paper | 158 x 88 cm

[11] Zeng is no longer interested in his early work and regards his mature work as beginning in the 1990s. His first solo exhibition held in New York in 1985 was of oil paintings. Email to the author, September 28, 2013. [12] Being the closest, the Museum of Fine Arts in Boston (the Asian collections of which had been built up by Kakuzō Okakura [1863–1913] and Ananda Coomaraswamy [1877–1947] see pp. 48) and the Metropolitan Museum of Art in New York were collections he constantly revisited, but be also traveled to study the Asian collections in Cleveland and Los Angeles as well as the National Palace Museum in Taipei. Email to the author, September 28, 2013. [13] Zeng Xiaojun, "Réflexions sur l'Amateurisme Éclairé et le Travail de Creation," in Catherine Delacour, *Rochers des Lettrés Itinéraires de l'Art en Chine* (exh. cat.), Paris, Musée des Arts Asiatiques Guimet, 2012. [14] *Zeng's Ming Dynasty Vines Planted by Artist Wen Zhengming* (2004), ink on paper, 211 x 179.7 cm. Weng Zhengming (1470–1559), one of the four great masters of Ming art, was a painter, calligrapher, poet, and scholar. This and other works by Zeng of this time are illustrated in Jason C. Kuo, *Chinese Ink Painting Now*, Hong Kong, Timezone 8, 2010, pp. 60–65. A more recent reference by Zeng to Wen Zhengming's vines, in which a comparison is made between the gnarled wood and a distant rock formation, may be seen in this exhibition. [15] *The Seven Junipers (The Seven Stars)* (1532), ink on paper, 22.8 x 362 cm, is in the collection of the Honolulu Academy of Arts. [16] *Connected Trees from the Forbidden City No.1* (2004), ink on paper, 220 x 138.5cm. [17] "Qing," "Qi," "Gu," "Guai" (2004), ink on paper, 199 x 467 cm. This work is based on a painting of four trees planted during the Eastern Han Dynasty (25–220). [18] Mee-Seen Loong, *Shuimo Water Ink Chinese Contemporary Ink Paintings*, New York, Sotheby's, 2013, p. 104. The work in question is *Untitled* (2012), ink on paper, 220 x 288cm. Email to author, September 28, 2013. [19] Wu Bin (dates not known but working in the time of the Wanli Emperor, 1573–1620). The two works by this artist that Zeng thought of while making this painting were *Five Hundred Lohans* and *Ten Views of Lingbi Stone*. (fig. 9) Email to the author, November 7, 2013. [20] Delacour, op. cit., p. 137. [21] Ibid., pp. 128–131. [22] Zeng, email to the author, September 29, 2013.

Hiroshi Sugimoto
The Faces of Infinity

1

2

3

This essay was published in separate English and Japanese editions of the book **Hiroshi Sugimoto** that was jointly published by the Mori Art Museum, Tokyo; Hirschhorn Museum and Sculpture Garden, Washington DC; and Hatje Cantz to accompany a touring exhibition of his work that opened in Tokyo in 2006. Kerry Brougher, who also contributed an essay to this book, approached Sugimoto's work from a photo-historical point of view but, as I had gotten to know the artist during my five years in Tokyo, I wanted to take a more personal tack, to write about how his work had evolved, what he thought it represented, and also about the elliptical role of humor—an essential part of his intelligence—that affects everything he does. Sugimoto and I are about the same age, have spent many convivial times together and, in the process of writing this, I realized that, partly, I was also writing about myself. Hiroshi Sugimoto was born in Tokyo in 1948, and, after living in the United States, is primarily based in Japan.

Love, all alike, no season knowes, nor clyme,
Nor houres, dayes, months, which are the rags of time.

– John Donne [1]

I. A Joke, a Path, a River (?), and a Frame

Hiroshi Sugimoto's work is not all that it seems. Almost outside time—like a tranquilizer working by slow release—it is full of pitfalls, byways, dead ends, false trails, changes of speed, and wordplays, all underwritten by a sardonic sense of humor that sometimes has been seen wrongly as misanthropic. In this respect, Sugimoto is the soul mate of Marcel Duchamp, an artist to whom he has unconsciously and consciously paid homage, both in his "secret," migratory life as an artist and in his work "Conceptual Forms" (2004), a recent series of photographs. **(fig. 17)** It is his way of working, not his work, that is similar to that of Duchamp, as well as his ambition to penetrate beyond surface, beyond appearance, to find an unholy amnesty among perception, unknowing, memory, love, and knowledge.

"The human eye, devoid of the shutter, is by necessity characterized by long exposure. The exposure of the human eye is one long process—it starts as soon as the newborn opens its eyes, and ends when the eyes are closed at the end of life. We continue measuring the distance between the self and the world, relying on the inverted virtual image projected on our retina from birth to death." [2]

The eye, with the mind, body, and soul attached to it, is a vast camera, and the exposure is as long as our journey through life. I cannot help thinking about a journey, a path through life, when I reflect on the totality of Sugimoto's work. At times it seems more like a river, narrow and fast-moving near its source, but later broadening, branching, and slowing down as it stretches towards the sea.

As Sugimoto has confessed to a liking for wordplay, I am reminded here of an English version of an old Irish joke that turns on the canny wisdom of the supposedly simpleminded:

City slicker [Western curator] in a car to country bumpkin [Japanese artist] sitting on a stile at a crossroads: *Excuse me, my good man, but can you tell me where I should find the next town?* Bumpkin: *Ooh, aah, I can certainly do that for thee Sir, but I wouldn't be goin' there from 'ere.*

Sugimoto has rather the same inflection in his comment, "Anything can be said about . . . [my] work, and nothing is wrong." [3] The point is that we all have to find our own path, our own way of approach, and this is actually part of the work, just as it has been for Sugimoto in making it—but there is a further dimension to the country bumpkin's comments. He knows where the town is but either can't, or won't, say how to get to it from this spot. His frame of reference is not the same as that of the city slicker: he sees and experiences the world in a completely different way.

The various paths that Sugimoto has taken—his peregrinations from Japan to the Eastern Bloc, from sunny California to cold New York, and then back

1 | From **Theaters** | **Prospect Park Theatre New York** | 1977 | gelatin silver print | 42.3 x 54.2 cm | images courtesy the artist

2 | From **Theaters** | **Cabot Street Cinema Massachusetts** | 1978 | gelatin silver print | 42.3 x 54.2 cm

3 | From **Theaters** | **Union City Drive-In Union City** | 1993 | gelatin silver print | 42.3 x 54.2 cm

[1] John Donne, from *The Sunne Rising*, a poem written in London after 1603 and before 1631. [2] Hiroshi Sugimoto, "The Virtual Image," in *Hiroshi Sugimoto: Theaters*, New York, Sonnabend Sundell Editions, 2000, p. 17. [3] Thomas Kellein, "An Art that Teaches No Belief," in *Hiroshi Sugimoto: Time Exposed*, Stuttgart, Edition Hansjörg Mayer, 1995, p. 9.

4

5

4 | Petrus Christus | **Madonna of the Dry Tree** | c. 1450 |
oil on wood panel | 17.4 x 12.3 cm | Thyssen-Bornemisza
Museum, Madrid

5 | Female Shinto deity | Heian period (794-1185) | from
Sugimoto's personal collection of antiquities

[4] Sugimoto, "Virtual Image," op. cit., p. 16. [5] Ibid. [6] Petrus
Christus (ca. 1410/20–75/76), Flemish painter. [7] Thomas
Kellein, "Interview with Hiroshi Sugimoto, October 13, 1994," in
Hiroshi Sugimoto: Time Exposed, Stuttgart: Edition Hansjörg
Mayer, pp. 90–91. [8] Hiroshi Sugimoto, "The Times of My Youth:
Images from Memory," in Kerry Brougher and David Elliott,
Hiroshi Sugimoto (exh. cat.), Ostfildern-Ruit, Hatje Cantz, 2006,
p. 12 [Tokyo catalogue]. [9] From a conversation with the author
in his New York studio, December 7, 2004. [10] Sugimoto, "In
Praise of Shadows," a series of photographs of candle flames
made in 1998. This statement appears in Tokyo catalogue on p.
207. Tanizaki's book *In Praise of Shadows* (1933), translated by
Thomas J Harper & Edward G Seidensticker, London, Vintage,
2001. [11] The Ise Shrine probably dates from the fourth or fifth
century. [12] Masashi Ogura, "Hiroshi Sugimoto Time Sealed," in
Sugimoto Motion Picture, Tokyo, Canadian Embassy, 1996, not
paginated. He was writing about the "Seascapes." [13] Sugimoto,
"The Time of My Youth: Images from Memory." Tokyo catalogue,
op. cit., p. 18. [14] Ibid.

again to Japan; his sense of humor; his frames of reference—toward thought,
time, feeling, and memory; and ultimately his work—together form the
thread that runs through this essay.

II. A Path

Of course, sometimes he has lost his way. Sugimoto writes about an early
experience of visiting a movie house with his mother to see a sentimental
film about the Vienna Boys' Choir. Lost in the narrative and overcome by
emotion on hearing their tremulous soprano voices, the return to reality at
the film's sudden end was almost too much: "I was utterly ashamed of having
lost myself and of shedding tears." [4] Subsequently the cinema becomes an
almost sacerdotal space: "There is something in common between watching
a film and having a dream . . . The sense of withdrawal from the mundane
is also similar to certain religious experiences." [5] For Sugimoto the cinema
was a secular shrine where people came to assert their shamanistic belief
in the representation of life, however fake it may be, and most of all to
experience real emotion.

And losing oneself is an indispensable part of following the path, just
as Sugimoto admits to his delight in "losing himself" in the detail and
craftsmanship of other artists' creations. **(fig. 5)** The same could be said for
looking at Sugimoto's own work. If you cannot lose yourself in it, if you
cannot relax your eyes and enter it, you will never begin to know what it is.

"People cannot really concentrate. They don't look at a thing for a long time.
Our eyes are always moving and searching for something else to see. We
have no quiet and peaceful moments to face something. This is a major
function of painting and photography. You can look at the portrait of a young
woman by Petrus Christus, [6] quietly, little by little, and study the details for
one hour, even two hours. So you get into the details of her face." [7] **(fig. 4)**

And he has become absorbed like this from early childhood, or believes he
has. "A snapshot taken when I was a little boy shows me crouching in a back
lane, peering at a cricket. This inclination toward clinical observation has
stayed with me to this day." [8] Maybe it is axiomatic that to find yourself, you
have first to be able and willing to get really lost?

Sugimoto's path began in the late 1940s in a comfortably well-off family
in an old Tokyo suburb that had been more or less obliterated during the
war. The city was very different then from what we see today. Tokyo was
still a collection of low-rise neighborhoods back then. Before the days
of television, *kami shibai* (picture-card theater storytellers) worked the
streets where children still played alongside George Grosz-like war cripples
hopping around on crutches. The city was occupied by American troops,
and black markets lurked under every railway arch. He was weaned on
his grandmother's dramatic and terrifying stories of the Great Kantō
Earthquake that in 1923 had destroyed vast tracts of Tokyo and in which
at least 140,000 people had perished. He also heard her tales of the fire-
bombings during World War II, when the death toll was even greater and
the destruction was still all too visible.

Here we can pinpoint the anguish that has tormented the Japanese of the
pre- and postwar generations and which younger people have only recently
started to throw off. In a city that, in a space of barely twenty years, had
twice suffered horrific destruction and human loss, stability appeared to be
an illusion. Anything could happen. Now, in a defeated and occupied country,
relationships with the West had to be both rethought and digested. This
tension between East and West, with a desire for some kind of resolution, or
at least redemption from it, can be clearly seen in Sugimoto's life as well as in
his work.

Often the opposition between East and West in Japanese culture has
been characterized in terms of the split between Japanese ambiguity—

6 | From **Dioramas** | **Polar Bear** | 1976 | gelatin silver print | 119.4 x 149.2 cm

7 | From **Dioramas** | **Hyena – Jackal – Vulture** | 1976 | gelatin silver print | 119.4 x 149.2 cm

8 | From **Dioramas** | **Earliest Human Relatives** | 1994 | gelatin silver print | 119.4 x 149.2 cm

9 | **Ingram Electric** | 1972 | C-print | 9.4 x 13.7 cm (each)

"shadowiness"—on the one hand and rationalism on the other. To reduce many differences to a conflict between "feudalism" and "enlightenment," however, is just a little too neat and in danger of confusing aesthetics with morality. Without doubt, in East or West, aesthetics are an *expression* of moral thought, and that is the point: they are a paradigm of experience, not the absolute state to which morality aspires. An examination or testing of moral life has been central to Sugimoto's work, but because he addresses history in so many of his images, and also no doubt because of his non-western origins, ironically he has often been consigned to the terminally amoral pigeonhole of the "postmodern."

But being described as "postmodern" presupposes a relationship to modernity to which Sugimoto, and many other non-western artists, would have a deep-rooted objection. Reacting against the historical confluence of western culture, ideology, and power and its effect on the rest of the world, he finds it difficult to approach such categories in anything other than a spirit of irony.[9] Writing about his series of photographs "In Praise of Shadows," he refers to the book on Japanese aesthetics from which he took the title. "Novelist Jun'ichirō Tanizaki disdained the 'violent' artificial light wrought by modern civilization. I, too, am an anachronist: rather than live at the cutting edge of the contemporary, I feel more at ease in the absent past."[10] **(fig. 19)**

The essential point in his objection to the western view of history and time is that it is located in an inimical conceptual framework. In Japan, the oldest and most revered Shinto shrine at Ise is rebuilt from scratch every twenty years but using time-hallowed methods and according to traditional plans.[11] Of course, details have changed throughout the centuries, but this is not regarded as significant—the spirit remains the same. In the West, the idea of cultural heritage is more materialistic. The fabric of the structure, not its appearance, must be maintained in that it alone is an authentic expression of the impulse out of which the building or object was generated. Anything else is fake, and in the materialistic, one-shot, one-life West, no taboo can be greater. Sugimoto is more engaged with timeless spirit than friable material.

Japanese critic Masashi Ogura hit the nail on the head when he remarked, "Eastern time, lacking the concept of the world's end, may be different in nature from western time that is based on the Jewish-Christian world view."[12] In Tokyo, the fear of destruction, even obliteration, is based on repeated experience; in the West, it is imbued with Christian religious ideology—and for unbelievers, or those unredeemed, the inevitable result of original sin.

In this mother of all battles between the religious ideologies of East and West, where could poor Sugimoto's soul find its place? As fate would have it, his mother had gone to a Christian school and he was sent to Rikkyō Episcopal School in Ikebukuro, where once a week he sang hymns in an ivy-clad chapel and learned art. From there he graduated to study economics in a Christian university, where "almost all the professors ... were Marxists—and atheists too, religion being 'the opium of the people.'"[13] Sugimoto regarded this prevalence of leftists as one of the vicissitudes of postwar Japanese politics. When the lines of the Cold War were drawn and America had fallen prey to McCarthyism, "reds" were hunted down and banished from public office. The ripples were even felt in occupied Japan: communists were forced out of national universities and into private institutions, including religious schools like Rikkyō University. "Yet by the latter half of the 1960s, society underwent tumultuous change, and suddenly only leftists were regarded as intellectuals. I was baptized in Marxism and Existentialism."[14]

Having embarked on this grand idealistic project, finding the idea of minding the family business a far from attractive prospect, and being locked out of the economics faculty of the university because of student unrest, Sugimoto unwittingly set out on his current journey in 1971, taking the ocean-going

10

11

12

[15] See Sugimoto, "Virtual Image," op. cit, p. 17. [16] Daisetsu
Teitaro Suzuki (1870–1966) was a Japanese Buddhist scholar
who taught at leading universities in Japan, Europe, and the
United States. His best-known books are *Zen Buddhism and
Its Influence on Japanese Culture* (1938; 1959); *Zen Buddhism*
(1949); and *Mysticism: Christian and Buddhist* (1957). [17] From
a conversation with the author in his New York studio, December
7, 2004. [18] This collection was exhibited with some of his
own work under the title "L'Histoire de l'Histoire" ("The History
of History") at the Hermès Gallery, Tokyo, in August 2004. A
catalogue was published. [19] Kellein, "Interview with Hiroshi
Sugimoto," *Time Exposed*, p. 93. [20] Sugimoto, Tokyo catalogue,
p. 77. [21] Each of these works was exposed for the duration of
the film that was showing at the time so that no moving images
appear, only the white light reflected of the illumination by the
projector on the screen. The "Drive-Ins" (started in 1992) were
a subsection of the "Theaters," (1978–2001). [22] Sugimoto,
Tokyo catalogue, p. 109. [23] Sugimoto regarded his series the
"Sea of Buddha" (1988/1995) (fig. 18), made in the temple of
Sanjusangen-do in Kyoto as being an extension of his "Seascapes"
(1980–2002); the series "Chamber of Horrors" (1994–99), based
on scenes he originally saw in Madame Tussauds wax museum in
London, followed from the "Dioramas," and the "Portraits" (1999),
photographs of wax figures of people of historical significance
developed out of them. The "Architecture" series (1997–2002),
for Sugimoto, relates to both the "Dioramas" and the "Theaters."
I also believe that the shadowy frieze of "Pine Trees" (2001), "an
imaginary pair of six-paneled screens" may be regarded as a
kind of altarpiece for which the candle flame images of "In Praise
of Shadows" (1998) is the predella. [24] See Takayo Iida, "The
Large Glass–Given: The Seen and the Unseen," *Hiroshi Sugimoto:
Conceptual Forms*, Paris, Fondation Cartier, 2004, p. 161.

liner westwards to connect with the Trans-Siberian Railroad, Moscow
bound. For several months he wandered across Russia, down through
Poland, Czechoslovakia, and Hungary, searching in vain for the fruits of
that great social experiment on which he thought he, too, was embarked.
He made some photographs at this time, and hand in hand with the
dispiriting but no doubt necessary death of western Marxist ideology in
his soul, he kept moving westwards until he could go no farther without
ending up back in Japan. Sugimoto settled in Los Angeles, where at the
Art Center College of Design he enrolled in the photography department,
specializing in advertising.

Not surprisingly, in the photographs that Sugimoto has kept from some
of his first student projects, time features as the main subject, and this,
next to light, became one of the most important motifs in his work. (fig.
9) A series of images promoting the Ingram Electric Clock Company was
far from "hard sell" but instead had more of the appearance of conceptual
art, yet for him the process of "measuring the distance between the
self and the world" had irrevocably started.[15] In Los Angeles and
later in New York, where he moved in 1974, Sugimoto began, slowly
at first, to understand his own nature as an artist. Experimenting with
hallucinogenic drugs was one path, a common enough recreation in
those years, yet paradoxically he filled the aching ideological vacuum
that had been left in his mind by the symbolic deaths of Feuerbach, Hegel,
and Marx, with an appreciation of the Japanese culture and spirituality
he had left behind. This came through the writings of Daisetsu Suzuki, a
scholar who had popularized Zen Buddhism and its ideas in the West.[16]

Then, as now, Sugimoto's parallel with the life of Marcel Duchamp
springs to mind. Both went into voluntary exile in the United States;
both were able to establish a new artistic identity there, and both
worked underground, researching art secretly, supporting themselves
by other means. In Sugimoto's case, he did this first as a carpenter, and
then in 1979, with his wife, set up a small antiques business, buying work
in Japan to be sold in New York. As part of this activity he recalls that
he "learnt the mentality of a curator," and his skill in observation meant
that he rapidly became expert in detecting quality.[17] The same is true
with his art. Sugimoto avidly learns and absorbs as much information
as he can about the subject he is photographing, and in this way he has
given himself a formidable education. The result was that from about
1985 until the middle of the 1990s he supported himself as a dealer
in antique Japanese religious art, even selling work to many major
museums. This gave him the freedom to concentrate intensively on
his own work without having to worry unduly about sales. He also
began to accumulate a fine collection of ancient Buddhist and
Shintō artifacts.[18] (fig. 5)

The form that Sugimoto's work was about to take was determined
primarily by physical considerations, such as the weight of his
camera—an American-made, 19th-century-style box on a tripod with
eight-by-ten-inch negatives. To get the quality of the image he wanted,
this was the maximum size he could carry by himself, a necessary
consideration when traveling. As a rule, he used only available light.[19]

His first series of works—"Dioramas" (1975–99)—was concerned with
transforming the fake into the real. (figs. 6–8; p. 288, fig. 1) These quaintly
old-fashioned tableaux of prehistory and nature, that until recently
were commonplace in large museums, provided Sugimoto with a base
for compressing time and space. Using careful lighting and impeccable
framing, by rendering the images in black-and-white, he made their
subjects seem almost real—endowed with a timeless contemporary life.
Cumulatively these moth-eaten figures became hyper-real, transformed
into wryly melancholic reflections on the changing nature of history,
human endeavor, knowledge, and understanding.

13

14

15

Soon—with the idea of "shooting a whole movie in a single frame"—Sugimoto also started to work on the "Theaters" (1978–2001).[20] He captured the idiosyncratic architecture and shining white screens of the interiors of these fast disappearing monuments of the golden age of cinema by exposing his film for the exact duration of the film that was being projected; then, from 1992, he extended this method into a series of portraits of drive-in cinemas, transient icons from the 1950s and '60s, that were also quickly beginning to disappear.[21] (figs. 1–3)

In 1980, Sugimoto pushed the nascent minimalism of the drive-ins further in the "Seascapes" (1980–2002) for which he traveled across continents to record little more than strips of sea and sky, sometimes delineated by a visible horizon. He described the origin of these works as the result of one of his "internal question-and-answer sessions. I asked myself, 'Can someone today view a scene just as primitive man might have?' . . . A hundred thousand or a million years ago, would Mount Fuji have looked so very different than it does today? . . . [But] although the land is ever changing its form, the sea, I thought, is immutable. Thus began my travels back through time to the ancient seas of the world."[22] (figs. 10–12)

This self-interrogatory way of thinking, a constant facet of his work, has opened up other subjects, more or less until the present.[23] Yet, over the past five years, Sugimoto's work has become increasingly concrete as well as more abstract. It has broken out of, or beyond, photographic illusion to touch the moment itself in an architecture of ideal space that may be rendered only by photography. This is clear in his series "Colors of Shadow" (2004), in which changes of daylight and shadow are carefully recorded on the walls of an apartment Sugimoto has rebuilt specially for this purpose. As part of this project he has been directing sunlight through a prism and then capturing the colors of the spectrum as they play on the walls at different times of day.

A desire to form space through light, as well as an engagement with religious history and art, is also clear in the Shintō Go-O Shrine that he refurbished on the island of Naoshima in 2002. A steep flight of steps made of slabs of optical-quality glass rises up to the shrine from a darkly recessed entry passage, capped by a large ancient stone, through which the light of the shrine and the sky beyond are funneled. (figs. 13–15)

Far away from God, in his series "Conceptual Forms" (2004), Sugimoto extended the idea of empowering and repurposing the original by making a simulacrum of it first begun in the "Dioramas." Here the history of science, mathematics, and physics was conflated with Duchamp's metaphysics. In these studies of found objects, the fecund, seductive, female surfaces of models made to simulate mathematical equations were set against the rigid, inflexible male screws and levers of machines that had been constructed to display the principles of physics. In this paraphrase of the sexual rubric of Duchamp's *The Large Glass* (also known as *The Bride Stripped Bare by Her Bachelors, Even*) (1915–23), the potential violation that Sugimoto was interested in was made manifest by the way the work was installed at the Fondation Cartier in Paris late in 2004: the "sexes" were segregated on either side of the entrance hall, and both were penetrated by the light and reflections of the real world, namely, nature and the cityscape seen from the garden and the street.[24]

10 | From Seascapes | Caribbean Sea, Jamaica | 1980 | gelatin silver print | 119.4 x 149.2 cm

11 | From Seascapes | Mediterranean Sea, Cassis | 1989 | gelatin silver print | 119.4 x 149.2 cm

12 | From Seascapes | Mirtoan Sea, Sounion | 1990 | gelatin silver print | 119.4 x 149.2 cm

13 | Aerial view of Go-O Shrine, Naoshima Island, and the surrounding Soto Inland Sea | 2002

14 | Go-O Shrine | frontal view over the main worship hall to the main sanctuary | 2002

15 | Go -O Shrine | view from the passage toward the exit | 2002

Ultimately, and perhaps perversely, this work now transmutes into a meditation on the impact of modernity on Japan. Although the models and machines that Sugimoto photographed were made in Great Britain and Germany at the end of the 19th century, they had been imported to Japan as teaching aids as part of the Meiji Emperor's program of modernization. (fig. 17)

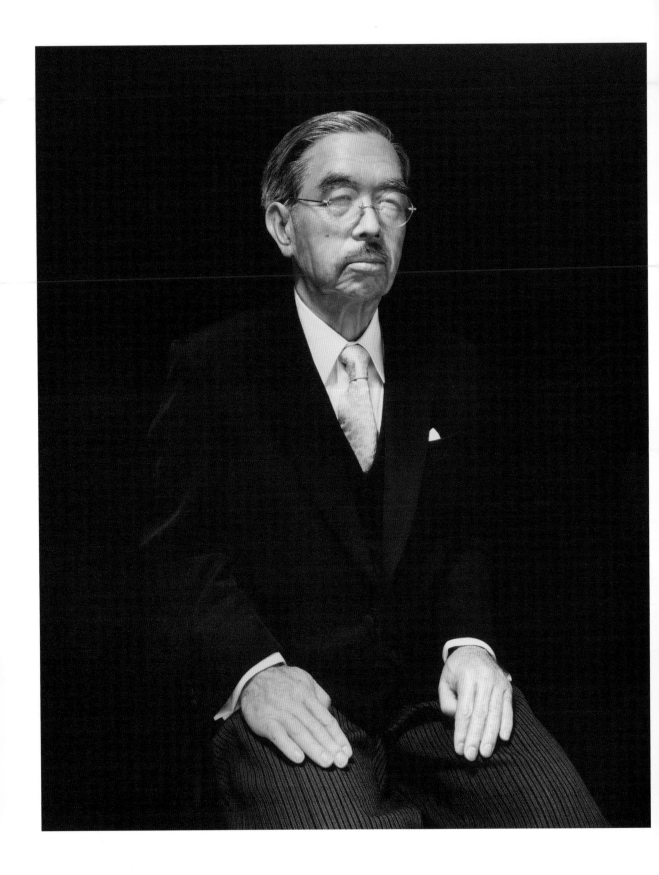

17

Sugimoto's multiple based on Duchamp's *The Large Glass* that was shown with this work told the same story. The negative was not taken from the "approved" version of Duchamp's work in the Philadelphia Museum of Art but rather from the "authorized copy" that Duchamp's friend, the surrealist poet and critic Shūzō Takiguchi, had made.

Their subjects may change, but, as with the "Dioramas" or the waxwork "Portraits" we are still looking at copies of copies. (fig. 16) What is more, these particular copies have become co-opted within and imbued with Japanese culture to such an extent that they have become absorbed within it. Far beyond Duchamp, we are contemplating a longstanding leitmotif in Sugimoto's work: the tragic, elliptical beauty of the impact of modernity on Japan—and everywhere else.

The path between Japan and the West is paved with hope and despair— and not a little love—its direction may flow either way. Distance provides knowledge, perspective, and rather like a disappointed lover, the artist, a voluntary exile, begins slowly to realize, perhaps with regret, that nothing is simple, nothing is pure. Everything is mixed up.

III. Two More Jokes

The first: Sugimoto once explained:

Four or five years ago, I decided to put all the "Dioramas" and "Wax Museums" together to make an illustrated storybook. The title is The First Visitor's Guide. *I even made a mock-up and have been writing text to accompany the images. It is a guidebook to the planet Earth for otherworldly creatures to get an idea of who inhabits the surface of this planet and its history. I plan to explain the history of life formation through my photographs of natural history museums and wax museums, through the fake material that has the pretence of being real, scientific, or historical. [...]* (fig. 16)

I will use these "Portraits" to record the final phase of human evolution after my portraits of dinosaurs. I entitled that section "Extinction." Extinction is the disappearance of a species from the Earth. Mass extinction is the disappearance of many species in a geologically brief period of time. Periodically, life forms on the earth experience mass extinction. Please avoid planning your trip to Earth during one of these infrequent but catastrophic events. [25]

The second: In preparation for a discussion about the title of this exhibition, Sugimoto prepared a long list of possibilities. Most of them were very facetious, and we laughed a lot. My favorite was "Hiroshi Sugimoto: The Indecisive Moment." [26]

IV. Bumping One's Head on a Frame

And maybe that's why the images in his "Architecture" series (1997–2002) are so blurry or the "Theaters" photographs have only a brilliant white screen. (figs. 20–22) Sugimoto just could not make up his mind about the right moment to release the shutter! Of course, I'm joking, but as in all jokes there is a kernel of truth. If the moment is indecisive—and the whole history and criticism of photography have been built on the idea of capturing the perfect shot—of what is time then made? And where does that leave photography? In fact, at times I wonder whether Sugimoto is really a photographer at all or is just using the medium for want of anything better. I am convinced that, deep down, Sugimoto distrusts the moment; it is far too flighty to be reliable enough to make art.

Can time exist beyond consciousness? And what exactly is time anyway, other than a word we have created to describe what we perceive as duration? Let's push this inquiry just a little further: in a world of illusion, what then is real?

16 | From **Portraits** | **Emperor Hirohito** | 1999 | gelatin silver print | 149.2 x 119.4 cm

17 | From **Conceptual Forms** | **Mechanical Form 0026 (Worm Gear)** | 2004 | gelatin silver print | 149.2 x 119.4 cm

[25] Tracey Bashkoff, "The Exactness of the World: A Conversation with Hiroshi Sugimoto," *Sugimoto Portraits*, New York, Solomon R. Guggenheim Museum, 2000, p. 41.
[26] This is a word play on Henri Cartier-Bresson's seminal book *The Decisive Moment (Images à la Sauvette* [Paris, 1952]). Cartier-Bresson (1908–2004) was an influential French humanist photographer, and his idea of the truth and typicality of a "pure," uncropped photodocumentary image of a single moment has been extremely influential.

18

19

From the very beginning Sugimoto has tried to confront such questions in his work—of course, inconclusively—but out of the process of questioning, looking, and thinking, the work is born. He admits as much himself: "I am a habitual self-interlocutor."[27] I doubt very much whether the Bachelor Sugimoto, on beholding his Bride, the world, for the first time, consciously realized that the "Theaters," "Seascapes," and "Dioramas" could be so neatly interpreted as symbolizing "the distinct spheres of man, nature, and culture," although in retrospect he was quick to retort that, on the contrary, they evoked "the interrelated disciplines of art, science, and religion."[28] I suspect that this all came together more slowly—yet within the space of five years, starting in 1975, Sugimoto had launched that fundamental trinity of genres out of which all his other work has grown.

Half-soldier, half-monk, Sugimoto uses the discipline of self-interlocution to locate limits or edges that together create a frame which enables him (and us) to comprehend the world as it is, how he came to be here, and perhaps, how he may progress into the future. The tool of language is part of this because, like photography, it enables him to maintain memory, and therefore he is able to communicate with others. Language, however, is a limit as well as a resource. Sugimoto has described the "Seascapes" as images of the world as it may have looked to man before language, before society, and in this sense they are not only a celebration of a state of primordial beauty but also of the melancholy of an isolated and lonely innocence.[29]

Yet, as soon as we begin to speak we become estranged from innocence; and from that point everything is a construct. Memory itself, like the camera or the eye, becomes a developing tray for fixing the conscious mind.[30] The inevitable question then arises: How may we penetrate beyond the frames of language or consciousness? Our mental faculties limit us from tackling such questions head on, and I suspect that Sugimoto's working method is actually a tool to test such limits. When considering why his photographs of modern buildings are blurred, he explains that this is a way of "erosion-testing architecture for durability," a conceit that has nothing to do with the buildings' physical structure but which is intended to attract attention to the human and spiritual values that some great buildings iconically express.[31] (figs. 20, 21, 22)

In terms of western philosophy, the result could be no better than an inevitable but productive impasse—what philosopher Ludwig Wittgenstein once described as, "a kind of simple meaningless discovery and the realization of having bumped one's head on the limits of words. That bump makes one realize the value of that discovery."[32] Sugimoto himself has relished Wittgenstein's words, no doubt seeing a parallel between the bump on the head and the slap from the Zen master that is intended to bypass the rational mind to provoke *satori,* a sudden enlightenment. The desire to test limits, to break the frame, is neither nihilistic nor futile nor quixotic, but it comes out of the fertilization of Japanese aesthetics by Buddhist morality many centuries ago, from the same womb that also nurtured Sugimoto's ideas about art. This is what motivates his acts of interlocution. (fig. 18)

The bumping of our heads on our own limitations is a life-affirming act because it makes us human. *Ma*—a concept that describes empty space, the absence of sound, color, or form—is also positive. No deathly existential void resides at the heart of Sugimoto's work, although we can see from what he shows us that he finds the idea of it sometimes disquieting, sometimes absurd. In Japanese aesthetics *ma* is a meaningful void, one connected with the rejection of illusion. It is an interval, a space for reflection that creates unexpected relationships. *Ma* is the whiteness of the screen in his images of movie theaters, the flat surface of sea and sky in his "Seascapes," or the vital pause before the delivery of a punch

[27] Tokyo catalogue, op. cit., p. 77. [28] Nancy Spector, "Reinventing Realism," *Sugimoto Portraits*, New York, Solomon R. Guggenheim Museum, 2000, p. 11. [29] Bashkoff, *Sugimoto Portraits*, p. 29. [30] John Yau, "Hiroshi Sugimoto: No Such Thing as Time," *Artforum*, New York, April 1984, p. 50. [31] Tokyo catalogue, op. cit., p. 181. [32] Ludwig Wittgenstein (1889–1951) was one of the most influential linguistic philosophers of the 20th century. Quoted by Sugimoto in a note on the concluding paragraph of Tanizaki's book, *In Praise of Shadows*. Quoted in Iida, op. cit., p. 164. [33] "Houres, dayes, months"; see note 1. [34] Ibid.

line of a joke. In other words it appears metaphorically or strategically to delimit the frame of our perceptions as well as the artist's intention.

In seeking to make a beautiful photograph, whether the subject may be grisly or sublime, Sugimoto harkens back to his most fundamental emotions. His art is like flickering shadows that depend on light for their existence and is an active reflection of the world that elucidates rather than darkens reality. **(fig. 19)**

Light is not only the engine of photography, but it also gives us life. Sugimoto's work challenges, probes, and throws light on our most basic assumptions in a way that, because of its generosity and openness, cannot fail to engage. Its scope and ambition are of such an order that it is able to brush the face of infinity whilst, at the same time, picking over "the rags of time." [33]

John Donne, the 17th-century English metaphysical poet and priest, would have appreciated Sugimoto's irreverent conceits and conundrums. In his poem *The Sunne Rising,* a passage from which begins this essay, the poet berates the sun for disturbing him in bed with his lover. "Why don't you go and bother someone else?" he complains, but he relents at last and concedes in a masterly conceit that, since the sun is so old, he should not strain himself so much because,

To warme the world, that's done in warming us.
Shine here to us, and thou art every where;
This bed thy center is, these walls, thy sphere. [34]

In his photographs Sugimoto creates similarly disruptive feelings of surprise, delight, even disquiet. By staring into the faces of infinity, he has telescoped space and time to a point where, by concentrating on the details, we can extrapolate an image of the whole universe. The same is true when we face the other way. By contemplating the entire image and all that it represents—including the frames we crack our heads against—we gain a heightened awareness of every particle. This expansive, poetic act of inspired compression lies at the very center of Sugimoto's work. ●

18 | From the **Sea of Buddha** | 1995 | detail | gelatin silver print, 48 joined panels | 42 x 53.3 cm each | overall length 2.56 m | Sugimoto used only the light of the rising sun to record the "installation" of the 1,001 Senju Kanon, a three-dimensional representation of the Buddhist afterlife in the Sanjusangen-do, Hall of Thirty-Three Bays, in Kyoto. He imagined that this may have been how the aristocracy of the Heian period (794–1185) might have originally experienced the work and wondered if the serial conceptual installations of contemporary artists might survive for so many years.

19 | From **In Praise of Shadows** | 1998 | neg: 980726 | This is one of a series of works made in response to Jun'ichirō Tanizaki's eponymous essay on traditional Japanese aesthetics

20 | From **Architecture** | 1997–2002 | **Seagram Building (Architect: Ludwig Mies van der Rohe** | 1997 | gelatin silver print | 149.2 x 119.4 cm

21 | From **Architecture** | **Einstein Tower (Architect: Erich Mendelsohn)** | 2000 | gelatin silver print | 149.2 x 119.4 cm

22 | From **Architecture** | **Church of the Light (Architect: Tadao Ando)** | 1997 | gelatin silver print | 149.2 x 119.4 cm

21

22

Leiko Ikemura
The House Beyond the Horizon

This essay appeared in both German and English in **Leiko Ikemura: All About Girls and Tigers**, a book published by Walther König Verlag in 2015 to coincide with the exhibition of the same title at the Museum für Ostasiatische Kunst in Cologne. I first encountered Ikemura's work in Tokyo when it was included in "The World is a Stage: Stories Behind Pictures," curated by Natsume Araki at the Mori Art Museum in 2005. More recently I included her work in "The Pleasure of Love. Transient Emotion in Contemporary Art," at the 56 October Salon in Belgrade 2015. Leiko Ikemura is based in Berlin.

2

I. Houses, Dreams and Poems

Inside the high garden walls, one came upon the latticed front of the house. An earthen passage led from the entrance through to the rear. In the rooms, lighted even at noon but by a dim light from the courtyard, hemlock pillars rubbed to a fine polish, gave off a soft glow ... Sachiko sensed that much of her sisters' love for Ōsaka was in fact love for the house ... She had often enough joined Yukiko and Taeko in complaining about it—surely there was no darker and more unhygienic house in the world ... and they felt thoroughly depressed after no more than three days there ... —and yet a deep indefinable sorrow came over Sachiko at the news. To lose the Ōsaka house would be to lose her very roots.

– Jun'ichirō Tanizaki, 1949 [1]

Leiko Ikemura was born in 1951 in Tsu, a small Japanese coastal town in Mie Prefecture not far from the ancient building complex of the Ise Grand Shrine. Set against surrounding woods and mountains, these fountainheads of pantheistic Shintōism, torn down and identically rebuilt every twenty years, were not only a national center of pilgrimage but also, paradoxically, an embodiment of the impermanence of all things in the death and renewal of nature. Although she did not realize it while she was still living in Japan, the beauty and transient spirit of this special place was later to become of lasting significance for the development of her art.

The town of Tsu itself, however, was much less prepossessing than the famous shrines. It had been heavily bombed during World War II but quickly rebuilt. Ikemura's predominant early memory is of the open horizon and unavoidable view of the ocean.[2] Home life was not happy. She has described a melancholic childhood with a father, unable to settle into a profession, whose inchoate frustration cast a pall over the whole family. In high school, she was a good, if at times rebellious, student, and literature became her solace.

Precociously, she read both European and Japanese authors and became acquainted with haiku, a traditional unrhymed, seasonal poem, its three lines usually containing five, seven, and five syllables.[3] These concise, abstract word pictures were her introduction to a new way of looking at the world that enabled her to come to terms with the different worlds she was later to encounter. At the beginning of the 1980s, when she first started to work independently as an artist, free-form poems and haiku accompanied many of her works.[4]

Her hometown was isolated from the big cities, museums were far away and she had little exposure to visual art. Her maternal grandfather, a master builder, was a strong influence; he showed her illustrated books about art and she began to take an interest in drawing. The house not only became a repeated image in her drawings but also an obsession, a doubled-edged motif of both security and anxiety that constantly resurfaces in her work:

"The 'house' is an obsession that has stayed with me since I was a child. I often dreamt of houses and stretches of water and I made notes of them. Some are fascinatingly lucid, others more traumatic ... Why this is so

1 | **Usagi Kannon II** | 2013–14 | glazed terracotta | 330 x 118 x 155 cm | images courtesy the artist

2 | **White House** | 1992 | glazed terracotta | 38 x 22 x 20cm

[1] Jun'ichirō Tanizaki, *The Makioka Sisters*, 1949, Book 1, Chapter 21, translated by Edward G. Seidensticker, 2000, London, Vintage, p. 99. [2] Leiko Ikemura, *Leiko Ikemura* (exh. cat.), Arnsberg, Sauerland-Museum, 2010, p. 143. [3] The European writers she remembers reading at this time include Albert Camus, Simone de Beauvoir, André Gide, Søren Kirkegaard, Frederico Garcia Lorca, Antonio Machado, Carston McCullers, Friedrich Nietzsche, William Shakespeare, and Leo Tolstoy. The Japanese authors she read include Yukio Mishima, Shikibu Murasaki, Natsume Sōseki, Kenzaburō Ōe, Sei Shōnagon, and Juni'chirō Tanizaki. Leiko Ikemura, *Leiko Ikemura: Transfiguration* (exh. cat.), Tokyo, National Museum of Modern Art, 2011, p. 225–226, and interview with the author, February 25, 2013. [4] In 1985, she made 22 drawings to accompany a new translation of haiku by the 17th-century wandering Zen poet Matsuo Bashō, *Hundertelf Haiku*, Zurich, Amman Verlag. Leiko Ikemura: "For me the art of haiku is universally valid, all my drawings are related to this. The character of haiku is poetry in its most concise form, aware of its transience, far from bombast or pretension, haiku sings the praises of nature and is nature itself. Only by distancing oneself sufficiently from one's ego, one ought to become, in one's essence, a part of nature's creation like in a haiku" in *Leiko Ikemura* (exh. cat.), Kunsthalle, Recklinghausen, 2004, p. 17.

3

3 | **Genesis + the Four Seasons** | 1978 | etching on paper | 29 x 26.5 cm | courtesy the artist | This work was made in Seville

4 | **Kamikaze** | 1980 | acrylic on paper | 120 x 90 cm

[5] *Leiko Ikemura im Gespräch mit Friedemann Malsch*, Cologne, Kiepenheuer & Witsch, Kunst Heute Nr. 20, 1998, pp. 65, 66 [Malsch]. Ikemura related her feelings about the motif of the house in her work to the writings of the French theorist Gaston Bachelard (1884–1962), who in his book *Poetics of Space* (1958) regarded an unbuilt or still to be completed house as a conduit for dreams. [6] Leiko Ikemura, *Leiko Ikemura: Transfiguration*, op. cit., p. 218. [7] Leiko Ikemura, *Leiko Ikemura*, Sauerland-Museum, op. cit., p. 140. [8] Yayoi Kusama (b. 1929) left Japan in 1957 to live and work in the United States where she made her vast "Infinity Nets" and dot paintings, as well as the installations for which she is now well known. When she returned to Tokyo from New York in 1973 after a breakdown, all of her achievements were initially rejected and she decided to sequester herself in an open clinic near her studio where she still lives. It was not until the early 1990s that her work began to be widely appreciated within Japan. Yoko Ono (b. 1933) experienced a similar case of rejection. She had moved to New York with her parents in the early 1950s and when she returned to Tokyo in 1963 after the breakdown of her first marriage was hospitalized with clinical depression. She left Japan as soon as she could and since that time has only returned as a visitor. Her reputation as an artist was also established outside Japan. [9] Very few Japanese women artists were able to stay in Japan and make a career for themselves. Atsuko Tanaka (1932–2005), a member of Gutai, has only become widely appreciated internationally since her death. In the mid-1950s, Toko Shinoda (b. 1913) broke through into the male-dominated medium of calligraphy after her work had been shown at the Museum of Modern Art in New York but only achieved recognition as a painter in Japan after a member of the imperial family purchased a painting. It was only during the 1990s that a younger generation of women artists began to emerge in Japan. The Japanese artist, a man, whose career path most closely mirrors that of Ikemura, however, is Hiroshi Sugimoto (b. 1948), who described himself as "baptized in Marxism and existentialism." See pp. 316–325. After being locked out of the economics faculty of his Tokyo university because of student riots, he left Japan in 1971, heading towards Moscow and eastern Europe. He eventually made his way to Los Angeles where he began to study photography, become an artist and, eventually, to learn about traditional Japanese culture and art. [10] See note 6. [11] Ibid. After the death of General Francisco Franco in 1975, Spain moved back to being a democratic monarchy under King Juan Carlos I. [12] Leiko Ikemura, "Erotik in ihrer Ausstrahlung hat eine unaussprechbare Trauer," interview with Gerlinde Gabriel, *Leiko Ikemura Stadtzeichnerin von Nürnberg*, Nuremberg, Kunsthalle, 1984, p. 10. [13] Ibid., p. 9. [14] Natsume Sōseki, *I Am a Cat*, trans. Aiko Ito & Graham Wilson, 1905–11, Boston, Tuttle, 2002, p. 3. [15] She held her first exhibition in 1979 in the small Galerie Regenbogen in Lucerne.

deeply embedded in me is that even as a child I wanted to build houses and this is probably to do with experience of our house being destroyed by a typhoon . . . The house is a living organism. The most amazing part for me was the cellar . . . Every house [in Tsu] had a place like this, dark and damp."[5]

On Sundays she attended school in a simple Protestant church and, although she would never describe herself as Christian, remembers this place fondly as a kind of "home" or refuge at a time when "people had little energy to be religious. I hardly knew what it was like to be in a community until I went to church . . . I was able to connect with people [there] in a way [it was] not possible with my family."[6]

Like many members of the generation of 1968 (and not only those in Japan), she clearly remembers early feelings of alienation, sadness, anger, and fragmentation. As part of this she cast a critical eye on the subservient role of women in Japanese society, particularly on the life of her mother and her relationship with her father, and this made her decide to get away. The pitiless descriptions of existence and free will in such seminal novels as Albert Camus's *L'Etranger* (1942), Jean Paul Sartre's trilogy *Les Chemins de la Liberté* (1945–49) or the ground-breaking analysis of the war between the sexes in Simone de Beauvoir's *Le Deuxième Sexe* (1949)—all of which Ikemura had read—struck chords with her own experience and convinced her that she had take responsibility for her own life to break from her past. This became a repeated pattern in her artistic development as she searched for new ways of working. "For a variety of reasons, the first chapter of my life was . . . cut off. Things are perhaps different for most people, people who live a continuous life. In my life there has been a series of radical breaks, it was as though I wanted to acquire a new identity each time."[7]

In 1970, at the age of 18, she left home to study Spanish literature and linguistics at the University of Foreign Studies in Osaka. In 1972, she was in Tokyo, working for six months, part-time, at the Cuban Embassy. By the time she was 21, she had left Japan, initially to study Spanish at summer schools in the universities of Salamanca and Grenada, little realizing that she would not return home for seven years and even then would not settle back to live there.

Ikemura has spoken about her need to move away from "from the strictness of Japanese tradition" at this time by giving the example of "'comrades' of my sex [who] have done so before." Undoubtedly she was thinking of such artists as Yayoi Kusama and Yoko Ono, who had both left Japan in the 1950s.[8] Ikemura, however, came from a very different background and was younger than either of them when she decided to leave. Perhaps because of this, her decision to move away was less premeditated, but her desire for freedom and her determination to establish herself were equally strong.[9]

In Granada, a chance encounter with an artist who carved religious images led to work in his studio and reawakened her childhood interest in art. Looking at her drawings and at the few objects she made there, he suggested that she should sit for the highly competitive, one-week-long admission exam for the Academy of Fine Arts in Seville. She went ahead and was offered a place. She started working there in the autumn of 1973 and graduated in 1978.[10]

Although she had managed to escape from the peculiarly Japanese fusion of feudal hierarchy and economic boom that she found so oppressive, she now found herself living in General Franco's Spain, where the government was one of the few survivors of the fascist dictatorships of the 1930s. This irony was not lost on her but in a strange way it enabled her to enjoy the liberation of being an outsider, which came with being, as far as she knew, the only Japanese person living in Seville. She remembers this time with elation as, "the most free in my whole life. Because daily life was difficult

4

and people were poor, we really helped each other. I had little money but I never went hungry. It was really the most beautiful of times."[11] (fig. 3)

By the standards of western Europe, the teaching at the Seville Academy was ultra-conservative. Ikemura studied art history, as well as the media and genres of traditional European art, drawing from plaster casts, painting allegories and religious images, carving and casting, engraving, etching, and making other kinds of prints, with an additional smattering of Cubism and Fauvism to bring it up to date. She was also able to travel widely throughout Europe—as far as Turkey and North Africa—visiting museums, galleries, churches, sites and monuments, absorbing a vast range of art and culture from ancient Egypt and Greece, through the Renaissance, the baroque, mannerism, classicism, romanticism and realism to modernity, comparing it with what she already knew. The classes of her drawing master in Seville stood her in good stead as they taught her to work quickly, fluidly, to capture movement from life. This formed the basis for her next development.

Unlike many of her European peers, Ikemura had no investment in being avant-garde. Following on from her experience in Japan, her starting point as an independent artist was in thinking about gender but she approached it from the point of view of eroticism rather than sexuality. While still a teenager she had been skeptical of the Christian doctrine of original sin and the sexual guilt that this inevitably implied. Once she began to travel outside Japan she found "the stereotypical divisions between art made by men and women absurd."[12] The erotic could be found in all forms and conditions of life, even in the church paintings of the Renaissance. It was "the concentration of existence and this is what distinguishes it from what we call sexuality. Sexuality does not really interest me because it has become a commodity in consumer society . . . the erotic, however, has a much greater dimension because it is a source of energy in nature."[13] Within Ikemura's rapidly developing cosmology of art, poetry and thought, the erotic was intimately concerned with the conflicting energies of rebirth and death.

II. Kamikaze, Cats and Horses

I am a cat. As yet I have no name. I've no idea where I was born. All that I remember is that I was miaowing in a dampish dark place when, for the first time, I saw a human being. This human being, I heard afterwards, was a member of the most ferocious human species; a shosei, one of those students who, in return for board and lodging, perform small chores around the house. I hear that on occasion this species catches, boils and eats us. However as at that time I lacked all knowledge of such creatures, I did not feel particularly frightened. I simply felt myself floating in the air.

– Natsume Sōseki, *1905–11* [14]

During her time in Spain, and the years immediately after, Ikemura had protected within herself a naively distanced view of life that is also clearly expressed in the words of Sōseki's egregious hero. A satire on the pretensions of different social types, the author makes his imaginary feline society and its interaction with humans an absurd Bakhtinian allegory that makes its point by turning dominant hierarchies on their heads. A similar sense of distractive subversion and humor can be seen in the first works that Ikemura made once she left Spain and started to work as an independent artist.

During the late 1970s Ikemura had been traveling increasingly throughout western Europe, spending the summers in Switzerland where she found summer jobs that helped support her throughout the year. Once she had graduated from Seville Academy it was time to move. Liberated from Franco's dictatorship, Spain was quickly rediscovering its past and making

5

5 | From **Wild Cats and Domestic Cats** | 1983 | a book of 61 drawings | Zurich, Editions Stähli

6 | **Kriegesgöttin ("Goddess of War")** | 1986 | oil on canvas | 200 x 250 cm

[16] Ikemura has retained this work in her collection. [17] Leiko Ikemura, *Leiko Ikemura: Transfiguration*, op. cit., p. 218. [18] Ibid., p. 194. [19] Ibid., p. 222. [20] Ibid., p. 225. [21] Ikemura exhibited as a Swiss artist in the 1988 Tokyo Biennale, as well as in a number of other international exhibitions during the 1980s. [22] Malsch, op. cit., p. 79. [23] Leiko Ikemura, *Wild Cats and Domestic Cats*, Zurich, Editions Stähli, 1983. This was her first artist's book. [24] During the 1930s and '40s Berlin-based painter Carl (Karl) Hofer (1878–1955) used the figure of *Der Trommler* ("The Drummer") in his work as an expression of warning and resistance against Nazism. It is the central motif in the second version of his famous painting *Die Schwarzen Zimmer* ("The Black Room," 1943), see p. 75, fig. 32. [25] *Unerwünschtes Kind*, acrylic on canvas, 120 x 200 cm. [26] Her first exhibition in a public space had been in 1981 at the Städtisches Bodensee-Museum, Friedrichshafen, Germany. [27] *Stadtzeichner*: a city-funded residency for an artist specializing in drawing. See the exhibition catalogue, *Leiko Ikemura Stadtzeichnerin von Nürnberg*, Nuremberg, Kunsthalle, 1984. [28] As in "Die Neue Kuenstlergruppe – Die Wilde Malerei," 1982, Klapperhoff, Cologne, Germany. [29] The term "personal mythologies" had been coined by Swiss curator Harald Szeemann in relation to these artists. Ikemura was extremely critical of this term, arguing that mythologies by their nature had to be collective. See *Leiko Ikemura Stadtzeichnerin von Nürnberg*, op. cit., p. 10. [30] Leiko Ikemura, *Korekara or the exhilaration of fragile being*, Berlin, Museum für Asiatische Kunst, 2012. [31] *Verkündigung*, 1985, acrylic on canvas, 210 x 240 cm.

a new future. In the intense social ferment that followed there was little space for outsiders. In 1979, Ikemura packed everything into a small car and drove from Seville to Lucerne, in Switzerland, where she settled for a few months before moving to Zurich and marrying an art historian she had recently met.[15]

She spoke not one word of German—nor *Schweizerdeutsch.* In a large, rented studio she started work on a series of large drawings and acrylic paintings on paper, the best known of which is *Kamikaze* (1980), a painting based loosely on a wartime photograph of a Japanese suicide pilot plunging towards an aircraft carrier.[16] **(fig. 4)** This work, emblematic of both Japanese and world history and also, ironically, of Ikemura's path as an artist, is the embodiment of a constantly flickering rite of passage: between life and death, light and darkness, being and nothingness, air and water: "When I was young, the art world was based on the attitude of taking a critical spirit toward the social system," she wrote, but by the 1980s "Artworks were being assimilated into the manufacturing cycle . . . and began to function within capitalist society."[17] For an artist with such misgivings, the move to Switzerland, one of the epicenters of world banking, was, after the dictatorship of Franco's Spain, another paradox to say the least.

Cut loose in a country she hardly knew, she began to regard "the space of my work [as] a contested arena"[18] and "allegorically expressed human aggression in the dark side and ugliness we unconsciously possess within us."[19] Ideas of "risk" and "freedom of consciousness" started to become important, and she struggled to express them in ways that were fluid, anti-formulaic and open to experience, however daunting or unpleasant the subject may be. Married, yet somehow still by herself, she had to test what she meant by "freedom of consciousness . . . the potential to create a universal expression that begins from an individual . . . [yet also] the responsibility involved in that freedom."[20]

Ikemura was quickly accepted in her newfound home, receiving in 1981 both a grant from the city of Zurich and the prestigious Kiefer-Hablitzel Foundation's Art Prize. She also got to know her new artist-neighbors and throughout the 1980s, even after she had left the country, exhibited with them abroad—including in Japan—as an artist from Switzerland.[21]

Drawings were her strongest and most prolific work at this time and she had clearly studied hard the jerky expressionism or tragic symbolism of early moderns such as Ernst Ludwig Kirchner, Ferdinand Hodler or the outsider artist Louis Soutter. Her academic training had previously familiarized her with many different historical styles and graphic media, as well as with the chameleon line drawings of Picasso and Matisse. She described line as "the skeleton of thought, visual thought, but also a memory of the body, . . . a seismograph of the soul" that expressed both depth and complexity of emotion.[22] Throughout the early 1980s Ikemura was drawing obsessively with line taking on a life of its own, playing through different motifs and ideas, many of which were to resurface in her paintings.

Wild Cats and Domestic Cats, a book of 61 drawings published in 1983, was edited down from many hundreds of different sketches and chronicles a darkly humorous sexual comedy in which the cat, as in Sōseki's novel, was an all powerful, elemental creature that commented on—and in the process subverted—the futility of human, in particular the male, endeavor.[23] **(fig. 5)** References in the drawings also point to Ikemura's reading of Jack Kerouac's Beat classic *On The Road* (1957), as well as to the edgier and more misogynistic writings of William Burroughs. In these works, with charcoal and pencil often mixed together, image builds on image with surrealistic verve: a naked male body lies in a pipe with one foot in a cat's mouth; carp, the symbol of Boy's Day in Japan, jump into cats' mouths; like a refugee from a painting by Carl Hofer, a man appears to be frenetically beating a

6

drum;[24] multiple zigzag bodies interlocked; disembodied "oriental" heads stacked, linked to each other by eccentric single lines; a cat's gaping maw swallows an airplane; a Japanese girl with hair pins morphs into a cat . . .

Her paintings of this time are less fluid than the drawings and suggest a more labored search for significant imagery. *Unerwünschtes Kind* ("Unwanted Child," 1982) depicts two robotic figures lying on the ground clasping "boy carp" kites on poles, the feet of one seemingly disappearing into the concrete-block-chest of the other.[25] It is an enigmatically disquieting work that relates back to previous drawings as well as forward to the looping self-wounding forms of yet-to-be made sculptures. *Kaiserin Tötet Kaiser* ("The Empress Kills the Emperor," 1983) is more obvious in its approach. On an acid green "barge," diagonally slanting across a bilious yellow "sea" are two dark-skinned, white-clothed figures. The standing woman wields a long "Japanese" sword above her head. Below her a kneeling man leans back, perhaps in dread. Painted in a consciously childish, cartoon-like way, this murderous scene discloses neither strong feelings nor detail of expression. In fact, paradoxically, it almost seems like a joke.

Ikemura's first large solo show in a public space was held in 1983 at the Kunstverein in Bonn, then the capital of the German Bundesrepublik.[26] During 1983/84 she moved to live in Nuremberg, a city that, like her hometown, had also been flattened by war; she worked there on a year's residency as the city's *Stadtzeichner* and showed a large selection of paintings and drawings at the Kunsthalle at the end of the project.[27]

The motif of being "cut off," "decapitated," of being separated from rational thought, is predominant in both her drawings and paintings of this time. In its place Ikemura was starting to suggest different visual equivalents of emotion but she was not yet sure what form these could take in painting. Her work was being noticed but it did not fit easily into any recognizable "box" and no one quite knew where to place it. In some exhibitions she was associated with the newly fashionable *Neuen Wilden*,[28] a generation of predominantly German, male, neo-expressionist painters who tried to synthesize different forms of "personal mythologies" in works that satisfied both an imagined *zeitgeist* and the art market.[29] But Ikemura rebelled against such superficial categorizations and intensified the process of self-interrogation that had initially led her to leave Japan. In 1984, immediately after her Nuremberg exhibition, she moved to work in Munich for a few months and then, later in the year, set up her studio in Cologne, at that time a vital hub for both artists and galleries. She did not return to Switzerland and her marriage broke up. The following year, her father died.

In Munich, she had first began to experiment with photography by producing *chemigrammes*, automatic drawings of chemicals on photo paper that appear rather like monotypes. In a recent exhibition at the Museum für Asiatische Kunst in Berlin, photographic still-lifes of withering plants expanded this idea, taking on the somber role of *memento mori*. Bridges between life, dreams, and death, these works provided a strong but barely audible base note for the sculptures installed in the same space.[30] Ikemura still continues to use photography as a fluid underpinning to her drawings and watercolors liking the fact that, during the process of printing, the images literally emerge out of the surface of the paper.

Her new large paintings in Cologne now began to combine surrealism with allegory. *Verkündigung* ("Annunciation," 1985) is a carefully modulated exercise in reverse symmetry in which an "angel" hangs upside down from the top edge of the painting to confront a standing "virgin."[31] Both appear to have wings but these may also be understood as large exotic leaves or the branches of trees. Paradoxically, both figures clamp their mouths shut with their hands. This is an annunciation in which nothing was said.

7

8

[32] Leiko Ikemura, *Leiko Ikemura: Transfiguration*, op. cit., p. 222. [33] At that time, Christa Wolf (1929–2011) was one of the leading writers and intellectuals in the German Democratic Republic, whose works were concerned with a scrupulously honest examination of self against the changing regimes of history. [34] *Kriegesgöttin*, 1986, oil on canvas, 200 x 250 cm. [35] This painting provided the name for the group of avant-garde artists, which included Kandinsky, who exhibited together in Munich from 1911 to 1914. [36] *Über das Licht*, 1987, oil on canvas, 170 x 250 cm. [37] This syncretistic approach continues throughout Ikemura's work from this time. See, for example, the works shown in "Mars Mother," Cologne, Kunst-Station St. Peter, 2005 and her solo show in the Kolumba Kunstmuseum des Erzbistums Cologne in the same year. It can also be seen in the development of her landscape painting over the past decade, particularly in the *sansuika* works that have been influenced by traditional Chinese and Japanese art. [38] Leiko Ikemura, *Leiko Ikemura: Transfiguration*, op. cit., p. 159. She was referring to the Swiss mountain village of Grisons. Giovanni Segantini (1858–1899) was popular Italian landscape painter who towards the end of his career became an avant-garde divisionist and symbolist. [39] *Leiko Ikemura*, Sauerland-Museum, 2010, op. cit., p. 142. [40] Her first scuptures were made in 1987 and 1988 and were exhibited in "Leiko Ikemura: Von der Wirkung der Zeit," Lingen, Kunstverein, 1988. [41] See note 39. This quote has been retranslated by the author. [42] Ikemura regards irony or cynicism as "too cold" and employs a more equivocal and distanced kind of humor in her work. Malsch, op. cit., p. 29. [43] *Sansui* refers to the Chinese characters for "mountain" and "water," the dominant characteristics of classical Chinese and Japanese landscape paintings: *sansuiga*. Her preferred Japanese artists include Tōyō Sesshu (1420–1506), Hasegawa Tōhaku (1539–1610), Nagasawa Rosetsu (1754–1799), Katsushika Hokusai (1760–1849), Utagawa Kuniyoshi (1797–1862). [44] These works were shown in her first solo exhibition in Japan. Leiko Ikemura, "Alpenindianer," Tokyo, Satani Gallery, 1990.

In *Haarwaschende* ("Woman Washing Her Hair, 1986), the dissolving, constricted forms and tortured colors suggest encounters with French *informel*, the early paintings of Francis Bacon and many other influences. Yet, for me, her most successful works of this time are the series made around the Trojan War.

These large paintings, made with oil paint on canvas, were prompted by two main ideas. She wanted to revisit the vexatious topic of recent Japanese history and could see in the Trojan myth an analogy through which she could approach the 1941 attack on Pearl Harbor and its aftermath without having to make literal references that would limit either the broader suggestibility of her work or how it related to the causes and impact of war. [32] But she had also recently read Christa Wolf's newly published novel *Kassandra* (1983), in which the siege of Troy was described as a gendered, Manichaean battle for economic power, the result marking a shift away from matriarchy to a society dominated by men. [33]

The consciously naive drawing and composition of *Kriegesgöttin* ("Goddess of War," 1986), one of the largest works in this series, sketches out a violently chaotic and divided territory rather like a dream map of unconscious conflicts and desires. (fig. 6) This is dominated at the center by a tall black "destroyer" who stomps on the head of a vicious, flat-headed, three-eyed, catfish-like creature with a long tail that snakes diagonally across the painting. [34] Women gather on the right, one firing down from a "breast enhanced" watchtower while the "destroyer" dumps disembodied heads and figures into a large vessel that occupies the left side of the painting. A white horse looks away in the opposite direction, not a wooden construction but of flesh and blood with a hollow stomach that seems to be disemboweled. The horse that appears in nearly all these works is reminiscent of Kandinsky's early painting *Der Blaue Reiter* ("The Blue Rider," 1903). [35] Within this carnage an almost comic element prevails, indicated by the chains of association provoked by the work's outsider imagery and style—the root of their sophistication. This tapestry of cruel and futile conflict between the sexes was elaborated further in such enigmatic and magisterial paintings as *Pearl Harbor* (1986), *Trojanischer Krieg* (1986), (fig. 7) and other related works.

As impressive as many of these paintings still appear, Ikemura was aware that she was facing a crisis in her work. Caught between the rock of mythology, an overused trope in the western art world during the 1980s, and the hard place of allegory, an approach still taught in the art academies of the East (particularly in the German Democratic Republic), she could see that she wanted to follow neither path. She felt dissatisfied with the paintings she had made but did not know how to act. For her, art has become a talisman against the alienation she had felt since childhood, yet the materialist art criticism that prevailed within Germany approached art dialectically as if there were embedded within it some unknown solution that could be discovered through reason. For her this was no solution, she had always approached the world intuitively and realized that what often appeared to be opposites were actually different aspects of the same thing.

During the latter half of the 1980s, her visits back to Japan became more frequent, and Ikemura started to learn more about the aesthetic traditions and history of Japanese art. The result was that she began to think about both her work and pictorial space in a completely different way. The beginning of this can be seen in the later works of the Trojan cycle in which narrative gradually recedes and illusionistic space dissolves into semi-opaque consecutive planes out of which figures and objects tentatively emerge. She was moving away from the idea of art as a depiction of something towards it being a prompt for sensation and feeling. In *Über das Licht* ("Over the Light," 1987), one of the last paintings in this series, light-suffused riders career across its surface while in the dark

background stands a tall, silent figure standing by a backlit aperture.[36] A corona seems to circle its head as if it were a supplicant Bodhisattva—or it may even have been a crown of thorns.[37]

III. Indians, Girls, and Other Strange Creatures

"That place was close to Segantini's village, but the high altitude light that entered from the thick, deep castle windows was extremely clear and I realized . . . that painting needed to be a non-physical, spiritual medium."

– Leiko Ikemura[38]

During 1988 Ikemura worked next to Lake Starnberg near Munich for two months. The flat, still reflection of the water helped her rethink: "I love the water," she later wrote "I'm addicted to it; creative forces come from the water . . . and from the sky. Nothing else. Whether it is the ocean, a lake or a river, water is the origin for me . . . [it helps me] arrive at new motifs and find motivation."[39] But water was not the whole picture. She had just started to make her first sculptural works out of unfired clay.[40] Modeled out of crude earth, these were the other side of the same coin. Small grotesque homunculi, reminiscent of medieval church carvings, their images had been derived from her paintings and drawings. From this point onwards her sculpture was both a complement to, and opposite of, her paintings and graphics.

In the autumn of 1988, spilling over into the following year, Ikemura spent six months working at Fürstenau Castle near the small village of Grisons in the Swiss Alps, an area that had attracted symbolist artists such as Segantini towards the end of the end of the 19th century. During her stay there, what she described as "a paradigm shift" occurred. Not only had she realized that she wanted painting to be "a non-physical medium" but also "embedded" in the mountain landscape in which she had discovered "crystalline forms and sculptural formations that were transformed out of their fixity by the simultaneous influences of immateriality and the dissolution of elements."[41] Ikemura had begun to enter a more fluid morphological universe just as she had begun to take a greater interest in sculpture.

Alpenindianer ("Alps Indians," 1989–90), a suite of nine acrylic paintings on canvas made during her stay at Fürstenau Castle, were conceived on a smaller scale than the Trojan works. Starting from the ironical motif of the "Alps Indian," no doubt a portrait of the nomadic artist herself, the space encompassed within these paintings indicates a completely different attitude towards figure and ground. Continuing in a more fluid way tentative spatial experiments broached in the later Trojan works, Ikemura now conceived of space as compressed, flattened, and stacked within the same planar matrix, rather as in classical Chinese painting. As is often the case, a short poem accompanies this series to provide a not-so-serious "narrative."[42] The primordial figure of the Indian, comprised of the same atoms as the surrounding mountainous landscape, appears in and out of focus like a shadow, becoming increasingly abstract as the traces of brush, sponge, and finger on the canvas veer away from description to acquire a haptic significance. Consciously slightly comically, Ikemura rethinks and refashions the tradition of the European Romantic landscape by rendering her reactions and emotions into visual incident. The *sansui* aesthetic of classical landscape painting became increasingly important in her work because it confirmed her natural proclivities.[43] To such an extent, in fact, that *Skifahrer auf dem Malojasee* ("Skier on Maloja Lake," 1990), the eighth work in the series, is based on the compositional layout of one of Tōyō Sesshu's most famous works, *Landscapes of Autumn and Winter (Winter)* (c. 1470), which is now in the collection of the National Museum in Tokyo.[44] (figs. 8, 9)

7 | **Trojanischer Krieg ("Trojan War")** | 1986 | oil on canvas | 190 x 300 cm

8 | **Alpen Indianer: Skifahrer auf dem Malojasee ("Alps Indians: Skier on Maloja Lake")** | 1990 | acrylic on canvas | 120 x 94 cm | Toyota Municipal Museum of Art

9 | Tōyō Sesshu | **Landscapes of Autumn and Winter (Winter)** | 1486 | ink on paper | 47.7 x 30.2 cm | National Museum, Tokyo

10 | **Mehrbrusthuhn (Many-breasted Chicken)** | 1990 | glazed terracotta | 33 x 20 x 19 cm

12

Ikemura's landscape paintings are never "pure" landscapes but also fulfil the role of psychic maps. Although their appearance has changed considerably since the beginning of the 1990s, her current attitude towards painting was forged at this time. Ikemura remembers that when making these works she often used to compare the landscapes of Sesshu and Cézanne, particularly their emphasis on construction and brush mark. The result was that a more analytical, planar construction of space replaced a former reliance on line. She now began to think of her own paintings as *sansuiga:* "The underlying context was to create an associative transformation of images, such as a human figure that is blended into a rock. In that expression the elements of a human figure and nature were united through an abstract formative language." [45]

In 1991, Ikemura was made a professor of painting at the Berlin University of Fine Arts and began to split time between there and Cologne. [46] As she had done ten years previously, she returned to drawing to help clarify visual and emotional thought. Drawings and watercolors of odd blobby figures, sometimes described as "cephalopods," translated themselves into paintings of strange unknown hybrid creatures. These images then began to resurface as glazed earthenware figures. Some were between about 20 and 40 centimeters high and shown on plinths, others were much higher and freestanding. The earliest terracotta works seem to be based on the visual equivalent of word plays: *Mehrbrusthuhn* ("Many-breasted Chicken," 1990) rhymes a coxcomb with the multiple breasts of an ancient classical goddess; (fig. 10) *Hausfrau* ("Housewife," 1990) is both a monolithic block and an open box rather like an ancient funerary urn, while "*Haus Mann* (House Husband," 1990) seems to be a cross between an animal head with pointed ears and a house with many windows. Around this time, she had become particularly interested in the sculptures, objects, and installations of Louise Bourgeois, as well as in the *spatial concept* (slash paintings), sculptures, and ceramics of Lucio Fontana. [47] These encouraged her in refining the fusion of autobiography, memory, imagination, and form in her own work along with ideas of positive and negative space.

In some of these works, the smaller heads run directly into the bodies, or could even be missing. Different-colored glazed busts depict non-specific creatures with benign, friendly expressions as well as some that seem anguished or in pain. Ikemura regards these works as "vessels of being," [48] in other words as physical expressions of the permeability between form and non form, life, and oblivion. (fig. 1) Creating this sublime interface, she often works on a domestic scale, citing animals (a long-eared hare or Miko, her cat) or vegetables (a "cabbage" head or a figure made of asparagus) to create dislocated, child-like hybrids that both contain and transmit emotion. (fig. 12) Sensory organs, such as eyes or mouth, are often expressed as wounds or holes in the surface of the clay, rhyming with the void that remains at the center of the work. (fig. 11) Ikemura uses the Japanese word *utsuro,* void or hollow, to describe this aesthetic which is related to the idea of *ma,* a gap, space, breath, or pause between pictorial elements, that now became increasingly important in her two-dimensional work. [49]

In 1995, Ikemura began to concentrate on series of minimal paintings of doll-like girl figures lying or standing against colored grounds. The size of these works was generally smaller than what she had done before and they were all executed in oil paint either on cotton duck or an absorbent rough burlap. Detail is stripped away, the features of these figures are indistinct and their forms often bleed into the background. What remains is a reference to, rather than a depiction of, girlhood and an almost music-like notation of color and form. Ikemura was well aware of the increasing infantilism within Japanese popular culture during the 1980s and '90s and how this was beginning to have an impact on art. The cult of the *kawaii,* the sickeningly cute, focuses on images of innocent, defenceless small girls or animals in order to fetishize them into an absurd parody of adult desire. [50] Her works, particularly her paintings and sculptures of girls and animals,

11 | **Indianerin (Indian Girl)** | 1996 | glazed terracotta | 38 x 24 x 18 cm

12 | **Yellow Figure with Miko** | 1996 | glazed terracotta | 73 x 35 x 34 cm

[45] Leiko Ikemura, *Leiko Ikemura: Transfiguration,* op. cit., p. 219. [46] From 1991 she lived and worked between Cologne and Berlin and is now completely settled in Berlin. [47] Louise Bourgeois (1911–2010), French-American artist. See p. 339, fig. 2 for one of her "house based" works. Lucio Fontana (1899–1968), Italian painter and sculptor. [48] Leiko Ikemura, *Being* (exh. cat.), Nagoya, Gallery Ham, 1995. See also Malsch, op. cit., p. 61. [49] For a discussion of the significance of void in both Cai Guo-Qiang's and Hiroshi Sugimoto's work, see pp. 301 and 325. [50] See *Bye, Bye Kitty!!!,* pp. 82–105.

13

14

15

are a response to this. But although partly a parody, they are also intent on reappropriating the image of girlhood as a neutral, even innocent, motif completely devoid of sentimentality.[51]

In a sense these girls are messengers from another world. Ikemura associates their floating or gliding quality (and lack of visible legs or feet) with the Japanese idea of *yurei*. Its literal meaning is "faint soul" but it signifies "ghost," the kind of terrifying creatures that appear in nightmares, classical novels and Japanese woodblock prints. Their otherworldly disembodiment makes them all the more unsettling as they wreak mute revenge on mindlessness, superficiality, and commercialism.[52]

IV. Beyond the Horizon

My first view of the ocean came as an awakening. Of course I must have seen the ocean before, but this is my earliest and most vivid recollection of it. I spied it from a Tokaido Line train, the seascape passing from left to right. It must have been autumn, but the sky had such vast eye-opening clarity. We were riding high on a cliff and the sea flickered far below like the frames of a motion picture, only to disappear suddenly behind the rocks. The horizon line where the azure sea met the brilliant sky was razor sharp, like the blade of a samurai sword. Captivated by this startling yet oddly familiar scene, I felt I was gazing on a primordial landscape. Perhaps it is strange that a child should have pre-life memories, much less words to express them. The experience left an indelible mark on me.

– Hiroshi Sugimoto [53]

Between 1997 and 1999, Ikemura started painting black backgrounds behind the girls. For her this was "the color of nothingness / warm eternal color / the color for being the loneliest." [54] **(figs. 13, 15)** The lying or crawling figure of the young girl that constantly reappeared in both the paintings and sculptures of this time was not only an enigmatic harbinger of discoveries yet to be made, of lives yet to be lived, but also a primordial expression of mourning and grief, a stripping down of detail and reference to reveal the mind-numbing realization of the works' silent, nonexistent core. **(fig. 14)** Not surprisingly, as Ikemura continued to work on this theme, the figure of the young girl grew into an adult. The women then began to appear in groups, bathing on the shore of the ocean, the notation of their bodies scattered across the surface of the painting not unlike the trees or flowers in the horizontal composition of a traditional Japanese screen. And in this continuous process of *transfiguration,* a word which Ikemura has often used to describe how she works, the figure faded away to leave only a horizontally striated background like a horizon, or a number of them, in divisions of color and space similar to that in *Kamikaze* (1980), one of her earliest paintings, in which the horizon marked a tremulous cataclysmic dividing line between the infinite expanses of sky and ocean.[55] **(fig. 4)**

The circularity of transfiguration is deeply inscribed within all animistic beliefs and the idea of layering—image, media, space, reality—is central to Ikemura's mature work. Throughout all of her works one form, thing, emotion or memory transforms into something else, taking on many different aspects. Talking of the "Horizon" paintings she has pointed out that "actually there is no stillness [only] stasis which emerges via movement." [56] The floating heads and women that appear in front of the horizons, and on plinths as larger terracotta sculptures, are "metaphors for an explicit intermediate state, one that doesn't actually occur [but] exists only in the imagination . . . Fragments of an existential condition [they become] a metaphor for permeability." [57] **(fig. 15)** In these works, Ikemura tries to imagine the sensation of flying in order to regress beyond perception to realize the communality of all things. This includes our relation not only to other animals but also to the framework of creation itself. I derive a

13 | **Reclining Girl** | 1997 | oil on canvas | 100 x 120 cm | National Museum of Modern Art, Tokyo

14 | **Lying in Angel Blue** | 1997 | terracotta | 26 x 103 x 34 cm

15 | **Face in Blue** | 2008 | oil on jute | 90 x 120 cm

16 | Utagawa Kuniyoshi | **Nozarashi Gosuke in a Robe Covered with Skulls Made of Cats** | 1843–46 | color woodblock print | 34.5 x 22.5 cm

17 | **Colonia** | 2014 | tempera on jute | 190 x 290 cm

[51] "Sentimentality is something I don't like. 'Sentiment' yes, in the sense of emotion but exaggerated emotionality and kitsch never go beyond cliché." Leiko Ikemura in Sauerland-Museum, 2010, op. cit., p. 146. [52] For a discussion of *yūrei* in Tomoko Kashiki's paintings, see p. 248. [52] Hiroshi Sugimoto, "The Times of My Youth: Images from Memory," in Kerry Brougher and David Elliott, *Hiroshi Sugimoto*, Ostfildern-Ruit, Hatje Cantz, 2006, p. 14. [54] Leiko Ikemura, *Leiko Ikemura: Transfiguration,* op. cit., p. 69. [55] "Transfiguration" is the title of her 2011 retrospective at the National Museum of Modern Art in Tokyo, as well as of a recent book: *Leiko Ikemura: Transfiguration From Figure to Landscape*, Berlin, Distanz-Verlag, 2012. [56] Leiko Ikemura, Sauerland-Museum, 2010, op. cit., p. 151. [57] Ibid., p. 148. [58] Constantin Brâncuşi (1876–1957), Romanian French sculptor; Odilon Redon (1840–1916), French symbolist artist; Emil Nolde (1867–1956), German expressionist painter; Xul Solar (1887–1963), Argentine artist, writer, and inventor of imaginary languages. [59] Leiko Ikemura, *Korekara*, op. cit. [60] Leiko Ikemura interview, Mie Prefecture, November 2010, in *Leiko Ikemura: Transfiguration*, op. cit., p. 217. [61] Leiko Ikemura, Malsch, op. cit., p. 102.

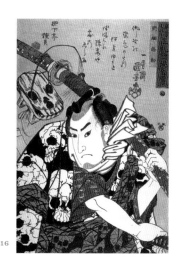

16

similar feeling looking at the barely visible details on Brancusi's simplified heads, which almost seem like water-smoothed rocks; the drawings of Odilon Redon in which an eye transmutes into a hot air balloon, a spider's body into a face, or a flower into a human being; the early drawings of Emil Nolde where gigantic, craggy heads are formed out of mountain tops; or the mystical cosmogonies of Xul Solar, in which words, bodies, fantastic creatures, mountains, and cities have interchangeable elements that express each other in their form. [58] A similar metaphysics of connectivity remains the central subject of Ikemura's art. (e.g. figs. 1, 11,17) This is humorously illustrated in a woodcut made by Utagawa Kuniyoshi some time during the 1840s, which she incorporated into a recent exhibition of her work: a posturing young samurai is dressed in a fashionable blue-and-white robe with a pattern of skulls printed on it. On closer examination, the skulls are made up of white cats playing with their kittens; a stool slung nonchalantly over the handle of his sword also reveals a scary face in the grain of its wood. [59] (fig. 16)

"I sometimes think that I'm a medium rather than an artist," she has recently said. "Similar to a *miko* [shrine maiden or spiritualistic medium], I feel as if I'm driven by some unknown force ... I cannot dissociate my production and my life. I've already lived in Europe for almost 40 years, but without figuring out if I have really adapted to European cultures. I'm connected to a cultural life while also feeling that 'I'm different in some respects.' This is a typical feeling for an *étranger*." [60] (fig. 17)

The fate of the artist is to be distanced — an outsider. Without this no context can be expressed, no clarity found, no valid self-criticism uttered. In relation to how emotions surface in her works Ikemura has often used the word "authentic," but I suspect that she means "truthful"—the ability to look experience in the face and to express even that which is painful. In the house that Ikemura has built for herself throughout her work, she has trodden a path that has led from the dark cellar of self-centered existentialism she experienced her youth to the glimmering horizon that expresses a different kind of void. (figs. 1, 2) Over a period of nearly forty years, *le néant,* the terrifying absence that opposes all existence, has been transmuted through experience into a positive understanding of the necessity for void or emptiness. Here the transcendence of self signifies the illusory nature of personal desire and a celebration of the infinite connectivity of the universe. "The compulsion to be happy is a collective psychosis. At the most it is only a brief fulfilment of desire. But I know another kind of happiness—better to say moments of happiness—I experience these in nature." [61] ●

17

Nezaket Ekici
The World in a House

This essay, written in Hong Kong, was published in German and English in **Nezaket Ekici: Alles, Was Man Besitzt, Besitzt Auch Uns** ("Everything That We Possess, Possesses Us Too") by the Walther König Buchhandlung Verlag for a large exhibition of Ekici's work at Haus am Waldsee, Berlin, in August and September 2015. I had come to know Nezaket and her work in Berlin, where she lives, and was strongly impressed by the ways in which she has combined her Turkish roots and sensibility with her education and life in Germany. In 2016, on Knez Mihailova, the main pedestrian street in Belgrade, she made, with about 25 local people, **Hatchet**, a new performance installation for the opening of "The Pleasure of Love: Transient Emotion in Contemporary Art," which I curated at the 56 October Salon. Nezaket Ekici lives and works in Berlin.

1b 2

1 | **Emotion in Motion** | 2000–15 | installation views | 2015 | 15 lipsticks, artist's lips, everyday objects, furnishings, monitor, camera, costume | photos by Andreas Dammertz | images courtesy the artist

2 | Louise Bourgeois | **Femme Maison** | 1947 | ink on paper | 25.1 x 18.2 cm | courtesy Solomon R. Guggenheim Museum, New York

[1] Ekici stresses that she is only critical of the veil if women are forced to wear it but not if they wish to wear it for religious reasons. For documentation of her earlier work, see *Nezaket Ekici – Personal Map To Be Continued...*, Herford, Marta/Bielefeld, Kerber edition, 2011. [2] Haus am Waldsee was built as a private mansion in 1922–23. After World War II the Berlin district of Zehlendorf devoted the space to the display of modern art. [3] Louise Bourgeois (1911–2010) subsequently repeated this idea and title in paintings and sculptures. [4] Japanese artist and writer Yayoi Kusama (b. 1929) lived in the US from 1957 to 1973. Ever since childhood she suffered from hallucinations and, at the age of ten, made a drawing of her mother covered by dots. During the late 1950s, she began to use these impressions in her work, initially in her *Infinity Net* paintings and then, from the early 1960s, in her "dot" installations in domestic interiors. See pp. 42, 43, 134 [5] Ekici. *Personal Map ...*, op. cit..

As the work in this exhibition so clearly shows, over the space of fifteen years, Nezaket Ekici (born 1970 in Kırşehir) has produced a phenomenal range of performances, projects, videos, and installations, often appearing in them as a central figure herself. Brought up in a traditional Turkish family that had migrated to Germany, and having initially studied art history and sculpture to eventually become a master's student in performance art under Marina Abramović at the Hochschule für Bildende Kunst in Brauschweig, she has had to negotiate many resistant, divergent, conflicting worlds. A thread of resistance—to irrationality, restrictive actions and blinkered ways of thinking—runs throughout Ekici's work as she has embarked on each encounter with romantic élan. Determined, stubborn, and fiercely independent, in earlier work, she memorably parodied the tyranny of the veil which, for her, was emblematic of a much wider oppression of women, not only within Islam but worldwide.[1] As an idealist she struggles to create a world in the way she would like to see it, but as a realist she works with what is in front of her, and realizes that she will never fully succeed. This quixotic sense of resistance is pervaded by pathos and humor; it is as if one could not laugh at the absurdity in oneself and the world, one would have no alternative but to cry.

"Everything We Possess, Possesses Us Too," the aphoristic title of Ekici's retrospective *Gesamtkunstwerk* at the Haus am Waldsee, homes in on the paradoxes implicit in possession and desire. When we surrender to a desire to possess something or someone, it can easily take on a life of its own and begin to possess us consuming our every thought. This realization is at the root of her struggle for autonomy in art.

In conceiving this exhibition, she has "dismantled" a powerful man's pre-war villa not to squat within its ruins but, rather, to build a many-roomed mansion of her own.[2] Here she tells a particular story about the development of her work—about how it has possessed her—and places it within the much wider context of her life and art.

The house and its interior has been a symbolic motif in the work of many previous artists on which Ekici has been able to build. Ever since the end of the 1940s, when French-American artist Louise Bourgeois's *Femme Maison* (1946–47) paintings hybridized her half-naked body with a house in a double-edged expression of protection and oppression, the idea of home has expressed both vulnerability and power in an image redolent of both suffering and nurture.[3] (fig. 2) In her New York installations of the early 1960s, Yayoi Kusama covered domestic interiors with brightly colored dots both as a wondrous expression of the dematerialization of matter into infinity, and as a reaction to the horror of being melted into oblivion.[4] As a surrogate for the body, the house had become a site of political struggle: between sensibility and possession, liberty and oppression, as well as of the different desires and aspirations of men and women.

Here, in a combination of what she has intuited and learned, Ekici takes inspiration from the previous functions of the villa's rooms. As in the introductory pages of *Personal Map*, a compendium of her work published in 2011, the first room serves as a "base camp" by presenting over 50 portraits of herself and her family.[5] Each photograph is framed in gold and hung on a turquoise wall as if in some exotic interior; they depict her life in Germany,

where she was brought up, and in Turkey, where she was born and where many of her extended family still live. The images also refer to her childhood, her education, her marriage, and her travels. (fig. 3)

Having presented her credentials in this fragmented form, the second room begins a gradual unfolding of her work, initially through a reiteration of *Emotion in Motion*, a performance that had first been presented in Munich and Basel in 2000. In this version, the room is set out as a private domestic space with its furniture, upholstery, ornaments, and surfaces all covered by bright-red lipstick kisses made by the artist. (fig. 1) A video within the room documents the performative process of making the room. This may be seen as a reference to the encompassing, form-dissolving dots of Kusama but, more significantly, it also presents a raw testimony of the smothering passions and pain of love—emotions she has strongly experienced, both within the family and outside it.

Moving out of this blood-red, kiss-spattered boudoir, the villa's former conservatory presents in *Whirling Ecstasy* (an installation conceived previously as an outdoor performance) a dynamic, cosmic view of nature. Here, a concentration of thousands of air-blown silk rose petals are thrown together with a female "body" in the form of a long transparent dress, constantly whirling as if it were a dancing dervish. [6] Centrifugal force drives the body from the center towards the edge of the space where its slipstream is ecstatically smothered by tornados of perfumed red petals. (fig. 4)

In the next room Ekici enters confessional mode when, in *Lifting A Secret*, she refers to a painful moment from her past. Traditionally, Turkish marriages were arranged between families, and a potential suitor would visit his intended bride's house with his parents to meet the girl and be formally served coffee by her so that they could assess whether she and her family would make a good match. As a teenager, Ekici was forced to endure this ceremony that, twenty years later, she exorcised in art. [7] Writing in transparent vaseline directly on the wall, Ekici describes her feelings at this time as well as the details of the event—apparently she did not know how to make coffee in the traditional way and her sister had to fake it. But, more importantly, the way the work is made refers directly to the invisibility of women's presence and desires, because initially the text cannot be read. Only when, in a re-enactment of anger and humiliation, she hurls coffee grounds at the wall do her words and emotions become legible. (fig. 5)

In *Ninety-Nine Commandments*, a live performance made in the villa's dining room during the opening of the exhibition that remains in the form of an installation and documentation of her performance, Ekici touches on the delicate topic of religious customs and taboos. A long oval table is set with 99 plates, at the center of which, both like a dish to be consumed and a fantastic ornament, she lies in a white dress holding a oversized rosary of 99 beads. [8] Not referring to any religion in particular, this number is suggestive of the many different names of God as well as of the various restrictive laws and commandments that believers have to observe. The performance lasts about an hour during which, surrounded by the divine mandorla of the oval table, Ekici places a rosary bead on each plate, uttering a different commandment as she does so until all the beads have been spent and the plates are full. (fig. 6) Although out of their religious context some of her injunctions sound humorous or absurd, the main point of this action is to replace the circle of the rosary with the oval of the table in a celebratory "meal" that is both an amplification and expansion of belief. The dimension of art is used here to crystallize the stultifying absurdity of restrictions upheld by different faiths.

Food and its consumption recur regularly throughout Ekici's oeuvre, as in the group of works installed in the long gallery adjacent to the dining room. In these videos she employs food as a metaphor to express different aspects of culture, life-style, transformation, religion, and belief. One screen concentrates on the sensual qualities of cooking vegetables in various locations in a compilation of extracts from her performance-in-progress *The*

3 | Installation shot of **Family Portraits** in the Haus am Waldensee exhibition | 2015 | personal photographs in gold frames | variable sizes, blue walls | photo by Andreas Dammertz

4 | **Whirling Ecstasy** | 2008–15 | site-specific installation | rose petals, costume, ten wind machines, motion detector, wooden infrastructure, lattice | photos by Andreas Dammertz and Junck Cristoph

5 | **Lifting a Secret** | 2007–15 | site-specific installation | 10 packs of coffee, coffee machine, water, five tins of Vaseline, furniture, costumes, brushes | photo by Andreas Dammertz

6 | **Ninety-Nine Commandments** | 2013–15 | performance, site-specific installation | table with white table cloth, 99 white porcelain plates, 99 prayer beads, white dress, scissors | photo by Martin Luther

Five Senses, of which versions have so far been made in Brazil, Ghana, Turkey and Vietnam. Other screens document more recent performances about food and its associations. In *Flesh (Not Pig but Pork)*, she confronts the irrationality of religious dietary restrictions. Dressed in a bathing suit, blindfolded, she fondles, licks, and sniffs vast cuts of uncooked pig meat. (fig. 14) In *Balance*, again blindfolded, Ekici adopts the pose of the figure of justice by trying to balance, for an extended period, heavy scales weighed down by knives, yet she is fascinated by the ways in which rules not only imply responsibility but complicity. Loaves of bread are suspended in the air, her long gown is smeared with butter: observers are invited to remove the knives from her scales, potentially causing imbalance, in order that they might feed on a wholesome meal of bread and butter. Justice may be blind, but is it possible for it to be nurturing or compassionate without all balance being lost? (fig. 9)

The travails of compassion also underlie *Imagine*, a video performance in which Ekici repeatedly reinterprets the advice of a flamenco dancing teacher about how to perform with true passion. She imagines that she is standing next to an apple tree from which she grasps a fruit, takes a bite and then, in an expression of pain and loneliness, roughly throws it away. Five hundred red apples hang above her head, and, as she works her way through them, each fatal gesture re-enacts not only the fall from grace in the Garden of Eden, but also what many Christians believe is the moment of the origin of sin. (fig. 8) *Salt Dinner*, the final work in this room, made jointly with Israeli artist Shahar Marcus, was filmed on the Dead Sea. Both artists float in its buoyant saline water to share a sumptuous meal. Eating there is difficult, but this work is not so much about balance, although the metaphor would be appropriate for this region, but more about the necessity for both salt and water to maintain life, and what this may mean when one pollutes or destroys the other. (fig. 7)

The work, installed on the landing of the first floor of the villa, documents *Water to Water,* a live performance specially made for the Haus am Waldsee. In this, Ekici stands like a mythical figure in the middle of the adjacent lake, linked to the villa's garden by an extended red dress that fans out in front of her that contains a covert mechanism for purifying and filtering water from the lake so that it may be drunk by visitors. In this ritual of libation, in which Ekici pumps water from the lake and through the filters, she adopts the posture of an ancient Greek Naiad, [9] a bringer of life and fertility, but within such a militantly contemporary context her extended red dress becomes both a banner and a warning: fresh water is an increasingly rare resource in many parts of the world and, in a predicted future of exponential global warming, will certainly be a source of conflict and war. (fig. 10)

The bathroom of the villa, perversely entitled *Living Room* after the work that is shown there, focuses on the act of bathing. A video projection from a performance Ekici orchestrated in the Fürstenfeld Forest in Austria in 2010 is reflected on the surface of the water in the bath, in which ten people from widely different backgrounds wash themselves in domestic bathtubs that had been transplanted among the trees. Her intention, however, was not incongruity for its own sake, she was fascinated by the different ways in which people bathe and by how this unconsciously represents historical and cultural traditions. Not only did she want to remove the act of bathing from domestic space and return it to a state of nature, but also to test and explore codes of intimacy as people performed their private bathing rituals in public. (fig. 11)

Other kinds of ritual are revealed in *First Contact*, a work-in-progress since 2011, for which Ekici devised a new section for this exhibition. She has worked with families of the Friends of the Haus am Waldsee who, although culturally informed, have had relatively little direct contact with contemporary artists; her aim is to encourage them to make art of their own. In each household videos record how she explains to the family the basic tools of performance: concentration, presence, awareness, duration,

7 | With Shahar Marcus | Salt Dinner | 2012 | video shot floating in the Dead Sea in Israel | 3'19" | photo by Maya Elran

8 | Imagine | 2012–15 | performance, video | 500 apples, nylon thread, stage | photo by Andreas Dammertz

9 | Balance | 2012 | performance, video | butter, bread, butter knives, dress, stage, two weighing trays | performance 20' | video 6'8" | photo by Andreas Dammertz

10 | Water to Water | 2015 | performance, installation | the artist with seven others working on the Wansee | with pedestal, boat, adapted red dress, water tubes, filter, buckets, trays, drinking glasses | performance 60' | video 7' | photos by Andreas Dammertz

11

12

13

repetition, and ritual, and asks them to think about their daily lives in ways in which they could produce an artwork. The material is the home itself: in the kitchen the performances might deal with food, in the living room, the bathroom, or bedroom, furniture, cosmetics, or clothing may be the focus; everyday things become art objects.[10] As a result, the house becomes a form of recorded living sculpture as all these actions are filmed, and are then digested through video feedback from both Ekici and the newly fledged artists.

A live performance made in 2012, provides the inspiration for *Living Ornament: Tapestry Version*, that occupies one of the bedrooms. Traditionally, the carpet or wall-hanging is one of the highest forms of Western and Central Asian art, and Ekici echoes that here through the replication of her own image, lying on a dark ground in a hermetic figure-of-eight, clad in a white dress with each of the medusa-like braids of her hair ending in a tomato fruit, some of which she holds in her mouth as if she is about to eat. This "ornamental" expression of infinity is, like a snake biting its own tail, self-sufficient and reflexive, and makes reference to the Garden of Eden (where she plays the roles of both Adam and Eve), as well as to the stone gaze of the terrible Gorgon. But, in spite of their similarity, in each manifestation she appears differently that, for her, symbolizes the processes of "life in itself" as each body, growing and decaying like a living tree, is in a constant state consuming itself.[11] **(fig. 12)**

The exhibition ends with *But All That Glitters Is Not Gold*, a video documentation of a performance made in 2014 while she was on a residency funded by the German government in Tarabya, Istanbul. In this, Ekici is closely confined within a golden cage in sight of 30 golden keys suspended beyond its bars, of which only one will free her. To solve this fairy-tale nightmare, she has to stretch, contort herself into impossible positions, and control her breathing so that she can reach the keys and try to unlock herself. Eventually she succeeds and climbs out of the cage. **(fig. 13)** Two metaphors collide in this work: a *Bird in a Gilded Cage*, the title of a popular music-hall ballad about the debilitating decadence of confinement in luxury that vulgarized the sentiment of centuries of world literature, and the proverb in the title that warns against a naïve belief in surface appearance. The former certainly points to the oppression of women both in Turkey and elsewhere, but the latter extends this further to a critique of the illusory material benefits of contemporary civilization that affect us all.

Echoing the words of Jean-Jacques Rousseau, uttered in France at the height of the European Enlightenment, Ekici reimagines here, with engaging but uncompromising humor, a mendaciously gilded world of drudgery and oppression: we may be born free, yet too often we willingly allow ourselves to be confined by chains that certainly glitter but will never be gold.[12] ●

11 | **Living Room** | 2015 | site-specific installation in bathroom | photo by Günther Pedrotti

12 | **Living Ornament – Carpet** | 2015 | printed carpet | 266 x 400 cm | photo by Andreas Dammertz

13 | **But All That Glitters Is Not Gold** | 2014–15 | performance and installation | "golden" cage, "golden keys," nylon threads, dress | performance 40' | video 8'50" | photo by Andreas Dammertz

14 | **Flesh (Not Pig but Pork)** | 2011 | performance, installation, video | performance 40' | video 9'34" | photo by Andreas Dammertz

[6] This work was first shown as a live performance in 2008 in the Wenkenpark, Riehen, Switzerland. [7] Although many families would have done so, Ekici's parents did not insist that she accept this young man's proposal; she was eighteen at the time. This work was first conceived in 2007 when Ekici was 38 years old. [8] The number 99 is a multiple of the 33-bead Islamic rosary *(tesbih)*. [9] Naiads are Greek goddesses of fresh water, wells, and springs. [10] Nezaket Ekici, email to the author, December 12, 2015. [11] Ibid. [12] Jean-Jacques Rousseau, *Du Contrat Social: Book 1*, Geneva, 1762.

Rasheed Araeen
The Dancer and the Flame

I wrote this essay in 2016 for the publication **Rasheed Araeen: Going East**, produced by Rossi & Rossi gallery, Hong Kong, to mark an exhibition of Araeen's work that had opened there at the end of the previous year. While working at the Museum of Modern Art in Oxford, I had followed his work closely in the 1970s and '80s and greatly valued revisiting it now. We had then both been highly critical of the unchallenged eurocentricity of the art world but from radically different perspectives. It was salutary now, for me at least, to realize now how close then we actually were. Rasheed Araeen was born in 1935 in Karachi and has lived in London since 1964.

2

I.

Initially in Pakistan and from 1964 also in the UK, Rasheed Araeen has, since the early 1950s, employed a wide range of media to create many different kinds of art. He attributes this diversity of production to the large number of "distractions" or "obstacles" with which he had to deal[1] but in spite of, or perhaps because of, this his reputation has now become established internationally, not only as an innovatory artist, but also as an important figure in expanding the discussion about the political, social, and aesthetic framework within which contemporary art is made.

Although in the middle of the 1960s, when his first non-objective sculptures were produced, few people knew about them, they are now accepted as pioneering works of minimalism. (figs. 9–11) He is also recognized as a writer and polemicist who has consistently championed the cause of "Black" and "Third World" culture (he was founding editor of two influential art journals, *Black Phoenix* [1978–79] (fig. 14) and *Third Text* [1987–2011]), as well as the instigator and curator of the controversial and seminal exhibition "The Other Story," which showed, in the UK for the first time, works by British-African, Caribbean, and Asian artists within the framework of a pluralistic, non-hegemonic modernism.[2] (fig. 2)

But the main "distraction" that has occupied Araeen's attention for more than four decades after his arrival in the UK, was in struggling to ensure that his work could be seen on an equal level with that of other contemporary artists. This simple requirement could not be taken for granted, as he was regarded as part of an "ethnic minority" and therefore, by definition, *not* as a member of the western mainstream. Such stereotyping, within a racially prejudiced, barely postcolonial environment, rendered his work (along with that of others in a similar situation) "invisible." It is not by chance, therefore, that his first book, a semi-autobiographical documentation of his work published in 1984, was entitled *Making Myself Visible*.[3]

The painful and dispiriting realization that visibility on an equal basis with other artists was a chimaera consumed a huge amount of Araeen's creative and emotional energy. It seemed that not only did he have to establish his own path as an artist, a difficult enough task in itself, but he also had to construct the road over which he (and others) could travel. Before he could set out to do this, however, he had to lay the concrete on which the foundations for this road could be built. For this Sisyphean task, the skills he learned as a civil engineer in Karachi and London undoubtedly stood him in good stead.

Bringing together theory with artistic practice, by providing alternatives to the myopic eurocentrism of western modernity, Araeen set out to build such a road. But in the more recent era of "open markets" and untrammeled global capitalism, previous distinctions between centers and peripheries, and "first" and "third" worlds, no longer seemed to hold. Since the turn of the century, invoking the example of his 1989 exhibition "The Other Story," he has moved forwards in a non-linear way by stepping outside the ghettoized trajectory of western history to invoke "other" cultural traditions. In particular, he has invoked aspects of early Islamic thought and culture that he had previously regarded as unrelated to modernism, as "natural" precursors of his own hard-won position.

1 | **"Paki Bastard" (Portrait of the Artist as a Black Person)** | 1977 | final sequence of a performance with 40 projected images | courtesy of Artists for Democracy, London

2 | Catalogue cover of **The Other Story: Afro-Asian Artists in Post-War Britain** | courtesy of Hayward Gallery, London | 1989

[1] "Rasheed Araeen: A Journey of the Idea," public lecture and interview by David Clarke given at Asia Art Archive, Hong Kong, December 3, 2015. The first chapter of Araeen's book *Art Beyond Art, Ecoaesthetics: A Manifesto for the 21st Century*, London, Third Text Publications, 2010, is also entitled "My Own Story: Or, A Journey of the Idea." [2] *The Other Story: Afro-Asian Artists in Post-War Britain*, London, Hayward Gallery, 1989, ISSN: 185332051. [3] Rasheed Araeen, with an introductory essay by Guy Brett, *Making Myself Visible*, London, Kala Press, 1984.

In a body of recent paintings, "Homecoming" (2010–14), he has brought together his earlier engagement with minimalist geometry with the intellectual, philosophical, and scientific achievements of the Abbasid Golden Age (750–1258), a high point of Islamic art and culture that "first formulated [those] ideas of geometric abstraction that, with symmetry and seriality," have figured in his work since the mid-1960s.[4] A series of recent brightly colored geometrical paintings is based on stylized Arabic letters that make up the names of illustrious Islamic philosophers and mathematicians who not only preserved and transmitted "lost" knowledge from the ancient world, but also built on it, adding their own theories and perceptions. (fig. 17)

The title of this exhibition, "Rasheed Araeen: Going East," acknowledges the artist's evolution beyond western modernism to be part of more deeply rooted, less fractured tradition that stretches back far beyond the European Renaissance. Its synthesis of mathematics, science, and art is in harmony with the holistic ecological concerns that have also recently resurfaced in his work.[5] The road that Araeen has constructed for himself as an artist has been far from straightforward, seamless, or premeditated, but the red thread that gives it continuity is typified by a moral sense of selfhood that shows respect for equality and other basic human rights within a framework that derives no benefit from the exploitation of others. At times mindfully, at others painfully, he has had to trace this wayward route, yet considering the overbearing conditions and contexts in which he has had to work, it is difficult to imagine how the path he has chosen could have been any different.

II.

Araeen was born in Karachi in 1935, then part of the British Raj, and split his childhood between that populous, bustling port city and the smaller coastal town of Somniani in Balochistan, about a two hours' journey to the west, where his father worked first as a teacher, then as an administrator, and he lived there until he was nine. Both sides of his family originated from East Punjab (now India), not far from the border with Kashmir, where he also frequently visited. At around the age of ten, he remembers feeling the sudden "urge to draw pictures"; his mother had previously primed his latent talent when she had asked him to trace flowers onto pieces of cloth for her to embroider.[6] He entered full-time education at the Sind Madressah in Karachi in 1946, at the age of eleven, where he excelled in religious studies and drawing, even though he strongly disliked his art teacher.[7]

The next significant step in Araeen's artistic development took place in 1952 during his last years at school. By this time, the Raj had dissolved and Pakistan was an independent state. On a walk through the labyrinthine streets of Karachi, not far from where he lived, he found himself standing in front of a grand building in a large garden that he discovered was the library of the United States Information Service (USIS). A board outside listing its activities included a sketch club, and he decided to join the library so that he could regularly attend the drawing classes. (fig. 4) Here, he received a basic education in art, had access to a large number of foreign books, and also met a number of established artists who encouraged him to join the artists' club that met each Sunday at the Turab Studios. (fig. 3) Over the next six years, these classes enabled him to build up skills and confidence in making images of landscapes and people.[8]

Araeen remembers that he had no thought then of becoming an artist, although he spent a lot of time making art. During his visits to the USIS library, he studied books on art, but was particularly impressed by the work of modern architects, that of Frank Lloyd Wright, in particular; however, as architecture was not then taught in Karachi, he decided that he would study civil engineering. In 1957, he designed a private house, since rebuilt, and made various other designs, including functional diamond-shaped window lattices that prefigured the form of his non-objective *Structures* of the late 1960s.[9] Yet, by 1958, he had started to become dissatisfied with the mimetic

3 | **A Sunday Session of the Artists' Club** | Turab Studios, Karachi | 1956 | images courtesy the artist and Rossi & Rossi gallery, London/Hong Kong

4 | **Trees in Garden of USIS Karachi** | 1953 | from series "Views of Karachi" (1953–56) | watercolor | 30 x 22 cm

[4] Rasheed Araeen, email to the author, January 18, 2016. He confirms that he was not aware of "Islamic art" until he saw "Exploration of Islamic Abstract Pattern and Design," an exhibition curated by Paul Keeler for the ICA in London in November 1971. See also Iftikhar Dadi, "Rasheed Araeen's Homecoming" in Amra Ali (ed.), *Rasheed Araeen: Homecoming*, Karachi, VM Art Gallery, 2014, pp. 87–98. [5] Rasheed Araeen's essays relating to ecology and capitalism are gathered in his book, *Art Beyond Art*, see note 1. [6] *Art Beyond Art*, op. cit., p. 7. [7] Amra Ali, "Before and After the Departure", in *Rasheed Araeen: Homecoming*, op. cit., pp. 13, 15. [8] *Art Beyond Art*, op. cit., pp. 8–11. His earliest work includes watercolor studies of landscapes (the USIS gardens and views of East Punjab, for example) as well as "People of Karachi" (1955–58), a series of portrait heads in pencil, ink, biro, crayon, and watercolor. [9] Rasheed Araeen, email to the author, January 19, 2016. The functional window lattices he designed from 1957 and 1961 are illustrated in *Minimalism and Beyond: Rasheed Araeen at Tate Britain*, London, Third Text/Tate, 2007, p. 1. After Araeen had left Karachi for the UK, the USIS library was burnt down by a mob in 1968–69 during protests against US backing for Ayub Khan's military regime. A low-class cinema was subsequently built in its place. *Art Beyond Art*, op. cit., p. 36. [10] Ibid., p. 12. [11] Ibid., p. 20. [12] Ibid., p. 16. [13] Ibid., pp. 12–14. In London in 1975, Araeen was to reconstruct this moment as a photographic installation titled *Burning Bicycle Tyres*, but at the time he "discovered" these structures, he had no knowledge of Marcel Duchamp's readymades or his *Bicycle Wheel* (1913). His first encounter with Duchamp's work was in London in 1967, when he saw a special Duchamp issue of the journal *Art and Artists*. Email to the author, January 18, 2016.

quality of the art he could produce. His paintings became larger and less tied to figurative imagery as "unexpected encounters with mundane reality of everyday life . . . put me onto the path of discovery and self-reflection" that was eventually to result, a few years after he had moved to the UK, in the conviction that he wanted only to work as an artist.[10]

Although an outsider in the nascent Pakistani art world, in which Lahore, not Karachi, was then the traditional center of activity, Araeen was becoming attuned to the allusive possibilities of abstraction, and began to synthesize his experience of the everyday into a lyrical freedom of line that, during the late 1950s, surfaced in drawings, watercolors, and paintings, initially of water, boats, and buildings, and then extended into the helical curves and swirls of what he described as "Dance Partners," which seemed to take on a life of their own. At the same time, he had begun to realize that he "felt constrained" by the provincialism of the modernity that surrounded him in Pakistan that to him "only promoted and valorized [the] stifling mediocrity that resulted from the blind emulation of whatever came from the West."[11]

Araeen regards two sequences of events—one related to dance, the other to fire—as symbolic of the new journey on which he was about to embark in his work: The first took place in August 1959 while he was sitting, chatting in a park with an artist friend, when a group of children gathered and started playing with hula-hoops, an international craze that had just reached Pakistan. His friend was so struck by this spectacle that he immediately wanted to transform it into a painting, but Araeen regarded this idea as kitsch and told him so. During the frank exchange of views that followed, Araeen remembers that he suddenly stopped talking:

"A silence engulfed me as my mind began to drift away. I then saw in my imagination, the hula-hoop dance undergoing an amazing transformation . . . The movement of the hula-hoop players had turned itself into some sort of upwardly whirling pure movement. This happened despite the fact that I had no interest whatsoever in the hula-hoop, let alone an inclination even to consider it as a subject for art. For me the whole thing was no more than children playing a game. It was so . . . bizarre. But now, suddenly, I was in a trance, overtaken by the very thing that I . . . disliked."[12] (figs. 5, 6)

The second sequence of events was more violent and far reaching in its implications. Late in November the same year, he had found a piece of twisted metal wire in the street, which he later realized was part an old bicycle wheel; he brought it home, cleaned it and put it on the table. Something about its "sculptural" quality fascinated him. A few days later, while standing at a bus stop, he was drawn to a pile of burning rubbish across the street that, even though he was smarting from the overpowering heat and smell of the fire, he could see was made up of bicycle tires. It appeared like an abject, ceremonial, "Third World" funeral pyre and, for some unidentifiable reason, he felt compelled to add to its flames, searching out two more old tires from a nearby bicycle repair shop and throwing these on top of the "pyre." Returning home the same evening, he saw that the fire had burnt out and that among the ashes were four twisted pieces of metal. He picked these up and took them home. Later, he described this act as "my first conscious attempt at making . . . sculpture."[13] (fig. 7)

Consciously and subliminally, Araeen's attitude towards the perceived world was undergoing a radical overhaul as he moved sharply towards abstraction in a direction few other artists in the Indian subcontinent would have recognized. On an intuitive level, he began to see a correspondence between the sinuous bodies of his "dancers" and the flickering helix of the flames around the burning tires. Yet, for his work at this time, the "dancers" were more liberating and important than the flames; it was only after he had arrived in the UK that he began to think seriously about burning off surface appearance and trying to make sculpture.

5 | HHI | 1959 | from Dancing Bodies, "Hula Hoop" series | 1959–62 | pastel and ink on paper | 35 x 26 cm | Sharjah Art Foundation, Sharjah | photo by Akram Spaul

6 | Untitled | 1961 | From Dancing Bodies, "Hula Hoop" series | 1959–62 | black ink on paper | 40 x 28 cm | Sharjah Art Foundation, Sharjah | photo by Akram Spaul

7 | Burning Bicycle Tyres | 1959 | Karachi | reconstructed 1975 in London

8

The form and style of some of the best paintings Araeen was to make before leaving Pakistan, a series of proto-geometric paintings (1962–63) inspired by the traditional wind-catchers that gave the architectural skyline of Hyderabad in Sindh its unique character, and a group of "Black Paintings," weightily entitled *Before the Departure* (1963–64), suggest that their supercharged modernity had derived energy, if not clear direction, from examples of French *peinture informelle* that he could have seen only in books and art magazines. **(fig. 8)**

III.

The "Black Paintings" were an unconscious premonition of the end, for several years, of Araeen's activities as a painter, and prefigured a tabula rasa from which he would emerge as a sculptor, conceptualist and performance artist; nevertheless, he took eight recent paintings with him on his move to the UK, thinking that he might be able to develop work from them. Liberated from the stifling provincialism of the Pakistani art world, his arrival in London in June 1964 promised a new beginning. Supporting himself as a civil engineer, he began to discover the gamut of modern art in Britain—good, bad and ugly. Nothing much happened during his first year but, although he is unable to recall exactly when he first saw them, the strong colors and aggressive, industrial materials of Anthony Caro's abstract sculptures impressed him greatly; so much so, that he looked, fruitlessly, into studying sculpture part time at the Saint Martin's School of Art, where Caro was a professor.[14]

At this time, the UK was in the middle of profound political and cultural change, as a generation that had neither fought in, nor remembered, World War II came of age. Resounding in its newfound belief in the "white heat of technology," the Labour Party swept to victory in October 1964, and a youthful pop culture was turning established society on its head by surfing the energy and classless optimism of a suddenly "swinging London," and other oscillating major British cities.[15] Yet this picture was less rosy than it may have seemed. In the industrial Midlands and the North, Britain's new prosperity was being underwritten by low-cost immigrant labor from the Commonwealth, initially from the Caribbean and increasingly from Asia. For the first time, racial tension was becoming a widespread political and social phenomenon: depressed inner-city neighborhoods were being transformed by their new occupants, and British workers felt their livelihoods threatened by the labor of others.[16]

Disorientated by such conflicting energies, seemingly limitless possibilities and lack of resources, Araeen found himself in "an extremely difficult and precarious situation" while, at the same time, he began to think "obsessively" about making sculpture.[17] By the end of 1965, drawing on his experience as an engineer, he decided to embark on a series of "industrial" sculptures of his own, based on the simple symmetrical forms of the square, the circle and the triangle. His drawings for the first group of works show militantly non-functional lines and cubic stacks. *Structure No 2 III* (1965/2015), an assembled cube of sixteen elements, was made up of four layers of four-foot-long, one-foot-wide, painted, rolled-steel I-beam girders. Because of their complete lack of referential image, these works were quite unlike anything else conceived in Britain at that time, but it proved impossible for Araeen to fabricate them because he had neither the resources nor the space in which they could be constructed, exhibited or stored; for many years they existed only as drawings.[18] **(figs. 9, 10)**

Simple materials and bright, clear colors also featured in his next two groups of work that, as well as being optically dynamic in their impact, were easy to move and construct because they were formed out of light wooden lattice modules. As he developed them, he realized that, because the units out of which the works were made could be easily placed in different configurations, he was moving away from the idea of a fixed, immutable object towards a more fluid definition of art.

[14] Ibid., p. 21. [15] In 1963, future Labour Prime Minister Harold Wilson had, in his address to the annual Labour Party Conference in Scarborough, spoken about the "white heat of technology" in advocacy of technical innovation as the natural partner of modern socialism. [16] Institutional racism was, and in some professions (such as the police) still is, widespread in the UK. During the 1960s, matters came to a head in Tory MP Enoch Powell's notorious "Rivers of Blood" speech (April 20, 1968) to the Conservative Association in Birmingham during the lead up to the Race Relations Act. Racism was also widely prevalent in the popular media as, for instance, in the BBC's weekly *Black and White Minstrel Show* (1958–78), or in the hit song *Goodness Gracious Me!* (1960) in which British comedy actor Peter Sellers plays the role of a love-smitten Indian doctor opposite Sophia Loren. [17] *Art Beyond Art*, op. cit., pp. 21–22. [18] It was not until 1987 that some of these works were fabricated for the traveling exhibition, "From Modernism to Postmodernism: Rasheed Araeen, A Retrospective," at Ikon Gallery, Birmingham; Cornerhouse, Manchester; John Hansard Southampton; and Chapter, Cardiff. [19] On the aesthetics of minimalism in the US and its political dimension, see Gregory Battcock (ed.), *Minimal Art: A Critical Anthology*, Berkeley, University of California Press, 1995. "Primary Structures" was the title of a group exhibition of British and American artists of many different tendencies that took place at the Jewish Museum in New York from April to June 1966. Only during the 1970s and through the '80s did Araeen begin to compare his early geometric structures directly with US minimalism. [20] Araeen remembers that his first "encounter" with American minimalism was at the end of 1968 when his wife-to-be wrote to him from Paris that in "The Art of the Real," a traveling exhibition originated by the Museum of Modern Art in New York, she had seen a work by Sol LeWitt that resembled his own. Rasheed Araeen, *From Innovation to Deconstruction: My Own Story*, http://1995-2015.undo.net/cgi-bin/openframe.pl?x=/Pinto/Eng/earaeen.htm. Last retrieved January 15, 2016. [21] Many of the early versions of these works were destroyed for want of anywhere to keep them; some, however, have survived in collections. Others have recently been reconstructed from contemporary drawings and photographs. [22] In his installation *What's It All About, Bongo?* (1991), Araeen embedded a number of different kinds of structure in a sand-filled room along with four TV sets showing news clips from the Iraq War. Around the walls of the gallery space ran the text of the *Golden Verses*, a (self-)critical work that—originally presented in the form of an Islamic billboard that in Urdu and barely legible English— "sold" the artist's "anger against both [those] Asians and the establishment who were in collusion . . . in denying my freedom to express myself as a free human being." Jean Fisher (ed.), *The Triumph of Icarus: Life and Art of Rasheed Araeen*, Karachi, Millennium Media, 2014, pp. 122–123. [23] *Art Beyond Art* op. cit., p. 29. [24] Ibid., p. 29, 51–54. Araeen was not aware of this aspect of Tatlin's work when he made "Chakras." On Tatlin's flying machine *Letatlin*, see Larissa Zhadova (ed.), *Tatlin*, London, Thames & Hudson, 1988, pp. 309–12, 413–36.

9

10

11

Char Yaar (Four Friends), a prototype of four two-foot lattice cubes, was produced early in 1968 and was followed, in the same year, by *From Zero to Infinity,* consisting of a hundred cubes with diagonal struts, a version of which, reconstructed in 2004, is now in the collection of Tate, London. (fig. 11) At the time he first made them, it seems that their matter-of-factness, combination of symmetry with asymmetry, mutability and, through this, their offer of direct interaction with an audience, were their salient features. The tension between symmetry and its disruption as an expression of infinity remains a leitmotif in his work.

In their appearance and date, these works are similar to the "primary structures" of American "minimalists" such as Carl Andre, Donald Judd or Sol LeWitt who, during the early 1960s, had been expanding their ideas about the "non-hierarchy" and "non-referentiality" of their objects into a political dimension.[19] Araeen, however, was not aware of their work until the end of 1968,[20] and his approach to object-making was, at this time, more spatial, being concerned with the optical movement of bright colors broken up by form as well as with the random formal reorientations visitors created by manipulating the work. As a result, in spite of their underlying geometry, these works seemed less programmatic, more intuitive and organic than those of their American counterparts, while being more rational, fugitive and interactive than the more "romantic," referential works of Anthony Caro and his circle in the UK.

Taking a lead from the formal energy expressed in his different drawings of "dancers," completed while he was still in Pakistan, Araeen quickly began to break out of the "cubism" of his first steel and wooden sculptures to both compress and extend his lattices vertically so that they appeared as repeated, sometimes shimmering, motifs, their colors "flickering" against different colored lattices, or against flat planes of different strong colors on a background wall. Sometimes, these works took the form of long "friezes" in low relief; at others, they were freestanding vertical towers, or corner pieces jutting out, unsupported by the floor, from the edge of a room.[21] During the 1970s, '80s and '90s, when his work had changed fundamentally, he continued to interpolate grids and *Structures* into his performances and installations, often within political contexts.[22] (see fig. 1)

IV.

In a series of works called "Chakras," made in the winter of 1969–70, Araeen extended his interest in random composition to the world outside the closeted art space.[23] In its first iteration, this work comprised sixteen, two-foot-diameter, wooden discs coated with fluorescent red paint that floated on the waters of St. Katherine Docks, where he had recently taken a studio. His idea was to transform the whole site into an artwork that would be constantly reformed by the water currents and wind until eventually it was swept into the River Thames and discharged into the infinity of the ocean. (fig. 12)

Around this time, he resigned from his engineering job and devoted himself fully to art and, as a next step in his project of bringing artistic production and life together, he decided to make the discs larger, so that they could support the weight of a person. He then added sails so that they could be used in a kind of popular water sport, rather in the same spirit as, at the beginning of the 1930s, Russian Constructivist artist Vladimir Tatlin had experimented (unsuccessfully) in designing a human-powered flying machine that could be used by anyone.[24]

Just as Araeen's art was beginning to open up in new ways, his realization that the opportunities for exhibiting it were extremely limited struck him very hard. The cruel colonial paradox that coming from (what was then called) the Third World automatically marginalized him from the western mainstream of modernism, from which the whole ethos of his work was derived, seemed to be insurmountable. This dead end led nearly

8 | **Before the Departure** | "Black Painting No IV" | 1963 | oil on canvas | 90 x 90 cm

9 | Drawing for **Sculpture No 2** | 1965 | part of **Drawings for Sculpture** | 1965–68 | Tate Collection

10 | **Sculpture No. 2** (first version, silver grey) | 1965/2015 | painted steel | 121 x 121 x 121 cm

11 | **From Zero to Infinity** | 1968 | performed at 198 Gallery in London in 2004 | Tate Collection

12

13

12 | Rasheed Araeen with Elena Bonzanigo (his wife) launching **Chakras** | 1969–70 | St. Katherine Docks, London | February 21, 1970

13 | **For Oluwale** | 1971–73 | third of four collaged panels | each 122 x 122 cm

[25] Araeen became heavily involved with the BWM following conversations with friends about the role of art in the anticolonial struggle and, for a time, was in charge of printing its free weekly newsletter. [26] *Making Myself Visible*, op. cit., p. 174. [27] Rasheed Araeen, from *Conspiracy of Silence*, an open letter from November 3, 1974, sent to Caroline Tisdall at *The Guardian* and Norman Rosenthal, curator at the ICA. It was eventually published in *AMPN9* in February 1975, and 1,500 copies were posted to various people in the art world. It was republished in *Making Myself Visible*, op. cit., p. 67. [28] Rasheed Araeen, *Preliminary Notes for a Black Manifesto*, London, June 1976, ibid., p. 91. He was subsequently to criticize the Arts Council's creation of InIVA in 1994 on similar grounds. [29] Old habits die hard: the only artist of color to be included in "Blast to Freeze: British Art in the 20th Century," a large British Council-sponsored survey shown in Germany and France during 2002–03, was Anish Kapoor. In 1989, Kapoor had refused to be included in Araeen's Hayward exhibition, "The Other Story," although he did participate in "India: Myth and Reality" at Oxford MoMA in 1982 (see p. 30, note 23). The British Pavilion at the Venice Biennale has shown the work of Chris Ofili (2003) and Steve McQueen (2009). [30] Rasheed Araeen, *Preliminary Notes for a Black Manifesto*, op. cit. [31] Ibid., and Jean Fisher (ed.), op. cit., p. 42. Although unsuccessful in its aims, the Grunwick strike is now seen as a first step in the move towards an inclusive and supportive trade union perception of ethnic minority workers in the UK. The charisma and articulate expression of the leaders of the strike also made a strong impression on the general public. [32] Rasheed Araeen, description of *"Paki Bastard" in Making Myself Visible*, op. cit., p. 114–15, 121. [33] Rasheed Araeen, *From Innovation to Deconstruction: My Own Story*, see note 20.

to a breakdown. In an autobiographical note published in 1984, his entry for 1971 baldly states: "Going through a period of identity crises . . . begin to lose interest in formal art activity. Reading a lot of literature on Black/Third World struggle, in particular Franz Fanon's *The Wretched of the Earth* [1961]. Also reading . . . about the death of [David] Oluwale, caused by the police in Leeds . . . thinking about making an art work dedicated to him." In 1972, he records, "an interest in the activities of radical black groups" and by the following year, he was an "active member of the Black Workers Movement [BWM] (formerly [the British] Black Panther Movement)."[25] Fanon's view of "blackness" as a political position was a decisive influence on him at this time, and inspired his *Black Manifesto* (1975–76).

For Oluwale (1971–73), the first major work that resulted from this period of ferment, not only marked his move towards an emotional and political statement against racism, but also incorporated a montage of documentation, newspaper clippings, and texts to communicate his views. (fig. 13) At the same time, he was also traveling regularly to Karachi, and making performances and works critical of local hierarchies of power quite unlike what he had made there before.[26]

"Art into Society, Society into Art," an exhibition of contemporary, socially engaged German art at the ICA in London in the winter of 1974 (that included work by artists such as Joseph Beuys, KP Brehmer, Hans Haacke, Gustav Metzger, and Klaus Staeck) helped Araeen to articulate publically why he was feeling so marginalized and excluded. A review of this show by Caroline Tisdall, in the left-leaning newspaper *The Guardian*, had omitted to acknowledge criticisms of it that had emerged in a public panel discussion in which she had taken part and Araeen had attended. He felt strongly that an opportunity to open up debate on a vital issue was being missed and, describing himself as "A Black Artist from the Third World," wrote an open letter to both *The Guardian* and the ICA that highlighted the discrepancy between the complacent faux radicalism of "the western international art world" and the "real situation that [actually] exists." He took particular issue with Tisdall's use "of the word 'international' . . . to describe the Euro-American art/cultural situation" without any acknowledgement of the continuing "plundering of the Third World by capitalism & imperialism which has forced . . . [its] people . . . to . . . search [for] their livelihood in the socially hostile capitals of Western Europe & America."[27] Araeen's forceful view that the economic legacies of colonialism still persisted in the inequity and exploitative nature of the so-called "postcolonial age" fell largely on deaf ears, particularly in the art world in which many so-called "British radicals" felt that their politics inoculated them from either criticism or action.

As a result, Araeen's activism became more confrontational and this also began to feed into his work. By 1975, he was working with Artists for Democracy, an organization dedicated to "giving material and cultural support to liberation movements worldwide" that had been formed the previous year by Filipino-born artist David Medalla; he had also begun his *Preliminary Notes for a Black Manifesto*, finally published in 1978 in *Black Phoenix 1* and *Studio International*, that outlined a theoretical position towards First and Third World relations that would inform his activities over the next two decades. (fig. 14) His art production at this time included actions, collages, tape-slide works and performances that elaborated on aspects of his written texts, while also elucidating his personal feelings and reactions to the situation in which he found himself.

At the same time, under the aegis of the Arts Council of Great Britain, an enquiry was underway into the whole question of "ethnic minority" arts; Araeen involved himself with this, strongly criticizing Naseem Khan's resulting report *The Arts Britain Ignores* (1976), as little more than a "pigeonholing" of Black and Asian groups into various ethnic categories that "relegated them to a subcultural level."[28] He was far more concerned that minority artists should be represented on an equal basis in exhibitions and

14 | Cover of **Black Phoenix: Third World Perspective on Contemporary Art and Culture** | London, no 3, Spring 1979 | drawing by David Medalla | **A Freedom Fighter** | 1974

15 | **How Could One Paint a Self-Portrait!** | 1978 | mixed media on board | 122 x 91.44 cm

16 | **Burning Ties** | detail | 1976–79 | performance and eight color photographs | each 75 x 50 cm | photographed by Elena Bonzanigo | courtesy Burger Collection, Hong Kong

surveys of British art, which, at that time, had never happened. This only began to take place well into the present millennium. [29]

During 1976–77, while writing the *Preliminary Notes for a Black Manifesto*, Araeen was planning a trilogy of new works, only one of which, *"Paki Bastard" (Portrait of the Artist as a Black Person)*, was realized. A live event with slides and sound, first performed on July 31, 1977, at Medalla's Artists for Democracy space in London, it was subsequently disseminated in the form of repeat performances and photo panels showing episodes from it. In Araeen's words, the whole work reflected "upon the predicament of black people in Britain; showing also how a black artist, uprooted from his original environment in the Third World, and rejected by white society in the West, eventually comes to terms and identifies with the reality of his people." [30]

In this, the first of a series of dynamic self-portraits, that also included *Burning Ties* (1976–79)—that referred, ironically, to his rite of passage on ceasing to be a civil engineer—Araeen appears dehumanized, victimized, bound, mute and blinded, as different images of desolation, loneliness and racial violence collide with and around his body. (figs. 15, 16) Yet, as his work moves increasingly towards activism and political engagement, images of his abstract lattice "Structures" continue to hover over him as both a protection and a seeming indictment of how much he had moved away from them, while an image of a sacrificial goat associated with the Islamic festival of Eid al-Adha is tethered by his side . . .

The performance ended with an intense montage of images of Asian immigrants from Brick Lane, of pictures of the ongoing strike of Asian women workers at the Grunwick Film Processing Laboratories in North London (1976–78) and of portraits of the artist's family in Pakistan. The soundtrack switched between the swelling Hallelujah Chorus from Handel's *Messiah* and tunes from Bollywood films, until the accusatory voice of a white worker rose above the tumult in complaint that the British Trade Union leadership was failing to support the Asian workers in the Grunwick strike. At this point, Araeen sawed a piece of red-painted wood in two and, seated cross-legged on the floor under one of his geometric structures, proceeded to mime playing it, as if it were a flute and he were the god Krishna, to the sound of clapping and catcalls by the striking workers outside the Grunwick factory. [31] (fig. 1)

Such emotive imagery raises the dilemma of Araeen's new position as a "political" artist, and he had to face the inevitable question: Should "art become an instrument of political struggle in a mechanical and functional way, or should it maintain its specific function vis-à-vis ideology?" In a note following his description of this performance, he answered this question unequivocally: "any prescription that marginalized the role of art must be rejected." [32]

V.

During the 1980s, Araeen began to appreciate that visibility, equality of opportunity and racism were not the only obstacles he had to surmount, and that the right to be different should also be both asserted and celebrated. As a result, the depth and complexity shared by both his performances and non-objective "structures" began to evolve into a different kind of systematized representational space in which modular grids, composed of nine panels, created a dynamic interaction between images of power, conflict, and violence within a clear dialectical framework.

These wall-mounted works, which could, at different times, combine photography with mixed media or painting, took the form of "anti-mandalas" in that they concentrated, through the language of a modernist grid, what Araeen described as a "divided world, the center—white, male Christian and globally dominant—and the periphery which aspires to the center but cannot get there due to this division. Yet both . . . are tied together in a violent nexus. Both are dependent on each other. The center defines the periphery and in turn is defined by it." [33]

17

The Golden Calf (1987), made towards the end of the Iran-Iraq War (1980–88), its title referencing both a sacrificial animal and false gods, is a classic example of such work. **(fig. 18)** Within its nine photo-panels, moving between close-up and long shot, four identical Andy Warhol *Marilyn*s define the end of each limb of a "crucifix" in which a single, tragic image of a dead Iranian soldier lies at its center; at each of the corners, uniformly tinted in "Islamic" green, the same photograph depicts crowds of faceless, mourning Iranian women. Uncannily prophetic in its statement of the causes and effects of direct US and western involvement in the Middle East in the Gulf Wars (1990–91, 2003) and in the subsequent US/UK invasion of Iraq, [34] Araeen brings together conflicting representations of art, reality, religion, ideology and gender within a framework that contrasts Hollywood and art-world fantasies with documentary evidence of the effects of continuing conflict and manipulative rapaciousness. Andy Warhol, a radical New York artist whose work hovered profitably between an exposé and celebration of capitalism, is subjected here to the same withering gaze that Araeen had previously cast over the German radical artists whose work he had seen in "Art into Society." A central question posed in this work, as well as in the others related to it, is: Whose kind of reality and ideology does western art represent?

Keenly aware that blindness is the enemy of visibility, Araeen has continued to explore such themes by making art, publishing, and writing. At the core of this impetus is the discrepancy between what he perceives as "successful" art in Euro-America and what he knows to be true from his own experience. In this particular form of "institutional critique," in which the institution in question is contemporary art itself as much as the museums or galleries that show it, two works, *A White Line Through Africa* and *Arctic Circle* (both 1982–88), first shown at Showroom in London in 1988, highlight the continuing impact of colonization and environmental despoliation by directly quoting the visual language of conceptual and land art. The first of these, a rectangle of bleached animal bones, questions romantic "innocence" and highlights the "blindness" of both the artist and the depicted landscape on a continent still blighted by exploitation and war. In the other work, the ideal of "pure nature" proves to be as illusive as that of any "noble savage," as the *Arctic Circle* in question is a motley disc of old wine and beer bottles that also mimics the large circles and other formations of primordial rock that artists such as Richard Long had collected and brought back from remote locations as art since the 1970s. Araeen focuses here on the actual, rather than ideal, condition of Africa as well as on the Arctic and its oceans by concentrating on the reality that they are increasingly at threat from ignorance, violence, and waste.

Araeen has consistently refused to compromise either the ambition or scope of his work or to be stereotyped as a member of a minority that "deserves" special treatment. This, for some, has created a barrier against the apprehension of his work; many western institutions, cultural and otherwise, often act out of a misplaced sense of entitlement and superiority, and are unwilling to enter into dialogue on any other basis. As recently as 2005, he refused to give a paper at the "Art and Globalization Conference" in Paris on the grounds that many participants from western countries were concerned with the idea "of helping Africa, Asia, and other parts of the world by promoting their art." [35]

Undoubtedly, however, both the art "world" and the much larger environment that surrounds it are changing, rapidly and fundamentally, and Araeen's requirement that his work be shown on an equal basis with that of others is slowly gaining acceptance and understanding. Some museums of modern and contemporary art are now beginning to build up collections that are not purely "western," and a new generation of museum curators and private collectors in Asia, Africa, and the Middle East has also started to take an interest in contemporary art from different perspectives and build up collections from local sources.

17 | **Home Coming: In the Midst of Darkness 2A** | 2012 | acrylic on canvas | 114.3 x 139.7 cm

18 | **The Golden Calf** | 1987 | mixed media | 151.8 x 178.4 cm

19 | **Astthesis** | 2005 | ink and colored marker pen on perforated notebook pages

[34] See note 22. [35] Rasheed Araeen, email to the author, January 18, 2016. [36] This is the subtitle of "Mediterranea," a chapter in his book *Art Beyond Art*, op. cit., pp. 95–110. [37] Rasheed Araeen, from the text of *Astthesis* (2005).

From the turn of this century, in step with the stimulus that the philosophy, mathematics, technology, and culture of the Abbasid period has brought to his work, as well as his long-standing appreciation of the work of modern non-objective painters such as Piet Mondrian, Kazimir Malevich, and Ad Reinhardt, Araeen has started to assemble ideas about art, science, and technology within a contemporary framework of ecology by weaving landscape and culture into a non-colonial and forward-looking "history." He sees this remapping of the world as "an unending, continuous conceptual art project." [36] In *Astthesis* (2005), an animated drawing of colored ideas extending over four sheets, he puts these concepts together within an aesthetic framework that "allows the energy of the ego to be freed from its narcissistic individualism . . . [so that it may] be directed towards the creativity of the collective." [37] (fig. 19)

The tension between the individual and the collective (whatever that may be)—the lambent energy between the dancer and the flame—has been present from the very beginning in Araeen's work. His determination to extend art beyond the limits of the self has not only prompted him to recycle old ideas and forms into new contexts and challenges, but it has also led him to look for different "solutions" and to repudiate strongly those that do not work. As always, the elegance of the dancer's line, along with the fire of anger and compassion, still lead him to search ceaselessly for new forms of art. •

Bharti Kher
Icebergs in India, Snowballs in Hell

This essay was published in Chinese and English in **Bharti Kher: Misdemeanours**, edited by Sandhini Podhar, to coincide with the exhibition of Kher's work she had curated for the Rockbund Art Museum in Shanghai in 2014. Kher was one of relatively few Asian artists who had been born and educated in the UK but who had moved back to Asia permanently to live, and I was fascinated by the different ways in which this impacted her work. I had previously shown her work in both the 17th Biennale of Sydney (2010) and the 1st Kyiv International Biennale of Art (2012). Bharti Kher was born in London in 1969, and now lives and works in Delhi.

2

3

1 | **Self-Portrait** | 2007 | digital C-print | 50 x 41.67 cm | courtesy the artist

2 | **Misdemeanours** | 2006 | fiberglass, wood, skin | 148 x 185 x 60.5 cm

3 | **The Hunter and the Prophet** | 2004 | digital c-print | 114.3 x 76.2 cm

[1] Bharti Kher, "Fragments of a Conversation with Aveek Sen" in *Bharti Kher*, London, Parasol Unit, 2012, p. 58. [2] Kher recently expressed these traditional humors in her bronze sculpture *Choleric, Phlegmatic, Melancholy, Sanguine* (2009–10). [3] Although *Hybrid* refers to a particular body of work started in 2004, I would argue that hybridity has been a fundamental presence within Kher's moral development as an artist. [4] Kher's work *Chocolate Muffin* (2004) in this exhibition plays with similar ideas.

I have always known that my body and my experience are quite small, quite contained. And if I venture very far out of it, I find it disconcerting ... confusing, maybe overwhelming, which is why I like to come to the studio everyday ... It's my center.

– Bharti Kher [1]

"Misdemeanours"—the title of both this exhibition and a work from 2006 in which a hyena draped with the pelt of another animal viciously glowers at visitors as soon as they pass the threshold—implies here not only minor crimes but also an enquiring and mould-breaking approach that goes against the norm. (fig. 2) Such an impetus may be seen throughout the whole of Bharti Kher's work.

A darkness huddles at its core that enables Kher to get close to uncomfortable or even dangerous aspects of reality by stealth. Through experience and intuition the artist has developed a strongly principled visuality that cuts to the essence of what is present. The cardinal humors that compose her work—skin, flesh, blood, bone [2]—appear symbolically in what she describes as "hybrids," within which the meaning shifts or glides according to their proportion or emphasis. [3] Refreshingly, these have flirted with the shock of the politically incorrect but with serious intent. By disrupting conventions of female beauty or bourgeois comfort, as well as stereotypes of gender and species, she has enabled us to see them all in their places more clearly. (fig. 1)

On one level, *The Hunter and the Prophet* (2004), an early "Hybrid" photo panel, could reflect a crisis of identity within the newly prosperous Indian middle class but its implications reach much further afield. It stars a red-booted, mini-skirted hybrid of a fit young female/feline predator triumphantly stepping on a supine goat carcass, just as if she were a protecting deity in a tantric painting. (fig. 3) Animal fur speckles her smooth skin, her teeth can obviously rip flesh, draw blood. As if it were a weapon, she wields a red feather duster in her right hand. Yet the absurdity of such works transcends irony or satire to strike at more profound truths about how we relate to our world, natural and cultural. These are influenced, of course, by political and social change but in their essence they remain fundamentally moral.

In the same year, *Arione* sprang to life in three dimensions, almost as if she were one of the hunter's avatars. A sassy, dark-skinned serving-girl in hot pants, her breasts prominently exposed, she stands, one hand on her hips, with her weight resting on a sinuous leg that ends tantalizingly in a hoof rather than in the stiletto that graces the other foot. In her right hand, she holds a plate on which rest two pink, cherry-topped chocolate muffins. (fig. 4) Within this framework, in which it is far from clear who, or what, Arione is, the intentionally crude visual rhyme between muffins and breasts highlights uneasy stereotypes of desire, cruelty, inequity, race, and perhaps even disability. This motif echoes the martyrdom of Saint Agatha of Sicily, one of the most suffering of saints, who having rejected the advances of a Roman prefect was sent to a brothel and on refusing to perform there was imprisoned and tortured. Her breasts were cut off, and the icons that venerate her memory show her in this form carrying her breasts on a plate. [4] (fig. 5)

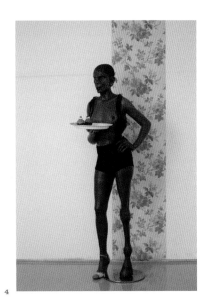

4

[5] Bharti Kher, "If I could remake my artistic career, I think I would be a minimalist painter. All the art that I love comes from the tradition of reduction—but I can't because I am super maximum!," "A Conversation with Chrysanne Stathacos and Susan Silas," see http://www.mommybysilasandstathacos.com/2013/11/01/a-conversation-with-bharti-kher. Last accessed July 8, 2017. [6] Bharti Kher, ibid. [7] Bharti Kher, Aveek Sen, op. cit., p. 57. [8] Bharti Kher, email to the author, November 23, 2013. [9] Nancy Adajania, "Bharti Kher: Of Monsters, Misfits, and the Biggest Heart in the World" in Gayatri Sinha (ed), *Voices of Change: 20 Indian Artists*, 2010, Mumbai, Marg, p. 230. A class trip to Amsterdam at the age of 12 to see Flemish Old Master paintings made a deep impression on Kher. [10] Susannah Tantemsapya, "Bharti Kher," *Whitewall*, New York, Summer 2013. [11] Holland Cotter, "Agnes Martin, Abstract Painter, Dies at 92," *The New York Times*, December 17, 2004. Kher also remarked on the importance to her of the strongly colored, carefully measured abstract paintings of British artist Bridget Riley (b. 1931). [12] Originating in philosophy, psychoanalysis, and postcolonial theory during the 1970s, by the 1980s, within the monocular vision of the western art world, the idea of "otherness" had become reduced to little more than a mantra that "permitted" the representation of oppressed groups or "minorities." [13] Typical examples of this "new romanticism" in art language were: the exhibition title "A New Spirit in Painting," London, Royal Academy, 1981 curated by Christos Joachimides, Norman Rosenthal and Nicholas Serota; Achille Bonito Oliva's theory of the *transavant-garde* that maintained that new forms of cultural nomadism had "created a short circuit between the traditional avant-garde and local conditions" (this was illustrated by a traveling exhibition of predominantly Italian artists beginning in 1981); the artistic persona and mythology of German artist Joseph Beuys (1921–1986); and the title of the exhibition "Les Magiciens de la Terre," ("The Magicians of the Earth"), Paris, Centre Pompidou, 1989, curated by Jean-Hubert Martin. For more on this period, see pp. 27–30. [14] Email to the author, December 12, 2013. [15] Kher talking about first moving to Delhi: "I remember being afraid to say what I thought, but eventually I just had to say: 'I don't believe in authenticity. I think it is bullshit.' I don't think that you have to be from a specific place to experience a more profound 'anything.' If we are going to talk about authenticity of cultures, then it's a completely fucked up prospect, especially in relation to experiencing art. Because art touches something that is common to us all." Bharti Kher, "A Conversation with Chrysanne Stathacos and Susan Silas," op. cit.

The studio is a place where ideas and things of this order come together. Reality of many kinds is transported here to be distilled, concentrated, and intensified. Contrary, complex, contradictory, necessarily unresolved, and sometimes defiant, the works shown in Shanghai are the tip of an iceberg of artistic production that can be traced back over twenty years. And the thing about icebergs is that you can never quite predict where they are headed. Shimmering masses of wonder and beauty from afar, they spell danger up close. In the scorching heat of an Indian summer even an iceberg will change slowly into something else. As we already may be beginning to suspect, potential peril and the need for warning are continuing motifs in the different parables that comprise Kher's work.

It was not initially clear where the peril lay when Kher imported from the United States a ten-ton block of obsolete radiators to her Delhi studio. She started off by thinking that she would make them sing, breath, or radiate an almost unbearable heat, but after five years of deliberation and tests, she decided to just let them be. Now, mutely echoing the rib cages of long extinct animals or the stacks of Donald Judd boxes, *The hot wind that blows from the West* (2011) has become an invisible monument to the monumental folly of hubris. (**fig. 6**) An admirer of minimalist art from the 1960s, Kher finds its aesthetic impossible to emulate because she regards herself as an incorrigible maximalist, yet she has learned much from its reductive method, factoring the impact of process as well as the possibility of failure into the final work.[5] She has described the idea for this as having arrived "like a message" but after a long time of self-analysis and reduction, the radiators were eventually returned virtually unchanged to North America. This flirtation with folly was "a warning," she explains, this kind of truth "is what art does."[6]

Kher's studio, it would seem, is much more than a refuge but a place where she can reflect and listen to her heartbeat. As a result she gains confidence to reveal her own folly as well as that of others. Folly has become an important and driving principle within Kher's work: "I had always interpreted it as an act of absolute freedom based on nothing but itself" and, related to the idea of abandonment, it gives her both freedom of consciousness and the possibility of loosing herself in the work.[7] Going to her studio enables her to converse with the world by letting it go. Seeing things more clearly in this way is her first step in taking action.

* * *

Kher was born in late 1960s London into a family that had recently arrived from India. Like many others, they had come with virtually nothing and through hard work slowly became established but, untypically, her parents quickly divorced and, with her mother, sister, and younger brother, she had to develop reserves of strength, independence, and perspicacity in order to survive.[8]

She grew up, an obvious outsider, but hardly speaking Hindi, in the bourgeois badlands of suburban Surrey. There was one hazily remembered visit to India at the age of four. By nine she was consuming piles of Indian *Amar Chitra Katha* comics illustrating the Hindu gods and myths that her mother had found in Tooting Market and, inspired by a teacher at school, was also precociously making drawings from life and developing an appreciation of the European Old Masters.[9] Single-minded, she never considered becoming anything other than an artist, her reason being that she could work with her hands. She studied painting at the Polytechnic of Newcastle upon Tyne, graduating in 1990 and struggled, as most young artists do, to find a voice of her own. In 1993, she flipped a coin to decide whether the next step should be Delhi or New York.[10] Unwittingly, the die was cast. Delhi it was; she fell in love there and decided to build both a family and a place for herself as an artist in India. But when she touched down on the acrid tarmac of that chaotic city, what baggage did she have in tow?

6

6

6

Perhaps the largest bundle was a sense of dissatisfaction, a prerequisite for any creative act, which youth inevitably derives from the hierarchies that bind it. Unless they learned how to play the market or went to teach, art graduates in Thatcher's neoliberal Britain had the art-life expectancy of a snowball in hell. The golden age of the Y[oung] B[ritish] A[rtist]s was just beginning to dawn, and British society had been broken in a way not experienced since the 1920s. Yet the atmosphere and reality of widespread religious and sexual violence that she now encountered in India was hardly a respite and must have meant that, on a social and political level at least, her move felt like a flip from one kind of dysfunction to another.

Kher's motive in moving, however, was not to escape but to change from one state into another, to develop, to grow. Not surprisingly, the memories she took with her to Delhi were mixed. On the strong side was the example of women artists who had interrogated both themselves and the world around them through their work: Louise Bourgeois (1911–2010) above all, then just beginning to get the wider recognition she deserved; but she also remembers the libidinous violence of Paula Rego's (b. 1936) paintings of young girls; (fig. 7) the glacial gaze of Marina Abramović (b. 1946), whose Medusa-esque, python-bound durational performance *Dragon Heads* (1990–93) she had seen at the Tyneside Edge Festival in 1990 (fig. 8); and, perhaps most surprisingly, the "minimal" paintings of Agnes Martin (1912–2004), who for a large part of her life had worked in isolation in the desert around New Mexico and, in spite of the subtly muted colors and faint lines by which her work is recognized, always regarded herself as an abstract expressionist.[11]

Among less fond memories was the brash hype of 1980s art magazines. Kher could not imagine how her still tentative paintings full of mutants, mannequins, dolls, and animal hybrids would ever fit into this glossy world. Prevailing cultural discourse was also a problem: along with sclerotic pop and ubiquitous Po-Mo, the word on the street was an elevation of the "Other."[12] According to one's perspective, this could mean almost anything—women, men, migrants, "people of color," or the LGBTQ community—and the acknowledgement of difference in this way, along with the art-political necessity of having a clearly defined, "authentic" identity, quickly became more important than making art itself.

The tacky veneer of the 1980s western art world was further varnished by its artspeak when buzzwords such as spirit, nomad, shaman, and magician quickly became part of the non-critical vernacular.[13] With the benefit of hindsight, such limp romanticism, sepia-tinged by the melancholy of empires forsaken, is reminiscent of the last plangent chords of *The Titanic*'s orchestra just before the unsinkable liner hit an iceberg and went to the bottom. A more spirited accompaniment for these times was the aggressive neoliberal quick step of successive British and US governments as they privatized and deregulated almost everything to the continuing detriment of public ideals, amenities, and space.

As a graduating art student in northeast England at the end of the 1980s, Kher was subject to these radical political and social changes. The region was still smarting from Margaret Thatcher's decimation of its coal-mining, steel, and ship-building industries, and in 1990 Newcastle joined London in becoming a hotbed of protest against cuts in further education and student grants and the unpopular new poll tax. She describes this time as her "first and last tryst with active politics."[14]

With regard to art theory, it seemed that "otherness" was little more than a smokescreen that enabled discrimination still to be enacted. Kher was and still regards herself as constitutionally "other" wherever she goes, and has an instinctive horror of being pigeonholed by other people's ideas of whom or what she should be.[15] Embarking on a painstaking and sometimes fruitless search for truthful forms of expression that were rooted in her own experience and background, she began to develop an equivocal,

4 | Arione | 2004 | mixed media | 180 x 50 x 50 cm

5 | Piero della Francesca | Polyptych of St Anthony: St Agatha | c. 1460 | tempera on panel | 21 x 39 cm | National Gallery of Umbria, Perugia

6 | The hot wind that blows from the West | 2011 | 131 radiators | 195 x 264 x 254 cm

7 | Paula Rego | The Family | 1988 | acrylic on canvas-backed paper | 213 x 213 cm | courtesy the artist

8

9

10

alternative, and critical private mythology that was first expressed in her early paintings and drawings from the late 1980s and early to mid 1990s.

The surrealistic framework created by Kher in this body of work, in which animals morph into monstrous human hybrids, is reminiscent of the caricatures of JJ Grandville, whose two-volume collection of drawings and fables *Scenes From the Private and Public Life of Animals* (with the telling subtitle *Studies of Contemporary Customs*) had been published in Paris in 1842.[16] **(fig. 9)** Kher's paintings suggest similar concerns as creatures are placed within what seem to be carefully ordered hierarchies. Kings and queens, or at least their crowns, are present, as is a red-shoed moppet (perhaps the artist), along with a naked black man (sometimes with a crown), dolls and mannequins, bananas (single and in bunches), an aggressive, rather angry ape, and a menagerie of other animals, many of them composites of different species. But in spite of all this obvious energy, it is never clear where power really lies.

The spaces in these works are also ambiguous: sometimes flattened, at others like board games, at others like dreams, but they all depend on the free associations that can be made between their images, spaces, and titles. In *The Last Supper* (1991), a painting dominated by contrasting shades of blue, a surrogate Mary Mother Mild cradles a pouting homunculus behind a cake with flaming candles. **(fig. 10)** Yet this work is not a parody of a religious icon, but rather a subtle transformation of an image of supporting motherhood into one of unspecified threat—in this case to a petulant, unprepossessing mini-male, sporting a gangster-like homburg and shades. In spite of the "mother's" quizzically benevolent expression, one suspects that the last supper will be the cake she stuffs down his throat.

Give and Take, a Rothko-on-its-side-like abstract of the same year, luxuriates in a large, unevenly brushed field of dark emerald green. To the full height of its left side, a bright yellow lozenge has been painted over the green but within this, as if it were an open doorway, stands a pale, naked, bound, and blindfolded figure, its prominent open jaws jutting out into the dark-green expanse. **(fig. 11)** A just taller, but dark, pot-bellied ape, brandishing a knife and fork in its hands, approaches rapidly from the right. A golden light illuminates its mouth that in its forward rush comes tantalizingly close to the open maw of the bound figure . . .

This strange painting is not a satire of abstract art but, within its overarching parody of cannibalistic desire, manages to consume this idea as well. Who can really judge what will be given or taken in this work? This bizarre exchange revolves around the bound figure set to swallow the yellow light that obviously animates the ape's forward movement. But this will be at the expense of its own white tender flesh readily yielding to the absurdity of the ape's knife and fork that hover so close. What kind of transaction are we witnessing here? Is it between stasis and synergy, entropy, and energy, or simply a miserable, if humorous view, of life and death?

The large, square-format painting *Snakes and Ladders* (1991) refers to this board game's Indian origin when, in the 13th century, it had been devised as a moral study for children, the snakes visualizing the forces of evil and the ladders those of good.[17] **(fig. 12)** Kher, however, adopts these conventions to reverse them. Pythons are entwined over its russet-crimson surface across which four ladders of different colors and thicknesses have been painted, some flat, others suggesting depth. As befitting such a board game, there are squares on an implied grid that have their own images or symbols but which appear randomly with little reference to the position of either the snakes or the ladders. Adding to the confusion, this painting seems to contain at least three kinds of space: the organic, "dragon-like" territory of the pythons, the ambiguous tilts of the ladders and what should be the control, the element that holds it all together: the uniform size of the square vignettes on the single plane of the board. Perversely, Kher places

[16] JJ Grandville (1803–1847), *Scènes de la Vie Privée et Publique des Animaux (Etudes de Moeurs Contemporaines)*, Paris, J. Hetzel, 1842, 2 vols. [17] Bharti Kher, email to the author, December 2, 2013. [18] Bharti Kher, Aveek Sen, op. cit., pp. 61–62 [19] Bharti Kher, email to the author, November 23, 2013. [20] Ibid.

11

12

13

these vignettes both in front and behind the other elements so that we have to infer that some of these squares are smaller or larger than the others.

Disparate images are highlighted in the squares: a head-and-shoulders portrait of what seems to be the British queen; a split, mirror portrait of the artist herself; a close-up of a python's jaws (an image that re-appears in the later "Hybrid" works); Adam and Eve in the Garden of Eden, a man with a gun pointing at his head, the body of a zebra morphing into a long-necked giraffe, a profile portrait of a postman with a Hitler moustache against a Van Gogh background, a Virgin and Child, a sheep in a hospital room, a donkey in an open landscape and what seems to be a map or an aerial view of land . . .

In these ambitious, at times unresolved paintings, Kher is bringing together different images, worlds, languages, and perspectives in ways that allow them to retain their original references while shifting to another completely different form of reality. But she gradually realised she was getting bored with painting and needed to explore other approaches and media.[18]

* * *

DE: You seem to have made very little work between 1993 and 1996 when you first arrived in India. Would you describe this as a period of digestion and adaptation?

BK: I call this my frustrated years . . . [I] made a load of really shitty art . . . I think that the whole period from 1994 to 1999 was basically me trying to find a voice . . . [to] say something meaningful. We [she and her husband, artist Subodh Gupta] were free because no one was paying us the slightest attention, save a few visitors. It was step-by-step . . . one work at a time and then testing it out on your peers and friends.[19]

Although not aware of it at the time, 1995 marked new approaches within Kher's work that are still being played out. *Misappropriate Functions* (1995) continues the engagement with lush tropical color of her earlier paintings but in it a dark female semi-nude wears a bra woven out of the artist's own hair and has a spiral pubis made out of the small stick-on eyes used to animate the statues of gods and goddesses.[20] (fig. 13) This is the first time Kher had used both relief and "ready-made" objects in her work—Marcel Duchamp's example of appropriating everyday objects to challenge the traditional media and institutions of art had provided a channel through which other ideas and ways of working could flow.

Gradually she began to paint less and started to rely on the numinous accretion of ready-made bindis to provide form, line, color, and volume in composite works that were assembled in increasingly complex formulations. Sometimes she incorporated bindis into paintings or sculptures or used paint in bindi works. The first of these was made in 1995. The bindi, a small, traditional, stick-on spot bearing different symbolic patterns, worn on the center of the forehead by Indian women, had a cosmetic function as well as a strongly gendered significance. In Kher's earliest works it seemed as if the gathering together of such insignificant, disposable objects to make strong, eye-dazzling forms implied a previously hidden and even ferocious female power. Yet, as her use of this material has evolved, the bindi has become more versatile and can act as a form of drawing, moving across objects as well as flat surfaces.

Lines of different colored serpent bindis snake energetically across the bare stomach, breast, and neck of *Arione's Sister*, a "Hybrid" sculpture from 2006, (fig. 14) while in *The Skin Speaks a Language Not Its Own* (2006), the same pattern in white creates a shimmering quality over the entire gray skin of a sleeping or dying cow elephant. (figs. 15, 16) In *Contents* (2010), a collection of twenty-one 19th-century medical charts on the subject of birth abnormalities, the bindis flow freely over the surface of the paper

8 | Marina Abramović | **Dragon Heads** | 1993 | performance series

9 | JJ Grandville | "La Chatte Anglaise" **(The English Cat)** | from **Scènes de la Vie Privée et Publique des Animaux** | vol. 1, p. 93 | Paris | 1842

10 | **The Last Supper** | 1989 | oil on canvas | 122 x 91 cm

11 | **Give and Take** | 1991 | oil on canvas | 90 x 90 cm

12 | **Snakes and Ladders** | 1991 | oil on board | 274 x 274 cm

13 | **Misappropriate Functions** | 1995 | oil on canvas, hair, ceramic eyes | 175 x 152 cm

14

15

16

decorating, coloring, and obscuring the horrific subject matter in what seems to be a propitiation of the suffering it implies. The bindis also indicate flows or energy that, according to the scale of the work, could suggest surfaces of skin, sea, sky, or land. In some of her large works these could just as easily represent the movements of microbes or viruses as comets or stars.

Target Queen (2013), one of Kher's works of this kind, was designed to cover the north facade of the Rockbund Art Museum. (fig. 17) Its strong color makes it clear that her concern for the language and color of painting is far from over. It is constructed out of specially made, super-sized bindis of differing colors and diameters that are superimposed in diminishing order on a uniform background. Radiating, target-like bursts of color explode out of its surface, while its modular circular forms provide a stabilizing substance and balance.

During 1996, Kher explored other approaches. The series "Making Monsters"[21] was a precursor, in thought at least, of the later monstrous "Hybrids." One part of this work, never publicly exhibited, began with a performance in which the artist, wearing an absurd "Benny Hill" nude apron as an extra skin, embarked on a search for the elixir of life. The photographs, shot in the kitchen, of what could be either a contemporary Genesis myth or a horror film were double-exposed showing her hands superimposed as they sliced and stirred while preparing the eternal brew which was really an apple crumble.[22]

The "monstrous" had become a recurrent character in Kher's thinking as it expressed in a humorous and unsettling way her belief that the mixing or bringing together of disparate elements—hybridity, in fact—was necessary for all aspects of life. And in an opposite sense, it could also refer to elements in the world she really did not like. Slowly she began to conceive of what was to become the "Hybrid" series (2004), framing her work within a domestic rather than a nonspecific or painterly environment. Here the humble vacuum cleaner, along with other cleaning implements played an important role. Fetish-like, its nozzle adopted the form of the rapacious heads of animals, while its still prosaic plastic body sought the sexual solace of others.

With the exception of the "Hybrid" series, *Self-Portrait* (2007), in which the head and shoulders of a young woman are morphed with the features and facial coloring of a baboon in a pose reminiscent of 17th-century Dutch painting, Kher decided never again to appear in her work and has used models for subsequent photographic and three-dimensional works.[23] (fig 1) It was as if she had realized that in order to preserve critical distance, it was necessary to create both a physical and mythical distance when depicting the female body.[24]

Kher carefully orchestrates the collision of words, images, and ideas that characterizes her work to create unpredictable spaces in which something else can happen. Her work occupies the world of the trickster—lords and ladies of misrule—who challenge hierarchies with their speed, wit, and humor of the shapeshifter, another figure from folklore and religion, who can move seamlessly from one state into another, or of the skywalker, looking down from above, for whom distance and scale are of little importance. Their form-changing super powers make these characters the natural progeny of Kher's earlier "Hybrids."

Within this context, three adapted body casts of "Goddesses" are shown here. In *And All the While the Benevolent Slept* (2008), the earliest of these, a naked, squatting female with wiry streams of copper blood spurting from her severed neck echoes the figure of Chhinnamasta, a tantric Indian goddess who personifies the interdependence of life, sex, and death.[25] A ferocious aspect of Devi, the Hindu divine mother, she feeds her followers with her blood, usually collected in a cup made out of the cranium of an upturned human skull. Kher, however, disrupts this model by putting a complete monkey skull in the figure's left hand that gazes in open-jawed rictus at her

[21] This work consisted of photographs, paintings, a sound work, and a recipe. [22] Bharti Kher, email to the author, November 25, 2013. [23] Kher's children, however, have made guest appearances as mini-hybrids in both *Angel* (2004) and *Family Portrait* (2004). [24] The artist's eyes appear in other "Hybrid" works but no other part of her body. The only exception is *Self-Portrait* (2007), (fig. 1). Ibid. [25] Gayatri Sinha, "Bharti Kher: A Bearer of Signs," in Parasol Unit, op. cit., p. 125. [26] Leonard da Vinci, *Lady with An Ermine*, 1489–90, oil on wood panel, 54 x 39 cm, Czartoryski Museum, Kraków. [27] Bharti Kher, email to the author November 25, 2013. [28] Bharti Kher, Aveek Sen, op. cit., p. 53. [29] Bharti Kher in Ziba Ardalan, "The Second Skin that Speaks of Truth," Parasol Unit, op. cit., p. 17.

17

18

19

non-existent head. Inevitably this strikes an absurd, almost Hamlet-like note, further accentuated by the fine porcelain teacup and saucer held firmly in her right hand. (fig. 20)

The light flesh-tones of the life-sized, naked female figure in *Warrior with Cloak and Shield* (2008) suggest a different but no less syncretic mythology. Her head sprouts monstrous antlers from which hang at one point, her "cloak," a discarded cloth. The "shield" is a large, yellowing banana leaf hung across one shoulder. Like the protagonist in Albrecht Dürer's famous engraving *Knight, Death and the Devil* (1513–14), this warrior radiates resolution and fortitude in the face of loneliness and desolation.

Within the western tradition, horned figures are usually associated with the devil or the violence of marauding vikings; within Hinduism, however, there are a number of benevolent horned gods often associated with Shiva. In this figure, Kher highlights the ambivalence of her symbolism by combining opposing signs in ways both unsettling and uncanny. Large horns are associated with the male of the species, the warrior is female; although they may be soldiers, women are not usually warriors; the horns, her weapons, weep as if they were the branches of a tree and would be useless for combat, their curved shape and the way they connect with her hands make them like a prosthesis; her shield and cloak are so flimsy that they would protect nothing. Yet in spite of all these conventional disabilities, the figure still seems strong, rooted, self-confident, even assertive.

The *Lady with an Ermine* (2012), which takes its title from a well-known portrait by Leonardo da Vinci, implies a similar balancing act. [26] Here the dark colored cast is of a naked, standing woman leaning against a large, rustic pitchfork around which is tied, at roughly pubis height, a swathe of nondescript fur. This rough visual pun is quickly forgotten as one looks at the figure's hunched stance and saddened eyes, gazing ahead through the "bars" of the pitchfork. What initially appears to be a tall conical headdress is actually a solid block of chiseled gray granite that has been balanced on the top of her head by slicing off its crown. This atrocity and the precarious balance of the figure itself (which has no stabilizing base) is further accentuated by a stack of four decorated porcelain cups and saucers, topped by a milk jug, which teeters on top of the headdress at the highest point of the sculpture itself. (fig. 21)

The idea of contrast—between materials, colors, textures, gravities, weights—is fundamental to this and other works in this series. They are all cast from women whom Kher knows and asks to be part of her work in what she describes as "a process of catharsis and memory." [27] By the time this process is complete, implacable and uncompromising, these figures have become denizens of a parallel universe, in which they remain "infinite in the sense of what they can do . . . they create awe and wonder and horror." [28]

* * *

In such works as *The Deaf Room* (2001–12), a large cubic enclosure constructed out of dark bricks made out of melted-glass bangles mortared together with rough clay, the idea of silence is an overwhelming impression. There is little sign here of those pretty, domestic objects that once used to adorn the arms of Indian women and would make a noise when they moved. In their changed state they have been forced to become silent, and a strong feeling of absence is inevitable when entering the tall confined space they now define. In one sense this work is a cell, but in material terms it remains echoingly empty. For Kher "the blackness/darkness of the work symbolizes the silence that the women in this house left behind when they were gone." [29] (fig. 18) In some respects one could describe Kher as now working on an architecture of absence. "Leave Your Smell," an exhibition held in 2011 at Galerie Perrotin in Paris, extended this idea further by showing stairways removed from old buildings that led nowhere. Sometimes their steps and risers were decorated with bindis, and often saris were draped along

14 | Arione's Sister | 2006 | mixed media | 185 x 127 x 76 cm

15 | The Skin Speaks a Language Not Its Own | 2006 | fiberglass, bindis | 142 x 456 x 195 cm

16 | The Skin Speaks a Language Not Its Own | detail

17 | Target Queen | 2014 | PVC, aluminum | site-specific installation with bindis based on 2007 painting | facade of the Rockbund Art Museum, Shanghai

18 | The Deaf Room | 2001–12 | glass bricks, clay | 244 x 244 x 244 cm

19 | The Night She Left | 2011 | wooden stair, wooden chair, sari, bindis | 266 x 91 x 280 cm

their length. For Kher, the sari "stands in for an absent person . . . a frozen moment."[30] (fig. 19)

These works are a kind of time capsule, almost intangible evidence of a once safe and happy domesticity that that can be perceived even after it has been destroyed so that it can be then mourned. It is difficult not to think of recently well-publicized sexual crimes against young women in India when thinking about these works, but there is no direct reference to them, and their redolence extends far beyond the particular case.

For Kher, "the role of art . . . is not to answer but to ask,"[31] and as part of her mission to interrogate rather than instruct, she has resisted the blandishments of both autobiography and propaganda in a continuing search for what she feels is true. Although inevitably present in her work, she does not reveal herself in the ways most people expect.

Not unlike icebergs in India or snowballs in hell, the question of her own presence or where her models come from is perplexing. The answer is "nowhere" and "everywhere." "But who are they—a friend, a model or just products of your imagination?" "'No,' she retorts, 'they are you.'"[32] ●

20 | **And All the While the Benevolent Slept** | 2008 | fiberglass, porcelain, plastic, mahogany, copper wire, bindis | 180 x 180 x 100 cm

21 | **The Lady with an Ermine** | 2012 | fiberglass, granite, wood, leather, fur | 230 x 60 x 60 cm

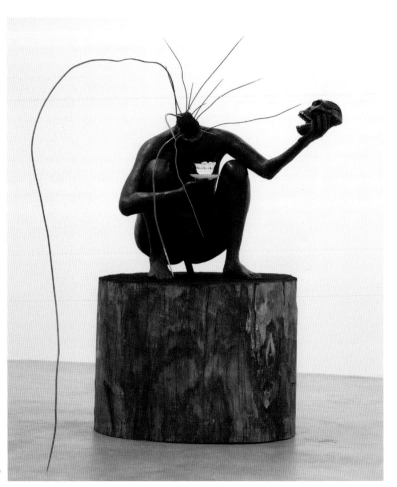

20

[30] Ibid., p. 18. [31] Bharti Kher, "A Conversation with Chrysanne Stathacos and Susan Silas," op. cit. [32] Bharti Kher in Martin Herbert, "Bharti Kher," *Art Review*, March 2010, p. 77.

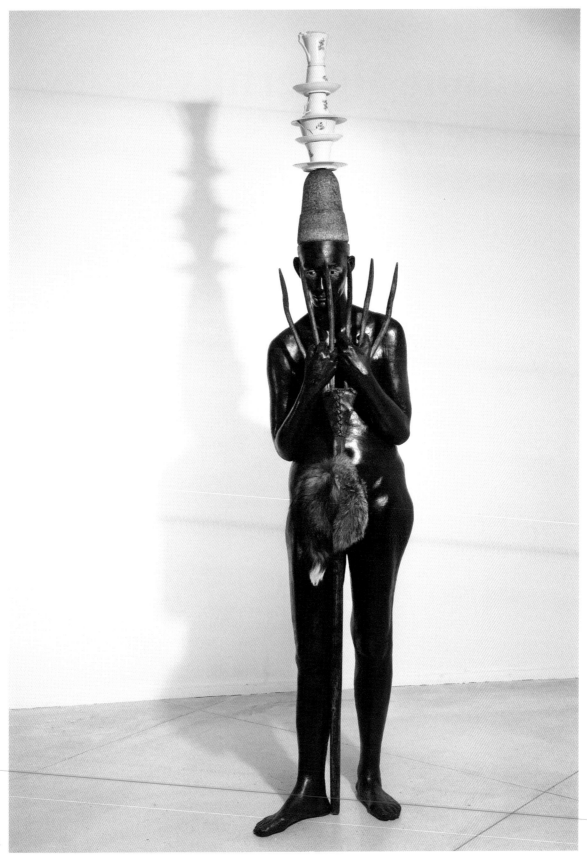

Epilogue
Tradition, Modernity, and the Present

And so, on this last visual note—a balancing act contrived by an established female Indian artist between a painting by Leonardo da Vinci, a contemporary sculpture of a giant Indian "deity," and an ironic statement about culture and individuality that extends far beyond its initial context—this book draws to a close. It has been a long, purposefully rambling journey—from the "slippered pantaloon" of its *commedia dell'arte* beginning (a figure, like spaghetti, almost certainly derived from an earlier Asian model)— to this powerfully syncretic figure. Like this image, this journey has been a celebration of exchanges, harmonies, rhymes, and profound disjunctures— not only between those of tradition, modernity, and the present, ostensibly the book's central topic, but also between similarities and discrepancies in collective and individual histories, between opposing notions of "East and West," between different realizations of identity and culture, and, most cogently, between wildly differing perspectives on how, where, when, if, or to whom, "progress" has been of benefit.

Driven by self-interest and hubristic faith, the European idea of modernity burgeoned out of impressive advances in science and technology. These, combined with what may now be regarded as a misplaced sense of moral —or racial—superiority, led to a derision of the past, along with those deemed consigned to it. This dead zone of history was quickly put to work—replaced by new, modern, "fit for purpose" forms that soon became appropriated or normalized as "traditions" themselves.

But in spawning modernity in many guises, the revolutionary cultures of 18th-century Europe and the United States could not foresee that they had created an unrealizable chimera. Within the system of trade, knowledge, conviction, and power that brought the western colonizers together, desire for happiness, enlightenment, freedom, and equality was systematically undercut by incompatible ideologies of destiny, property, and entitlement that, until now—whether under free-market capitalism or state communism—have never been adequately reconciled. In this respect, modernity has been deeply flawed from the outset and has continued needlessly to condone (both in its own name and that of tradition) the most inhuman acts on "others," ourselves and on the world we inhabit.

* * *

In contriving this absurd confluence of art and trousers, I have tried to use a different prism to counteract the reflexive historical kneejerk of eurocentricity and prejudicial knowledge. It is one that regards modernity as one tradition constantly mutating among many to allow for a wider consideration in art of both existential and aesthetic concerns. In the art discussed here, living traditions in contemporary Asian art have been mixed with the multifarious impacts of modernity upon them, many of them—but not all—independent of colonial origin.

[1] Many of the works discussed above address both these and other, more personal, approaches but, to generalize: those by Makoto Aida, Chatchai Puipia, Choi Jeong Hwa, Heri Dono, Bharti Kher, Leiko Ikemura, Tomoko Kashiki, Song Dong, KG Subramanyan, Rodel Tapaya, Xu Bing, Yeesookyung, and Zeng Xiaojun have, at different levels, been involved with rethinking the politics and representation of tradition in the present. The works of Ai Weiwei, Rasheed Araeen, Cai Guo-Qiang, Nezaket Ekici, Naiza Khan, Jitish Kallat, Rashid Rana, Chiharu Shiota, Hiroshi Sugimoto, Sun Yuan & Peng Yu, Xu Zhen, and Miwa Yanagi have also been concerned with the philosophical and/or political connotations of the perception of time.

By following this approach, unusual parallels have emerged: in the reactive ways that art and trousers have both expressed and satirized power, for instance, as well as in the, often random, ways in which their forms and functions have moved from one culture to another, or in the fashion by which they have been thought to connote either "civilization" or "barbarity." These parallels go far beyond Asia. Our brave new "global" world is, in many respects, not so very new. Art, migrations, trade—and trousers—have existed since the dawn of history.

I have also applied the same prism specifically to the history of art. Essentially, contemporary art is no different from any other in that its best examples crystallize the energy, thought, and life of their time. Yet, as can be seen in the interchanges, artists' lives and works described here, a critical distance, pivoting on a transforming self-consciousness and perceived role for the artist, has intervened in this continuum. This has been expressed by the desire, or need, to step outside time in order to evaluate the vagaries of power and how these relate both to the present and to the evolution of cultural tradition. In other cases, artists have taken a more philosophical path by questioning, from different points of view, the fundamental nature of time, space, place, and being in their work. [1]

And in having to navigate these shifting sands of tradition, modernity, and the present, the viewer, or reader, assumes the necessary role of arbiter. Regardless of the characteristics, or beliefs, of the individuals who produce it, art (wherever, whenever it is made) can only make sense as a strategic, aesthetic-moral gesture that reverberates within humanity—even if it may initially appear as dubious or ambiguous. Any further step will ultimately depend on an artist's good faith being reflected in that of the viewer as well as on willingness to give art time. And, of course, not everyone will agree with everybody, on everything, all the time.

* * *

Art is fundamentally concerned with the aesthetics of representation—in different forms, on many levels, from various perspectives—which serves as a bridge between the humanity of an individual and the world at large. At its best, its intelligence, generosity, acuity, and talent impresses (not always pleasantly) minds, bodies, and hearts. But it also provides experience that could not take any other form and that may, in time, open up possibilities of unique insight and, perhaps, delight.

This history of trousers, and the collection of essays about art that accompanies it, are devoted to this cause. It is dedicated to the present and future of contemporary art in Asia—and elsewhere—as well as to those who create and enjoy it. •

INDEX

art & trousers
Tradition & Modernity
in Contemporary Asian Art

First published **2021**

Copyright **David Elliott & ArtAsiaPacific Foundation**

The moral right of the author has been asserted

Published by **ArtAsiaPacific Foundation, Hong Kong**

Distributed by **NUS Press, Singapore**

Printed in **Hong Kong**

ISBN **978-0-98968853-6**

Designed by **Anıl Aykan** at **Barnbrook**

Publisher **Elaine W. Ng**

Editor **HG Masters**

Proofreader **Brady Ng**

Image requests **Esther Chan, Pamela Wong, Sophie von Wunster**

Editorial assistance **Ysabelle Cheung, Xuan Wei Yap**

The publisher gratefully acknowledges the generous contributions to the book by Yoshiko Mori, Judith Nelson, Aey Phanachet and Roger Evans, the Charina Foundation, Rossi & Rossi, the Korea Arts Management Service (KAMS), Pace Hong Kong, Perrotin, Mizuma Art Gallery, and Ota Fine Arts.

Every effort has been made to identify and locate the rightful copyright holders and to secure permission, where applicable, for the reuse of such material. Credit, if and as available, has been provided for all borrowed material, either on-page, or in the acknowledgement section of the book. Any error, omission or failure to obtain authorization with respect to material copyrighted by other sources has been either unavoidable or unintentional. The author and publisher welcome any information that would allow them to correct future imprints.

A note on the transliteration of names: All the names in this book have been romanized, unless specified by the individual or their estate. For the names of people of Chinese, Japanese, and Korean heritage, the author has used the order of their first and last name as it most commonly is used in international (and English-language) contexts. In the case of Ottoman-Turkish names, we have used the modern Turkish spellings.

artasiapacific
foundation

korea Arts
management
service